things as they are

BY MARY PANZER AFTERWORD BY CHRISTIAN CAUJOLLE

things as they are

aperture foundation

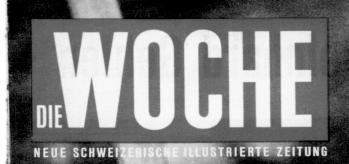

Wasseralarm gibt dieser Walliser Bauer, der mit seinen Kameraden seit vier Tagen bei Siders regen das Hochwasser kämpft. Die anhaltenden Regenfälle haben vor allem im Wallis und im Jura die Bäche und Flüsse in zeißende Ströme verwan-delt und auch in andern Schieten der Schweiz zu Überschweimungen und schweren delt und auch in andern Schieten der Schweiz zu Überschweimungen und schweren delt und auch in andern Schieten Bildbericht auf Seiten 16-17.)

WOCHE

Olten / Zürich. 17. Jan. — 23. Jan. 1955 Verkaufspreis 50 Rp. Deutschland 70 Ptg. Frankreich / Saar 60 frz. (Italien 100 L. Österraich 3.20 Sch.

3 3001 00913 963 4

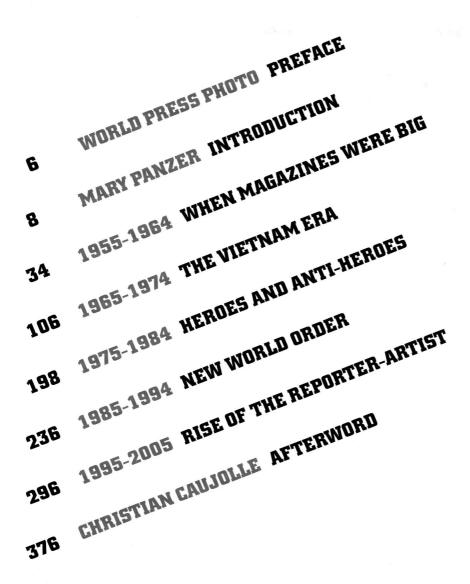

WORLD PRESS PHOTO PREFACE

TETE SET

#BXBDJLN ############EBR-RT LDT##C-025#1159 3935 740#TD 7532PR01 A DEE04BEDRBE R MELTDND042TRACDR ARSPC ELCTRONIC SYSTEMS #0049D305 RICHARDSON RDP00534LANSDALE.PA 19448-2495

www.time.com AOL Keyword: TIME

In its first fifty years, World Press Photo has become a truly global platform for professional press photography. Our annual contest draws more participants than any other photography competition and the exhibition of award-winning work is shown all over the world. Until on-screen publication took off a few years ago, the printed page was always the main vehicle for the presentation of photojournalism, so it seems fitting to celebrate our first half-century with the publication of a book.

Rather than produce a commemorative anthology of World Press Photo prizewinners, we decided to look at the history of photojournalism over the period of our involvement. And while most exhibitions and books of photojournalism – including our annual contest – assess the achievements of photographers by showing images outside their original press context, here we examine the form in terms of its original production and use. We do so at a time of rapid change in the field, in order better to reflect on what photojournalism is, how it has developed and where it might go from here.

This book with its related exhibition is a celebration of photojournalism and its contributors – the photographers, of course, but also the publishers, art directors, editors and agencies that work with them to depict our societies and account for the history of the world in pictures. Unlike our annual competition, it is not intended to show 'the best', but rather to tell the story of photojournalism through the selection of published features. Here we have relied on a wide group of editors, photographers, historians and magazine collectors to suggest ingredients for this story, and on Mary Panzer, Christian Caujolle and Chris Boot to put it all together. We are proud of the selection while recognizing that such a history is inevitably partial, and that even 400 pages are far too few to do justice to everyone's involvement. We trust that this book will be accepted as we intend it – as a tribute to the endeavour of each person who has helped shape the story of photojournalism, whether or not their work is directly represented in the following pages.

This book features rather more publications from Europe and America than from other parts of the world, reflecting their dominance in the history of photojournalism to date. But things are changing. If we publish a similar book half a century from now, it will undoubtedly reflect a broader geographic spread. In the last decade, our global educational programmes have become a core World Press Photo activity, alongside the annual contest and exhibition. We currently contribute to the training of photographers and editors in many countries outside the mainstream of the traditional Western media. The exposure of work produced by our alumni in different continents is growing. The talent, dedication and quality apparent in their photography are a source of pride to us, and we hope that throughout the world we will see the emergence and growth of publishers who may do credit to their talent.

We hope too that this project will promote knowledge of photojournalism to a broad public and that alongside World Press Photo's educational programmes, it may contribute to the empowering of photographers to navigate this dynamic environment with awareness and confidence – especially those at the beginning of their careers. Above all we hope that it will challenge, excite and serve all those involved in photojournalism, upon whose labours all our activities depend.

Michiel Munneke, managing director Gerrit Jan Wolffensperger, chairman World Press Photo

MARY PANZER INTRODUCTION

1.20

'The contemplation of things as they are, without substitution or imposture, without error and confusion, is in itself a nobler thing than a whole harvest of invention.' Sir Francis Bacon (1561-1626)

'Photojournalism' is a term most people understand, but it has thus far defied precise definition. Harold Evans, former editor of the Sunday Times, defined it as 'pictures on a page' while for Wilson Hicks, longtime photo editor at Life magazine, it was 'words and pictures'. Dan Mich, Hicks' counterpart at Look, called picture stories 'the modern picture magazine's most important contribution to the art of communication', characterizing them in terms of function - 'storytelling ... done by related pictures arranged in some form of continuity', accompanied by subordinate text. More recently, German photojournalist and historian Robert Lebeck, following contemporary literary critics who take the response of the audience into account, has defined photojournalism as 'the sequence of pictures on the printed page which [appears] in magazines and ... actually reaches the reader'. All accept photojournalism as serving a descriptive purpose photography with the function of recording and reporting 'things as they are'.

Here we present 120 picture stories made over the past fifty years, each one shown in the context in which it was published (in most cases, as it was first published). Although we approach our subject from the viewpoint of photographers and photography, we consider photojournalism in context; that is, as the work of many authors - the photographers who make the pictures, the writers who create the text, the editors and art directors who organize the story on the page (and who in many cases conceive and commission it), the journals that print the story, and the audiences who read it. We have chosen to look at the picture essay - the sequence of pictures - rather than the single-picture story, because we feel this better allows us to look at ideas and approaches being explored within the medium, and to see how these have changed over time. We have also focused far more on magazines than on newspapers; while magazines that present stories over many pages have been the primary vehicle for the sustained picture essay, they dominate here for more practical reasons. Magazines tend to be collected and saved in their original form, while newspapers are often preserved only on microfiche. It has been beyond the scope of this project to research and track down copies of original newspapers around the world.

Ultimately, this book reflects the combined wisdom of a community of photographers, editors, historians and collectors, deeply engaged with the history of photojournalism, whom we consulted in the process of selecting stories. Amongst all the valuable advice and suggestions we received was a sceptical response from John Szarkowski, one of the last century's most important commentators on photography: 'I thought I had made it clear in my own writing on the subject that the photojournalism experiment was on its last legs by 1955, when you begin your story. ... I share your hope that I was wrong in this judgement, and that your exhibition and book will be more than one more fat compendium of the pictures that editors expect photographers to make.' His words proved a challenging starting point for the project, as we begin at precisely the moment in time often characterized as photojournalism's golden age: the year of The Family of Man and the era of W Eugene Smith's legendary stories for Life magazine - the point when photojournalism had arguably reached a zenith of sophistication and maturity. But had it already run out of ideas then, so soon after it began? Did it subsequently become a set of editorial tropes to be endlessly reproduced? Our selection criteria became, in part, an exercise in avoiding the 'pictures that editors expect photographers to make'. Whether or not the reader thinks the last fifty years prove more interesting than photojournalism's well documented beginnings, we trust we demonstrate at least that it is a dynamic, changing form. 2005 is far too soon to declare it dead.

Selecting and preparing the book's contents has been an exciting and unpredictable journey into the recent past - but perilous territory for anyone claiming to be a historian. We do not claim that this history is definitive. It is a celebration and an exploration of what photojournalism has been and has become, and while patterns and sub-plots begin to emerge, more time must pass and more work needs doing before the shape of this story and the major monuments that mark its progress can be decisively identified. Nor do we claim that what we show here is the 'best' - for each story included there are a hundred others that might work just as well in its place, and we are painfully aware of all those important contributors to the medium that are not featured and just how many stones remain unturned. After the process of assembling this book, the story of photojournalism since 1955 in context remains fresh territory still. With the related exhibition and the debates that follow, we hope it will contribute to momentum for further study.

This account invokes - and criticizes - a myth of its own: that photojournalism is a global practice in which a single community of photographers, editors, publishers, agents and readers enjoy access to every story that appears in print everywhere around the world. At times this myth appears to be true - on the corner news-stands of New York, Paris or Tokyo, with their array of international magazines; in the offices of the photo agencies; at photojournalism festivals such as Perpignan; and at the exhibition of World Press Photo's annual winners. But while selecting stories, we have repeatedly been forced to acknowledge strong obstacles to this utopian view. Access to, and knowledge of, the world's photojournalism is far from universal, even in the age of the internet. Like all journalism, it exists only in the form in which it reaches an audience, or, as Benedict Anderson calls it (in Imagined Communities, 1983), a community. For Anderson, that community exists largely in the

shared imagination of its particular readership; he uses the example of British imperial subjects living in Bombay who, as readers of the *Times* of London, shared a single national identity although many thousands of miles away from 'home' – for many, a place they had never seen.

In fact, wherever a community can support its own periodicals, one can construct a self-referential history of photojournalism, and many such histories exist chronicles of fashion photography, sports photography, or of photography that has appeared before readers who share a language or a national identity. There are many moments when these communities intersect around the work of an especially talented photographer (for example, Henri Cartier-Bresson), or a widely recognized event (the Olympics, the death of Gandhi, or the war in Vietnam). There are also individual publications - National Geographic, for example that serve such a large community of readers and that are so widely available internationally, that it often appears that their pages accurately represent the medium as a whole. Yet it is clear that the world contains many communities, which for reasons of distance, language and culture are isolated from each other. In the Soviet Union, in Japan, in China, even in Brazil, one can find dozens of photographers whose interesting work has rarely been seen by outsiders or, if seen, has been exhibited in a museum or published in a book, where the original purpose is lost,

Below: *New York Daily Graphic*, 4 March 1880 Right: *Le Figaro*, 23 November 1889, photographs by Paul Nadar along with the original context. Photojournalism may be a universal language, but the uses to which it is put invariably remain local. There cannot be one single history of photojournalism for there is no single goal shared by all photographers, publishers and readers. In its stead, we have a dazzling array of publications, the product of many dispersed communities.

This book has been titled with a quote from Sir Francis Bacon that was a favourite motto of documentary photographer Dorothea Lange. It served her as inspiration, and she used it to explain her work to others. It applies just as well to photojournalism: the caution against 'substitution or imposture ... error and confusion', and the contrast with 'a whole harvest of invention', focus us on what exists before and beyond the creation of the photographer. Henri Cartier-Bresson used 'things as they are' to define the subject of photojournalism in his introduction to The Decisive Moment (1952). Meanwhile, there is a paradox in our application of the phrase to a history in which things appear not as they are, but as they were once, seen through the subjective filter of photographer and journal. Photojournalism is a collaborative project, in which photographers, writers, editors and publishers creatively interpret and translate the chaos of life into a product that can be distributed to readers. In the end, the business of representing reality is all about invention, and this book is a tribute to its value, power and persistence.

13º Année - Numéro 47

RÉDACTION DU SUPPLÉMENT A. PÉREVIER SECOLITAIJES AUGUSTE MARCADE ET PAUL BO

Paris - 26, rue Drouot - Paris

LE FIGARO STIPPLEMENT LITTEBAIRE

Ce Supplément ne doit pas être vendu à part

Entrevue Photographique





Nous attorn; mu un varies, and the plus commode.
A quoi hon i fait le photographe.
- Comment, c'est dans cette petite pièce que vous opérerez ? Il ne vous faut pas plus de lumière ?
- Colle-ei est très suffisante. Lei nous aurons l'arantage de vous prendre dans votre eadre mâme. Je n'ai plus qu'à vous prier, mon genéral, de ne pas faire attention à moi et de causer avec votre Dangeau comme vous avier. Thabitude de le faire à Thoté du Louvre ou rure Dumons Hourille.
- Et bien, cher ami, me dit le général, allumons une cigarette, asseyonmous et oublions Nadar.

— Je commenterai, mon genéral, par déplorer avec tous vos amis, que vous pas sogre installé si loin de Paris. Loraque vous éties à Londres, huit hurse automent séparateir de vous les membres de votre paris. Ils pouvaient se tettre en route quand ils voulsient. Quelle difference aujourd'huil Pour venir à aint-Bléire, c'est toute une affaire. Il ne part de Graaville que deux bateaux ar semaine, aux hueres les plus diverses. — Javais des raisons sérieuses pour ne pas rester à Londres et je vais vous a dire.

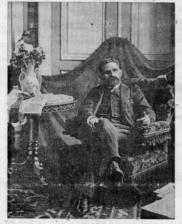

— Vous me permetter de stênographier, mon genéral; — Je vous y invite. Après les grandes dépenses nécessitées par les élections, ne celles que pours aviger l'impréva. Il m'était indispensable de faire des nomies. Or, il ne faux jamais rearreindre son trais de mision dans l'endroit ne où l'on a overt as boarse sans compter. Les familiers, les visiteurs y ent une diminution de la personne. — Mais, d'autre part, ne perferevous point à avoir moins de visiteurs?

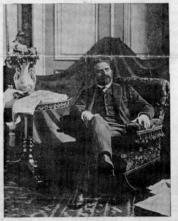

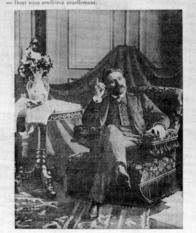

EASTIMAN HISTO LAN-PHOTOGRAPHIC COLLECTION 6 2 Cromer Collection 6 2 Samedi 23 Novembre 1859 6 2

Prix du Supplément avec le Numéro :

MES & PARIS - 25 CENTIMES HORS PA

sent spécial du SUPPLEMENT LITTERAIR Numiro ordinaire compris :

12 FR. PAR AN

Qu'importe l J'apprendrai ici à connaître mes vrais amis.
Vous me pernettrez néanmoins de regretter personnellement que vous ne soyre par estourné à Bruzelles.
Le gouvernement belge m'aurait imposé les conditions qu'il me faisait autréfois pour y restrir no jaminés convoquer mon comité, ne recevoir que des visites individuelles, ne donner lice à aucune manifestation, n'envoyer aux journaux neucone lettre signés. Bref, un enterrement politique! Me croyee-vous disposé à me laiser mettre en bière?

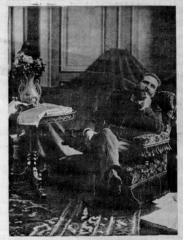

Le boulangisme, reprit gaiement le général, a la vie dure. Croyeremoi, Dans toute campagne il y a plusieurs combats. On ne les gagne pas tous, Nous en avons perdu deux, coup sur coup. Estec que nos troupes ne sont pas asses colledes pour en gagner d'autres J Ceux de mes anis qui n'ont renis aucun de nos principes, aucun des dogmes du programme révisionniste, sont d'une énergie dont vous ne vous doutes pas. Il sont, dans facception la plus large du mot, prêts à tout. Aree de tels hommes, que rien ne saurait abattre, le succis final est certais. Nous aurons le denirier mot, j'en réponds. Nous pourrions dire d'ailleurs que notre délaite est encore nue victoire, puisque la Chambre qui se comptait que to boulangistes, en compte maintennat qr. Il y en surait bien davantage ei nous n'avons à nous reprocher des fautes...

en aurait teine davantage es nous n'avions a nous reprocher dei fautes... Sur ces mots, le général Boulanger se leva, faisant deux ou trois pas, les mains dans les poches. Des reproductions de chacun de ses mouvements ont été prises. Par maiheur, toutes n'ont pas été également bien venues, et M. Kra-kow n'a graré que les meilleures. Celles qu'un verre plus loin sont de dimensions différentes. Il est, croyons-nous, inutile d'en expliquer la raison. M. Nadar, dont nous ne nous occa-pions point, allait et venait dans la piéce, tantot écloirpant, tantôt se rappro-chant, se servant aussi parfois d'un appareil de poche.

Au, moment où nous sommes, le général a la main gauche appuyée sur le dos d'un fauteuil, la main droite sur la hanche. Il semble regarder *le passe*. Après un silence, il reprend

Photojournalism before 1955

The birth of the modern picture press can be traced to the Illustrated London News, which began in 1842. A year later, L'Illustration began in Paris and the Leipziger Illustrirte Zeitung in Germany. These journals inspired hundreds of imitators and competitors, publishing photographic images along with original engravings and lithographs. Before photographs could appear in printed form, engravers first had to copy them onto woodblocks, to be set in a frame along with moveable type. Captions regularly identified the image as being 'from a daguerreotype' or, eventually, 'from a photograph'. Photography combined with text on the printed page created a new form of communication that profoundly altered the relationship of the viewer to the world. In Photography and Society (1974), Gisèle Freund, a photojournalist and one of the medium's first (and best) historians, describes this shift by means of a simple metaphor: 'Before the first press pictures, the ordinary man would visualize only those events that took place near him, on his street or in his village. Photography opened a window, as it were. The faces of public personalities became familiar and things that happened all over the globe were his to share. As the reader's outlook expanded the world began to shrink.'

The first mechanically printed photograph, 'Shantytown', appeared in the New York Daily Graphic in 1880 (see page 10) – depicting squatters on the edge of Manhattan's Central Park, but in fact illustrating a story about modern forms of photographic reproduction. In Paris in 1886, Le Journal Illustré and Le Figaro began publishing what were the first photographic essays – sequences of photographs recording encounters with notable figures by Félix and Paul Nadar (see page 11). By the end of the century, photographic illustration invaded newspapers around the world. After the invention of rotogravure in Germany early in the twentieth century, many Sunday newspapers came to feature special picture sections, the forerunners of today's Sunday supplements. For use of photographs in the daily press, the widely recognized leader was the London Daily Mirror, which began in 1904, equating information with photography with its trademark motto: 'See the news through the camera.' Many papers followed its successful formula, increasing the demand for and value of photographic images. Newspapers competed for the pictures the way they once competed for stories, and picture agencies were set up to meet the demand. In London in 1894, the Illustrated Journals Photographic Supply Company opened, with the promise to deliver stock pictures to clients within 24 hours of placing an order. In 1898 American newspaperman George Grantham Bain established the Bain News Service to cover what we now call 'breaking news'. He sent his staff photographers to cover important stories, and sold their images to newspapers and magazines around the country. Bain's service turned photojournalism into a paid profession. (Before Bain, writers had hired their own photographers, or took their own pictures without additional compensation.)

Pictures attracted readers, and thereby enhanced the value of the commodity that all illustrated press produced - its audience of consumers. Advertisers used magazines to reach new markets, and magazines flourished as a result. In the United States, magazines like Collier's, Leslie's, McClure's and the Saturday Evening Post published illustrated articles about contemporary life at home and abroad. In France, it was Le Journal Illustré, Lectures Pour Tous, L'Illustration, and Le Panorama; in Britain the Graphic and Illustrated London News; in Germany Die Woche. Illustrated magazines especially designed for women blossomed in the decades before World War I: Ladies Home Journal in the United States, Femina in France, Die Welt der Frau and Frauen Rundschau in Germany, and in Britain, Queen and Nash's. Halftone illustration provided an essential element for all these magazines - not simply through illustration of stories devoted to fashion, home decoration and gardening, or through fanciful illustration for fiction, but also because halftones made effective advertisements for consumer goods like shoes, soap, corsets and cast-iron stoves.

Illustrated periodicals satisfied an essential human desire to capture and conquer the novel, the exotic, the strange. Using the language of current social critics, we can say that photographic illustration makes an ideal form through which to view 'the other'. Where was 'the other' to be found? National Geographic made the quest fairly simple - sending writers and photographers to record distant places and civilizations. But exotic subjects can be found at home, simply by crossing the boundaries erected by class, political affiliation and cultural taboo. Long before photography, crime and impoverishment provided highly popular subjects for illustrated books, articles, prints and engravings. Photographic studies of the streets of New York, the sewers of Paris, and the back-alleys of London, Shanghai, Calcutta and Rome continued this well-established tradition. The hellish environments created by industry provided fresh turns on old subjects, often accompanying reports on the need for reform. Street life, and especially the fate of children, became the special subjects of Jacob Riis and Lewis Hine in New York, Paul Martin in London, and Heinrich Zille in Berlin. A V Casasola, who began as a photographer covering the Mexican political elite, organized the first Mexican press agency, and compiled a private archive devoted to indigenous Indian culture. He was also known for his collected photographic documents of the Mexican Revolution.

As the illustrated press sought to increase sales, they quickly discovered that some stories sold better than others. Natural disasters proved an attractive subject, especially when the events depicted took place far away. Hurricanes, floods, volcanoes and earthquakes made compelling subjects for pictures, along with shipwrecks, train crashes and fires. And war sold journals best of all. In 1903, a leading American magazine known for its picture stories promised that 'whenever there is an army in the field and the clash of arms and bullets and the thousand tragedies of war, there, too is a man from *Collier's*'. At the turn of the twentieth century, photojournalists documented warfare in South Africa, Mexico, Turkey and the Philippines. For the most part, these early images were surprisingly bland. Reporters (or their publishers) regularly made a tacit agreement with the authorities: in order to get access to the front, they would submit images to official censors. This practice was well established by the time World War I began. The periodical press, itself working under state control in the warring nations, published few if any truly grim pictures of life in the trenches, though plenty survived in the form of private snapshots which surfaced later.

In Germany after World War I - and especially in Berlin, one of Europe's major publishing centres - the illustrated press began to take on its recognizably modern form. Enormous political and economic turmoil had followed Germany's defeat. The socialdemocratic Weimar Republic replaced the German Kaiser's monarchy, bringing freedom of the press, a democratic government, and widespread dissent. Although the Republic collapsed after only fifteen years, during its brief tenure Germany witnessed an astonishing growth in art, drama, music, literature and film for avant-garde and popular audiences alike. This culture produced the political theatre of Brecht, the cinema comedies of Ernst Lubitsch and the expressionist fantasy of Franz Kafka. At the Bauhaus, photography was pushed to its abstract limits, and students applied their lessons to the concrete, practical art of advertising. The cultural leaders of this generation saw photography as a metaphor for modernity. Designer Jan Tschichold declared

(in *Fotografie und Typografie*, 1928) that photography was 'such a characteristic sign of the times that our lives would be unthinkable without it'.

What separates the German illustrated press from the illustrated periodicals that appeared before the war? As Gisèle Freund explains it, 'the task of the first photo-reporters was simply to produce isolated images to illustrate a story. It was only when the image itself became the story that photojournalism was born.' This new form of communication appeared in the pages of weekly magazines such as the Berliner Illustrirte Zeitung (see page 8), the Münchner Illustrierte Presse and the leftist journal Arbeiter Illustrierte Zeitung. Photojournalism also relied on the development of a kind of camera that was small, fast and easy to load. In the mid-1920s, two small cameras came on the market in Germany. The Leica first appeared in 1925; hardly bigger than a man's hand, it had a sharp 50mm lens and held a 36-image roll of 35mm movie camera film. Photographers could work easily without attracting attention, and they could manipulate their point of view with unprecedented freedom. The Ermanox, introduced in 1924, was equally important, though it was bigger than the Leica, used glass plates, and was heavy enough to require a tripod. Its large, fast lens eliminated the need for flash powder, and freed photojournalists to work indoors without noise, smoke or commotion.

The development of the photo story can be traced to a surprisingly small number of people, whose careers

UHU number 4, January 1929, photographs by Erich Salomon

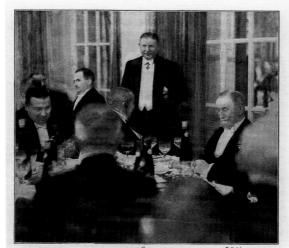

Der unbewachte Augenblick: Der Historiker Geh. Regierungszat Prof. Hans Dolhräck lächelt über einen Witz, den Reidawehrminister Dr. h. e. Greener während einer Rede auf den 80 jährigen Jubilar macht: "... als Einjähriger hat er abledt geschosen, aber ei in doch noch was zun ihm geworden ..."

Aufnahmen von Festabenden, Sitzungen und Banketten Von Dr. Erich Salomon

Der Mensch ist ein Haustier. Jeden-Europäer ist eins. Wenn er auch ausnahmalos im Bert, also in einem nicht sein ganzes Leben im Hause ver-Schlafraum, und, soweit nicht Ausflüge

der Reisen besondere Bedinungen schaffen, befindet er ch auch bei Tage im gehlossenen Raume, im Wohnimmer, im Büro oder in Vernumger auf diesen Räumen ret Wege zu diesen Räumen räumen, die nicht minder eschlossen sind, trotzdem sie ch auf Rädern befinden.

sick auf Rädern befinden sic sich auf Rädern befinden sidieren will, wer seine Leidenschaften kennenlernen, wer sein Gebärdenspiel auf die Platte bannen will, der muß ihm wohl oder übel in die geschlossenen Räume folgen.

Friedliches Attentat mit der Kamera auf eine junge Berühmtheit: Knud Eckener nach der Rückkehr von seiner Amerika-Luftfahrt in Friedrichslafen

13

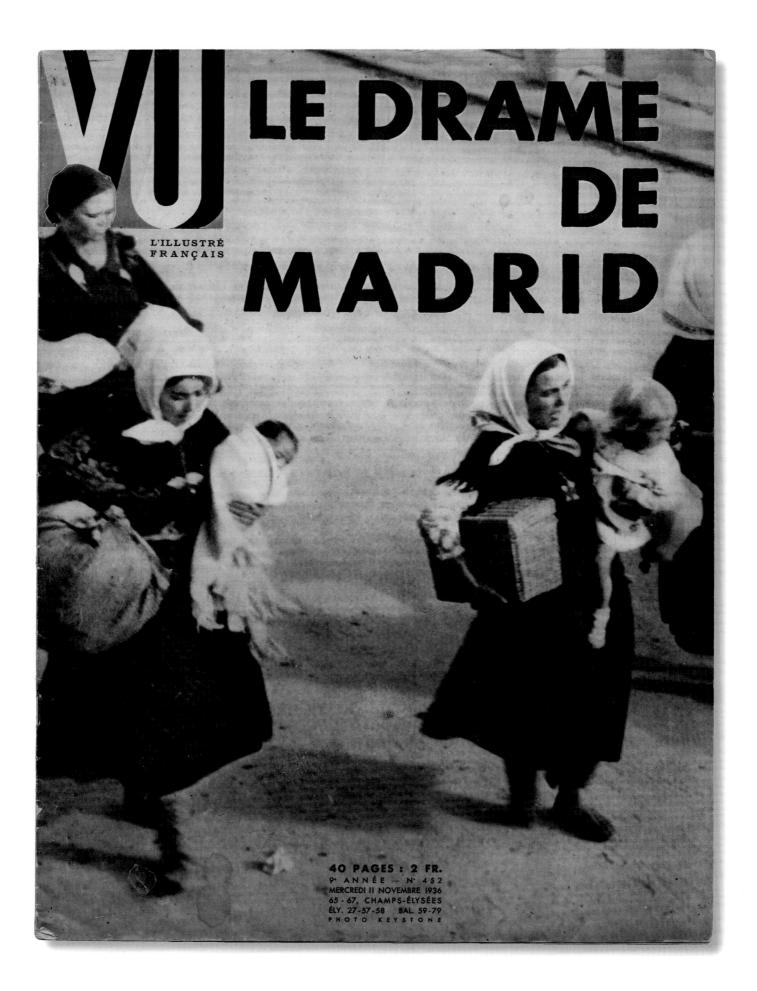

continued to shape photojournalism for decades to come. They include editors Kurt Korff and Kurt Safranski at the Berliner Illustrirte Zeitung, and Stefan Lorant at the Münchner Illustrierte Presse, photographer Erich Salomon in Berlin, and younger photographers such as Felix H Man, Alfred Eisenstaedt, Fritz Goro, Martin Munkacsi, Robert Capa, Tim Gidal, Lázlo Moholy-Nagy, Gisèle Freund, and 'Umbo', who established the Dephot agency where Capa - at the time known as André Friedman got his start. Erich Salomon was among the very first photographers to use these new cameras to make new kinds of pictures for publication. He had studied law before the war, and came home to Berlin, where he joined the publishing firm Ullstein Verlag as a publicist. He took up photography in order to document his advertising campaigns. Salomon's first published photograph appeared in February 1928, when he illegally smuggled his Ermanox into a courtroom to photograph the teenage defendant in a sensational murder trial. The resulting story earned him immediate notoriety, and he soon became a full-time photographer, most closely associated with Ullstein's Berliner Illustrirte Zeitung.

Today Salomon is best known for his candid studies made during the Hague conferences, where the most powerful men in Europe had gathered to negotiate terms for establishing the League of Nations (see page 13). These powerful diplomats doze and

Left: *Vu*, 11 November 1936 Below: *USSR in Construction* number 3, 1931, photograph by Max Alpert gossip, utterly unaware of the camera, and Salomon's photographs seem more like Daumier's satirical cartoons than conventional newspaper pictures. While he was not the first to grab pictures of famous faces on the street or in public settings, he used the added camouflage supplied by his aristocratic bearing, his tailcoat, and his mastery of five languages to penetrate environments normally shut off from public view. His photographs still carry a thrilling sense of trespass. Salomon's career took shape quickly; he photographed the famous all over Europe, and became a celebrity in his own right. But his work ended in 1932, when he and his family fled Germany for the Netherlands. He died in a concentration camp in 1942.

In Paris, photographers contributed to many illustrated magazines that flourished between the wars, including Marianne, Paris Match, Regards, and Voilà. Photography also played a prominent role in small, avant-garde publications, such as the surrealist Minotaure and the magazine for graphic design, Arts et Métiers Graphiques. The most important was the illustrated weekly Vu (see left), founded in 1928 by journalist, designer and editor, Lucien Vogel. He placed photography at the centre of the new magazine, promising 'pages packed with photographs translating foreign and domestic political events into images ... linking our readership with the entire world'. His art director, Alexander Liberman, experimented boldly with photomontage, and employed the best photographers - including Germaine Krull, Man Ray, André Kertész, Martin Munkacsi, Lucien Aigner and Robert Capa. Capa's famous image of the falling Spanish soldier was first

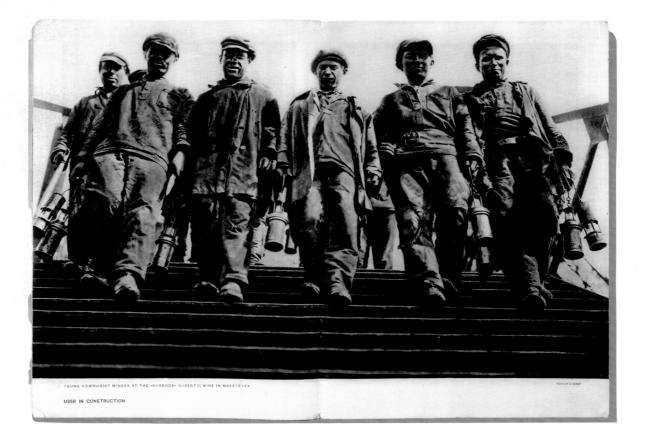

published in Vu. Vogel's left-leaning views did not win advertisers, and his special issue on the Spanish Civil War, with its strong support for the Republicans, finally alienated his Swiss backers altogether, forcing him to resign. The magazine folded in 1938.

Modernist schools of applied art offered another fertile site for this generation of photographers and designers. An important training ground was the Moscow school of applied art and architecture known as VKhUTEMAS, whose influence can be seen clearly in the dazzling pages of USSR in Construction (see page 15), first issued in Moscow in 1931. This is where Alexander Rodchenko, El Lissitzky, and Gustav Klutsis applied innovative graphic techniques to nation-building propaganda, in the process creating picture stories of unrivalled formal beauty. This magazine folded by 1941, but it established a graphic standard for all subsequent pictorial journalism in the Soviet Union. Its influence can be seen in bold compositions, caption-free design and forceful use of figures, echoed for years afterward in the pages of the weekly Ogonyek, where photography was also influenced by conventions associated with Socialist Realism.

When the rise of Fascism and war in Europe forced these creative communities to disband, many refugees found work in London and New York. Stefan Lorant came to London, working at *Weekly*

Below: *Lilliput*, September 1938 Right: *Ken*, 7 April 1938, photographs by Dorothea Lange *Illustrated* and *Lilliput* (see below) before moving to *Picture Post*. Many came to New York right away: Alexander Liberman came to *Vogue* from *Vu* while sports photographer Martin Munkacsi covered fashion for *Harper's Bazaar*. In 1935, a group of émigrés led by Ernst Mayer founded the Black Star agency, which provided an important source of support for fellow refugees as they re-established their careers in a new country. By the end of World War II, the photojournalism that began in Berlin as an experiment had become an established institutional form in New York and London.

The figure of Henry Luce towers over the history of magazine publishing in America. In 1936, he started his third magazine, Life, with the help of Karl Korff and Alfred Eisenstaedt, who already knew the Berliner Illustrirte Zeitung and Vu. But Luce also relied on a vigorous American pictorial publishing industry, which blossomed in New York after World War I with the support of publishers like Condé Nast, advertising moguls such as J Walter Thompson and publicists such as Edward Bernays. Among the most important photographers were Edward Steichen at Condé Nast's Vogue and Vanity Fair and Margaret Bourke-White at Fortune (and later at Life), who each developed a style that worked equally well for advertising and editorial work. Steichen was chief fashion and portrait photographer for all Condé Nast magazines through the 1920s and 1930s, immediately setting a national standard with his trademark sharp focus, stark lighting and dramatic poses. The same techniques also featured in his campaigns for many of

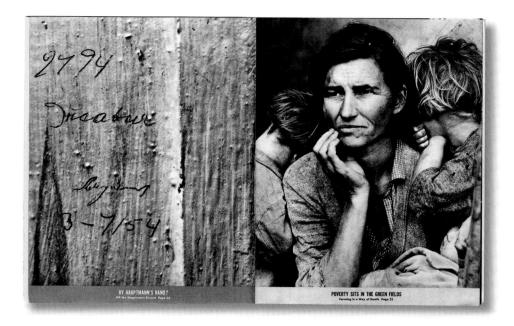

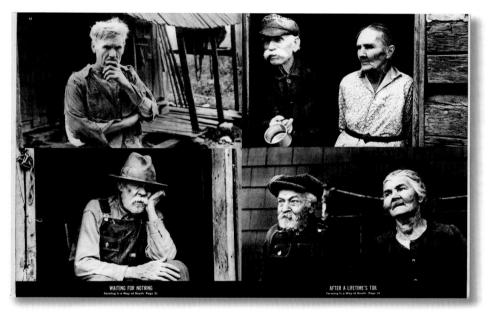

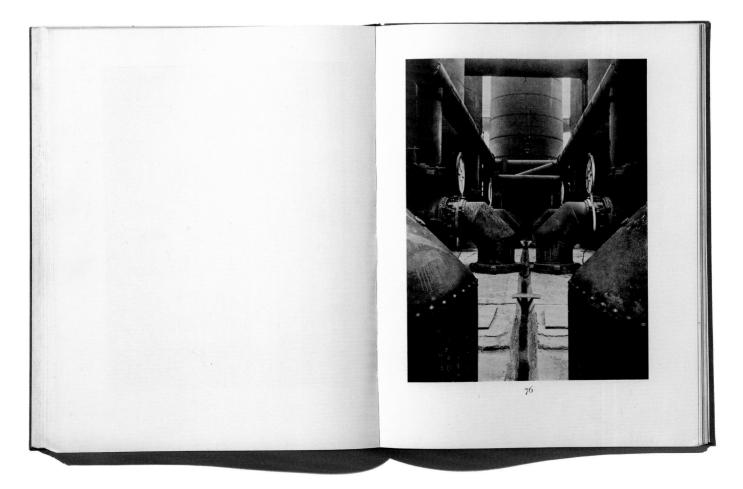

their advertisers. Henry Luce hired Margaret Bourke-White when he started *Fortune* in 1929, establishing the magazine's tradition of fine photography. Her essays combined artful documentation with subtle persuasion. Her photographs turned paper-mills, steel plants and industrial looms from gargantuan machines into sleek contemporary sculptures that were, implicitly, better than ordinary works of art because they produced things that people could use. In 1936, Luce commissioned her picture of Fort Peck Dam, published on the first cover of *Life* magazine. Bourke-White went on to produce dozens more covers, and she shot some of *Life*'s most dramatic war stories while stationed in Europe during the early years of World War II.

In addition to the modernist movement that favoured bold graphics and streamlined shapes, photographers, writers, film-makers and artists were strongly influenced by the powerful aesthetic that we now call 'documentary'. It permeated the art of the 1930s. The documentary movement inspired filmmakers Robert Flaherty and Sergei Eisenstein, the fiction of Henry Miller and the social commentary of George Orwell, the photographic studies of Bill Brandt, and the social realism employed by photographers working for the Farm Security Administration (and published for instance in the liberal Chicago bi-weekly Ken, see page 17). In France this impulse to record the present became a central ingredient of surrealism - so that the surrealists were the first important champions of documentary photographer Eugène Atget, whose work inspired Berenice Abbot's subsequent architectural survey of New York City. In Germany, the documentary impulse was at the heart of an art movement known as 'Neue Sachlichkeit' - New Objectivity - led by Albert Renger-Patzsch, whose celebrated photographic manifesto was Die Welt ist Schön (The World is Beautiful, 1928, see opposite). He produced sharply focused compositions of everyday subjects, both natural and man-made - a smoke stack, a tree branch and the skin of a snake all served his aesthetic ideal.

In this context, it is easy to accept the myth of photography serving - as a matter of course - the greater knowledge of humanity. Yet in 1934 (in The Author as Producer) the Marxist critic Walter Benjamin presented the limitations, even dangers, of such seductive documents. He pointed out that a photograph alone, without a caption, can say one thing only: 'What a beautiful world!' And photographs could turn even the most difficult subjects into fashionable pictures, 'transforming even abject poverty ... into an object of enjoyment'. To counteract this aestheticizing tendency, he asked photographers to supply information in the form of words, or narrative context, so that images might communicate something about their subject. 'What we require of the photographer is the ability to give his picture the caption that wrenches it from modish commerce

Albert Renger-Patzsch, pages from the book *Die Welt ist Schön*, 1929 and gives it a ... useful value.' His challenge to photojournalists to produce more than strong pictures – to test their value as information alongside their impact as images – remains relevant today.

Until recently, most histories of photography in World War II have been written from the perspective of the big photographers and the big magazines, focusing on Life reporters such as Carl Mydans, Margaret Bourke-White and W Eugene Smith, the Navy work of Edward Steichen, and the many essays by Robert Capa whose reporting on the Spanish Civil War led Picture Post, in 1938, to call him the 'greatest war photographer in the world'. Less familiar is the work of French journalists like Julien Bryan, who worked for Paris Match, or the British home-front essays of Kurt Hutton or Cecil Beaton. And because the war photographs of Hans Hubmann, Hilmar Pabel and Wolfgang Weber appeared only in German magazines, they were virtually lost until Robert Lebeck recovered and published some of the best examples in Kiosk: A History of Photojournalism (2001).

As Lebeck points out, the mission of the photographer did not change during war-time. Virtually all journalists shared the interests of editors and publishers, and worked to promote the national interest. After the war, new choices and responsibilities arose, beginning with the challenge of representing the horrors of the Holocaust and the aftermath of the bombs dropped on Hiroshima and Nagasaki. In later wars, journalists would often find themselves caught in a vice between patriotism and morality when the needs of the nation conflicted with personal conviction. Some resolved the dilemma by choosing to make the most complete document possible: what veteran war reporter Sidney Schanberg (in his Village Voice essay 'Press Clips', 2005) called 'getting the story right ... The goal was to come as close as possible to make the reader smell, feel, see and touch what I had witnessed that day. "Pay attention" was my mental message to the reader, "People are dying. This is important.""

The Postwar Years

After World War II, big picture magazines appeared throughout the world to signal the emergence of new consumer confidence: in Johannesburg Drum, in Rio de Janeiro Manchete, and O Cruzeiro (see page 20), in Tokyo Chuo Koron, in Italy L'Europeo and Epoca and in Germany Kristall and Stern, to cite only a few. Everywhere, these magazines assumed a paradoxical mission. Following the model of Life or Paris Match, they advertised the modern, sophisticated, international aspect of the particular nation or region of their publication. At the same time, magazines served to promote and consolidate national identities with stories about media stars, revered monuments, politics, the landscape, local heroes and scandal, applying distinctly national perspectives to international events and issues. Their audiences were mainly new: affluent enough to interest advertisers, and self-regarding enough to seek news about their own culture and politics.

Before the era of television, and before the print media fragmented into a myriad of cultural niche markets, big magazines shaped and articulated the unfolding narratives of national consciousness.

The big story of the postwar years was the Cold War, and its opposing ideologies must inform any survey of the press over the last half of the twentieth century. Its themes inform every story Life or Ogonyek published about science or the military. The same backdrop informs many stories in National Geographic, where the apparently innocent exploration of exotic cultures and ancient civilizations was undertaken with implicit, if unstated, support from the United States government, as they charted contested territory on the frontiers of the Cold War. Even Gordon Parks' heart-warming story of slum-kid Flavio surviving in the favelas of Rio (see page 91) was conceived as part of Life's effort to support President John F Kennedy's fight against the prospect of Communism in South and Central America. Henri Cartier-Bresson's sympathetic view of everyday life in the Soviet Union (see page 38) becomes much more interesting when considered as a piece of sophisticated political protest, making a clear distinction between the Russian people and their system of government. In Cuba, European photographers produced romantic travel stories about the island's thriving hybrid culture, while local journalists like Raúl Corrales, Norberto Fuentes and Roberto Salas, without neglecting local scenery and culture, produced long stories on new power-plants, modern sugar cane harvests and peasant soldier-farmers that owed much to models found in Ogonyek.

Historians of photography have tended to emphasize photography's role in promoting universal values that transcend geopolitics - best articulated by Edward Steichen in The Family of Man exhibition that opened in 1955 at the Museum of Modern Art in New York. Its title was its self-explanatory manifesto. In its installation, the museum walls resembled the pages of Life, with images in many sizes, accompanied by explanatory texts and short, lyrical quotes from poetry or folk-tales. Visitors walked through the exhibition as if strolling inside the pages of a magazine. John Szarkowski has called the exhibition Steichen's 'most important work of art', although comprising photographs made by others. Even while Steichen's exhibition included dark passages - images of poverty and human suffering, and including a wall-sized image of the atomic bomb's ominous mushroom cloud - it established a relentlessly idealistic, even stifling, set of expectations for photojournalism. Its persuasive strength created pressures on photojournalists to repeat its optimistic, life-affirming story, in a way that comforted both readers and advertisers. Reviewing the Paris showing of the exhibition, Roland Barthes observed that its reverent presentation of the human condition 'suppressed the determining weight of history'.

One of the memorable photographs in the exhibition was W Eugene Smith's 'The Walk to Paradise Garden', in which his camera captures a small boy and girl (his own children) walking hand in hand along a shadowed path into the light. Smith was the pre-eminent exponent of the photo story at this point. In the late 1940s, after recovering from war injuries he received in the Pacific, he rejoined the staff of *Life* to produce some of the most memorable

O Cruzeiro, 16 March 1957

and sophisticated narratives of the genre. Refining the Life formula of building an issue-based story around an emblematic central protagonist, he offered photojournalists a model with 'Country Doctor' (1948, see below) and 'Nurse Midwife' (1951). 1955 marked a new departure in his career. He resigned from Life (over arguments about the editorial point of view given his Albert Schweitzer story, published in 1954) to join the Magnum Photos co-operative, dedicated to the artistic freedom of its photographer members. Smith and the photographers of Magnum were not alone in seeking freedom from the requirements and compromises that accompanied the security of a staff position. Most of the leading photojournalists were already freelance. Once an employed workforce charged with the responsibility of fulfilling the vision of their employers, photojournalists increasingly insisted on recognition as creative individuals in their own right, driven by their own goals. Photojournalists and magazines remained mutually dependent; magazines supported many independent careers, and freelance photographers in turn supplied the stories needed to fill pages and lure advertisers and readers. The era of the independent creative photojournalist was underway.

Photographers impatient with the requirements of consumer periodicals began to publish their work in camera magazines aimed specifically at other photographers. These included *Popular Photography* (which first published Smith's Pittsburgh essay, see page 76) and *Modern Photography* in the USA, *Camera* in Switzerland, *Photo Magazin* in West

Life magazine, 20 September 1948, photographs by W Eugene Smith

Germany, Photo Communiqué in Toronto, Die Fotografie in East Germany, and Fotografisk Tidskrift in Sweden. They championed good photography across all genres in and around their columns on new equipment, tips for amateurs, and competitions. Many other specialized publications welcomed picture essays in the 1950s and 1960s. At the business magazine Fortune, Henry Luce hired Walker Evans as a photography editor in 1945, and Evans used the magazine to issue beautiful portfolios of images, including his first photographs in colour. He also used his position to endorse promising photographers, including Robert Frank, who produced a dark, subtle portrayal of the American businessman in a story on 'The Congressional', the deluxe train that ran from New York to Washington DC (see page 46). In Switzerland, the art magazine Du expanded to include photography, allowing space for long photo essays uninterrupted by advertisements; although these stories were rarely accompanied by significant amounts of text, the magazine has sustained a commitment to photojournalism ever since. In Japan's Chuo Koron, Tomatsu Shomei's picture essays appeared through the mid-1960s (see page 82). They balanced sharp social satire with lyrical description of postwar Japanese culture - and never claimed to be objective. The artist's contribution was always evident, in his choice of subject and idiosyncratic framing, within unsentimental investigations into the clash between traditional Japanese culture and the West.

A new form of journalism blossomed at the end of the 1950s in the men's magazine *Esquire*, where editor Harold Hayes shifted the magazine from cheesecake pictures and nondescript articles on sports and business to some of the nation's most advanced

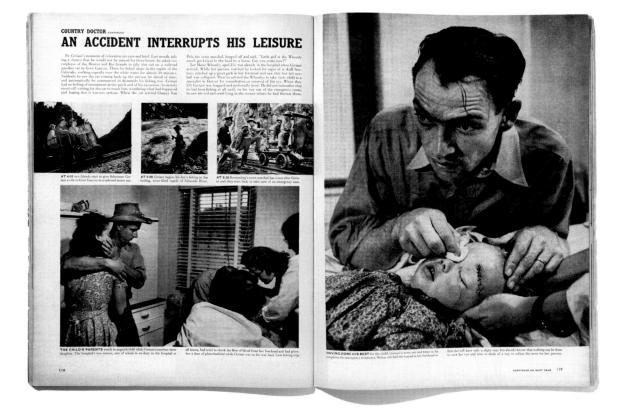

satire, fiction and political commentary. *Esquire* hired Diane Arbus to shoot picture stories (see for example page 87) and celebrity portraits. Her highly personal style matched the magazine's sophisticated sensibility – confident, critical, and offbeat. *Esquire*'s writers became known for their personal, opinionated accounts of modern life – the style was called 'new journalism' and Arbus was its photographer. In 1967, this school of journalism inspired John Szarkowski to introduce the work of Arbus, Lee Friedlander and Garry Winogrand in a show called *New Documents* at the Museum of Modern Art.

Arbus was part of a growing generation of artists who actively contributed to the construction of a new international 'counterculture' of music, poetry, fiction, fashion, art and politics. Journalists engaged with it faced a dilemma. In the style of earlier Bohemian cultures, artists and writers set out to resist the conformism of the mainstream press and to offend its middle-class audience - yet they exerted a powerful allure, making them attractive to precisely those audiences and publications they opposed. One photographer who became synonymous with the counterculture of the early 1960s was Will McBride. Working for the German youth magazine Twen, he developed a distinctive style that was both abstract and sexually charged. When Twen published 'Siddartha' in 1969 (see page 182), homosexuality was a very new pictorial subject for publications beyond the underground or pornographic press, and McBride's homoerotic presentation of male affection was far more disturbing to his first audiences than the pictures might suggest to viewers four decades later.

By the end of the 1960s, almost everyone wanted to look hip. Even photographers known in the fields of high culture and haute couture responded to the provocative mood. Both Irving Penn and Richard Avedon contributed to Look magazine's 1969 celebration of the new era (see pages 148 and 152). Penn took on the assignment for Look after Vogue turned down his offer to go to San Francisco in search of new cultural icons. In a trademark bare studio, under cool natural light, he photographed the Hell's Angels, a hippie family and two rock and roll bands, all in the same monumental style he had earlier used to portray traditional icons such as Alfred Hitchcock, Marcel Duchamp, and the Duchess of Windsor. Avedon photographed the Beatles, borrowing from Andy Warhol, Robert Rauschenberg and the language of psychedelic rock posters, to come up with a series of iconic portraits in acid colours. Photographer William Klein applied street photography to fashion work for Vogue, sending his models out into traffic, updating the approaches of Munkacsi and Avedon, with references to French nouvelle vague film, giving the fashion houses dynamic contemporary expression.

Throughout the 1960s, American magazines lost audiences and advertisers to television (although for a brief period in the mid-1960s, when federal law banned cigarette advertisements from television,

Ken Domon, pages from the book Hiroshima, 1958

magazines reaped considerable benefits in the form of large, sustained magazine advertising campaigns). The dominance of television as the medium for daily journalism was enhanced by the assassination of John F Kennedy in Dallas on 22 November 1963. Americans turned decisively to television for information about his shooting, and for coverage of the events that followed - which unintentionally included the live broadcast of the murder of Kennedy's accused killer, Lee Harvey Oswald. Within days, Life magazine published its own extended account of the events, including a spread showing frames from the footage by Abraham Zapruder, an amateur with a movie camera who was standing just vards away from the President's motorcade when the bullets hit. For years after, Life would cite the layout of the Zapruder stills as proof that photojournalism still provided unique and essential information about the world. But to many critics it was already clear that television had stolen the magazine's greatest single asset: its unified family of readers. This was what advertisers paid for, and it had moved to television.

The story was not the same in Europe – at least not yet. Powerful journals like Paris Match and Stern established formidable national audiences with photojournalism that did not rely on the ability to compete with television to deliver the news. These magazines were able to give over many pages to a single story when necessary, frequently extending coverage throughout an issue, or over several weeks, sometimes returning to it serially over months or even years, as for example with Paris Match's coverage of the French colonial war in Algeria, and of the courtship, marriage and family life of Princess Grace and Prince Rainier of Monaco. For this form of journalism, depth and detail were more important than speed. It generally required more than one photographer. When Paris Match covered the 1956 uprising in Budapest (see page 50), the long story included the work of staff photographers, wire services and freelancers. The result was a complex composite whose author was Paris Match itself.

In considering the way photojournalists in the West became active participants in the movement to overthrow dictatorship, guarantee civil rights and promote justice during the eventful decades of the 1950s and 1960s, we can observe how stories in the media changed over the period. Early in the 1950s, political demonstrations were reported in a detached manner, as isolated incidents worthy of a single image - a burned-out bus, an isolated skirmish, a protester going to jail. By the end of the 1960s, the work of engaged photojournalists (like James Karales, Charles Moore and Flip Schulke working in the United States, Ernest Cole and Peter Magubane in South Africa, and Don McCullin and Gilles Peress in Northern Ireland) documented struggles in a way that demonstrated awareness of the broader context and in a way intended to argue for social change. At the centre of the emerging link between photojournalism and politics is the Vietnam War. Initially most Western journalists sympathized with the American

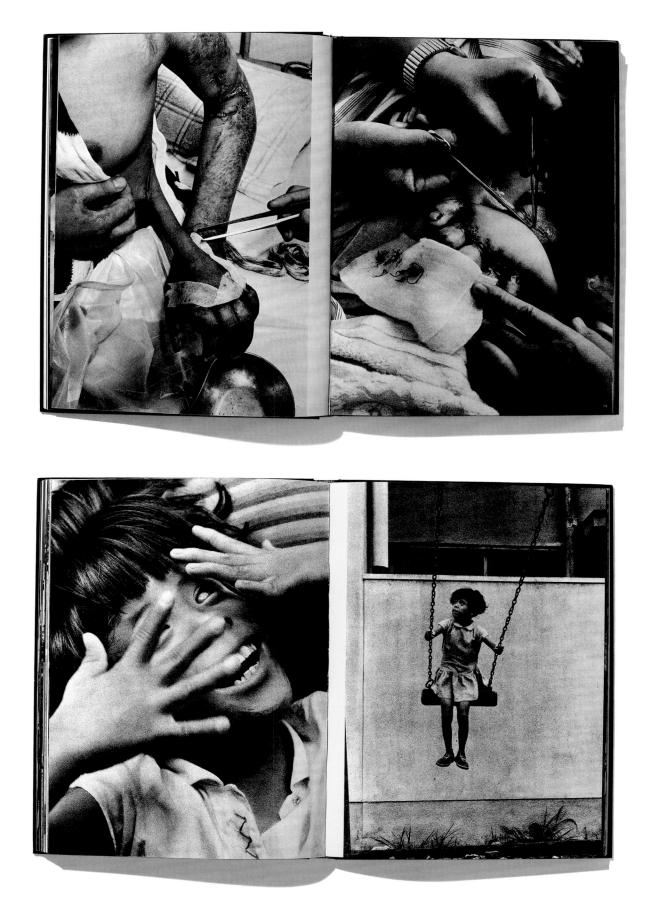

government and its soldiers. But by the time the war ended in 1975 world opinion condemned the US presence – a consensus that many attributed to the free access journalists enjoyed, and the many independent uncensored stories that appeared, especially picture stories.

Three single images made during the war in Vietnam have come to represent the power of photojournalism in the public imagination. These famous photographs are all single 'breaking news' shots, distributed by the Associated Press along with brief captions, and they appeared in newspapers all over the world. They stand apart from the feature story for a magazine or newspaper supplement, made by a writer-photographer team working over weeks or months. Their prominent place in common memory makes them significant to any story of photojournalism in the twentieth century. The first was Malcolm Browne's 1963 record of a Buddhist monk who set himself on fire in the middle of a downtown street, as a protest against the corrupt regime in Saigon (see page 37). Eddie Adams made the instantly famous picture in 1968 of a Vietnamese officer shooting a prisoner in the days following the Tet Offensive (when the Viet Cong scored their most notable victory against the American and South Vietnamese armies, see page 109). This event was also filmed by television cameramen, and broadcast widely, but critics regularly credit Adams' picture - printed on front pages around the world - with turning public opinion against the war. The third image, made by Associated Press photographer Huynh Cong 'Nick' Ut outside the village of Trangbang in 1972, shows a

William Klein, pages from the book *Life is good and good for you in New York...*, 1956

naked Phan Thi Kim Phuc, running down the road in tears, her arms outstretched, attempting to escape the napalm South Vietnamese pilots had mistakenly dropped on their own villagers (see page 108). All three images meet the requirements for what philosopher Umberto Eco (in his essay 'A Photograph', 1986) calls an 'epoch making' image where meaning 'has surpassed the individual circumstances that produced it; it no longer speaks of that single character or of those characters, but expresses [larger] concepts'. In so far as Eco's 'epoch making' images are all photographs that have attained this mythic status, they also demonstrate that, by the 1970s, audiences no longer equated photojournalism with the delivery of facts.

It was also in this period that photojournalism increasingly adopted a new idiom: colour. The transition took place easily in Europe, more slowly in the Americas. Although colour images had appeared in magazines since the late 1930s, they were normally reserved for exotic editorial subjects, advertisements and covers. (An exception was National Geographic, who began using colour early in the twentieth century and staked out a style that remained distinctive to that magazine alone - until the German Geo challenged their monopoly in the 1970s.) Until 1965, the technology to make and reproduce colour images remained awkward and expensive, although a few photojournalists of the postwar period became known for their colour reportage - among them Ernst Haas, Eliot Elisophon, Dmitri Kessel, David Douglas Duncan and Brian Brake. Their work often emphasized atmosphere, mood and design over storytelling content. Even after colour became practical for the pages of most magazines, it stayed closely identified with commercial work, considered by many less serious and more ephemeral than black

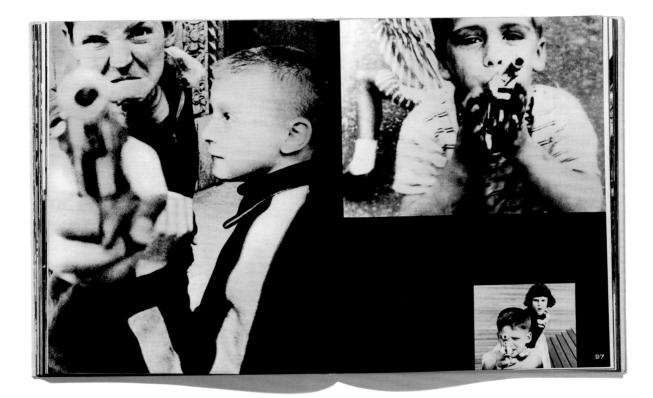

and white. Colour had also become the medium for the amateur, whether in the form of snapshots, slides or home movies. Before photographers, editors and audience could accept colour in photojournalism, these associations – more daunting than any technical obstacles – had to fade.

The most important demonstration of colour as a medium for serious photojournalism came in the mid-1960s, when Don McCullin, Larry Burrows, David Douglas Duncan and Philip Jones Griffiths produced extraordinary colour essays about the war in Vietnam for Life, the Sunday Times magazine, and the Daily Telegraph magazine, even while black and white photography remained their preference. McCullin and Burrows especially focused on the lives of the soldiers, using the war as a background against which to show the drama of the individuals as they fought in battle or supported one another. This approach also enabled them to avoid any overt judgement about the war itself. By the time the war ended in 1975, colour had become the common idiom for magazine war reportage.

By the 1960s, many photographers who started out working for magazines took advantage of inexpensive new forms of printing and an emerging interest in their work among book publishers. Bypassing periodicals altogether, they pursued their photo essays in book form. These include Ed van der Elsken with Love on the Left Bank (1956), Ken Domon with Hiroshima (1958, see page 23), Danny Lyon with The Movement (1964) and The Bikeriders (1967), and, at the beginning of the 1970s, Bruce Davidson with East 100th Street (1970) and Philip Jones Griffiths with Vietnam Inc (1971). Building on a tradition of photography books that includes Ilya Ehrenburg's Moi Parizh (1933), Brassaï's Paris de Nuit (1933) and Bill Brandt's The English at Home (1936), these books together begin to define a genre of their own quite distinct from magazine features, museum exhibitions or the photographer's portfolio.

Two figures tower over the history of the photo essay in book form, although neither is considered a photojournalist: William Klein whose Life is good and good for you in New York was first published in Paris in 1956 (see left), and Robert Frank, whose The Americans was first published in Paris in 1958 and brought out in an American edition a year later. American critics attacked Frank's book. One review called him 'a liar, perversely basking in the kind of world and the kind of misery he is perpetually seeking and persistently creating', and another 'neurotic [and] dishonest' with an 'intense personal vision marred by spite, bitterness and narrow prejudices'. Their anger stemmed from Frank's failure as a reporter, for his work abandoned all pretence at objectivity in favour of expressing his own distinct sensibility. But both his and Klein's seminal books steadily influenced the form and aesthetics of the photo essay thereafter.

In retrospect, the point when photojournalists chose to publish their work in their own books coincides with the moment when the form began to outgrow its origins. A creation of the press, the photo-

journalist was beginning to claim a role beyond it. It is relevant that Robert Frank's monumental work took shape in America during the early stages of what Szarkowski refers to as photojournalism's long decline. This is also the moment when the first photographic art galleries, such as Limelight, opened in New York, and when the Museum of Modern Art established itself as the leading institution for collecting and exhibiting photography as art. While at the beginning of the period The Family of Man made no distinction between photojournalism and art photography, in the following years art photographers came to define their work in opposition to the narrative, representational work that appeared in magazines. Although several leading photographers for example Henri Cartier-Bresson - worked successfully in both worlds, the view that photography could be either art or journalism, but not both, became dominant. It would be another quarter-century before these lines began to blur again.

The Last Decades

When Life magazine shut its doors in 1972, the press was full of sentimental memoirs and reverent obituaries - for the magazine, its illustrious staff, and the art of photojournalism in general. In the eyes of a large group of American journalists and critics, Life magazine had invented modern photojournalism, and when it folded, photojournalism died with it. This immensely sturdy myth has long caused critics and historians to overlook the large and often innovative volume of photojournalism produced subsequently. The world had no shortage of news to digest. Historian Eric Hobsbawm (in The Age of Extremes, 1994) bluntly characterized the history of the 1970s and 1980s as 'that of a world which lost its bearings and slid into instability and crisis'. And crisis continued to produce great photo opportunities.

Without doubt, photojournalists faced new obstacles. According to popular opinion, the unfettered reporting in Vietnam brought an end to public support for the war, and the US government conducted all future wars with the press on a much tighter rein. The other leading world powers never tried the same experiment with press freedom. Whereas 400 journalists had been stationed in Vietnam in 1968, only three photographers were permitted to accompany the British troops sailing for the skirmish over the Falkland Islands in 1981, with their work strictly managed through the pool system. While coping with restricted access to hard news, photographers now worked in the shadow of the television camera. Arguably, after the Vietnam War, the taste for visual drama developed into a hollow sensationalism. Writing in 1986 (on the tenth anniversary of the founding of Contact Press Images) historian and critic Fred Ritchin identified a sinister trend toward pictures that were deceptive and spectacle-laden: 'Where sensation bypasses information, photojournalism too often becomes nothing more than a perverse voyeurism, responding to nothing but the desire to be entertained, not the

desire to know.' In 1989, journalist Michel Guerrin, writing for *Photo*, disagreed, insisting that 'many photographers have negotiated difficult obstacles to photograph war in a meaningful way'. For Guerrin, the spirit of Robert Capa survived in the present, in the work of James Nachtwey, Anthony Suau, Susan Meiselas and David Turnley. The journalists he named were all Americans who were widely published in magazines outside the United States.

In the United States, photojournalism survived in news magazines - although they rarely ran photo essays, their sponsorship of photojournalism contributed to scores of major features published by magazines elsewhere - while it began to thrive in magazines serving more specialized audiences. Some took on ambitious stories, for instance when Rolling Stone, long identified with the incisive, intensely personal political reporting of Hunter Thompson and Tom Wolfe, assigned Richard Avedon to cover the presidential campaign season of 1976 (see page 204). Big city newspapers offered advertisers access to an audience defined by geography or region, and Sunday supplements in Boston, Los Angeles, Philadelphia, Detroit, Sacramento, Miami and many other cities published high-quality picture stories that had a local or regional hook. And as Popular Photography had for W Eugene Smith, the photography press opened its doors to inspiring stories that in an earlier era would have been found in the big picture magazines; in 1981, when Eugene Richards looked for a magazine that would publish the searing personal account of his wife's tragic struggle with breast cancer, no magazine would print it - until he approached American Photographer (see page 220).

In Europe, magazines were booming, and from the end of the 1960s Paris became the undisputed

Daily Mirror, photograph by Reuters, 30 May 1985

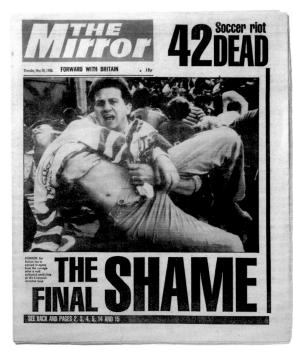

capital of photojournalism. War horse *Paris Match* led the field. It acquired a new design and a new slogan, promising readers 'the shock of the photos, the weight of the words', making text subservient to its double-page spreads for big pictures. No advertising interrupted stories that appeared in the centre section of the magazine. In the wake of the student protests of 1968, new left-wing publications began in Paris, including *Actuel* in 1968 and *Libération* in 1973. *Zoom*, a lavish bimonthly devoted to photography as art and design, was established in 1970.

An important aspect of the Parisian photo scene was the presence of new independent agencies, the most significant being Gamma, started in 1967 by Raymond Depardon, Gilles Caron, Hubert Henrotte, Jean Monteux and Hugues Vassal. The Gamma model was followed shortly by Sipa in 1969, Sygma in 1973 and Contact Press Images in 1976, all working alongside established agencies including Rapho and Magnum in Paris and Black Star in New York. Agencies supported photographers in the field, and promoted their finished stories to picture editors around the world, seeking simultaneous sales in different national and language markets where possible. They offered magazines and newspapers the sustained essays that did not come over the news wires. Picture editors competed for the chance to get hot stories, and agencies sought out strong layouts and high-paying publications. Many photographers remember the lively, competitive market of the 1980s as a new golden age, where almost any story they chose to pursue was easily sold and published. A new generation of agencies began in the late 1980s, beginning with Agence Vu in 1986 and followed by, among others, Editing in 1988 and Métis in 1989.

In 1985 Reuters, the wire service for news, began to sell photographs to subscribers (for example, see left), unsettling the equilibrium established between Associated Press, United Press International, and Agence France-Presse. The consequences for AFP were especially pointed, as they had long worked without serious competition in the French market. The improved quality and range of wire photography, and the faster speed of its delivery, increased the pressure on agency photojournalists to distinguish themselves more clearly in terms of their depth and individuality. Arguably, by the early 1990s it was the improved wire services, supplying powerful photographs to newspapers (now printing in colour) that did more to harm the broad European market for current affairs photo essays than any further encroachment by television.

In Great Britain, throughout the 1970s, the single most important publisher of photojournalism was the *Sunday Times* magazine. Under the campaigning leadership of Harold Evans and the art direction of Michael Rand, photography became a crucial component of the magazine's trademark investigative approach. From 1964 to 1986, Don McCullin covered political conflict around the globe, making stories unmatched for their emotion and clarity of purpose (see pages 156 and 192). In addition, the *Sunday Times*

bought agency stories that less courageous periodicals wouldn't or couldn't touch. In Germany, photojournalism flourished at Stern, with stories published over 20 pages or more by the likes of Hans-Jürgen Burkard and Sebastião Salgado. A new breed of general interest newspaper supplement such as those of the Süddeutsche Zeitung and the Frankfurter Allgemeine Zeitung offered competition by developing distinct visual approaches of their own, and in 1977 Gruner und Jahr, publishers of Stern, began Geo, updating the popular formula of National Geographic. Like its precursor, Geo was devoted to seeing the world, providing informative pictorial stories about exotic landscapes and foreign cultures. While both magazines gave many pages to a single, colour picture story, in place of the didactic style of National Geographic, Geo offered more visual drama with bolder images and layout. In turn, it influenced National Geographic's approach, and a distinctive French Geo, launched in 1978, became a major success.

New magazines emerged throughout Europe. In Spain, the death of Franco in 1976 made it possible to publish without censorship. The result was a wide variety of new magazines, from the serious (El País Semanal) to the relentlessly upbeat (¡Hola!). In Italy, the new supplement Sette offered competition to the established magazines L'Europeo and Epoca. In the Soviet Union, Ogonyek underwent a new design, partly in response to technical changes in paper, printing and ink, bringing it closer in appearance to magazines in the West - a small early sign of the coming thaw in the Cold War. In Prague, Leipzig, Budapest, Vilnius and Minsk, photographers whose work was severely restricted in the governmentcontrolled newspapers joined local amateur clubs, where any work that resisted official policy was justified by being deemed 'art'. Slowly, photographers trained in the Soviet Union like Antonin Kratochvil, Boris Mikhailov and Ljalja Kuznetsova began to publish their work in the West, but even after 1989, as more photographers from the Soviet bloc exhibited in the West, they continued to promote their work as personal expression rather than documentation or journalism.

Japanese publications dominate the development of photography in Asia. Although the work of photographers like Ken Domon, Yonosuke Natori and Shomei Tomatsu satisfy our criteria for 'photojournalism', there are significant variations on the Western model. While mainstream Japanese newspapers published fewer photographs, and few other magazines addressed world affairs, photographers created photo essays for their own books and for radical art journals like Provoke (see page 178). Here text played no role, and documentary photographs were presented as personal expression rather than as factual accounts about places or events. As with photographers from the Soviet Union, those whose work did travel to the West came via the art world. Even the most journalistic reporting was stripped of historical reference. Hiroshi Hamaya's work on the rice harvest became a sentimental document of a vanishing rural culture; Kikujiro Fukushima's photographs of Hiroshima were treated as a bold experiment in design; Takuma Nakahira and Daido Moriyama's work for *Provoke* became an expressionist statement of personal discontent.

In the postwar years, illustrated journalism flourished in Central and South America, in magazines and newspapers such as Proceso and La Jornada in Mexico, Caretas in Peru, O Cruzeiro, and Manchete in Brazil, Clarín, La Opinión and La Prensa in Argentina, and La Nación in Chile. But with political instability and repression, freedom of the press and the development of photojournalism suffered. Much of the memorable reporting was done by outsiders, like Susan Meiselas, who were able to publish their work in Europe and the United States. For those who stayed, publication was often impossible, or required brave and creative remedies - as in 1988 when one group of Chilean photographers made themselves into a 'living newspaper', demonstrating against General Pinochet by carrying their work through the streets.

In Argentina, a group of photographers gathered around Sara Facio and Alicia D'Amico, publishing their work in the form of books and garnering support within the art world. In the last decades of the twentieth century a similar movement in Mexico propelled the careers of many young photographers who worked in a style inspired by the 'Magic Realism' of Gabriel García Marquez, including Graciela Iturbide and Luis González Palma. Others like Oscar Molinari, borrowing from the crime photography of Enrique Metinides, created photo-novels published in Sucesos in the 1970s and Luna Cornea in the 1990s. In the context of the history of photojournalism, these strategies can be seen as a means to protect and publish photography, as also used successfully by photographers in the former Soviet Union. At the end of the century, the shift towards democracy and freedom made it possible for artists and writers to bring many hidden images and texts to light. In one example among many, photographers Vera Lentz and Mayu Mohanna joined Peru's Truth and Reconciliation Commission, which placed the collecting and exhibiting of photographs - unpublished in newspapers at the time - at the centre of a national project to identify the causes and perpetrators of violence that plagued Peru during the 1980s and 1990s (see page 28).

The growing dominance of colour pictures challenged a long list of deeply rooted assumptions about the definition of news, the visual characteristics of truth, and the capacity of photojournalists to represent stories objectively. This shift coincided with a rising scepticism towards all claims of objectivity, and was accompanied by a greater tolerance of, and interest in, the personal and contingent. This position was identified variously with new journalism, structuralism and post-modernism, and applied to all forms of representation from non-fiction writing to feature films. A group of photographers within Magnum led by Gilles Peress, participants within the press but activists against its narrative formulae, offered a 'new photojournalism'. Its characteristics were exemplified by Peress's Telex Iran (1983), with its impressionistic sequences of photographs and nonconformist text (telexes exchanged with his agency, regarding deals with magazine clients, rather than captions concerning Iran). This informal movement led authors of all kinds to become more clearly present in their work; as Mary Ellen Mark explained in an interview with Janice Bultman (in Darkroom Photography, 1987): 'In the kind of social documentary photography I do, you're never a fly on the wall ... You're as much a part of the scene as your subjects.' Meanwhile, Peress's disruption of the conventions of composition of the journalistic image influenced a generation of photographers in Europe and America, who found a new vocabulary in his work for creating dynamic, attention-grabbing frames - for example in the bold graphic approach of photographers working for the Danish newspaper Politiken in the 1990s (see opposite).

By the end of the period, and notably with the popular success of Sebastião Salgado's epic *Workers* exhibition that began touring in 1992, photographs once seen only on the pages of magazines appeared again on the walls of museums and galleries. What made one photograph a work of art, and another a piece of journalism? In a late interview (quoted in *On The Line: The New Color Photojournalism* by Adam Weinberg, 1986) Walker Evans placed the

Below: Octavio Infante, pages from the book Yuyanapaq. Para Recordar, 2003 (showing photographs of seven journalists massacred at Uchuraccayin in 1983) Right: Politiken, 14 February 1998, photographs by Joachim Ladefoged responsibility with the viewer: 'No one says "This picture is art, it belongs in a museum. This picture is journalism, it belongs in a wastebasket." The viewer can decide.' But of course it was not the viewers who decided. In Evans' own case, despite his credibility within the art world from the 1930s onwards, the colour essays that appeared in the pages of *Fortune* were not seen in a museum, and, until the 1970s, there were no museum exhibitions of colour photographs at all. Some identified the distinction as a matter of economics – journalism was bought and paid for by a publication, with art the responsibility of the artist alone.

The last years of the Cold War era were full of eventful news stories indicating the end of old orders. Tens of thousands of students and workers demonstrated for democracy in Tiananmen Square until government tanks fired on the crowd. In Berlin, a spectacular, exuberant celebration accompanied the fall of the Berlin Wall. Elections in Poland, Czechoslovakia, Hungary and Bulgaria installed democratic governments for the first time in decades. In Chile, free elections overthrew the ten-year rule of Pinochet. Another sign of change became significant only in retrospect: when journalists set out to cover the Gulf War in 1990, they could not know it would be the last major war to be recorded on film.

The Digital Age

One breaking news photograph does not differ from another simply because one travels by satellite phone, and another reaches the picture desk in the form of film carried in the pocket of a passenger on the Concorde flight to New York – a method still popular at *Newsweek* as late as 1992. Images had long been transmitted by phone line – the Associated Press first

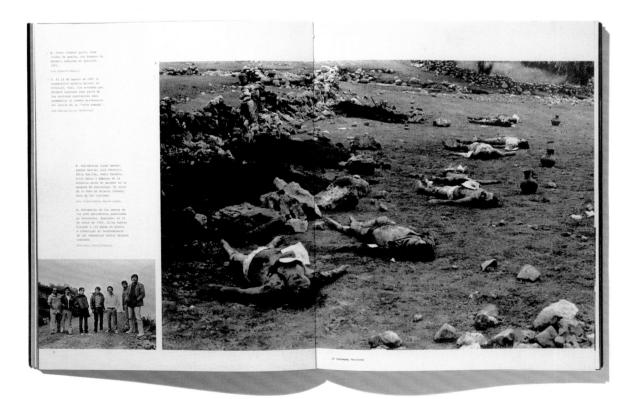

Det er helt vildt

The design of the second

Do Fulitikens yngete fotograf medite på vægt i de formiddage og fik at vide, han netop havde vundet førsteprisen i World Press store internationale fotokonkurrence, smilde han hånligt og villdøde med gjonne. Der er nemlig ingen, der skal tage på på den 27-årige Joachim Ladefogel. Først dræ flore nedstatesen havde af

lagt ed på nyheden, troede den vantromidtjyde så småt på meldingen, men han skulle lige hen og tjekke på Internettet. Den var god nok, og han faldt ned af stolen. Mere cool er han trods alt ikke.

stepris Arst automotion we need that are far presselforografier i kategorien People in the Newsöltories. Altes gruppen for fotoserier med nyhedsreportage og mennssker i fokus. Hedderen og de 10.000 priskroner får han far 12 sort/ hvide billdører fra urvälgsderre i Al-

Fire gunge besøgte han landet bevæbnet med skulkkart kamera. To gange udsendt af Politiken og to gange for ogen regning, før han syntes, det var færdigt arbejde i den omgang.

Gennembrud

Mens champagnepropperne sprang, og dagens farste evjørstu hverdet sig til resten af redaktionen på Råfhusphadsen i Kabenhavn, fad World Pvens hjennæside fru Holland over af nyheden om en ekstra hattagfor til ungervendens skaldede isse. Et af hans albanske fotografier havde ogak vundet 3. prisen i en kategori for enskeltføtss.

presasefotografer fra 115 lande 56.041 billeder i konskurrennens in skallige afdelinger, og aldrig tid har nogen dansk fotograf ognåt a men global en hæder som Joachin defogeds førstoplads. Kolliger og venner strømmade ti Het fotograffering i blocket og kom på Århus Stiftutidende eller en på som vulantær bos fotogruppen l for den jyske hovedstad. Bvendebrevet kors i hus for kom siden, og kort efter blev Joachim af Fisikarn i Kabanshave. Sid bo

> t at gi starit. Talenist, rovorrig den og intersesen for den aktualis portage var isjoefaldende, og han zype blik for det nøgterne, poreise og ginale presedelided har allerede ud ref han mod en like hådelidel hjemsi fotopriser.

annerton ancore komme an merragt, er das nebr mens overeraskale over. Ognå mör en ert belgask kollinga allorede for føn ager siden læste hann billiedtekstem på aggets ved den suropaniska Puji komurrørnes i fatanbal. Joachtin havde naton vundet det sa-

panaka fotofirmas lokale konkurrence for Danmark, men hana billoche for Albanien blev ikke placeret i Tyrkief. Ti gregeld späede köllegnen i satolagy, st de ville komme til tops hos den uaf

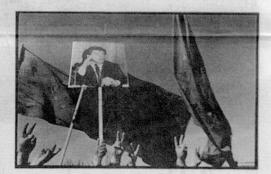

hængige og non profitable World Press Photo Foundation. Den clairvoyante belgier fik ret.

Som søn af en enlig mor med tre bærn og konstant flytterrang blev det ak som så med Janchin Ladefogden skningene. Påmillen vær i kunstant opbrud unskring Sikasborg. Skandørberg og Arbus. Han tidede at stilte bekendiskab med omkring en som skoler, inden han ofter sin rygden sjuttede 10. klasse med udvidet

Sit aprogramme er ham til stor prounder de mange reportageneise i tu landet for Politiken, men ellers har h den og fremneset stocheret billeder. T utgesårens enskring den berente Misnim gruppe, soms de hjennige lespin forer er esere som Kras Kissente, R Skang og Heisen Poligress.

Nu hare berefingen faktask overhaltet di attimale messier, og veredos og frem den ligger han kloen. Men færsikele asær-fonchinn til arbeide bere på Plad m. Om kort til reijer han på regoris totspunds at sik sig ned asen førsike etter til Köne, og å dørsmære han om p totspunds at sik sig ned asen førsike red sex tid i New York. Den inng redsessmatte skal deg lige bjens n

Bla Bog

 Ioachim Ladefoged, presselotograf, 27 kr.
Uddarnet på Årtus Stittstidende 1991-95. Enrinden uninstan

POLITIKEN

hex fotogruppen Fokus, 12 Poltiken 1993. Nationale priser: 1, pris, Årats

 Ny/headabilitada, 1996, 1. pris.
Acata Prassampartnati, 1997, 2.
pris, Aneta Handhingdotto, 199
pris, Reportagebilisida, Fugi Komkumence, Davenark, 1998.

Model Press Phone I Agengorien People in the News Sources med serie på 12 bilader fra Albarien, 3. pris I samme kategoris affor enkelfniturgene Landers

mess et ur de abasosa preparentos, • Furbilleden Den internationale Magmen groupe sant de heendige Kras Klement, Stig Statig, Heine Pedersen og Futogruppen 2. Maj.

Fremtulaplaner: Et ars orlow som 5 mar i New York

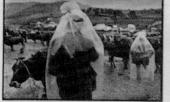

Narrative by Gilles Peress

Bosnia, Feb. 19

As I am walking through this destroyed landscape, through the remains of a war now gone, I am overwhelmed by the silence, the absence of explosions. I can hear the birds singing. The ending of war is almost more depressing than war itself because once you don't have to run for your life, the evidence of waste is fully there to contemplate as slowly as you want, inch by inch, bullet hole by bullet hole.

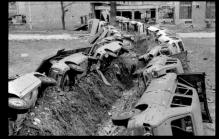

The sense of hangover of the day after the party, after the house was trashed, after the family was destroyed, the children dispersed, colors every one of my feelings. There is a bitter taste. People in Sarajevo and in the Serbian suburbs are sullen; there is none of the joy that one would expect from the coming of peace.

I am listening to the BBC World Service when a sudden announcement on the 6 o'clock news explodes like a shell in the middle of a sunny day: the Serbs have to leave Sarajevo's suburbs within three days. We, and I suspect they, all thought that the deadline was a month later: the 19th of March.

I quickly check the information; the deadline has been moved for some of the suburbs so that the evacuations would be staggered. The Serbian neighborhoods will go over to the Bosnian authority one after the other at intervals of six or seven days. The first one to go -- in three days, as announced on the radio -- is Vogosca.

INDEX GRID CONTEXT FORUMS

PREVIOUS MORE NEXT

transmitted photographs by satellite in 1967 - but before digital cameras, the process was laborious. News stories in the late 1980s involved photographers making pictures during the day, processing film in the hotel bathroom during the evening, and scanning and transmitting (via imperfect phone lines) overnight. Media visionaries like Andy Grove saw that this technology was 'about where the horse and buggy business was when Henry Ford first cranked up the assembly line'. By the time the United States invaded Afghanistan in 2001, photographers still travelled by donkey across the desert, but they carried powerpacks to transmit images via satellite to their distributors, able to reach any newspaper in the world in seconds. And with the war in Iraq in 2003, digital images travelled back to waiting websites as soon as exposures were made. Still pictures now beat television in the race to broadcast breaking news.

The rise of digital technology and the internet occurred following the fall of the Soviet Union and the collapse of Communism. The result of both events was what media mogul Rupert Murdoch has called 'a borderless world'. The consumer marketplace now spans every continent – kids want the same sneakers, see the same TV shows, hear the same music, whether they live in Paris, Beirut, Rio or a village in sub-Saharan Africa. Political and geographical borders have become less significant, while power shifts to global economic networks established by trans-national corporations

Left: *New York Times*, website 1996 with a page from 'Bosnia: Uncertain Paths to Peace' by Gilles Peress Below: *Vanity Fair*, February 2002, photograph by Annie Leibovitz such as Viacom, Sony, Bertelsmann and Disney.

While major print publications initiated new experiments with on-line storytelling - the most notable early example is the New York Times publication of Gilles Peress's on-line story 'Bosnia: Uncertain Paths to Peace' in 1996 (see left) - the facility to communicate on the internet and an emerging culture of do-it-yourself media have broken old monopolies over the production and distribution of news. Organizations have emerged that change the relationship between producers and consumers, one such being Médecins Sans Frontières. Founded by a group of French doctors in 1971 to deliver medical care to at-risk populations, from the outset they linked medical assistance with efforts to sway public opinion, generating stories and bringing media attention to crises that would otherwise go unreported. In their words, 'without a photograph there is no massacre'. For media historian Robert McChesney, the most serious consequence of a world without borders is the phenomenon which (in Rich Media, Poor Democracy, 1999) he calls 'convergence', defined as 'the manner in which digital technology eliminates the traditional distinctions between media and communication'. It is no longer easy to draw a line between the technical design of a website, its content, and its sponsors. What is an advertisement, and what is an editorial feature? What is information, and what is propaganda?

Just as significant, while owners of newspapers, magazines and television stations have never neglected the need to make a profit, they earlier viewed serious (and often expensive) journalism as a means to enhance the prestige of their organization and provide a service to their community. This

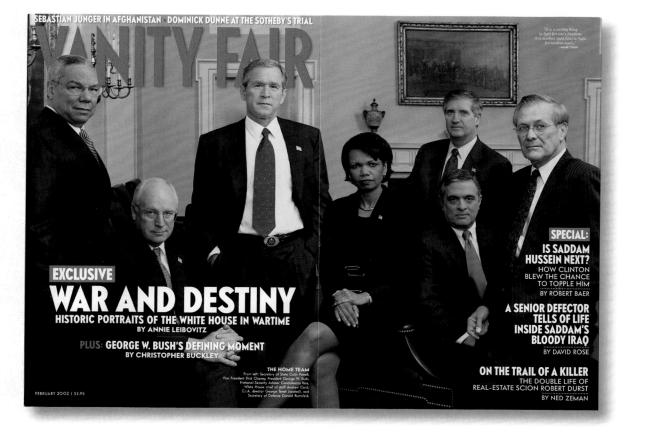

civic-mindedness declined in the early 1990s, with information services seen as one more business investment, measured in terms of profit. Expensive work was consistently cut back, with networks, magazines and newspapers putting fewer reporters and photographers on staff, and with writers and editors relying instead on the wire services and the consolidated mega-agencies Corbis and Getty for most of their international news. The kind of stories that take time and money have often been set aside in favour of today's immediate breaking news, local crime stories, accidents, celebrity antics and athletics contests. In 1998, the *Economist* declared, 'In this information age, the newspapers which used to be full of politics and economics are thick with stars and sport.'

For the world's photojournalists, its combat zones have steadily divided into two groups: those in which America and the other main global players are involved, that are accessible on the warring powers' strict (and self-interested) terms; and wars in the rest of the world, that are freely accessible (if dangerous) but which fall outside the scope of the world media's interest. Photographic work in the latter category is frequently unpublished except in the pages of photojournalism magazines such as Ei8ht or as the winners of contests such as World Press Photo. Documenting America's wars independently, meanwhile, becomes the game of only a daring few. Even when it is possible, mainstream publishing opportunities remain limited. Kenneth Jarecke worked under the restrictions set up by the US Department of Defense during the first Gulf War, and contributed images to the pool distributed to the

Proceso, 9 December 2001

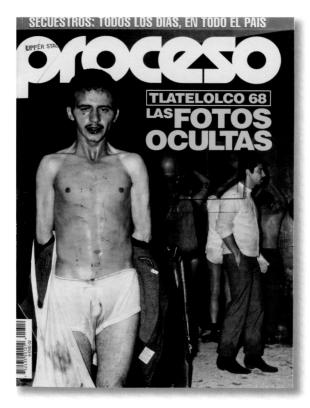

media during the war. But he remained in Iraq as a freelancer, and strayed into forbidden territory – coming across the charred remains of a vehicle holding Iraqi soldiers. American publishers would not touch the resulting photograph. It ran first in the *Observer* of London (and then only the conflict was over), becoming an icon of the desert war in America only much later.

A useful comment on the state of the publishing world today can be found in Walter Benjamin's observation (referring to the press of 1930s Berlin in his 1934 essay 'The Author as Producer') that the modern newspaper was a 'theatre of literary confusion', full of information on a limitless array of subjects, arranged with no particular order, organized by no principle other than one imposed by the reader. But for Benjamin this state of confusion also offered an opportunity: 'As writing gains in breadth what it loses in depth, the conventional distinction between author and public ... begins to disappear. For the reader is at all times ready to become a writer.' Today his words offer an optimistic note. For example, the existence of independent satellite networks broadcasting over television and radio has made it possible for ordinary citizens in places like Peru, Argentina and Chile to challenge a press that was strictly censored. In however limited a way, the open skies of satellite communication make corruption and political censorship easier to expose, and protest harder to control and suppress. This climate benefits both the present and the historical record, and makes it possible to publish images that were once too dangerous to release, overturning years, even decades of censorship - for instance, with Proceso's publication of previously suppressed photographs of the 1968 student riots in Mexico City (see left).

Technological change has been accompanied by new directions across photojournalism. When Benetton's Oliviero Toscani developed Colors magazine, he forged a radical, stylish update of the kind of photomontage once published by Arbeiter Illustrierte Zeitung capable of graphically relaying information about complex topics such as immigration, sexuality, consumerism and Aids. A host of new visual magazines are exploring the boundaries of reportage while in the mainstream press minimalist compositional approaches, reminiscent of Walker Evans, have resurfaced alongside new varieties of photographic virtuosity. Photographers like Susan Meiselas and Pedro Mayer have published websites that incorporate historical information, contemporary reportage and contributions from readers and viewers - in Mayer's case, developing the non-linear, autobiographical narratives that he explored on CD-ROM in the early 1990s (and which, ten years on, already seem technologically antique).

Without fanfare, photographers, publishers and audience alike have agreed to abandon sharp distinctions between art and journalism. The blur between personal expression and reportage also influences the formal characteristics of work today. Annie Leibovitz, for instance, makes overt references

to the style of the Dutch Masters in her group portrait of the Bush War Cabinet, commissioned by Vanity Fair in 2003 (see page 31). The distinctive compositions and prints - made by photojournalists such as James Nachtwey and Stanley Greene have earned them exhibitions, books and a new following in the art world based on images originally produced while covering a story for publication. Other photographers trained in photojournalism have left the magazine entirely behind, to produce photographs specifically for the museum wall - notably Luc Delahaye with his 'History' series - that then find their way back into magazines in the context of reports about the artists' work and exhibitions. In a reversal of the trend, artists whose photographs regularly hang in museums and sell in galleries have recently turned to magazine reporting. When the New York Times sent artist Nan Goldin behind the scenes to follow the career of rising fashion model James King (see page 304), Goldin's trademark style, with its lurid colour and aggressive intimacy, gave a grim story glamour and suspense.

Perhaps most significant is the way in which digital photography and new channels for publication allow anyone with a camera to find an audience for his or her work. This 'democracy of photographs' was heralded as the subtitle of the exhibition, website and book *Here is New York* (2002), featuring contributions from both professionals and the masses of amateurs whose cameras recorded the events surrounding the 9/11 attack on the World Trade Center. In the spring of 2004, investigative reporters uncovered amateur digital images made in the prison of Abu Ghraib, outside Baghdad, and exposed the illegal torture of Iraqi prisoners by the American military, in violation of the Geneva Conventions (first exposed in the pages of the *New Yorker* in 2004, see below). While photojournalists strive to distinguish their work from each other's, it has become a commonplace to see riveting news events illustrated by the guileless snaps of non-professionals.

The borderless media world, with its promiscuous appropriation of images, has forced journalists to reexamine the relationship between authors, publishers and readers. The publications of the future promise entirely new forms of communication – as different from our present magazines as *Vu* and the *Berliner Illustrirte Zeitung* were from their predecessors. In the 1930s, a great transformation in communication came about in part because rogue photographers like Erich Salomon used new cameras to make pictures that were inconceivable beforehand. In the era of the internet and the camera-phone, photographers and editors are inventing new means to reveal things as they are, and readers, photographers and publishers are forging new contracts.

The application of the term 'photojournalism' to camera-phone pictures of the 2004 tsunami will be questioned by some, but as published in magazines or on the internet, our criteria for its use here are met. We are forced to conclude either that photojournalism is alive and well and in the process of a dynamic reinvention. Or that something else is emerging from its history to take its place – and which has yet to be given a name.

large jails, eight battalions, and thirty four hundred Army reservists, most o whom, like her, had no training in han dling prisoners.

There was stumming evide port the allegations, Tagut vas five, is "detailed witness statemen vilian life, ernew job. mber with eos taken by the soldiers as

antes at Aba 'Ghraih, 'Inconfision now are better rision than at home. At one in the wave concentration of the ywouldly want to leave.' A month later, Ceneral and a contrasting of the prinkly and formally alded, and a mayier interesting in itto the Army's prison medic in Irag, was under A fifty-dime-page report, and by *I* abbe. Jones, the fifty-dime-page report, and by *I* abbe. Jones, and other in Irag, was under A fifty-dime-page report, and by *I* abbe. Jones, and other in Irag, was under A fifty-dime-page report, and by *I* abbe. Jones, was plated in late Fortuna's find chains about the instion system were desuata-Specifically. Tagaka found

tember of ADUS there were neroous instances of "addistic, blar, and wanton criminal abuse" at Ghraib. This systematic and llegal ee of detainees, Taguba reported, was pertated by soldiers of the 372nd itary Police Company, and also by hers of the American intelligence munity. (The 372nd was attached the 320th MLP Battalion, which rered to Karpinski's brigade headquar-D'aguba's report listed some of the

Recaking chemical lights and pouring the phosphoric liquid on detainese pouring cold water on nakied detainese, beating detainese with a broom handle and a chairy literatening male detainess with rape, allowing a military police gaard to brite the wound on a detainese who was injusted after being slammed against the walk in his scells soldmitzing a detainese stick, and using military working a dege to stick, and using military working a dege Print

reats was reassigned to Fort Bragg, North Arting Carolina, after becoming pregnant. The photographs tell it all. In one, Prisup-vate England, a cigarette dangling from

her mouth, is giving a jaunty thumbs-up sign and pointing at the genitals of a young Iraqi, who is naked except for a sandbag over his head, as he masturbates. Three other hooded and naked Iraqi peis-

> irely crossed over their genials. A fifth prioren thas hands ar his sides. In another, England and sen is a with Specialis Graner, both are grinning and gring the thumbs-up behind a cluster of perlaps behind a cluster of perlaps were makel laps', hore here, other in spremid There is anerber in spremid There is andred priorenz, again plate in graners and the size of the photograph shows distert and in front of him, bending even and she, too, is mother Cluster of photograph shows a henceling, naked, unhousded male priner, band momentum height photograph. Show is mediamany of the strength photograph shows the net, bed momentum height proform the samen, posed forming oral sex on another forming oral sex on another

able in any collimate hore is a materic property of the second second second second second are against Idamic law and it is humilsing for men to be maked in frost of other men, Bernard Haykad, a professor of Middle Eastern studies at Now York University, explained. "Being part on top of each other and forced to maturbate, being maked in frost of each other—with all a form of otherms," Haykel asid. Two Imaji faces that of appear in the photographis are those of dead men. There is the battered face of prisoner No. 153999, and the bloodied body of another prisoner, verapped in cellophane other prisoner, verapped in cellophane

told he would be electrocuted if he fell off the box; Specialist Charles Graner and another soldier with det

adcast on CBS's

1955-1964 WHEN MAGAZINES WERE BIG

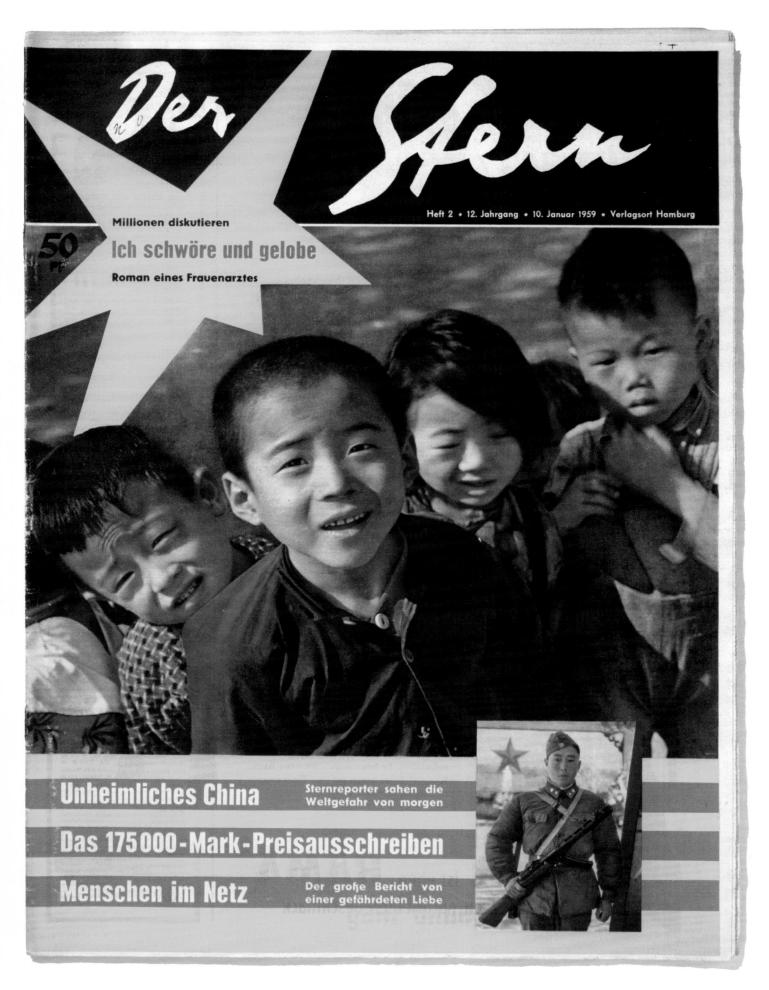

HENRI GARTIER-BRESSON THE PEOPLE OF RUSSIA 38 RENRI LARIER BEAUTIES OF THE COMMON TOOL 44 WALLANE ENANG THE CONGRESSIONAL 45 ROBERT FRANK NERUES UF BUURFEST FARIS MATER SWISS BORDER 56 NALDEMAR DÜRST REFUGEES AT THE SWISS BORDER 56 nuorana anana ang uununua ang Ag DAVID DDUGLAS DUNCAN GAZA STRIP 47 1955 IUNI 4NUNUV NEW IUNN 20 IAVID DDUGLAS DUNCAN PICASSO AT HOME 59 1955 1955 TAZIO SECCHIAROLI LA TURCA DESNUDA 66 1956 1956 ALGERIAN LIBERATION ARMY AL ARABI 67 1956 1957 ROLF GILLHAUSEN CHINA 68 HENRI CARTIER-BRESSON CHINA 72 1958 1958 WEUGENE SMITH PITTSBURGH 76 RUBERT LEBECK THE KING'S SWURD 1958 anumei iuminiau iwwanuni 64 PETER MAGUBANE SHARPEVILILE FUNERAL 86 1958 1958 DIANE ARBUS VERTICAL JOURNEY BI WINNE ARE WALLEE IN A DELHI SLUM 9D 1959 1959 1960 1960 GORDON PARKS FLAVIO 91 DICKEY CHAPELLE HELICOPTER WAR 1960 RAUL CORRALES FARMER-SOLDIERS 98 1960 GIANFRANCO MOROLDO DAM BURST 100 THE POPE VISITS THE HOLY LAND EPOCA 1961 1961 1961 1962 1963 1963 1964

1955-1964 WHEN MAGAZINES WERE BIG

The magazines of the late 1950s are big in every way – with big pages, big pictures, big audiences, big photographers and big stories. Although the power of television grows constantly during the period - particularly in America magazines that enter millions of homes around the world remain the most important source of visual information about the news of the day. As the postwar world is reshaped to new Cold War and post-colonial conditions - the Berlin wall is constructed and Pakistan separates from India - much remains for the photographer to discover and present for the first time in pictures. The world shrinks with sophisticated visual accounts of cultures - and conflicts - in the Soviet Union, China, Vietnam, South Africa, Cyprus, Japan, Algeria, Cuba and the Congo. Postwar austerity in Europe and America is steadily replaced by economic prosperity. Celebrities are in the front line of new consumer cultures and sell the most magazines - Grace Kelly weds Prince Rainier of Monaco, the good-looking Kennedy family enters the White House, and the genre of the 'paparazzi' is initiated in Italy. Photojournalism amplifies the celebrity charisma of Elvis, Fidel Castro and Pablo Picasso. As the Soviet Union pulls ahead in the battle for outer space, with Yuri Gagarin the first man to orbit the earth in 1961, Cold War tensions and alliances dominate the perspective of every nation's press. In late November 1963, the media momentum begins a decisive shift, as the coverage of the assassination of US President John F Kennedy brings a nation together to watch and mourn - on television.

MOGENS VON HAVEN

Competitor tumbles off his motorcycle during motorcross world championships. Volk Mølle racecourse, Randers, Denmark. World Press Photo of the Year 1955

YASUSHI NAGAO Mainichi Shimbun

Hibiya right-wing student assassinates Socialist Party Chairman Inejiro Asanuma during speech. Hall, Tokyo, Japan, 12 October 1960. World Press Photo of the Year 1960

HELMUTH PIRATH Keystone Press German World War II prisoner released by the Soviet Union is reunited with his daughter. West Germany. World Press Photo of the Year 1956

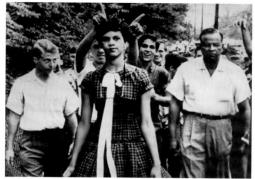

DOUGLAS MARTIN Associated Press

Dorothy Counts, one of the first black students to enter the newly desegregated Harry Harding High School. Charlotte, North Carolina, USA, September 1957. World Press Photo of the Year 1957

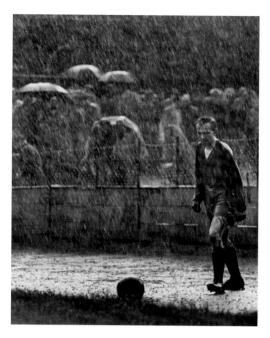

STANISLAV TEREBA Večerni Praha National soccer championship between Prague and Bratislava Prague Czechoclovakia September 1955

National soccer championship between Prague and Bratislava. Prague, Czechoslovakia, September 1958. World Press Photo of the Year 1958

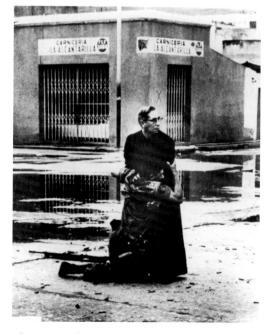

HÉCTOR RONDÓN LOVERA Diario La República Priest Luis Padillo with soldier mortally wounded by a sniper during military rebellion. Puerto Cabello naval base, Venezuela, 4 June 1962. World Press Photo of the Year 1962

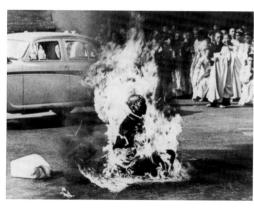

MALCOLM BROWNE Associated Press

Buddhist monk Thich Quang Duc sets himself ablaze in protest against alleged religious persecution by the South Vietnamese government. Saigon, South Vietnam, 11 June 1963. World Press Photo of the Year 1963

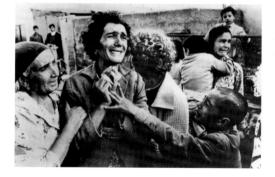

DON MCCULLIN *Observer, Quick, Life* A Turkish woman mourns her dead husband, victim of the Greek-Turkish civil war. Ghaziveram, Cyprus, April 1964. World Press Photo of the Year 1964

1955 HENRI CARTIER-BRESSON THE PEOPLE OF RUSSIA PARIS MATCH

To continue his series of sweeping profiles of countries in transition after World War II, Henri Cartier-Bresson reached Moscow in July 1954 after an eight-month wait for a visa – the first Western photographer to be granted access after Stalin's death the previous year. Independently produced, *Holiday* magazine considered giving an entire issue over to his pictures before *Paris Match* and *Life* magazine both bought the rights. In a sense, the story is simply that Cartier-Bresson went, and saw, and while he clearly bore some sense of responsibility toward the themes of interest to the magazine reader, his exploration of street-level Russia and the persistence of peasant culture in the modern state was a free-spirited engagement on his own artistic terms. He explained his goal as seeking to photograph 'human beings in the streets, in the shops, at work and at play, anywhere I could approach them without disturbing reality', and he used his inability to speak Russian as a shield, deflecting attention toward his official translator and away from his camera. The genius of Cartier-Bresson's work during this period lay not only in his images, but in his success at packaging his personalized vision so accessibly and intelligently for the photojournalism market. (29 January and 5 February 1955)

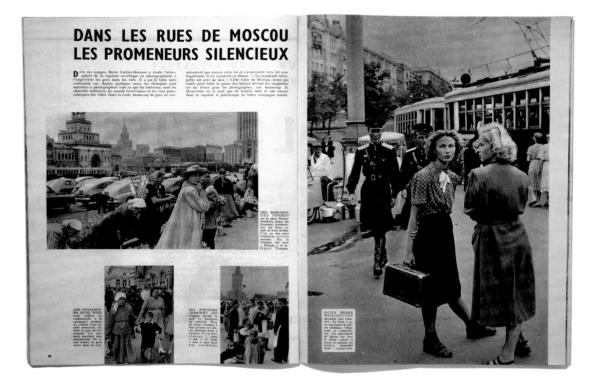

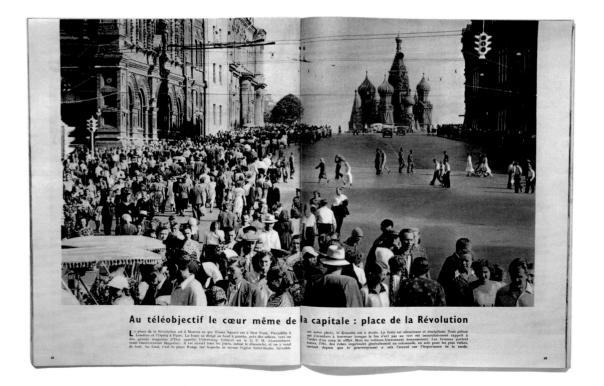

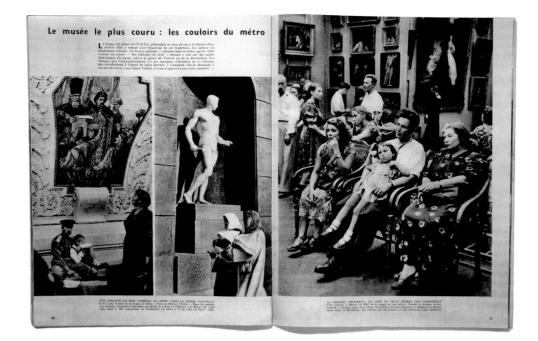

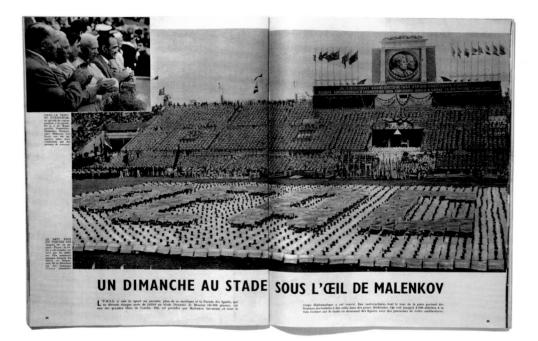

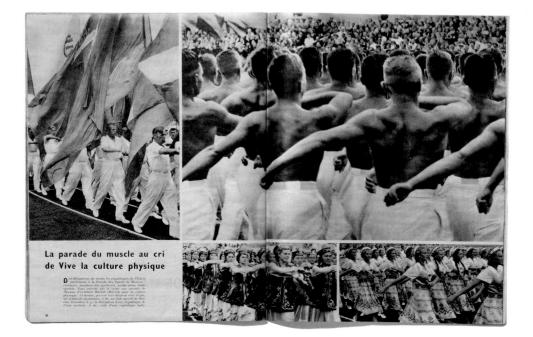

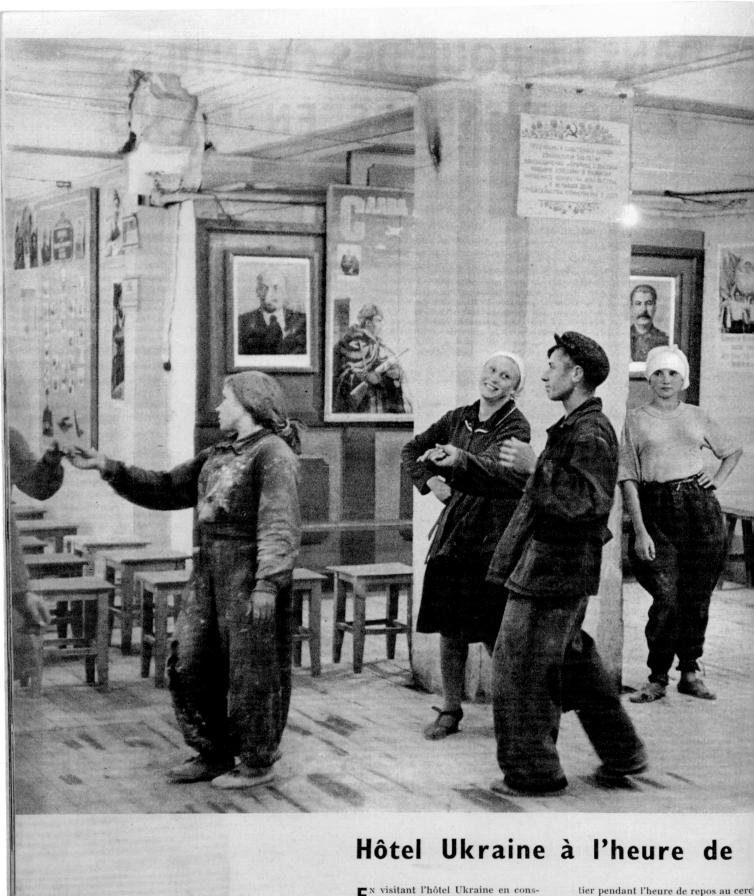

E^N visitant l'hôtel Ukraine en construction, Henri Cartier-Bresson a surpris les ouvriers et les ouvrières en train de danser au son de l'accordéon. La scène se passe dans le chantier pendant l'heure de repos au cerc du club du bâtiment. A gauche, u danse populaire. A droite, une dan occidentale. Le jazz est admis de no veau. Dans les chantiers, les ouvrie

60

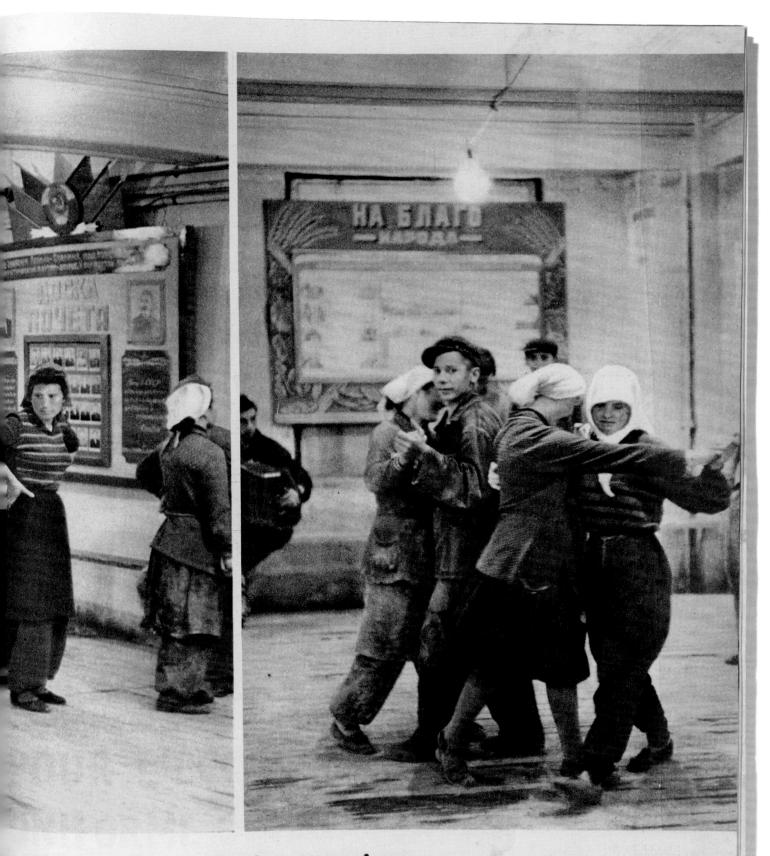

ause : le fox-trot des ouvriers

travaillent en équipes de jour et de nuit. Il est cependant difficile pour la construction de suivre la cadence de l'augmentation de la population moscovite. Toutes les maisons anciennes ne sont pas détruites. Celles qui ont un intérêt artistique sont conservées. Si elles se trouvent dans la zone à reconstruire, on les déplace en les emmenant sur des rouleaux.

61

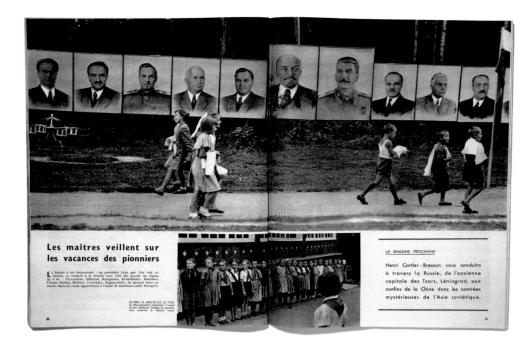

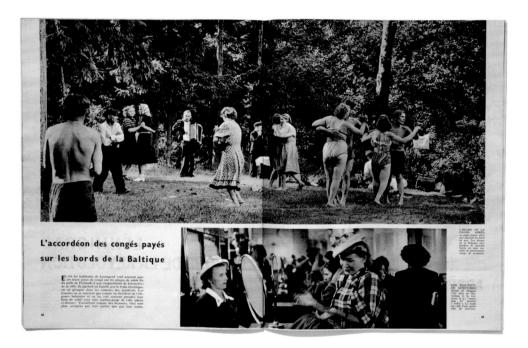

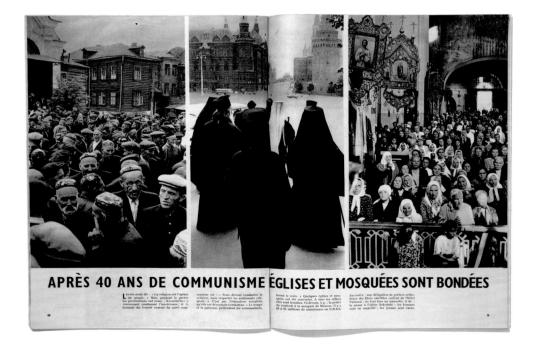

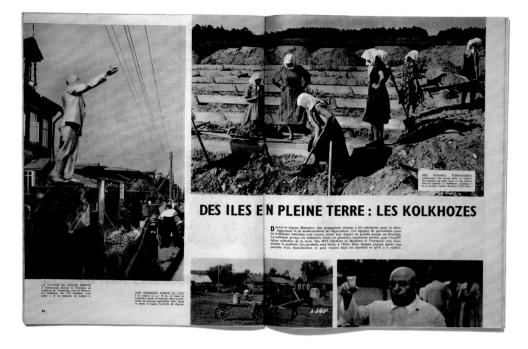

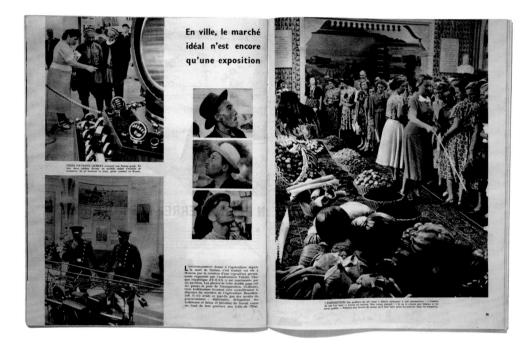

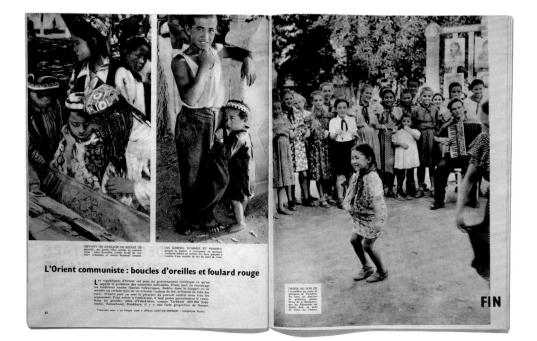

1955 WALKER EVANS BEAUTIES OF THE COMMON TOOL FORTUNE

In 1945, Walker Evans became the first staff photographer for *Fortune*, where he remained until the early 1960s. Alongside routine assignments, he produced photo essays that recalled his work for the Farm Security Administration, on topics such as coalmining in Kentucky and the decline of small-town America. In 1948, with the new title of 'Special Photography Editor', Evans began to produce portfolios of photographs – about thirty in all – that aimed to 'take a long look at a subject, get into it and without shouting tell a lot about it'. One of the most successful was 'Beauties of the Common Tool' in which he photographed twelve ordinary objects using a technique he had employed to record African sculpture for the Museum of Modern Art, New York. For Evans, these tools embody an aesthetic that is both masculine and sensual, and his plain, descriptive images turn them into emblematic metaphors for human labour. In his own text he describes a hardware store display as 'a kind of offbeat museum show for the man who responds to good clear ... design', by definition, full of 'elegance, candor and purity'. (July 1955)

Beauties of the Common Tool

A portfolio by Walker Evans

Among low-priced, factory-produced goods, none is so appealing to the senses as the ordinary hand tool. Hence, a hardware store is a kind of offbeat museum show for the man who responds to good, clear "undesigned" forms. The Swedish steel pliers pictured above, with their somehow swanlike flow, and the objects on the following pages, in all their tough simplicity, illustrate this. Aside from their functions—though they are exclusively wedded to function each of these tools lures the eye to follow its curves and angles, and invites the hand to test its balance.

Who would sully the lines of the tin-cutting shears on

page 105 with a single added bend or whorl? Or clothe in any way the fine naked impression of heft and bite in the crescent wrench on page 107? To be sure, some design-happy manufacturers have tampered with certain tool classics; the beautiful plumb bob, which used to come naively and solemnly shaped like a child's top, now looks suspiciously like a toy space ship, and is no longer brassy. But not much can be done to spoil a crate opener, that nobly ferocious statement in black steel, as may be seen on page 104. In fact, almost all the basic small tools stand, aesthetically speaking, for elegance, candor, and purity. —w.E.

1955 ROBERT FRANK THE CONGRESSIONAL FORTUNE

One of the successful magazines published by flamboyant, conservative businessman Henry Luce, *Fortune* was about business and wealth, using lavish design, beautiful illustrations and solid reporting to lure a small, affluent group of readers – and the advertisers who wanted to reach them. Walker Evans gave work to documentary artists such as Ezra Stoller and Berenice Abbott to enhance the magazine's sophisticated appeal. In 1955, when the exclusive 'Congressional' train began express runs between New York and Washington DC, a subject he knew would appeal to *Fortune*'s readers, he assigned Robert Frank to photograph it. Frank's images depicted his powerful subjects and their setting without sympathy or condescension, creating an essay of subtle suspense. Simultaneously, Evans supported Frank's application to the Guggenheim Foundation for a grant 'to produce an authentic contemporary document' of American life, showing 'the things that are there, anywhere and everywhere – easily found, not easily selected and interpreted'. The grant and Frank's travels resulted in *The Americans*, published first in Paris in 1958 and in New York in 1959. (November 1955)

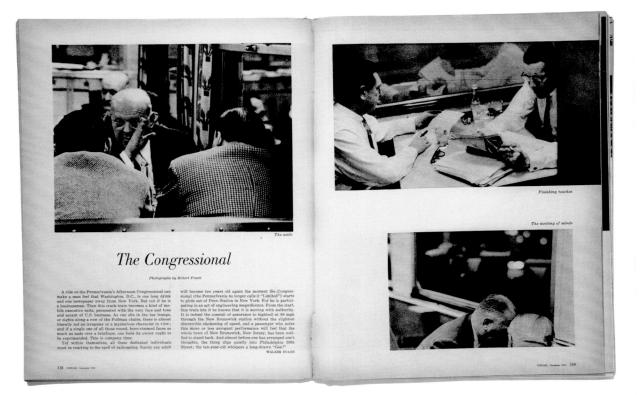

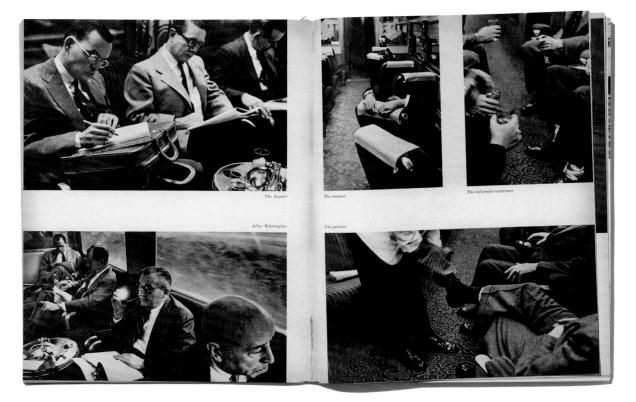

1956 DAVID DOUGLAS DUNCAN GAZA STRIP COLLIER'S

Shortly after David Douglas Duncan left the staff of *Life* magazine, *Collier's* published twelve pages of his colour photographs of Gaza. Using a few portraits and many landscape studies, Duncan represents military occupation with the same even gaze that he gives to timeless views of ocean and desert. At a time when the American press and public overwhelmingly favoured Israel, the report aroused a sharp response. Some readers welcomed the representation of Palestinian subject matter, while others complained that it amounted to pro-Arab or anti-Israeli propaganda. The magazine, first published as *Collier's Once a Week* in 1888, was one of the earliest American magazines to exploit the technology for reproducing photographs. Having established its reputation for promoting social reform issues early in the twentieth century, it reached the peak of its success during World War II – becoming for a moment *Life*'s liberal rival, when its contributing writers included Martha Gellhorn and Ernest Hemingway. However it did not survive the competition of television; in 1953 it started to publish fortnightly instead of weekly, and in 1957 it folded. (3 August 1956)

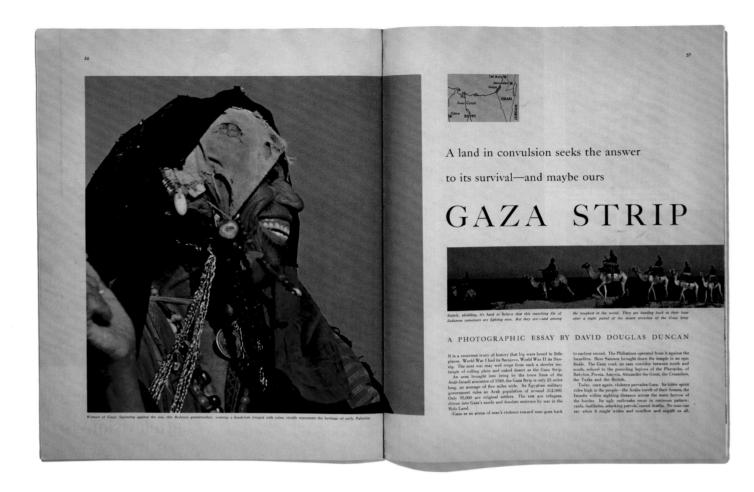

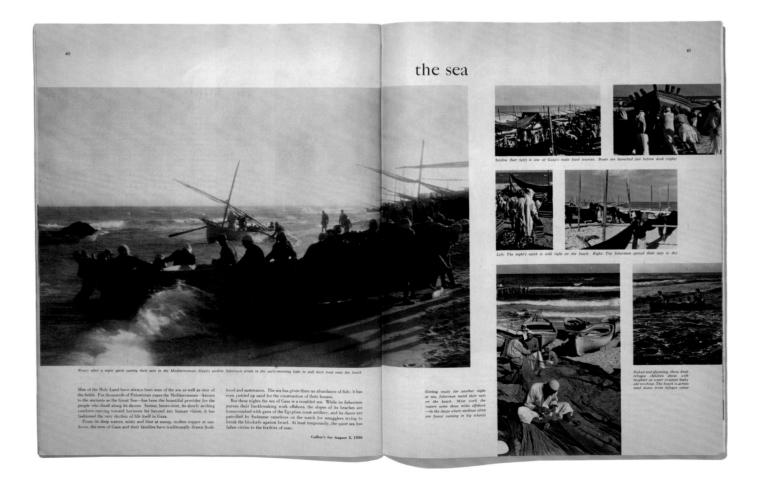

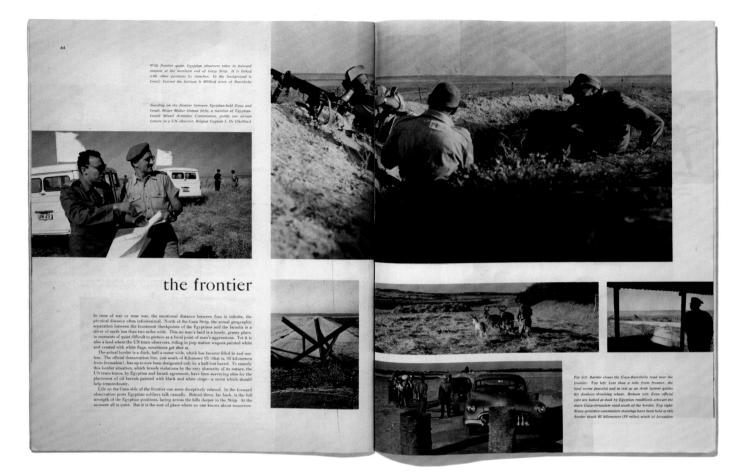

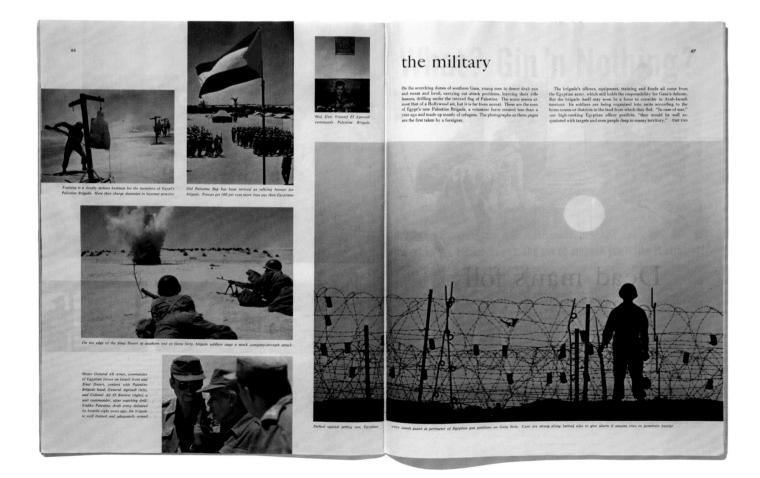

1956 HEROES OF BUDAPEST PARIS MATCH

The headline reads: 'From inside the capital of the revolt our special correspondents risk their lives to bear witness to the Hungarian people's fight for freedom.' *Paris Match* took a partisan stand during the popular uprising that began on 24 October 1956 against Hungary's Communist government and its Soviet backers. Its spectacular feature went to press before Soviet tanks retook the city on 4 November and during the brief but exhilarating moment of victory while partisans remained in control of Budapest. The 'heroes' of the title were both the Hungarian rebels and *Paris Match*'s own team of writers and photographers, among whom was the magazine's own martyr – Jean-Pierre Pedrazzini, who was injured during street fighting and died in a Budapest hospital before *Match* published his pictures. A particularly striking ingredient of the story was the bought-in series of images made by *Life* magazine photographer John Sadovy on the first day of fighting, showing the shooting of seven young Hungarians believed to be collaborators. Their uniforms identified them as officers in the loathed Soviet police force, but several weeks later readers learned that they had in fact left the Soviet army and wanted to defect. (10 November 1956, with photographs by Melcher-Berretty, Franz Goezs, Erich Lessing, Paul Matthias, Jean-Pierre Pedrazzini, John Sadovy, Jean-François Tourtet and Vick Vance)

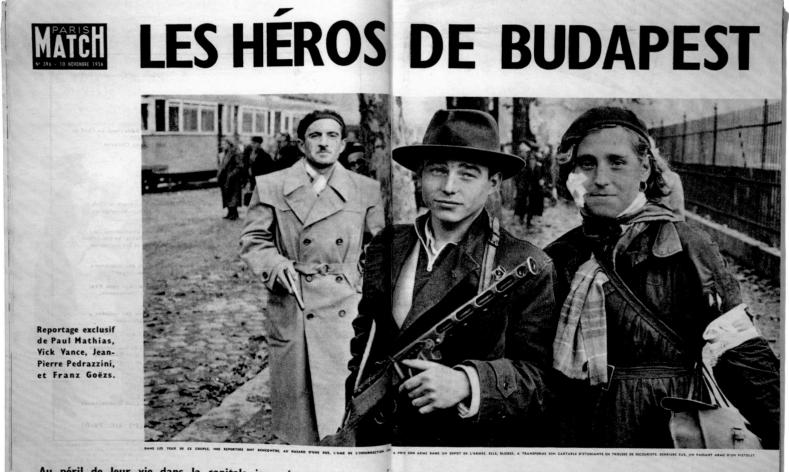

Au péril de leur vie dans la capitale insurgée, nos envoyés spé ciaux témoignent de la lutte du peuple hongrois pour la liberté

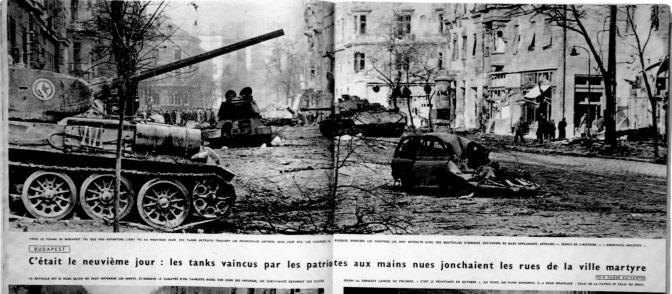

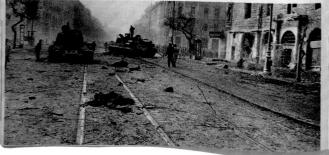

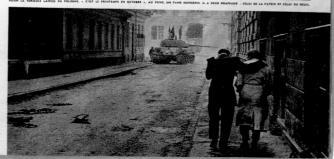

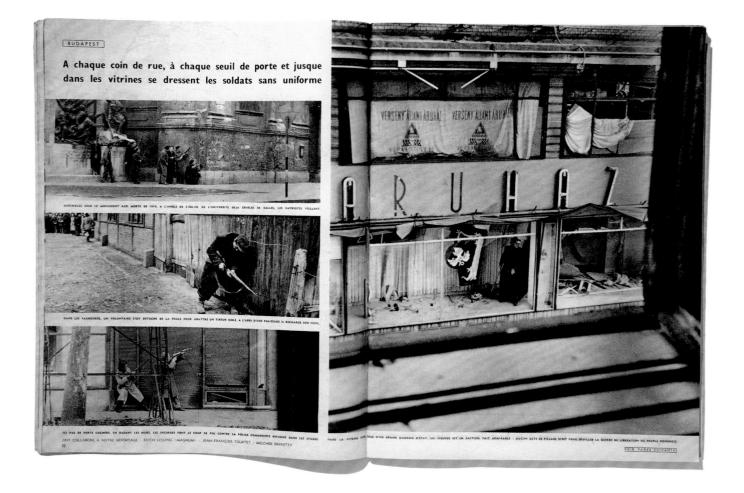

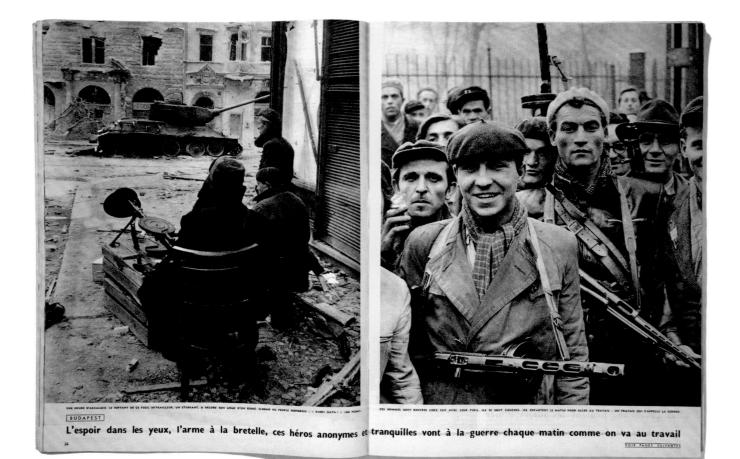

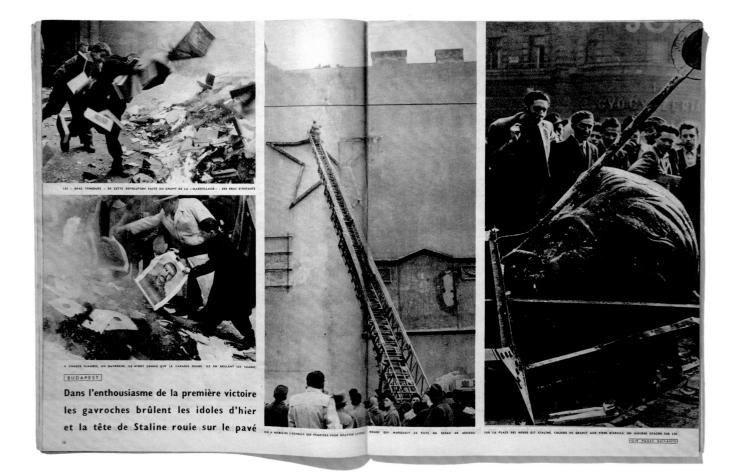

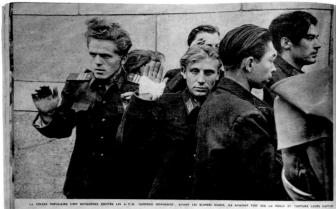

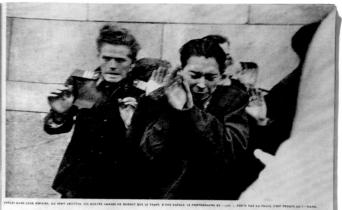

BUDAPEST

Onze ans de colère sourde explosent ici. Les policiers du régime détesté tombent au coin d'une rue sous la salve d'un peloton d'exécution

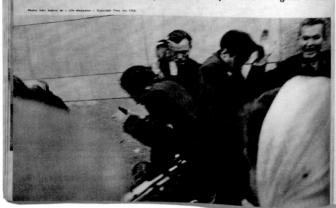

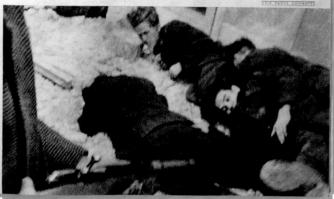

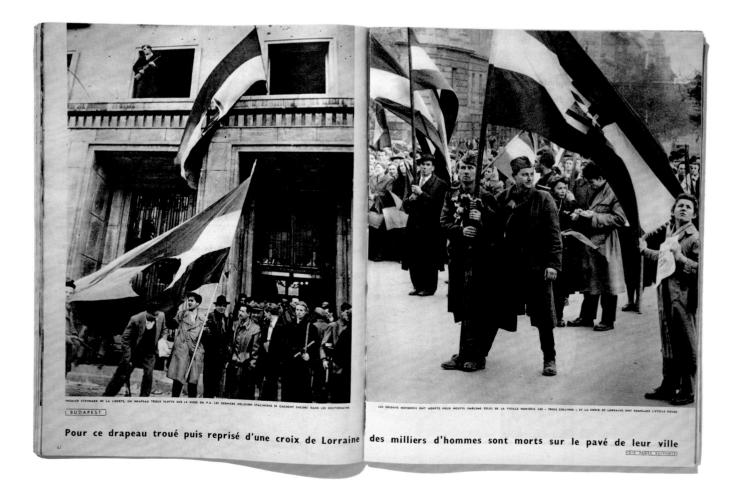

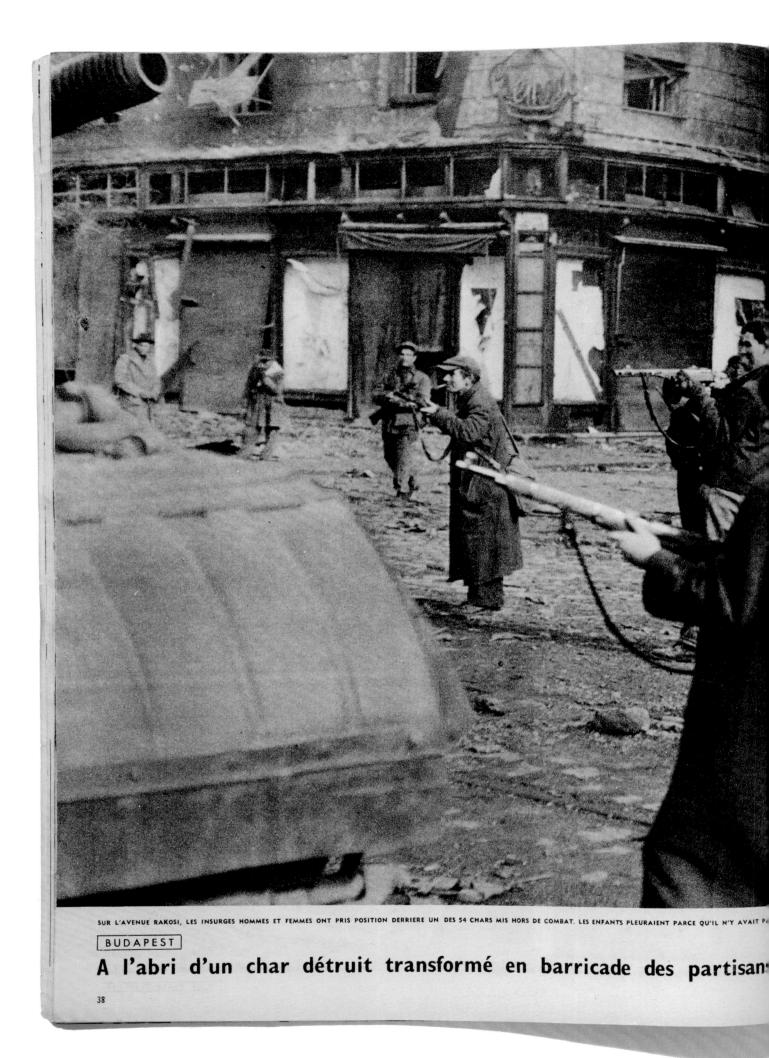

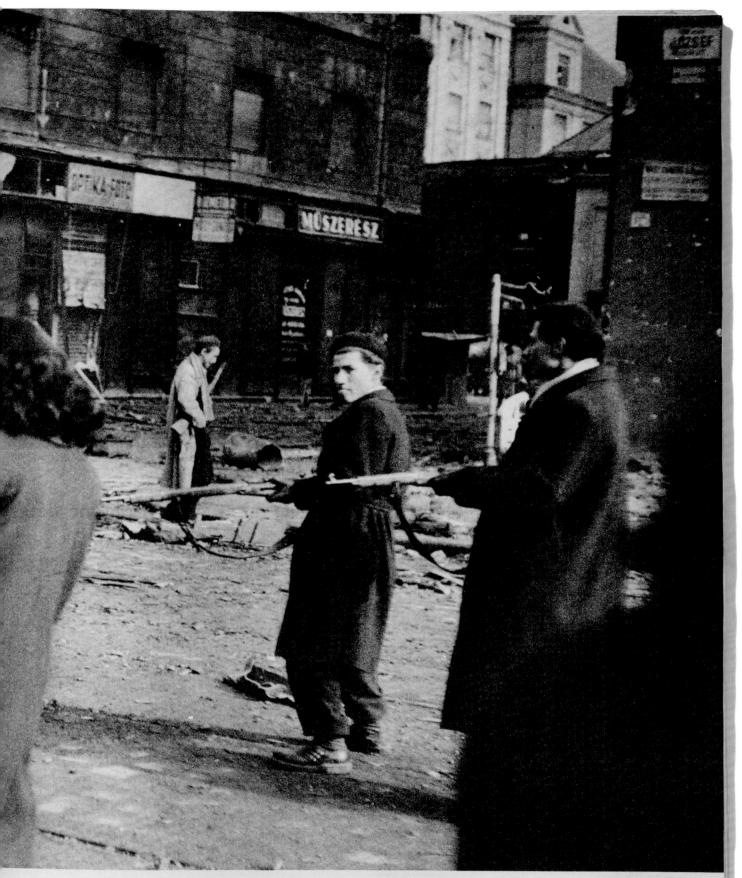

LS POUR EUX, MAIS ILS AVAIENT MIS AU POINT UNE TECHNIQUE : SAUTER SUR LE TANK PAR-DERRIERE, JETER UNE GRENADE A BOUT PORTANT ET SAUTER AVANT L'EXPLOSION.

més de fusils semblent composer le dernier tableau de l'insurrection

VOIR PAGES SULVANTES

1956 WALDEMAR DÜRST REFUGEES AT THE SWISS BORDER DIE WOCHE

When Switzerland opened its borders to Hungarian refugees in 1956, Waldemar Dürst used his story on the subject for *Die Woche* (accompanied by his own text) to present a heartfelt essay on the plight of the refugee in the postwar world. He challenged readers (who might be tempted to celebrate Swiss generosity) by noting that the welcome given to just one thousand refugees was nothing more than a 'lonely gesture', rooting his invective in identification with those working toward a 'Free Hungary'. Though impoverished, his refugees appear conspicuously dignified, firmly positioned within a genre of humanistic representation. Dürst grew up in Switzerland, studying photography in Vevey under modernist Gertrude Fehr (who also influenced Bruno Barbey, Luc Chessex and Jean-Loup Sieff) before turning to photojournalism. He worked for *Die Woche* and other Swiss publications from 1952 until the early 1970s when, discouraged by the limited scope for his brand of concerned humanitarian approach within the illustrated press, he abandoned photography. (12 November 1956)

1957 YURI ZHUKOV NEW YORK OGONYEK

From the late 1940s until the late 1970s, Yuri Zhukov was one of the USSR's best-known and most admired journalists, and a regular interpreter of US politics and culture. In a paradox typical of the Cold War, he was also one of the best-known Soviet figures in the West, and whether in print or in casual conversation, his words were understood to express official government policy; in 1976, for instance, the *New York Times* referred to him as 'the Master's Voice of *Pravda*'. In 1957 Zhukov contributed this picture story to *Ogonyek*, showing New York City and especially Times Square, as the grim seat of capitalism – where nature was absent and time had no meaning. Advertisements were everywhere 'with letters that dance and change pitilessly, hypnotizing a man into giving up all his dollars'. Ironically, Zhukov's dark style echoes the work of his exact contemporary, Robert Frank, who was pursuing his own bleak (and equally un-American) vision of the continent at the same time. (January 1957)

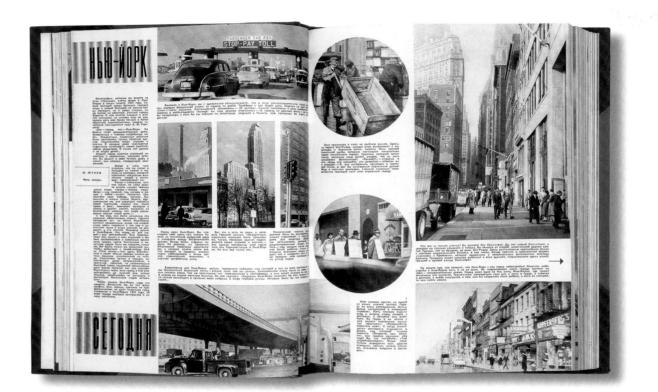

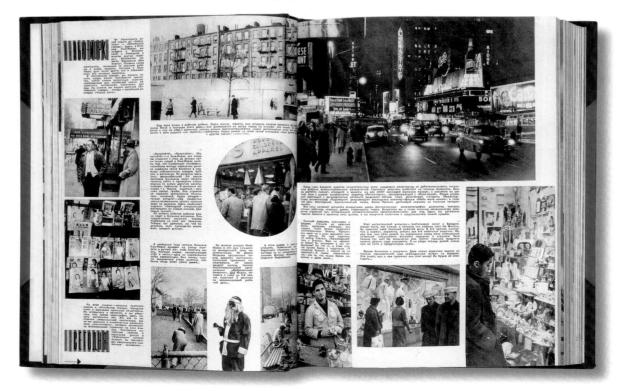

1958 DAVID DOUGLAS DUNCAN PICASSO AT HOME PARIS MATCH

David Douglas Duncan met Pablo Picasso in the summer of 1956. The thirty-year-old war photographer dropped in unannounced at the door of the world's most famous painter, his only useful credential being the friendship of Robert Capa. From that moment until Picasso's death, Duncan served as Picasso's personal photographer. He copied paintings, took snapshots of Jacqueline and their two young children, and recorded the family at home in the South of France. Picasso even allowed Duncan the rare privilege of shooting in the studio while he worked. 'Picasso: à la maison' appeared in *Paris Match* the year after they met – a light-hearted, intimate essay showing Picasso alone with Jacqueline, dancing by himself, playing with Claude and Paloma in a studio stacked with his work. This story set the standard for nearly every subsequent article about the artist, and provided a model for stories about distinguished celebrities in old age. Before Picasso's death, Duncan shot more than 10,000 negatives. Together, painter and photographer established a durable modern myth: Picasso as the creative, potent, painter who would live forever, with a photographer as his most trusted friend. (12 April 1958)

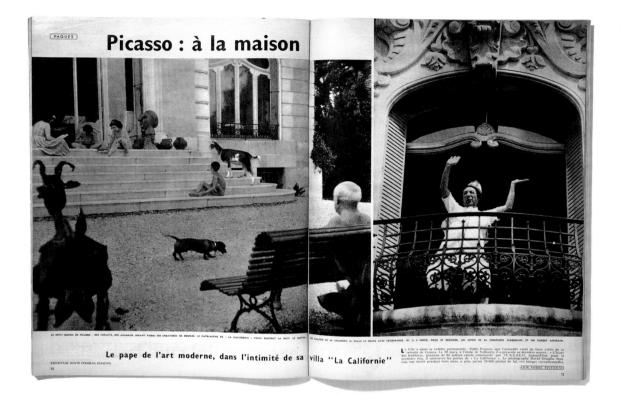

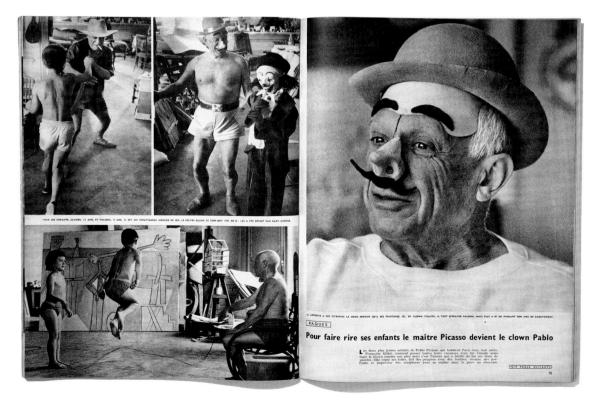

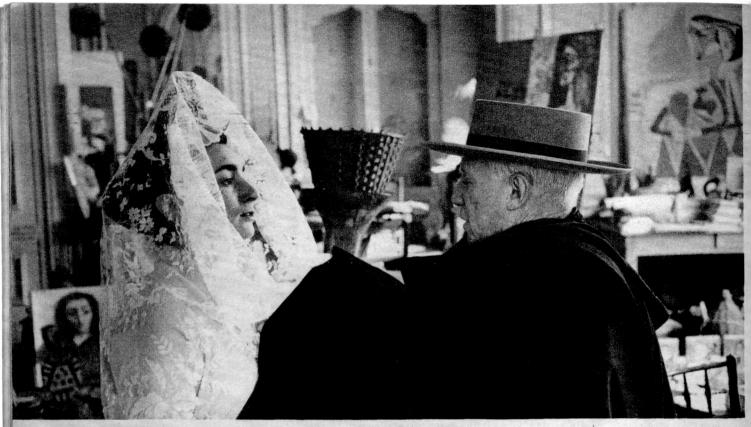

EN FEUTRE DE CORDOUE ET CAPE DE TORERO, IL TRANSFORME LA FEMME QU'IL AIME EN ANDALOUSE. IL GARDE LA NOSTALGIE DE L'ESPAGNE QU'IL N'A PLUS REVUE DEPUIS VINGT ANS

PAQUES

Toujours d'avant-garde à 77 ans, le peintre a un secret : sa joie de vivre

JACQUELINE veille à ce que rien ne rompe le calme de la maison quand Picasso est dans son atelier. Elle coupe la sonnerie du téléphone et ferme toutes les portes à clé. La seule loi impérative de cette vie bon enfant : ne toucher à rien. Les appartements privés sont un extravagant amas de meubles, de toiles, de des sins, de vêtements et d'objets souvenirs qu'il faut escalader pour pouvoir entrer.

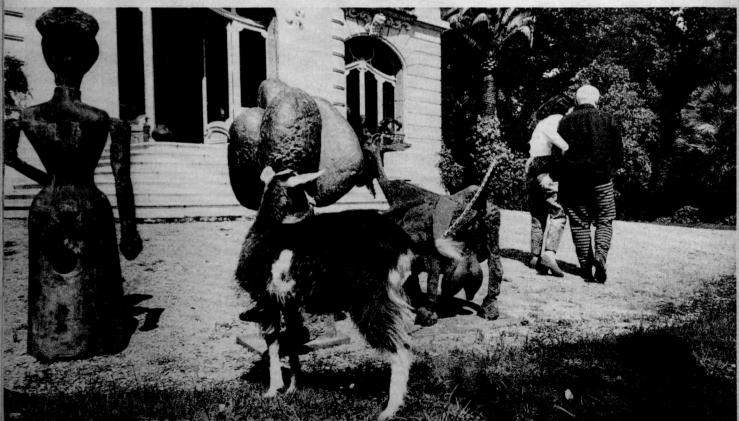

DELAISSANT LA CHEVRE ET SA REPLIQUE EN BRONZE, ILS SE PROMENENT DANS LE PARC EN AMOUREUX. SES ETRANGES PANTALONS SONT COPIES SUR CEUX QUE PORTAIT COURBET

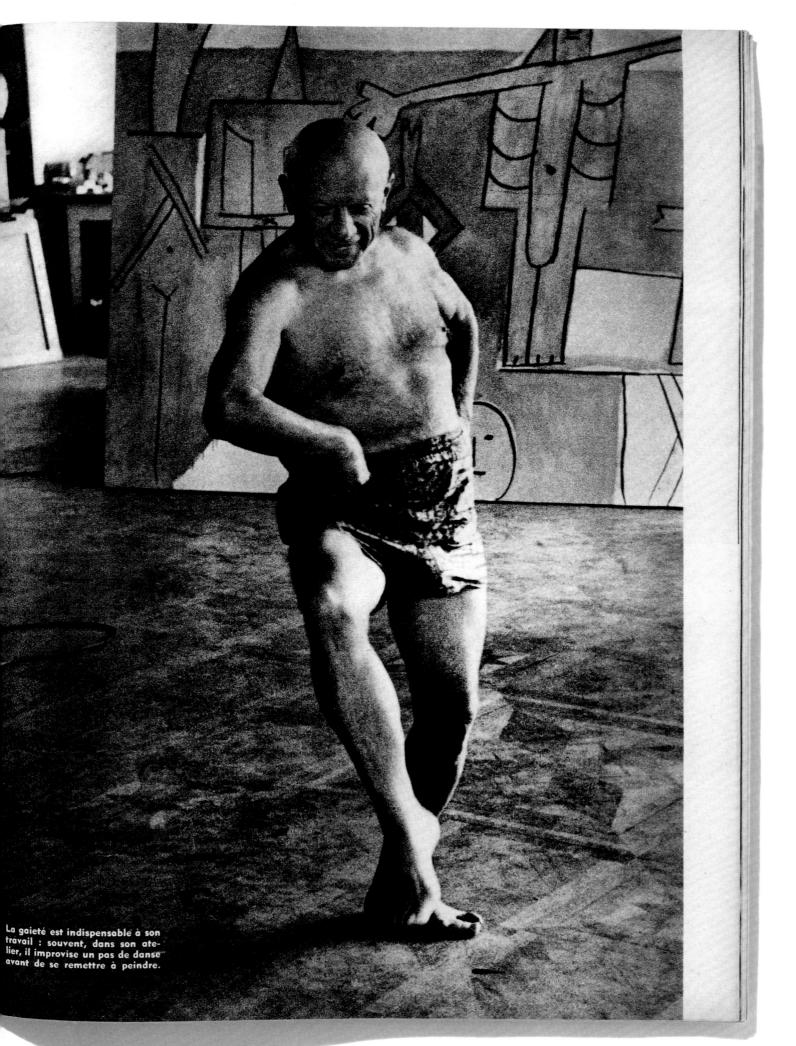

1958 HÉCTOR GARCÍA VALLEJISMO OJO

Héctor García was an established photojournalist working in Mexico City when the railroad workers' strike led by Demetrio Vallejo (and known as the 'Vallejismo') brought the city to a standstill. Government troops used violent means to end the protests. Although *Excelsior*, the leading national daily, had encouraged García to cover the sequence of events, they declined to publish evidence of police or army brutality. García was determined to find a way to make his pictures public and set up his own newspaper, *Ojo* – in Spanish, 'eye' – as a means of distributing the work. The first print run of 4,500 copies sold out early on the day it first went on sale, but a reprint was prevented; the press on which it had been printed was smashed by the authorities within hours. García has since remained one of the leading figures in Mexican photojournalism. In a recent interview, he explained his view that photojournalism can only flourish where the photographer is fully engaged with his subject; when 'the photographer breathes the action, and seeks the collision of human life [with] human history'. (October 1958)

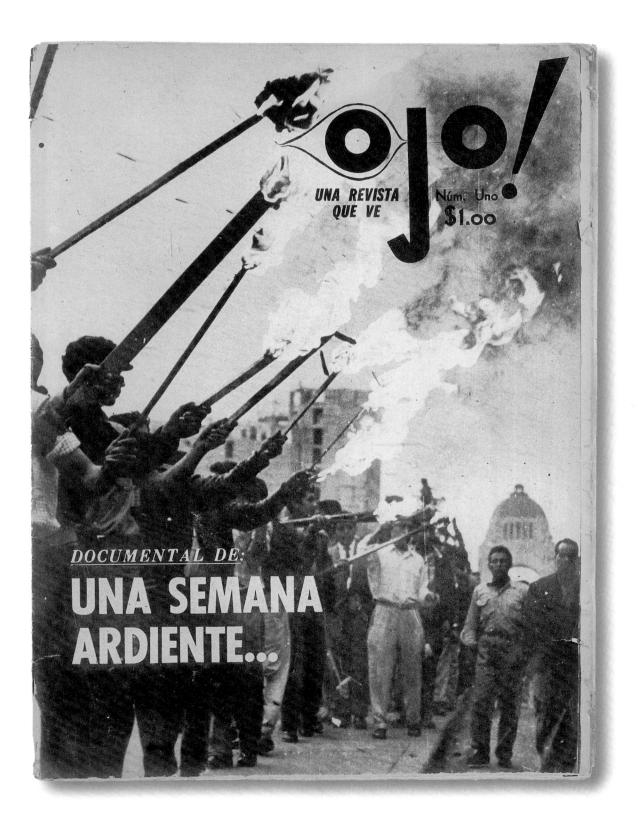

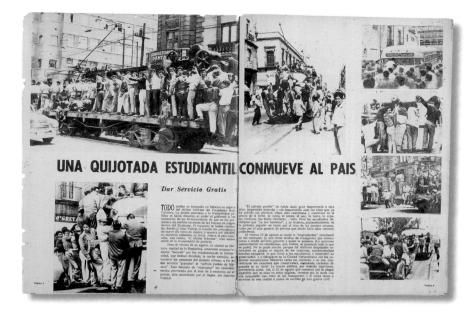

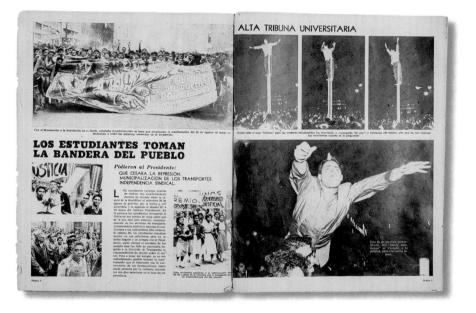

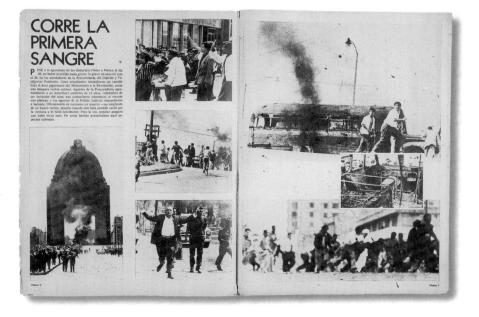

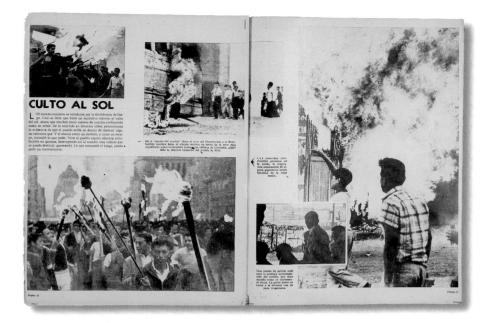

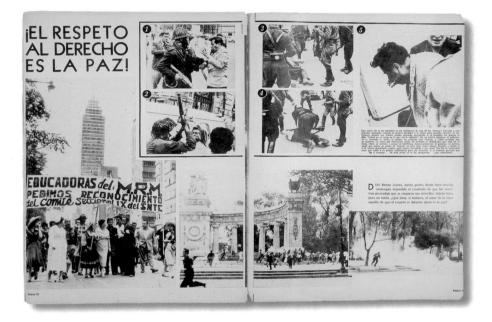

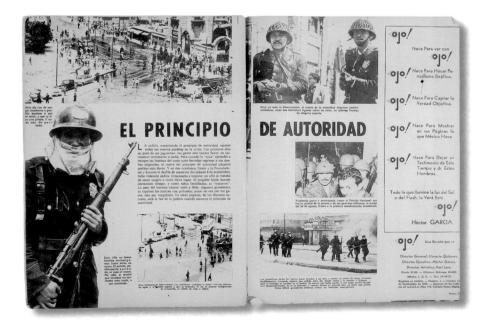

1958 TAZIO SECCHIAROLI LA TURCA DESNUDA L'ESPRESSO

'Nothing will stop us, even if it means overturning tables and waiters ... Even if the police intervene or we chase the subject all night long, we won't let go. We'll fight with flashguns!' This is how photographer Tazio Secchiaroli described the mission of the paparazzi in an interview in 1958. After World War II and the end of dictatorship and censorship, a taste for scandal developed in the Italian press, with a growing number of photographers aggressively patrolling the streets of Rome – particularly the Via Veneto – looking for Hollywood stars and members of the international aristocracy. It was 'Mr Paparazzo' in Federico Fellini's 1960 film *La Dolce Vita* who lent his name to the practice, with many of the film's scenes inspired by the adventures of Secchiaroli and his peers. Its striptease scene was a recreation of Secchiaroli's photographs of Turkish socialite Aiché Nanà at a birthday party in the Rugantino restaurant in Rome. When published in *L'Espresso*, they triggered a scandal that led to the banning of the issue and a public outcry. Young aristocrats were seen in the pictures, offering visual proof of the decadence of society. 'What happened before me was indescribable in those days,' Secchiaroli commented years later, 'the most sinful, transgressive thing I had ever photographed.' (2 November 1958)

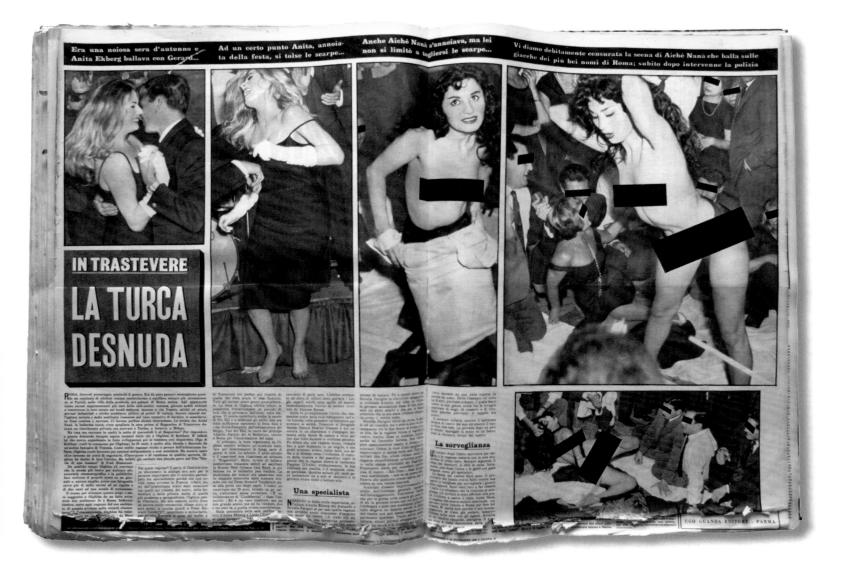

1958 ALGERIAN LIBERATION ARMY AL ARABI

The Kuwait-based magazine *Al Arabi* was first published in 1958, aimed at a broad readership, with a wide selection of general interest features on subjects from culture and literature to science and politics. It was born with a clear agenda – to promote a common culture across the Arabic-speaking world and to support Arab independence movements throughout the Middle East and North Africa (at a point in time when Kuwait remained a British protectorate). The first issue opened with this photo feature about Algeria's National Liberation Army, the guerrilla army that from 1954 to 1962 fought against the French for the independence of Algeria. With text made up of revolutionary slogans, it proclaimed the heroic acts of the combatants in portraits and images of daily life and training. The photographs of women fighters – proud and unveiled – have become part of Algeria's national iconography, while the story testifies to a political era preoccupied with issues of national rather than religious identity. *Al Arabi* has published continuously since 1958, maintaining its mission to promote the advancement of Arab culture. (December 1958)

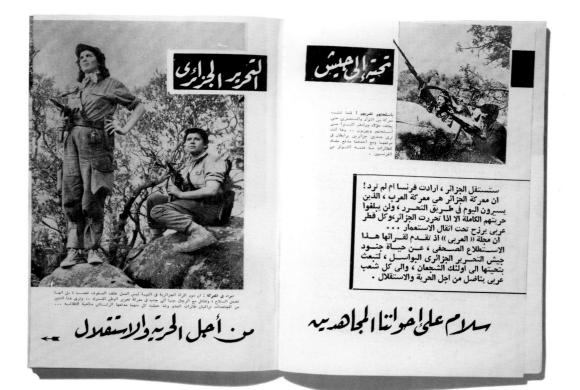

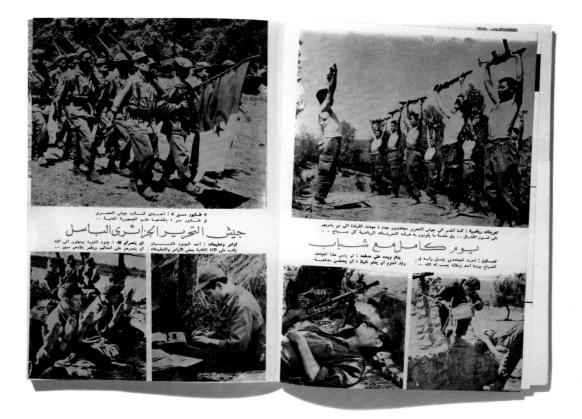

1958 ROLF GILLHAUSEN CHINA STERN

Rolf Gillhausen, a rising young photojournalist at *Stern*, initially proposed a story on the Trans-Siberian Railway as a vehicle to look at Russia under Communism. It resulted in his travelling over 12,000 km with writer Joachim Heldt, exploring China instead – what Heldt called 'Mao's great mysterious experiment into human history'. Published serially from late December 1958 until the following March, *Stern* gave more than 70 pages to the story. The photographs combine several familiar visual traditions; Gillhausen appropriates panoramas of happy workers and gleaming technology from Socialist Realism while drawing on the much older conventions of orientalism (in which all of Asia and the Middle East is seen as simultaneously alluring and inscrutable, different and dangerous). It set a new, high standard for postwar magazine layout, editing and design. Gillhausen remained central to the story of magazine photography in Germany thereafter; in 1965, he put down his camera to take over as *Stern*'s lead picture editor, becoming famous for his ruthless judgement and relentless energy; and from 1976 he served as a founding editor of the new *Geo* magazine. (12 December 1958 – 7 March 1959)

68

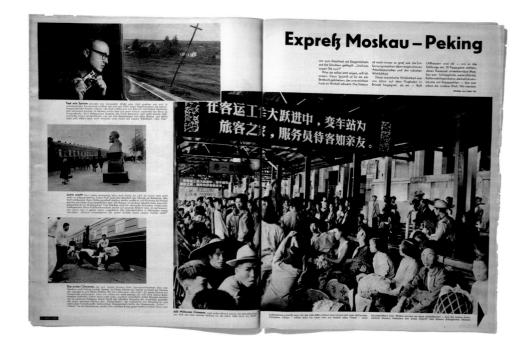

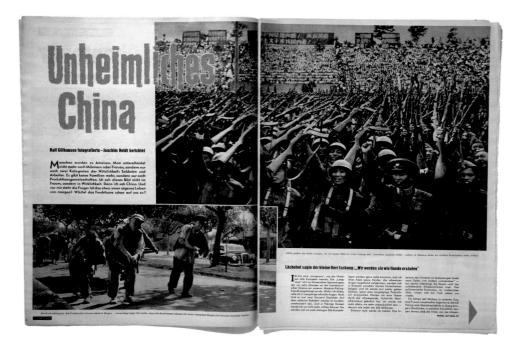

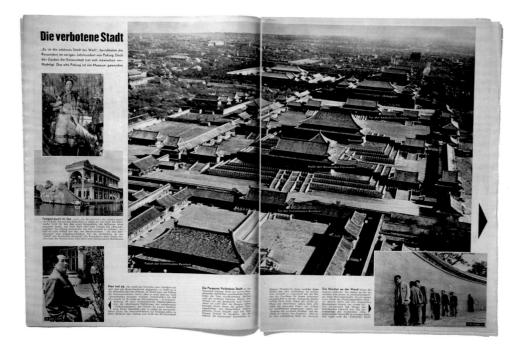

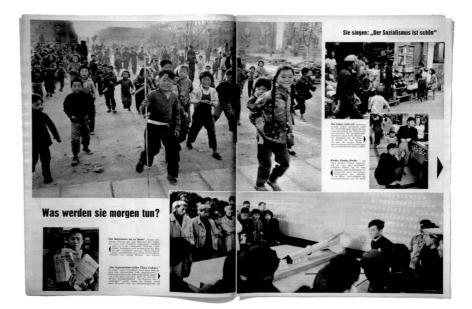

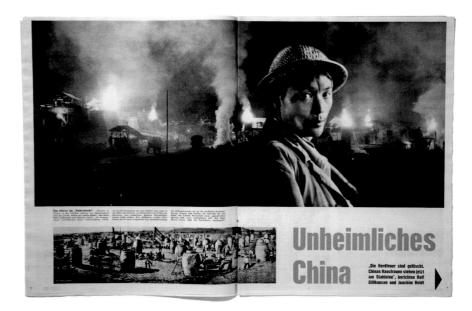

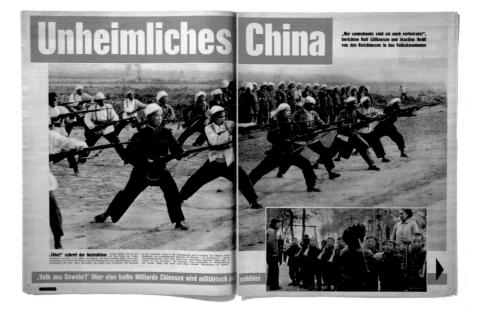

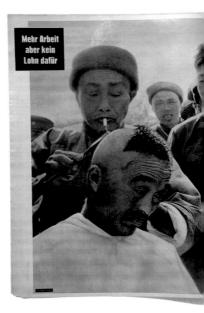

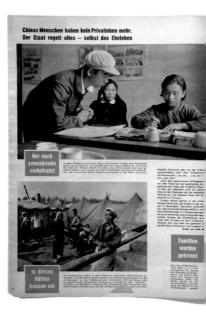

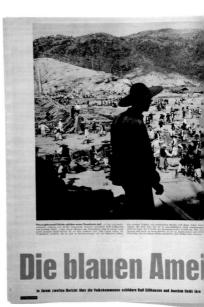

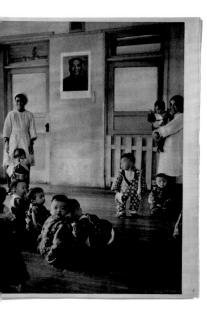

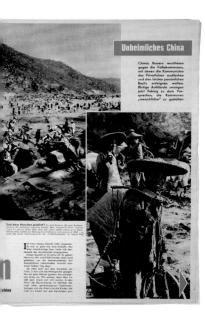

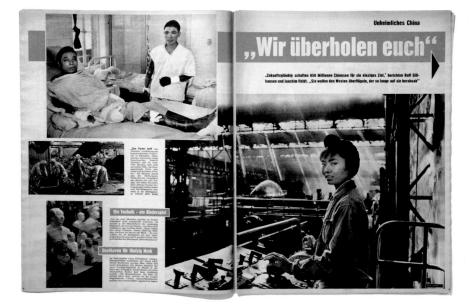

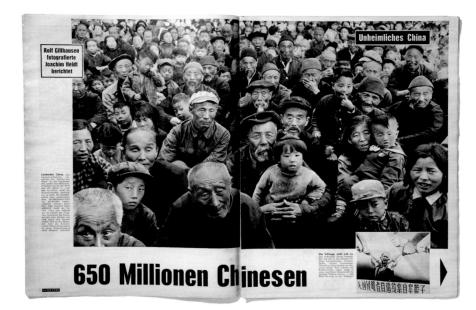

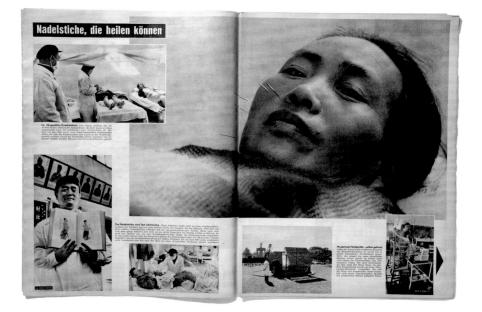

1959 HENRI CARTIER-BRESSON CHINA LIFE

In 1958, *Life* magazine assigned Henri Cartier-Bresson to China as a new phase of its economic development began. He travelled 7,000 miles in four months, resulting in *Life*'s 18-page picture story in both colour and black and white – a rare glimpse at a struggling new nation. If Cartier-Bresson's colour journalism now comes as a surprise, it is because he later destroyed virtually all of his colour transparencies. The biggest problems he faced, as he later explained to *Life*, stemmed from the fact that his subjects found him highly exotic; wherever he went, he attracted crowds, making it hard to capture individuals without their being aware of him. Thanks to his sympathetic style, his images contradict the text that accompanies them: where the reporter describes China as a nation of faceless industrial workers, Cartier-Bresson's photographs show plenty of individuals; where the writer finds a harsh, manipulative social order, typically Cartier-Bresson shows satisfied people in orderly spaces. (5 January 1959)

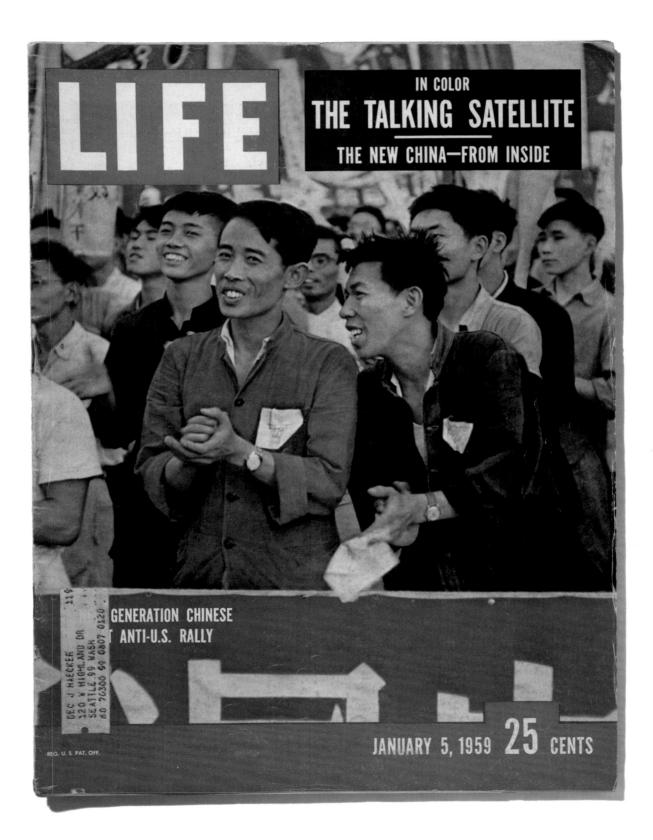

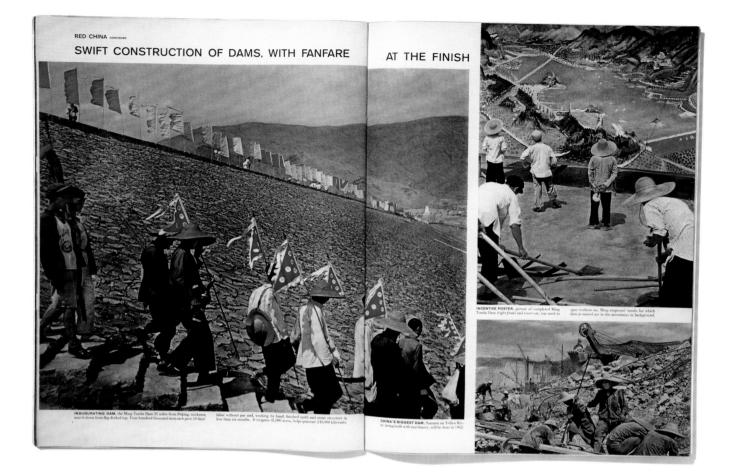

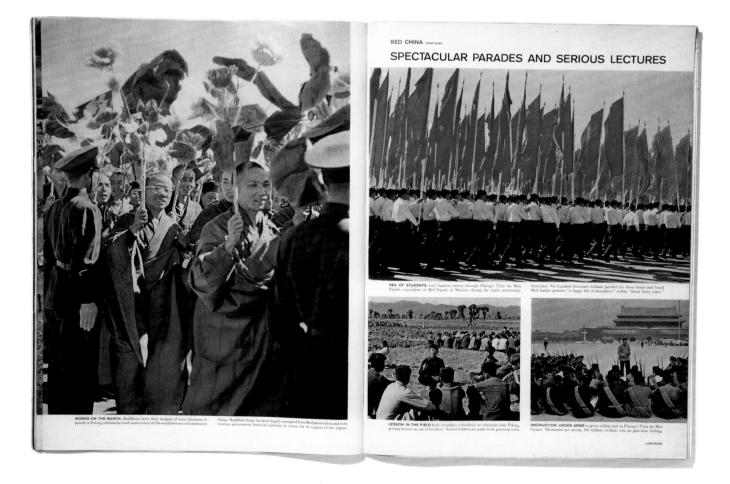

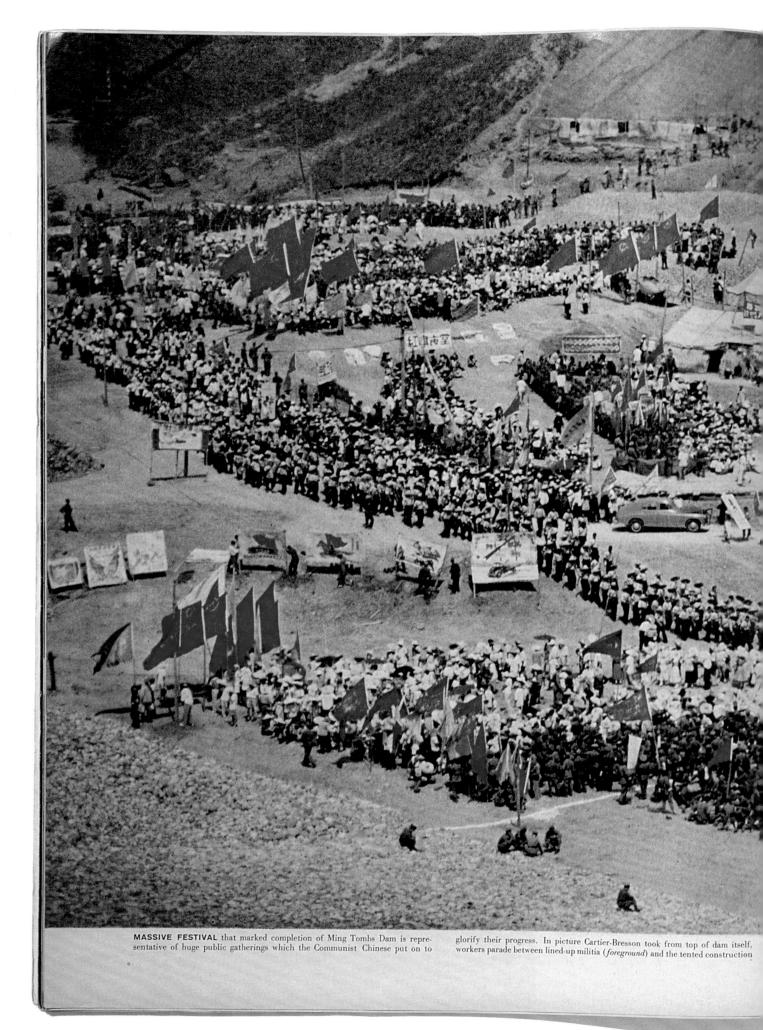

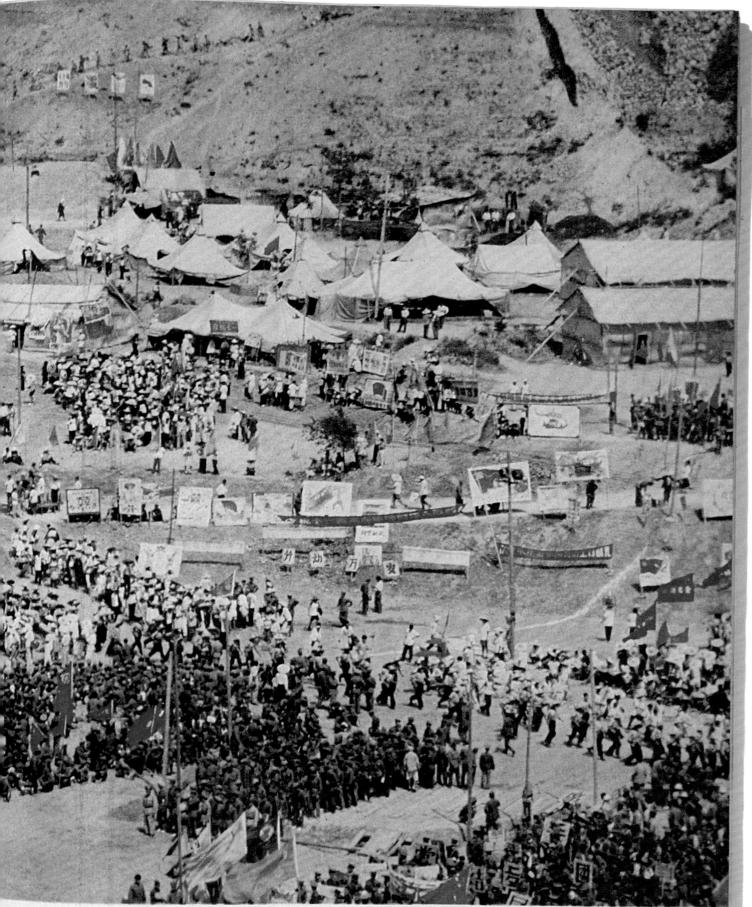

camp. Festival, which was attended by many of the 400,000 who had helped to build the dam, wound up with spirited folk dancing and group singing. Blue

Russian-manufactured "Pobeda" sedan (center) was special attraction to Chinese. They make a few cars but ordinary Chinese are not allowed to own them.

CONTINUED

1959 W EUGENE SMITH PITTSBURGH POPULAR PHOTOGRAPHY

Working for *Life* magazine in the late 1940s and early 1950s, Smith produced a series of photo essays that have become established landmarks of photojournalism. But in 1954 he resigned, convinced he would be able to produce his best work independently, without artistic compromise. He accepted a three-week assignment from former *Picture Post* editor Stefan Lorant to shoot illustrations for a book celebrating Pittsburgh's bicentennial, believing it presented an opportunity to make the masterpiece photo essay he felt he and the genre were capable of – a symphony in photographs that (as he told his brother) would 'influence journalism from now on'. He persisted with the project for four years, in poverty and with his life falling apart around him. It was first published over 38 pages of *Popular Photography*'s small-format 1959 annual, where its editor allowed Smith the scope to lay the work out exactly as he chose. By then, the story had become as much about his struggle with his own demons as it was about Pittsburgh – as Smith acknowledged in the title he gave it: 'Labyrinthian Walk' – and he deemed it a failure. It stands both as an epic experiment and as a moral fable for a generation of photojournalists. Smith redeemed himself, and contributed to the reinvention of the photojournalist as campaigner, with his triumphant 'Minamata' story in 1972. (December 1959)

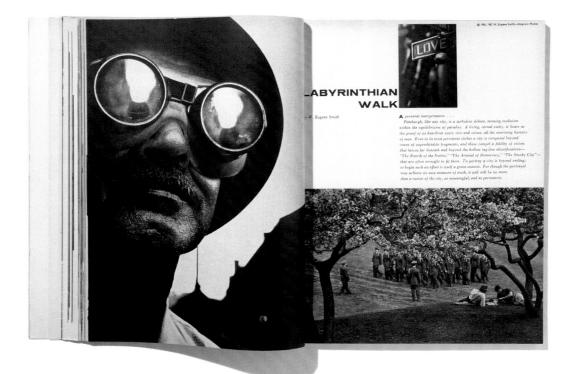

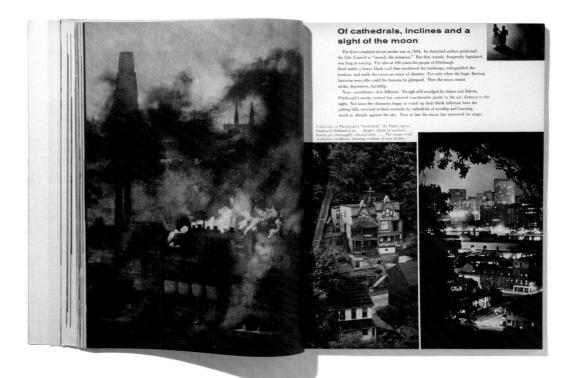

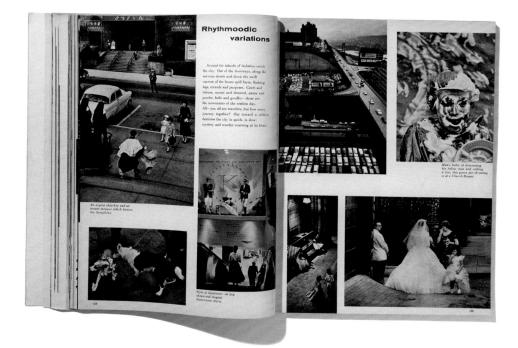

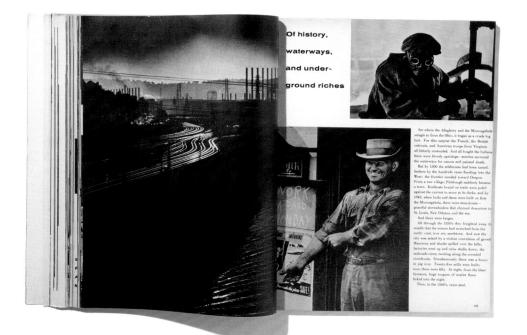

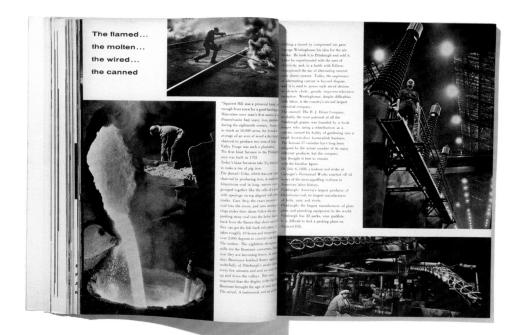

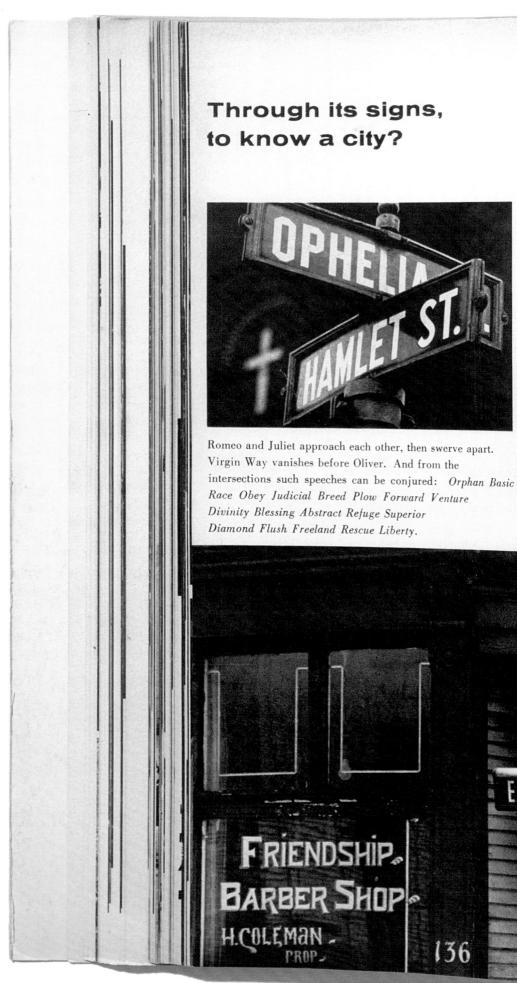

1960 ROBERT LEBECK THE KING'S SWORD KRISTALL

In 1959 and 1960, Berlin-born Robert Lebeck spent twelve months in Africa, where he saw seventeen new nations declare independence from their former colonial rulers. His travels ended in Leopoldville, the capital of the Belgian Congo where King Baudoin was preparing to cede power to the newly elected President Joseph Kasavubu and Prime Minister Patrice Lumumba. The ceremonial parade was disrupted by dissident Joseph Kalonda; diving into the King's open car, Kalonda seized the King's sword and brandished it in front of the crowd (and Lebeck's camera) before military officers took control. The last in Lebeck's African essays for *Kristall*, it conveyed the facts of the skirmish as well as its allegorical implications: 'A harmless story. And a symbol. Just as Joseph Kalonda seized the sword, so have African men seized ruling power.' Lebeck is a key figure in the story of photojournalism in Germany, with a career that includes 30 years working for *Stern*. He was the also the co-founding editor-in-chief of *Geo* magazine. (Issue 16, 1960)

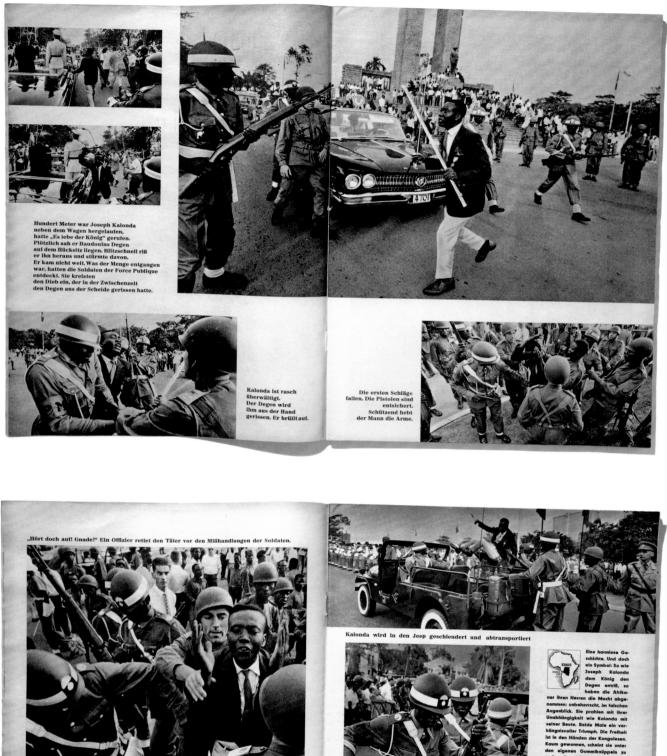

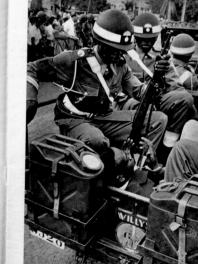

Deg bol,

1960 SHOMEI TOMATSU IWAKUNI CHUO KORON

In 1961, in a debate published in *Asahi Camera*, Shomei Tomatsu, the influential leader of a generation of Japanese photographers, called for a new form of reportage: 'In order to prevent the hardening of photography's arteries,' he said, 'I believe we should drive off the evil spirits that haunt "photojournalism" and destroy the existing concepts carried by those words.' In the early 1960s, in the pages of the general interest magazine, *Chuo Koron* (meaning 'Central Review'), Tomatsu pioneered a raw new language for photography in Japan, rejecting the familiar descriptive terms of photography and filling the magazine's pages with wall-to-wall images, without text. In challenging and unexpected juxtapositions and sequences, he defied the traditional terms of descriptive photography, while dealing with the contrasts between traditional culture and the demands of a modern industrial economy, and the clash between Japanese society and the West. His values are exemplified in his essay about Iwakuni, the ancient city south of Osaka profoundly changed by the influence of the occupying Americans operating out of the local marine base. By 1965, Tomatsu had joined the art faculty of Tama University, and ceased to publish picture stories in the mainstream press. (April 1960)

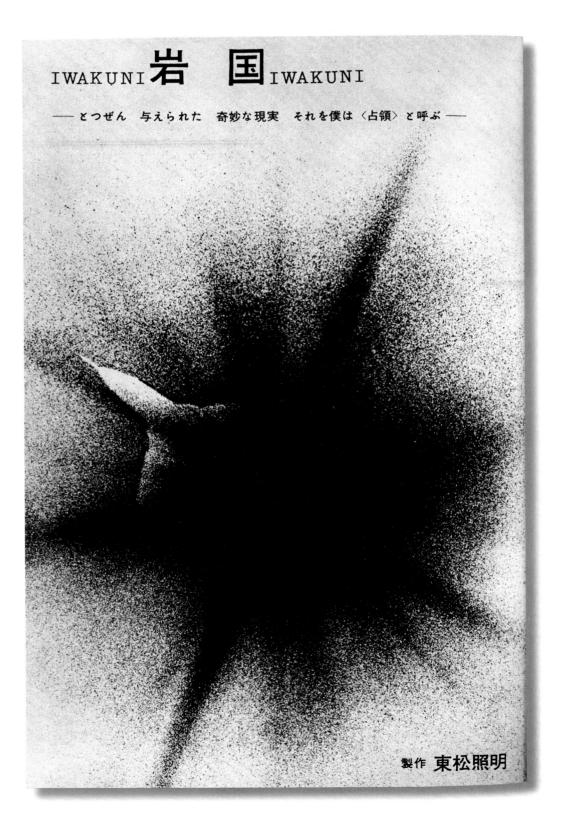

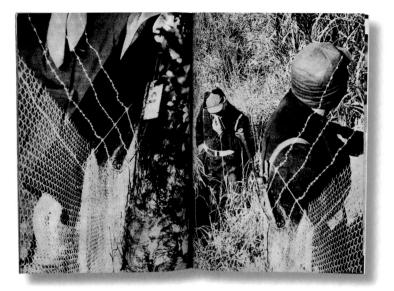

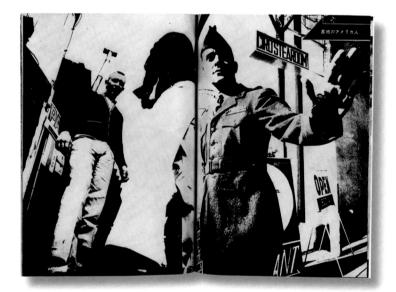

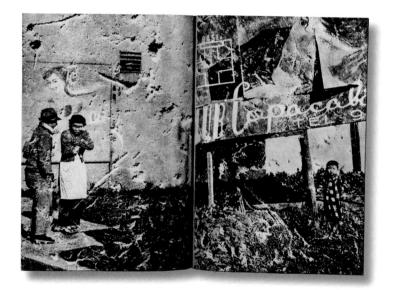

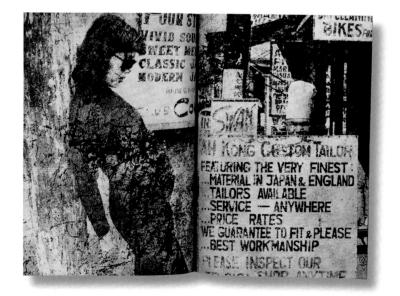

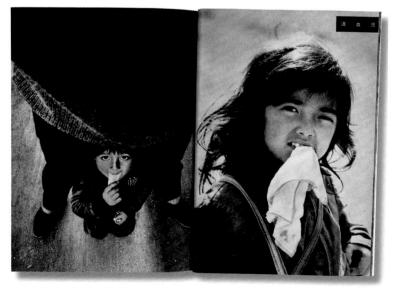

1960 PETER MAGUBANE SHARPEVILLE FUNERAL DRUM

Peter Magubane began working at *Drum* as a driver in 1954 while he was in his twenties, with his first photographic assignment to cover the annual meeting of the as-yet un-banned African National Congress the following year. On 21 April 1960, Magubane covered a demonstration at the Sharpeville township that turned into the now-famous massacre. But editor Tom Hopkinson did not publish Magubane's work: 'He said "there are no close-ups, no photos here that will sell the magazine". I explained that I had been shocked. He said "Get the pictures first, then you get shocked.' He was right!' Magubane recalls this story as the moment his career truly began. 'From that day I made up my mind that I shall think of my pictures first before anything. I no longer get shocked. I am a feelingless beast while taking photographs.' Weeks later, when Magubane covered the funeral of 35 Sharpeville martyrs, he produced a dark, vivid picture story – an early triumph as one of the key documentary witnesses of the Apartheid years. (May 1960)

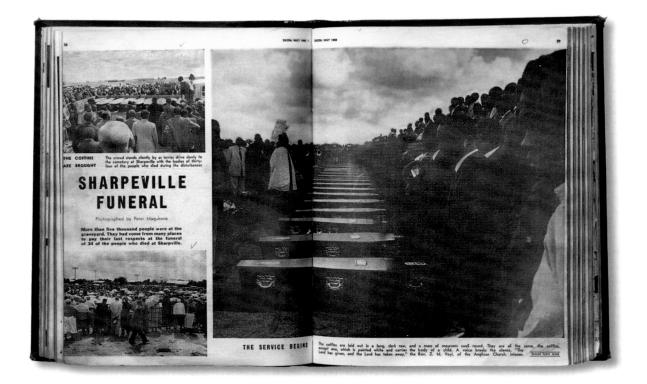

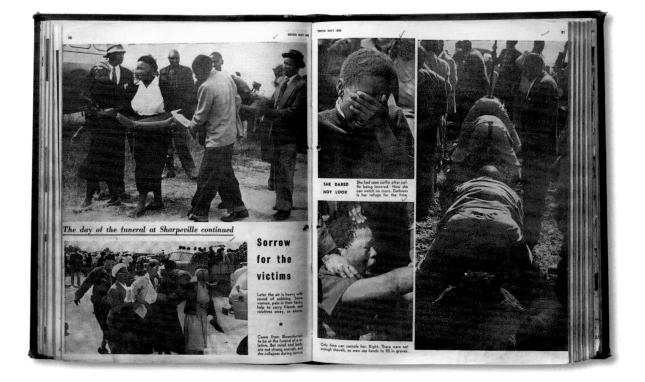

1960 DIANE ARBUS VERTICAL JOURNEY ESQUIRE

The first of many stories Diane Arbus shot for *Esquire* appeared in a special issue devoted to New York. Her contribution took the form of six portraits (with interviews) which challenged established standards of taste and style. Her images are blurred, uneven, flawed – utterly unlike a sharp newspaper shot, or a polished magazine illustration. She turns this affecting style on subjects invisible to *Esquire*'s urbane readers: Hezekiah Tramble, who performed daily as the 'Jungle Creep' in a Times Square sideshow; a shirtless one-eyed Bowery bum named Walter L Gregory; and midget entertainer Andrew Ratoucheff, who impersonated Marilyn Monroe and Maurice Chevalier. Her story includes other unconventional subjects: pretty blonde Dagmar Patino sitting with a balding man in a tuxedo, and genteel Flora Knapp Dickinson standing alone in her apartment (in the text she tells us about her distinguished ancestors). The final image shows us the bare feet of a nameless corpse found in the city morgue. They are all part of a New York City that only Arbus could reveal, and the series opened a wide new territory for photography, beyond the familiar definition of journalism. (July 1960)

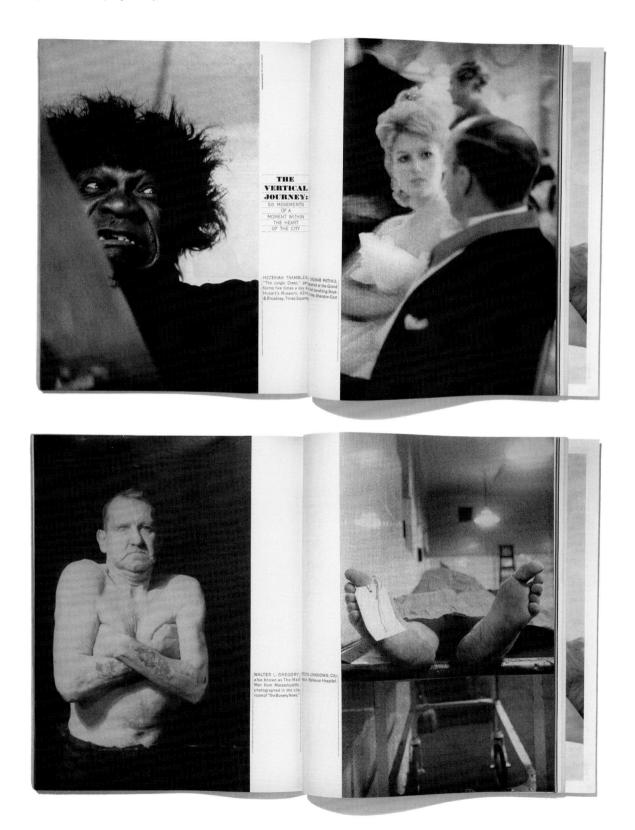

FLORA KNAPP DICKIN-SON, Honorary Regent of the Washington Heights Chapter of the Daughters of the American Revolution

RATOUCHEFF, n his Manhattan Duse following a erformance of his nitations of Marie, and Maurice singing "Valen-

1961 KISHORE PAREKH LIFE IN A DELHI SLUM HINDUSTAN TIMES

Kishore Parekh's weekly front page photo reports for the *Hindustan Times*, usually accompanied by his own text, made him a treasured local celebrity and hero throughout the 1960s. Alongside his contemporary Sunil Janah working for the *Illustrated Weekly of India*, Parekh's photo essays set a national standard both for their exquisite form and for their ability to communicate clear, forceful statements about everyday life. With stories like 'Floods and Tears along the Cauvery', 'Tibetan Refugees', 'Coalminers of Asansol' and 'A Day with Police at Naxalbari', Parekh established a frank, emotional connection between his subjects and his readers, without drifting into sentimental formulae – a notable achievement given the hackneyed conventions that often governed representation of the impoverished of India. Parekh came to photojournalism while unable to find work in his chosen field, cinematography, and as the result of a chance meeting with powerful industrialist and owner of the *Hindustan Times*, G D Birla. Birla saw his potential as a popular storyteller, and he was rewarded by Parekh's central role in raising the national profile of the paper. Parekh's career was cut short, in 1970, when he died in an accident in the Himalayas. (30 May 1961)

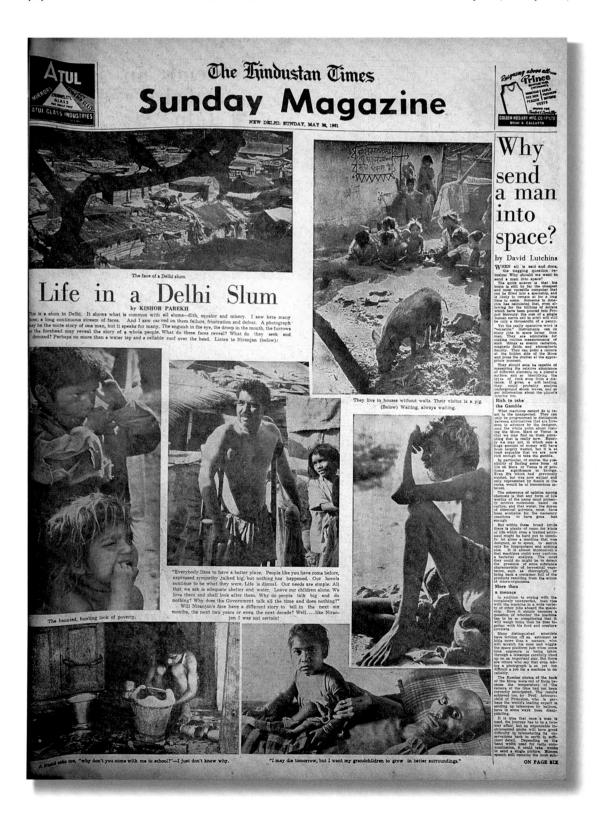

90

1961 GORDON PARKS FLAVIO LIFE

One of the best-remembered *Life* stories of the 1960s was its presentation of Gordon Parks' and reporter José Gallo's trip to a squatters' *favela* outside Rio – part of a larger political report showing Latin America's 'teeming poor' as 'a ripe field for Castroist and Communist political exploitation'. Parks put the focus on José and Nair Da Silva and their eight children, especially twelve-year-old Flavio, the eldest, who cared for his siblings while their parents scavenged for food. Flavio was sick, with his progressive asthma almost certain to end his life in a few years. Inspired by *Life*'s urgent rhetoric and Parks' emotional images, the magazine's readers rallied to assist Flavio and his family. Within a month, their contributions helped the Da Silvas leave the *favela*, and Parks brought Flavio to a renowned asthma clinic in Denver. Today historians cite Flavio's story as an example of photography's power to inspire action and change a life. But even at the time, *Life* cautioned its readers against this conclusion; after all, the editors explained, 'Flavio is just one in a numberless multitude', all of whom need help. (16 June 1961)

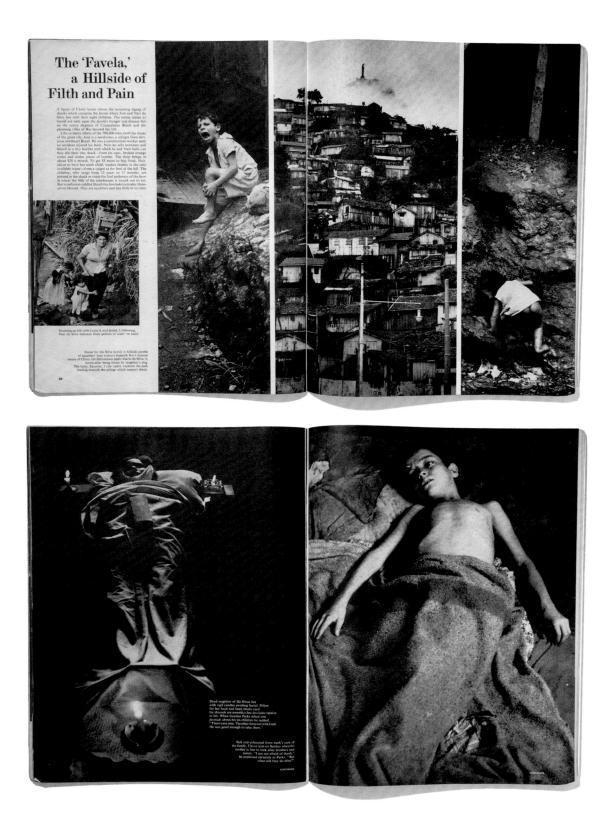

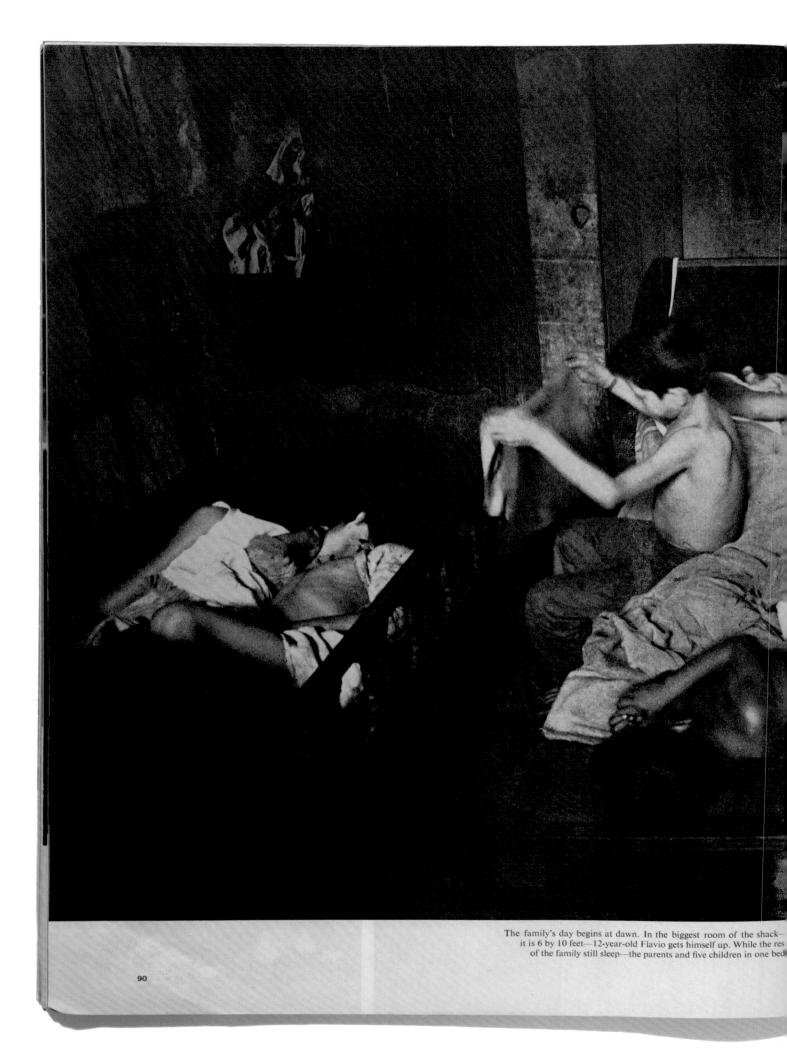

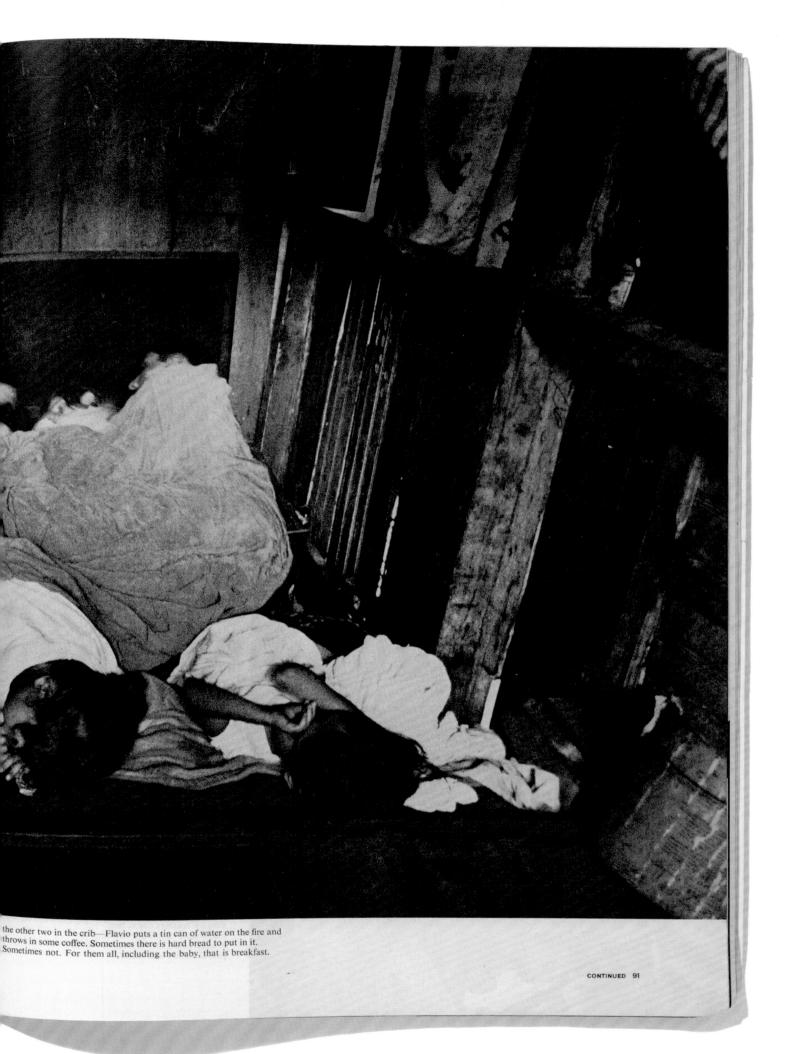

1961 BRIAN BRAKE MONSOON PARIS MATCH

Although its approach may now seem familiar and obvious, on its publication 'Monsoon' was widely seen as a milestone in the poetic use of colour within photojournalism. Developed and shot by New Zealander Brian Brake over nine months, it calls on a visual inventory of the Western myth of South Asia – crouching women in saris surrounded by children, a sea of pilgrims under black umbrellas, a weeping woman waist-deep in the river at Benares – to create an exotic experience of Indian colour, simultaneously didactic and impressionistic. Brake drew on the ground-breaking imagery of Ernst Haas, one of colour photography's earlier pioneers and a colleague at Magnum Photos, while combining it with the careful construction of concept and storyline, in the tradition of *Life* magazine and W Eugene Smith. Every element was considered to achieve the right effect, from the identification of subjects through to the sequencing of images on the page. (The famous 'monsoon girl' picture was constructed in a studio with model Aparna Sen, a fourteen-year-old actress who went on to become a major Indian film star.) The story was a great success for Brake, whose sequence of images was run as he intended in major magazines worldwide, including *Life, Epoca, Queen* and *Paris Match*. (23 September 1961)

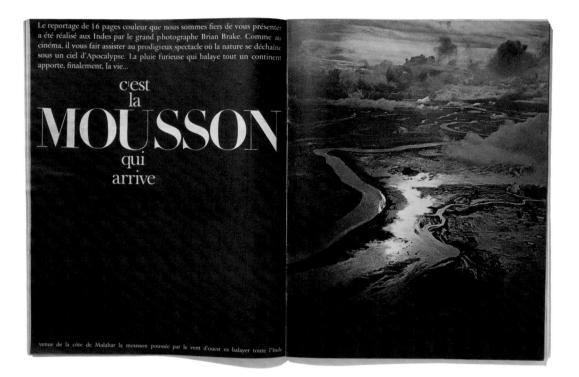

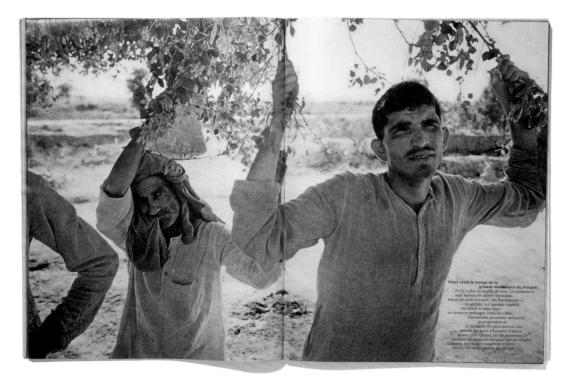

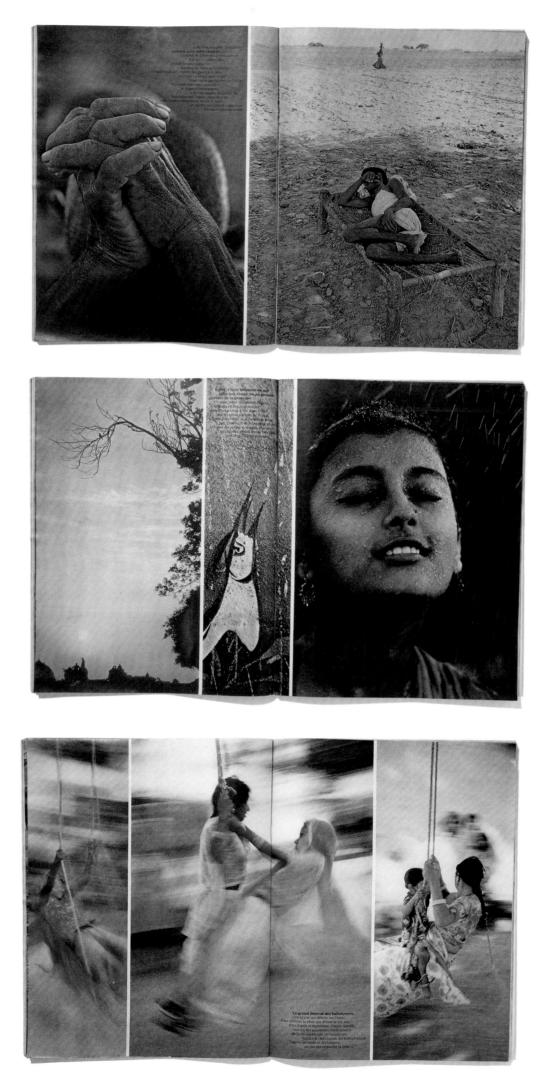

1962 DICKEY CHAPELLE HELICOPTER WAR NATIONAL GEOGRAPHIC

Dickey Chapelle became a foreign correspondent during World War II in order to accompany her husband, a Navy pilot and photojournalist. She covered the Marines in Iwo Jima and Okinawa and later used her connections to reach the front lines in Korea and Lebanon. From the mid-1950s, Chapelle also officially gathered military intelligence, which gave her unusual access to military sites and required her co-operation with the US Defense Department's censors. Naive, ambitious and patriotic, Chapelle readily agreed. She arrived in Southeast Asia early in 1961 on assignment for *Reader's Digest*, one of a tiny handful of Western reporters covering an obscure civil war. Chapelle became increasingly unable to reconcile official policy with 'what my own eyes have taught me'. In 1962, she objected loudly when censors cut pictures of combat-ready armed Marines from her story for *National Geographic*. 'I am alive to make this protest only because of such readiness,' she answered, 'I cannot accept any effort to bury these facts.' The story ran as she wrote it. Chapelle's life ended on 21 November 1965, in Chu Lai, Vietnam, where she became the first American woman reporter to die in action. (November 1962)

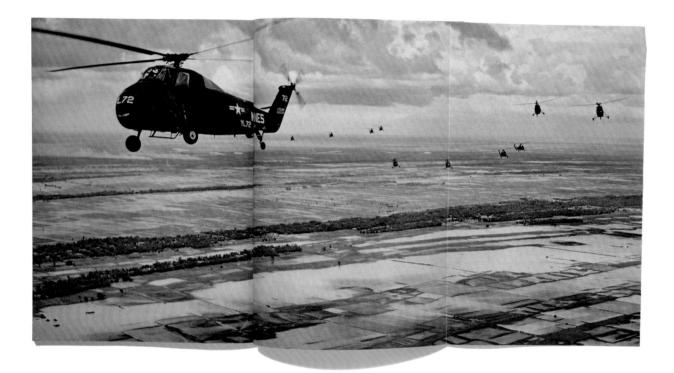

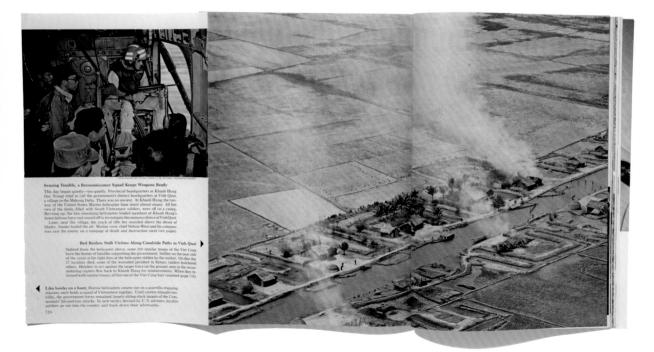

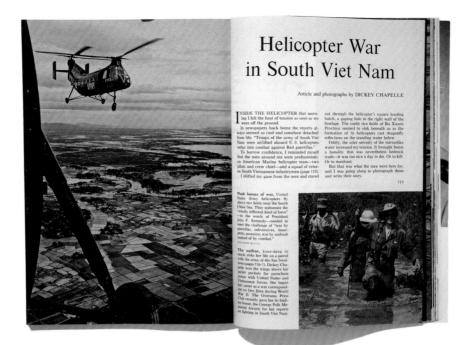

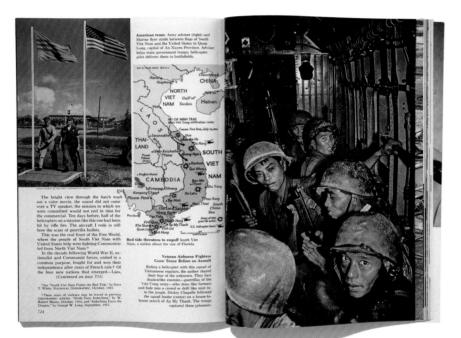

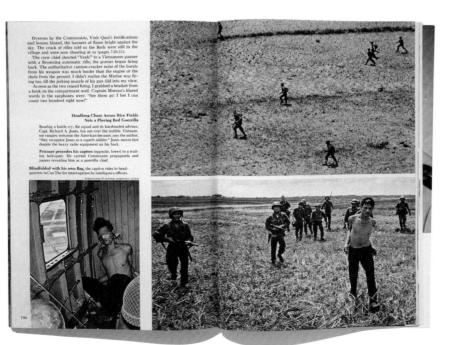

1963 RAÚL CORRALES FARMER-SOLDIERS CUBA

Raúl Corrales is best known today for his lyrical photographs of the Cuban Revolution – 'La Caballería' and 'The Dream'. He also made important photographic stories about everyday life in Cuba, first in 1959 for the short-lived *Revolución*, and then for *Cuba*, which began publication in 1961, modelled on *Ogonyek* and *Life*. In its early years, *Cuba* reflected the heartfelt exuberance of the Revolution while also publishing more predictable propaganda stories about Fidel Castro and his good works and celebrations of the picturesque Cuban landscape. In stories such as 'El Hombre, su mochila, su fusil', Corrales took on the more difficult task of developing a new kind of iconography, adequate to the representation of life in Cuba after the Revolution. Drawing on references to the Mexican Revolution fifty years earlier, his matter-of-fact depiction of Cuba's farmer-soldiers made no secret of his admiration for these subjects, yet rendered them too explicitly to invite sentimental clichés. Corrales's career began in 1944; he worked for newspapers, magazines and briefly for advertising before becoming Castro's official photographer in 1959. (September 1963)

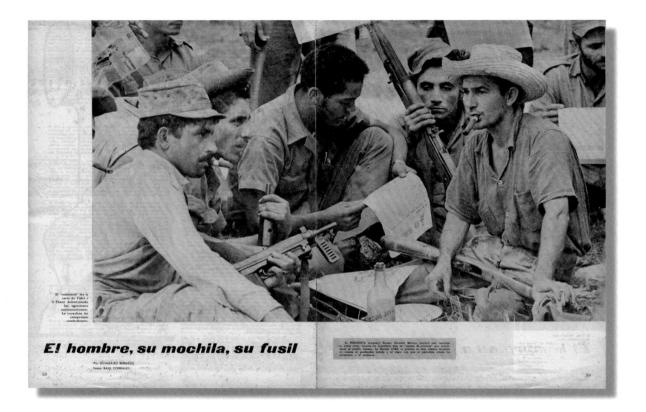

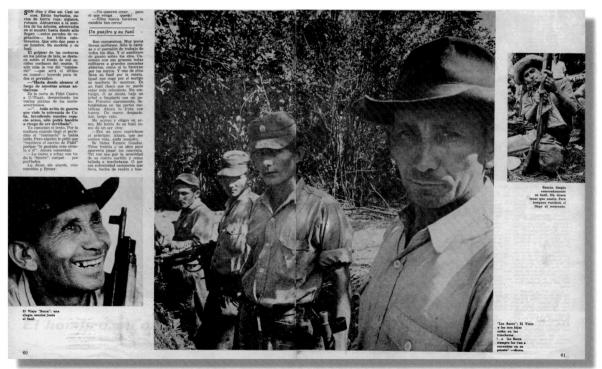

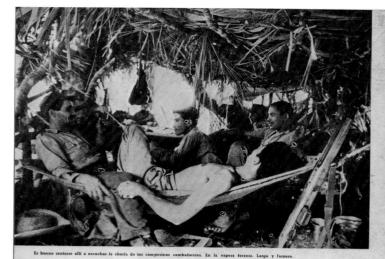

na educación natural, que le hace guardar una distancia unitoria con su interlocutor. Del Toy compañero, las con-diciones han variado ... devine mastado ... quiên me las a vasas de mampoterin, las eléctrica, ducha, escuela pal y entrima du con grafía ... de persona al mes-

Repesos ai mes. Ramón trabaja en una Jranja del Pueblo de la zo-la. Su mujer se llama Silvia. Y tiene dos hijos de ocho y liez años: Nancy y Ramón lipólito. Es una familia muy inida: "todos somos uno pa" do." Que se siente segura. on una vida propia. Pero intes...

--Los yanquis quieren vol-vernos a eso. Nosotros (habla despacio, masticando las pa-labras), le digo con sinceri-dad, no lo permitiremos. Lo prueba esta moviliza-ción. Que ha sido "una salva-pida.

Los "Borra"

El viejo sonrie con satts-facedor. — To que paredo fauscho, en ante al la sonrie de la sonrie de la son-— Y el guata éstar cerca. — Y le guata éstar cerca. — Y le guata éstar cerca. — Y el guata éstar cerca. — Y el guata éstar cerca. T años. Proque Bartaro. — Van de la sonrie ante de la sonrie de la sonri El viejo y los tres hijos están en las trincheras. Son de apelido Yerea. Pero en el campamento nadie los conoce sino como "los Borra." Por tostados y bajitos. El viejo tiene cincuenta" años. Bajo el sán acera de su sombrero "de ciudad" aparece su rostro simpálico

vaciamo un peine, le dimo candela a la caña y lo cogi-

Porque los "Borra" son de la opinión de que "los yan-quis se tira", y "como se ti-no". Alos "Borra" los van a encontrar en su puesto --dice d viejo sibitamente serto---estar en au puesto. Noscro-va digimo: si alguno de la fa-miliame vira contra la Revo-lación, eso corre de cuenta mestra nontra la Revo-lación, eso corre de cuenta

En las hamacas



Hace falta gente que estudia

-Hace falls gent que est-tado or service of the se

-El Ché luce dice años más -La Váde a Bierra - dice. - As Váde se muy dura es transmante en luce directores and cantodal ille service directores - and dierio. Para ver "como di que concelor en la Unión soviética. Porque Martín Gó mos estudió un dio mecanica la directores directores and soviética. Porque Martín Gó mos estudió un dio mecanica del noguela de campaña, cervi del noguela de campaña, cervi de pregunta como encontor tangle.". Essonde com en - mou-line. Tans de como encontor - mou-line. -

le pregunta cómo encontró "quedio." Responde con con-"ducto. Encontro de la con-que Fidel nos mandara aun-que Fidel nos mandara aun-que Fidel nos les años paí-las de la contra de la con-tro de estra la camise y pa-salar los botones. Quere contrar lo que vio en los cam-positivas en la contra de la con-contrar los perior en los cam-positivas en los contras en los con-contrar los perior en los cam-positivas en los contras en los con-contrar los perior en los cam-positivas en los con-contrar los perior en los cam-positivas en los contras en los con-tros en los con-contras en los con-las cabezas empiezan a las entras empiezan a las cabezas empiezan a las entras empiezan a las entras empiezan a las entras entras en los con-las entras entras entras en los con-las entras entras entras en los con-las entras entras entras entras en-las entras entras entras entras entras entras entras las entras en

uno. —Pues, palomas... como allá quieren decir la paz... puedes tener todas las que

64

--;Cuándo se acabará esto! A mi me gusta cavar la tie-rra... pero pa'plantar frijo-les.

El parque de los Combatientes

El jegi time que detenerse. Hacia el camino se adelanta un arbusto con un fusil. Es la posta. Las ramas le brotan cinturón, de las botas. Un ros-tro arbudo emerge entre las hojas. Les dojes brillan y des-constructor de las botas. Un ros-ros donde van ustedes" — A donde van ustedes" — Tasta el Estado Mayor. "Or vicio el combatien-"-".

Las duras manos campesi-nas entrelazadas. Los cuerpos acompasándose con la música. Finalizan:

"...y se alcen los pueblos con valor..."

Las voces roncas, desafina-das, llenas de fervor:

-iViva Cuba libre! -iViva!

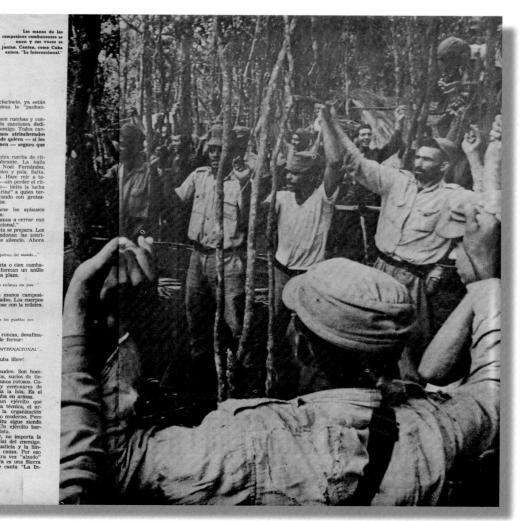

saxofón y clarinete, ya están listos. Empieza la "pachan-ga."

Trimer son rumbas y com-rum son rumbas y com-nas. Después canciones dedi-cadas al enemits. Todos can-tan "Etamos strincherados quedan." Companya y com-negativa superior que los superiors de l'entrantes de quedan." Com la companya de companya de companya de la companya de compa

cos faconazos. Al apagarse los aplausos alguien grita: —Oye, vamos a cerrar con "La Internacional." La orquesta se prepara. Los rostros abandonan las sonri-sas. Se hace silencio. Ahora cantan:

"Arriba los pobres del mundo..."

Son ochenta o cien comba-tientes que forman un anillo en torno a la plaza. "...de pie los esclavos sis pan."

1963 GIANFRANCO MOROLDO DAM BURST L'EUROPEO

L'Europeo, launched in November 1945, was the first weekly magazine to be aimed at Italy's new postwar class of professionals and intellectuals, rapidly establishing itself as a critical voice in a rapidly changing society. In around 2,000 stories produced for *L'Europeo* over 30 years, its staff photographer Gianfranco Moroldo documented the reconstruction of Italy and its social conflicts, while bearing witness to earthquakes, homicides and wars in Vietnam, Egypt, Sierra Leone and Ethiopia. The Vaiont Dam, one of the highest in the world, was completed in 1961 but after heavy rains in 1963, landslides into the Vaiont reservoir caused the stored water to spill over the dam, sweeping away the villages in the valley and causing the deaths of 2,000 people. Moroldo's photographic account of the survivors, caught in the desolate landscape where their villages had stood, deeply touched a country that was struggling with rapid modernization. Moroldo's focus on the survivors was characteristic of his approach: 'There is nothing interesting in showing a man lying dead on the floor,' he once said, 'It's the drama of the man alive that interests me.' (20 October 1963)

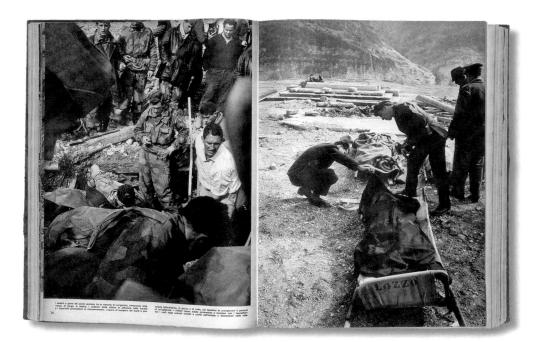

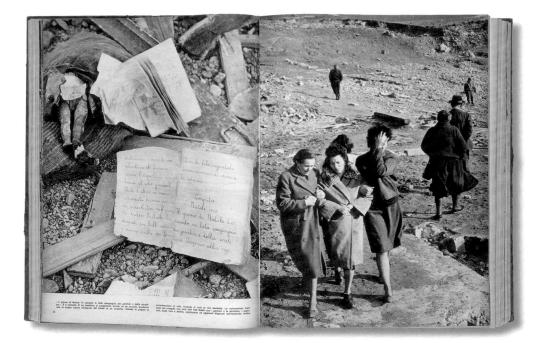

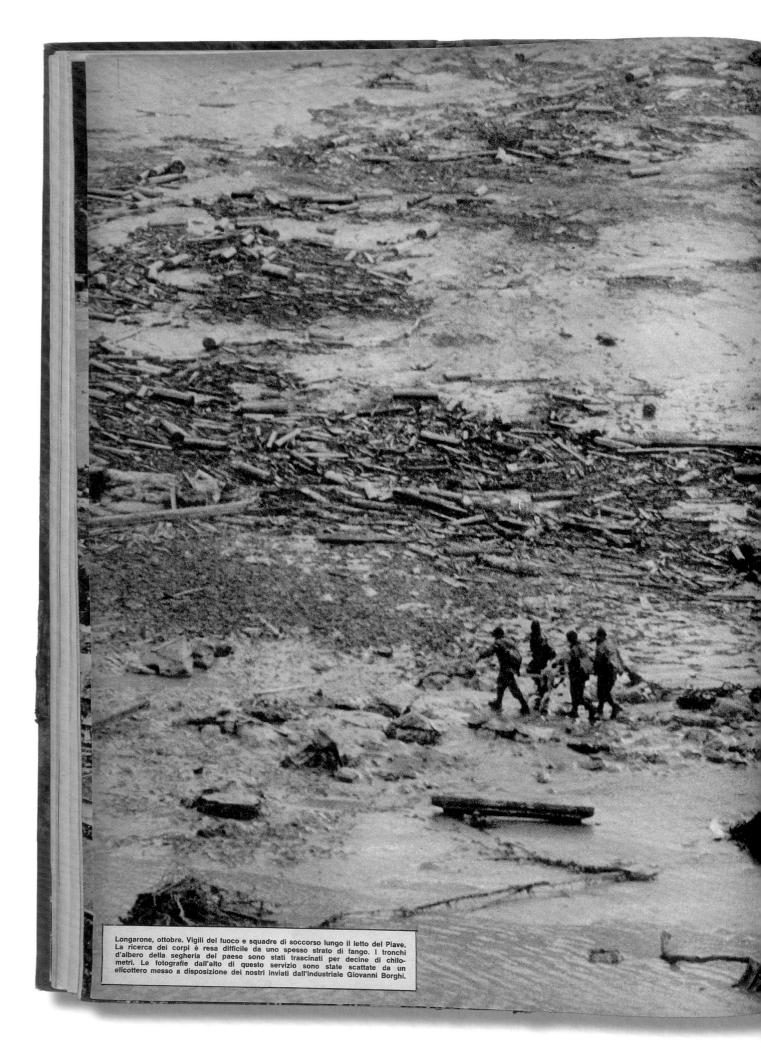

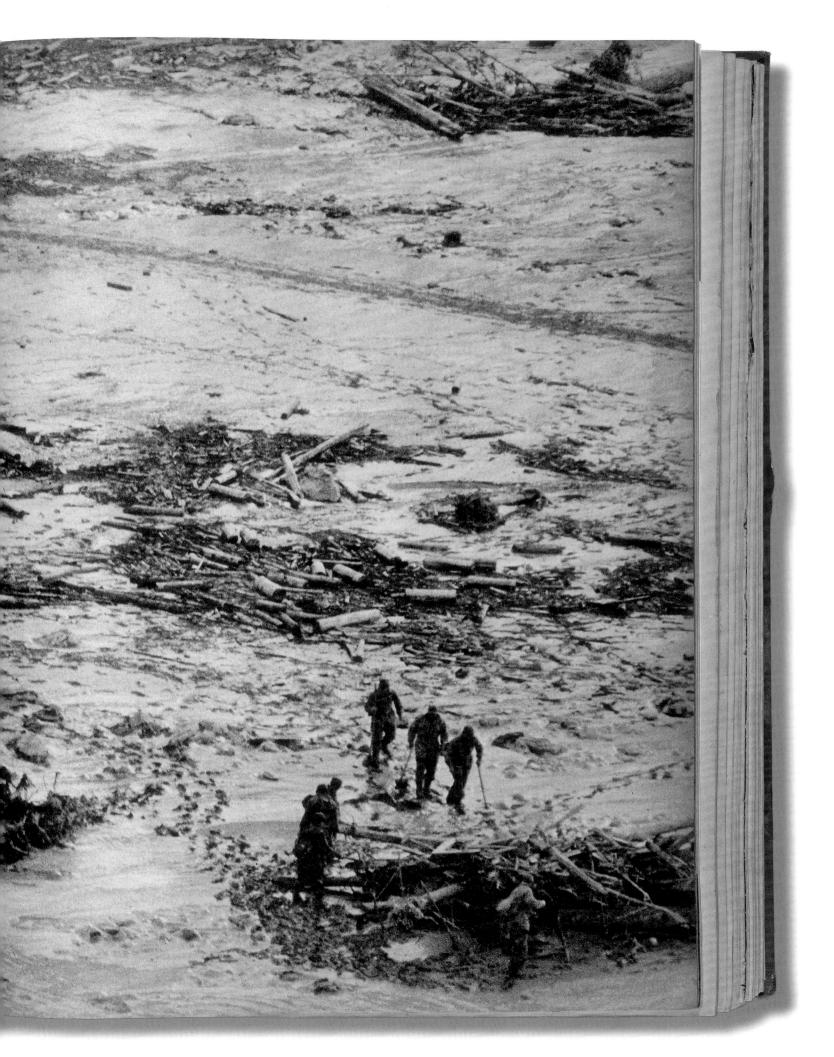

1964 THE POPE VISITS THE HOLY LAND EPOCA

Pope Paul VI's visit to the Holy Land in January 1964 was a historic event for the Catholic Church. Including visits to Jordan, Israel and Syria, it was the first pilgrimage that a pope had made to the Holy Land and it carried powerful religious and political significance – especially so because he included the territories occupied by Israel in his itinerary. Subject to media and public scrutiny throughout, the pilgrimage inaugurated a new strategic model for papal evangelism, developed further by Pope Paul's successor, John Paul II. The Italian weekly magazine *Epoca* – founded in 1950 and inspired by the American magazines *Look* and *Life* – sent a team of its ten best journalists and photographers to create a special issue on location. Covered as a strictly chronological narrative, the three-day visit was presented moment by moment, from the incoming flight of the Pope's airplane onward. Its style was simple and direct yet highly polished, and it made utterly compelling viewing among an audience of Catholics who, as yet, had limited access to television. (12 January 1964, with photographs by Mario de Biasi, Giorgio Lotti, Walter Mori and Sergio del Grande)

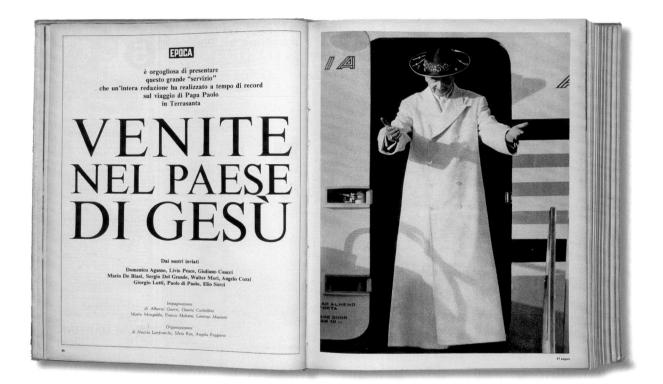

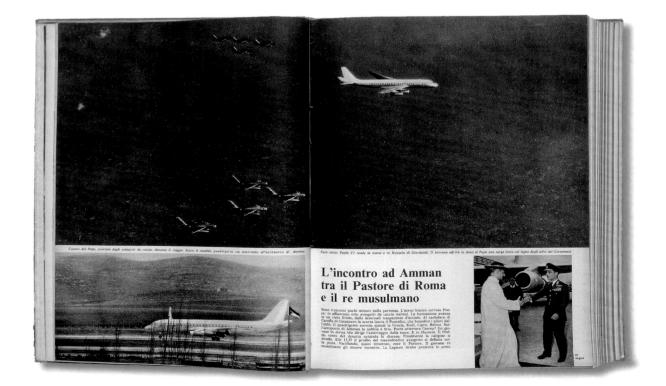

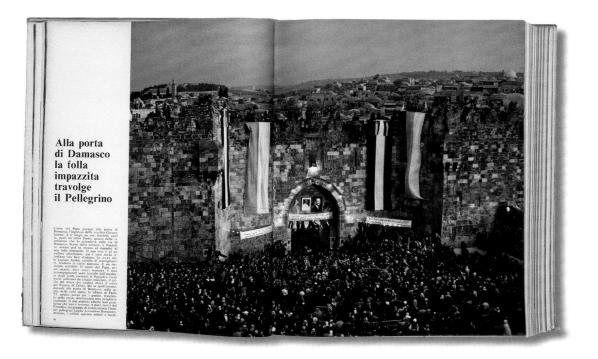

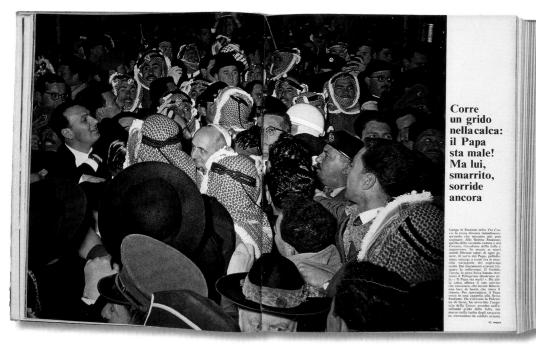

1965-1974 THE VIETNAM ERA

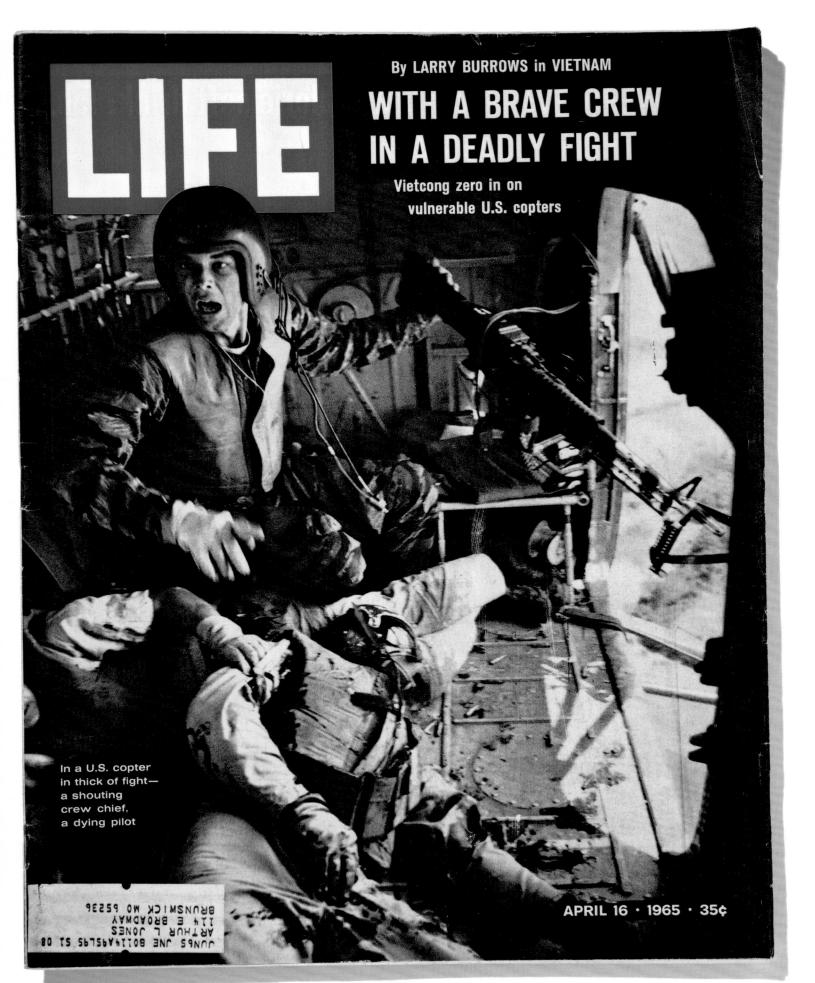

LARINI BURRUW³ IANREE FAFA 13¹¹³ MARCH 118 JAMES KARALES THE SELMA MONTGOMERY A AND A JAMES KAHALES THE SELMA MUNITUUMENT MARINE 118 JAMES KAHALES THE SELMA SPORTS ILLUSTRATED 120 SONNY LISTON VS GASSIUS CLAY ABRANAM LAPRUUER RENNEUX ASSASSINATIUN 1,34 ABRANAM LAPRUUER REELS TO BE BLACK IN SOUTH AFRICA 138 ERNEST COLE HOW IT FEELS TO BE BLACK IN SOUTH AFRICA 138 FRITZ GORD PRENATIVITY 122 MIKHAIL SAVIN ARCTIC SOLDIERS 140 ROBERTO SALAS REROIC VIETNAM 142 ED VAN DER ELSKEN EUBA 144 RICHARD AVEDON THE BEATLES 148 IRVING PENN THE INCREDIBLES 152 BINNE UNVIUSUN ENST IUUIN SINE IUUIN BIAFRA 164 FLORIS DE BONNEVILLE & GILLES CARON DON MEGULLIN BATTLE FOR HUE 156 RARIZZIUWENI RUUZZIRARZI RARIZZIRALU IDA REAUDIA ANDUJAR PROSTITUTION IN SAO PAULO 170 REAUDIA ANDUJAR PROSTITUTION IN SAO PAULO 170 PHILIP JONES GRIFFITHS SAIGON 172 * ****** www.execution water a state of the MOON 176 BILL ANDERS VIEW FROM THE MOON 176 DAIDO MORIYAMA UNTITLED 178 WILLE MEDALUE JUUMAANLAA 104 ON THE MOON 186 NEIL ARMSTRONG & EDWIN ALDRIN DON MEGULLIN SIEGE OF DERRY 192 MUNICH MASSAGRE PARIS MATCH 196

1965-1974 THE VIETNAM ERA

It's hard to imagine that one ten-year period could have generated so many of the century's historic headlines. Men walk on the moon, rock and roll music becomes the defining voice of a generation and Mohammed Ali becomes sport's greatest star. War in the Middle East comes and goes in a week. In Mexico City, Paris, Prague, Tokyo and Washington DC, demonstrations protesting government policies threaten a global revolution and are quelled with violence. Martin Luther King is assassinated while championing black America's fight for civil rights. Global terrorism erupts in the cause of nationalism and ideology. Over the changing visions and beliefs of the period, the violent debacle of the Vietnam War casts its shadow, polarizing and mobilizing public opinion. It motivates a generation of photographers, making campaigners of them as well as witnesses. The war prompts many of the iconic achievements of photojournalism, with photographs of its brutality provoking the passions of the era, but the times also see the end of the great American behemoth, Life magazine, which closes in 1972. The global headquarters of photojournalism moves to Paris, while Europe's colour magazines become its cutting edge - Paris Match in Paris, Stern in Hamburg and the Sunday Times magazine in London. Photojournalists establish their reputation for independence of thought and action, in a new environment for journalism, working mainly as freelancers through Paris-based agencies. Driven by missions they define themselves, and beginning to publish their work on their own terms in books, photojournalism begins to outgrow the press that gave it birth.

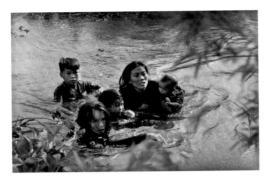

KYOICHI SAWADA United Press International

Mother and children wade across river to escape US bombing. Loc Thuong, Binh Dinh, South Vietnam, September 1965. World Press Photo of the Year 1965

HANNS-JÖRG ANDERS Stern A young Catholic during clash with British troops. Derry, Northern Ireland, May 1969. World Press Photo of the Year 1969

WOLFGANG PETER GELLER Shoot-out between police and bank-robbers. Saarbrücken, West Germany, 29 December 1971. World Press Photo of the Year 1971

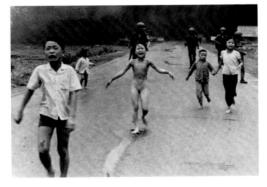

HUYNH CONG UT Associated Press Phan Thi Kim Phuc (centre) flees with other children after South Vietnamese planes mistakenly dropped napalm on South Vietnamese troops and civilians. Trangbang, South Vietnam, 8 June 1972. World Press Photo of the Year 1972

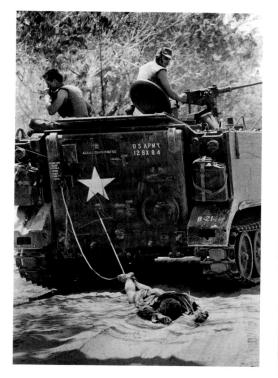

KYOICHI SAWADA *United Press International* American troops drag the body of a Viet Cong soldier to be buried. Tan Binh, South Vietnam, 24 February 1966. World Press Photo of the Year 1966

CO RENTMEESTER Life US tank commander. South Vietnam, May 1967. World Press Photo of the Year 1967

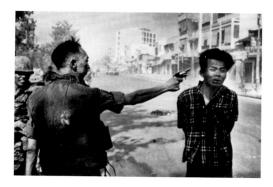

EDDIE ADAMS Associated Press

South Vietnam national police chief Nguyen Ngoc Loan executes a suspected Viet Cong member. Saigon, South Vietnam, 1 February 1968. World Press Photo of the Year 1968

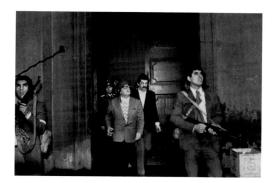

ANDN. *New York Times* Democratically elected President Salvador Allende during military coup, at Moneda presidential palace. Santiago, Chile, 11 September 1973. World Press Photo of the Year 1973

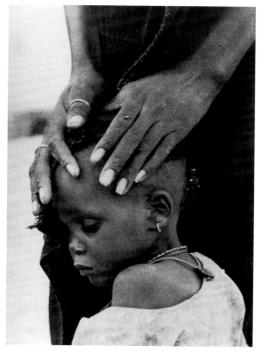

OVIE CARTER *Chicago Tribune* Drought victim. Kao, Niger, July 1974. World Press Photo of the Year 1974

1965 BILL EPPRIDGE HEROIN LIFE

Bill Eppridge might well be considered the quintessential professional photojournalist of the postwar American illustrated press. Sports, war, 'human interest', Hollywood and all manner of breaking news were efficiently and graphically documented by Eppridge as a staff photographer for *Life*. He adeptly photographed the Beatles on their first arrival in the United States in 1963, and in 1968 made the most widely seen images of the slain body of Robert F Kennedy. After the demise of *Life* he continued for Time Life Inc, working for magazines including *Fortune*, *Sports Illustrated*, *People* and *Time*. 'We are animals in a world no one knows', with its second instalment, 'Panic in Needle Park', is probably his best-known essay – though typical neither for Eppridge nor for *Life*. Illustrating a darker side of suburban America, the story follows the daily activities of an attractive, white, middle-class, New York couple who are heroin addicts, forced by their habit to turn to robbery and prostitution. With their moody drama, the pictures stylistically evoke a *film noir* approach. The story made a big impression on its American audience, the first to present the use of illegal drugs in the mainstream press. It remains among the best-remembered photo essays published by *Life*. (26 February 1965)

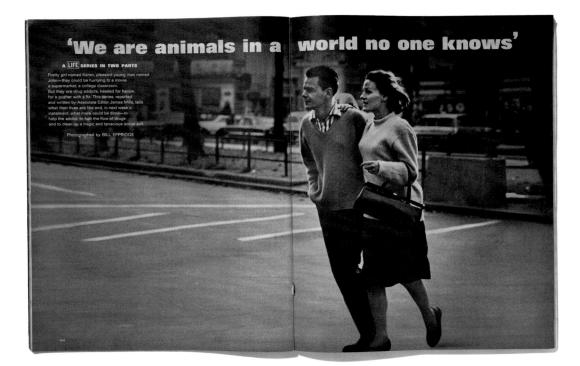

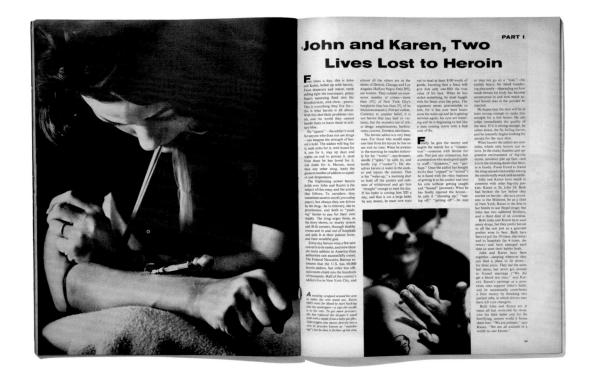

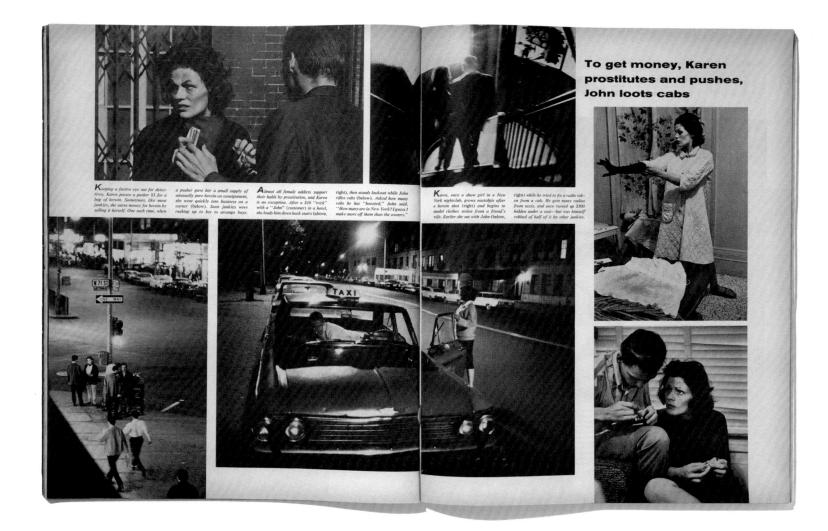

He visits her in a hospital: 'Stop nodding, they'll throw me out'

Kareno mich kongital, Johnry karen ersten kongital, Johnry kinge om herorin und agener kinge om herorin in stronder her wendel ag en her inveske her wendel ag en her inveske her her stronder (räght). "Vori er p strongital (räght). "Vori er konson händing, piese för a week, an stron molding, piese arbitetti för a stroken. för ä treve kingen och stronder för ä treve kingen och stro

Leaving for a beapting. Kinra kines a case, Her. Boole had built up such a high solences to herein them are was having results getting results to hold of utilitation (symptoms, She herew that dipe a couple of works areasy from the day in a basiful, the works the bable to start her holds of presh—getting a surger "high" from a samble day.

 T_0 win admittance to the hospital, Kawin pretends to be in great pain from heroin withdrawol, while a nurse fills out forms. After a few questions and a quick search for drugs in her belonginges, the hospital finally let her in.

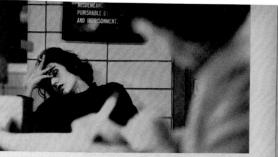

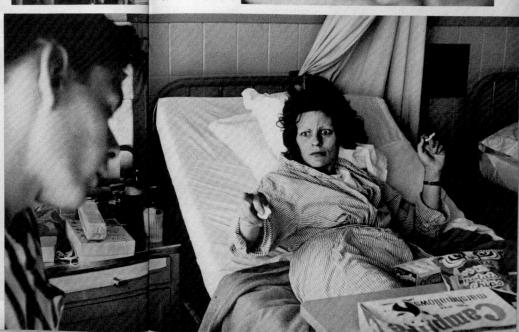

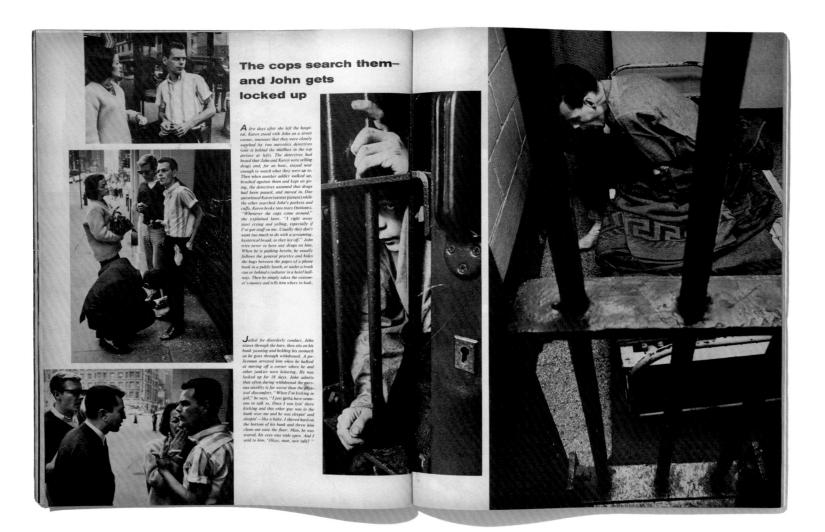

One of the jump's notional essentia is the consider, the "OD"-a shot that the consider, the "OD"-a shot that is body can arrive. In these pictures, show while Johney was in juit, Kores while an while billing of a young addler somed Billy. Here expressions (right) for the other shows arranging. Billy colliqued in a hotel room after sunbing of the Dorbein subjects and these maintaining a shot of horein. Though the other shots and the somaintaining a shot of horein. Though the other shots are hold at an array of the start of horein. Though

Sint only half-onuscions, thit at with a crighter in the hand and are we invest thereas our his next. Now the her can will be binned, Karn-methher and the binned fills of setting the complete sensing and the setting the setting complete sensing. "Man, that was, good bay," Here and the setting the set here a setting the setting the setting the setting the setting the setting the complete sensing." Man, that was, good bay, "Here and the setting the setting the setting the setting the here. Annual every due in how Yes City an addies of an oriented here and transition has here an at the set appears. Address call the setting the description of the setting the s

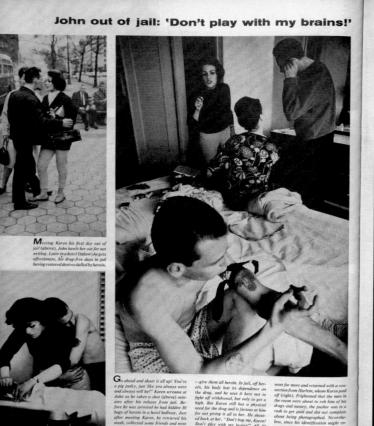

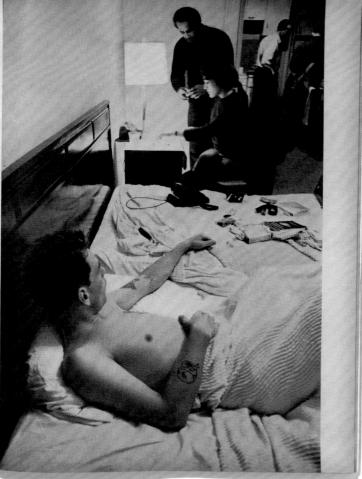

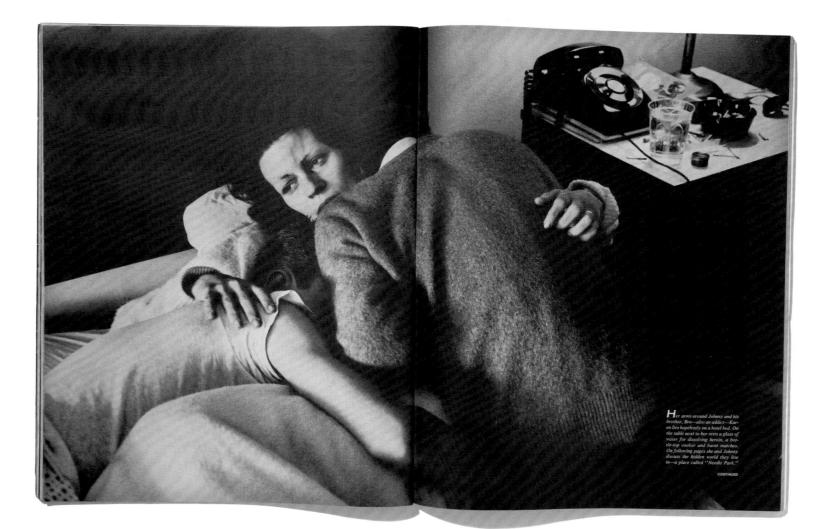

1965 LARRY BURROWS YANKEE PAPA 13 LIFE

The three photographers who made the most important essays about the Vietnam War – Don McCullin, Philip Jones Griffiths and Larry Burrows – were all British, but only Burrows worked for the American press. He began his career at sixteen, as a technician in *Life*'s London darkroom, and was already a senior photographer in 1962 when the first American military 'advisers' arrived in South Vietnam. According to Burrows' colleague, journalist David Halberstam, 'Vietnam what was what he had long been waiting for ... He was drawn to it by both its elemental humanity and its parallel cruelty and violence, and by the fact that it lent itself so well to what he wanted to do – the magazine photo spread.' He was a consummate reporter and storyteller as well as image-maker. An advocate for the individual soldier and the victims of war rather than for any political point of view, he was perfect for *Life*; while his stories were full of emotion and gritty detail, they did not question the justice of the war itself. Burrows lost his life in Vietnam, in a helicopter crash in 1971. (16 April 1965)

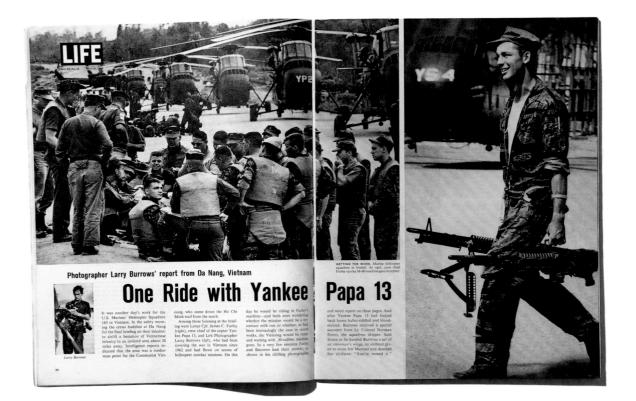

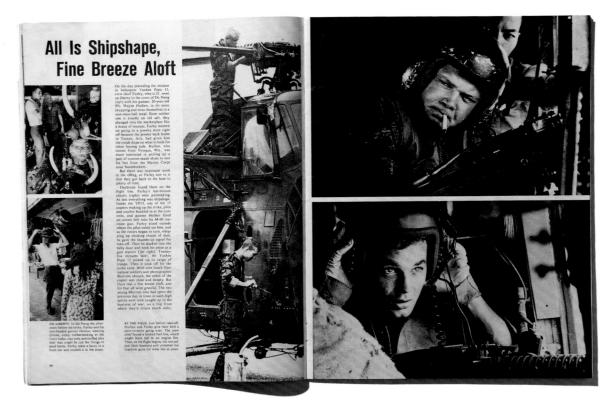

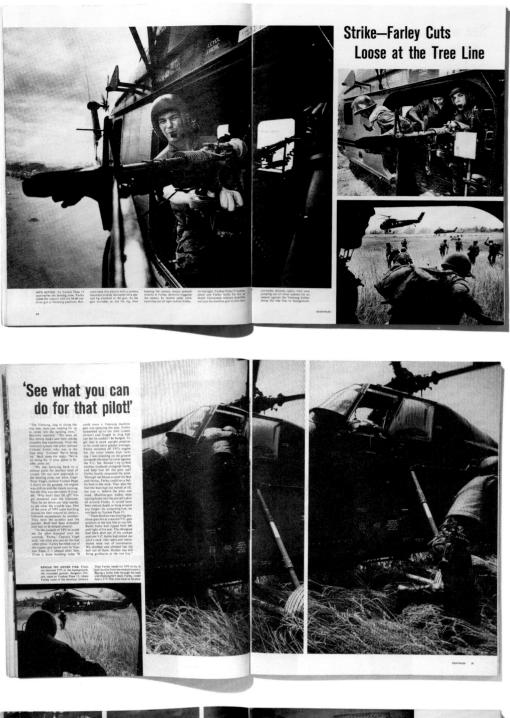

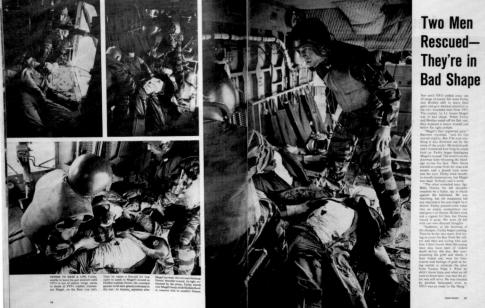

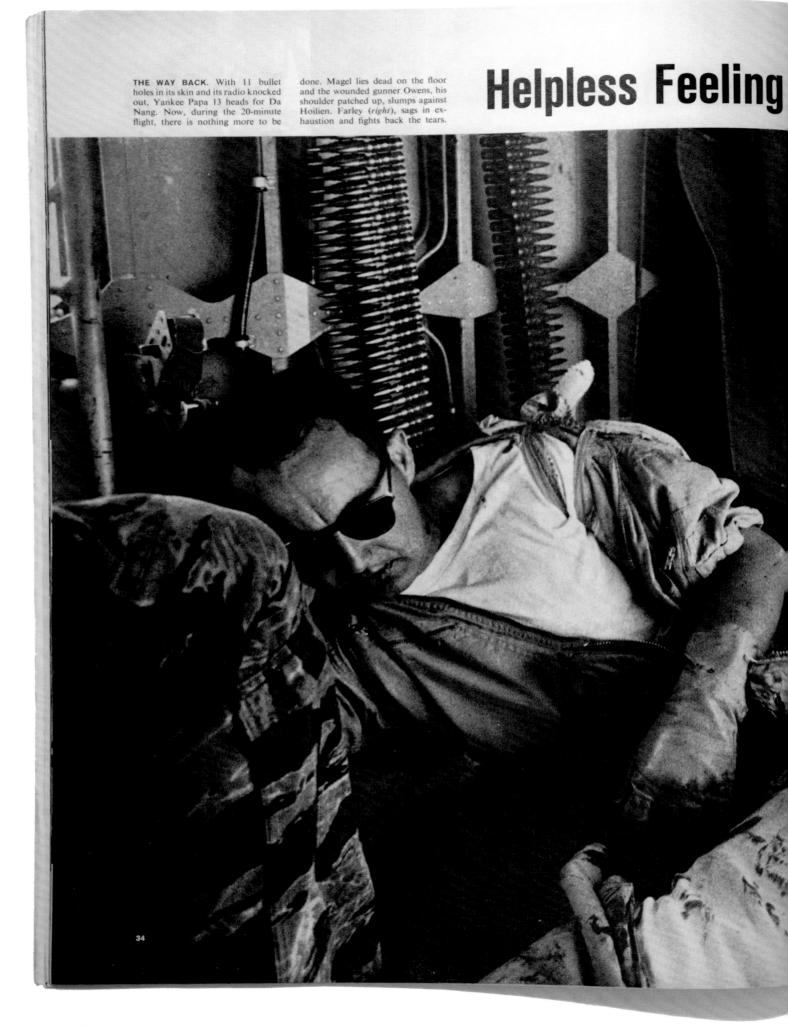

As a Lieutenant's Life Slips Away

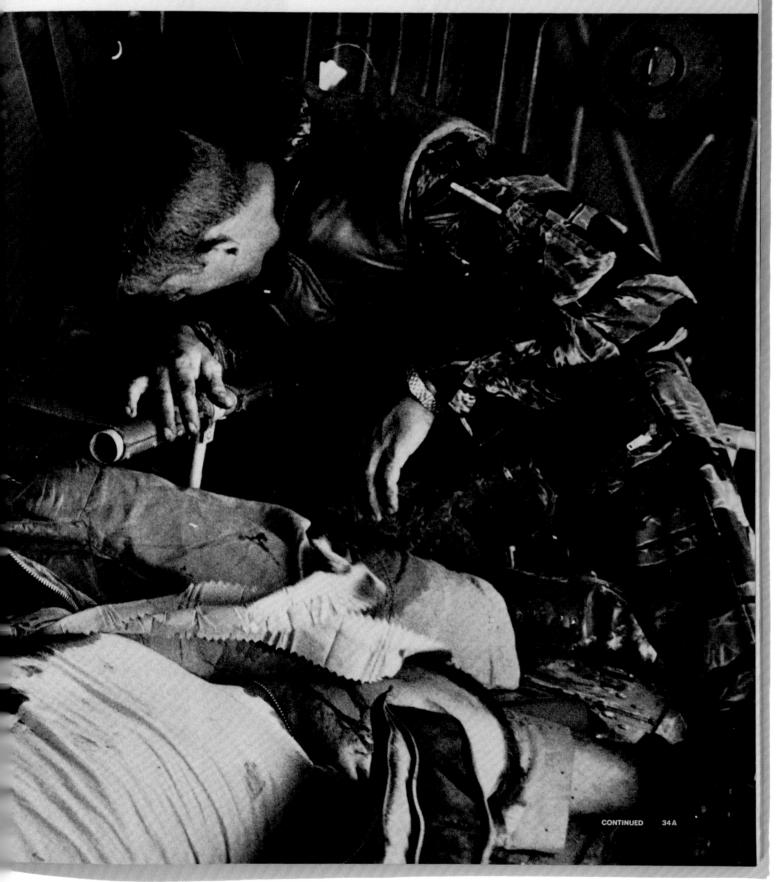

1965 JAMES KARALES THE SELMA MONTGOMERY MARCH LOOK

The Civil Rights movement in the United States reached a turning point on Sunday, 7 March 1965, when television and newspapers covered a bloody battle between the Alabama police, armed with clubs, whips, and tear gas, and 600 mostly black civil rights demonstrators led by Martin Luther King. Thanks to the cameras, King's campaign – until then seen as a Southern phenomenon and problem – began to receive wide support across America. With the momentum raised, a crowd of over 3,200 left Selma on 21 March demanding equal voting rights, swelling to 25,000 by the time they reached Montgomery. When James Karales and writer Christopher Wren covered the story for *Look*, they faced a perennial magazine reporter's problem – they could not cover this urgent story as breaking news, because the magazine's slow production time meant that it would not reach the news-stands until the middle of May. In seeking an angle, they chose to focus on the growing strength of support for King among white clergy, many of whom participated in the march. Among the ten images the magazine ran, one became Karales's most famous – the endless column of peaceful marchers carrying American flags along an open highway – and an optimistic metaphor in the fight for social justice. (18 May 1965)

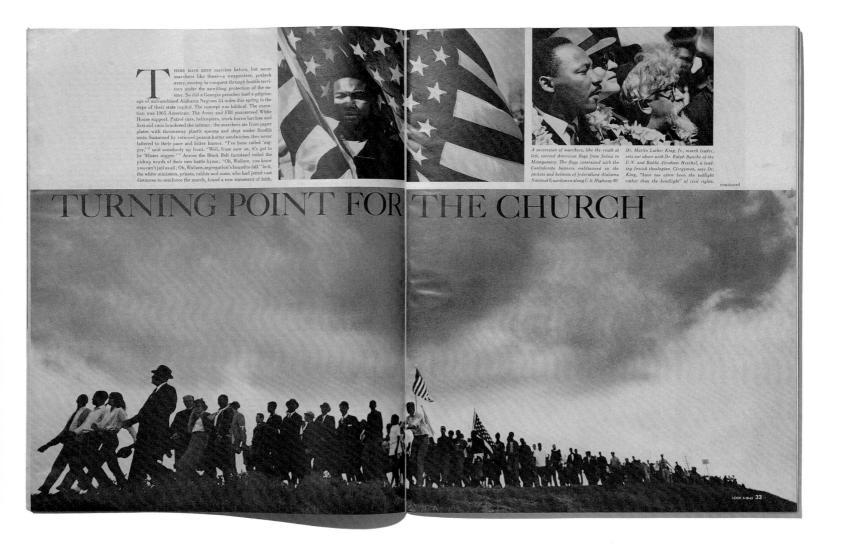

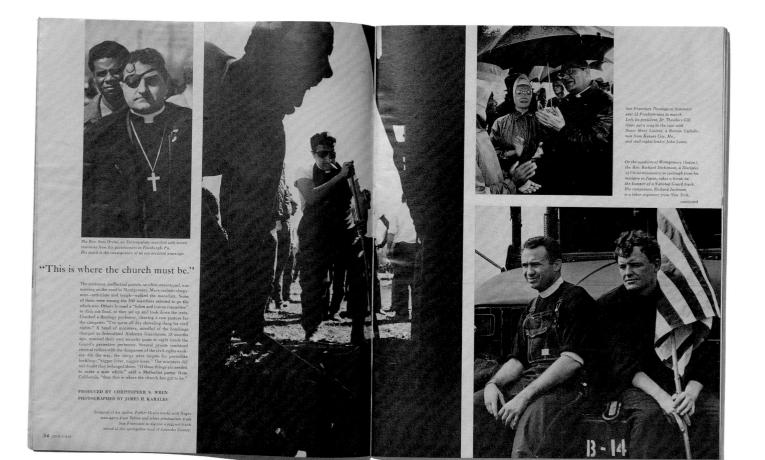

"Without us, it could have become a riot."

The match on Monigomery may be remembered most for those thorounds of thergy who deviated to put on walking down, hortow a sleeping bay and shows the Charlon Helewart. The charact reached a turning point whon its mesongness on U.S. 40 shows with their feet that random runs against the months of any faith. They pegged the level of protost high. A Remart Cathicito priori holder atoms him at the warty while face of state troopers, the resultful black faces of source reactions. Without any at could have be concer as in a "character of the state of the state of the state of the state of the reaction of the state of the state of the state of the state of the reaction of the state of the s strongly Leonsites Const. The tracking a datase are non-indicating at the site number here rules are good coll and and the second strength of the second streng

hrick and mortar open one hour a week?" Fortmately, loyal particulours and his own superier have backed him. Bulop Analon Pardieo of Phatoarphonoso do net porticer sensure." The synar fost are tired, or you don't feel well, he me come and take syou rater for you show the Souloy." Of Our ministers have and herm as larky. At least one reportedly lot him Midwast parish for going down to mark. The elergymon with whom Loax talked for? regret have ingo ut them? you such lies. They are least india, and reform

Atlanta put it, about "comforting the afflected and afflictin the comfortable." Those who go away with being relevant i Selma will try it again at home, even if they embarrase their colleagues who can look on and be silent. "I went South," asys Dom Orstin of his week in Alabama

"not realizing 1 would study the North when 1 was there. I saw in Selma what 1 had never realized was also in Pittsburgh. Our discrimination is just noor sophisticated up here." A group of ministers arrested in Selma several days before the march was predictably labeled "outside agitators" by police. "Why not?" one quipped. "An agitator is the part of

The trouble with those "agitators" who walked in Ala

Dre Ker, Arthur Matot, a Presbyerian misser oran Perth Andrey, N.J., tidax arms with Father Orisin and Sister Mary Leosine, Sanharred and Blattered, they march through downtoine Manzgomery Lat downtoine Manzgomery Lat mile, singing, Their wats —bright orange-sidensity them as having wilded all

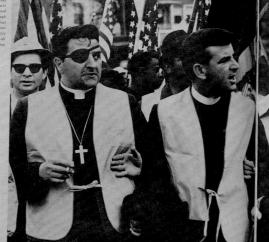

1965 SONNY LISTON VS CASSIUS CLAY SPORTS ILLUSTRATED

The second World Heavyweight Championship match between boxers Mohammed Ali and Sonny Liston was an important moment in the history of boxing and in Ali's career. Ali won his first title in 1964, when he was still known as Cassius Clay, and had since converted to Islam, arousing some scepticism from the mostly white sports establishment. In a fight no-one believed Ali could win, he landed three punches. Liston fell on his back, and it was over in sixty seconds. The crowd yelled 'Fake!' Ali, anxious to prove his victory was real, broke regulations and stood over Liston shouting 'Get up and fight, sucker!' *Sports Illustrated* called it 'the fight you never saw' – though magazine readers got several pages of pictures, including spectacular photographs by Neil Leifer and a cover by George Silk. With this fight Ali secured his title and his new name – which he announced shortly afterwards. It made a hero out of Leifer too – with typical modesty, Leifer later claimed how Ali 'made every single person who got close to him a hero' – helping him consolidate a reputation for reliably catching the critical moment in a career in news and sports that lasted over 40 years. (7 June 1965)

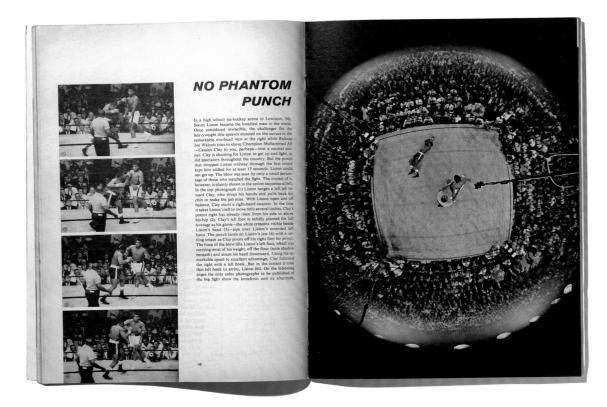

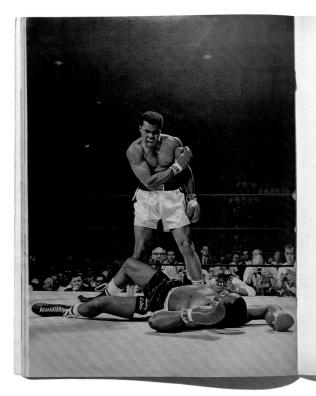

THE DRUBBING BY JIM MURRAY

Anong the few observers who had a clear view of the fight as well as its implications was Jim Marray, one of America's most treachant—and acerbic—sportswither. Marray, formerly with SPORTSILUSTRATED, now writes a syndicated column for the Los Angeles Times. The following are ex-

cerpts from the story he filed immediately after the fight. King Kong got knocked off the Empire State Building. Cassius Marcellus Aladdin Mulligan Montmor-

Liston's time to knock nim kicking in a setting as improbable as the fight. Sonny Liston hit the floor like a guy slipping on a cake of soap getting out of the bathtub. This is the second time this fight has ended with several thouand neonel looking at accho ther and acking: "What

Well, I'll tell you what happened. That's what I'm here for. Sonny Liston got the hell beat out of him is what happened. This time I was looking for it and I saw itt an old man grooping his way into a speedy insolent reckless kid. He was like a guy braving a

the never will. The closest he ever got to the world's foremos Arabian fistfighter was the weigh-in. When he didn hit him then he was volunteering for an evening of catching. He should have worn a catcher's mitt of

I counted three times when Cassius staggered him. The first time was when the bell tech haddri tide down yat. Cassius is an ad-lib fighter, and he thought up a beaut to get this dance under surg-a right cross. Nobody sever started a heavyweight tills fight with a right before. That's the kind of dirty trick your wife woold ty: But Cassius metsed up Liston's unpretty features with a creazy right that he satted to throw when he lot his correct. Siteon Model have he down

We all knew Sonny was slow, but we didn't thind he'd need to call a cab to get to center ring. Actually he should have called a cab to take him home. Tw years ago we were saying this guy was the best heavy weight in history. Now, he's not even the best heavy weight in Lewiston. And if you think that isn't comedown, you're never been to Lewiston.

© That too Angeles

EFUSING TO GO TO NEUTRAL CORNER, A SNARLING CLAY CHALLENGES LISTON T

yould have scratched him. Cassie

to out off Cassius' retreat in mid-ring. The roub trouble was Somy always got thera after Cassius felt. His problem seemed to be he had to surround Clay. The closest Liston ever got to Clay was the same ring. In my fight notes, if you care, I have "CC stops I, with a right" and later "CC staggers him" and then "L leaped at him." That was the trouble. To get at Cassius, Liston would have had to set the

The orderly thing to do would have been for Casis to go to his corner in an orderly manner. But suiss never does anything in an orderly manner. But suiss never does anything in an orderly manner, it it doesn't detract from the fact that he drubbed enans we all thought be should fight with bullets to thought only a silver bullet would floor Liston. turned out a right cores could do h. If I were that g in St. Louis whose leg he broke, I'd get a rematch

The only trouble with Cassius Clay is that, if ever a y misplayed a role in history, it was he. Not Anna en in her worst movie could have topped this. You ve to think Cassius would play Hamlet for laughs d the Marx Brothers as a tearjerker.

uy who was going to kick sand back in the bully's He was going to show that crime didn't pay. y Liston at that time would have been the sentiial underdog in a rattlesnake hunt. took Cassius and a bunch of shaved-headed, sevend types one war to turn Liston into the

popular public favorite since St. George. They Cassius the part of the marshal in *High Noon*, he wanted to be the guy in the black hat. He's the of guy who could get people rooting against the ors in an epidemic. ro 264 days, 23 hours and 59 minutes he might

tacked-up kid. But for 60 seconds Tuesday night it Sonny Liston so bad he'll probably need etting in and out of bed for a week. Whatever so Clay is or believes in, he's all ours. Sonny couldn't get close enough to hit him with a to 'b indised. It's going to be terrible on the ot Cassius is right back where you have to listen and he's coming in loud and clear.

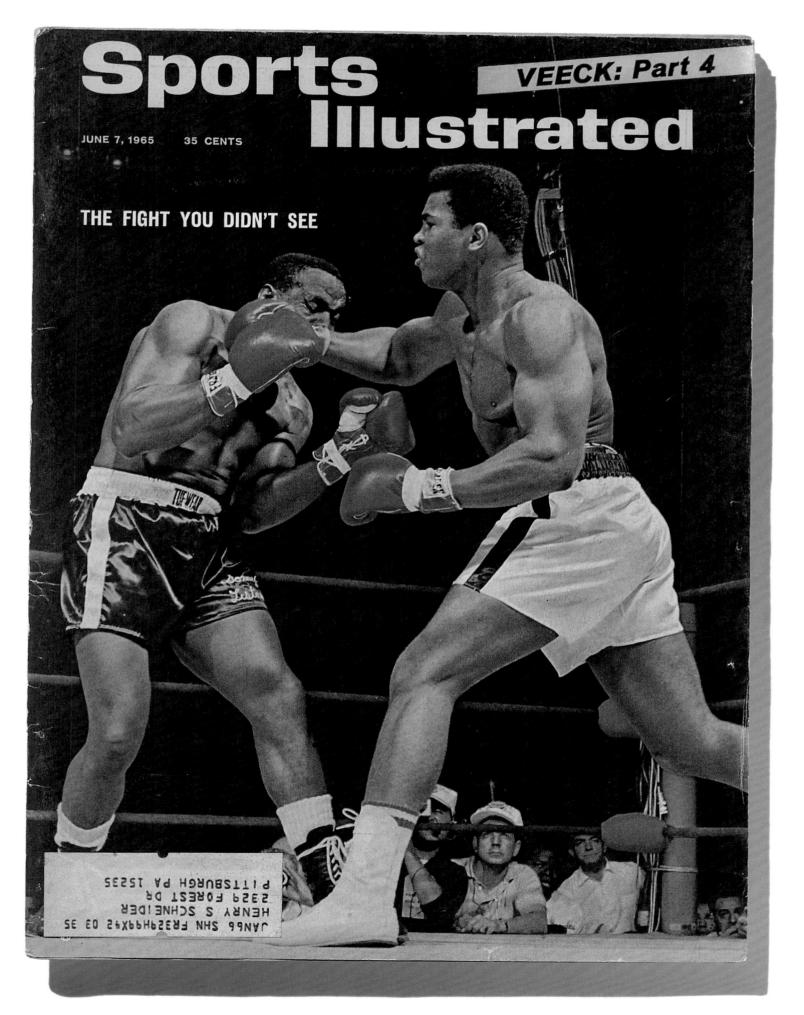

1965 FRITZ GORO PRENATIVITY LIFE

Science writer Stephen Jay Gould called Fritz Goro 'the most influential photographer that science journalism (and science in general) has ever known'. Born Fritz Goreau in Germany at the turn of the century, he trained at the Bauhaus and worked for magazines in Munich and Paris before coming to America in 1936. There, along with other German refugees, he joined the Black Star agency and, in 1945, the staff of *Life* magazine. For the next forty years, Goro's images introduced *Life* and other magazines' readers to spectacular innovations in the fields of physics, biology, and chemistry. He visualized the DNA molecule and was the first to make still photographs of blood circulating in living animals. His essays addressed the processes of cancer and popularized molecular science. He modestly described his mission as making 'the truth so attractive that people will look and learn at once'. For many of his readers in the 1960s, the story was a revelation. (10 September 1965)

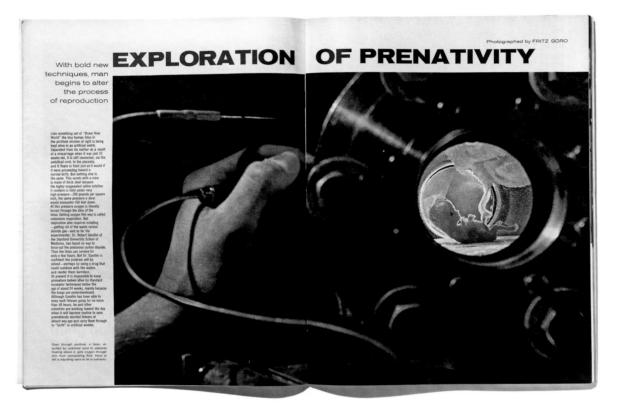

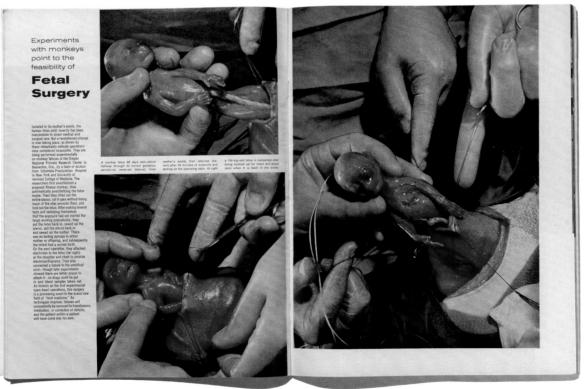

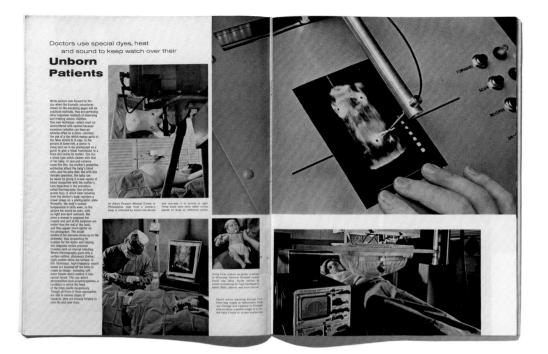

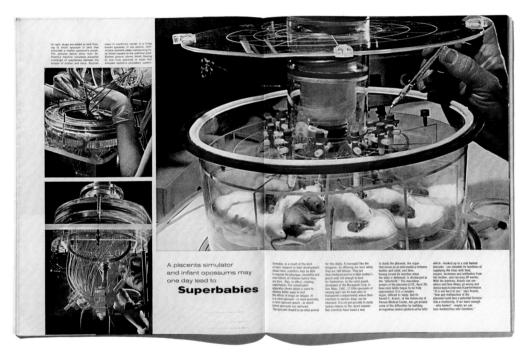

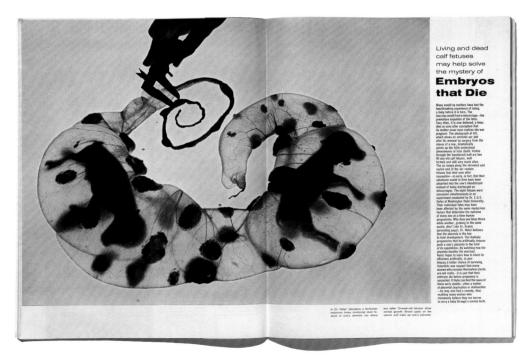

RADIOACTIVI

Hardly any problem alarms scientists more than the world's population explosion. They spend a lot of time and energy devising more effective birth-control methods. The most popular contraceptive in the U.S. is the famous pill which prevents the ovaries from releasing eggs. It was developed at the Worcester Foundation for Experimental Biology where further research (left) is in progress. Researchers elsewhere hope soon to perfect a once-a-month injection to replace the pill-a-day. Meanwhile most existing contraceptives, including the pill, are too expensive for most of the world's people. As an interim measure,

more and more people are using the so-called intra-uterine devices (IUDs). These are simply odd-shaped pieces of metal or plastic—some tied with bits of thread—that resemble free-form pieces of costume jewelry. They are inserted into the uterus by doctors and simply left there. No one is sure how they work—but they do.

At left two cow ovaries under glass (upper right) are kept alive by apparatus that simulates heart-lung functions to study how they react to radioactively tagged hormones. Below are intra-uterine birth-control devices.

1966 SERGIO LARRAIN VALPARAÍSO DU

It was while a student of forestry at Berkeley, in San Francisco, that Chilean Sergio Larrain first took up a camera. He travelled in Europe before choosing to live in isolation, not far from Valparaíso, where he read poetry and philosophy and produced photographs on excursions into Chile's harbour city. Although he went on to freelance for a while for Brazil's *O Cruzeiro* magazine, there is nothing conventionally professional about his approach. Larrain has described receiving his images in a 'state of grace ... the grace that appears when one is free like a child in his first discovered reality'. His work recalls the 'magic realism' of his Latin American contemporaries – writers Gabriel García Márquez, Mario Vargas Llosa, and Pablo Neruda; the latter became Larrain's close friend and collaborator in his ongoing photography of Valparaíso. First seen in the Swiss cultural magazine *Du*, a regular publisher of extended photo essays that satisfied the criteria of both art and reportage, his pictures demonstrate a wholly original vision in which dream and association are as important as facts or reality. Before the end of the 1960s Larrain gave up photography, retreating again – this time into the Chilean mountains – to devote himself to the study of Eastern culture and mysticism. (February 1966)

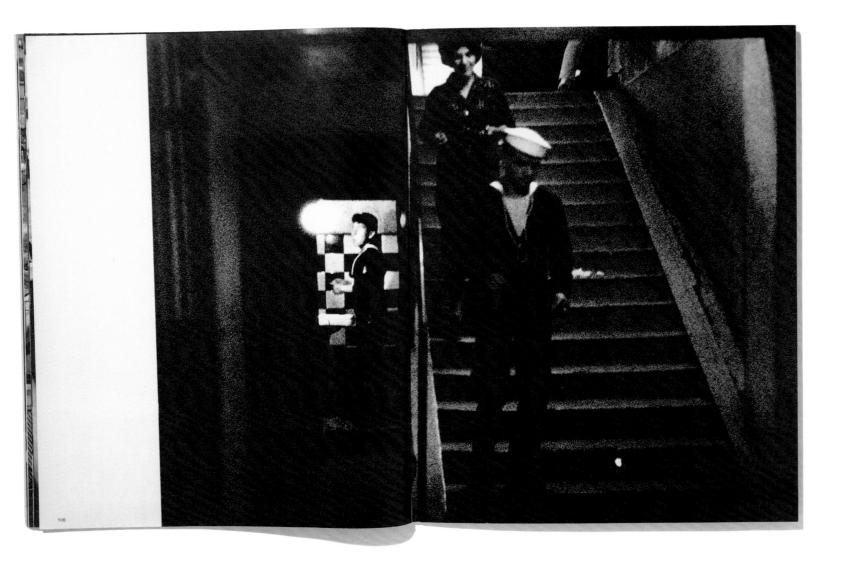

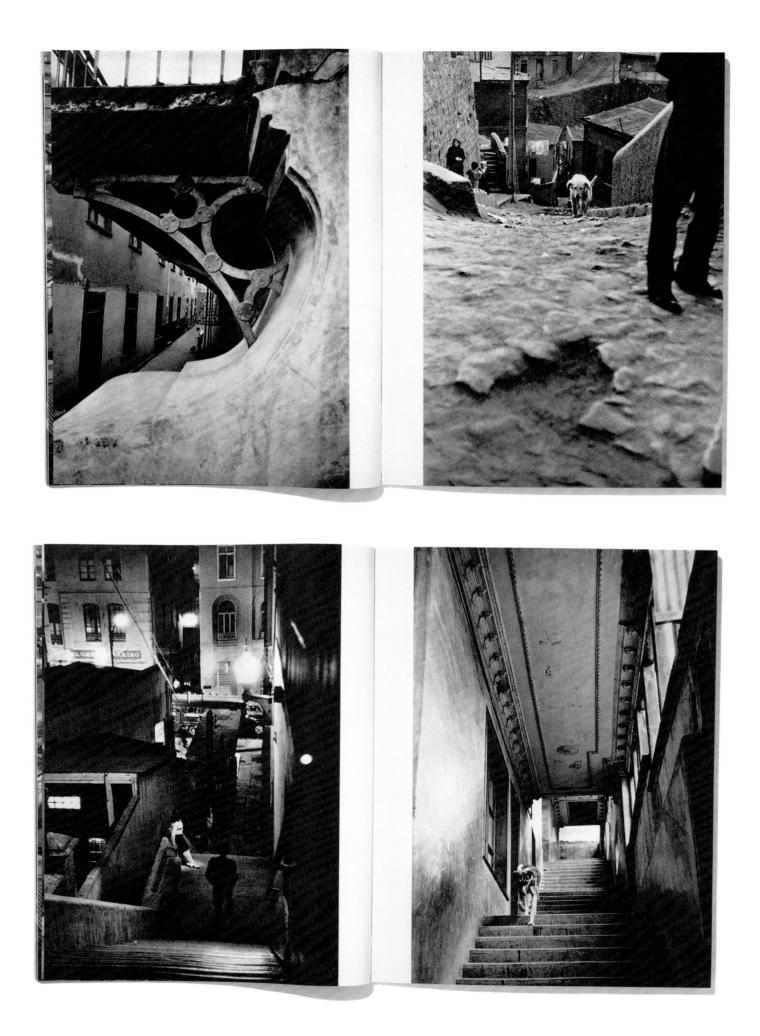

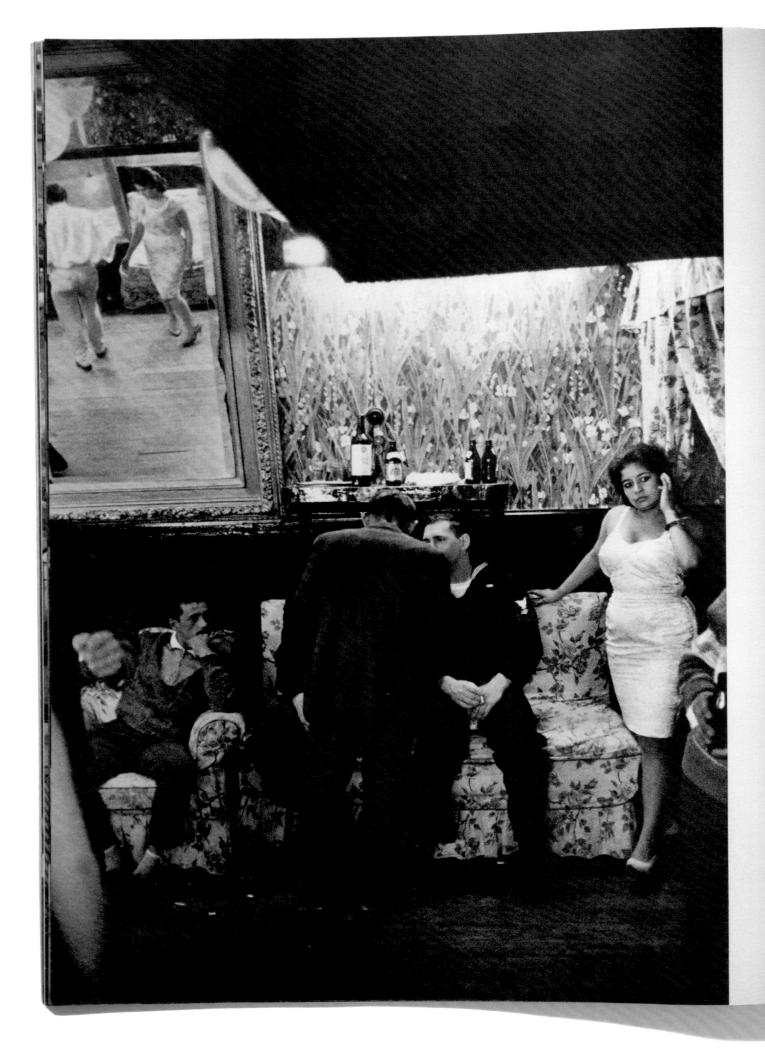

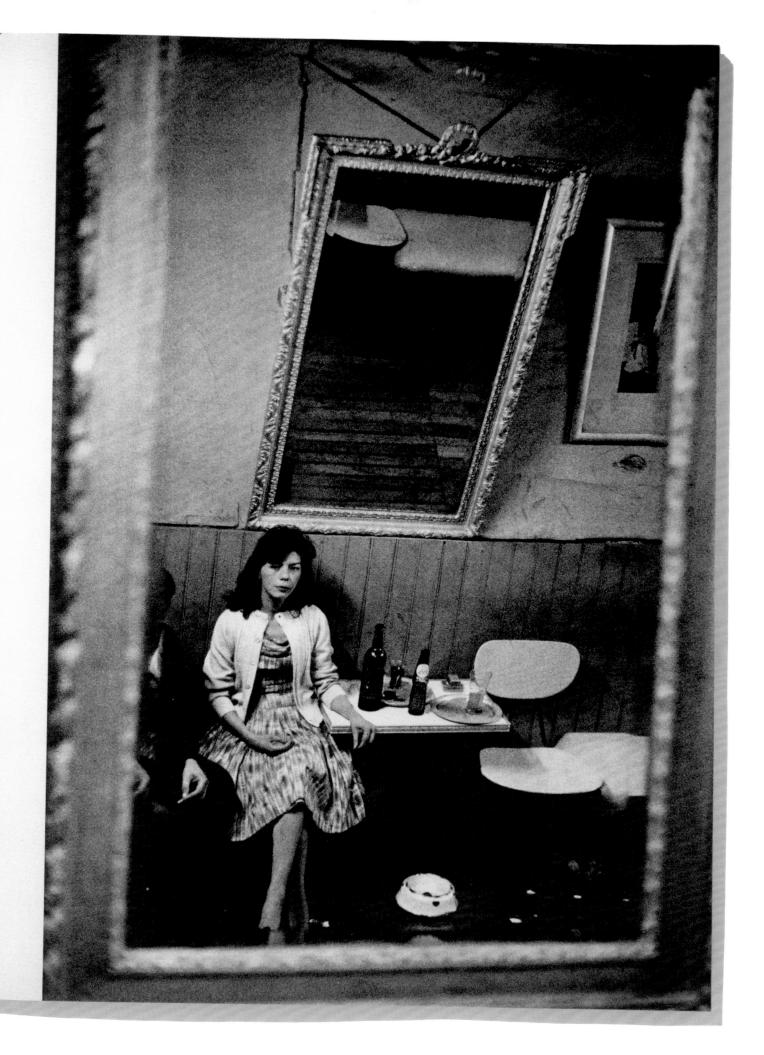

1966 LENNART NILSSON CREATION REALIDADE

Swedish photographer Lennart Nilsson worked as a photojournalist reporting for *Picture Post*, *Life* and the Swedish magazine *Se* before becoming a pioneer in the photography of events inside – rather than outside – the human body. It was in the late 1940s on an assignment at Sabbatsbergs Hospital in Stockholm, that he first photographed human embryos, stored in glass jars. Several years later he showed the pictures to *Life* magazine, who published them and encouraged him to pursue the idea. He explored the use of microscopes and, in the 1960s, ultra-slim endoscopes that allowed him to get closer to his subjects and to photograph inside the body. He started recording the human embryo at each stage of its development, taking four years to complete a comprehensive account of the creation of a human being. First published in *Life* magazine, his ground-breaking story, as pictorial as it was scientific, created an immediate sensation. Adding a profound new ingredient to the iconography of human life, it reached vast audiences in magazines throughout the world, including in the Brazilian magazine *Realidade*. (April 1966)

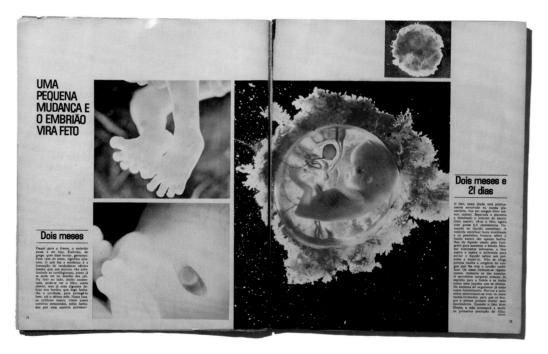

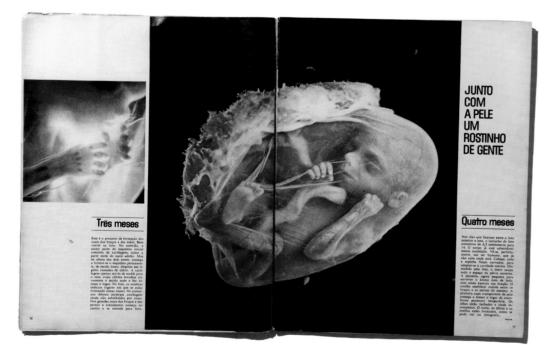

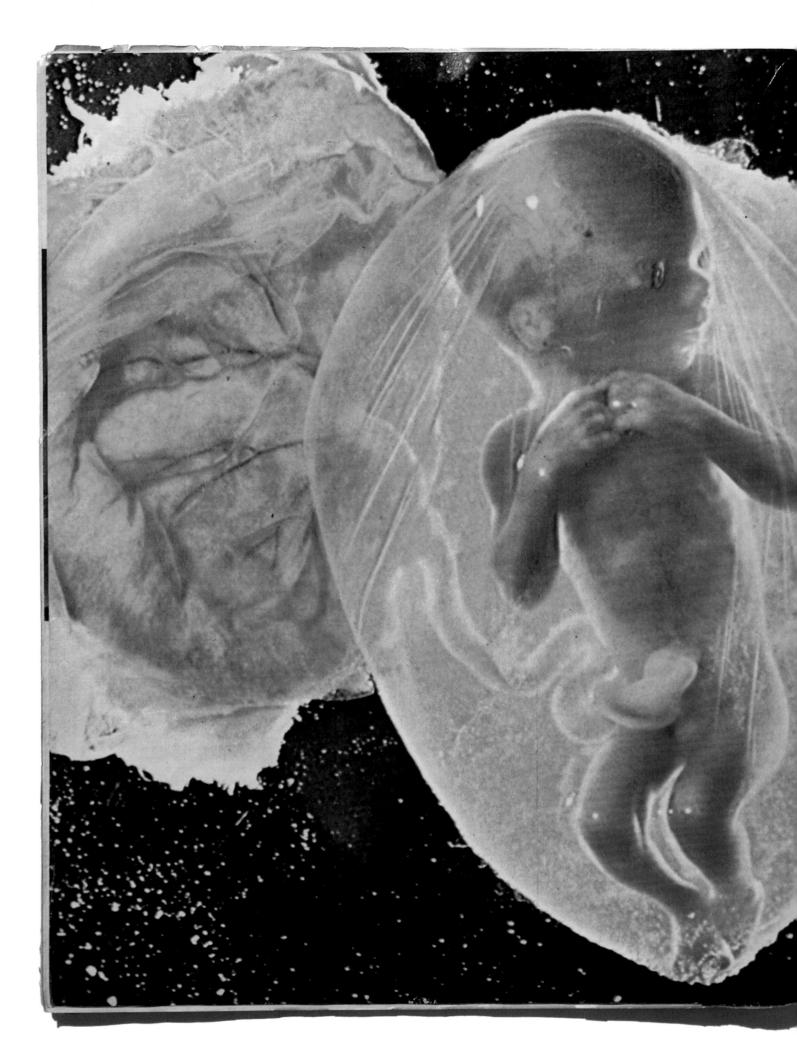

dedo na bōca Para aprender A viver

Quatro meses e meio

O menino, com menos de 5 meses, já põe o dedo na bôca. É exercício, que o prepara para alimentar-se espontâneamente logo que nasça. Sua pele é tão delicada e transparente, que a rêde de vasos sanguíneos parece estar na superfície. Por ser delicada, à pele é vulnerável ao contato das unhas. Elas crescem ràpidamente e podem até causar pequenos arranhões antes do nascimento. Ås vêzes, uma das primeiras tarefas c'a enfermeira que assiste no parto é cortar as unhas já bem compridas do bebê, para que não se machuque. Aos quatro meses e

meio, o feto é vigoroso e ativo. Faz frequentes flexões. Pode fechar o punho, dar socos e pontapés. Consegue até fazer os movimentos do chôro. Tem as cordas vocais mas não pode emitir som, porque não existe ar. Está com 16 centímetros. Ainda vive submerso, mas, enquanto cresce, vai tomando conta de todo o âmnio e deixa cada vez menos espaço para o líquido. O que sobra é levado pelo sangue, através do cordão umbilical e da placenta, ao organismo da mãe, para ser eli-minado. Dez semanas depois, o desenvolvimento do feto está pràticamente concluído. Algumas crianças nascem prematuramente nessa época. Porém, o resto do tempo em que o feto permanece no útero lhe dá mais fôrças e lhe permite receber da mãe importante imunidade contra várias doenças, nos primeiros meses de vida. SEGUE

1966 ABRAHAM ZAPRUDER KENNEDY ASSASSINATION LIFE

Although there were dozens of photographers in Dallas along the route of the presidential motorcade, the most famous images of John F Kennedy's assassination come from a Super-8 film shot by businessman Abraham Zapruder. In a previously unprecedented act of 'chequebook journalism', *Life* reporter Richard Stolley secured the original film and all rights from Zapruder. Fragments of the film appeared in *Life*'s memorial issue on Kennedy, although it was printed in small, black and white strips, conveying little information. Its memorable publication came three years later, when *Life* covered the release of the Warren Commission report that officially reviewed all the evidence (including Zapruder's film) and confirmed that Lee Harvey Oswald was the assassin. This time, *Life* printed the film fragments in colour, greatly enlarged and presented frame by frame in the manner of forensic evidence (albeit with the most gruesome frames edited out). *Life* chroniclers have cited publication of the Zapruder film as proof that even moving pictures can find their most significant release in the form of still images on the printed page, although live coverage of the Kennedy funeral marked the moment when television replaced newspapers and magazines as the main source of breaking news. (25 November 1966)

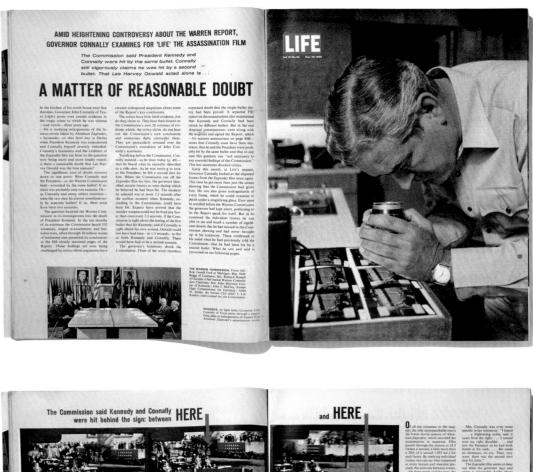

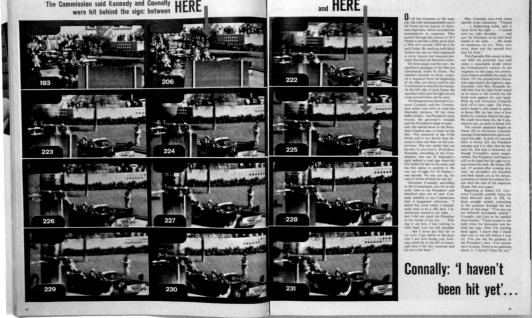

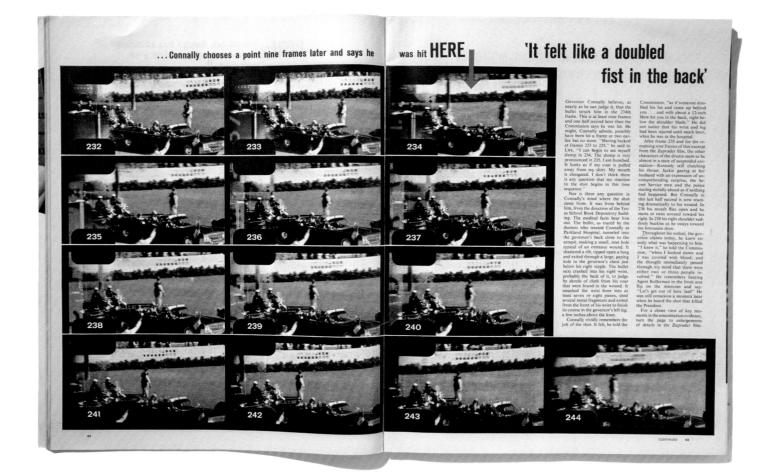

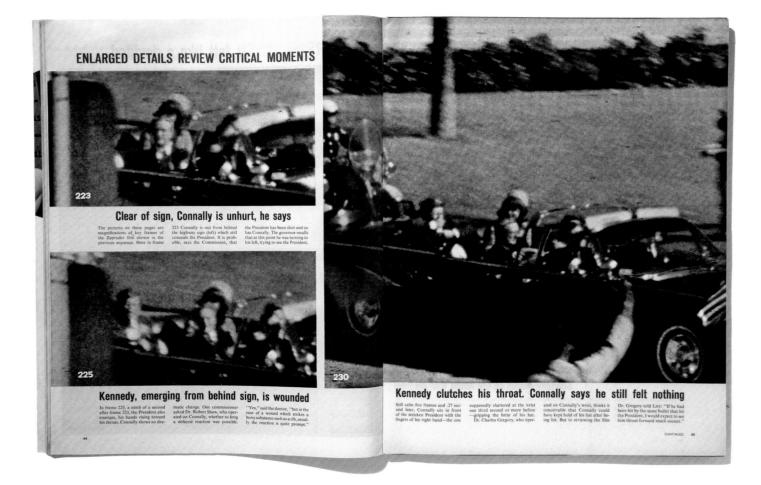

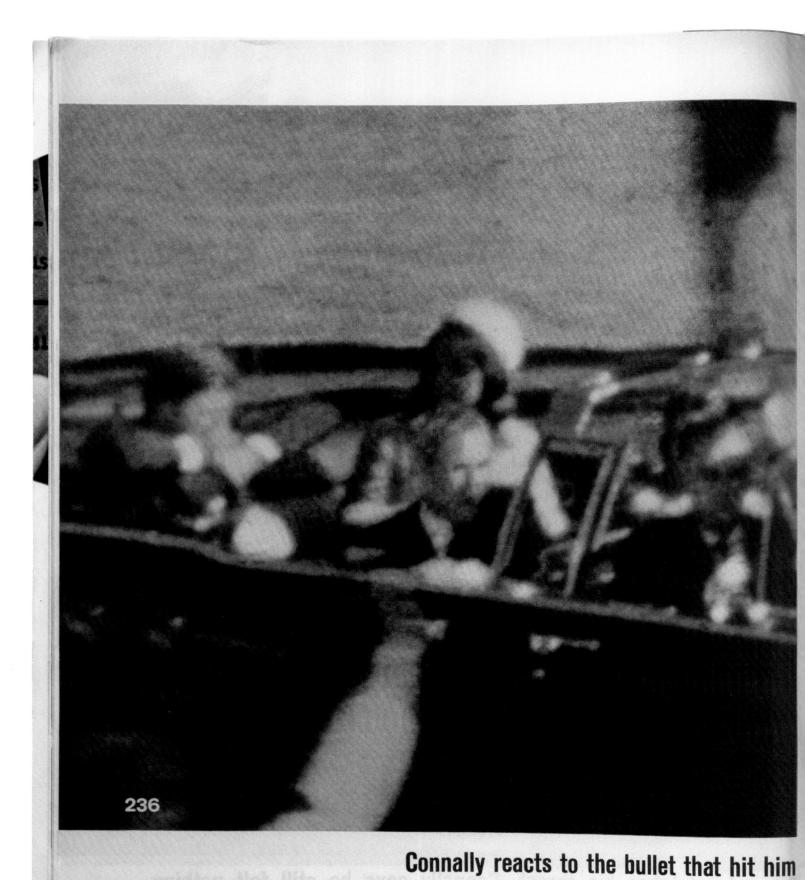

In this enlarged detail of frame 236, Connally is now reacting to the bullet. This is one ninth of a second later than frame 234, which Connally marks as the moment he was hit. It is two thirds of a second since Kennedy began responding to his neck wound, and this raises an important question: is it likely that Connally would have

i sec-

had a delayed reaction to the hit while Kennedy's reaction was almost instantaneous?

In frame 236 Connally's mouth has flown open; his right shoulder

sags. But he still appears to be holding on to his hat with his right hand, which is now to his right and level with the top of the car door. In frame 242, one third of a sec-

46

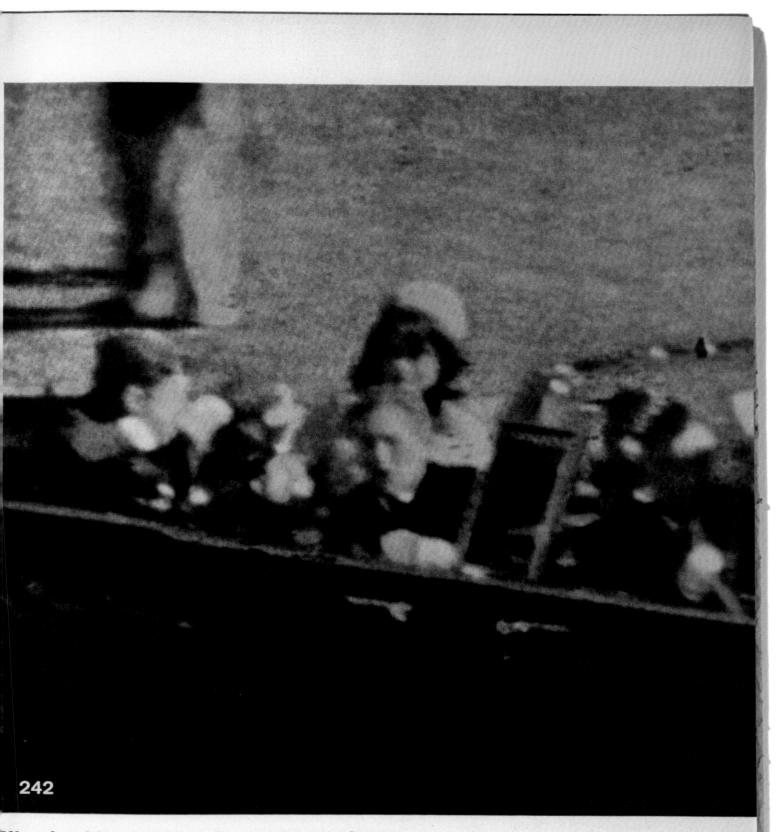

His shoulder buckles, he starts to slump

ond later, Connally is caving in. His right shoulder has slumped dramatically. The change can be seen best by noting the red patch behind him which was identified as

a bunch of red roses lying on the seat next to Mrs. Kennedy. In 236 the roses are only barely visible behind Connally's right shoulder. In 242 much more of the roses can be seen, showing that Connally's shoulder has been jerked downward and perhaps also forward by the impact of the bullet. His head has snapped around to the right and his mouth seems to be framing a cry, perhaps the exclamation that his wife heard him utter soon after he was hit: "My God! They are going to kill us all!"

1966 ERNEST COLE HOW IT FEELS TO BE BLACK IN SOUTH AFRICA SUNDAY TIMES

Having served in the design and graphics department of *Drum* magazine in the late 1950s, Ernest Cole spent six years freelancing for the South African press, pursuing his idea of documenting Apartheid. The *Sunday Times* publication of his essay was not only a triumph of photojournalism but a triumph of subversion against the regime he depicted. The South African state was mindful of the need to censor its portrayal abroad as a segregated society. Photography was monitored and restricted and, categorized as 'African', Cole was denied a passport. When questioned about his activities, he disguised his true intent under the cover of documenting black youth crime. He later exploited the contradictions of the Race Classification Board to have himself officially reclassified as 'Coloured' – allowing him both greater freedom of movement within the state and the opportunity, for the first time, to travel abroad. Having outmanoeuvred the authorities, and with the support of Magnum Photos, he left *Drum* magazine and brought his work to Europe and America. A year after the *Sunday Times* ran 'How it Feels to be Black in South Africa', he published his classic book *House of Bondage* (1967). (27 November 1966)

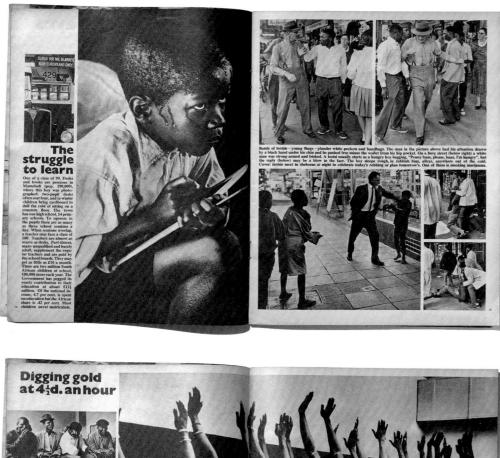

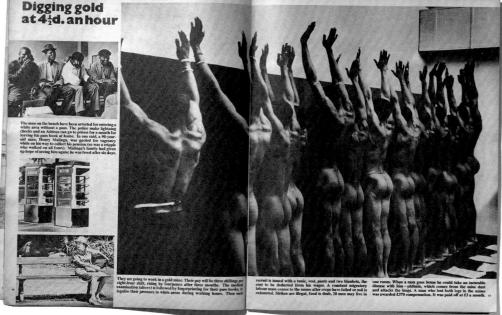

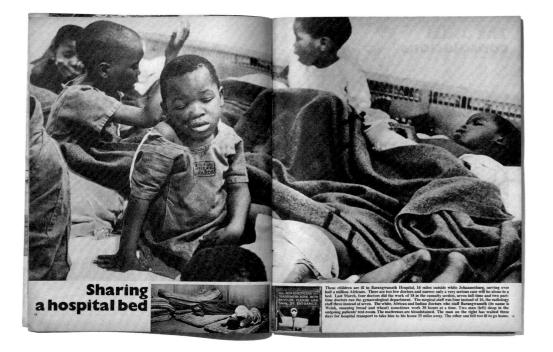

1967 MIKHAIL SAVIN ARCTIC SOLDIERS OGONYEK

Mikhail Savin, like Yevgeni Khaldei and Dmitri Baltermans, is best known outside the former USSR as a war photographer, but Soviet readers first knew his work from the charged Socialist Realist pages of *USSR in Construction*. After the war, Savin joined the team of *Ogonyek* magazine. *Pravda* (the official newspaper of the Communist Party) started *Ogonyek* in 1923, and for the rest of the twentieth century it was the most popular illustrated magazine in the Soviet Union, a combination of *Time*, *Life*, *Holiday* and *Ladies Home Journal*, with regular historical features, a literary department and a crossword puzzle. As the magazine's leading colour photographer, Savin's work appeared frequently in the magazine's signature colour section where it occasionally featured as a stand-alone picture essay. The ingredients of his story on the Soviet Army in the Arctic echo the utopian forms of his earlier work while reflecting the responsibilities of a senior Soviet photojournalist at the height of the Cold War. His representation of brave, attractive, young Soviets set alongside gleaming military technology, reproduced in spectacular colour-saturated compositions, hover just short of kitsch. (21 March 1967)

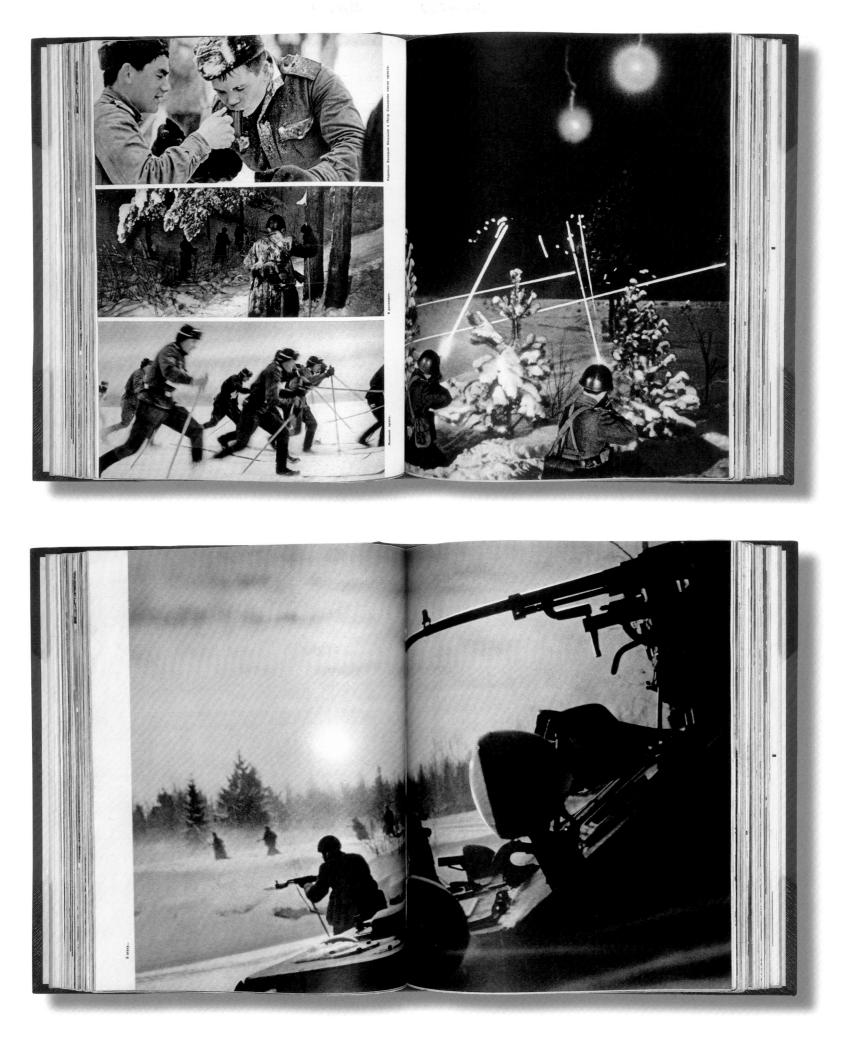

1967 ROBERTO SALAS HEROIC VIETNAM CUBA

Cuban photographer Roberto Salas spent several weeks in Vietnam in the spring of 1967 to produce a report on the US war against the socialist government of a small, rural country much like his own. Salas worked on several separate essays, on subjects including the ruins of Vietnamese civilization that he found in the North, the peasant army in the South with whom he travelled through the jungle, and life in Hanoi. Salas's reportage, although obviously sympathetic to any struggle against the USA, differs in many ways from the images made by photographers working for North Vietnam. He employed the style of classic photo reportage, with a strong individual point of view that sets his photographs apart from those made purely for propaganda. Salas, son of the celebrated photographer Osvaldo Salas, was born in New York City, returning to Cuba among a small group of photographers sanctioned by the Cuban government and working principally for its leading newspaper, *Revolución*. He describes the period 1959-68 as the 'golden age of Cuban journalism'. (June 1967)

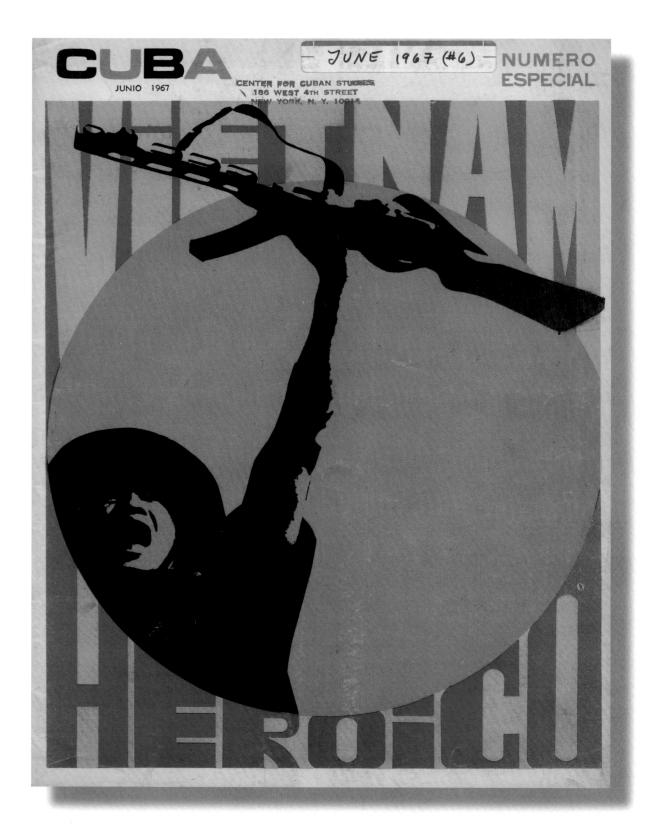

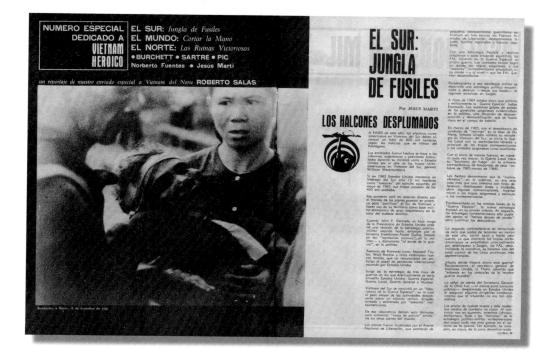

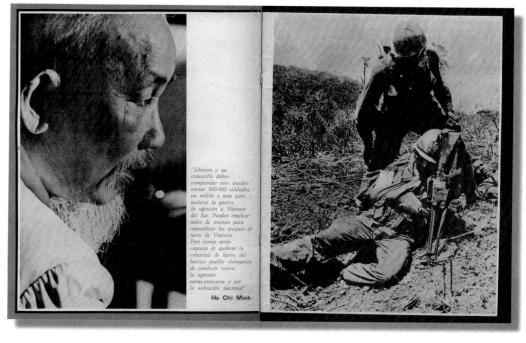

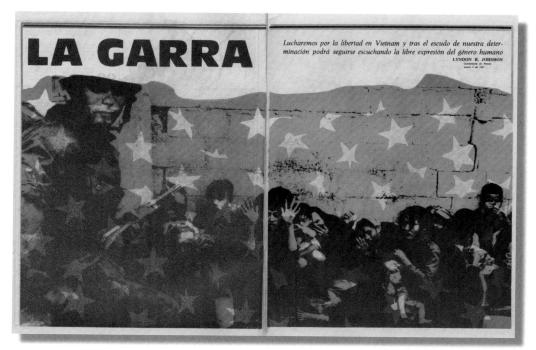

1967 ED VAN DER ELSKEN CUBA AVENUE

In 1956 Ed van der Elsken, the *enfant terrible* of Dutch photography, won immediate praise for his first book, *Love on the Left Bank*, a frank semi-fictional picture narrative about Bohemian life in postwar Paris. It led to the prolific production of many further books, always of street photographs (celebrations of the personalities he met on the street rather than campaign documents) and characterized by the energy of his layouts and ideas. After five years working as a film-maker, he returned to photography in 1967, shooting regular travel features for *Avenue* magazine. Van der Elsken's story on Cuba – one of his earliest for *Avenue* – demonstrates the approach for which he is best known: a depiction of street style, shot with a rhythm and pace learned from *cinema vérité*, with magazine pages used like a movie storyboard combining close-ups, panoramas, and candid asides to create a narrative that keeps the reader involved, on edge and constantly surprised. (December 1967)

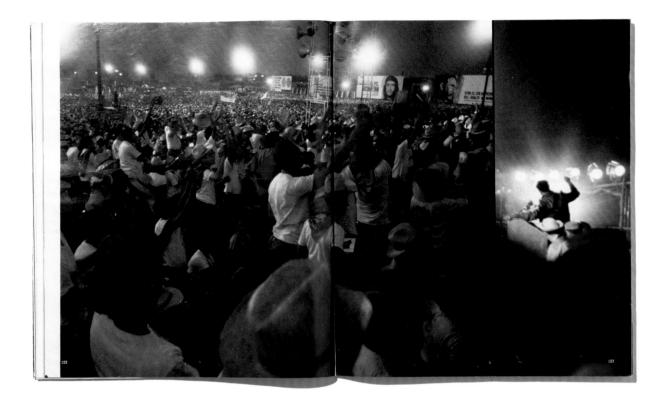

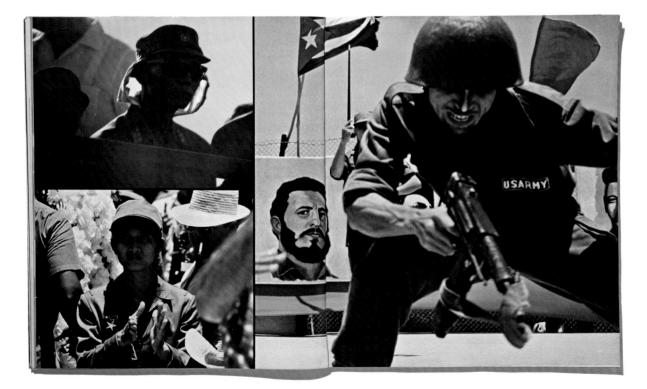

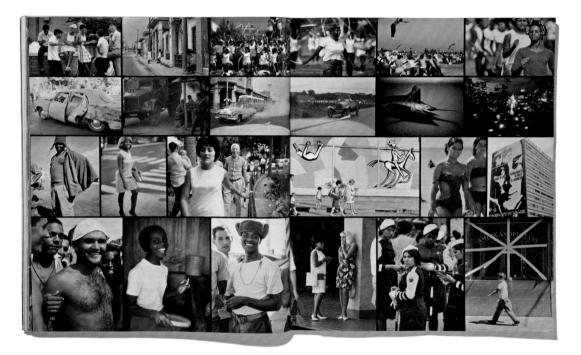

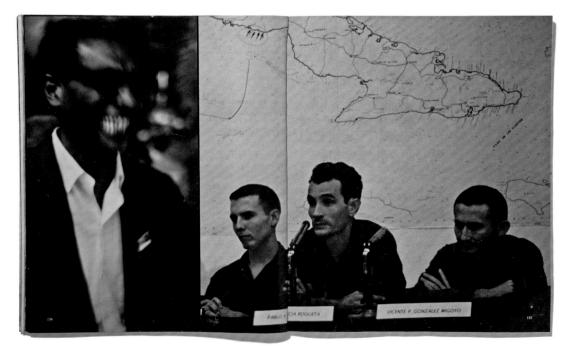

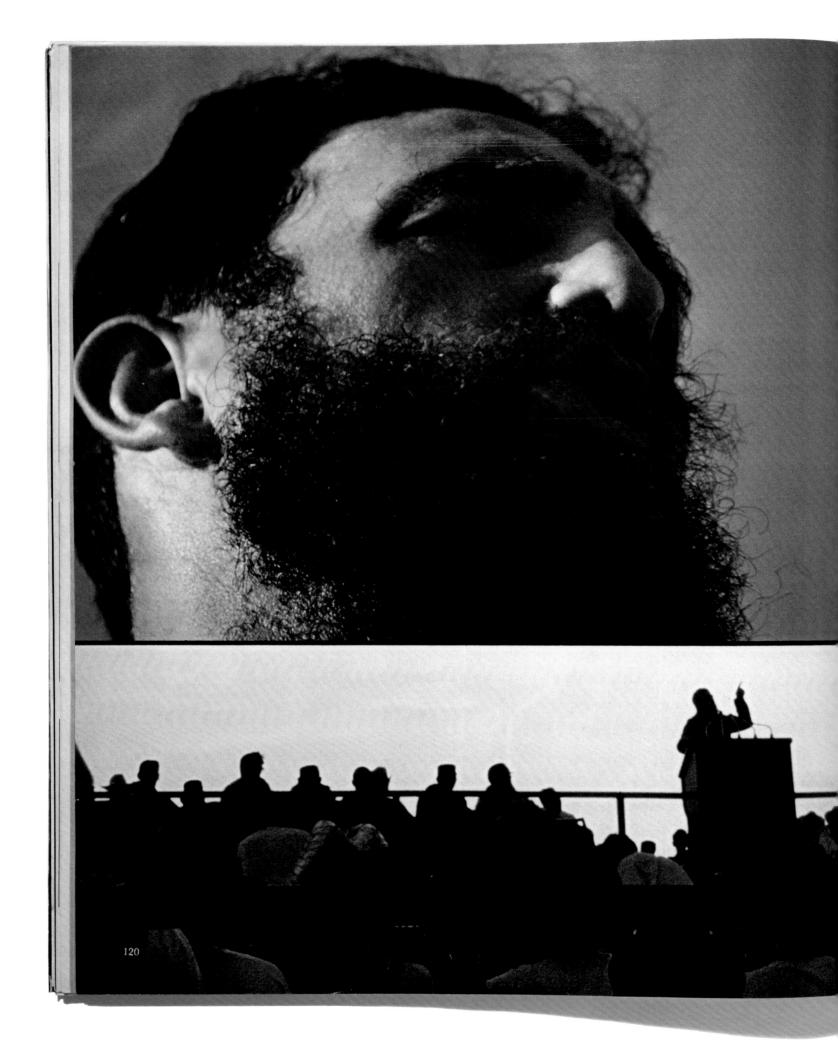

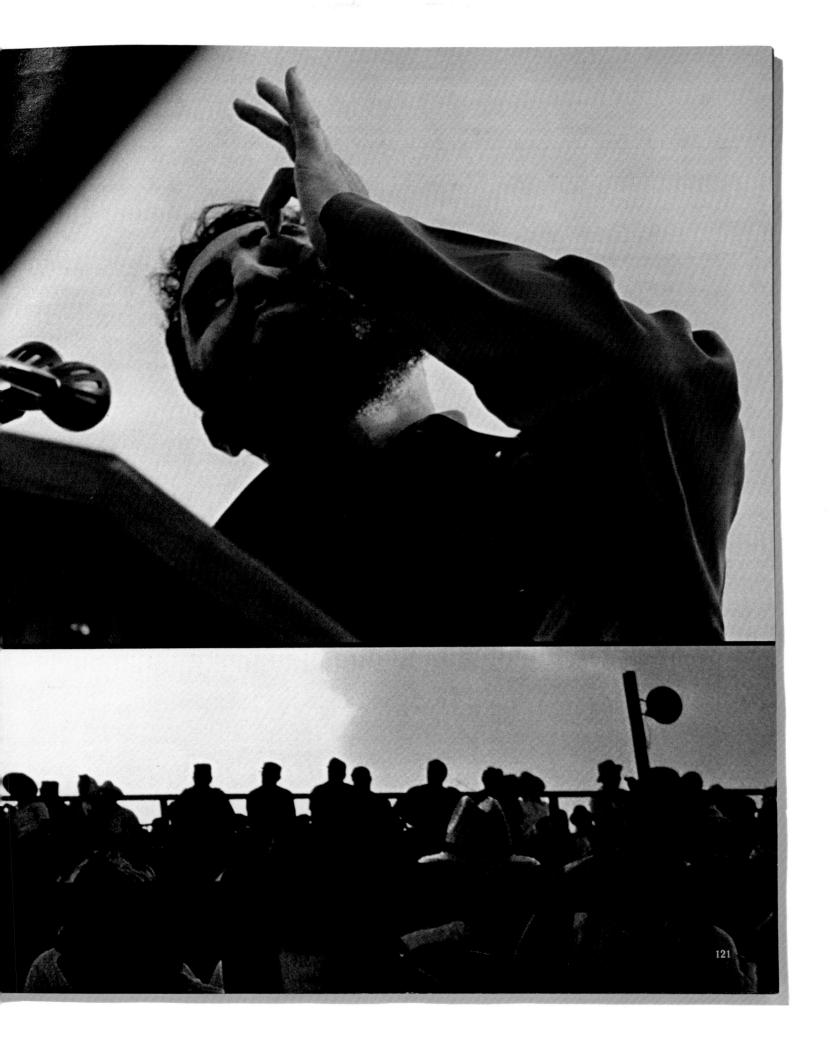

1968 RICHARD AVEDON THE BEATLES LOOK

In 1967, the Beatles commissioned five portrait posters from Richard Avedon, placing reproduction rights with three magazines that reached three distinct markets: *Look* magazine in the United States, the *Daily Express* in the UK and *Stern* in Germany. Although it is hardly remarkable to see a group of rock stars exert control over their public image, this was a moment when mass culture and the counterculture united in promotion of a single, multi-national image. Significantly, the Beatles chose to distribute these universally appealing pictures through the pages of the general interest press who in turn understood exactly how they could be used to boost their own publicity, prestige and sales. When the Beatles chose a high profile fashion photographer and portraitist, they left behind the visual language of fanzine. For his part, Avedon used the assignment as an opportunity to appropriate a colourful pop style, that infused countercultural fashion, graphics and music journalism. The resulting psychedelic portraits are eloquent artefacts of 1960s exuberance – a perfect blend of celebrity portraiture, rock-journalism, publicity and pop art. (9 January 1968)

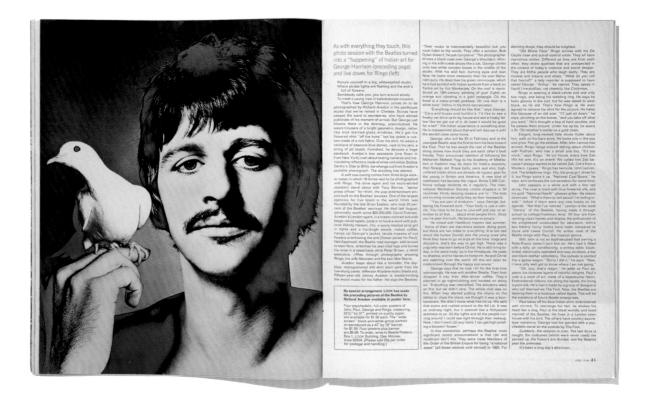

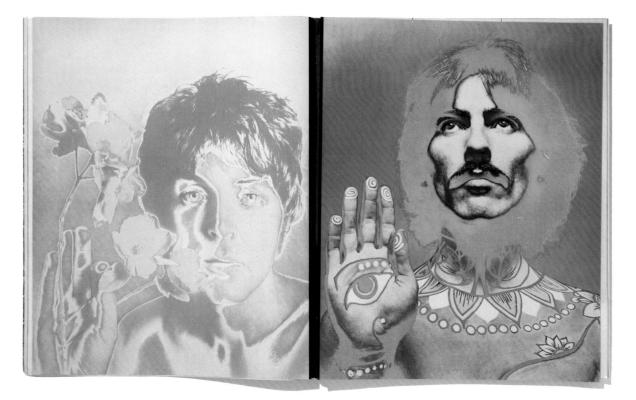

148

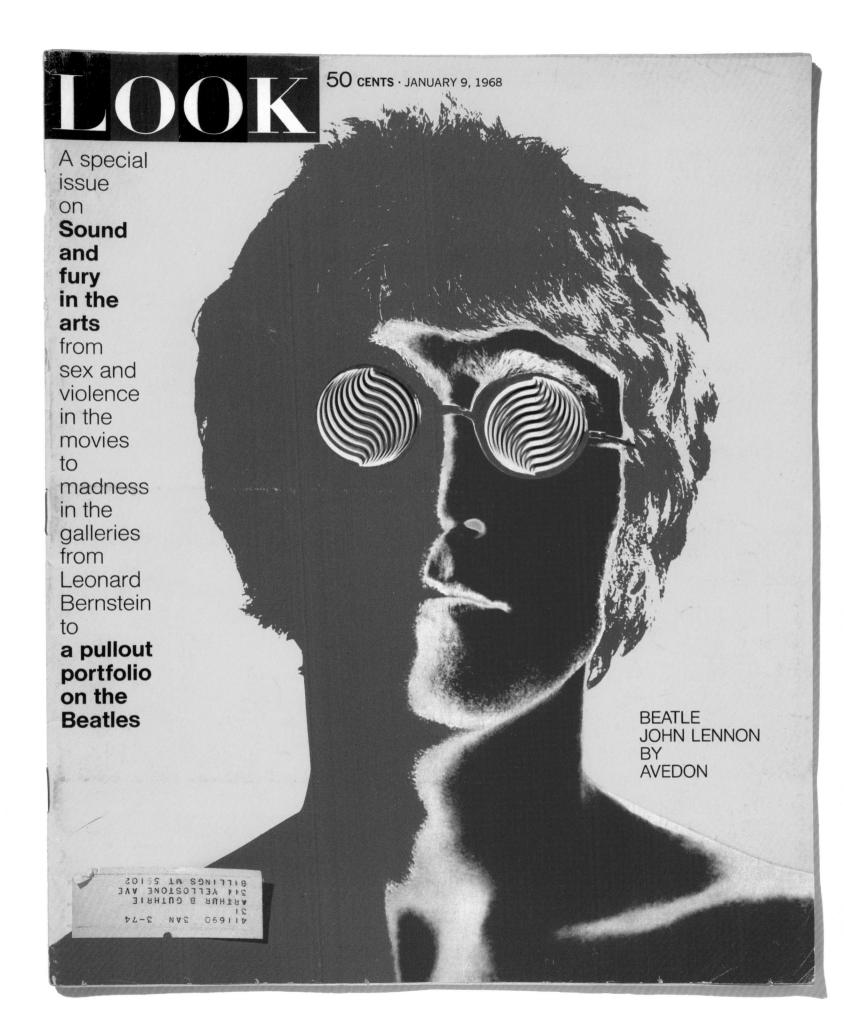

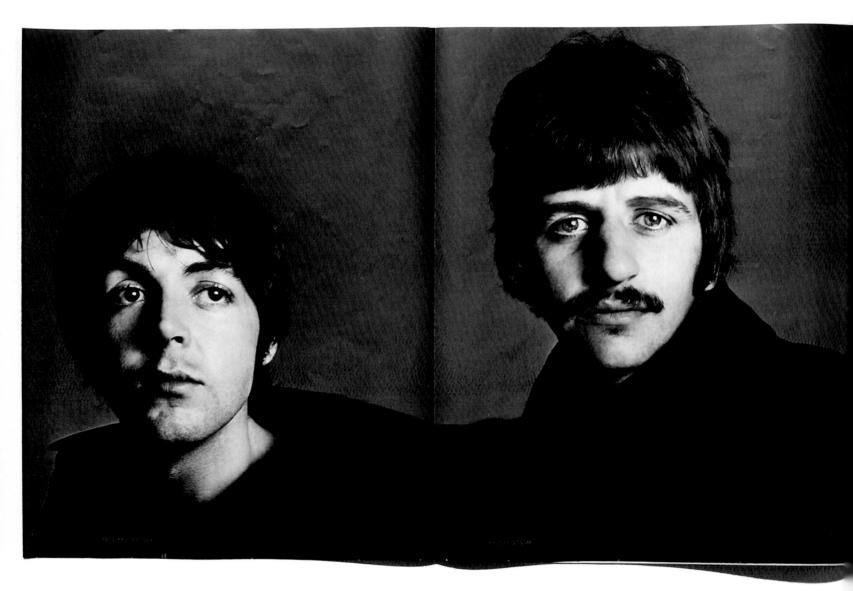

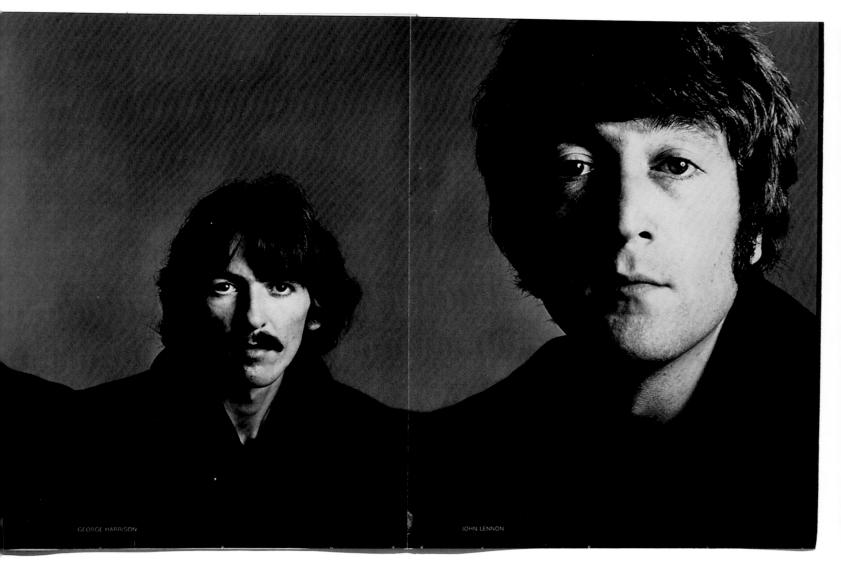

1968 IRVING PENN THE INCREDIBLES LOOK

When Irving Penn could not convince *Vogue* to let him shoot a story on Californian counterculture, he took the idea to *Look* magazine, who eventually published the story in their special issue devoted to the 1960s. Penn went to San Francisco for several weeks, where he and *Look*'s West Coast editor sought the right subjects for a series of portraits. Many sitters were suspicious of a mainstream photographer working for a national magazine – the Hell's Angels only agreed after careful negotiations conducted over several meetings. Penn selected his sitters in part because of their commitment to change everyday society by any means available – whether through music, art or fashion, or by otherwise redefining traditional norms of work and family. Members of 'Big Brother and the Holding Company' explained: 'Nothing's separate – job, rehearsal, living, the way we dress ... To us it's just a lifestyle, a total thing.' These sitters could not foresee the profitable celebrity culture that their music and lifestyle would help create, but Penn clearly understood the glamour. (9 January 1968)

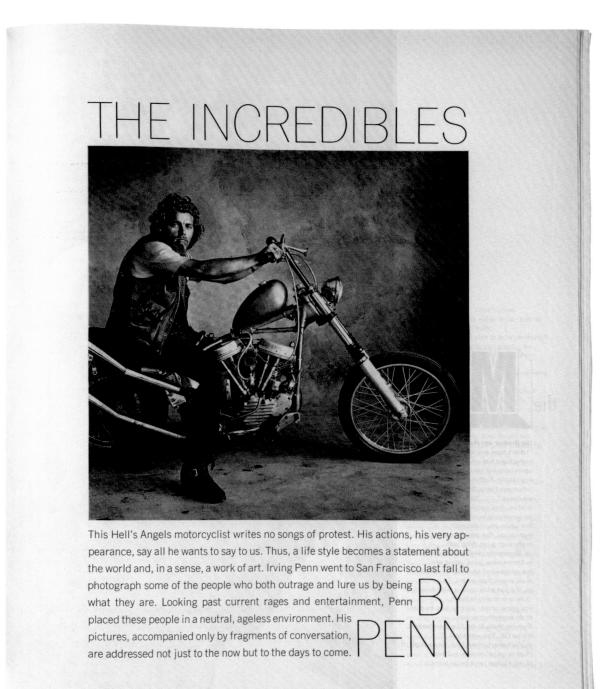

continued

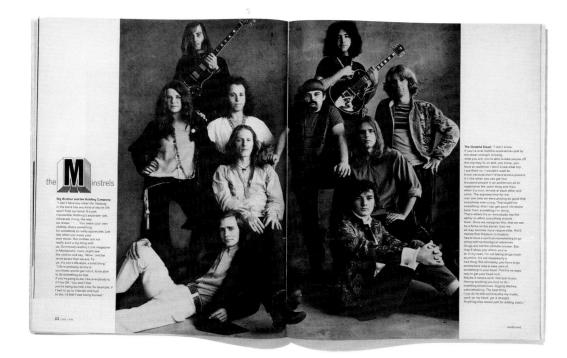

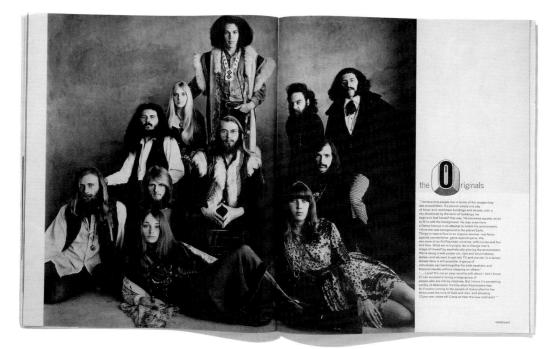

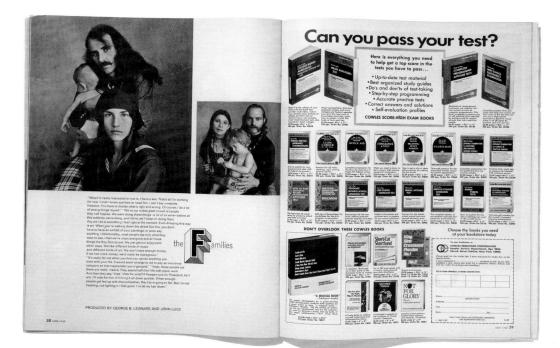

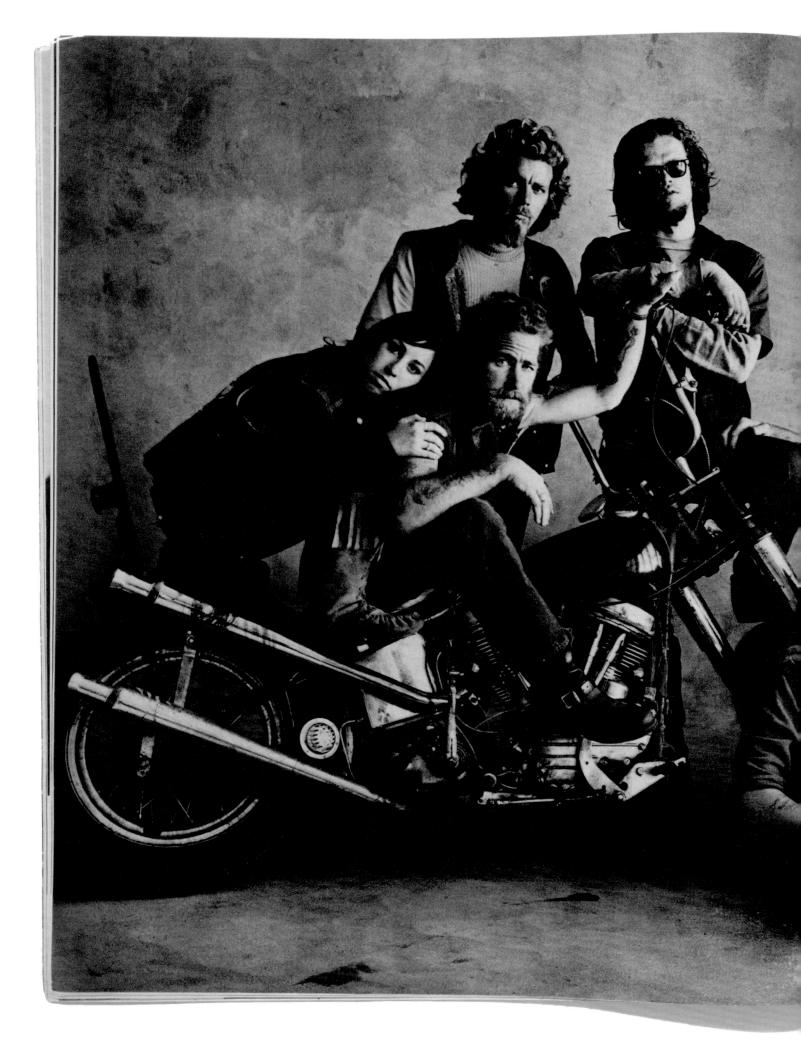

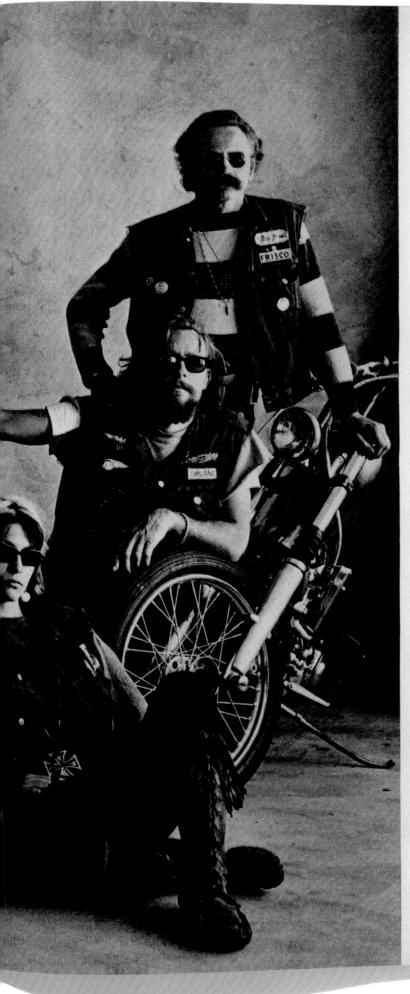

"There's only one thing that really means anything to me and that's the Hell's Angels patch I wear. I can get me anything else-a new bike, a new old lady or money-but I can't get me another patch." "We've had a few deaths this year, but otherwise, it's been a good year. By that I mean we haven't had much police harassment." ".... It's like being brothers. Like, every man in the club's your brother." "Power. That's what it feels like when we ride in. On a three-day weekend, we might have one-fifty, two-hundred bikes out on a run. People all get excited when they see us coming, and-I don't know-it's beautiful." "... You know what it is, it's a mind-blower. They come around with movie cameras. It's really beautiful." "If somebody messed up one of our brothers, it would be complete

retaliation. An eye for an eye." "... My brothers--that's my whole life. My

brothers. It's all I've got."

continued

1968 DON MCCULLIN BATTLE FOR HUE SUNDAY TIMES

Don McCullin provided both text and images for this story about the US counter-offensive against the Imperial city of Hue, captured by the North Vietnamese during the Tet Offensive. This was his second assignment in Vietnam and McCullin welcomed the chance to join the Fifth Marine corps, charged with taking the city's picturesque old city. Its age and beauty reminded him of Jerusalem when he covered the Six Day War, an assignment that then made him feel that he 'would like to do war photography every day of the week'. A 24-hour battle was expected but it took 11 days to retake the Citadel. McCullin's photographs are dramatically harrowing in their depiction of the battlefield, and almost painfully intimate when showing the soldiers' dedication to each other. The story also conveyed the emerging disillusionment with the war that McCullin felt himself and that he saw in the soldiers. Things had changed since his assignment two years previously: 'Then they were confident about the war and felt sure they had a right to be there. Now they have doubts.' (24 March 1968)

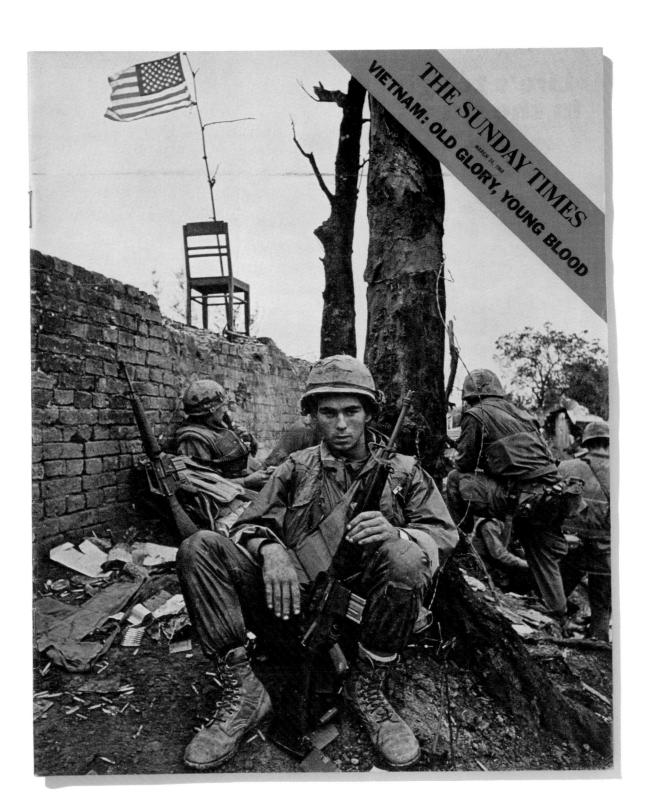

THIS IS HOW IT IS

Phengraphs and commentary by Danish McCallin This is Danish di McCallin's photographic export on a bunch of young American with the Vict Cang. His own word describe what is happening in his pictures: "This big Nergo was doing what they call hand-to-hand fighting. Both sides were dog in and lobbing grenades at each other. Un-fortunately on this occasion the Marines were short of grenades. Were trying to advance along the carthwork top of the Cladel wall of Hoia and the grenades suce being passed up the line of dug-in men one at a time. Naturally there had to be a pause in particular the standard standard standard agreeads. If yiels taken this picture before its append. . . the grenade landed short but it wunder the Gi mutaria the standard agreeads. If yiels taken this picture before its append. . . the grenade landed short but it wunder the Gi mutaria but its word the Gi mutaria the standard agreeads. If yiels taken this picture before its append . . . the grenade landed short but it wunder the Gi mutaria possible that there were so few mattree possible the command post is soly 24 and the average age of the platoons possion to all the standard significant the theory of the contrast of the American shelling. Their ships out at sa were hitting the streets righting their appeared of us. "The most impressive that great the sawy were landing 200 yards shead of us." "Something I found very moving was the verify out the Whites have de-veloped this noneany kind of relationship while they're fighting together. They cook other is anteense. It's strange. A kind of four-this to that the Whites have de-veloped this time they find and great the Market out the systems on the part of the Negross. It's not that the Whites have the hydron optoctrienees on the part of the Negross. It's not that the White have of the adrive strand of the strange A kind of four-the to the the White have of the hydron strand the they were condited about the ward optopectivenees on the part of the Negross. It's not that the White hydron of the ad

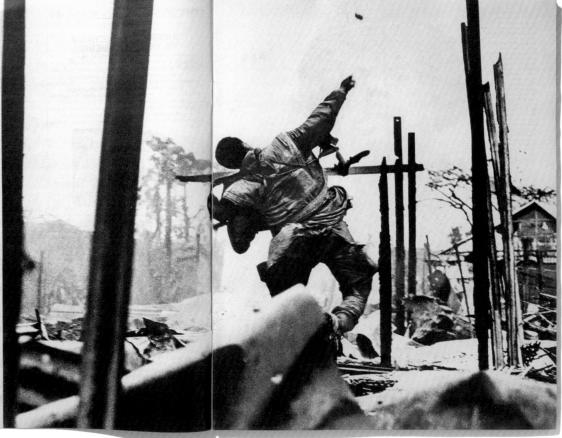

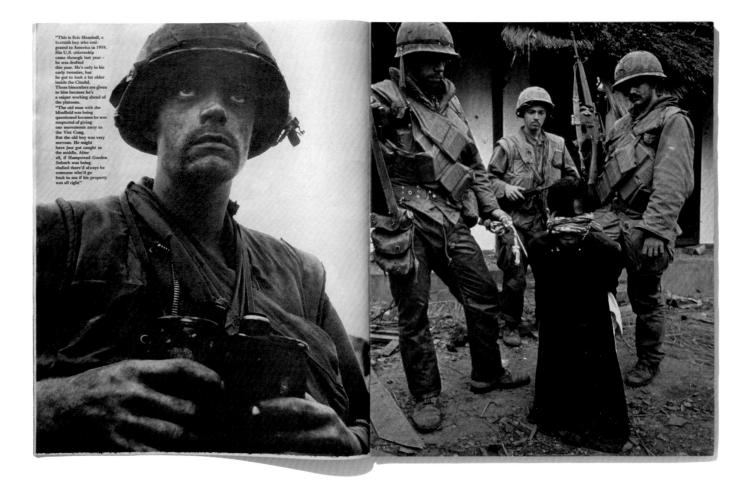

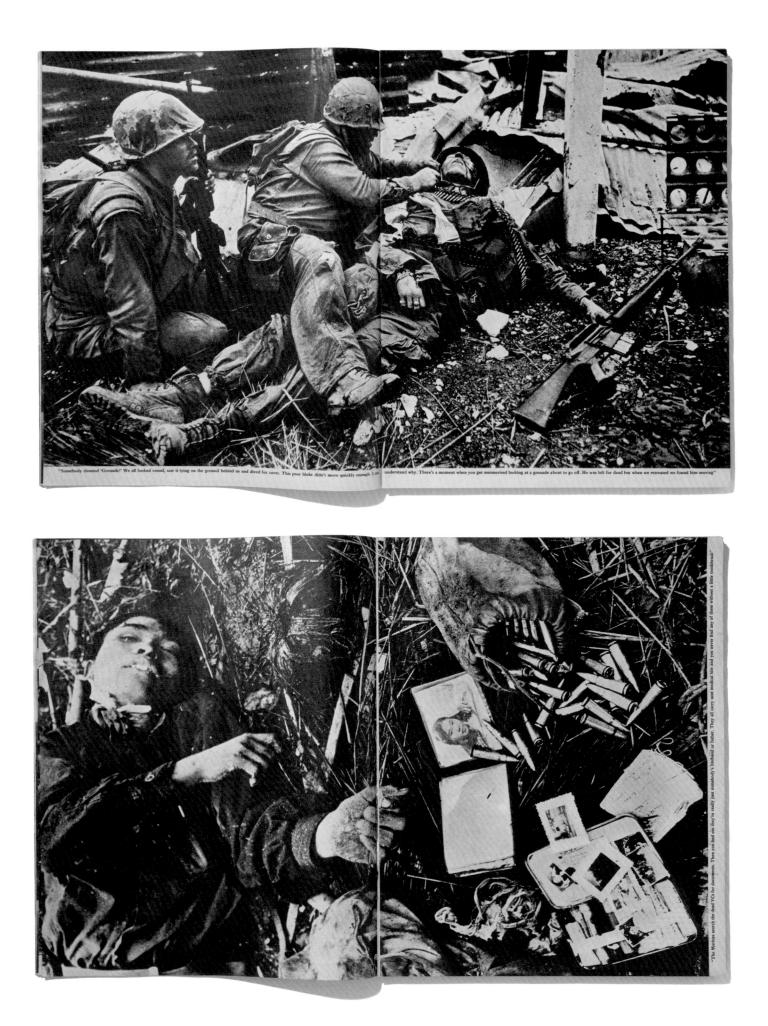

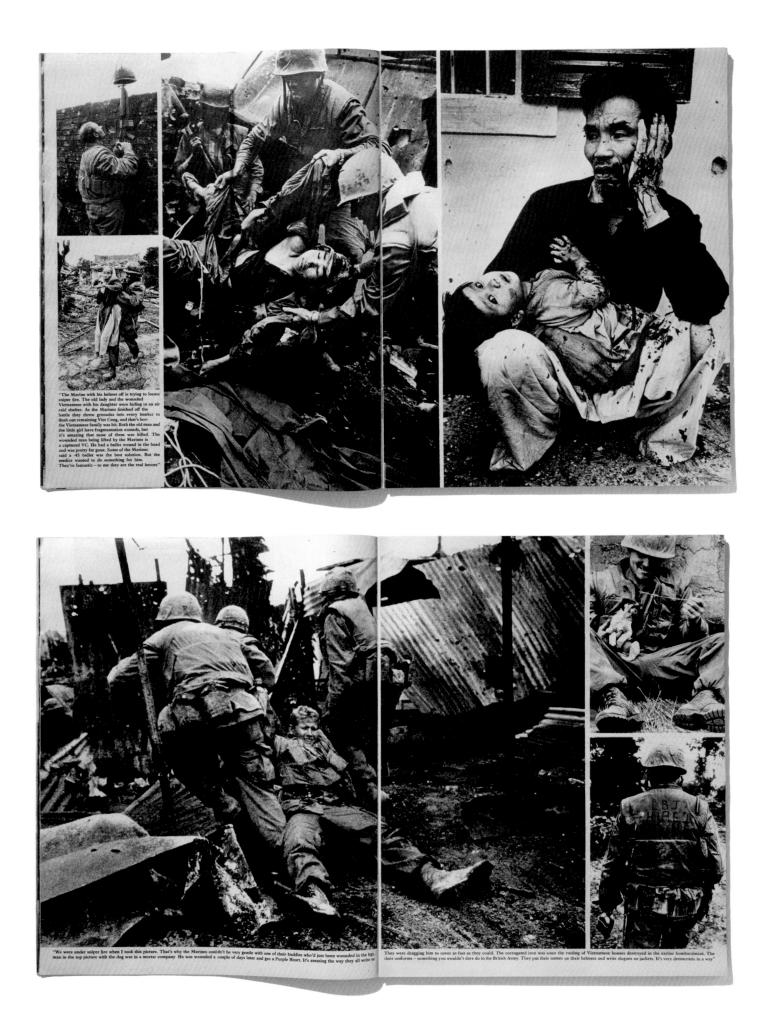

1968 BRUCE DAVIDSON EAST 100TH STREET SUNDAY TIMES

In 1966, with the aid of the first grant given for photography by the National Endowment for the Arts, Bruce Davidson began a two year project to photograph the residents of East 100th Street in Spanish Harlem, New York. Prompted by glimpses of street life on this notorious city block that Davidson saw through the window of the elevated train he regularly took from Grand Central Station, he said 'It was at the same time as we as we were sending men to the moon. I felt we were losing our focus; that we had to go into inner space not outer space: the inner space in the centre of our broken-down cities, in order to recover our humanity. I wanted to get inside and to explore it.' Shunning the photographic language usually applied at the time to stories about poverty, Davidson used a 4x5 view camera mounted on a tripod, making direct, non-judgemental portraits with the participation of his subjects. In the wake of the riots that erupted in American cities during the 1960s, his intimate view of America's black underclass was widely published. (21 April 1968)

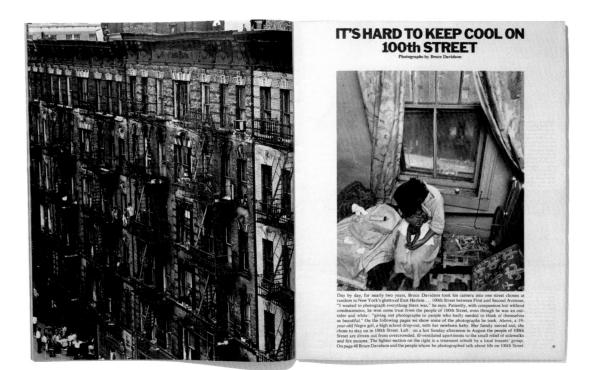

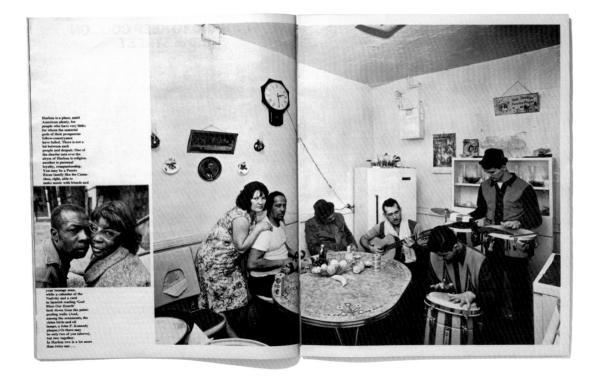

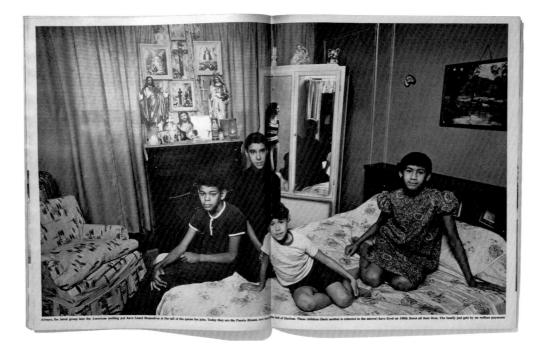

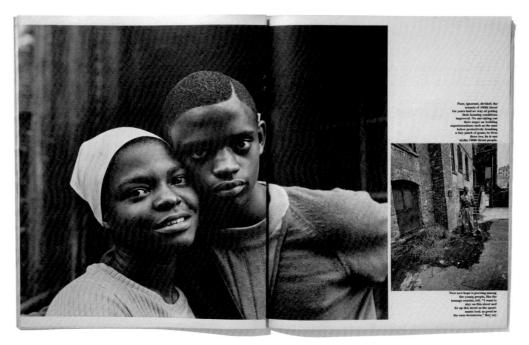

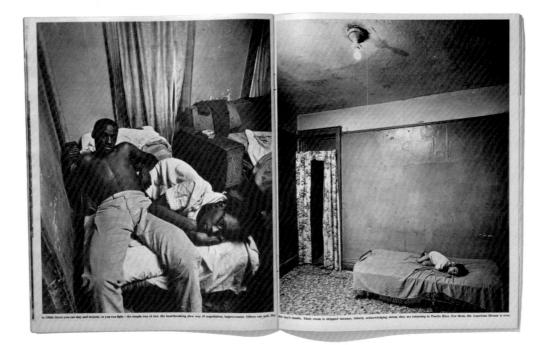

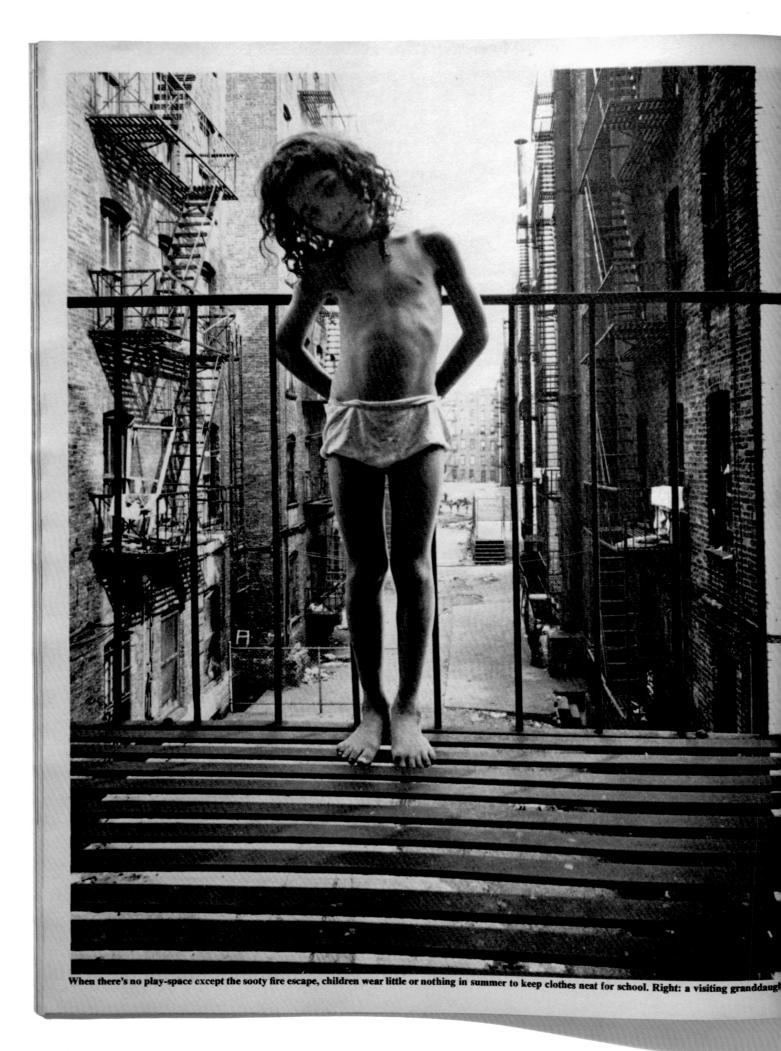

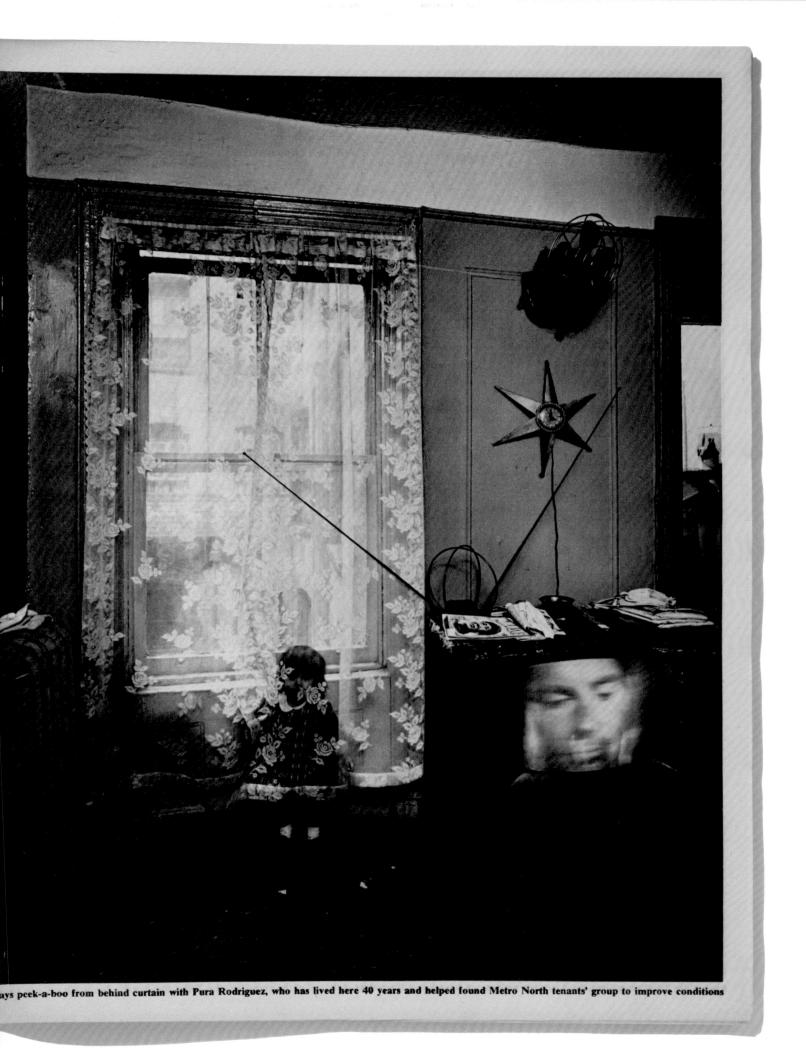

1968 FLORIS DE BONNEVILLE & GILLES CARON BIAFRA PARIS MATCH

The Christian Ibo people's war of independence against the Nigerian state had been going on for nearly a year, and 200,000 combatants had already died before this first photojournalistic account of it was published. Gilles Caron's black and white photographs documented life with the rebel army without sentiment; for example, we see soldiers ordered to pass by their own wounded colleagues because there is no time to care for them. Meanwhile Floris de Bonneville provided brutal colour shots of the aftermath of battle: the magazine's opening shot shows a body burning, with a double-page spread showing a road strewn with cars wrecked by a mortar blast. Together, the images brought readers close to the action but without arousing their sympathy. Eventually Nigeria found a more effective way to fight the rebellious Ibos, by inducing famine conditions inside Biafra; at this point the press filled with images of starving civilians, many of them children, which attracted international humanitarian assistance. But the Ibos' political mission had failed, and in 1970 Nigeria reabsorbed the rogue nation. (4 May 1968)

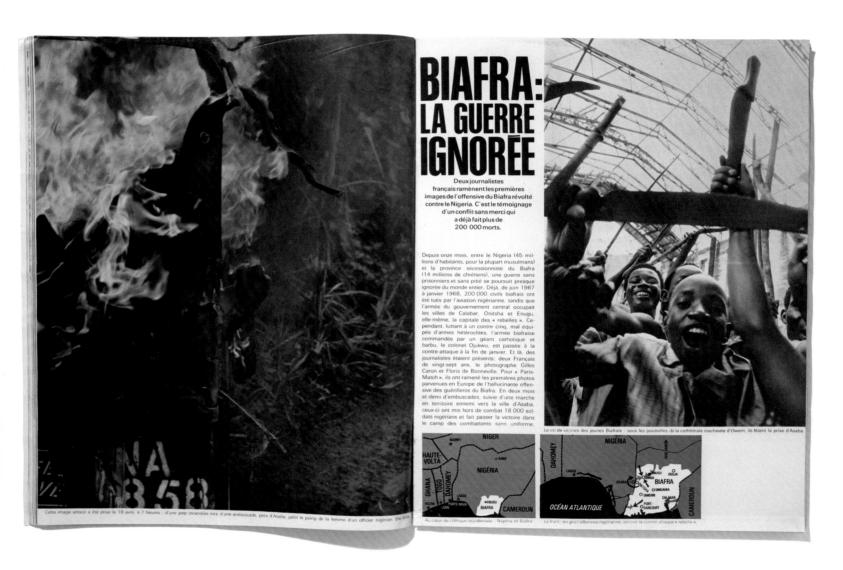

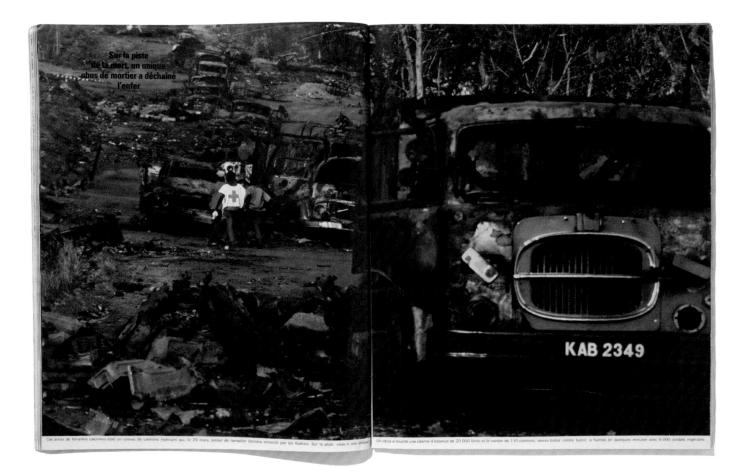

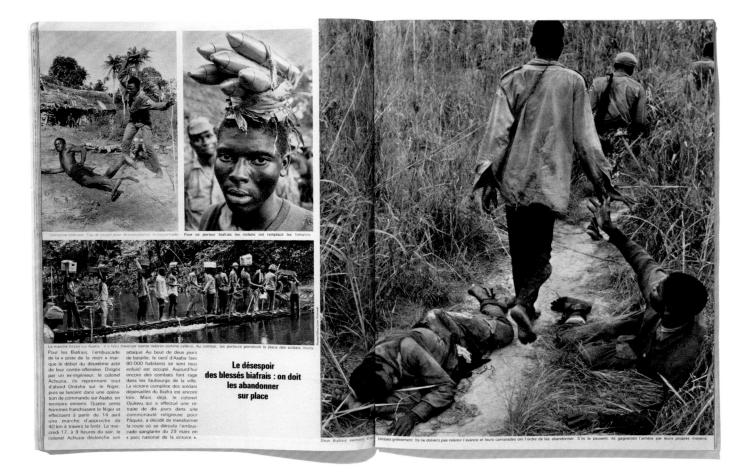

1968 PARIS STUDENT RIOTS PARIS MATCH

In the issue of May 18, *Paris Match* devoted a special report to the widespread insurrection that flared in the streets around the Sorbonne in the days between 6 and 11 May 1968. Photographs by a dozen reporters include an hour-by-hour photographic account of the battle between students and police that took place over the night of 10 May, climaxing with Gilles Caron's now famous image of a lone student in flight from a policeman. The accompanying essay by Jean Maquet seems now to have missed the mark. For him these events were not part of 'a crisis of society around the world', merely a dramatic student gesture against rampant materialism. He could not know that within days the revolutionary spirit of the students would capture the country, with over ten million workers on strike for better wages and working conditions. As a result of subsequent events, these records of the intense excitement and suspense that filled the streets of Paris in the early days of May 1968 became iconic references for a new generation come of age. (18 May 1968, including photographs by Claude Azoulay, Gilles Caron and Patrice Habans)

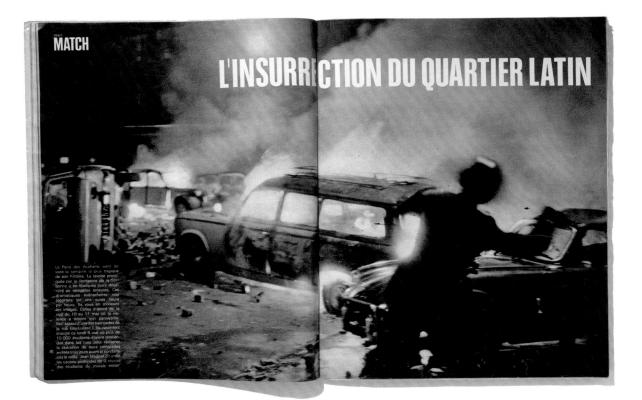

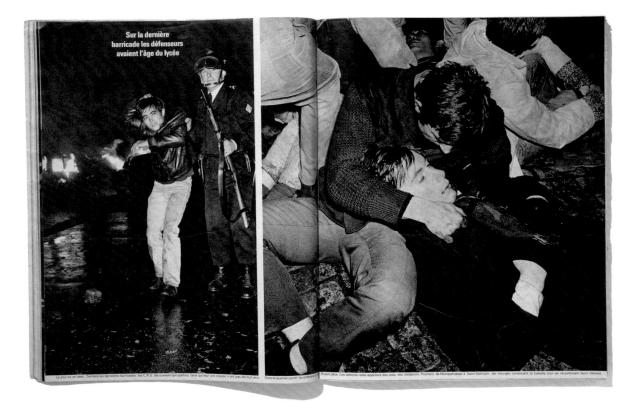

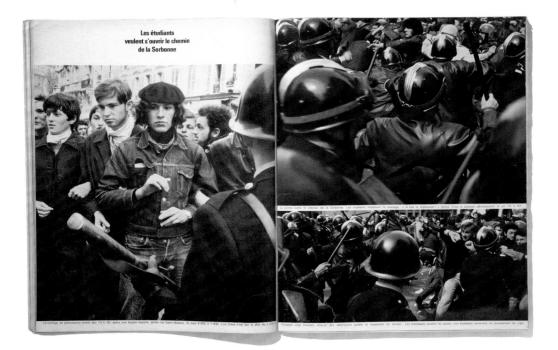

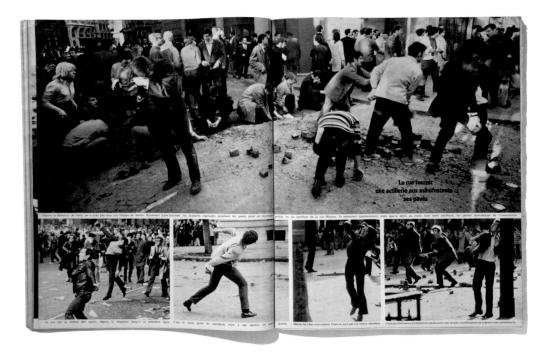

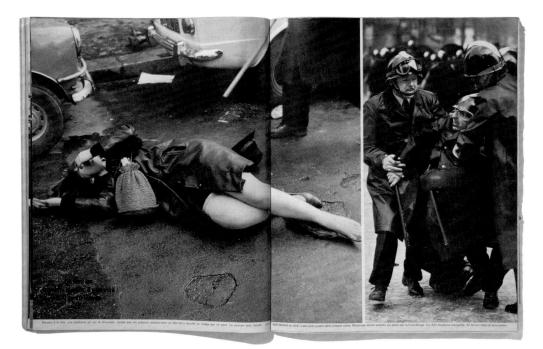

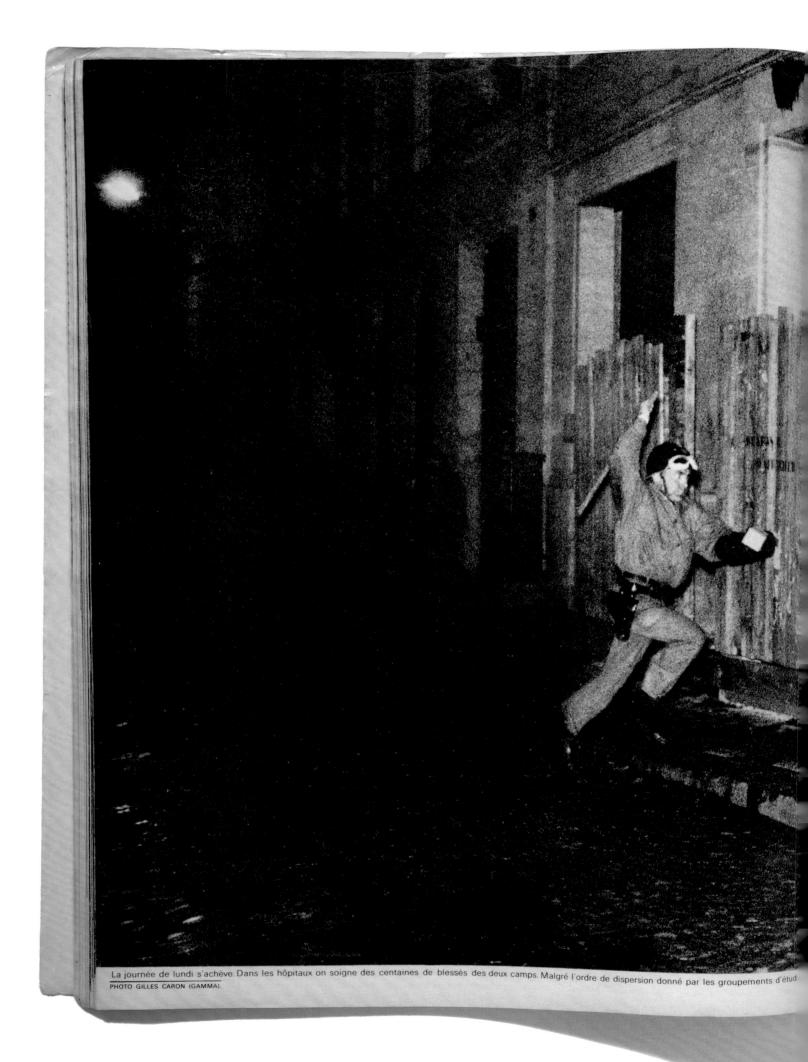

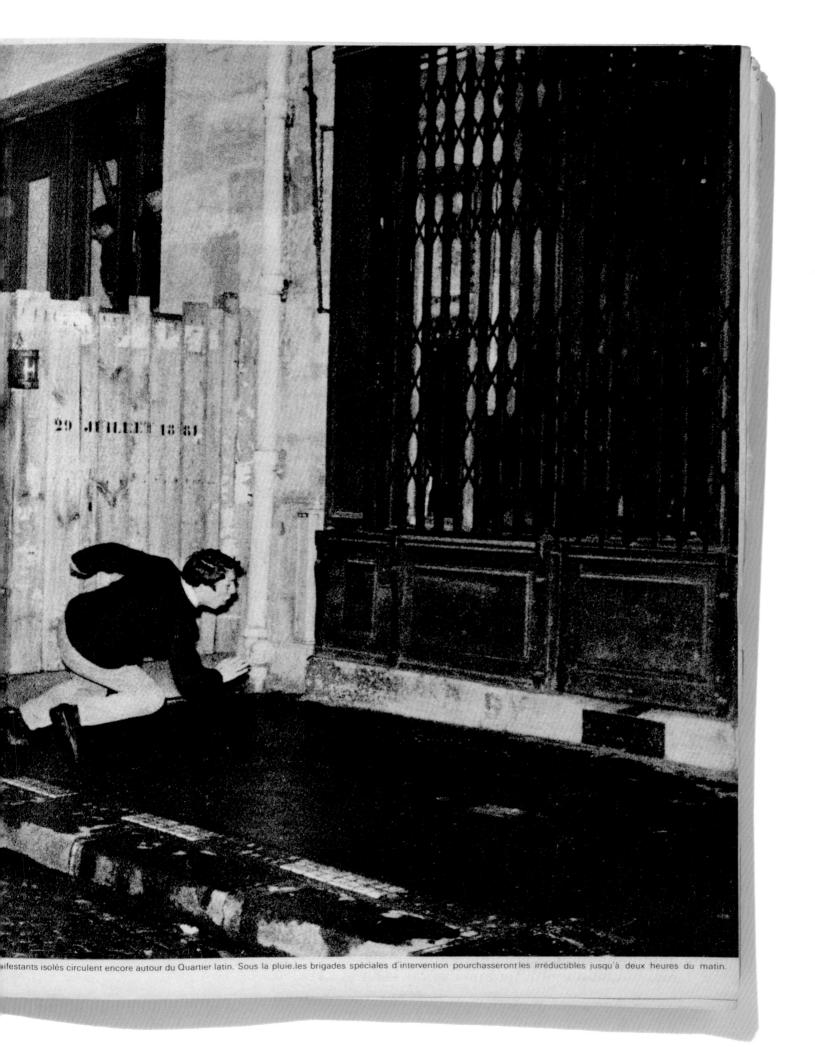

1968 CLAUDIA ANDUJAR PROSTITUTION IN SÃO PAULO REALIDADE

In its short life, the Brazilian magazine *Realidade* achieved the status of myth in publishing history. The magazine started in 1966 with a progressive social and political agenda, but closed after five years during a time of widespread cultural censorship introduced by Brazil's military rulers. Claudia Andujar, a Swiss photographer who emigrated to Brazil in 1955, worked for *Realidade* throughout the years it published. Her photo stories, notable for an aesthetic that was ahead of its time, pushed at the moral boundaries of conservative public opinion; when *Realidade* published her story on the lives of prostitutes in São Paulo, it was considered 'immoral', and her sympathetic treatment of her subject 'insulting'. The issue of the magazine that featured another Andujar story, about midwives and showing the birth of a child for the first time in the Brazilian press, was found offensive and immediately withdrawn from circulation under censorship rules. She continued working on controversial issues after *Realidade* closed, Her photographs of the Yanomani Indians, in whose interests she campaigned, also challenged conservative taboos of Brazilian society; in this case, her efforts were rewarded, in 1992, with the creation of the Yanomani Park reserve. (July 1968)

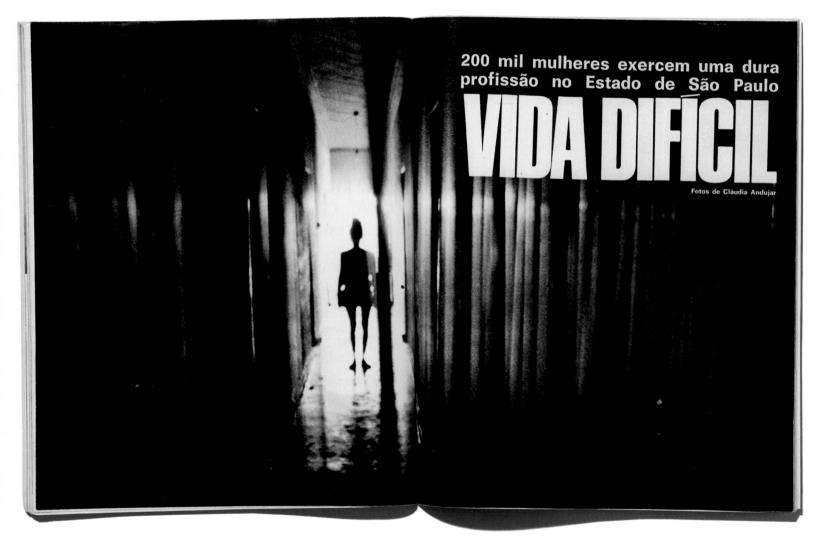

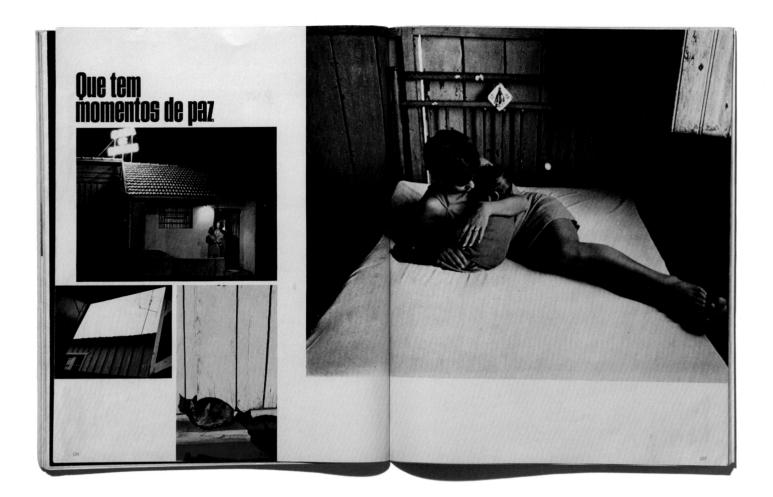

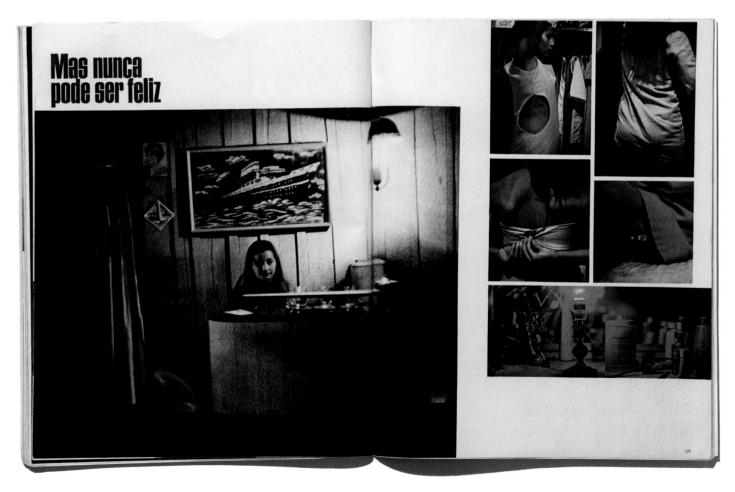

1968 PHILIP JONES GRIFFITHS SAIGON DAILY TELEGRAPH

By 1967 America was committing 200,000 troops to Vietnam in an escalating and increasingly bloody war. Welsh-born photographer Philip Jones Griffiths, whose Celtic background predisposed him to empathy with the underdog, discovered Vietnam to be a 'goldfish bowl where the values of the American and the Vietnamese can be observed, studied and because of their contrasting nature, more easily appraised'. He went further than other photographers of Vietnam in his explicit critique of American involvement and its subjugation of the Vietnamese, and as a result faced difficulties getting his photographs published; the London *Daily Telegraph* magazine went where few American magazines were prepared to go in presenting his photographs of Saigon following the Tet Offensive. He supported his photographic vigil with income earned from a scoop – pictures of Jackie Kennedy on holiday in neighbouring Cambodia in 1967 – and finally published his complete essay on the war in his book *Vietnam Inc* in 1971. While other photographers' work was used to serve anti-war arguments, Griffiths' invective documentary account established a new model for the anti-war photographer-campaigner. (2 August 1968)

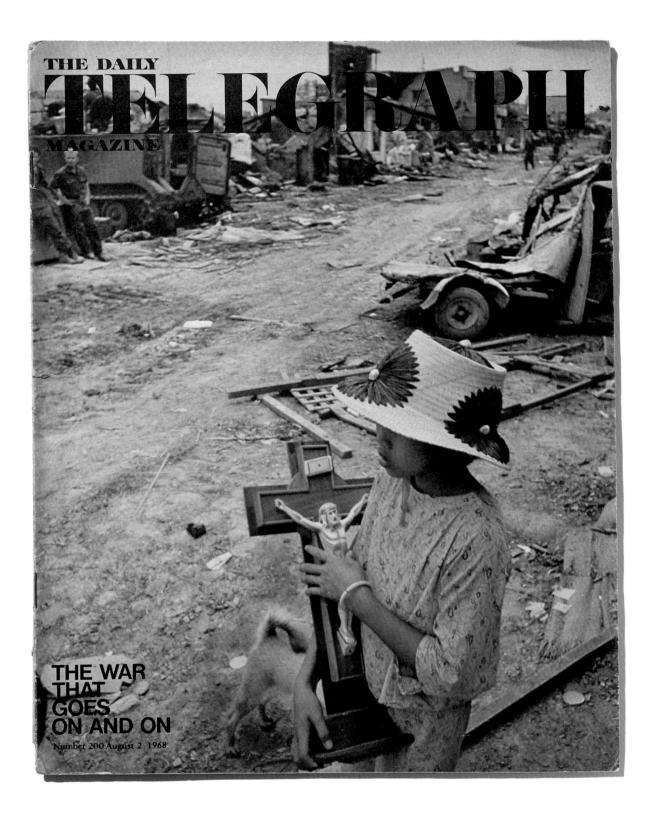

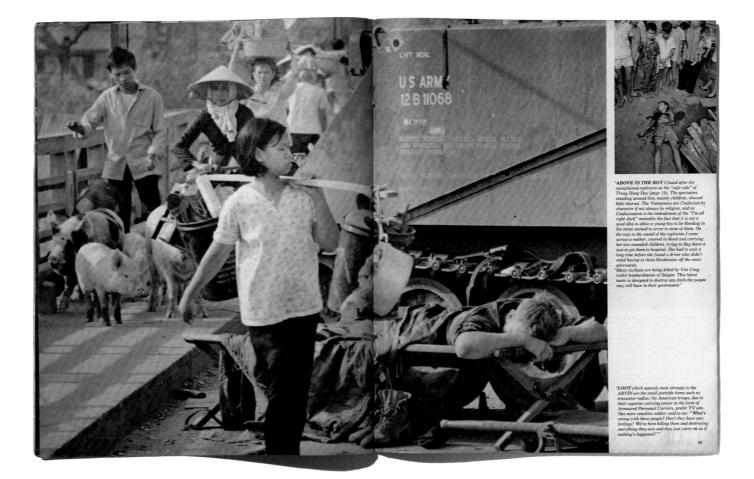

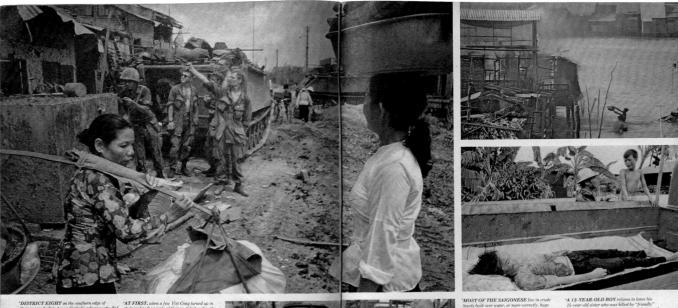

Salation uses hult he hause Catchlic refuges useh felt from Necht Victure un hest the cattry was particianed in 1954. District Explit was the shoughner schere studing. American semicaristic the Americanis Sent efforts in Victures, hult it uses som deterroyed usen honoligid of Victure Conge moved in The Americanis – unitational in biasce to-honic and the Americanis – unitational in biasce to-honic transfer. For every deal Vict Cong. Conference to and the Americanis and the Americanis and redet bombercheses. In the photograph schoor, prophematic honocies, in the photograph schoor, prophematic honocies. In the photograph schoor, prophematic honocies and the school and the Americanis of a grange of Americanis schoor to photograph and the school and the school and the school and and the school and the schoo use midd, the people of Soligon dith it realizes the appendix and the second second dith it realizes the appendix appendix the length dith personation with the appendix appendix the length dith personation with the appendix appendix the length dith personation with the length of the second by the Solid Victuanizes American subliver. Many cellular and the line of the length of the length of the length dith of the line length of the length dith of the length dith and the length of the length dith and length dith and the length of the length dith and length dith and the length dith and the length dith and length and the length dith and length dith and length and the length dith and length dith and length and the length dith and length dith and length and the length dith and length dith and length and the length dith and length and length dith and the length dith and length and length dith and the length dith and length and length dith and the length dith and length and length dith and the length dith and length dith and length and the length dith and length dith and length and the length dith and length dith and length and length dith and length dith and length at length and length dith and length dith and at length dith and length and length at length and length dith and length and length at length and length dith and length and length at length and length dith and length and length at length and length and length and length and length at length and length and length and length and length and length and length distances and length and len

baseds half are taster, a more correctly, huge coses paids (12), American afficial point out the the paperains) for rehabiling better homes. But this has never happened after frees in the past at millely to happened after frees in the past at millely to happened after frees in the past at magnetic part of the past American equipment in suggifted with the finest American equipment hape for engines which are undertained y undbh penetrate large areas of Saigno because the stre are too narrow. As the men trying to save their in in this picture surely house, what toos needed in free boat? Is case, additional addition of the day "from the" owich for near Change, a for mile south word of Signs. Here holy is bries taken anny by the Signs. Here holy is bries taken anny by the Signs. Here holy is bries taken anny by the Signs. Here holy is bries taken anny by the Signs. Here holy is bries taken traps on the other angers about LS. 90. Dission traps on the other series of the northy Signs Singlerhause. The Well Will additional traps of the start of the signs and the start of the signs series of the start of the signs series of the start of the signs of the signs of the signs share the signs of the signs of the signs share the horizon of the signs of the signs share the horizon of the signs of the signs share the horizon of the signs of the signs share. The horizon of the signs of the signs share the horizon of the signs of the signs share the horizon of the signs of the signs share. The horizon of the signs share the signs of the horizon of the signs of the signs share the horizon of the signs of the signs of the horizon of the signs of the signs share the horizon of the signs of the signs share the horizon of the signs of the signs of the horizon of the signs of the signs of the signs of the horizon of the signs of the signs of the signs of the horizon of the signs of the signs of the signs of the horizon of the signs of the signs of the signs of the horizon of the signs of the signs of the signs of the horizon of the signs of the signs of the signs of the horizon of the signs of the signs of the signs of the signs of the horizon of the signs of the signs of the signs of the signs of the horizon of the signs of the signs of the signs of the signs of the horizon of the signs of the signs of the signs of the signs of the horizon of the signs of the signs of the signs of the signs of the horizon of the signs of the signs of the signs of the signs of the horizon of the signs of the horizon of the signs of the signs of the signs of the signs of the horizo

and with a stoicism bred during a lifetime from the adjacent house produced a hose of violence hosed away the pool of blood She spoke a little English (she had at. Her knowing what had caused the explosion towns and cities. The civilians of Saigon One Sunday morning while I was based in Saigon, something exploded - no one probably worked in a bar). She couldn't blast I found a boy, bleeding from wound surrounded by a crowd of slightly bored en hi supporters was quite sure what - on the "safe side had been hurt. She made it cl NON As peace negotiations drag on, the war in Vietnam continues – a war that has correspondents all the action is only a eventually been taken away, a woman moved from the countryside into the now live daily with the full horror of leading to Cholon. At the site of the of Trang Hung Dao, the main street understand why I was interested in concern to her and ude umericans promi tnam and rom t Surprised mixture of force and res warfare and for the foreign onlookers. When the boy had 200 ten-minute taxi ride away. be lova nouse whi ather made her responsil one regret was that the in front of her house wh to the city from their vi Many of the Saigonese. protected tway the blood govern hat it was of ertainly not Aove to t he photo seduction odw br **America**

1969 BILL ANDERS VIEW FROM THE MOON LIFE

The seven-day Apollo VIII mission over Christmas 1968 was the first manned orbit of the moon and provided, for the first time, high resolution colour photographs of the earth as a singular orb viewed from space. Although the image of the earth from space has since become an indelible icon of global consciousness, picturing it was literally an afterthought on the part of Bill Anders, the astronaut in charge of the mission's photography. What was of interest to NASA were the images that mapped the far side of the lunar surface while it was lit by the sun: vertical and oblique overlapping photographs shot on black and white film (providing a higher degree of resolution and image clarity than colour) that would enable scientists to chart the geology of the moon and identify potential future landing sites. In the build-up to the mission, rumours of the Soviet Union's readiness to launch its own manned lunar orbit persisted. For the readers of *Life* magazine the story yielded welcome evidence of American dominance in the race for space, and anticipated the excitement of the moon landing to come. (20 January 1969)

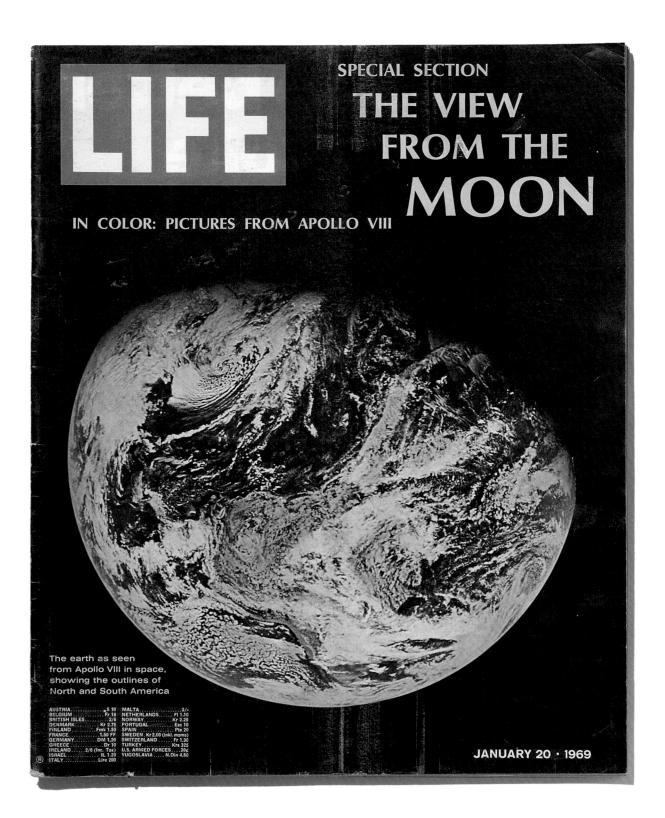

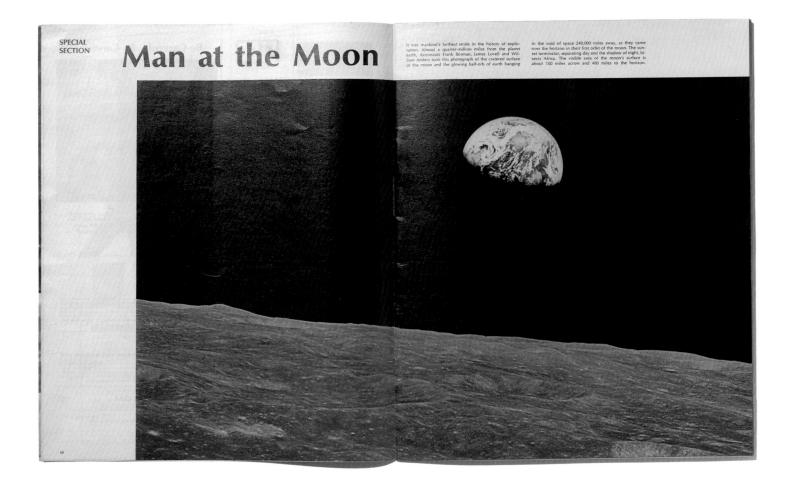

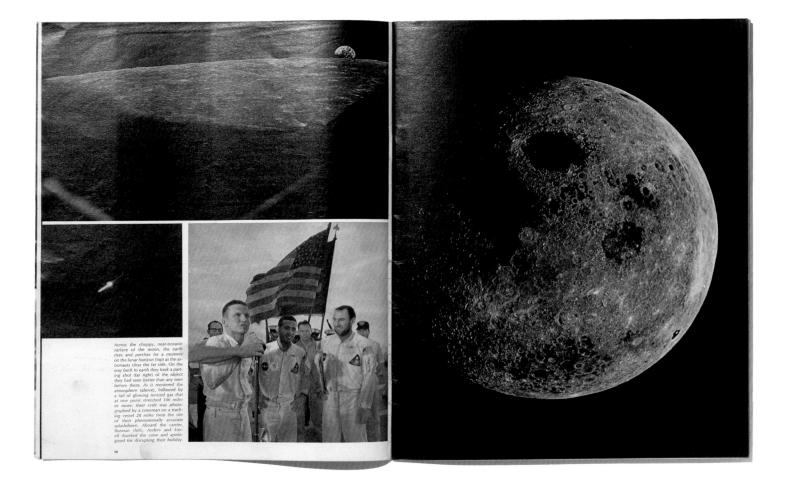

1969 DAIDO MORIYAMA UNTITLED PROVOKE

Daido Moriyama was one of a group of leading photography innovators who gathered around the magazine *Provoke*, published in Tokyo by photographer and writer Takuma Nakahira and the art critic Koji Taki. Following photographer Shomei Tomatsu's call for a radical new language of photojournalism, *Provoke* sought new ways to describe and respond to a society in upheaval in the late 1960s. Moriyama's contribution to *Provoke*'s third and final issue was a series of photographs of shelves of Japanese and Western consumer goods. Spontaneous and deliberately artless, they were both conceptually articulate (Moriyama identified the influence of photographs by Weegee and William Klein, and the writing of Jack Kerouac) and uncompromisingly raw. In an interview he explained: 'For me, photography is not about an attempt to create a two-dimensional work of art, but by taking photo after photo, I come closer to truth and reality at the very intersection of the fragmentary nature of the world and my own personal sense of time.' *Provoke*'s disruptive approach to conventional rules took it way beyond accessibility to most consumers of photojournalism, but it influenced a generation of photographers in Japan and, later, the vocabulary of photojournalism in the West. (August 1969)

6.971 177 1.371 7.371 1.971 197 17 170 AL N 5 38 - ---------

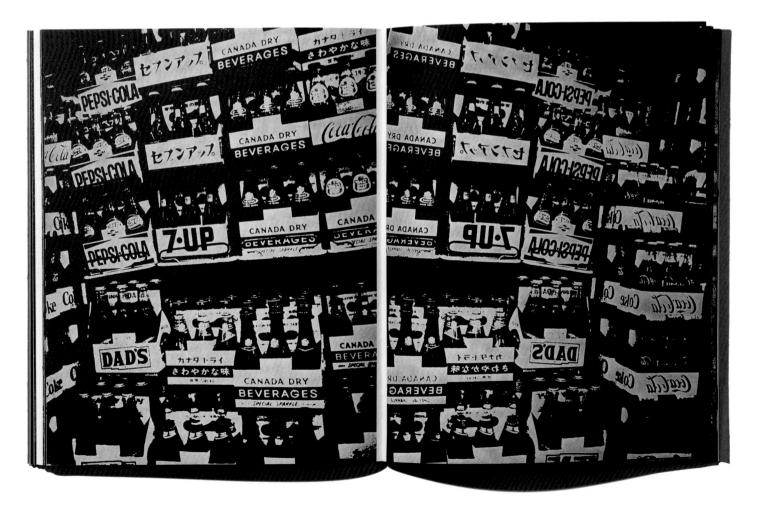

1969 ONE WEEK'S DEAD LIFE

In June, 1969, *Life* magazine devoted its cover and 11 pages to 242 photographs of American soldiers who died in Vietnam between 28 May and 3 June 1969. Aside from an opening paragraph and a short concluding essay, the story was comprised entirely of portraits provided by families and mainly showing their subjects in uniform. *Life*'s register was the solution to a problem: how to illustrate and illuminate the extent of the war's American casualties – at that point running to a total of 36,000. There was a precedent in July 1943, when *Life* had honoured 13,000 soldiers who died in the first 18 months of World War II by printing their names and addresses on pages bordered with dark stars; but in this case standing each reader face to face with those who had died transformed an abstraction into an unforgettable experience. According to *Life* editor Loudon Wainwright, this was 'possibly the first time the magazine dropped its life-long posture as the earnest, cheerful broker of the high-mindedness and good intentions of the American establishment' to side with 'the growing mass of dissidents'. The essay established an approach that others would follow, for instance when the *New York Times* recognized the victims of the 9/11 attack on the World Trade Center with the publication of domestic portraits and short biographical essays. (27 June 1969)

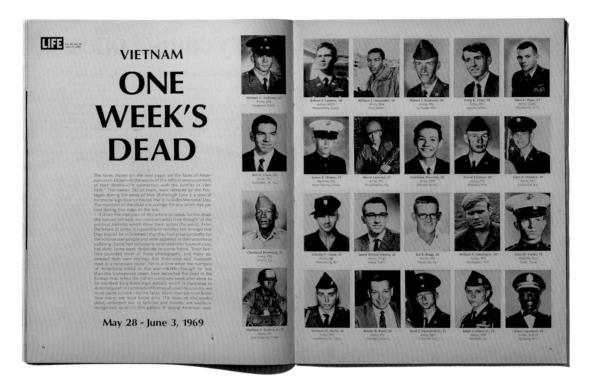

1969 WILL MCBRIDE SIDDHARTHA TWEN

Brainchild of art director Willy Fleckhaus and named after one of the first brands of jeans sold in Germany, *Twen* was first published in Cologne in 1959. It combined clean design grids with Alexey Brodovich's emotional style in an innovative new attitude to magazine layout. With its progressive politics – the magazine promoted sexual liberation, anti-racism, multiculturalism and the legalization of homosexuality – *Twen* inspired the German beat generation. It used photography as an art form, rather than as illustration, introducing international photographers like Irving Penn, William Klein, Bruce Davidson and Guy Bourdin to the German public while launching the careers of several young photographers, most notably the Cologne-based American, Will McBride. Initially with black and white photographs of his friends having fun, drinking whisky and listening to jazz music in Berlin, and later with sophisticated colour stories from exotic locations, McBride's work was the product of collaboration with his art director – Fleckhaus sometimes drew sketches of possible compositions for him. When Fleckhaus came back from the United States with a copy of *Siddhartha* by Hermann Hesse, he asked McBride to go to India and shoot a story inspired by the novel. The result was this essay about coming of age and the journey toward spiritual and sensual enlightenment. (July, August and September, 1969)

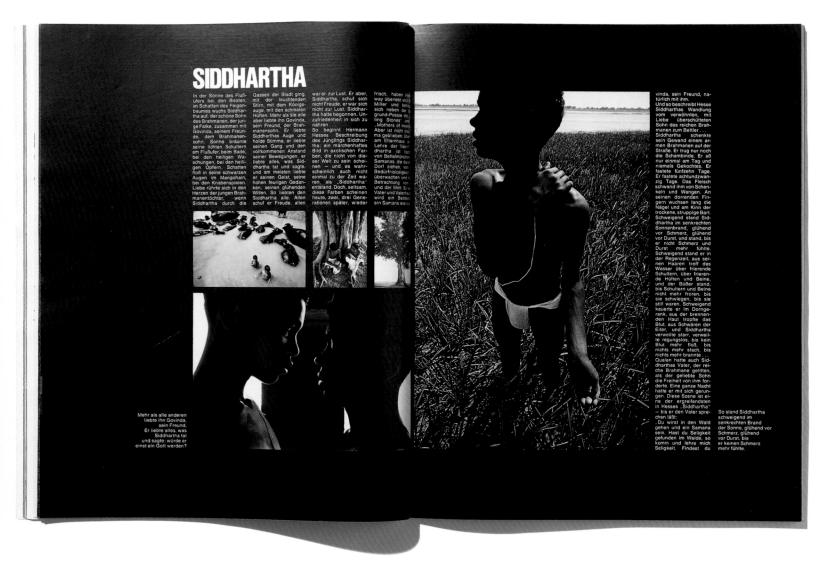

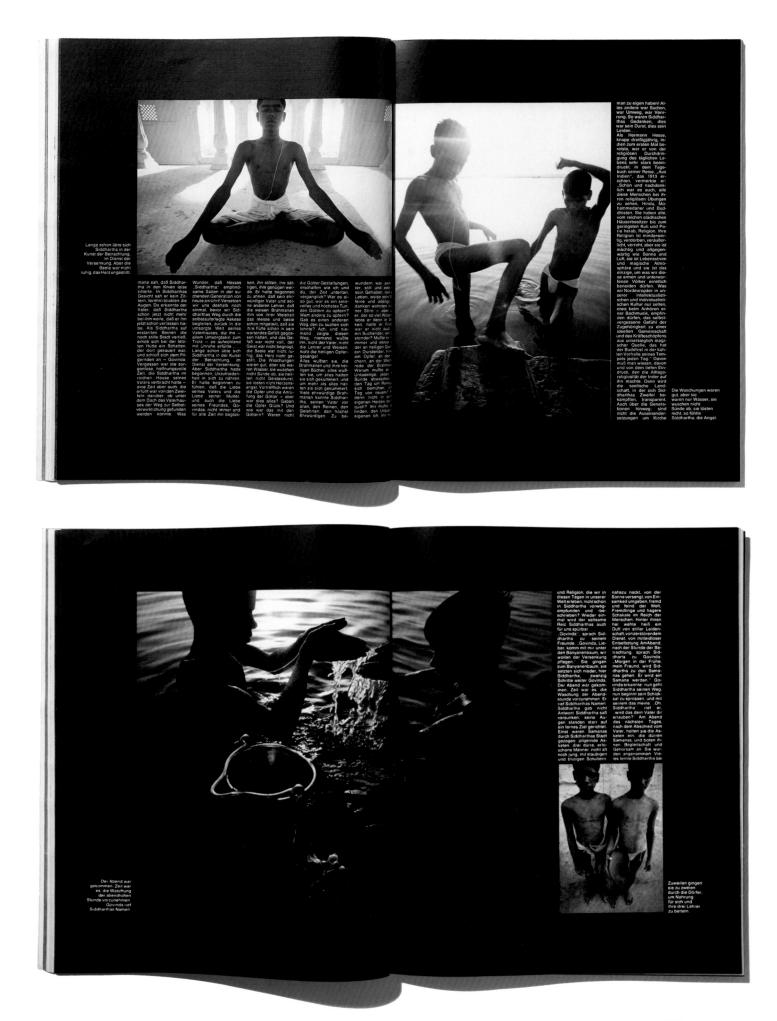

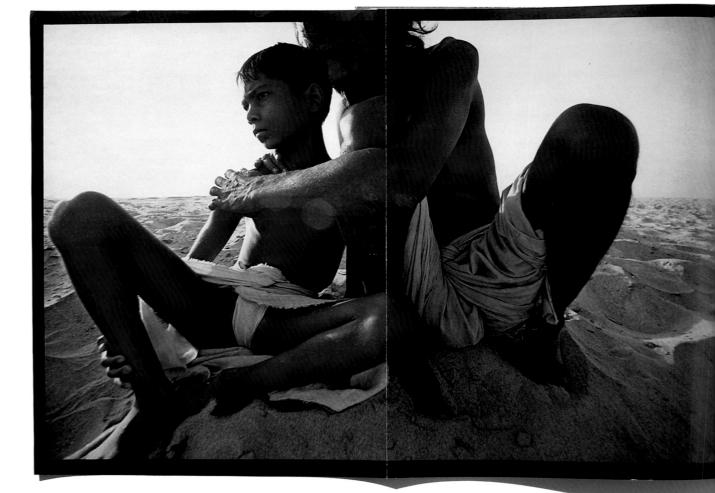

O Traum vom Lebenslicht, Leer werden, sich on Durst, leer von Freud eid. Von sich selbst wegführt n, nicht mehr Ich sein, entn Herzens Ruhe zu finden, volle niefsetsteten Denken dem kelm her affen schen..." (Herauss

> c, Stödhartha, Frank- stern so unbeck stiet 19.) Dichter Hermann und Freiheit, auf einnah war ich ij träumt vor Jahrzehnträumt vor Jahrzehnissin, nach Indien ge- seines Träumens, jetzt kehrt er heim. Montagnola. Wu us Amerikä! Widdes einem der kreisr täher sendete es die schaute, die mit us Amerikä! Widdes viene der kreisr täher sendete es die schaute, die mit us Amerikä! Hudes viene der, zeisr äher sendete es die schaute, die mit todischer Geisrückeit Rand fei mein Blit orgen denken, fühlen einen Blit griem denken, fühlen einen blit, einem Ste utfällig Haus. Morzwängt, einem Ste kommen die herz- rassen abgewonn üße von Hermann In der Mitte des New York, aus Bever- ein einet prodes, to

Hitler nd K

ury in der Bundesury in der Bundesury in der Bundesurs. S. und Das alles hätten Sie dus Frankfurt haben Lugano, d sonnenbrand, glüsetzten lind hmerz, glübend vor sen auf de bis er nicht Schmerz Salvatore. Frankfurt 1967, und höcks dus LSD Traum des schon der

10); O Ladenuffreicher stehende Stern. kmord, du lachst dich ka-Kerzenlicht und Mondlid: 11. Hesse, Der Steppen-12. Sa sa s. Klingsors Z dry, Seite 159) -- hir habt garten vor, und die Bäustidenen fücktender, Blumen, die mofrigen blüchtiger junger Menschen höhlen, die Jasnindu hrt, nicht über ihre Wirk-Schnecken, die auf f Über drei Folghat twen nun da

 n nonień, die Sauf feuditen
Schnecken, die auf feuditen
Über drei Folgen hat twen nun das Leben des Brahmanen-Sohnes
Siddhartha, so wie es der deutsche Dichter und Nobelpreisträger
Hermann Hesse in seinem Roman schilderte, in Farben aufgeblättert. Die plotzliche Liebe zu Hermann Hesse, die in Amerika aufgefammt ist und sich in Buchauf-

ie Tuffstein glänzende Spurbänder (I n zogen, das tropfende Wasser S r- unter den Zypressen: das war " r- das Urbild von Hesses Zauberer des Urbild von Hesses Zauber-

simnis- Und nun war es auch der unseren ticko- doppel: der Garten in seiner ru trassin Wirklidskeit und der Garten im bei bis ge- Buch. Der wirkliche gehörte far toten zu Montagnolas seltsamstem, Sder schönstem, seit einem Jahrhum- H-Aber dert vor sich hinträumenden, uden Täume gebierneten Haus. der n m Ort Casa Camuzzi. Da wohnte Heim Grin Lass der Ausen der der der der sin is se, der Monte, nalte und staabder der vorsten eine der der der der nitren weilväligigen Manarder und staabder fange auf der der der der der der berüher seine Welt, seine Bücher als ge ter auf Aphrodisika. Er saß damäls fer nit Ter- einem inmer verwegen schief bischenden Schimm; ich versuchte i stand auf der Turmplatform der Ca-T

 "Oh, nicht von deiner schönen Maria?"
"Nein. Auch die hast du "mir geschenkt. Sie ist wunderbar."
"Sie ist die Geliebte, die du brauchtest, Steppenwolf.
Hübsch, jung, guter Laune, in den brauchtest, schepben und nicht

der Liebe sehr klug und nicht h jeden Tag zu haben. Wenn · du sie nicht mehr mit anderen e teilen müßtest, wenn sie bei dir - nicht immer bloß ein flüchtiger e Gast wäre, ginge es nicht so gut." Ja, auch das mußte ich zugeben."

Ja, auch dar mußte ich zugeben." lagen äußert, die in die Hunderttausende gehen, und die ihre Wellen zurück zu uns schlägt, kann nicht bestritten werden. Streiten jedoch kann man darüber, ob Hesses Dichtung nun wirklich so

Vasser S. war "Hermine", und meint s war "schöne Maria" war in Min auberchen, nicht immer zu haben, und deshalb einverstanden, daß wi unsere nach Montagnola gefahren wa seiner ren. Die Parallelen waren gege ten im ben. Wir tauchten durch fila ehörte farbene Tage und schwarzblau newn Sternnichte immer tiefer in di

Sternnante immer treter in die Hesse'sche Pappwelt ein, stellten uns in sein bengalisches Licht, möblierten unster Phantasie mit seinen Panoptikumfiguren, den Brahmensohn dort, den Rocker Harry Haller hier, den Steppenwolf. Wir lachten dabei über uns, waren voll der Ironie und Tanzten

als Boden unseres Bevußterins über m Hesses schreckliche Ernshaftigter keit hinweg. Wir trieben Milib trauch und Schabernack mit the ihm und liebten uns. Bis eines an Tages das kleine Mäsichen der sie Porthalterin kam und mich von der Ternsze weg ans öffentliche eit Telefon rief, wo ich "Marias" ". Stimme körte und sie mit sägte, re- Hitler habe gestern seine ersite Gewalnätigkeit gegen julische Arzte und Anwälle durchge

"Mariel sideharen Pielen Da niel sideharenthas Hitte krachsiehen eine Sternen und 24 Jehnnden später waren wir wieder in Munchen. Et war der Frühling des Jahres 1933. Der Dichter und Scher von Montagnola sah noch 30 Jahre auf seinem Tessiner Hügel. Und jetzt, was für ein Späch. hat Amerika den Mann aus Montagnola (Lesen Sie wirter auf Scite 154)

(Lesen Sie weiter auf Seite 154) verehrungswürdigist. Der Schriftsteller und Journalist Alexander Parlach kennt die Welt, in der Hermann Hesse lebte und dichtete, aus eigener Betrachtung: Als junger Mann wohnte er einmal einen Sommer lang in Hermann Hesses früherem Haus in Montagnola.

1969 NEIL ARMSTRONG & EDWIN ALDRIN ON THE MOON LIFE

Photography had a negligible role in the early days of the race for space – for instance, the astronaut John Glenn bought a 35mm drugstore camera to make the only in-flight record of the Mercury mission in 1962. However the public relations potential of photography became central to the Apollo programme. Astronauts were trained and equipped to use video, film cameras and 70mm Hasselblads. The first moon landing on 21 July 1969 was a televisual event broadcast live to an attentive world. Magazines had to wait a further two weeks for the return and processing of their material. *Life* was first off the mark with a cover and 12-page spread, opening with a sequence of film frames before offering readers the triumph of still photography: carefully composed, richly detailed and iconic images of the astronauts, leaving the imprint of their boots, saluting the American flag, collecting samples and conducting geological experiments. (8 August 1969)

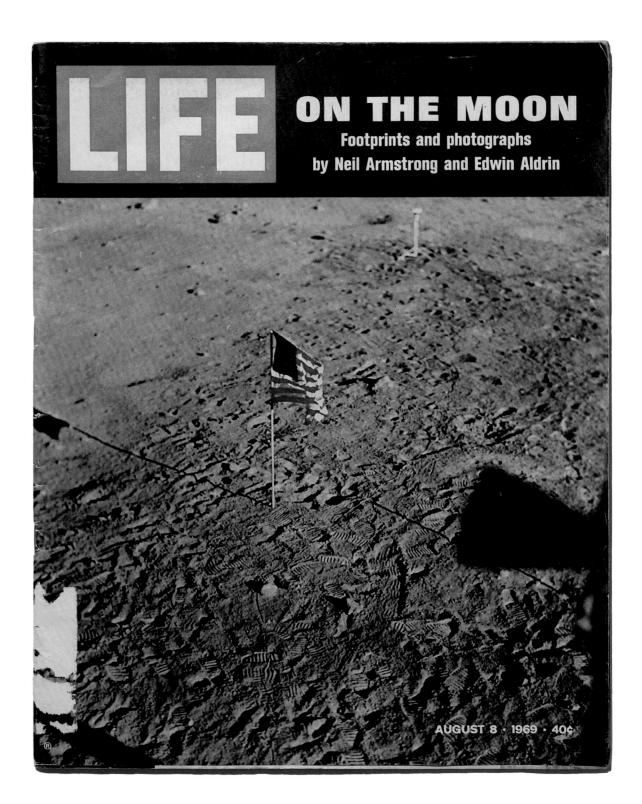

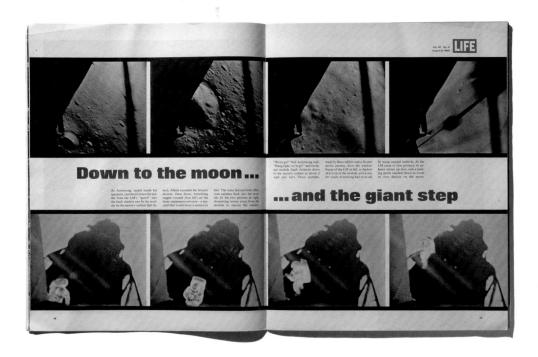

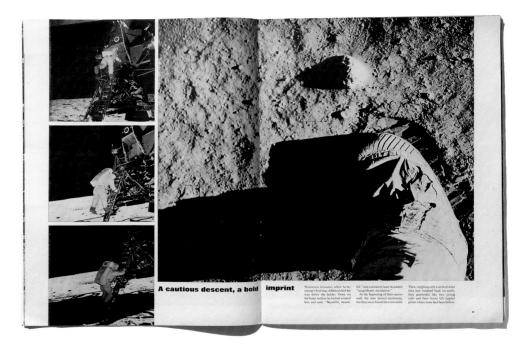

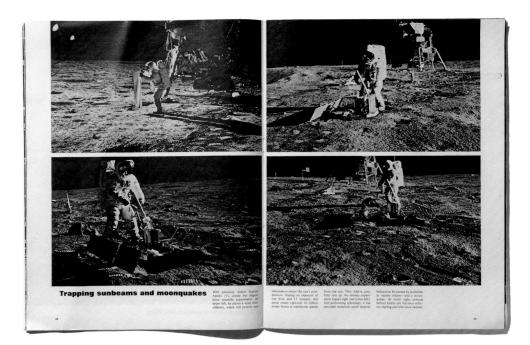

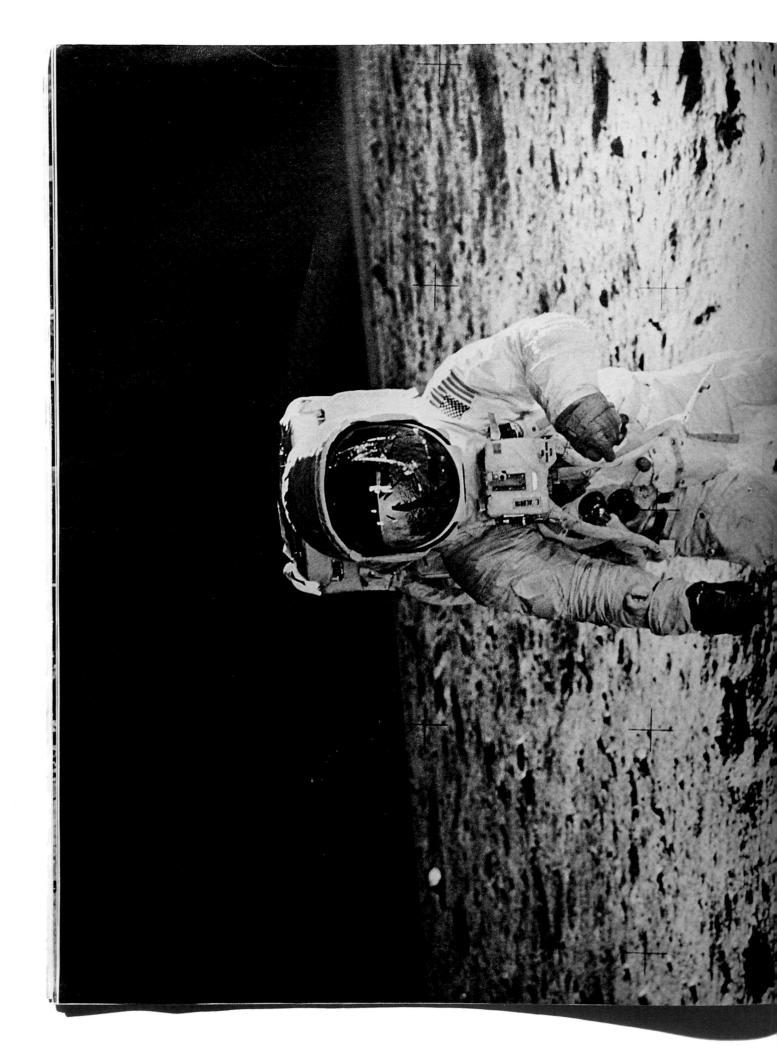

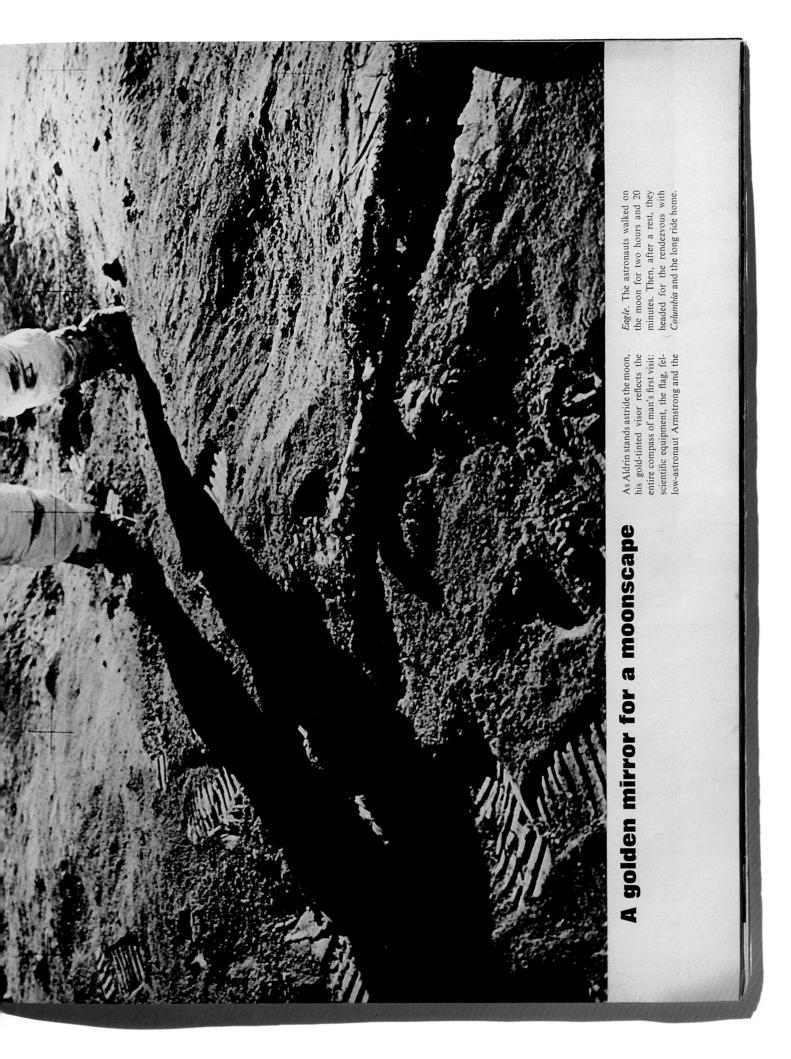

1969 RON HAEBERLE MY LAI LIFE

My Lai was a village in Vietnam where the massacre of around 500 Vietnamese civilians by American troops in 1968 was recorded by army photographer Ron Haeberle. He was about to finish his tour of duty, having seen little action, when he volunteered for a mission that promised to be 'hot'. He recorded events on three cameras – one loaded with black and white film which he turned in to the Army, and two loaded with colour which he kept for himself. For a year, Haeberle showed his photographs to civic groups in his native Cleveland, but faced disbelief – 'They caused no commotion ... Nobody believed it. They said Americans wouldn't do this.' Internal reports of the massacre forced an Army investigation in the summer of 1969, and a commanding officer, Lt William Calley, was accused of murder. But the full story only reached the public through the work of freelance journalist Seymour Hersh in the *Washington Post* and the London *Times*. After the story broke, Haeberle found an audience, initially in the *Cle-eland Plain Dealer*. Its subsequent publication in *Life* created a storm that helped turn American opinion decisively against the war. (5 December 1969)

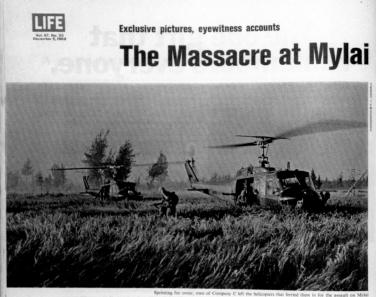

and the contrast of company C left the hencopters that ferried them in for the assault on M

the weekly Saigon briefing in March of 1968. Elements of the Americal Dowison hard made contact with the cremy near Quangnaji city and had killed 128 Vietcong. There were a few rumors of civilin deaths, but when the Army looked into them—a month after the incident—it found nothing to warraw disciplinary measures. The matter might have ended there except for a former GI, Ron Ridenhour, new a California college student. After having about Mylai from former commisse, he wrote letters to congressmen warming that "something rather dark and bloody" had taken place. Now an officer has been charged with murder of "an unknown number of Oriental human being" at Mylai, and 24-other men of Company C, First Battalion, Roh Indanty are under investigation. Congressmen are de-

Photographed by RONALD L. HAEBERLE

nd whether or not U.S. troops have committed simila

Because of impending courts-martial, the Army will say tite. The South Vietnames government, which has conucted its own investigation, states that Mylai was. "hance's was "and that any talk of atrocties in just Vietneong proaganda. This is not true. The prictures shown here by Romtory of misipusable horror-...be deliberate absughter of old new, women, children and bables. These sprayinges acouts, by the men of Company C and surviving willingers, nullet the the American troops encountered little fargustel fargued only one casualy enzy solidiers in the village and suffered only one casualy enzy solidiers in the village and suffered only one casualy enzy solidiers in the village

> "Guys were about to shoot these people," Ph tographer Ron Haeberle remembers. "I yelle 'Hold it,' and shot my picture. As I walked awa I heard M16s open up. From the corner of my e saw bodies felling.

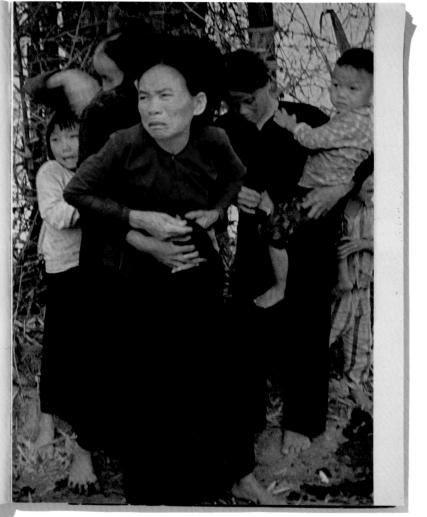

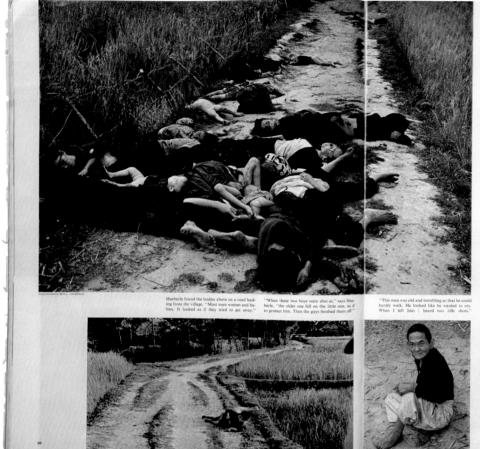

'The order was to destroy Mylai and everything in it'

On the day before their mission the men of Company C met for a briefing after supper The company commander, Capa-tian Ernest Medina, read the official prepared orders for the assual against Mylai and spoke for about 45 minutes, mostly about the pro-cedures of mesonement. At least two other com-pany would also participate; They, like Com-

n Medina was a stocks

Ch

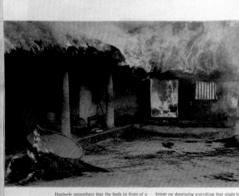

front of a Intent on destroying everything that might and that use to the Vietcong, a soldier (*below*) stokes in him." with the baskets used to dry rice and

'You don't call

ut 9 or 9:30 in a

them civilians-to us they were VC'

started firing at her, aiming ner over and over again. She into one of those things that ice paddies so that her head target. There was no attempt or anything. They just kept You could see the bones fly-p by chip. Jay and I, we just

e and composition composition and an entry of the sector o

at." "The G1 "" repaddies and heard the sound of were coming down a sharply of were coming down a 25 feet lahead of them, were six me with basket, coming to-hese people were running every "The G1 "the feet wave from on, running every

way. It's hard to c rom a papa-san when everybody has on pajamas." He and his squad opened fire their M16s. Then he and his men kept g down the road toward the sound of the in the road toward the sound of the the village, aid in my heart already," says West, id in my mind that I would not let east me. I had two accomplishments. The first was to serve my govern-to accomptish my mission while I staam. My second accomplishment

re d wasn't cryin Habberle knelt down to A GI knelt down t ocked him back, the so to the air. The third she e body fluids car ti up and

"The people who ordered it probably didn't think it would look so bad," says Sgt. Michael

ttle boys popped up from orle. "The Gts I was

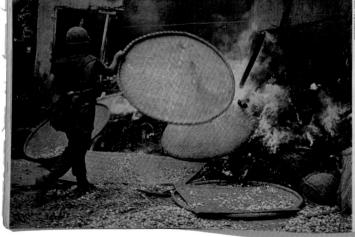

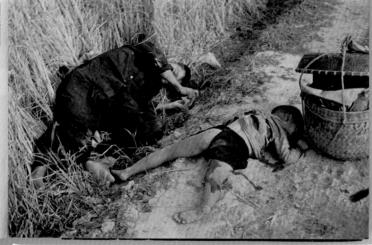

1970 DON MCCULLIN SIEGE OF DERRY SUNDAY TIMES

On the Sunday before Christmas, in an edition loaded with advertisements for cognac, port and gift boxes of cigarettes, the *Sunday Times* magazine underscored its reputation for uncompromising photojournalism by offering as its lead story a portfolio of 12 photographs about the escalating conflict in Northern Ireland. Don McCullin had first visited Northern Ireland in 1969 and had been making frequent trips to the Catholic Bogside district of Derry throughout 1971. With typical obstinate courage he worked the streets amongst the armed British troops and the dissenting young Catholic men as they fought increasingly violent pitched battles; he was hit in the back and temporarily blinded by CS gas while working on the story. McCullin's direct and perfectly crafted photographic vision was complemented by its treatment in the magazine. Under the overall editorship of Harold Evans, the magazine's approach to photography was handled by art director Michael Rand and designer David King; their respect for photographs and photographers, along with the magazine's fearless approach to difficult subject matter, led to the freshest and most powerful magazine layouts of the period. (19 December 1971)

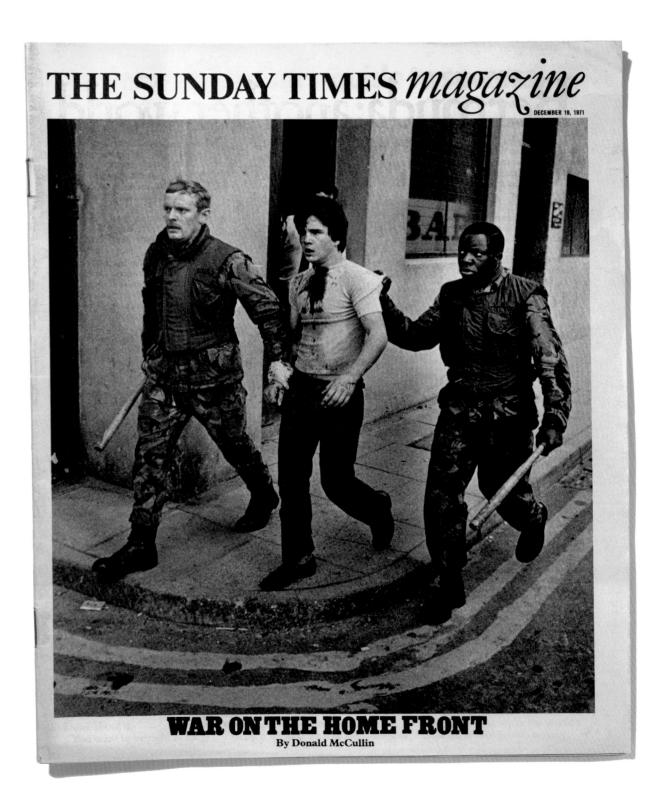

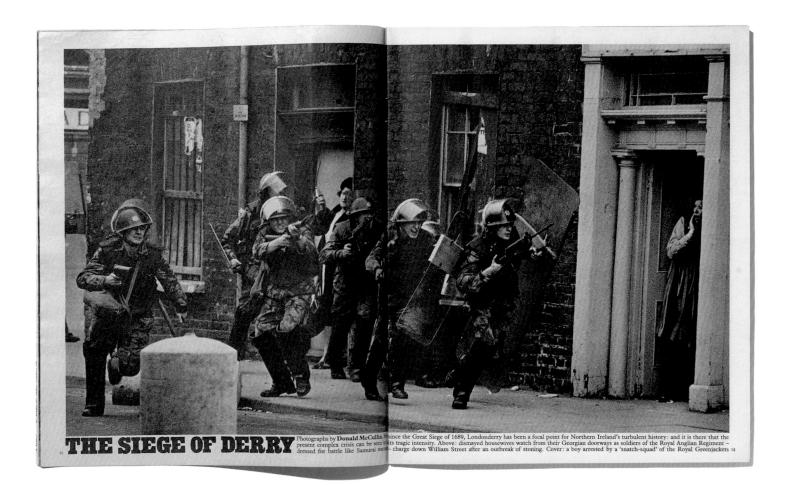

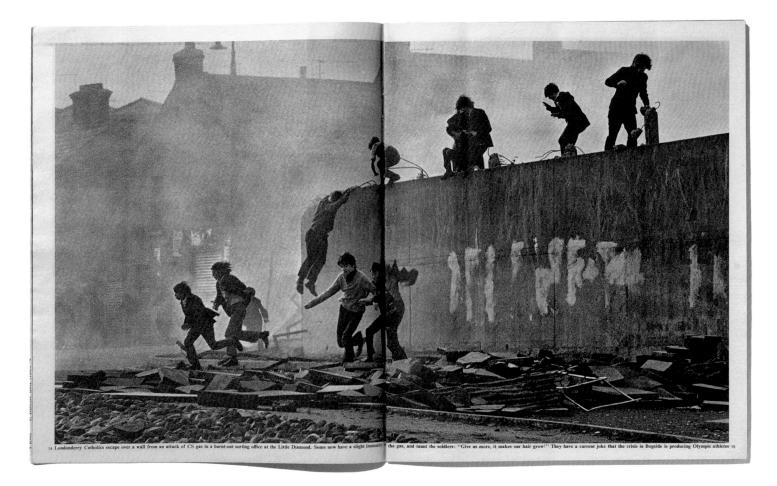

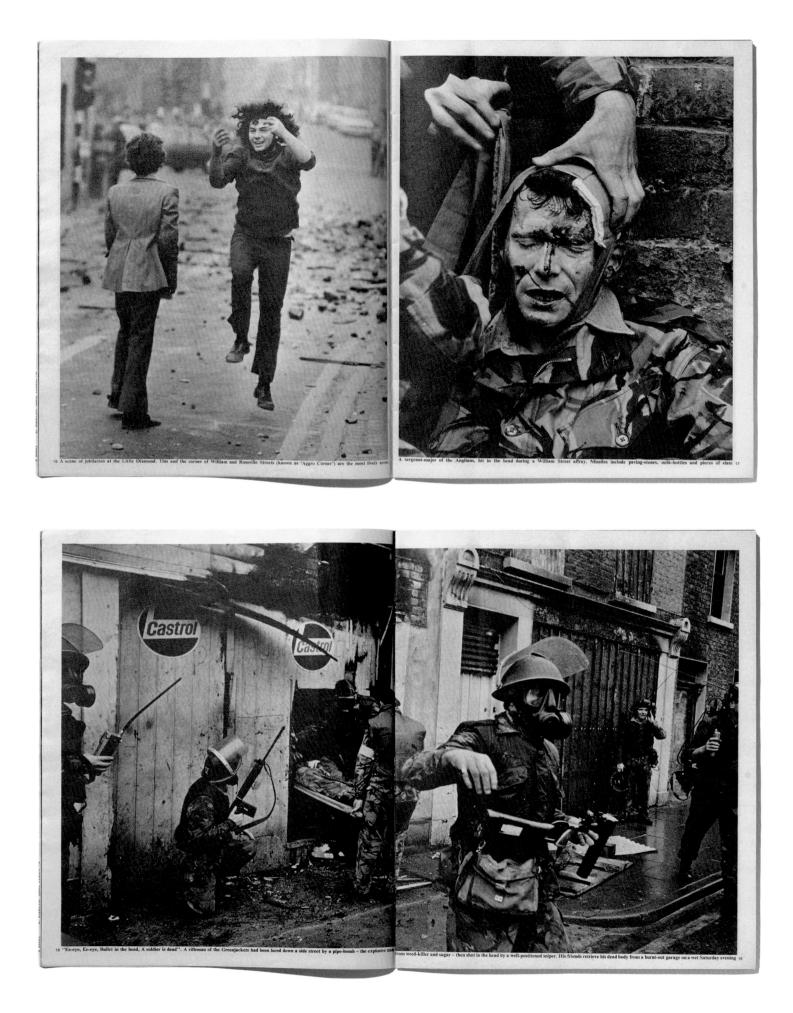

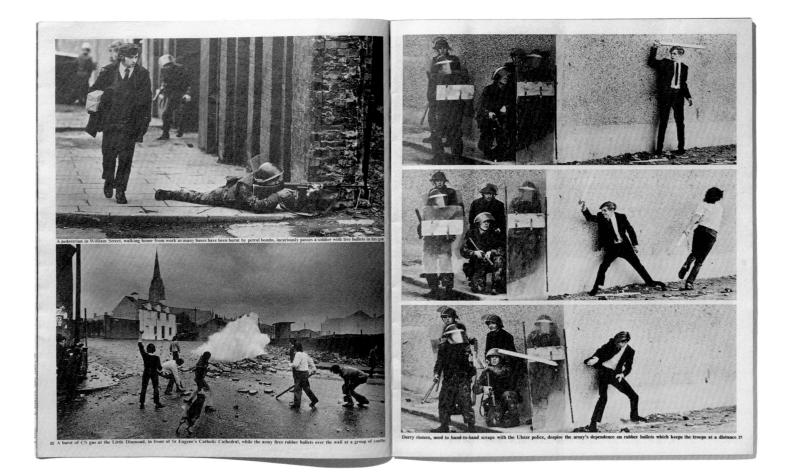

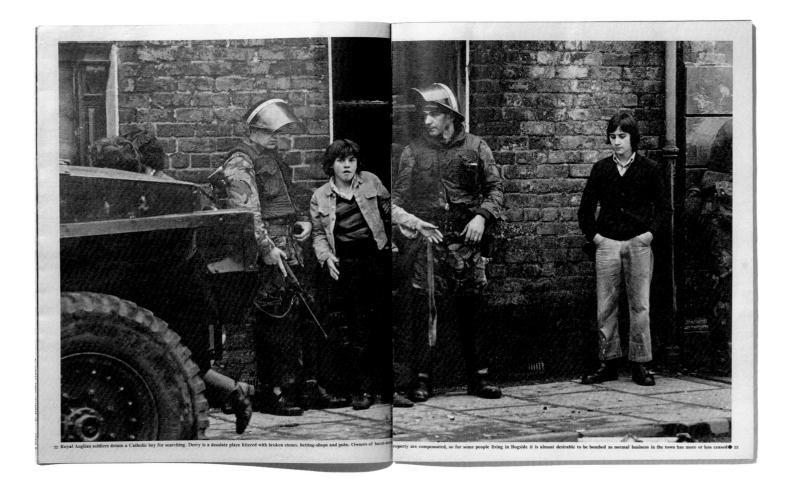

1972 MUNICH MASSACRE PARIS MATCH

In the summer of 1972 the Olympics made a historic return to Germany. On 5 September, eight Palestinians – under the name 'Black September' – invaded the Olympic Village, killing two Israeli athletes and taking nine others hostage. They demanded the release of 234 Palestinians being held in Israeli jails. The crisis received widespread media attention, including many hours of live television broadcast. Eighteen hours later, a botched rescue effort resulted in the deaths of all the Israelis, a German officer and five of the terrorists. Within a week, *Paris Match* published a clear and suspenseful 16-page account of the crisis. An hour-by-hour narrative brought readers close to the action by means of eerie telephoto shots of the fedayeen, detailed accounts of clandestine negotiations, and graphic images of the attempted German rescue as it went wrong. The report reflected the skill of *Paris Match* reporters and the enormous access to information that the magazine could command. It also showed how a magazine could still deliver an account of a major news event capable of successfully competing with round the clock television news. (16 September 1972, including photographs by Michel Sola and Robert Boulay)

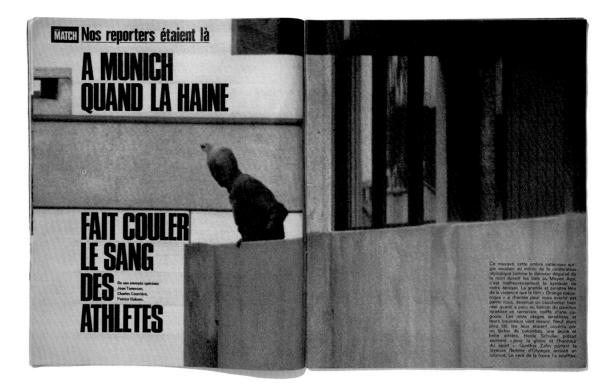

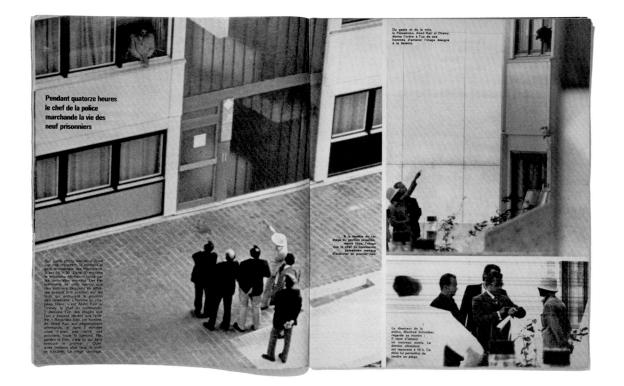

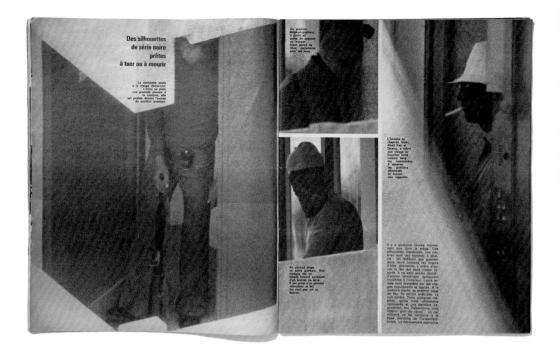

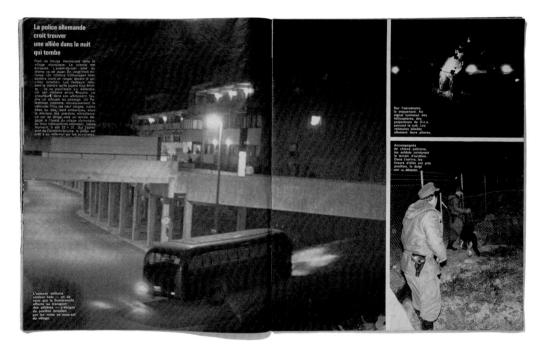

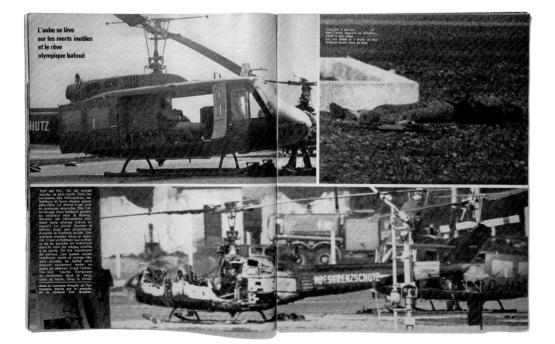

1975-1984 HEROES AND ANTI-HEROES

HIROJI KUBOTA BANGKOK 202 RICHARD AVEDON THE FAMILY 204 SUSAN MEISELAS NICARAGUA 206 ANDERS PETERSEN GAFE LEHMITZ 207 HELMUT NEWTUN BERLIN ZIU BATTAGLIA & ZEECCHIN MAFIA ASSASSINATION 212 1976 1976 EUGENE RICHARDS DORRIE'S JOURNEY 220 1978 1979 EUVERE ALURAANU PALKLAND ROAD 224 MARY ELLEN MARK RAYMOND DEPARDON NEW YORK DIARY 228 1979 1980 1980 BRUCE WEBER DLYMPIANS 23D VERA LENTZ SUCCUS MASSACRE 233 1980 1981 1981 RAGHU RAI BHOPAL 234 1981 1984 1984 1984

1975-1984 HEROES AND ANTI-HEROES

By the middle of the 1970s, the Cold War shows signs of ending – symbolized by the link up of Apollo and Soyuz spacecraft in orbit in 1975 - and its familiar storylines begin to fragment. The swift spread of American commodities and culture - Nike, McDonald's, Coca-Cola, MTV and the unifying brands of rock music - feeds the idea of the global village but global inequalities grow. A new front line between the rich 'north' and the poor 'south' begins to emerge that for photojournalists will replace the intense urgency of the Vietnam War. Meanwhile, old-world dictators and popular new heroes star in a myriad of plotlines. The dockworkers in Gdansk, Poland, mobilize world support in their campaign for democracy. War in Lebanon descends into a web of complexity that defies the best of journalists to explain. Franco dies, and Spain welcomes a new democracy and a free press. In Nicaragua, the Sandinistas oust dictator Somoza, as Central American conflicts pit grassroots rebels against US-backed military forces. The Ayatollah Khomeini establishes a religious state in Iran and Queen Elizabeth II celebrates her jubilee to the punk soundtrack of the Sex Pistols. The Viking probe sends back the first pictures of Mars, and the mysterious deathly illness affecting mainly gay men is named as Aids. As audiences for magazines break up into niche markets and photojournalism seems momentarily diminished, new directions in visual reporting take hold between the cracks.

STANLEY FORMAN Boston Herald

A woman and a girl are hurled off a collapsing fire escape in an apartment house fire. The woman was killed but the child survived, her fall cushioned by the woman's body. Boston, USA, 22 July 1975. World Press Photo of the Year 1975

DAVID BURNETT *Contact Press Images* A Cambodian woman cradles her child while waiting for food to be distributed. Sa Keo refugee camp, Thailand, November 1979. World Press Photo of the Year 1979

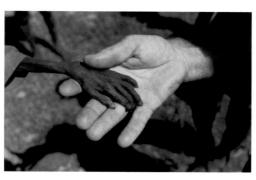

MICHAEL WELLS Starving boy and missionary. Karamoja district, Uganda, April 1980. World Press Photo of the Year 1980

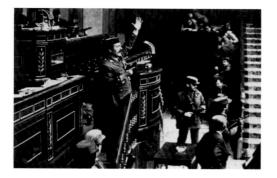

MANUEL PÉREZ BARRIOPEDRO Agencia EFE Lt. Col. Antonio Tejero Molina and members of the Guardia Civil and the military police hold the Spanish parliament hostage. Madrid, Spain, 23 February 1981. World Press Photo of the Year 1981

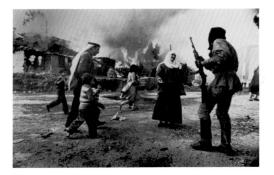

FRANÇOISE DEMULDER Gamma

Palestinian refugees in the district La Quarantaine. Beirut, Lebanon, January 1976. World Press Photo of the Year 1976

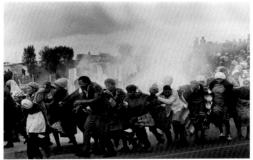

LESLIE HAMMOND Argus

The police tear-gas inhabitants of Modderdam squatter camp outside Cape Town protesting against the demolition of their homes. Modderdam, Western Cape, South Africa, August 1977. World Press Photo of the Year 1977

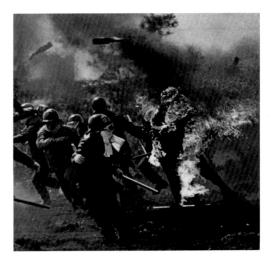

SADAYUKI MIKAMI Associated Press Protest against the construction of Narita Airport. Tokyo, Japan, March 1978. World Press Photo of the Year 1978

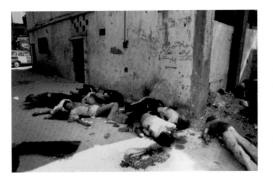

ROBIN MOYER Black Star/Time Aftermath of massacre of Palestinians by Christian Phalangists in the Sabra and Shatila refugee camps. Beirut, Lebanon, 18 September 1982. World Press Photo of the Year 1982

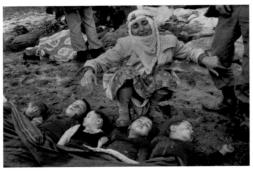

MUSTAFA BOZDEMIR Hürriyet Gazetesi Kezban Özer finds her five children buried alive after a devastating earthquake. Koyunoren, Turkey, 30 October 1983. World Press Photo of the Year 1983

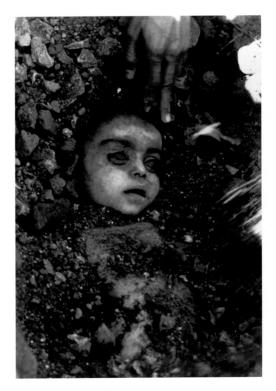

PABLO BARTHOLOMEW Gamma Child killed by the poisonous gas leak in the Union Carbide chemical plant disaster. Bhopal, India, December 1984. World Press Photo of the Year 1984

1976 HIROJI KUBOTA BANGKOK SEKAI

The influential left-wing monthly journal *Sekai* – literally 'the World' – was launched in 1946, dedicated to building 'peace and social justice' and 'freedom and equality' in postwar Japan. Dominated by political analysis and argument, each issue began with a 16- to 24-page photo essay printed in gravure that in most cases profiled a city or a country in the region – part of a programme to promote 'harmony and solidarity with the peoples of East Asia'. *Sekai*'s photo essay contributors included Shisei Kuwabara, Shinzo Hanabusa and Hiroji Kubota, with Kubota producing over 40 essays for the magazine between 1967 and 1980 on topics such as China, Burma and Okinawa under American occupation. It was as *Sekai* correspondent that Kubota became the first freelance Japanese photographer allowed to visit North Korea in 1978, and he produced four stories on Thailand during a period when the Kingdom feared a Communist takeover. His gentle, respectful reportage style was a reaction to the suffering he witnessed as a child in Japan during World War II, and proved a useful vehicle for *Sekai* to foster mutual understanding between its audience and the nations Kubota photographed. (September 1976)

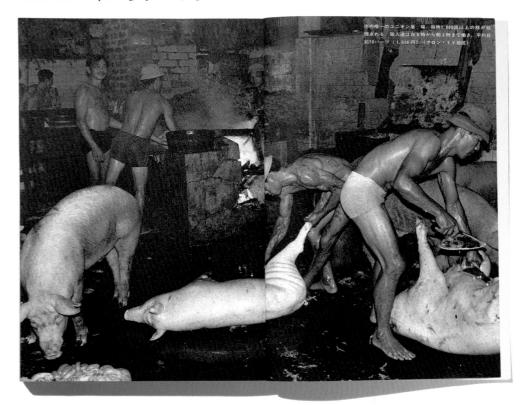

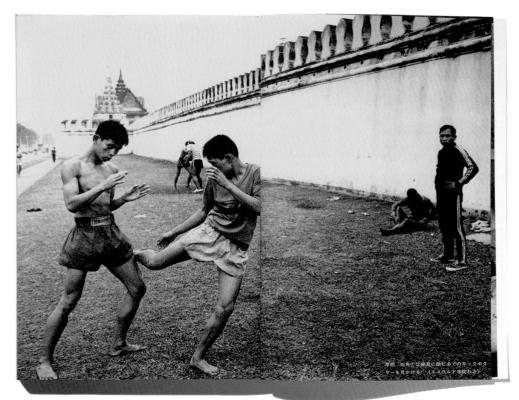

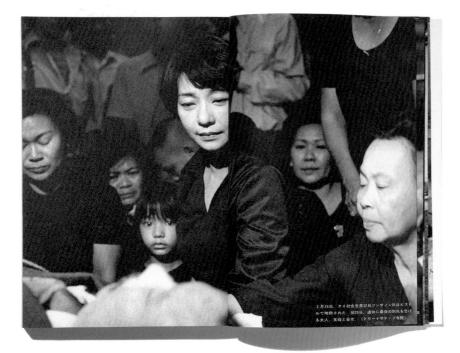

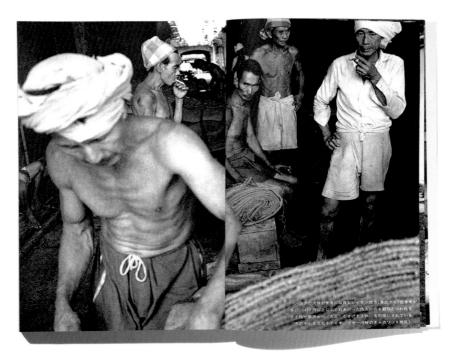

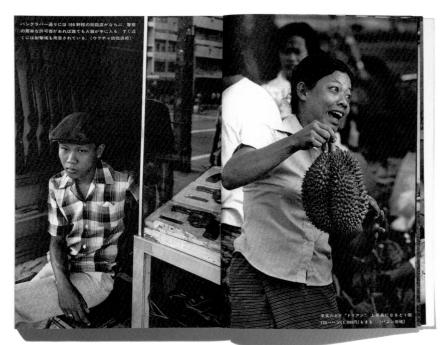

1976 RICHARD AVEDON THE FAMILY ROLLING STONE

In 1976, while celebrations of America's Bicentennial stirred patriotic emotions and shut out painful memories of Watergate, Nixon and Vietnam, *Rolling Stone* hired Richard Avedon to portray the political landscape in the lead up to the 'bicentennial Presidential election'. Avedon shaped the assignment according to his own style and convictions. He felt that 'the real story was not simply the candidates, but a broad group of men and women – some of whom we have never heard of before – who constitute the political leadership of America'. The project included more than 70 portraits made with an 8x10 view camera, each figure standing against a plain white background and run throughout the entire issue of the magazine. The only text takes the form of the sitter's official entry in the biographical encyclopedia *Who's Who*. Adopting an approach neutrally dedicated to facts alone, this essay was Avedon's response to 'new journalism' – the highly personal reporting style closely associated with *Rolling Stone*. The project was an important landmark in Avedon's own career, as he moved from fashion and advertising photography to journalism and art. (21 October 1976)

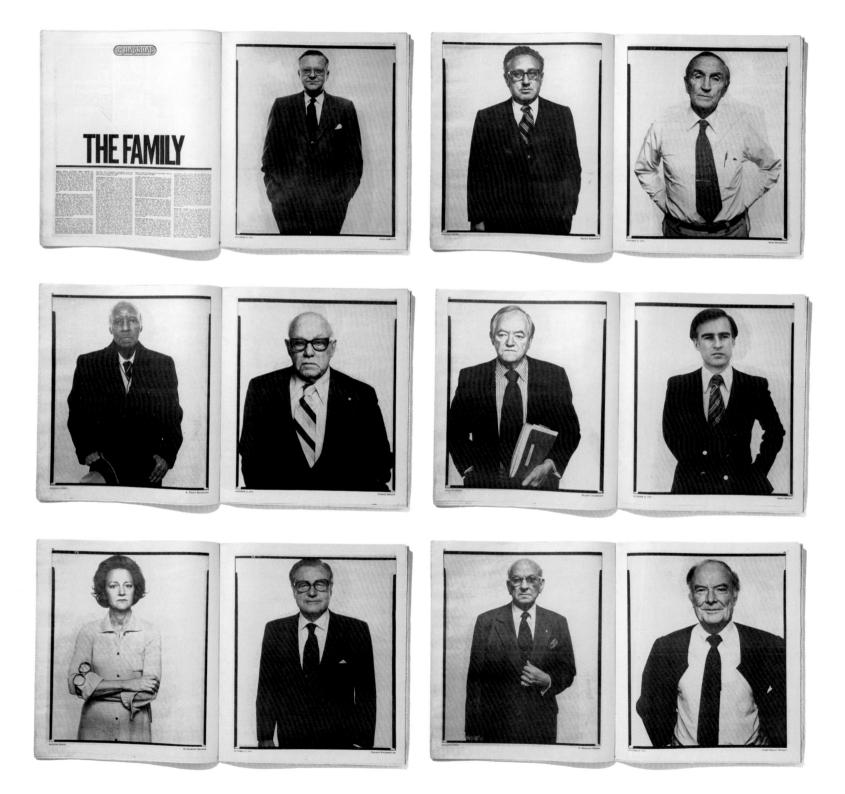

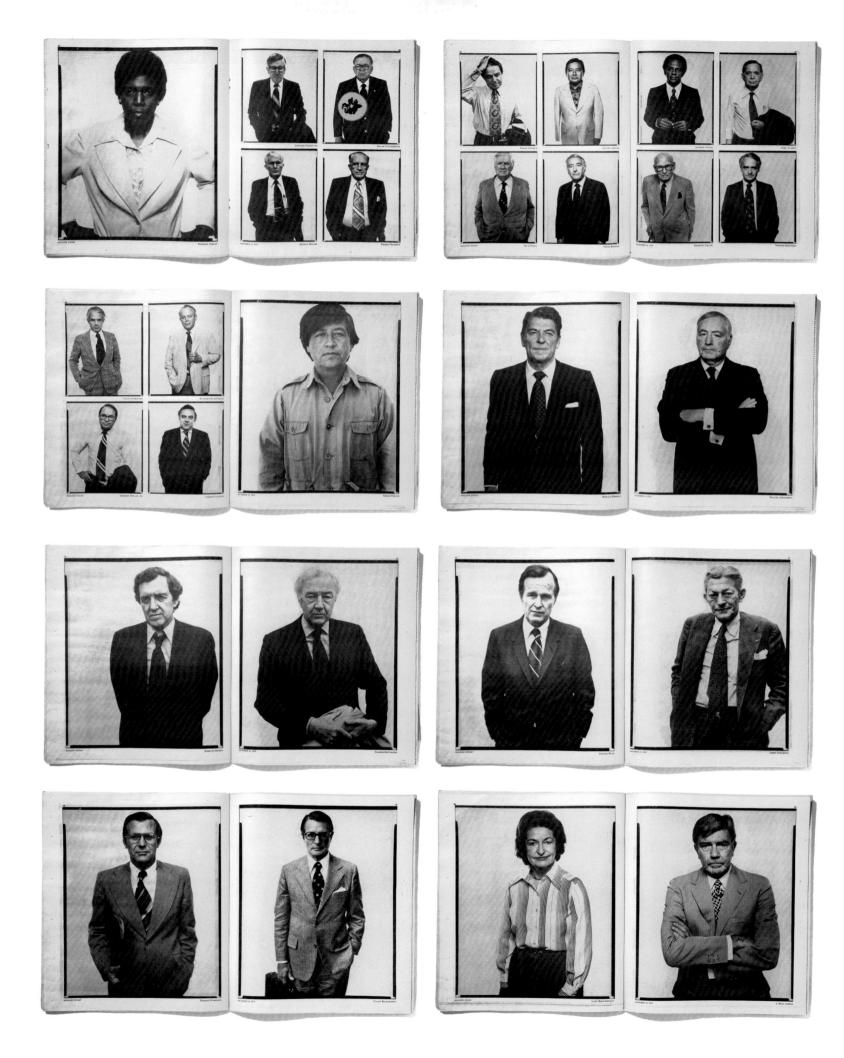

1978 SUSAN MEISELAS NICARAGUA NEW YORK TIMES

Susan Meiselas came to Nicaragua early in 1978, not as a war photographer entering a war zone, but as a young documentary photographer looking for a subject, pursuing her curiosity in the growing opposition to the country's military dictatorship. She was prompted to go by the murder – apparently by members of Nicaragua's National Guard – of Pedro Joaquín Chamorro, the opposition leader and journalist publisher of Nicaragua's *La Prensa*. His death also proved a decisive event in uniting opposition to the regime, stirring the beginnings of a revolution. Without media interest in her pictures, Meiselas recorded the rise of the Sandinistas while getting to know 'the rhythm of Nicaragua's history'. When the *New York Times* magazine sent a writer to describe the emerging revolution, it 'picked up' Meiselas's unpublished photographs for a cover story that turned her gripping portraits of masked insurgents into icons of the revolution. This story also propelled her from obscurity to the front line of international photojournalism, presenting her with opportunities to photograph other conflicts. She preferred to stay in Nicaragua, developing an independent practice, financially supported by 'guarantees' towards her work rather than assignments. (30 July 1978)

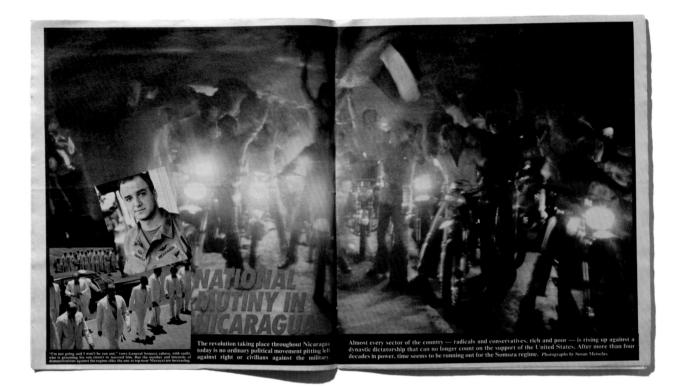

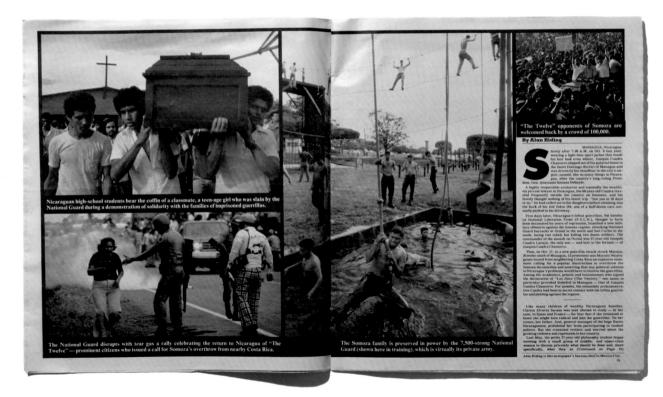

1979 ANDERS PETERSEN CAFÉ LEHMITZ STERN

Café Lehmitz was located near the Reeperbahn in Hamburg, Germany. Open around the clock, it was frequented by a colourful group of social outsiders, including sailors, cab drivers, prostitutes, pimps, poets and small-time criminals. 'The people at the Café Lehmitz had a presence and a sincerity that I myself lacked,' said Swedish photographer Anders Petersen, who first came across the café in the late 1960s and over the next three years spent much of his time there taking pictures of its customers. 'It was okay to be desperate, to be tender, to sit all alone or share the company of others. There was a great warmth and tolerance in this destitute setting.' A student and follower of the seminal Swedish photographer Christer Strömholm, Petersen borrowed from his teacher's stark black and white style while adopting his participatory approach to observation. Like Strömholm, who spent years with the transsexuals of Place Blanche in Paris for one of his best-known series of pictures, Petersen became a part of the Bohemian life of Lehmitz community himself. The pictures published by *Stern* show the intimacy he shared with his subjects, while never exposing them to ridicule or giving the impression of voyeurism. (11 November 1979)

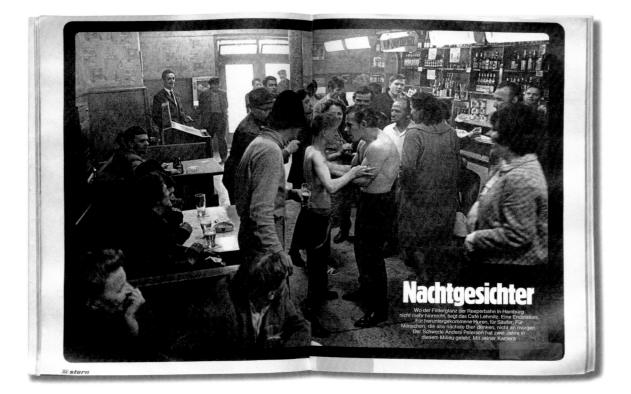

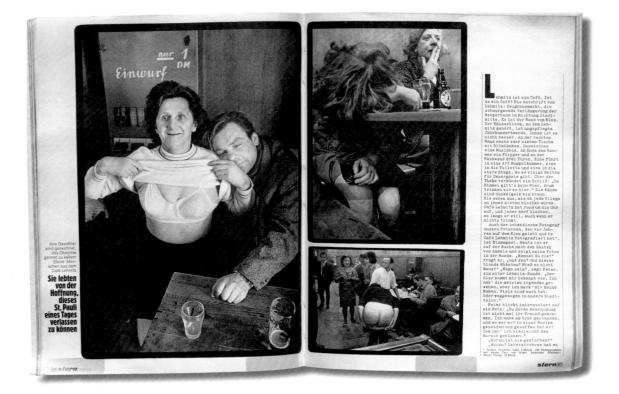

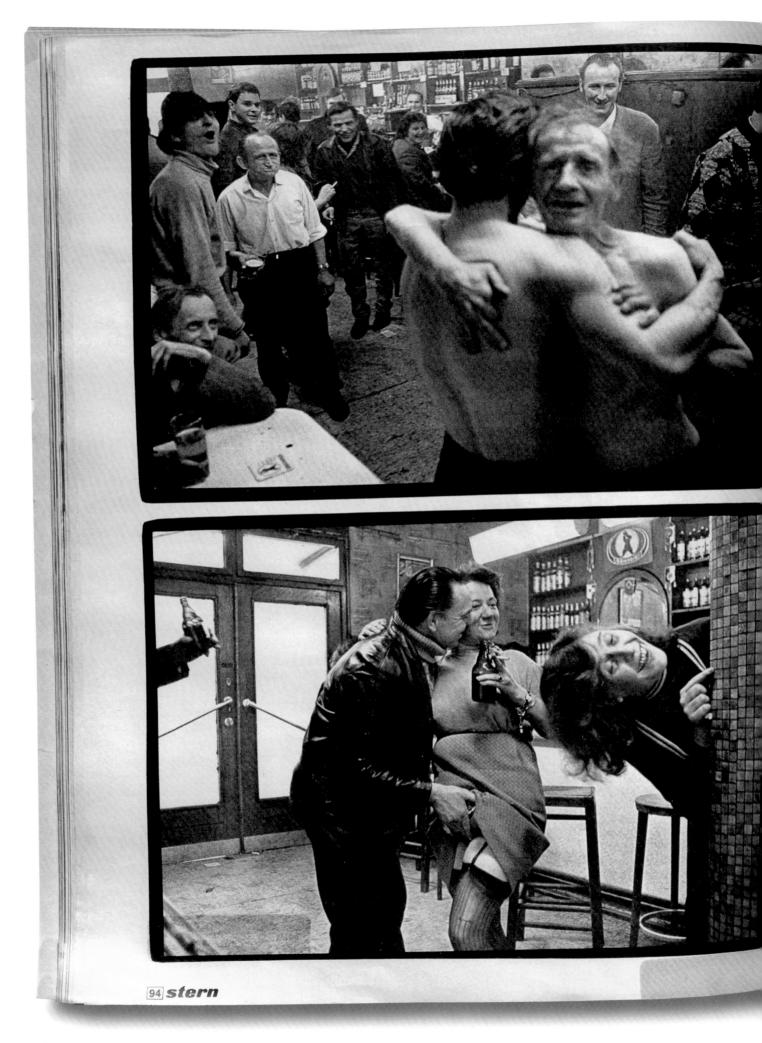

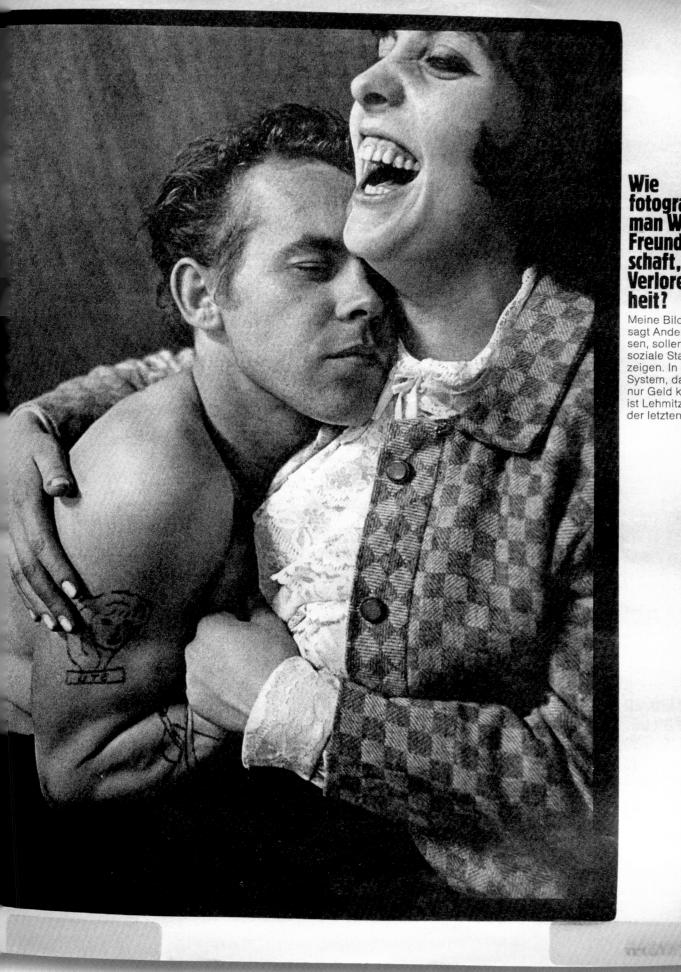

Wie fotografiert man Wärme Freund-schaft, wie Verloren-heit?

Meine Bilder, sagt Anders Peter sen, sollen eine soziale Station zeigen. In diesem System, das nur Geld kennt, ist Lehmitz eine der letzten

1979 HELMUT NEWTON BERLIN VOGUE

Helmut Newton once said that while other photographers recorded what they saw, he photographed what he had *once seen*. His life's work was a sustained autobiographical essay about his perceptions of the world, particularly the mores and codes of 'Old Europe', reflecting on scenes from his past overlaid with contemporary erotic narratives, and usually shot for the editorial pages of fashion magazines. Newton was born in Berlin in 1920, escaping the Nazi persecution of the Jews in 1938. When he returned on assignment for *Vogue*'s German edition, the idea was to record the places of his childhood as he remembered them. In some he found items from his past and used them as props, such as the furniture of a lakeside restaurant he used to frequent. In each location, he worked at the edge of available light, creating an appropriately melancholic mood. The models, meanwhile, were an intrusion of the modern world, set in contrast to the Berlin of the past. While Newton could never be described as a photojournalist, his substantial contribution to magazine photography was as a narrative storyteller, absorbed by the question of how to represent reality. (November 1979)

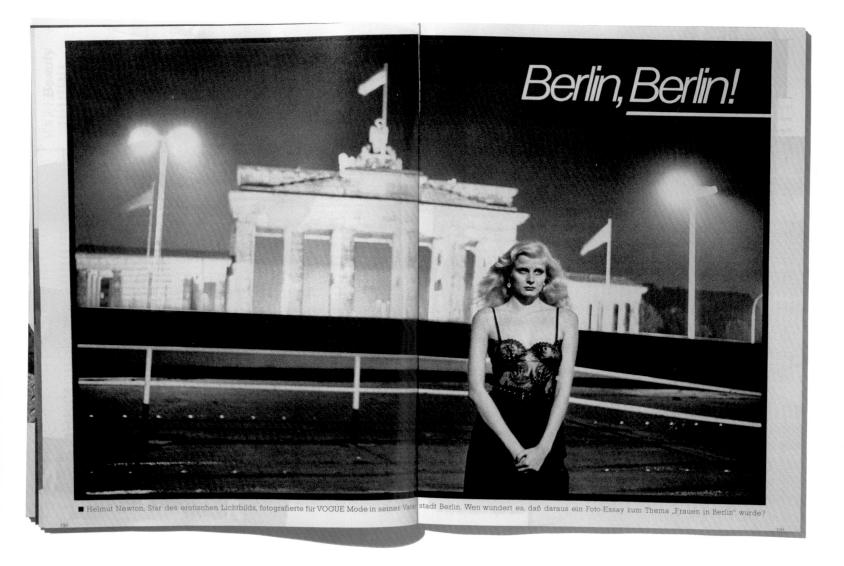

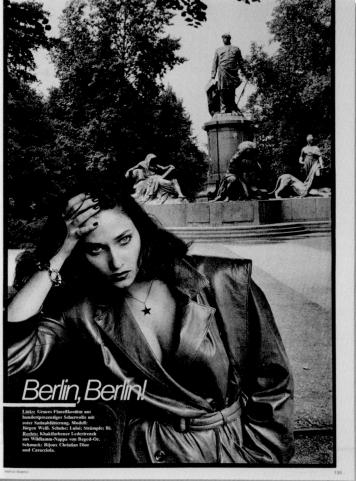

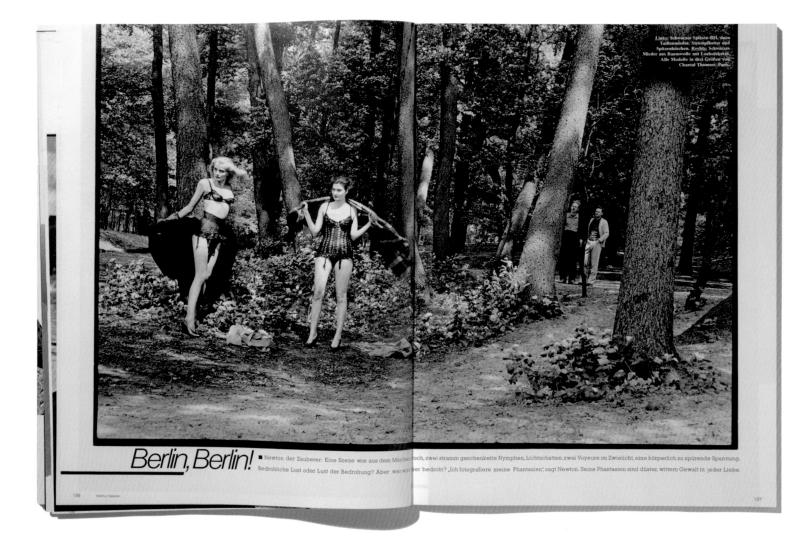

1980 BATTAGLIA & ZECCHIN MAFIA ASSASSINATION L'ORA

Photographers Letizia Battaglia and Franco Zecchin joined the staff of Palermo's leftist newspaper, *L'Ora*, in 1974 where their most important work for the paper was in documenting the evidence of the ongoing police, judicial and political war against the Mafia. By 1981, one Mafia murder was taking place every three days. On 6 January 1980, Piersanti Mattarella, President of the Sicilian region, was shot in his car by the Mafia after speaking out publicly about the involvement of establishment politicians in organized crime. Battaglia and Zecchin arrived at the crime scene minutes after the shooting when the politician was still alive and while his wife, who was in the car with him, desperately clung to his body. They followed the story from the rush to hospital, through anxious waiting, until the announcement of his death. Talking about her work during the period, Battaglia said: 'I felt it was my responsibility, as a Sicilian, to fight. It is not acceptable for one evil part of the society to decide the future for all.' She organized large public exhibitions devoted to exposing Mafia activity and invited other photographers to participate. Most declined. She subsequently set up a school for photographers, a gallery and a publishing house – becoming herself a symbol of the war against the Mafia system. (7 January 1980)

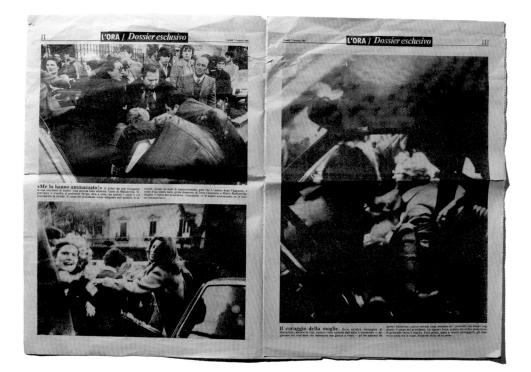

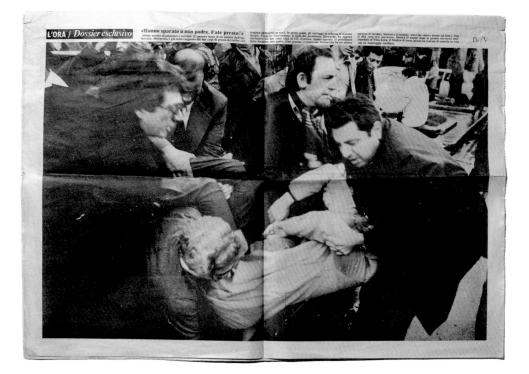

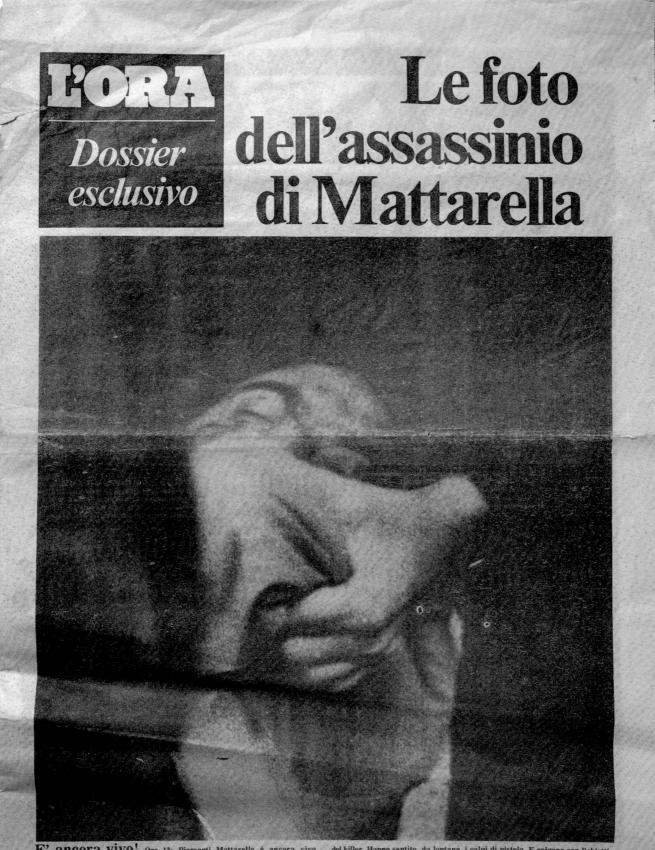

E' ancora vivo! Ore 13: Piersanti Mattarella è ancora vivo. Con questa drammatica immagine s'apre il dossier fotografico, esclusivo dell'agguato al presidente della Regione siciliana. I fotoreporters Letizia Battaglia e Franco Zecchin si trovano in via Libertà pochi attimi dopo la fuga

del killer. Hanno sentito, da lontano, i colpi di pistola. E colgono con l'obiettivo il volto sofferente ma composto di Mattarella mentre familiari e passanti lo soccorrono. Fotoservizio esclusivo L'ORA - Letizia Battaglia e Franco Zecchin

1980 GILLES PERESS IRAN NEW YORK TIMES

Gilles Peress began a five-week visit to Iran shortly after the Revolution. He went during the hostage crisis, with Iranian militants holding 179 Americans, while much of the US media described Iran's revolutionaries as mad fanatics and only represented the scene at the Embassy. Peress, always untrusting of the media, wanted to see for himself. Employing what he describes as his 'strategy of drift', looking for the visual and historical 'patterns that emerge from reality', he explored the rhythms of Iran's city streets. In a blend of journalistic enquiry and subjective observation, he recorded both spectacular scenes and minute details, in what the *New York Times* called a 'jarring array of images'. At one level this was an appropriate journalistic response to the confusion of Iran at the time, but this was also Peress's disruptive antidote to the safe formulae and simplistic narrative tidiness of conventional journalism. His photographs challenged the viewer to engage with the issues of history but at the same time, to distrust the storyteller's objectivity. Peress's book *Telex Iran*, published four years later, had a profound impact on the practice of documentary photography thereafter. (15 June 1980)

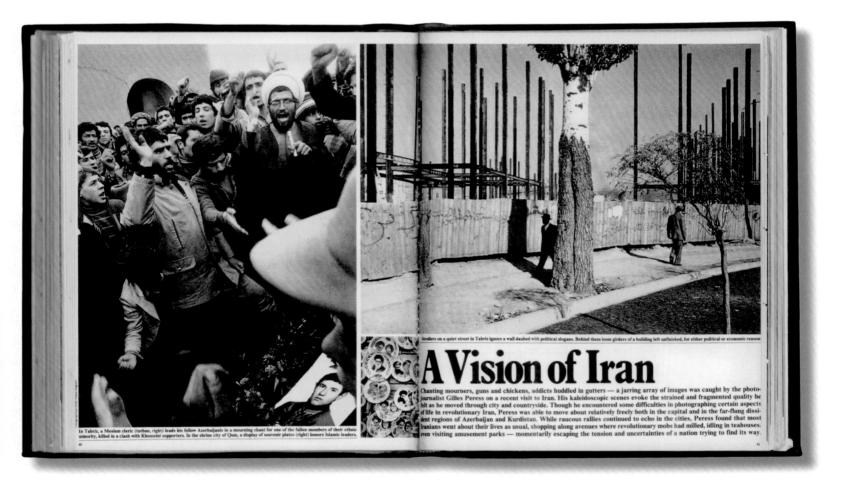

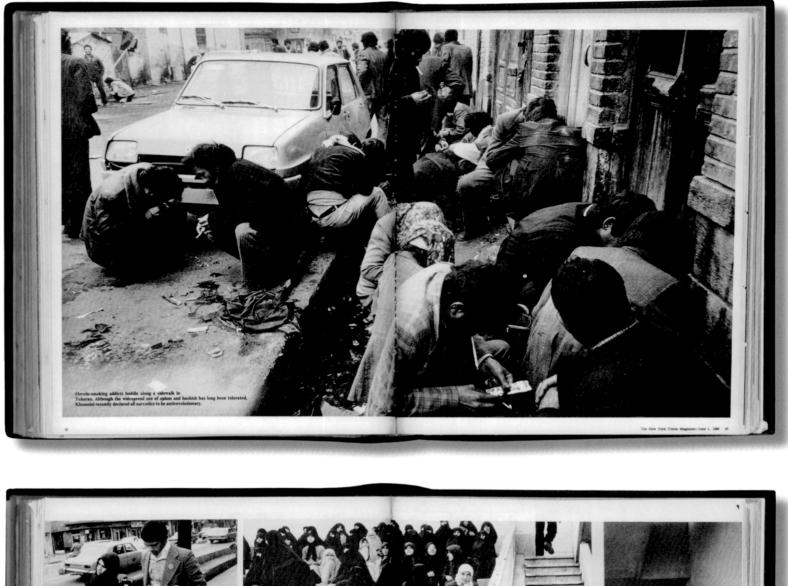

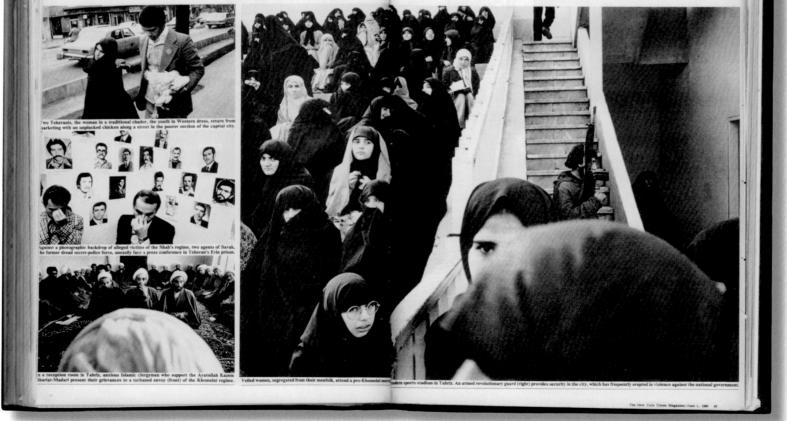

1980 ALAIN BIZOS SOLIDARITY ACTUEL

In 1980, Alain Bizos accompanied Jan, a young labour leader representing his factory, over two weeks of negotiations between the shipyard workers and the Polish government. The story published by *Actuel* takes the form of images arranged in sequence with conversational captions, in the style of a scrapbook or diary. We see the strike unfold from Jan's point of view, feeling the claustrophobia of strike headquarters, and enduring the tedium of waiting for news. The meeting with Lech Walesa, a hero to Jan, is a climactic moment in this choppy, episodic account when Walesa's charisma shines through. Bizos creates a particular feeling of authenticity with his snapshot style, at once awkward and spontaneous, and with his use of colour ironically emphasizing the harsh characteristics of ordinary environments. There is no suggestion of an objective summary of events here. On a subject where there are many competing points of view, it is the personal account that becomes the most reliable. (October 1980)

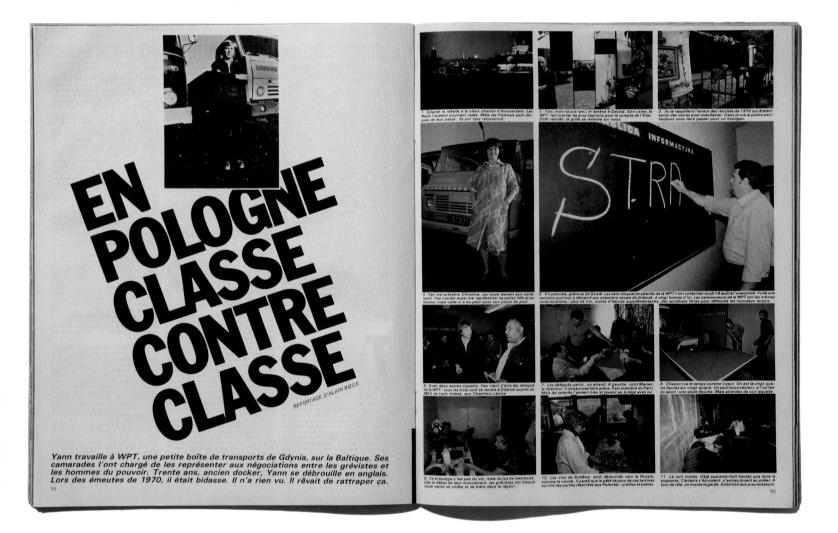

12. Le lendemain, je retrouve Yan et son camarade Zdzislaw parmi les familles de grévistes qui attendent devant l'énorme portail des Chantiers Navals Lénine.

13. «Viens voir notre grand leader]» dit Yan avec une pointe d'ironie. Voici donc l'incroyable moustachu qui fit tomber Gomulka en 1970 : Lech Valesa.

15. Les délégués viennent se présenter au micro en une queue ininterrompue : toutes les heures de nouvelles entreprises se mettent en grève. Au train où ça va, Yan et ses deux potes vont bientôt faire figure d'anciens. Ils en rient. Mais on s'inquiète : le téléphone ne marche plus. Gdansk est coupée du reste du monde.

17. J'ai discuté avec ces types : leurs têtes fonctionnent aussi bien que les mains du bricolo qui a fait la maquette. Ils craignent les Russes et la faiblesse de Gierek.

20. Les délégués, eux, foncent dans leurs usines pour tout raconter. Przemeck a pris des photos. Sitôt rentré à Gdynia, ses pellicules sont développées. 94

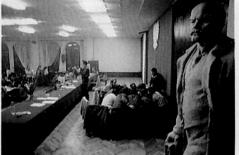

18. Vladimir Illitch Lenine détourne son regard courroucé du petit groupe des dix-huit qui mênent la danse autour de Lech Valesa depuis le début.

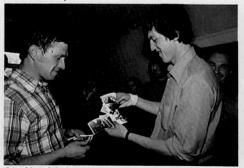

21. C'est fait. Les ouvriers se ruent sur les photos. A quoi diable peut bien ressembler une assemblée libre de délégués ouvriers ? J'ai du mal à m'y faire : c'est leur première grève.

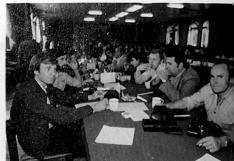

14. Dans la salle de conférence des Chantiers Lénine, Ye. Zdzislaw et Przemek ont mis un carton devant eux : « Entr prise WPT de Gdynia. » Pour eux, même cela est neuf.

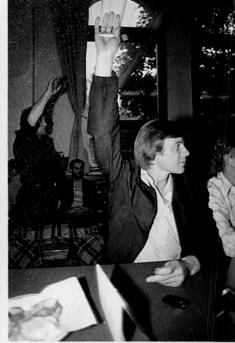

16. « Nous ne négocierons pas sans téléphone », annoncer les grévistes. « Ni sans radios : envoyez-nous des repo ters l » Lentement le pouvoir a cédé sur ces revendications

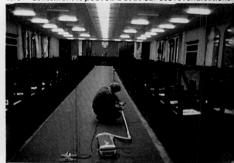

19. Une danse réglée : depuis combien de temps la grève s préparait-elle ? Dès que l'assemblée générale des délégué grévistes se termine, vers 21 heures, hop, on nettoie tout

22. La nuit tombe sur Gdynia, au bord de la Baltique. Ur autre longue veille commence. Je les bluffe un peu : « E France, nous avons une grève par jour ! » Ils en restent coix

YAN REND UNE RAPIDE VISITE A SA FEMME. ELLE NE VEUT TOUJOURS PAS DE MOI DANS LEUR APPARTEMENT. YAN MEN FAIT UNE DESCRIPTION: TRENTE METRES CARRES POUR EUX DEUX, LEUR ENFANT ET SES PARENTS A ELLE. LE JEUNE COUPLE DORT DANS LA CUISINE. PAS DE SALLE DE BAIN

23. Voici la fameuse et unique douche de l'entreprise WPT.

6. Ces deux-là à l'arrière d'un autre camion sous une âche. On est en août et pourtant ça caille dans la région.

9. Voici l'homme qui raconte les histoires les plus drôles. es camarades l'ont baptisé Le Poulet. A votre avis, passe-tréellement ses nuits entre les dents d'une pelleteuse ?

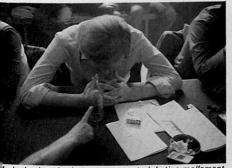

 Le lendemain, le gouvernement s'obstine mollement ans son refus de négocier. De retour à Gdansk parmi les dégués du MKS, Yan s'écroule de fatigue.

24. Mais ici en Pologne, malgré un sens de la combine assez développé, la plupart des ouvriers n'ont pas de douche chez eux. Ça reste un luxe.

27. Un quatrième a installé son lit au pied d'un établi. Comme ça au moins on ne volera pas d'outils. Mais pendant la grève, l'honnêteté est de rigueur.

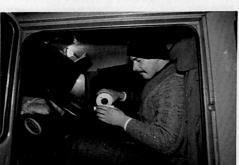

25. Bref, après s'être lavés sous l'engin que vous venez d'apercevoir, les camionneurs s'installent pour la nuit, chacun dans son coin. Celui-ci dans la cabine de son poids lourd.

28. Un mec dort sur un matelas prêté par l'hôpital voisin.

30. Un dernier dormeur et je m'arrête. Le bureau est un peu trop court pour lui. Pourtant il va s'endormir béatement comme un enfant. Et sans une goutte de vodka i Comment font-ils pour rester si calmes, quand chacun se demande si les chars russes ne vont pas débouler d'un instant à l'autre ?

32. Les ouvriers grimpent aux fenêtres pour regarder leurs délégués.

33. Le voici, l'éminent communiste. Il s'appelle Jagielski. Toutes les télévisions du monde ont filmé sa figure lugubre quand il débarque à Gdansk. 95

1981 EUGENE RICHARDS DORRIE'S JOURNEY AMERICAN PHOTOGRAPHER

Eugene Richards had trouble finding anyone willing to publish his photographic essay on Dorothea Lynch's three-year battle with breast cancer. Magazines turned it down as too gruesome, and as a subject of little interest to their readers. Their response masked the real problem; even as late as 1981, strong social taboos prevented the exposure of cancer, and its treatment, to public scrutiny. Breast cancer was the most forbidden topic of all – at the time of her diagnosis, Lynch had no idea what a mastectomy would look like. But *American Photographer* gave the story 14 pages and a bold layout, adding a 'backstory' about Richards himself. Dorothea Lynch was Richards' longtime companion – they later married – and his record of her treatment and recovery was in part a document of his response to and coming to terms with her illness. This story was among the first frank depictions of surgery and chemotherapy. Lynch survived another two years, and in 1986 Richards published the full story of her illness as a book, *Exploding into Life*, that became a landmark of a new kind of autobiographical photojournalism. (June 1981)

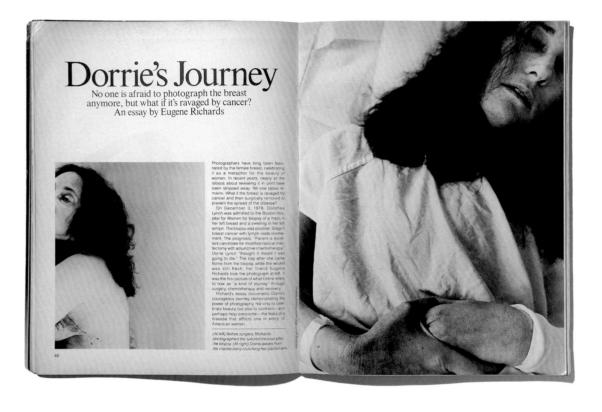

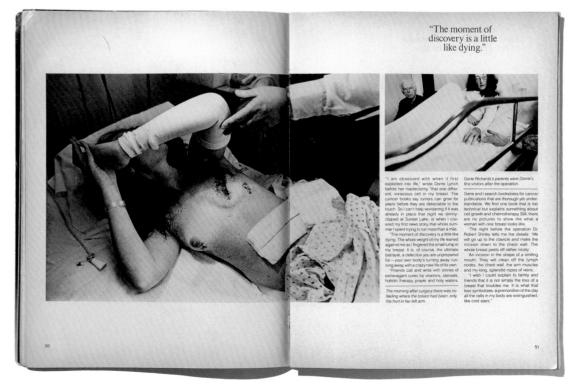

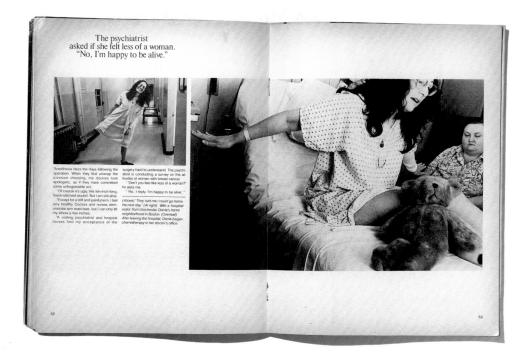

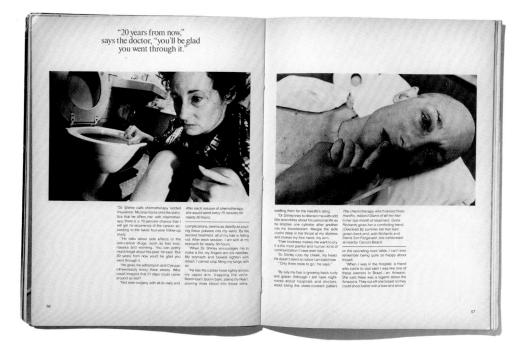

1981 MARY ELLEN MARK FALKLAND ROAD STERN

Mary Ellen Mark first saw Bombay's notorious Falkland Road, with its prostitutes in cages, on her first trip to India, in 1968. After several attempts to take photographs there – 'the women threw garbage and water and pinched me' – she returned ten years later with an assignment from *Geo*'s American edition. Her initial approach was simply to wait; Mark spent days sitting in cafés, pacing the streets – arousing much curiosity – before finally being invited by a madam into her brothel-room for tea. That meeting began a friendship, and Mark was soon able to photograph freely. The resulting photo essay contains many familiar elements of 'orientalist' fantasy, with the fact of its colour – it was *Geo*'s editors who wanted the story in colour – breaking with traditional documentary representations of this kind of subject. The story brings readers close to a way of life that is alternately fascinating, repulsive, sensual and disarmingly affectionate. When Mark returned home, *Geo* considered the pictures too raw and disturbing for its American audience, and declined to publish. The same was not true for Germany, where the story was avidly picked up by *Stern*. (9 September 1981)

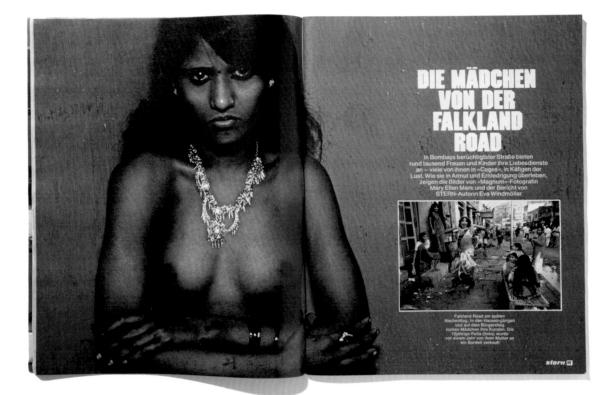

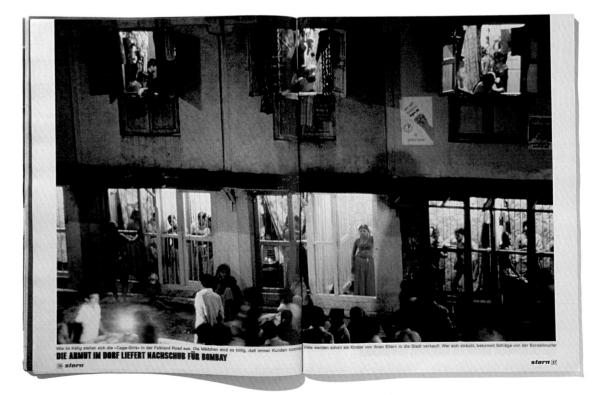

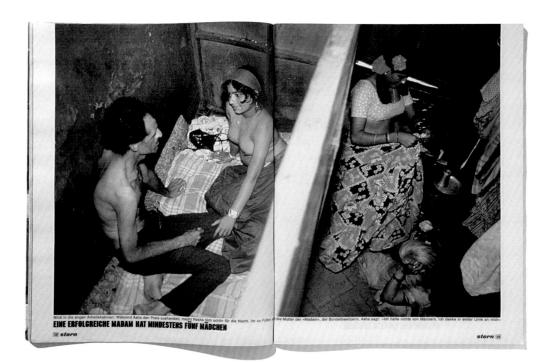

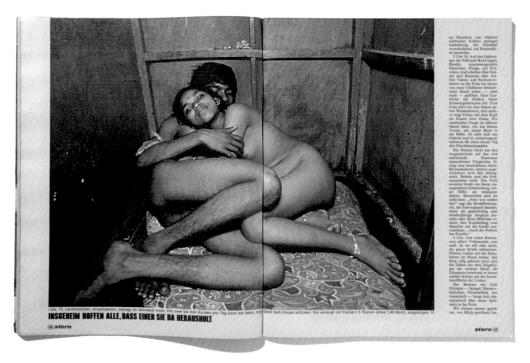

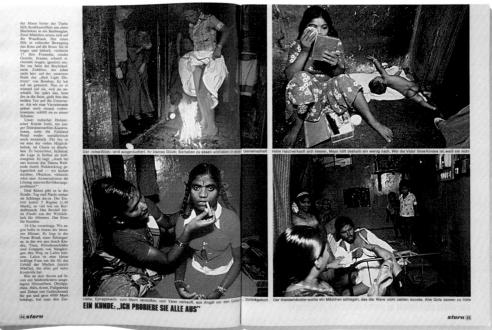

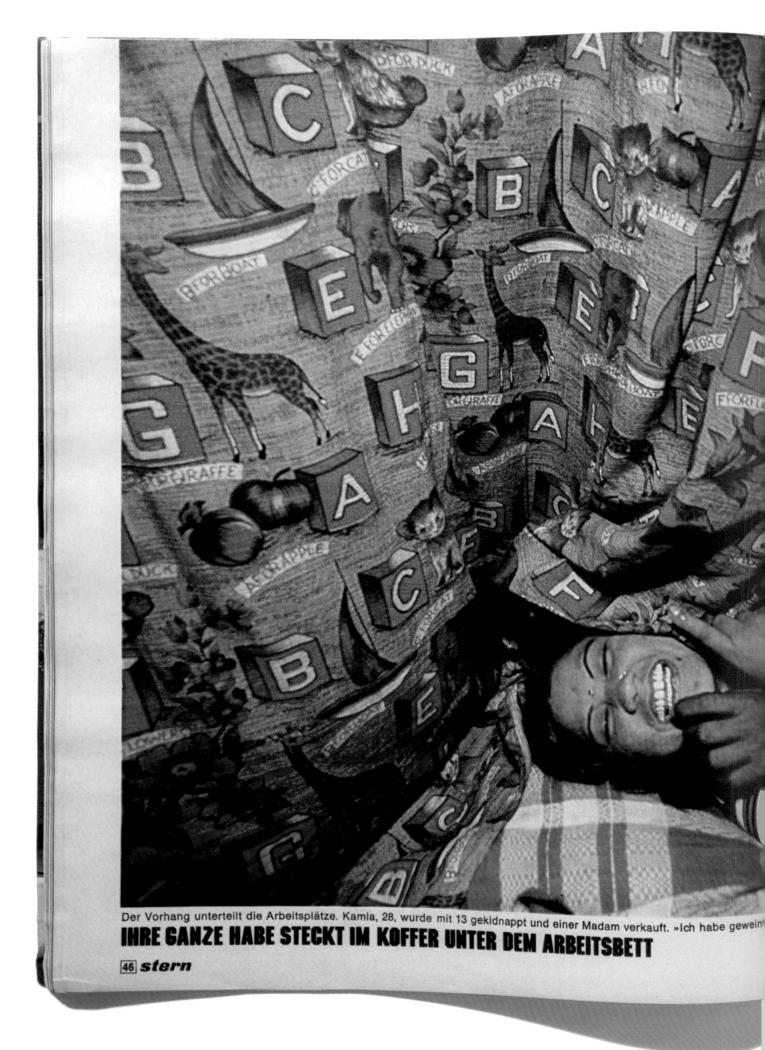

weint, aber dann mußte ich Make-up auflegen und anfangen.« Sie hat jetzt einen Freund

druck, daß der Laden läuft. Lalita liebt die hingelagerte Körperhaltung auf Decken und Kissen. Sich nicht bewegen zu müssen bei der Hitze ist nicht nur angenehm. Es gehört auch zu ihrem Status, andere für sich springen zu lassen.

Für Lalita springen zwölf Mädchen. Lalita ist — wie jede gute Madam — herrisch und zugleich mütterlich. Die Mädchen fühlen sich abwechselnd als Sklavin und als Tochter. Die Fotografin Mary Ellen Mark war Zeuge, wie eine 13jährige von einer anderen indischen Madam geschlagen wurde, weil sie von einem Betrunkenen zu wenig Geld genommen hatte. In der Nacht umarmte sie ihre Herrin, massierte ihr den Rükken.

"Wenn ich ein Mädchen schlage", hat jene Herrin gesagt, "muß es fünf Minuten später wieder bei der Arbeit sein. Mit fröhlichem Gesicht."

Zwölf Mädchen zu haben ist viel. Die Norm liegt zwischen drei und zehn, fünf gilt als guter Durchschnitt. Lalitas Mädchen stehen kichernd an der Wand aufgereiht, laufen für Wasser, Tee, Curryreis und Betelspuckschale nach hinten. Die Jüngste mag 15, die Älteste 22 sein, viele wissen ihr Alter selber nicht. Schreiben und lesen kann keine von ihnen (Analphabeten-Rate in Indien: 65 Prozent der Bevölkerung).

Lalitas Mädchen sind die teuersten in dieser armen Gegend. 25 Rupien (7 Mark) kostet hier der Bordellbesuch, 150 Rupien eine ganze Nacht, 300 Rupien das Mieten eines Girls außer Haus. "Manche Kunden", sagt Lalita, "wollen ein Girl nicht für Sex, sondern zum Reden oder fürs Kinogehen. Das kostet 30 Rupien. Aber ich lasse sie nie alleine gehen. Ich schicke immer einen Aufpasser mit."

Lalita läßt ein Tablett mit scharfem Curry bringen und rollt ihn mit flinken Fingern in dünne Brotfladen, aus denen die Soße tropft. Sie schiebt uns die Fladen, da gibt es keine Widerrede, in den Mund. Sie schmecken ausgezeichnet.

20 Kunden hat Lalita täglich, macht 500 Rupien, mindestens. Ein Arbeiter im

stern 47

1981 RAYMOND DEPARDON NEW YORK DIARY LIBÉRATION

Raymond Depardon's career maps the spectrum of photojournalism, from his beginnings as a teenage paparazzo, to becoming a leading international news photographer (and founder of the agency Gamma), to his success as a documentary artist and film-maker. His New York diaries mark a significant break between two phases of his career. Feeling confined by the treadmill of photojournalism within Gamma, he moved to Magnum in 1978. As he sought a new direction, he went to New York for the summer of 1981, as a place to think – as a non-English speaker, he compared the experience to that of being a recluse in the desert. He had the support of a bold assignment, to file his daily observations to *Libération*. Behind the published musings on the street life of the city, in pictures and words, was a soul-searching reflection on his professional role and identity. New York made him see things differently, and it was there that his future path became clear: he would make a film about the Sahara desert and to go back to his parents' farm in France. The desert and the farm became the two major themes of the next 25 years of his work. (8, 9 & 27 July, 5 & 8 August, 1981)

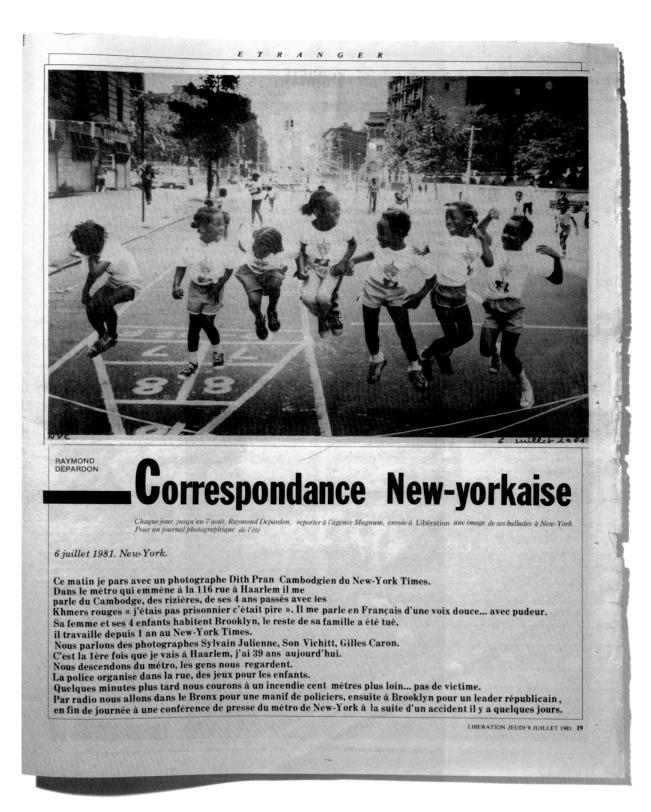

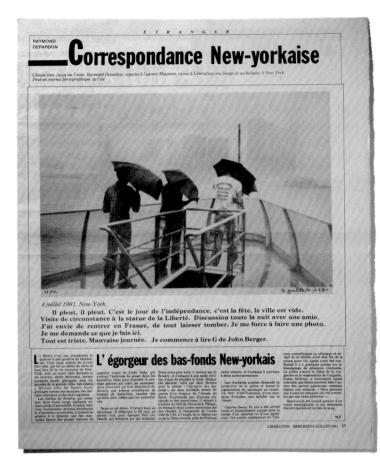

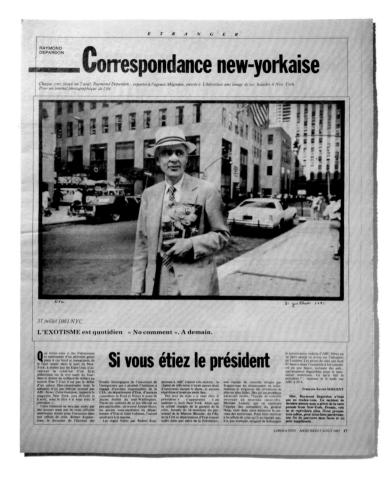

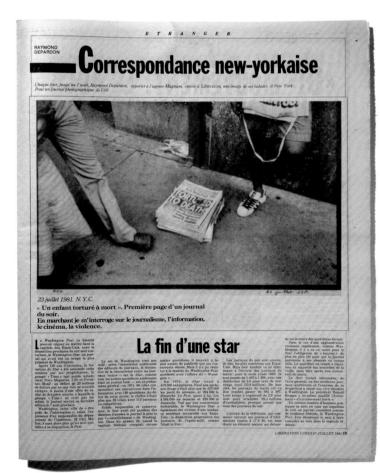

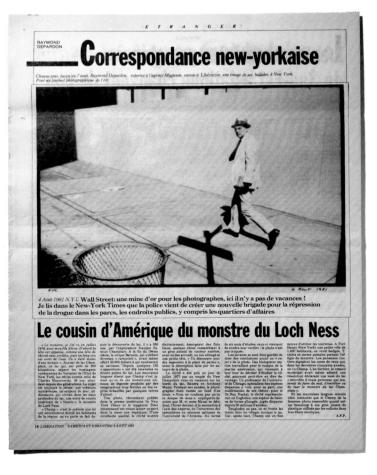

1984 BRUCE WEBER OLYMPIANS INTERVIEW

Throughout the summer of 1983, Bruce Weber travelled across America with a collapsible tent studio and a crew to photograph around 250 athletes preparing to compete in the upcoming XXIII Summer Olympic games in Los Angeles, for a 90-page portfolio in *Interview*. Weber compared the journey to a rock tour, full of long delays but with moments of great exhilaration. He saw his subjects as beautiful misfits, made different from the rest of us by their talent and drive. He shot them in a style that deliberately recalled the Olympians of 1936 as photographed by Leni Riefenstahl, although perhaps most 1984 viewers would have been more reminded of Weber's advertising photographs for Calvin Klein that dominated public spaces at the time. His advertising, fashion and celebrity portraiture balanced the influence of the prewar avant-garde with a sensual feel-good hedonism. This perfectly matched the iconoclasm of Warhol's *Interview* magazine, which defined a new journalistic territory with its mixing of celebrity gossip, social satire and acute documentary reporting. (January/February 1984)

Carl Lewis

by Carolyn Farb

At 21, Carl Lewis may be the greates track athlete of all time. A master of the long jump, with a personal best of 28'9" Carl is the only man to have approaches Bob Beamon's still unbroken 1968 recors of 29'24". Actually, Carl has cleared over 30°, but the jump was disqualified over of 10°.

much-disputed marginal foot fault. A phenomenal sprinter, Carl Lewis speeds through 100 meters in 9.96 seconds and covered that distance faster than anyone in history in the final leg of the 4.500 meter relay at last year's Helsinki games. Videotapes show his time to have been an amazing 8.9 seconds.

Carls uso netward at tecora in the 200-meter dash. As the J983 T.A.C. (The Athletics Congress) meet, the exuberant runner, anticipating his victory, threw his arms up in the air, pulling back slightly as the broke the tape at the finish line. His elation cost him a world record by J100th

A patriotic, born-again Christian, Carl is only one of a family of outstanding athletes, including his younger sister, Carol, the United States women's long jump champion. Carolym Forth space with Longie in the

library of her Texas home, later continuing the conversation at the University of Houston track where "the best American athlete since Jesse Owens" trains.

CAROLYN FARB: You and Mary Decker are strangely compared to one another. CARL LEWIS: 1 think that Mary and 1 are linked together because we're somewhat unique. I am somehow in a position of following a hero in Jesse Owens and Mary Decker is something of a darling. CF: How do you renin?

CL: I train rather differently. I guess, because I spend two hours ad yon rit, eleven months a year. I train as a sprinter and a long jumper, so it is a very intricate but very interesting type of workout schedule. I usually work two days a week on my sprinting and two days a week on my didn't do as well in that week. *CF: How do you know when* you do well?

something you feel? CL: It's something 1 feel, basically, because 1 think when a person does well at anything he tries, he feels a personal satisfaction. They realize they really worked hard for it and it's something they can recognize

Cr. 15 miler a special way you menially perpary sources [for a race? CL. 1 might be a little more low-key than most. I've never been the kind of person who has had to sit down and ponder the situation to psych myself up. 1 just feel a confidence in competition that comes from training well and having a good idea of what I'm doing. I have a sense of confidence because I've worked hard and I have a peace of mind and ease about competition so I down't have any secrets or do

CF: Do you look at your body as if it were a finely tuned machine? Do you have a little mental check-out that you do?

CL: 1 do in competition. Mainly because the programmed of the second second second second second how hard you work and how well you CF. This work will be the second second second second second how have to mentally check yourself and CL. The second an idea of all the areas you want to step the most be ready to ob-marker of things you sant movied in That way you can keep the visuit body as finely unced as possible. vess the encouragement came from inst. They started a sports program wr where I'm from in New Jersey, y gave me the opportunity to start and field. My sister Carol and J got program as the years went by it a situation where they pushed. I we wret a little reluctant to get us a mainly because they were a flatted of the start and and because they were a flatted of the start mainly because they were a flatted of the start and and the start of the start of the start mainly because they were a flatted of the start and the start of the start of the start of the start and the start of the start of the start of the start and the start of the start of the start of the start of the start and the start of the start of

They taken I want you to be disaputed, perhaps. Exactly. They maybe held us back a e at the beginning, but Carol and I kept hings and pushing and they just opened hings and let us get involved. *They* in back concluse reme's they?

hools now. I remember one particular at when a meet was going on and it was reported to the second second second second ratio with my father's team leading by point, and it just started to pour out of where. They had to postpone the rest of meet until the following Thuroday. We re sitting in the house with my parents rival coaches. There were no dinners sked.

wit' you have any? Li don't have a lot and I'm involved in addor/Television at the University of addor/Television at the University of meeting and a some of the sports activities meeting and a some of the sports activities with the next and there. I advertise for the first hore and there. I advertise for the set of Japan and BMW of America so that are mere you and little things I doeaking engagements and intervives like scelar dystophy. ...millions of thingsnacellar dystophy. ...millions of thingsthe set of the sport and the sport and the set of the sport and the sport and the sport of the sport and the sport and the sport of the sport and the sport and the sport of the sport and the

> tian organizations. (i) you have a lot of fan worship? and I think one thing is that I come the pical situation. I was in sports at a ung age. Most people say that if at at six or seven you burn out and pits public at the seven you burn out and

e of program and 1 went from noowhere 1 am right now. Until high ers was a small athlete, scrawny and a Omer. By being that way, 1 was able an oth sides of the coin. My sister was not sides of the coin. My sister was at different. She was always utin the s, always won, always the best. I ally the opposite. I think 1 was cypical in that respect, and that's in sple can relate to me—I always let supple can relate to

and say you're very easy to know and now id be good at anything you did. Coach Doollite described you as an "arist"— Doollite described you as an "arist"— CL: Of course, I take it as a compliment cause anyone who is respected must save a tremendous amount of confidence of a anything active as well as a lot of fisicipline and a lot of concentration. So I discipline and a lot of concentration. So to poper taming under them and always tothen along very well with them. To how other along very well with them.

> ng. ng. ng. t is the difference between a hard a long distance runner? c difference, of course; is meet e -sprinters are just not born with CL: Y ta. There are different types of bers in the body called "fast same a task of the state of the state

called "fast fast twitch are players, track 86 86 Slow faster. It's like a cycle. The perperior in gets to the ico prmat keep and experiment of the star of the star of the star when they get to a point or an infinite they can't improve anymore, takes step down and someone delations of the star way that the star of the star in the star of the star of the star of the star in the star of the star of the star of the star of the star in the star of the star in the star of the star of

in scholarship money. Let's up ig more down. My more and board and in the paid for and 1 get 520 amonth is even and board and its price full checked was that the paint of the second second second that the paint of the second second second second that the paint of the second second second second that the paint of the second second

Coulds. the running community? to other L. "Use, the running community is to be a set of the the set of the the university pays on. That we have the set of the set of the set of the set of the could get the set of the the set of the the set of th

> end wersites and run amateur. Once they't use wersites and run amateur. Once they't leave track and field and join backball. They're starting to become younger and byounger, and now footabli is going to start younger, and now footabli is going to start to the N.C.A.A. is going to have to may change their rules or they'll lose too many theters.

> b) stered controvery, Of CL: think the philosophy laws it that, when I was young, I was expect or sterevist, has its 7d heard about them. When I was out of high school 1 heard taw What is thir? The coach tool and the hai my event, it deals it may a start of the deals of the high school and the hai my event, it deals it may a start of the deals that the high school and the hai event, it deals it may a start of the deals that the high school and the hai event, it deals that the school and the deals that the high school and the second of the high school and the provide the school and the school and a little his trace, host you it has the make mistakes anywy. I deal results for help that much. But, as itsued before, if someone decise to take started is that if a someone decise to take started is the school and any school and the school and school and the school and school and school and the school and sch

think it's right or good but....
CF: You're not sitting in judgement.
CL: Exactly. Anyone can do what they
want to do. Who am I to indee?

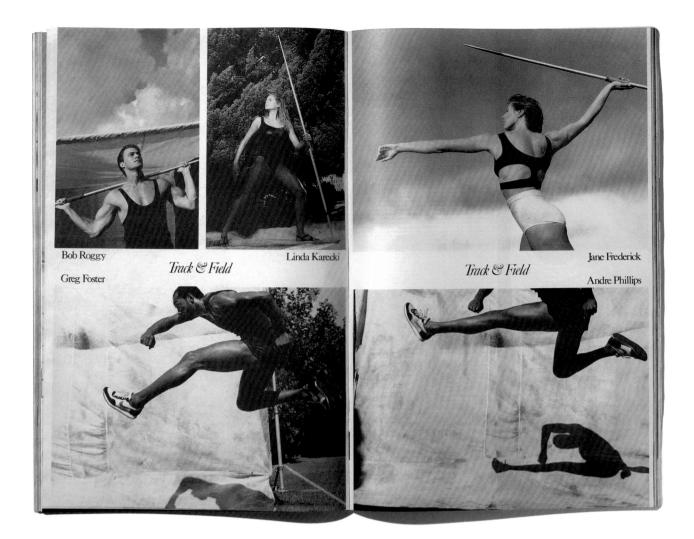

Greg Louganis

by Scott Cohen

<section-header><section-header>

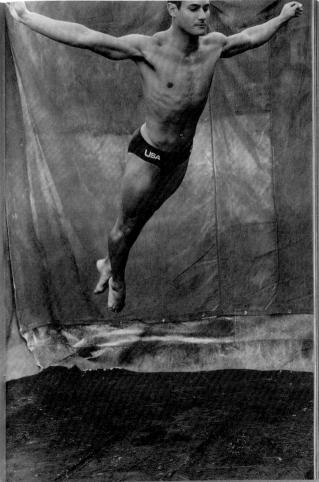

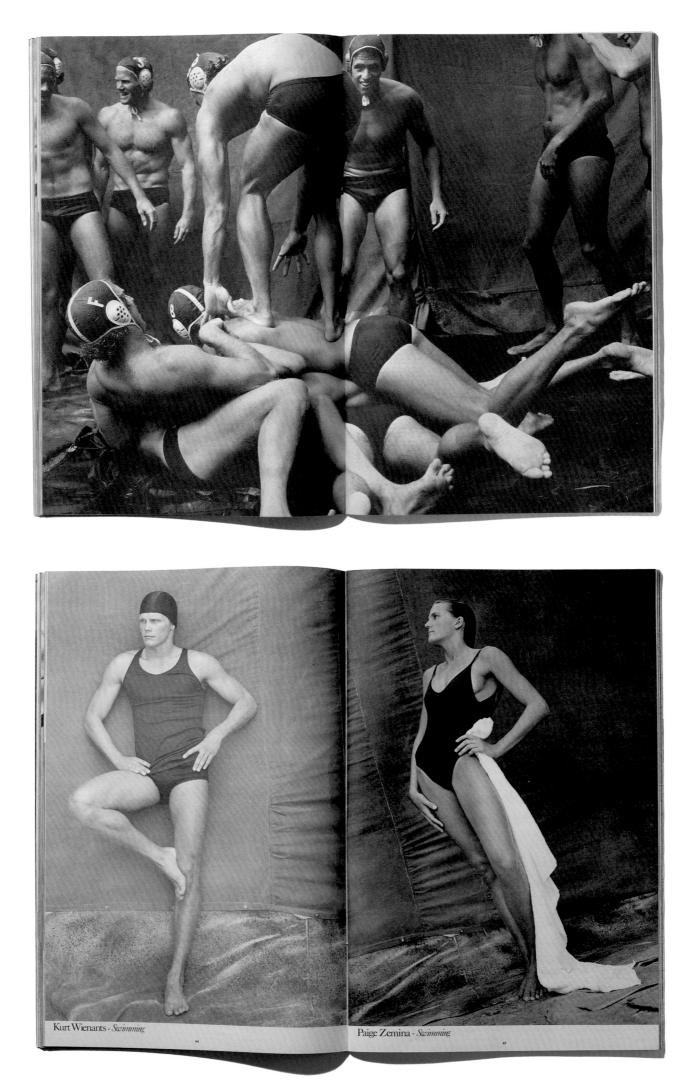

1984 VERA LENTZ SOCCOS MASSACRE KONKRET

Peruvian photographer Vera Lentz photographed Peru's internal conflict – between the Shining Path, other revolutionary groups and the government's counter-insurgency forces – from the early 1980s, seeking to document some of the rarely reported civilian atrocities. Her photographs-as-evidence are examples of a particularly brave campaigning journalism; working as a photojournalist here was intrinsically dangerous, with those enquiring into government-sponsored atrocities regularly joining the lists of the murdered or missing. Her story, published anonymously and modestly in the German magazine *Konkret*, investigates a massacre that took place in Soccos, in the Ayacucho region of the Andes, showing the excavation of the mass grave of 34 members of an Indian family gunned down during a wedding celebration. Eleven members of the Civil Guard were later convicted of their murder. With the end of the civil war, Lentz became a leader within the Movement for Truth and Reconciliation; a Commission was established in 2002, after which these photographs were finally exhibited and published within Peru. (3 March 1984)

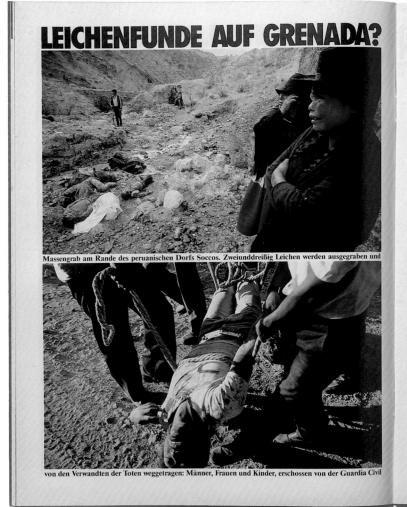

eldungen nach dem Überfall (f Grennda, die US-Marines titten Massengrabber entdeckt) ist bis heute unbekannt, wer ses Lüge in die Well gestetzt it. Warum sie geboren und in amerikanischen Journalien für wahr gehalten werden nnte, erklären diese Bilder. es faanmen aus einem jener atten Lateinamerikas, mit den Regierung die USA einver-

Am Abend des 13. November Af eierte ein indianische Familie in dem peruanischen Dorf Soccos ein Yaycupacu, eine Verlobungsfeier. Plotzich erschien eine Gruppe Sinchis, Polizisten der Guardia Civil, Am Tag zuvor hatten die Polizisten den Indios ein Rind gestohlen und es geschlachtet. Nun luden sie sich bei den Bestohlenen zum Feiern ein

Als die unfreiwiligen Gastgeber es wagten, über den Vichdiebstahl zu sprechen, war die Feier zu Ende. Mit vorgehaltenem Gewehr trieben die Polizisten die Gäste aus dem Haus. Männer, Frauen und Knider. Zumichst ginge zum Hauperugartier der Polizei auf dem Männern und Frauen Handfesseln angelegt. Dann wurden sie vors Dorf geträchen. Für einige Zeit wurden Männer und Frauen getrennt. Vas in dieser Zeit mit den Frauen geschahl, ist unbekannt. Schließlich trieb die Polizei wieder alle zusammen, zweiunddreißig Menschen.

Sechs Tagespäter, am 19. November, erschien ein Untersuchungsrichetr am Ort der Tat. Es dauerte fünf Stunden, bis alle zweiunddreißig. Leichen ausgegraben waren. Alle waren zuerst erschossen und dann zugeschüttet worden.

wirde, war die einer jungen Frau mit ihrem sechs Monate alten Kind, das sie auf dem Rucken getragen hatte. Die Ärzte begannen mit der Autopsie, Verwandte der Toten rugen die Leichen in Tachern ins Dorf. Eine der letzte Toten, die gefundem wirden, war eine schwangere Frau im achten Monat. Die Kugel, die die Mutter tötete, hatte auch den Foetus getroffen. Es wäre ein Mädchen geworden. Requisesat in pace

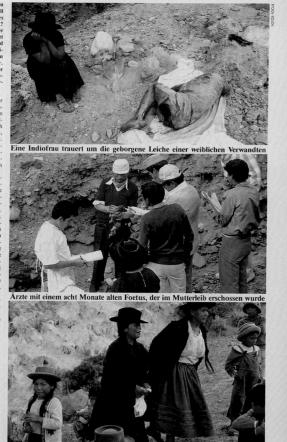

rige der ermordeten Indios am Rande des

1984 RAGHU RAI BHOPAL INDIA TODAY

Raghu Rai began work as a photojournalist in the mid-1960s on the staff of the New Delhi paper the *Statesman*, and established his reputation as India's foremost current affairs photographer in the following decade. It was while director of photography at *India Today*, the leading news weekly published in English and Hindi, that it fell to Rai to address the massive explosion at the Union Carbide chemical plant in Bhopal on the night of 3 December 1984. He arrived in the city at daylight on the following morning, before the enormity of the disaster had become clear. Lethal toxic gas had filled the city, killing 3,800 people immediately, with thousands more permanently injured. Rai witnessed the chaos of the first response to tragedy, with hospitals crammed with sick and dying, and rescue workers grimly searching the rubble and gathering the dead for burial and cremation. His methodical coverage balanced heartbreaking details with panoramas conveying the scale of the disaster which *India Today* ran throughout the magazine between its text commentaries and analysis. Rai's photographs have become the documents of record, and tools in the ongoing campaign for compensation for Bhopal's victims. (31 December 1984)

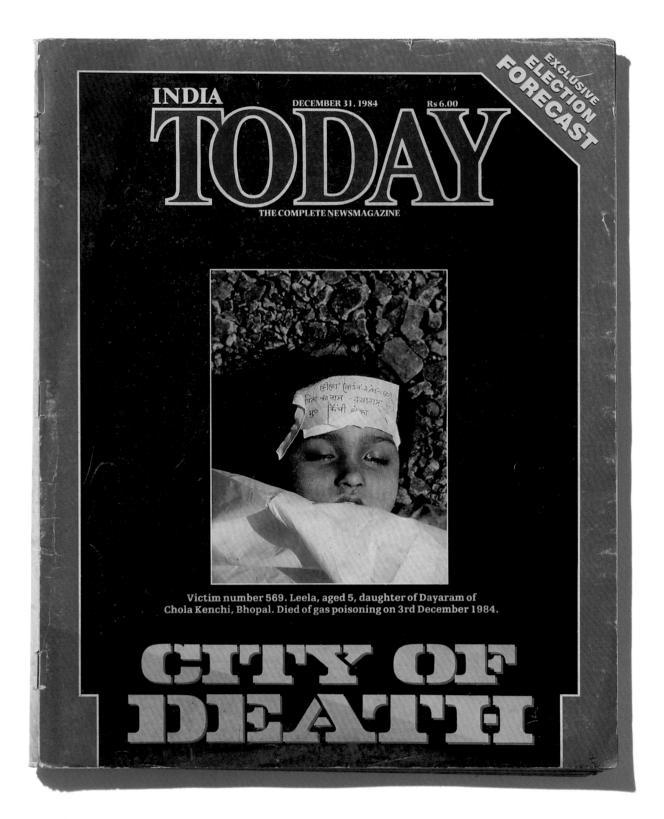

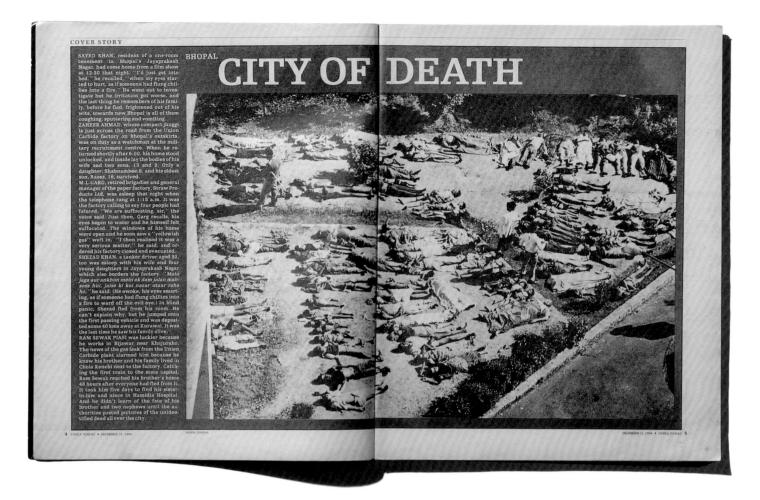

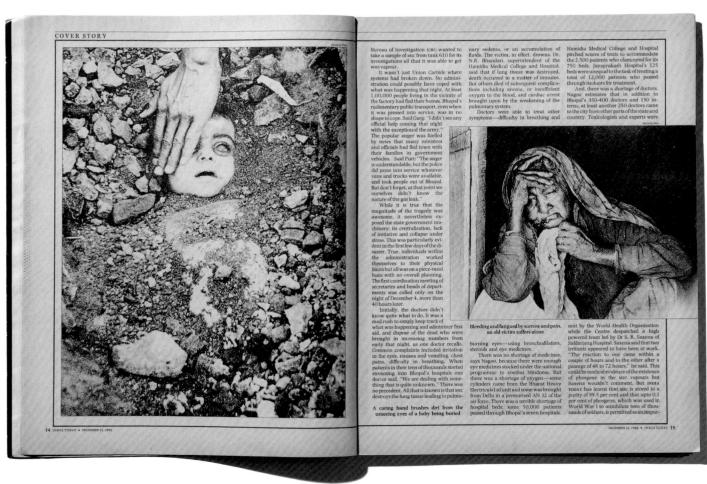

1985-1994 NEW WORLD ORDER

neen « manuuunen ueunas anan 243 SEBASTIÃO SALGADO SERRA PELADA 243 DONNA FERRATO DOMESTIC VIOLENCE 246 BERND HOFF STAMMHEIM 7TH FLOOR 250 ALON REININGER ANDS IN THE USA 252 1985 ERIC VALLI HONEY HUNTERS OF NEPAL 254 1985 Enu VALUI AUREL AURIENDUR AERDUR EN SOUARE 256 PATRICK ZACHMANN TIANANMEN SOUARE 26 1987 FALL OF THE BERLIN WALL PARIS MATCH 258 1987 MIRE ABRAMANA LEAU JEJEU J LEURINE 200 ANTONIN KRATOCHVIL POLILITION IN EAST EUROPE 264 ERULU UT ARE BERUN WANN FRANKS PURA 260 TRANS GERUSESGU'S LEGACY 260 MIKE ABRAHAMS 1987 1988 AN LURIN ARALUURINA FUMAU ANUN AN ARAU 266 KILLING THE CHICKENS 1988 1988 1989 AND-JURUEN DURINARU DUVIEL MARIA 213 DANE EVELYN ATWOOD RUSSIAN WOMEN'S PRISON 278 rnuurre puungeuwen enur uun ur ma 274 FANS-JÜRGEN BURKARD SOVIET MAFIA 1989 19⁹⁰ 1990 1990 WOLFGANG TILLMANS LOVE PARADE 282 1991 1991 1991 ALFRED SEILAND NEW ENGLAND 29D 1992 1992 1992 BRUND BARBEY FES 292 1993 1993 1993 1994

1985-1994 NEW WORLD ORDER

The twentieth century seems to come to an early close with the fall of the Berlin Wall, the end of Apartheid, and the handshake of Yitzhak Rabin and Yasser Arafat on the White House lawn. As the Soviet Union dissolves, a new and better post-Cold War order is proclaimed. New democracies arising out of the embers of Communism give cause for optimism, but are short-lived as the world descends rapidly into new wars and revived ethnic conflicts. Chinese students launch a democratic revolution on live television - and are shot down. Croatia's war of independence against the Yugoslav state signals the start of ten years of brutal conflict in the Balkans. An American-led assault on Iraq following Saddam Hussein's invasion of Kuwait demonstrates a new generation of technological weaponry and a new style of media war. Mass ethnic violence erupts in Rwanda, exposing as hollow the slogan that the world would 'never again' allow genocide to take place while it watched. A colossal famine ravages Africa's Sahel. The turning of world events seems to offer photojournalists a myriad of storylines, with more magazines filling more pages with more stories than ever. But the media's focus is moving steadily away from uncomfortable subjects, into the cosy retreat of celebrity chat. Along with rapid technological change, shrinking magazine budgets and the beginning of consolidations and closures in the industry, photojournalists face a new order of their own. But Sebastião Salgado becomes photojournalism's first global star, offering his peers a new model for engagement.

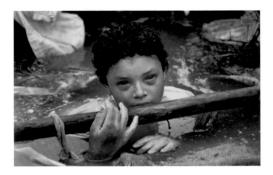

FRANK FOURNIER Contact Press Images

Twelve-year-old Omayra Sanchez trapped in the debris caused by the eruption of Nevado del Ruíz volcano. After sixty hours she eventually lost consciousness and died of a heart attack. Armero, Colombia, 16 November 1985. World Press Photo of the Year 1985

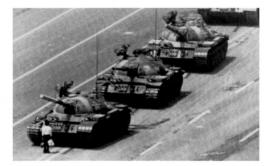

CHARLIE COLE Newsweek Demonstrator confronts a line of People's Liberation Army tanks during Tiananmen Square demonstrations for democratic reform. Beijing, China, 4 June 1989. World Press Photo of the Year 1989

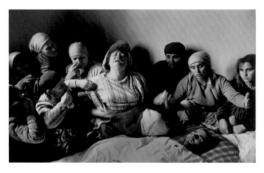

GEORGES MERILLON Gamma

Family and neighbours mourn the death of Elshani Nashim (27), killed during an Albanian nationalist protest against the Yugoslav government's decision to abolish the autonomy of Kosovo. Nogovac, Kosovo, 28 January 1990. World Press Photo of the Year 1990

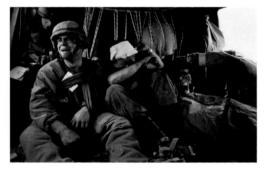

DAVID TURNLEY Black Star/Detroit Free Press US Sergeant Ken Kozakiewicz mourns the death of fellow soldier Andy Alaniz, a victim of friendly fire on the final day of fighting in the Gulf War. Iraq, February 1991. World Press Photo of the Year 1991

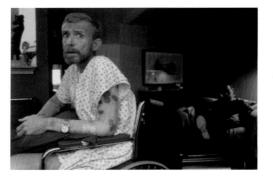

ALON REININGER Contact Press Images

Ken Meeks' skin is marked with lesions caused by Aidsrelated Kaposi's Sarcoma. San Francisco, USA, September 1986. World Press Photo of the Year 1986

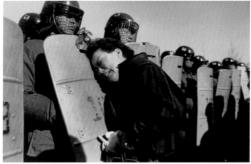

ANTHONY SUAU Black Star

A mother pleads with the riot police after her son is arrested at a demonstration accusing the government of fraud in the presidential election. Kuro, South Korea, 18 December 1987. World Press Photo of the Year 1987

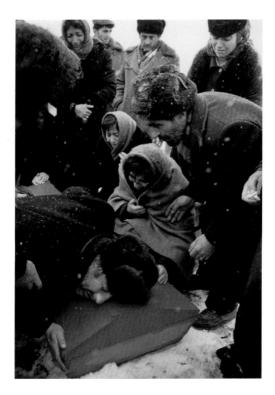

DAVID TURNLEY Black Star/Detroit Free Press Boris Abgarzian grieves for his 17-year-old son, victim of the Armenian earthquake. Leninakan, USSR, December 1988. World Press Photo of the Year 1988

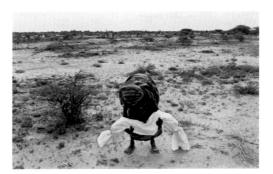

JAMES NACHTWEY Magnum Photos/Libération Mother lifts up the body of her child, a famine victim, to bring it to the grave. Bardera, Somalia, November 1992. World Press Photo of the Year 1992

LARRY TOWELL Magnum Photos Gaza City, Palestinian Territories, March 1993. Palestinian boys raise their toy guns in a defiant gesture. World Press Photo of the Year 1993

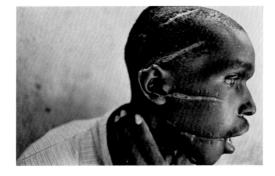

JAMES NACHTWEY Magnum Photos/Time Hutu man mutilated by the Hutu 'Interahamwe' militia, who suspected him of sympathizing with the Tutsi rebels. Rwanda, June 1994. World Press Photo of the Year 1994

1985 SEBASTIÃO SALGADO FAMINE IN THE SAHEL LIBÉRATION

Sebastião Salgado first came to the Sahel in 1984 to make photographs for Médecins Sans Frontières (who were bringing world attention to the refugee crisis in the Horn of Africa), and for *Libération*. Over 2.5 million refugees had left homes in Chad, Ethiopia, Mali, southern Sudan and northern Somalia in order to escape the combined effects of drought and local unrest, and in the course of Salgado's coverage, the situation worsened into a severe famine. Already a highly regarded current affairs photographer, it was with this project that Salgado found a new ambition in his work and developed his signature style – what Christian Caujolle, then *Libération*'s picture editor, has called 'epic ... almost biblical' in its employment of majestic compositions to convey great human suffering. Salgado's emblematic images were suited to *Libération*; although rough newsprint could not easily render minute detail, the tabloid format and the newspaper's graphic sophistication gave them power and authority. His work aroused controversy – some critics argued that his gorgeous aesthetic was inappropriate for the subject matter, inducing passive admiration in his viewers rather than enlightenment or action. Popular response has been quite different – the images drew large, enthusiastic audiences wherever they appeared. (24 January, 16 April & 21 August 1985)

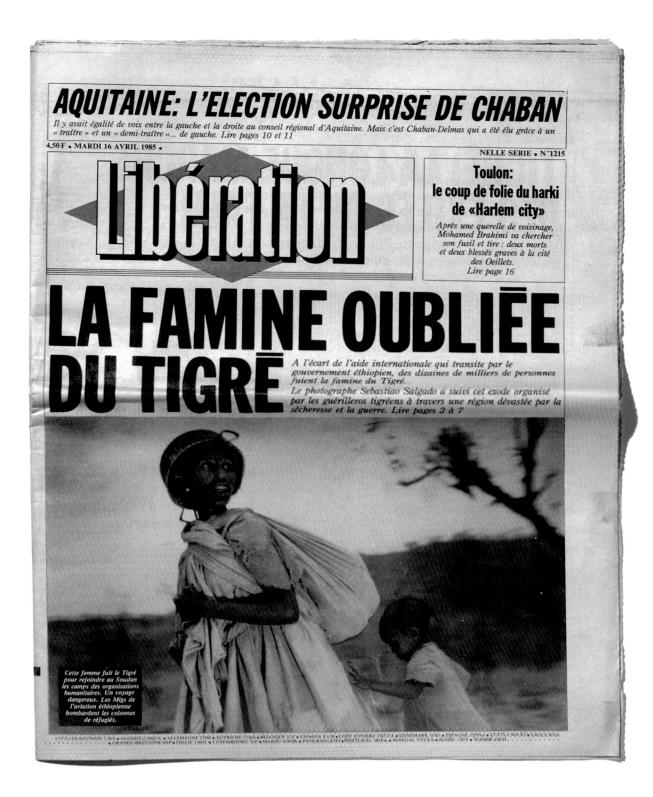

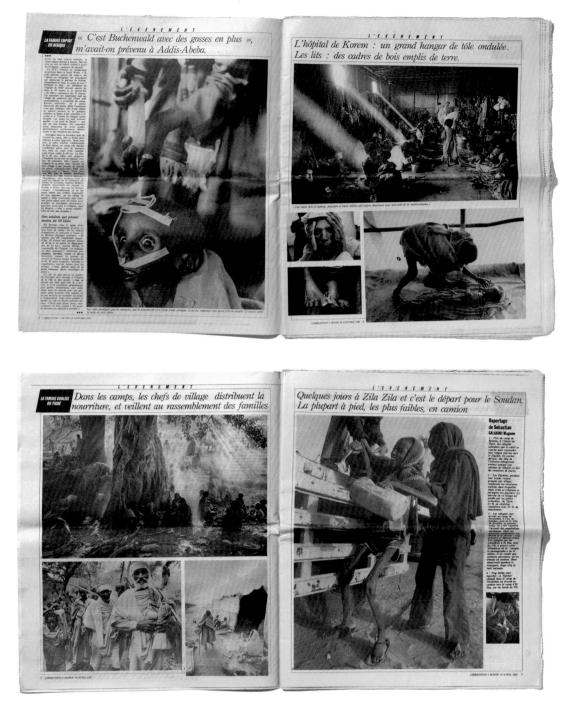

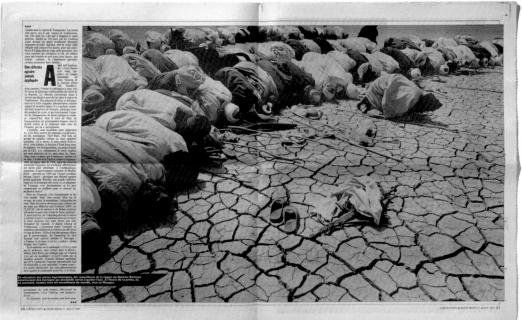

1985 REZA & MANOOCHER DEGHATI IRAN IRAO WAR LIBÉRATION

Five years after the start of the Iran Iraq War, *Libération* commissioned a photo essay from Iranian Paris-based photographers Reza and Manoocher Deghati. (The brothers' dissident activities inside Iran led them to work under their first names only.) Rather than engage with the geopolitics of the region, their reportage looks at events from the viewpoint of the individual soldiers and their families. This is war reporting from a distinctly contemporary perspective – the photographers have not flown in to cover the action as detached voyeurs but understand the language and culture of the area and are engaged with its issues on personal terms. At a time when the West viewed the Iranian religious revolution with deep suspicion, and treated the whole inaccessible region as an oriental mystery, *Libération*'s approach was both brave and practical. Twenty years later, in 2001, Reza and Manoocher established Aina, a photo agency and school in Kabul to train Afghan photojournalists to tell their own stories, to give 'local actors access to new technologies [and to promote] the emergence of independent media ... where democracy is still fragile'. (14 February 1985)

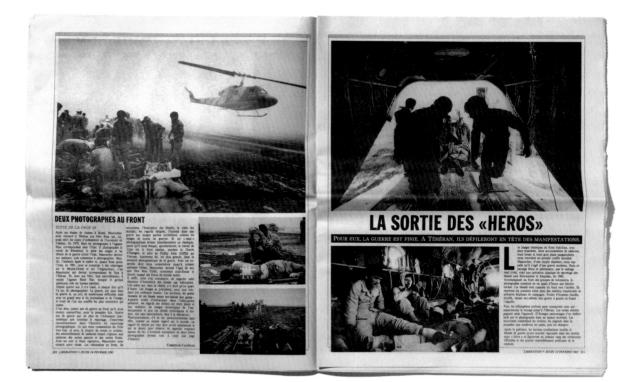

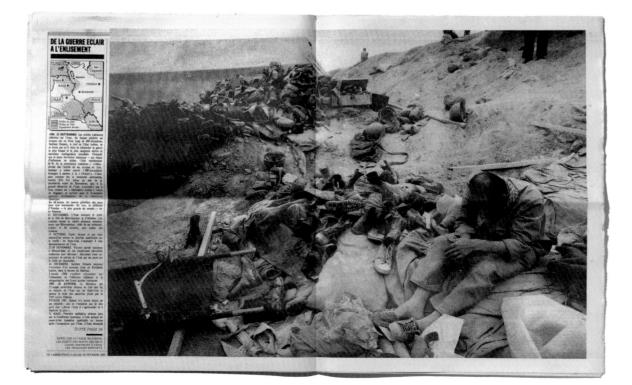

1987 SEBASTIÃO SALGADO SERRA PELADA SUNDAY TIMES

Much is made of the fact that Brazilian-born Sebastião Salgado trained and worked as an economist before becoming a photographer in 1973. And with good reason: his survey of 'Workers' around the world – of which 'Serra Pelada' was the first instalment – is dramatic visual evidence of a global economy dependent on cheap raw materials and cheap labour. His depiction of the open cast strip mining of Bald Mountain, in the heart of the Amazon, offered access to a complex story about local and national politics, ecological damage, world bullion markets, debt repayment and the relations of freelance prospectors to the large mining companies. The photographs seared into the public imagination, inviting comparisons with Hieronymus Bosch's and Dante's visions of hell, and the story's publication around the world (first in the *Sunday Times* magazine) made Salgado the era's first global star of photojournalism, helping to renew public interest in photojournalism generally. Also, the manner in which he developed and marketed the 'Workers' project thereafter, with each instalment a chapter within his broader story and the whole made available within multi-chapter magazine contracts, offered independent photojournalists a new model of practice that was widely imitated. (24 May 1987)

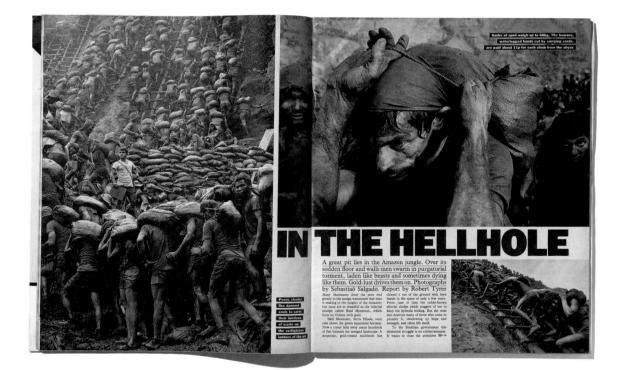

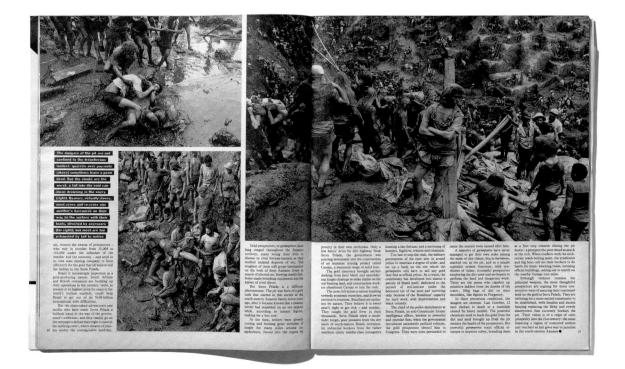

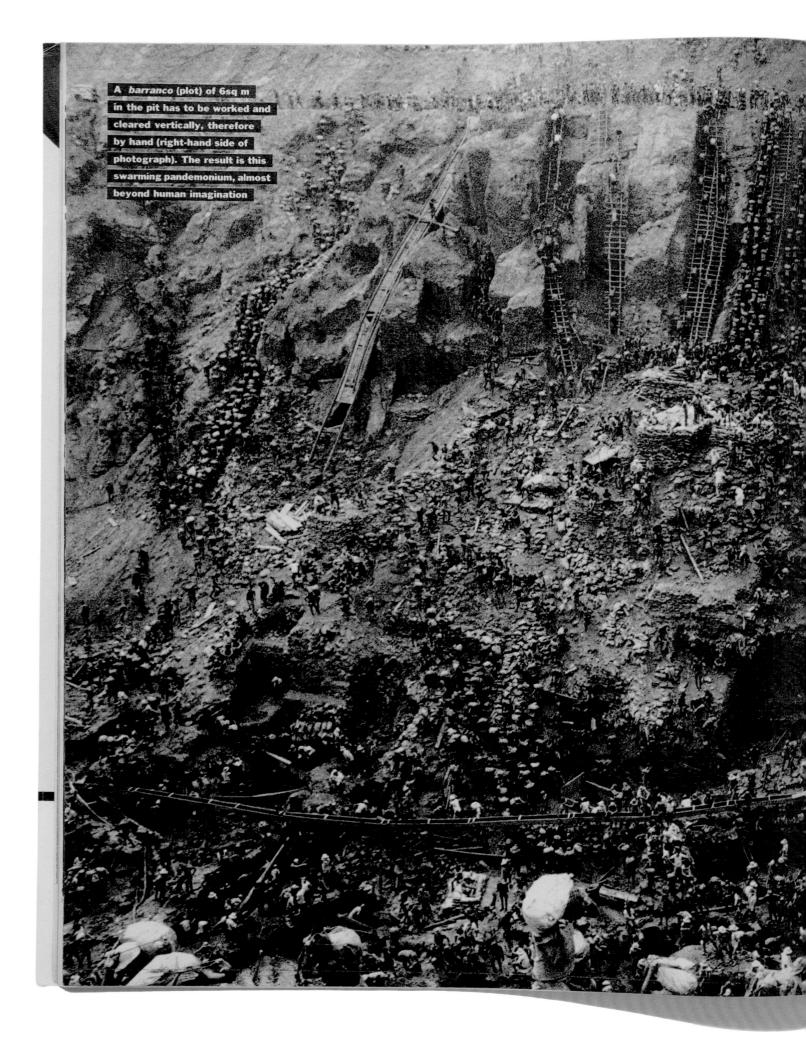

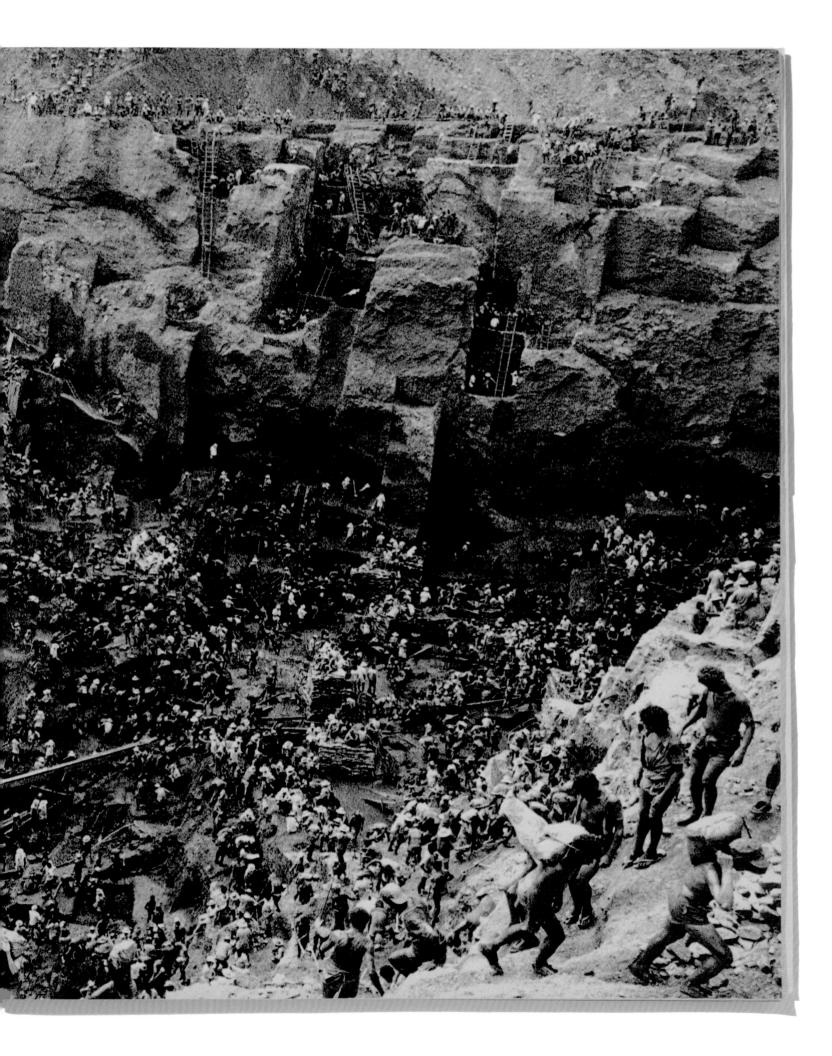

1987 DONNA FERRATO DOMESTIC VIOLENCE PHILADELPHIA INQUIRER

In the 1980s, American photojournalists found new supporters in the Sunday supplements published by regional newspapers such as the *Philadelphia Inquirer*, *Boston Globe*, *Denver Post* and *Detroit Free Press*. In 1987, the *Philadelphia Inquirer* backed Donna Ferrato to shoot an investigative essay on the almost invisible phenomenon of domestic violence against women and children, a subject she had first encountered a few years earlier while working on a story about 'swinging' suburban life. Its publication propelled Ferrato's work as journalist and activist and as publicist for the movement to recognize and stop domestic violence. Her career became a model for a style of political journalism that combined advocacy, agitation and public art. Ferrato's photographs are distinguished by their unusual ability to reveal sexual transgression without appearing to compromise the dignity or privacy of its victims, and they continue to occupy a disturbing space that hovers between voyeurism and rage. While the subject certainly continues to be current, Ferrato's own relationship to this material has grown – her book *Living with the Enemy* (1992) has achieved a place in the overlapping canons of feminist art and documentary practice. (26 July 1987)

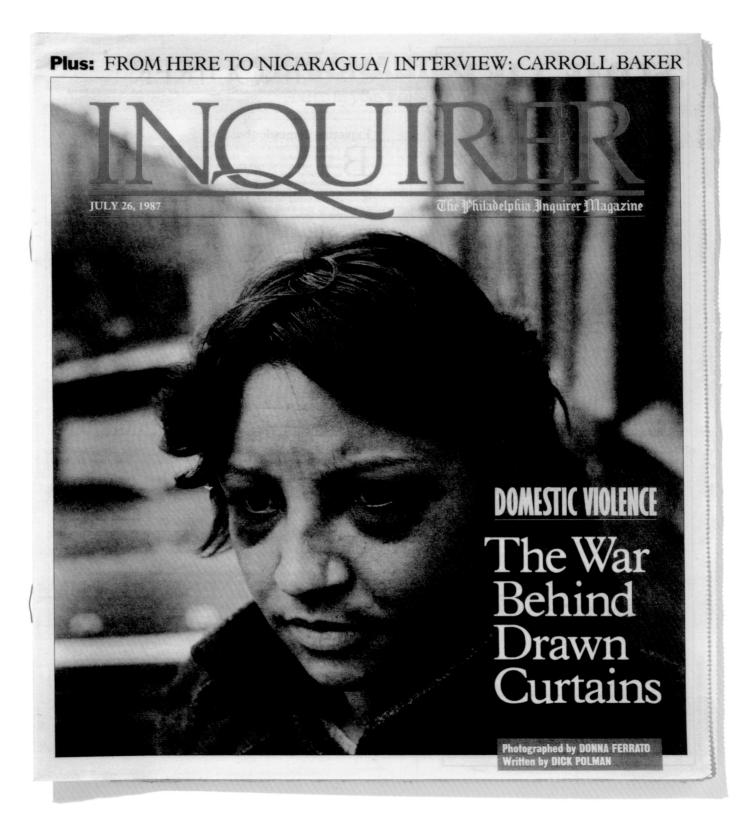

DÔKESTIC

PART ONE

Photographed by DONNA FERRATO Written by DICK POLMAN

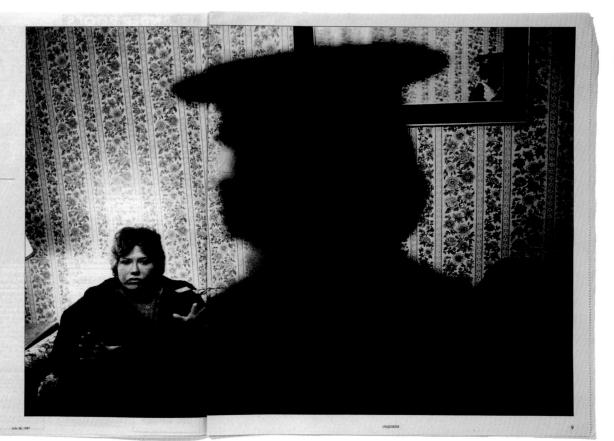

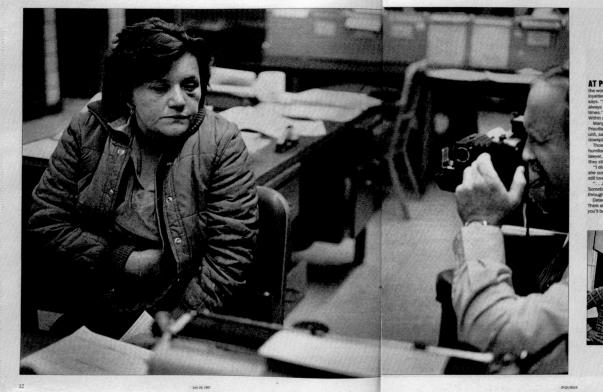

AT POLICE HEADQUARTERS

d get worse again and

13

Hospital, Jesse tells of being stabbed by his girlfriend after they argued over a roll of film, then says, "She's still on my mind a little, as far as love goes. Love is blind. I don't think she really meant it." At Episcopal Hospital late one night, Martha talks about the stab wound in her leg. Echoing Jesse, she explains why she won't have her boyfriend arrested: "He didn't mean it. It's hard [to press

charges] when you love somebody, it is . . . Put it this way, love is blind."

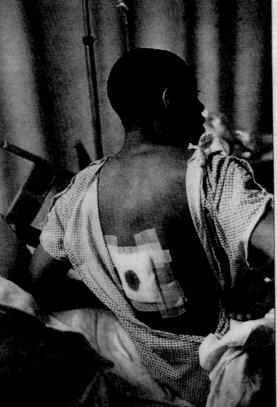

July 26, 1987

DOMESTIC VIOLENCE

14

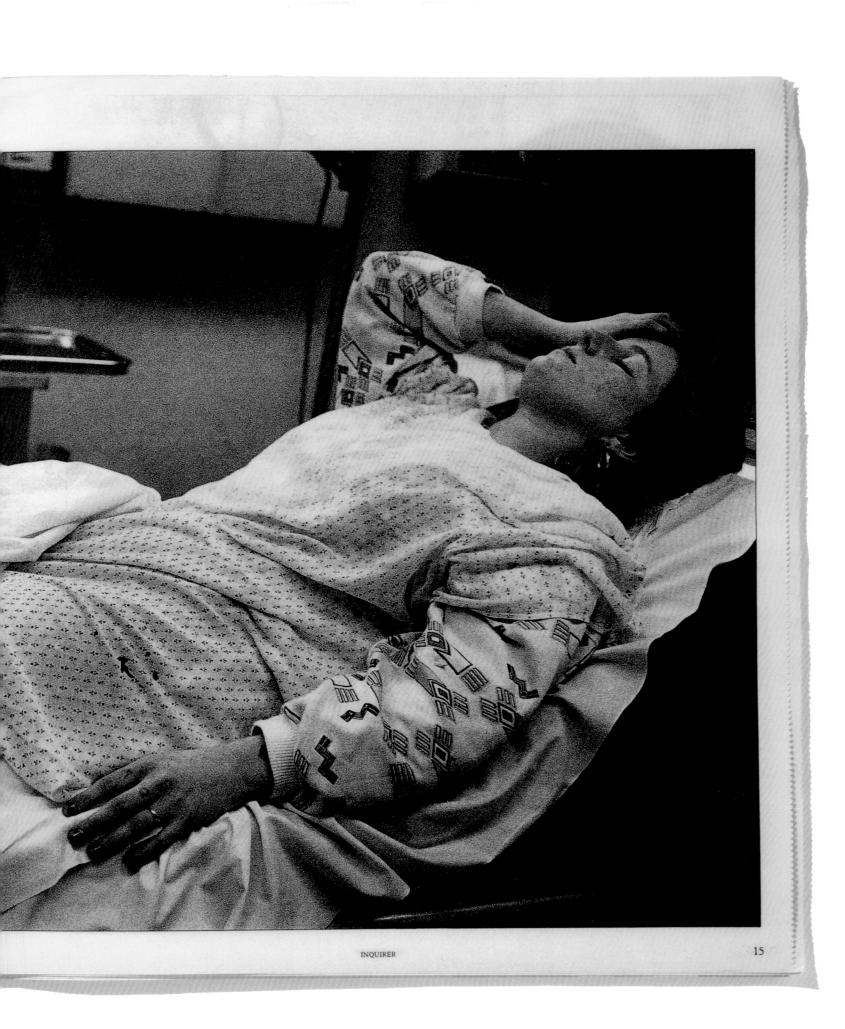

1987 BERND HOFF STAMMHEIM 7TH FLOOR TEMPO

'Stammheim' is the name of the Stuttgart prison that housed the most prominent members of the 1970s German terrorists, the Red Army Faction, while on trial. The 7th floor where the prisoners were held was billed as the most secure prison section in the world, but this did not prevent guns being smuggled in to them by their lawyers – guns that on the night of 17 October 1977 contributed to the suicides of the Faction's leaders, Andreas Baader and Gudrun Ensslin. When young photographer Bernd Hoff was making a profile of the city ten years later for *Tempo* magazine, he found himself allowed access to the notorious 7th floor while the section was empty and being refurbished. The pictures he made of the banal details of Baader's and Ensslin's cells, with their direct flash and saturated colours, were a journalistic coup. They were also an early example of an emerging magazine photography aesthetic that would overturn the familiar ingredients of reportage. *Tempo*, Germany's youth-oriented lifestyle magazine, also carried classic reportage stories, but became known for its opinionated, post-modern approach; for instance, it was among the first in Germany to embrace the photography of Martin Parr. (October 1987)

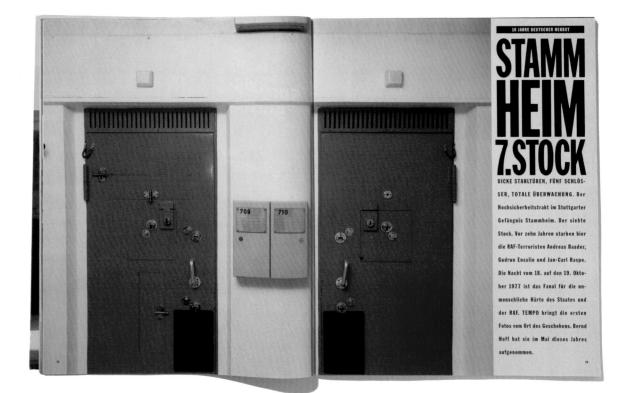

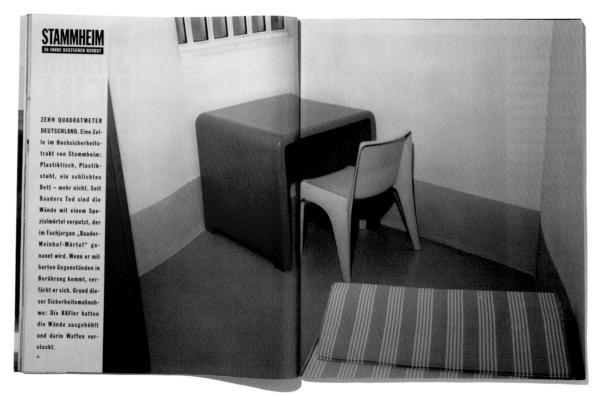

STAMMHEIM TO JAHRE DEUTSCHER HERBST

DER SIEBTE STOCK, FRISCH GEBOHNERT. Hinter einer der Türen sitzt Christian Klar, der Nachfolger Baaders. Er ist der einzige Gefangene im Hochsicherheitstrakt. Videokameras registrieren jede seiner Bewegungen.

KUNST AM BAU. Vor dem Haupttrakt stehen moderne Skulpturen. Die Gefangenen können sie nicht sehen. Ihre Fenster sind mit Blenden verrammelt. Strafverschärfung oder humane Maßnahme – angesichts dieses Ausblicks?

WÄCHTER VOR DEM TOR ZUM GEFÄNGNISHOF. Sie erinnern sich nur ungern an die Zeiten, als Andreas Baader den siebten Stock regierte. Er behandelte die Beamten wie den letzten Dreck, Gudrun Ensslin beschimpfte die Wärterinnen als "alte Fotzen".

DIE BESUCHERZELLE. Eine dicke Panzerglasscheibe trennt die Gefangenen von ihren Anwälten und Angehörigen. Kein Händeschütteln, kein Kuß, keine Berührung. Trotzdem gelang es RAF-Helfern, ein ganzes Waffenarsenal in die Zellen zu schmuggeln.

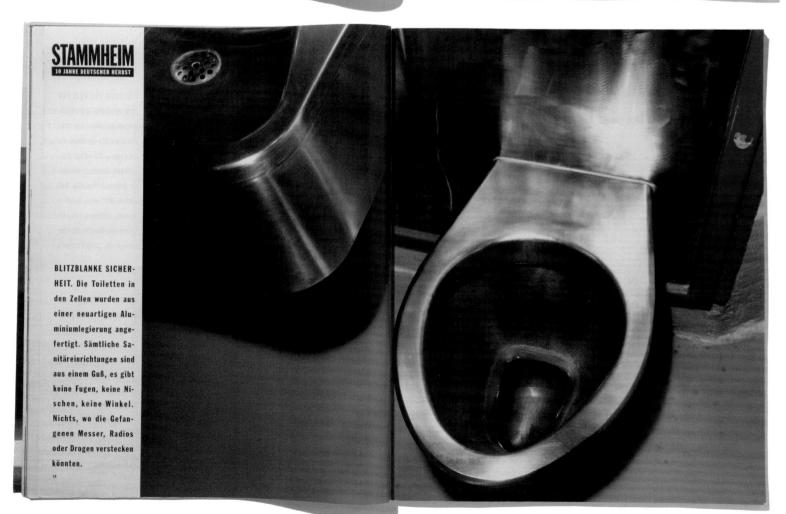

1988 ALON REININGER AIDS IN THE USA LIFE

Alon Reininger began to address the mysterious cancer killing gay men in America in 1981, with a story on the Veterans Hospital in New York, before the disease was named 'Aids'. Among the first photojournalists to address the subject, he sensed a story of enormous consequence and he decided to stay with it despite formidable obstacles. At the outset, in so far as the mainstream media recognized Aids as a problem at all, it was seen as a concern only to gay men in metropolitan centres. Indifference was succeeded by public and media hysteria, with the disease branded a 'gay plague' and with gay men and people with Aids subject to widespread prejudice and discrimination. Reininger struggled to find people with Aids willing to be photographed, and struggled to find magazines to take the pictures seriously when he did. As shock and bewilderment in the gay community turned into anger toward government and media, photojournalists were charged with pursuing sensational images of people dying of Aids rather than life-affirming images of people fighting it. It was 18 months after Reininger made his iconic image of Ken Meeks that the resurrected *Life* magazine first published a serious essay of the work. (January 1988)

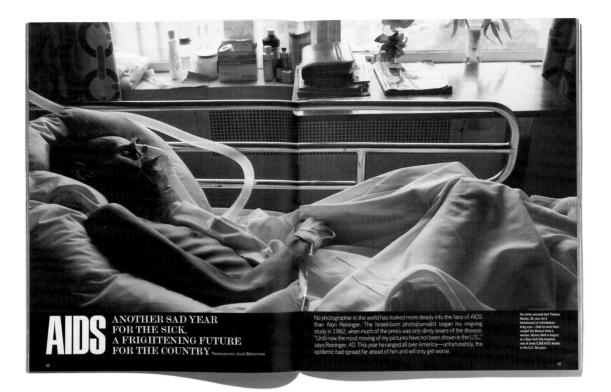

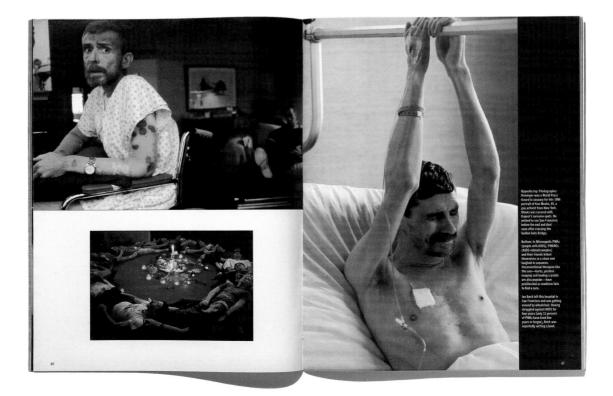

1988 LIALIA KUZNETSOVA GYPSIES OGONYEK

Lialia Kuznetsova began her social portrait of the Roma in Russia in the late 1970s. When her project began, the gypsies were a much-maligned group, living in poverty on the steppes – marginal inhabitants of a remote corner of a vast continent. Her earliest images document migrant bands who lived and travelled under conditions that had barely changed since the nineteenth century. Kuznetsova recognized the metaphoric power of this culture; her camera shows how this primitive existence also granted them remarkable freedom within the boundaries of a powerful totalitarian state. Over the next 15 years, Kuznetsova continued to document gypsy settlements as they became more permanent. She followed gypsy families into Odessa as they began to take up conventional employment. By the late 1980s, when *Ogonyek* published Kuznetsova's 'Gypsy Style', her photographs had already changed meaning; the humanistic documents of a rogue culture had become a safe romantic eulogy to an authentic folk culture in decline. (30 July 1988)

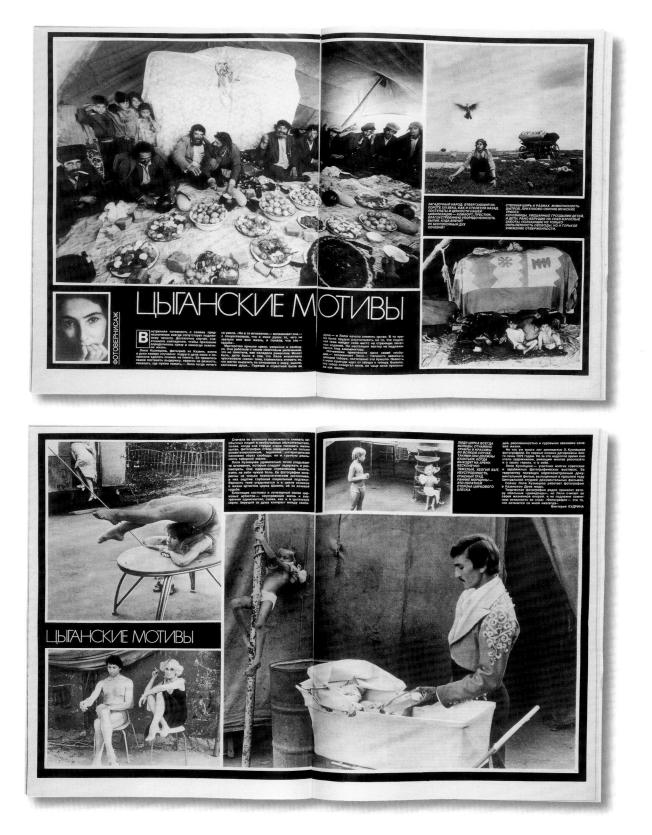

1988 ERIC VALLI HONEY HUNTERS OF NEPAL NATIONAL GEOGRAPHIC

While many photographers develop a lasting affinity for a particular subject, French-born Eric Valli went a stage further, making the Nepalese/Tibetan Dolpo-pa culture both the subject of his work and the centre of his life. The former cabinet-maker met his future wife travelling in the region and settled there, raising a family and immersing himself in the local language and culture. His access to the remote master honey hunters of central Nepal, who dangle on rope ladders over 120-metre cliffs to harvest the thick slabs of honeycomb from *Apris laboriosa* (the world's largest honeybee), results from his deep local knowledge. The worldwide audience for the story, first seen in *National Geographic* and published widely thereafter, was amazed by the technical virtuosity of both the honey hunters and of Valli himself. The popular epitome of the romantic adventurer, explorer and storyteller, Valli worked closely with *National Geographic* on many further photo stories and documentary films – until 2001 when, frustrated with the limitations of being able to 'grab things' but not to 'recreate the emotion I witnessed or felt', he combined fiction with his documentary approach in a feature film based on his experience of trekking with Dolpo-pa yak caravans through the Himalayas. (November 1989)

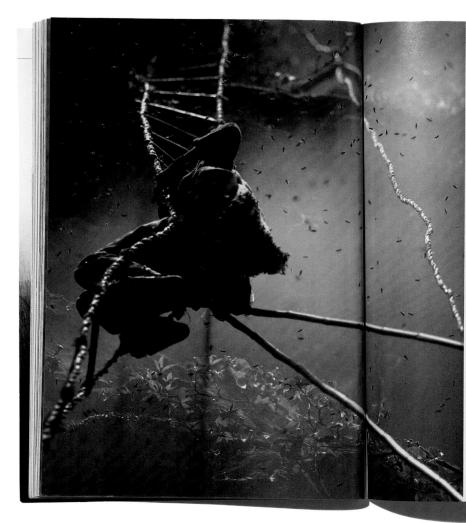

the swaying ladder like a spider on a frail strand of web. The slightest error of judgment would mean death (left). Mani Lal stops beneath an

overhang to face a nest nearly as large as he is. Its surface ripples with a thick, lack layer of bees. Two of the honey hunters, Krishna and Akam (above), have climbed a third of the way up the cliff to secure the ladder. Clinging to the rock, they pull the rope against the cliff to biring Mani Lal closer to the comb. Meanwhile a fire has been set at the base of the cliff to disori-ent the base of the cliff to disori-ent the base of the cliff to disori-ent the base with smoke and encourage them to leave the mest. But the wind is blowing the mest. But the wind is blowing the smoke away. Gesturing toward the top of the cliff, Mani Lal issues a silen d Mani Lal pushes it under the bees with a hamboo pole. Now panie runs over the living surface of the nest as the bees furiously depart in the smoke. Nothing distracts Mani Lal however. The golden comb has been unveiled.

A husband and wife team, ERIC VALLI and DIANE SUMMERS live in Kathmandu, Nepal. Their book on the honey hunters will be published this month by Harry N. Abrams in New York, by Thames & Hudson in London, and by Nathan in Paris.

665

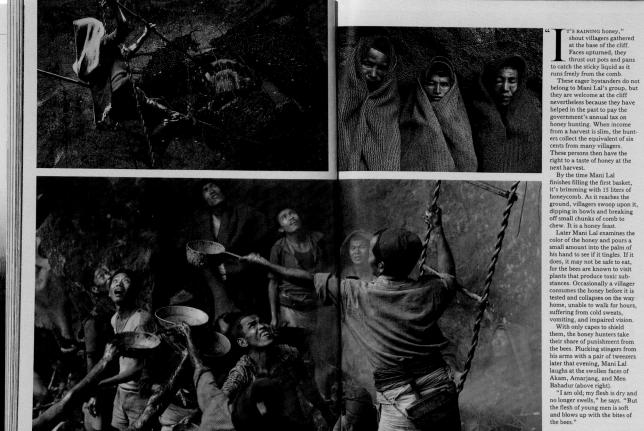

1989 PATRICK ZACHMANN TIANANMEN SQUARE SETTE

In 1987 *Corriere della Sera*, Italy's bestselling newspaper, launched a supplement called *Sette*, conceived as a visual magazine of extended photo essays. Its editor Paolo Pietroni (also founder of the innovative *Max* and *Specchio* magazines) and photo editor Giovanna Calvenzi chose to fill the magazine with double-page spreads, with only short texts and prominent profiles of the contributing photographers, renewing a tradition of popular photojournalism in danger of being lost. Patrick Zachmann was commissioned by *Sette* (as part of an international co-production) to cover the peaceful protest of Chinese demonstrators in Beijing, mainly students who had occupied Tiananmen Square for seven weeks and were refusing to move until their demands for democratic reform were met. The filmic sequence, characteristic of Zachmann's work, depicts the expectations, hopes and determination of the young Chinese before the protest's unexpected, bloody repression. *Sette* came out after television had covered the dramatic denouement; but rather than pull the story, it ran as a beautiful and touching testimony of the demonstrators' hopes, all the more dramatic for the knowledge that many of them died. (June 1989)

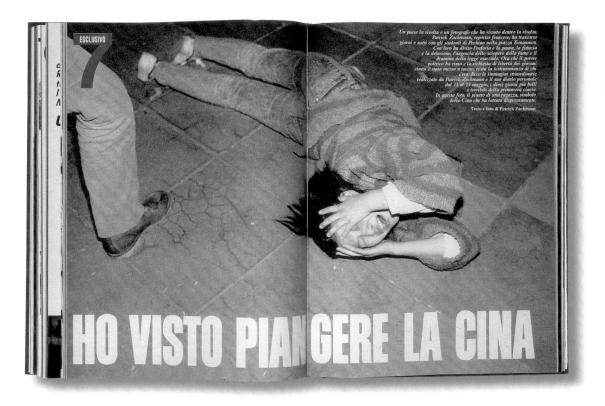

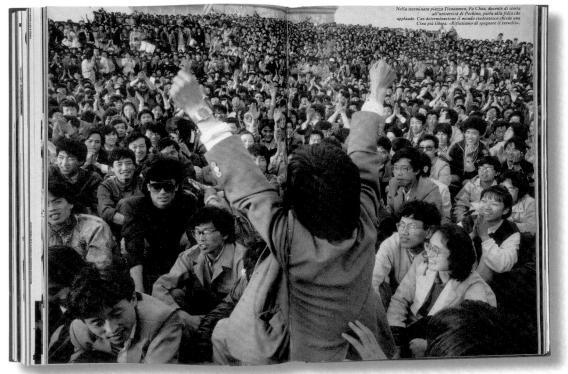

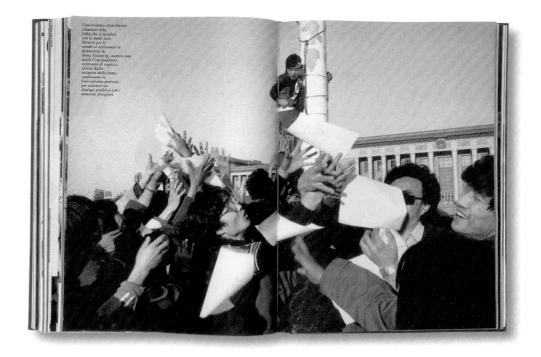

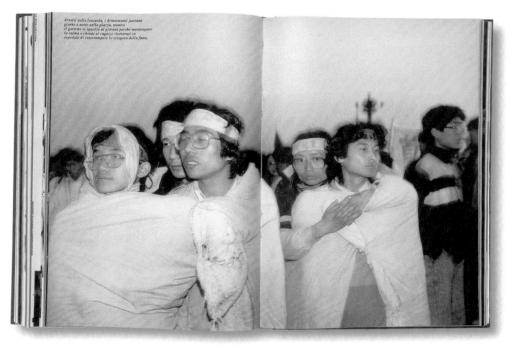

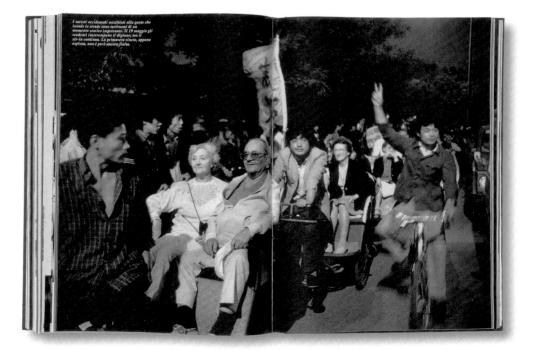

1989 FALL OF THE BERLIN WALL PARIS MATCH

Paris Match acknowledged the fall of the Berlin Wall with a special issue run two weeks after a spontaneous popular demonstration began its symbolic destruction. It was essentially a 50-page history of the Wall as seen by the magazine, from its construction in August 1961 to its fall. This retrospective view represented a strategic choice on the part of the editors, who had to find a good and interesting way to cover a story that had already entranced television viewers in real time, and was far from over. By leaning on history, they were able to put together a souvenir picture narrative that would not become obsolete with the next political upheaval that took place. The special issue staked out a particular territory for photojournalism – not the first line of pictorial coverage (long ceded to television), but extended historical accounts in visual form. It demonstrates how a well-produced reflection on contemporary events could be critical to popular understanding of a major story. It also proved how photojournalism remained an essential resource – the most valuable tool for the presentation of the history of our own time. (23 November 1989, including photographs by Patrice Habans, Yevgeni Khaldei and Vladimir Sichov)

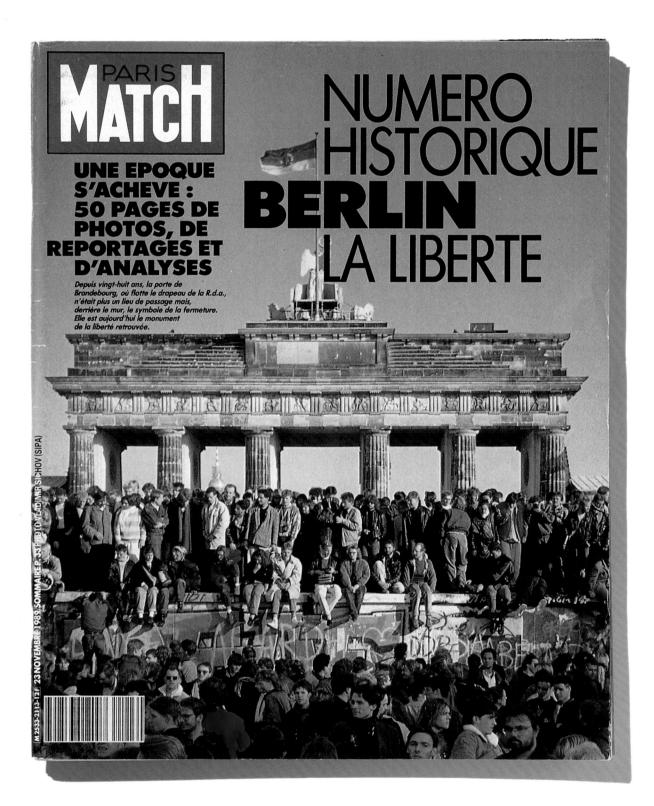

DANS LES DECOMBRES DE LA CAPITALE DU REICH, LES RESCAPES ERRENT COMME DES FANTOMES

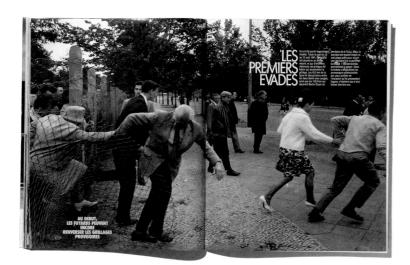

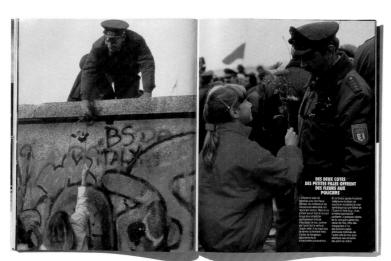

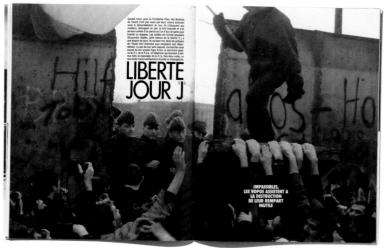

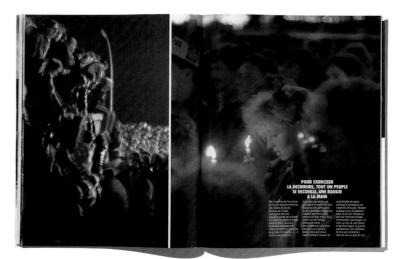

1990 MIKE ABRAHAMS CEAUSESCU'S LEGACY INDEPENDENT

Through the 1970s, the expected role of a photojournalist in relation to social upheaval was to show it as it happened. But by the late 1980s, with television and the wire agencies now dominating the supply of hard news, many established photo essayists were removing themselves from the media frenzy, seeking to distinguish themselves instead with reflections on the consequences or legacy of historical events after the 'news' was over. The format of the 'think piece', with reflective text accompanying a photo essay, allowed photojournalists the scope to work as street photographers, with an obligation to general relevance but no obligation to particular events or personalities. This story model was particularly favoured at the *Independent* magazine, and was used by Colin Jacobson to support and publish the work of independent essayists like Mike Abrahams. Jacobson also expressed a clear taste for classic, lyrical photographs of daily life, usually in black and white, that became a defining feature of the magazine. (3 March 1990)

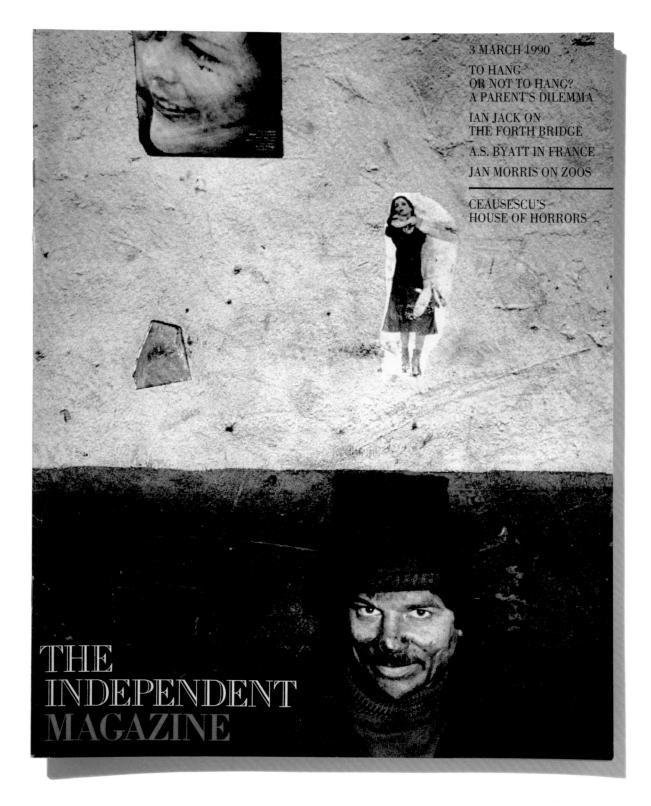

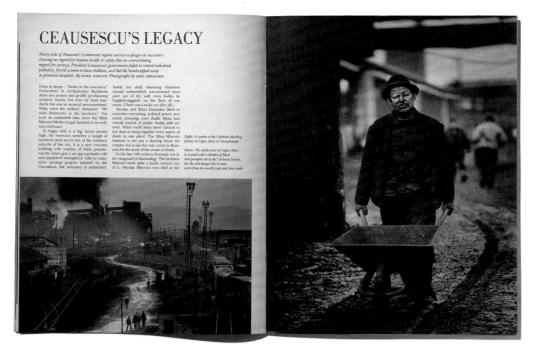

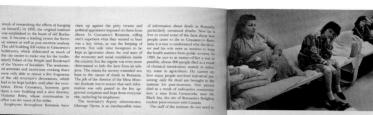

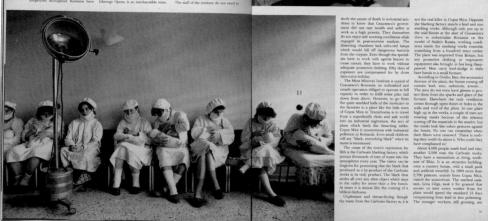

4.47: Unoran saming for adversars, which have only how logical low of the Dambergie diverse readings, adverse that the Federatory for the scale scales in surgering from the dynamics. They below, between on balance at a surgering the low of dataset as memory and the low of dataset as the mere scales of the two fitteesman. At the mere scales of the two fitteesman dominal of by the Catasettical formation of by the Catasettical formation of by the Catasettical for adverse scale of the Antonio States of the Catasettic Integrate of the Antonio States of the Antonio and the Antonio States of the Antonio States of the Catasettic Integrate of the Antonio States of the Catasettic Integrate of the Antonio States of the Catasettic Integrate of the Antonio States of the Antonio State

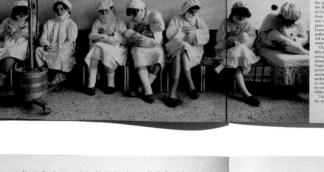



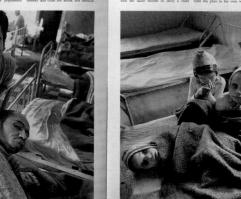



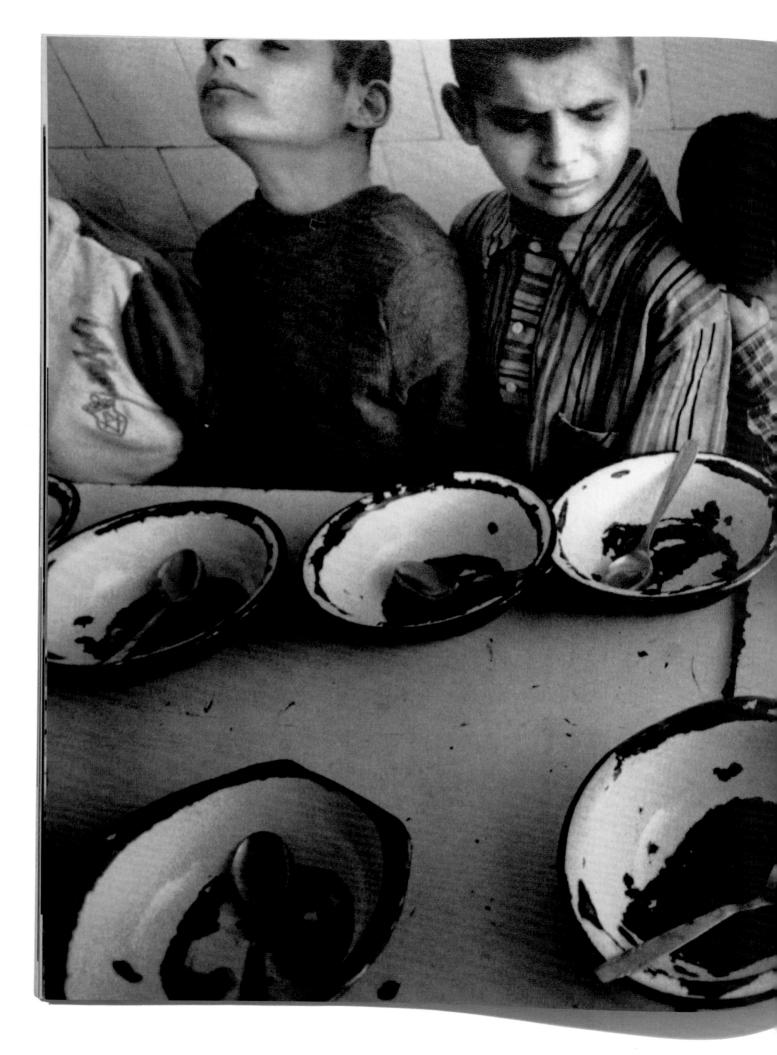

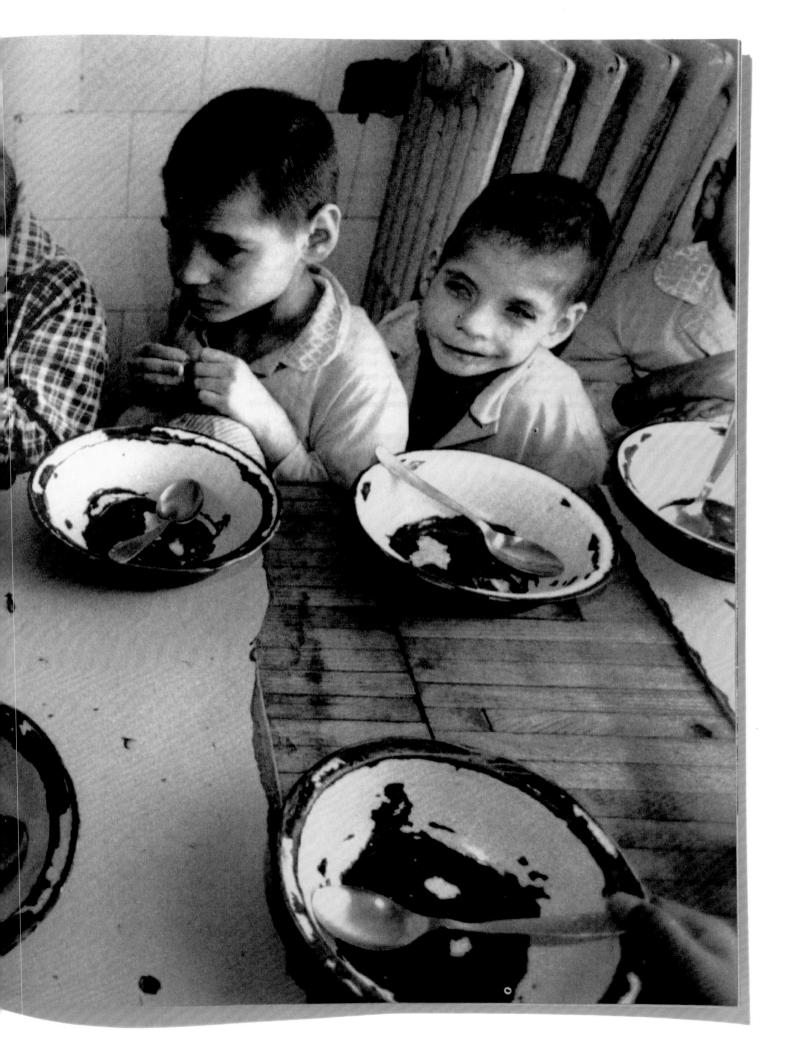

ANTONIN KRATOCHVIL POLLUTION IN EAST EUROPE NEW YORK TIMES

Czech-born Antonin Kratochvil emigrated to the West in the 1970s and spent many years working as a journeyman reporter and commercial photographer before establishing a reputation within photojournalism with his expressionistic study of East European landscapes wrecked by pollution. More than just a shocking story of industrial greed and governmental indifference, his work was welcomed by magazines as a visual metaphor for the consequences of life under Communism. These hellish views, made in Poland, Ukraine, East Germany and Czechoslovakia, are populated by bleak figures reminiscent of Dorothea Lange's documents of the American dust bowl. Kratochvil's graphic compositions and chiaroscuro palette earned him a place alongside Sebastião Salgado and James Nachtwey in a small group of high-profile photojournalists who, by the beginning of the 1990s, were achieving broad public recognition for their beautiful, emotion-laden images about forbidding subjects shot in black and white. One signal of Kratochvil's growing stature appears on the cover of the *New York Times* magazine – where the photographer's name has become part of the title of the story. (29 April 1990)

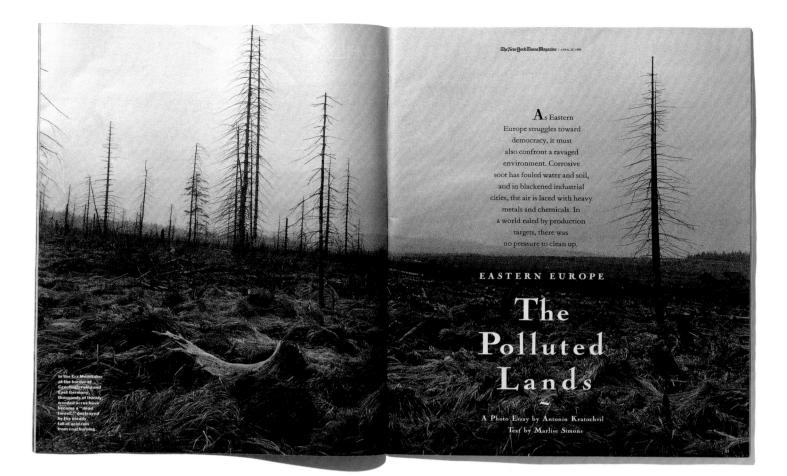

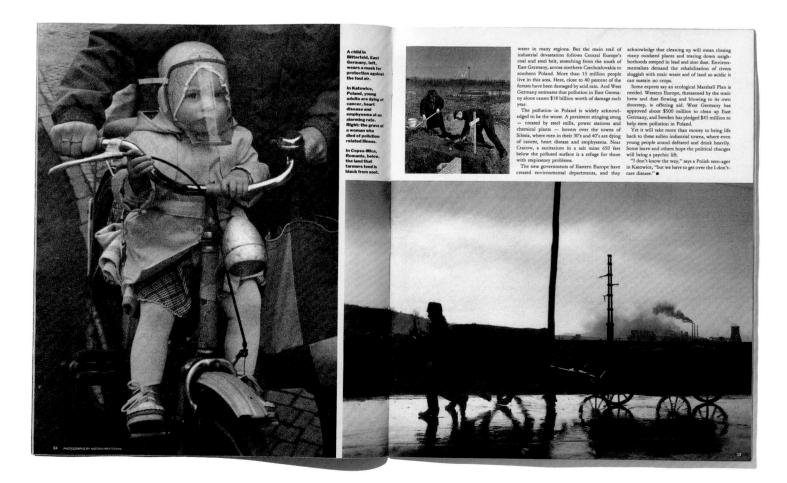

1990 KILLING THE CHICKENS INDEPENDENT

The title for this story comes from a Chinese proverb, 'Killing the chickens to scare the monkeys', referring here to the strategy of targeting the enemies of the Chinese government by making an example of the 'hooligans' and 'parasites' who supported them. According to Amnesty International, hundreds of 'chickens' (Chinese dissident sources put the number much higher) were killed in the months following the military crackdown at Tiananmen Square on 4 June 1989, in a blunt warning to all participants in the movement for greater democracy. The *Independent* magazine published these shocking photographs on the condition that neither the execution site nor the photographer – who made the images as part of a government record – would be identified. The story is unforgettable, yet it also demonstrates the contingent nature of photographic meaning. Although the photographs offer compelling evidence of a death by firing squad, without supporting recorded facts – the name of the photographer, the names of victims, details of where and when the depicted events took place – any certain conclusions must remain in doubt. (2 June 1990)

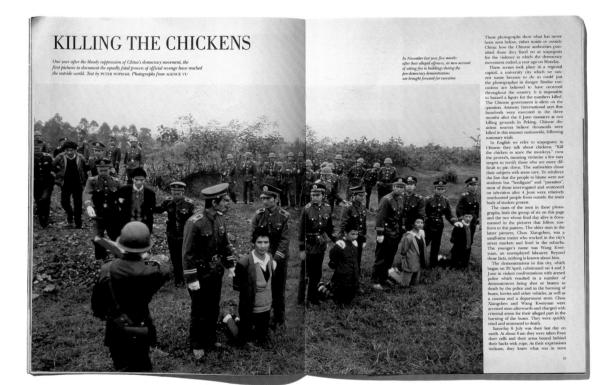

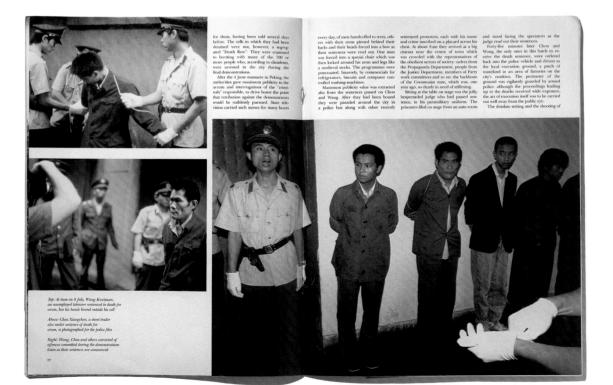

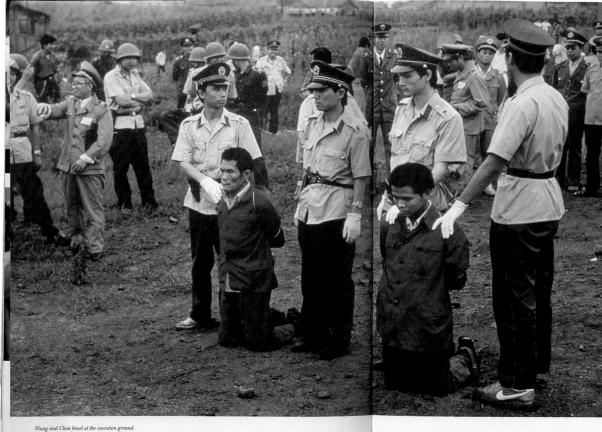

The in e judge who sentenced them is n at far left, in peaked cap and spectacles

THE INDEPENDENT MAGAZINE 2 JUNE 1990

THE INDEPENDENT MAGAZINE 2 JUNE 1990



clear. China says that only about 6,000 activists were arrested in the wake of the 4 June crackdown, and claims that many dhose have since heen released. Annexty harmed from 'various sources' that the taused of base arrested may run into the uses of thousand. The organization has submitted to frome minister Li Peng, the ma whole of the prime run ster Li Peng the ma whole of the prime Square massace, a list of the prime Square starsace, a list of the prime Square massace, a list of the prime whether they have been charged, tried or sentenced. Li Peng, not

surprisingly, has yet to furnish a reply. Even those who avoided imprisonment have been made to confess their wrong-doing. The ritualistic humiliation of writ-ing self-criticisms, studying "important speeches" of Deng Xiaoping and so on, have been imposed on workers and stu-cents all over the country by local Party committees. Such punishments continued well into this year. For large numbers it was a question of going through the self-names or dates or doing anything which would allow the authorities to carry the purge further. And many Party cadres,

whose job it was to impose such punish-ments, went along with such acts of dis-creet disolectilence, it is suid, displaying an unmistakable lack of eard for their task. None the less, the government can feed well pleased with its efforts the em-bers of revolt have been very thoroughly sundhered, and the country whose peace ful uprising heralded the onset of the gear of revolutions remains stuck quie as firmly as before in the mud of stagnation and terror. The uncamry, subter calm that descended like a log after 4 june shows to sign of shifting. Everyone is waiting for someone to die. •

Below: The executioners, with a single bullet each, prepare to shoot

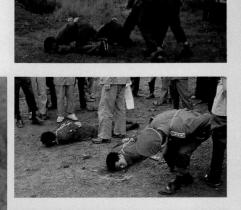

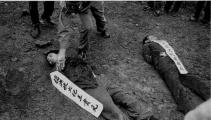

Top: After the shots, the two men slump forward Centre: The bodies are checked for signs of life Bottom: Labels indicating the dead men's names and crimes are placed against the bodies for the taking of final official photographs

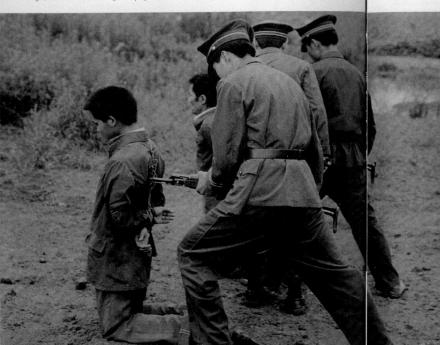

1991 GULF WAR NEWSWEEK

The first Gulf War, waged on Iraq by a US-led coalition and authorized by the United Nations, began on 18 January 1991 and ended less than a month later. It was the first major war to engage US forces since Vietnam, and the first to be reported according to a strict new system devised by the US government to limit and control press access. The innocuous-sounding 'Department of Defense Pool' forced hundreds of reporters to rely on the work of a small group, and photographers who refused to follow the established rules worked on the margins of the war at their own risk – and this included the risk of conservative editors declining to publish images that questioned or implied criticism of the government. *Newsweek*'s first war reports appeared with mostly generic images, but reporters released new images that offered explicit information about the fighting, in time for their 11 March issue. Nearly a dozen photographers contributed to this dramatic war portfolio – including Ken Jarecke, whose damning image of the scorched face of an Iraqi soldier subsequently became an icon of the brutality of a war obscured behind the US government's public relations machinery. (11 March 1991, with photographs clockwise from top right: David Turnley, Sadayuki Mikami, Gary Kieffer, Charles Platiau, Mark Peters, Kenneth Jarecke and Philippe Wojazer)

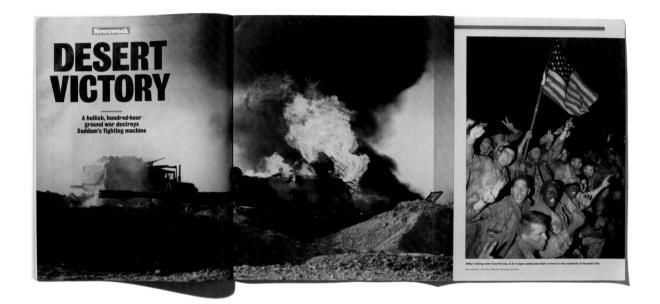

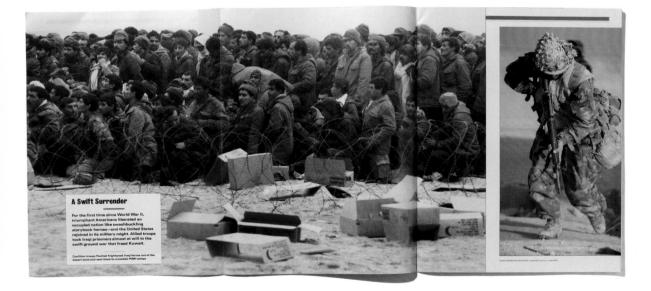

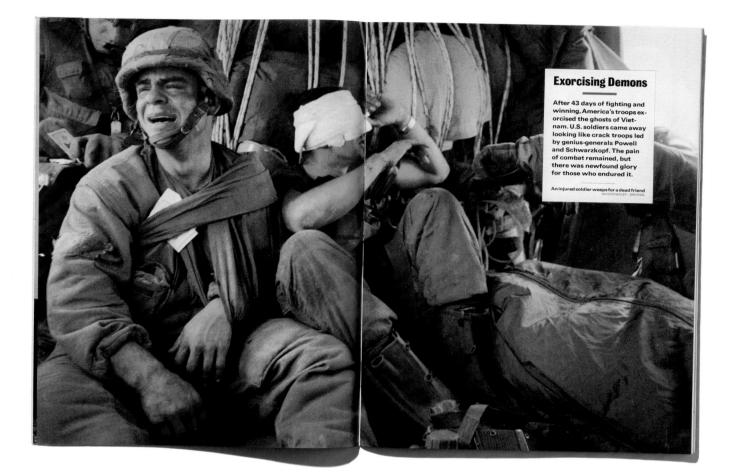

Triumph and Devastation

Saddam Hussein's pathetic claims of victory were drowned out by Kuwaiti cheers and allied firepower. The multinational forces pounded furiously on the fleeing Iragis in the war's final hours. A new world order seemed possible, providing America is as wise in victory as it was in battle.

Kuwaitis rejoice as the war winds down, but an Iraqi convoy could not leave their capital fast enough

NEWSWEEK : MARCH 11, 1991 25

1991 PHILIPPE BOURSEILLER ERUPTION OF MT PINATUBO DAILY TELEGRAPH

In 1991, geologists were able to predict the eruption of Mt Pinatubo, giving the Philippine government sufficient warning to prevent tragedy by evacuating 75,000 local residents in time. But there was no way to foresee that the eruption would coincide with a passing tropical storm, causing the explosion to cover the surrounding island of Luzon with a snowy volcanic ash that in some places reached a depth of 13 inches. Nature journalist Philippe Bourseiller arrived on Luzon in time to see the eruption take place, and to photograph the island under its ashy blanket. An expert in the photography of harsh settings such as the Sahara and Antarctica, Bourseiller had not photographed a volcanic eruption before. He called the experience 'a true thunderbolt' – a life-changing event that revealed to him the shape of his own emotional relationship to nature. The result was a sequence of surreal tableaux that also offered an eloquent allegory of disaster in the twentieth century; it is hard to look at these landscapes – intact, empty, covered with dust – without imagining that we see a picture of nuclear holocaust. (15 June 1991)

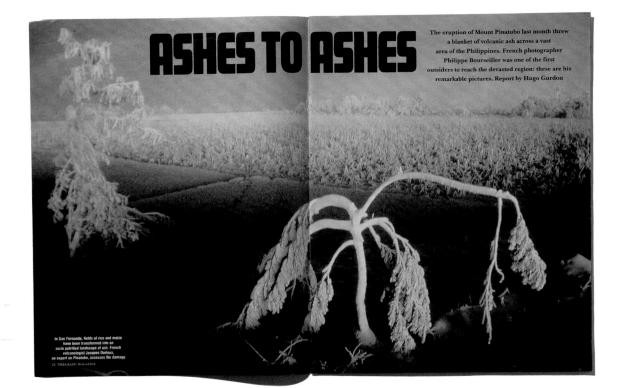

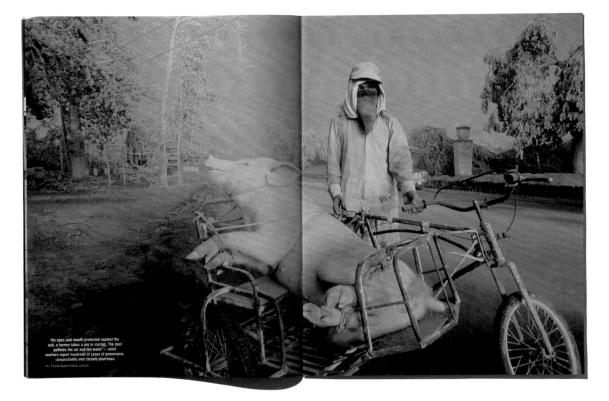

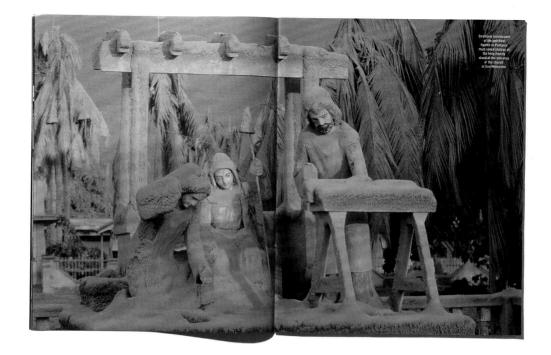

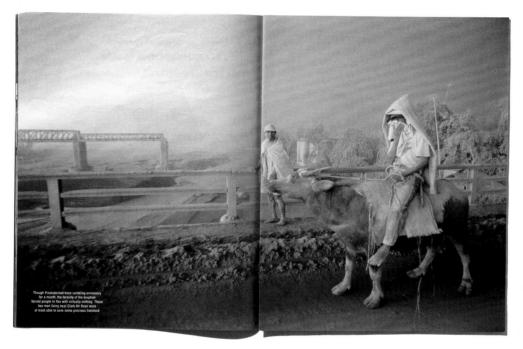

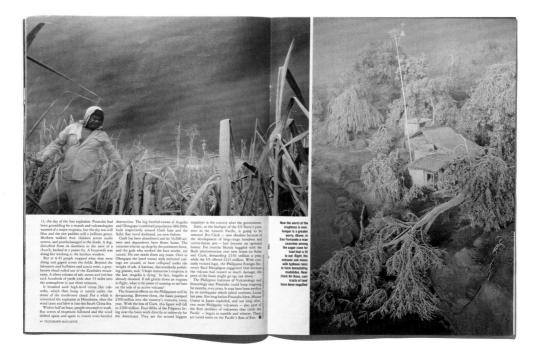

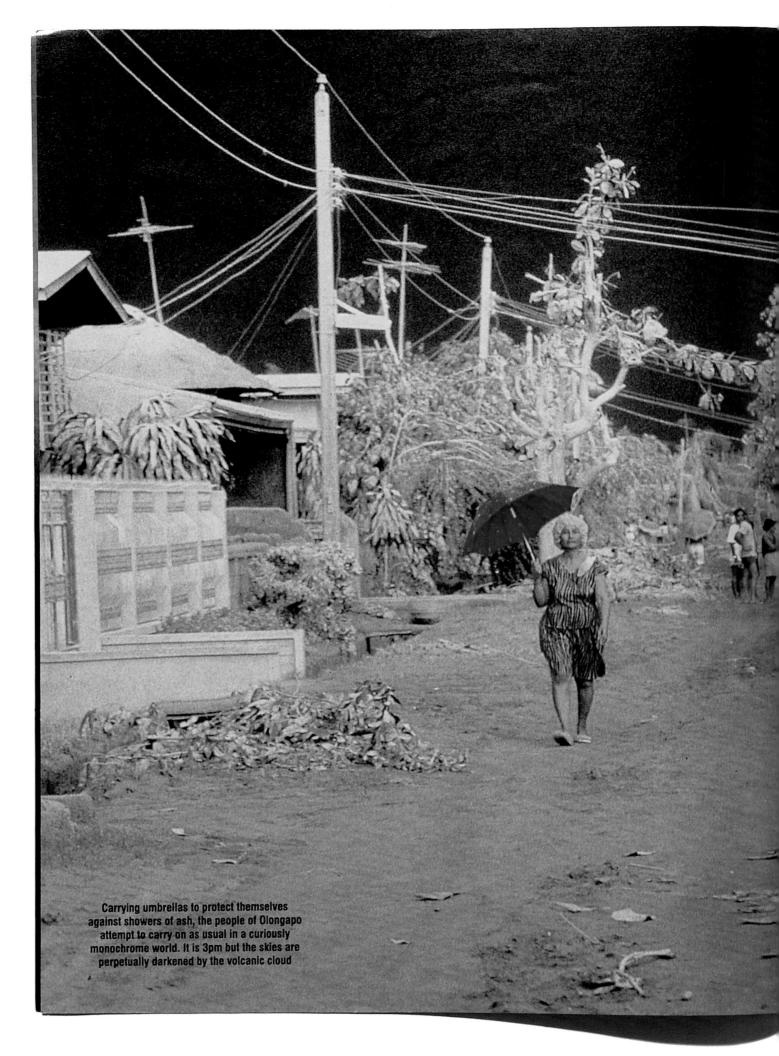

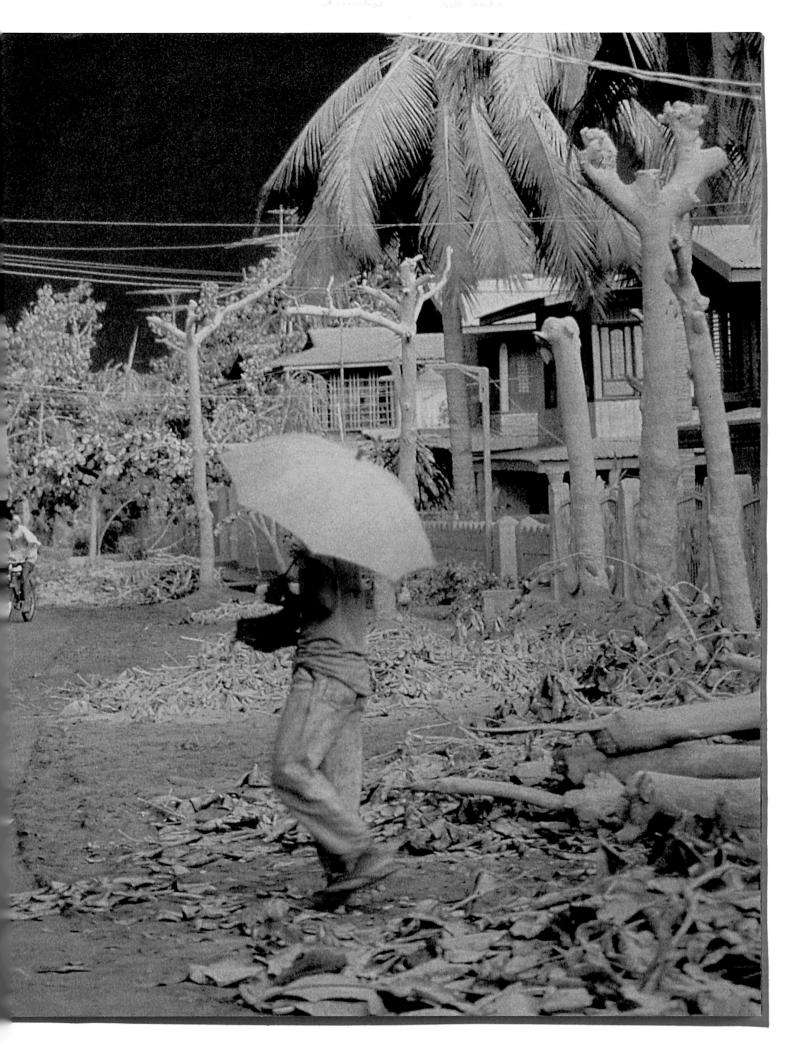

1991 HANS-JÜRGEN BURKARD SOVIET MAFIA STERN

In 1989, photographer Hans-Jürgen Burkard started working for *Stern* magazine, the beginning of a collaboration that produced a series of distinctive photo essays over the following years. Comprising visually dramatic colour photographs lit with flash and run over consecutive full-bleed double-page spreads, his main subject was Russia during the collapse of the Soviet Union. His investigative talents and his unusual freedom of movement inside the country (Burkard was only the second foreign photographer to receive official accreditation in 1989) gave him wide access to subject matter not previously seen in the Western media. Stories on subjects including pollution in Siberia, the emergence of an extreme right wing and Moscow nightlife established Burkard as *Stern*'s dynamic monitor of the fast-changing Russian society. His investigation of the Russian Mafia, at that time little known, was the product of nearly a year's work following the RUOP, the division of the Ministry of Internal Affairs dedicated to combating organized crime – dangerous work during which he was often beaten up and his life threatened. His work became the epitome of *Stern*'s approach to photojournalism at the time: bright, serious and sensationally compelling. (28 November 1991)

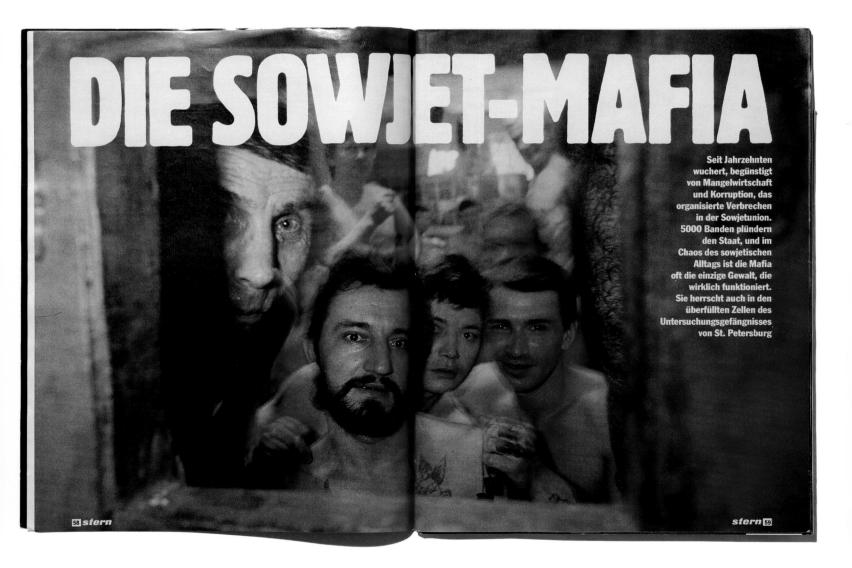

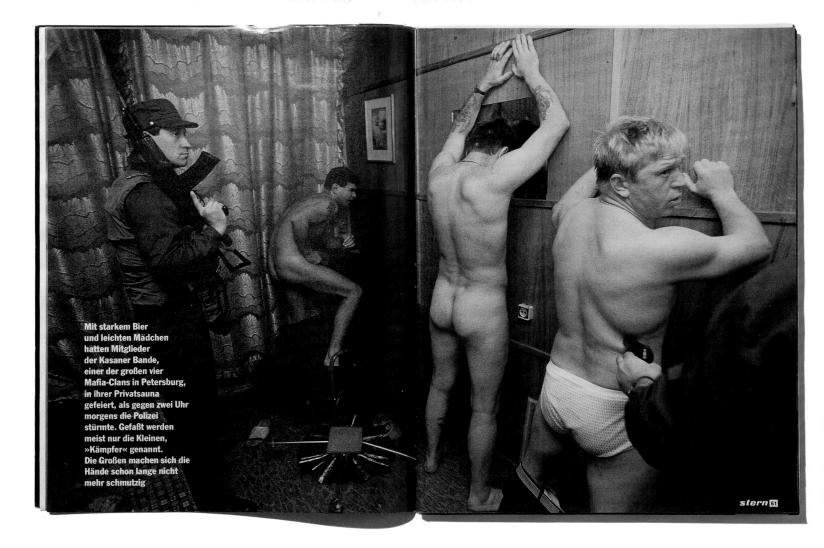

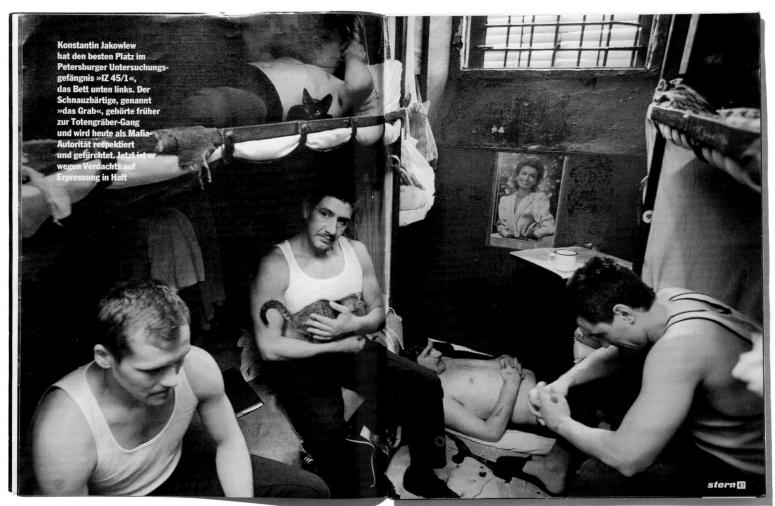

In einem verdreckten Moskauer Treppenhaus wurde dieser Ermordete gefunden. Es waren vermutlich »Geschäftspartner«, die ihm mit einer selbstgebastelten Pistole ins Herz schossen. Gelangweilt führt ein Kripo-Beamter Protokoll. Alle 22 Minuten wird in der Sowjetunion ein Mensch ermordet – ebensooft wie in den USA [:]:

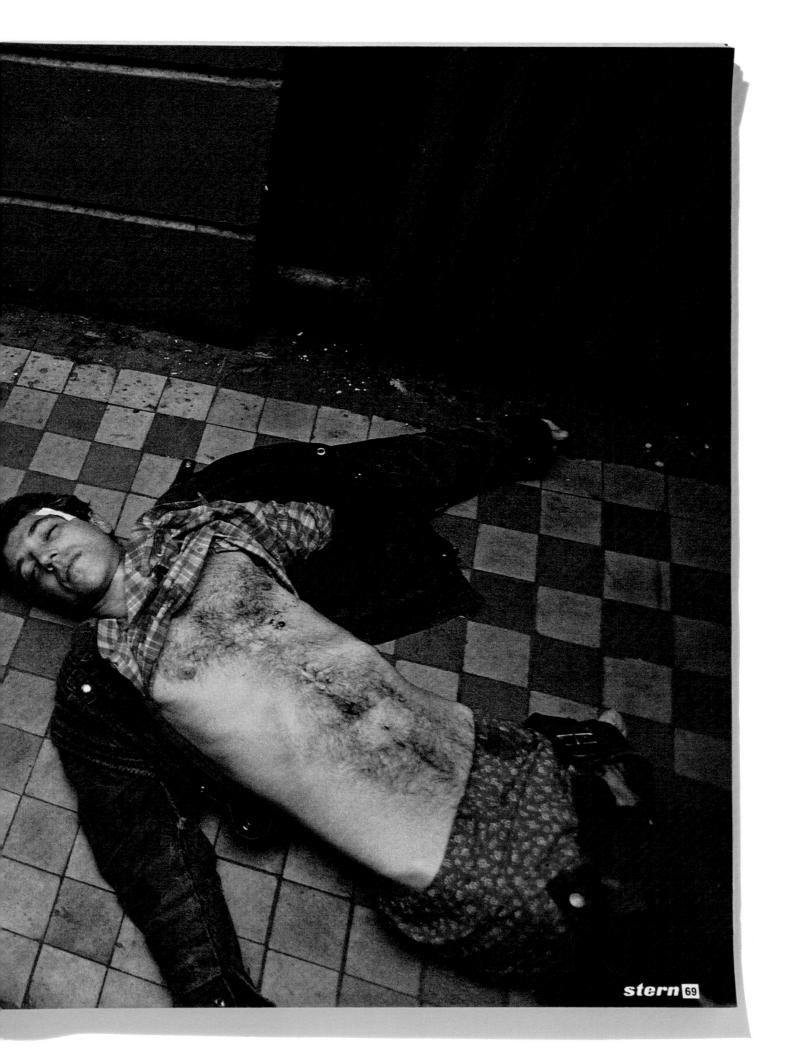

1992 JANE EVELYN ATWOOD RUSSIAN WOMEN'S PRISON INDEPENDENT

During the early 1990s Russia began to open up to international journalists working on daily life stories, although not without the help of expert local fixers (in Atwood's case, Stas, her street-wise young interpreter who helped to pull official strings). Once inside this women's prison in Perm, Siberia, she was able to win the trust of her subjects – both prisoners and warders – and documented it from their point of view. Curiosity was the initial spur for the story, but her surprise, shock and bewilderment at what she found gradually turned to a rage about the unjustified incarceration of women whose crimes were often responses to domestic violence and abuse. Atwood felt compelled to develop the project. Drawing on the model of Sebastião Salgado's 'Workers', with its instalments on related subjects, she produced essays on over forty women's prisons around the world that became chapters in an extended documentary essay, made over a ten-year period and involving extensive interviews with her subjects. (25 January 1992)

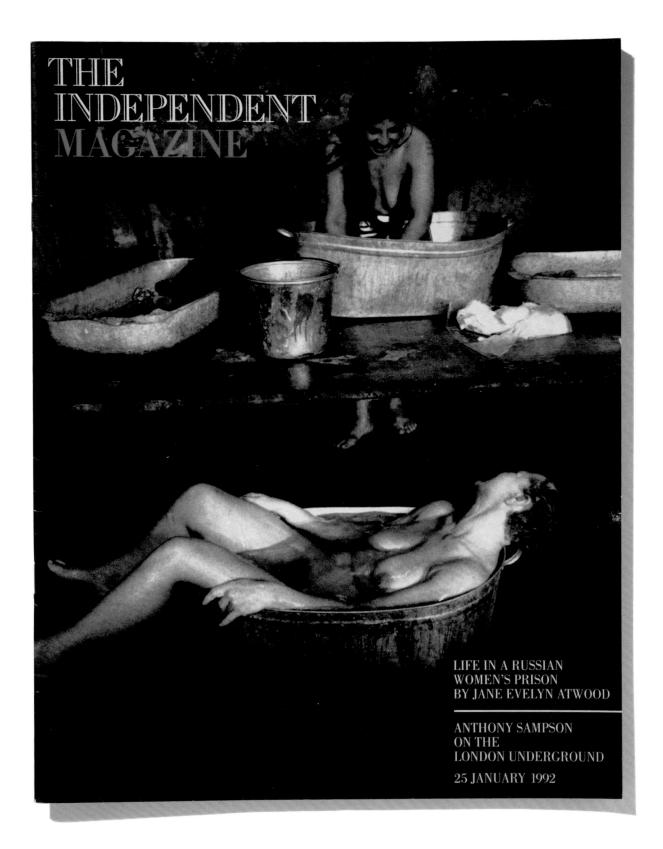

why the read

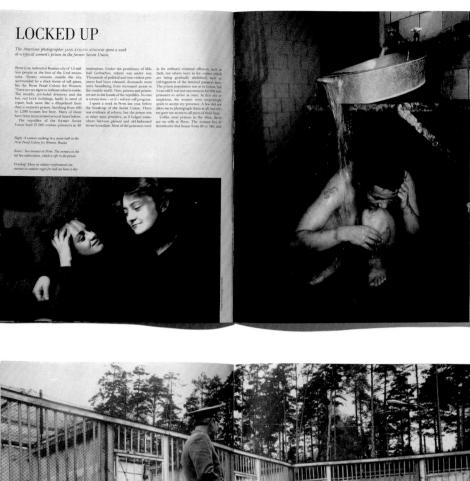

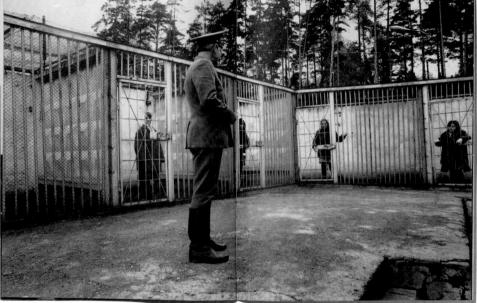

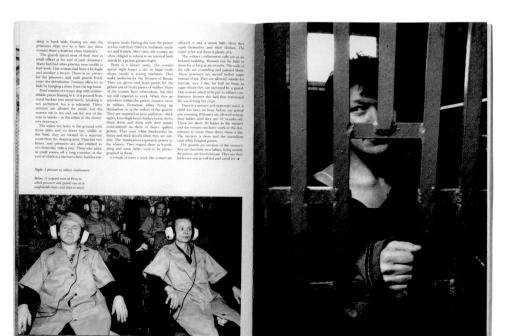

1992 DANIEL SCHWARTZ BURMA DU

Since 1990, Swiss photographer Daniel Schwartz has produced complex documentary essays, infusing travel stories with political content. When he produced his essay about Burma, the country had just been taken over by its military and renamed the Union of Myanmar. All political parties were banned, and the country's elected leader, Aung San Suu Kyi, was placed under house arrest. Schwartz's essay conveys the sense of crisis without resorting to melodrama or cliché. Unlike many of his contemporary photo essayists (for whom strength of imagery takes priority over content) he employs economic analysis and an understanding of cultural history to drive his work – without giving up the chance to make beautiful images. Over the following years, Schwartz continued to work in Vietnam, Cambodia and Bangladesh. His resulting book, *Delta: the Perils, Profits and Politics of Water in South and Southeast Asia* (1997), marries the qualities of the artistic portfolio with the pointed analysis of a development report. (November 1992)

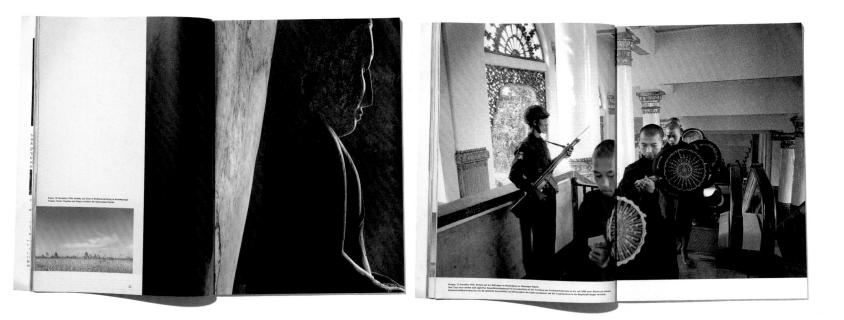

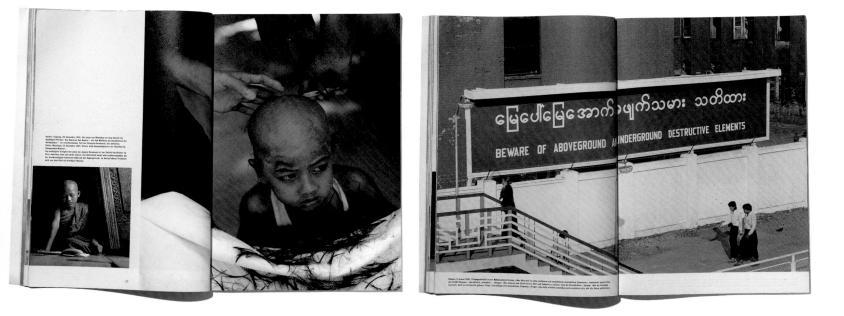

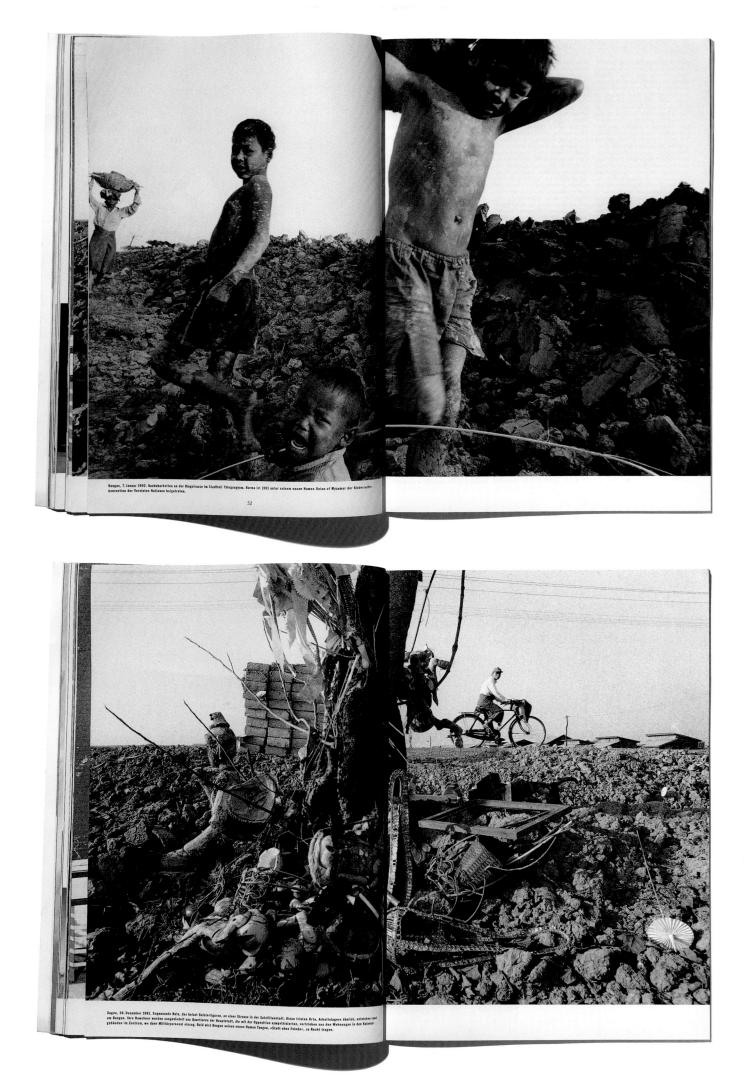

1992 WOLFGANG TILLMANS LOVE PARADE I-D

In 2000 Wolfgang Tillmans became the first photographer to be awarded the Turner Prize for contemporary art, for installations that included large inkjet prints and pages of magazines attached to the wall with pins. From the outset, Tillmans broke conventional boundaries. Exhibiting photographs on gallery walls as well as on the pages of magazines, and blurring the lines between reportage and fashion, commercial and art photography, he contested the traditional hierarchy of artistic value coined in Walker Evans' ironic statement, 'This picture is art, it belongs in a museum. This picture is journalism, it belongs in a wastebasket.' Tillmans' influential early work involved photographing and designing iconoclastic visual reports on cultural events for *I-D*, the British youth lifestyle magazine, combining portraits, still lifes, and staged and reportage photographs. In a diary-like cataloguing of his preoccupations – boys, friends, clothes, politics – no one thing matters more than any other. He expresses equal pleasure in everything. (September 1992)

the love parade

Against a backdrop of united Berlin, the Love Parade, a 15,000-strong techno demonstration, took over the city centre. But it wasn't just a good party, it was a sign that the continuing divisions between East and West Germans

kies opened and the rain came lags bounced off the digital handom the sound systems, lightning the heavenly strobe, and i looved.

c dancers on the lorriss and the pavements for need their arms, velocining the showners if it is a haavenly endorsement of their celebration sugpleted the final rush. If a singlet the final rush is a climax to July 5 Love Parade, it couldn't the their norder right. Rainfall, codified in a huma science to July 5 Love Parade, it couldn't the them more right. Rainfall, codified in a humand urged average to cleansing. Iberationary force, and urged average to the technone to the kultimate to an urged average to the utilimate of the standard science to the utilimate of the science to the utilimate and urged average to the utilimate of the utilimate of the utility of the utilimate of the utilimate of the utilimate of the utility of the utilimate of the utilimate of the utilimate of the utility of the utilimate of the utilimate of the utilimate of the utility of the utilimate of

washed any last inhibition into the Ku'damm gutters and urged everyone towards the ultimate abandon. Delying the physical reality of waterlogged clothes and squekching boots transcending and dodging the storm, behind. The collective intual was consummated. The Love Parade is Berlin's yearly celebration of

techno unity: A convoy of floats, each with its own sound system, music and decor, sakes its way down the Ku'damm (a shopper's mecca similar to Londra's DAvida Sterel) on a Saturba of and Benin chois itse Planet, Franktier, sound aparts Frankfurt, Cologne, Munich, Dressen and Legoris Insaffast, bus angle one from Statin lour own -DNoveMute float). An estimated 15,000 line the perments, dinking in the technicolul ristry and sampling each float's musical wates. Dhese stowd as angling each float's musical wates. Dhese stowd floors as the where in of low of the store of the store.

The most impressive, and the one which draws the biggest crowds, is manned by Berlin DJ Tamith and friends. Tamith's float is technic: 'Apocalypse New' set to a hard-fifting grows. If a decked out like a tank, all camouflage and netting, with the DJ as a demented millaser, commandant leading the troops from his guin turnet. As the basedoum powerdrifts, the commands set of stroking company filters. Out and the storemotopers in combast gener function of skipley the pages sign camited on the back of this uniform.

The Love Parade has grown in stature atorguide germany's technolosene. In 1986, it consisted of a mare 2000 huige antibulasts. In 1960, there were Loop in 1991, '2000, the year. It body noise Germany's new capital. 'It's about people with the amere aims meeting once a year and demonstrating their togetherness,' says Juergen Laarman, one of the parade's organises. 'All the people and clubs who might be in competition all year get together and get on. We show all the 'normal' people watchtest, that we can live a better life.'' Frankfurt DJ, musicien and sharneless exhibition.

IST SVEH VADI, WHO WARED DIE KO

can be overcome. little more than cycle parts and hair extensions, sees the parade as a signifier of liberation, a chance for people to publicly lose inhibitors that are intrisit to the German character. "The Love Parade is way important for German shearable otherwise you would never see people expressing themselves on the street. The German metality is not to show

Their feelings, this a good sign for the future - exception It was also a global activation for an indige-It was also a global activation for an indigemented cub cutture. With labels like Low Spirit, Tresor and MFS, Berlin has established itself as Germany's musical capital as well as its party capial. From trance detections to throubing noisecoids, aserples, breakbasts and ragps 'junglism' of British river' music. London DJ Colin Deals uses the phrase intelligent techno' to describe such music. Berlin DJ Tanith asey is 'a 'hardcore buicktmakit'. Everyone concerned is more bothered about stayng underground than coming Dautothmiks. Berlin DJ Tanith asey is 'a 'hardcore buicktmakit'. Everyone concerned is more bothered about stayng underground than coming Dautothmiks. Berlin DJ Tanith asey is describe such music. Berlin DJ Tanith asey is advanced to the state of the early '80s Neus Deutsche Welle, or as ritual. A ritual based on the besci of the drum, a derwidt dance to the state of tarence, techno connects with down rituals from the ancient to the schemit to the advanced the carbon that the state of tarence, techno connects with down rituals from the ancient to the schemit to the

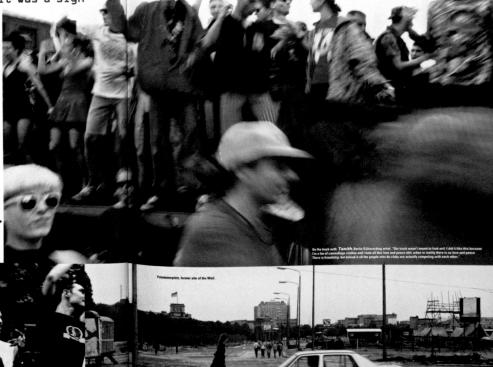

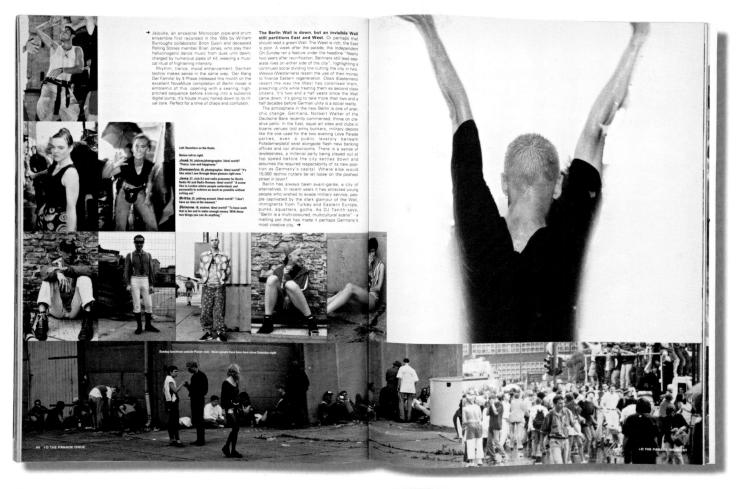

1993 STEVE MCCURRY AFGHANISTAN NATIONAL GEOGRAPHIC

Steve McCurry began photographing in Afghanistan in 1979, when he was smuggled into the country to report on mujahedeen resistance to Soviet forces. The resulting story began an affinity with the region – a relationship with its people and landscapes and an aptitude for navigating its social conventions. It also earned him a Robert Capa Gold Medal, launching his long relationship with *National Geographic*. In the spring of 1992, accompanied by writer Richard Mackenzie, McCurry returned for the first time since the departure of the Soviets to report on the Afghan recovery. While his earlier photographs are raw by comparison, by the time McCurry revisited he had perfected a craft that was at once old-fashioned, in the traditions of humanist reportage, while employing a heightened awareness of light and colour within a seductive, contemporary pictorialism. Always informative and relentlessly optimistic, his pictures have become a central ingredient of *National Geographic* from the early 1980s to the present – in forty major stories and some of its most memorable covers – as the magazine sought to outshine its rivals with the brilliance of its pictures. (October 1993)

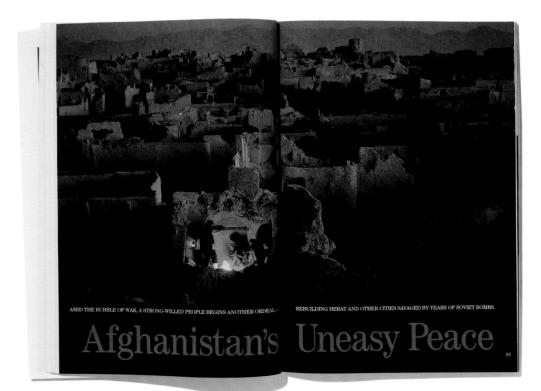

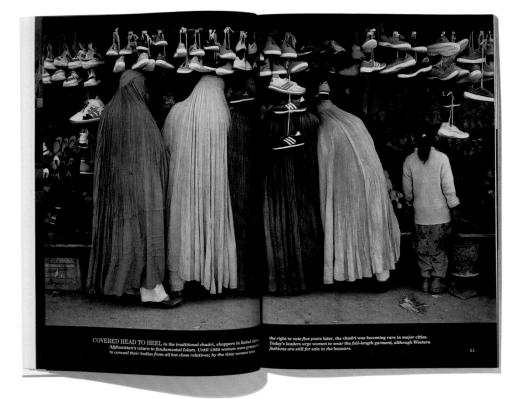

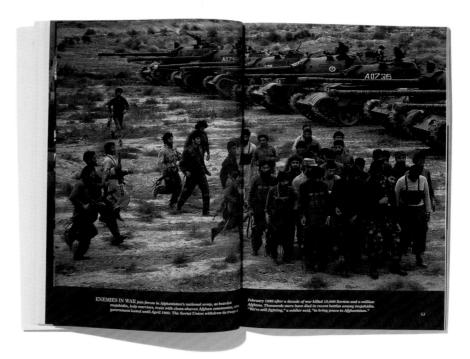

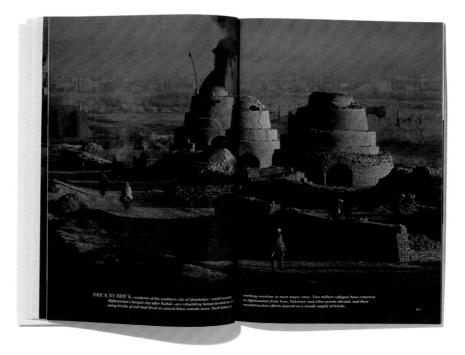

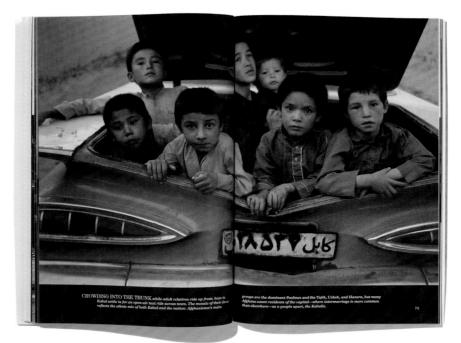

GIDEON MENDEL ZIMBABWE AIDS WARD INDEPENDENT 1993

South African-born Gideon Mendel provides both text and photographs for this story, which was the first in his campaigning engagement with the Aids epidemic in Africa. It features the bleak Malaga Mission Hospital in southern Zimbabwe where two Swiss doctors and a dozen African nurses care for 118 patients. On a formal level, these images are complex, with emotional relationships taking physical form, as shapes and volumes intersect and overlap. Mendel also becomes part of the story, as a witness or, perhaps, as an intruder; his edit includes one image showing a man in his wife's arms at the moment of his death. Mendel wrestled with the decision: 'In that situation, seconds after the man had died, as the reality of the situation began to strike me, his family began to wail and break down. I put my camera down and stopped photographing. But the doctor looked at me calmly and said, "Come on man, do your job." In that context of medical crisis it was the constructive thing I knew how to do.' (27 November 1993)

Next Wednesday is World Aids Day, and nowhere on earth is the 20th-century plague more prevalent than in Africa. GIDEON MENDEL visited a remote mission hospital in Zimbabwe to record the treatment of the afflicted and the suffering of their relatives. His photographs and report are printed here

sion Hospital stands hillocks that dot the flat Zimba nd of empty he of death a ng adults

cent of patients with sexually diseases are infected with HIV. While no full survey has been carried ernment sources the adult pop

Zimbabwe. In some parts of the country, many as 20 per cent of pregnant women AZINE 27 NOVE

is of the

population have This

The cours, at the Malaga Mi uthern Zimbabwe d by a Swiss hospital nce; at Malaga The rubber gloves h

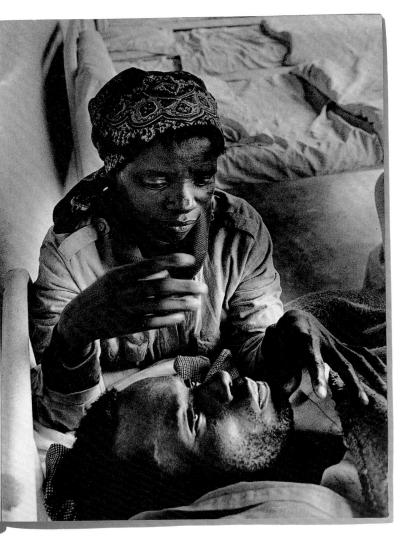

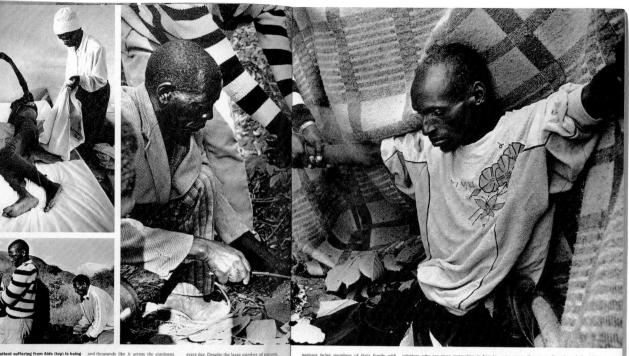

ed in

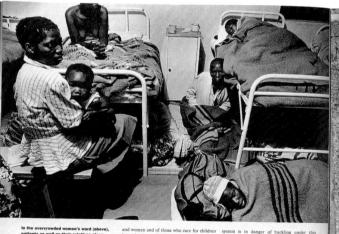

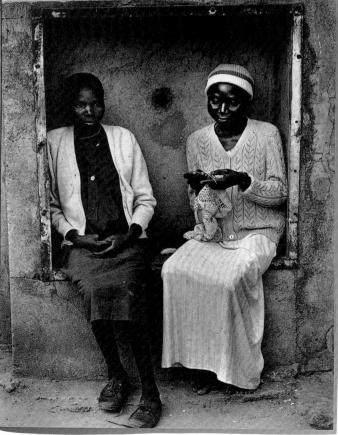

287

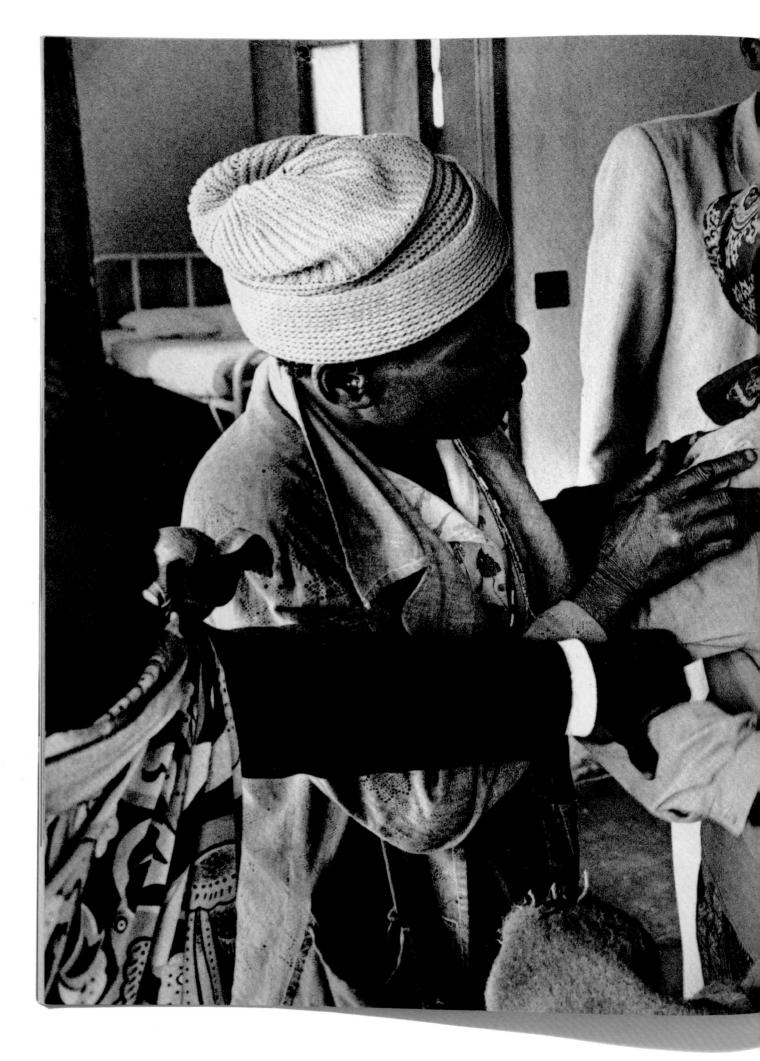

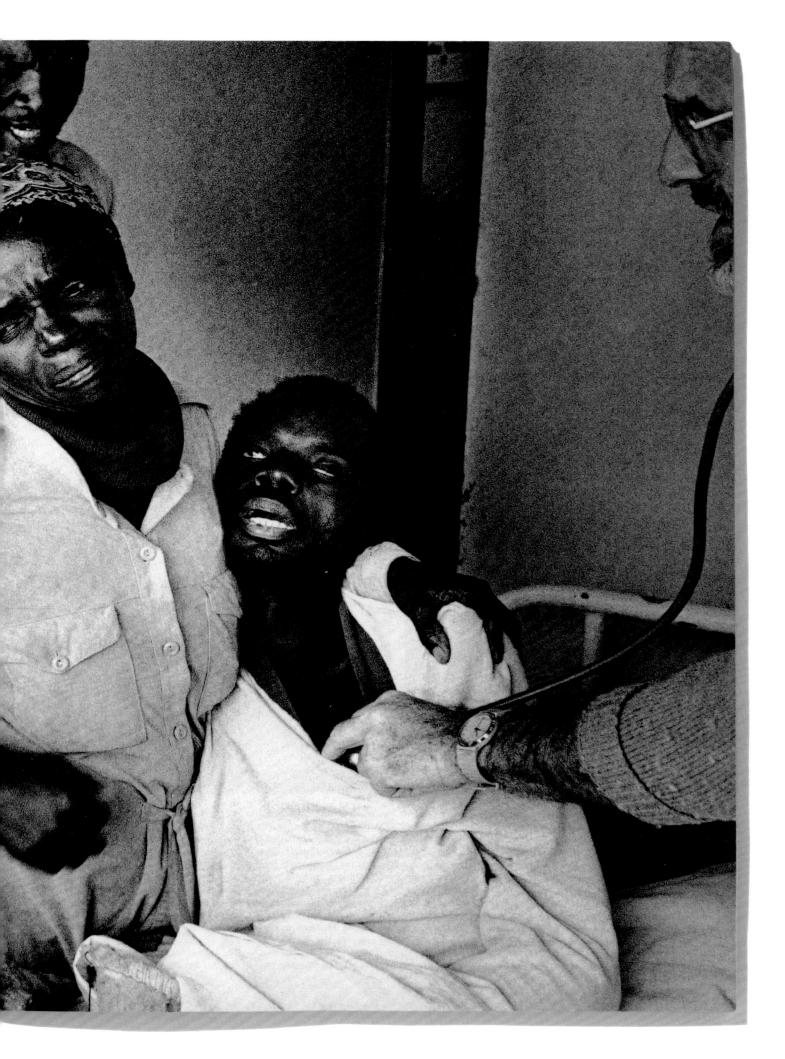

1993 ALFRED SEILAND NEW ENGLAND FRANKFURTER ALLGEMEINE MAGAZIN

On Christmas Day 1979, *Twen*'s creator Willy Fleckhaus, and his protégé Hans-Georg Pospischil, conceived an idea for a colour supplement for the urbane readers of the *Frankfurter Allgemeine Zeitung* to satisfy the paper's need for a vehicle for colour advertising. It would not cover conventional current affairs stories, nor in fact 'stories' in the narrative sense at all, but would rely on extended photographic sequences that would be moody, often abstract or, to use Pospischil's term, 'mystical'. Carefully chosen photographers defined the sophisticated aesthetic style that the magazine could call its own – the exact opposite of the flamboyant, sensationalist *Stern*. Flash photography was banned. The cover would always feature photographs framed by a simple black background. Fleckhaus died before the first issue was published in 1980, but the magazine consistently maintained its strict criteria over the following 19 years with little variation. Alfred Seiland was one of the small group of favoured contributing photographers chosen by Pospischil. His essay on New England, with quiet airy landscapes captured in minimalist frames and rendered in muted colours, exemplifies the magazine's refined, contemplative approach. (30 December 1993)

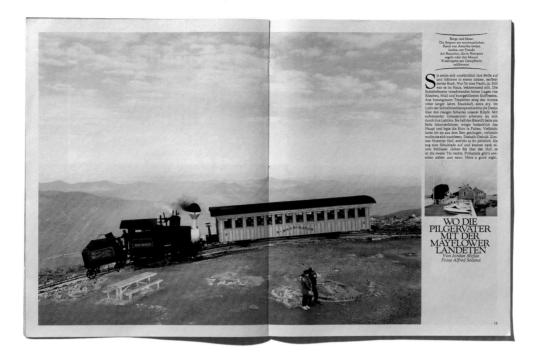

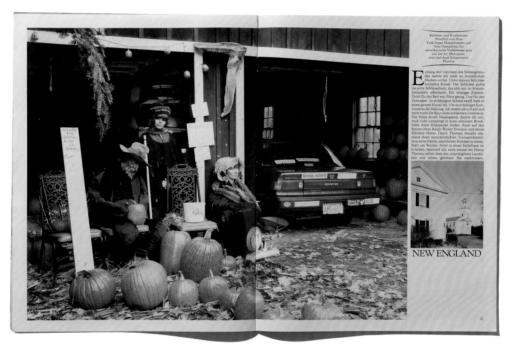

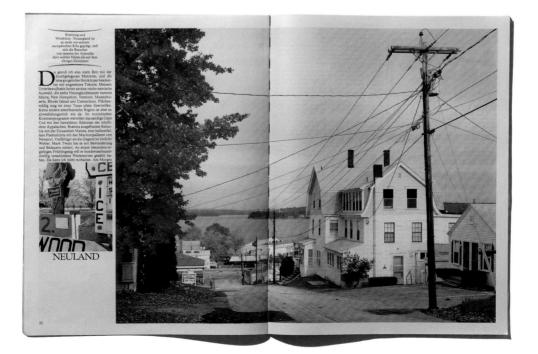

1994 BRUNO BARBEY FÈS DU

In his essay on Fès that appeared in Du, Bruno Barbey demonstrates his unmatched ability to make compositions of formal beauty and significance within the framework of thematic reportage. Born in Morocco, Barbey spent his youth in Paris and studied commercial photography in Switzerland, before covering war and conflict around the world during the 1960s, in the manner of the traditional photojournalist. But from the late 1970s, he began a steady retreat from the genre and into an ongoing personal essay on Morocco. Combining the timeless subject matter of Delacroix with the decorative colour of Matisse, this was more than an exercise in pursuing the 'pure pleasure of aestheticism' for Barbey. Informed by a knowledge of customs and popular superstitions, and by his own vivid childhood memories, his essay is an enquiry into Morocco's culture and his relationship to it – a puzzle defying resolution – as well as a personal celebration of its patterns, designs and structures. By the time of Du's publication, his pictures of Morocco had evolved from their illustrative beginnings to a striking level of sensual power. (July/August 1994)

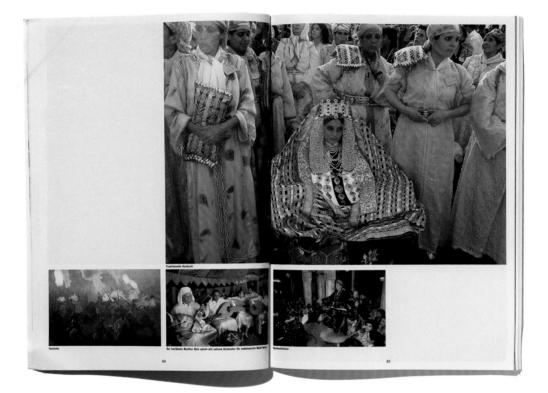

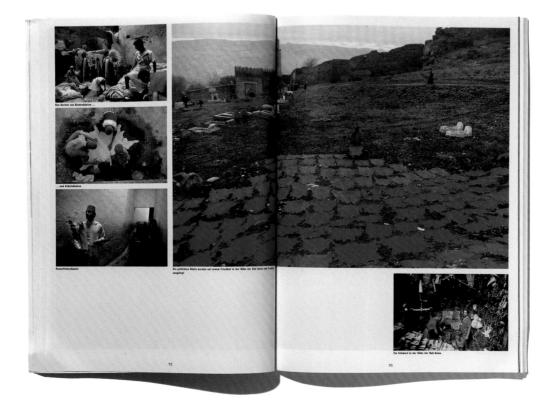

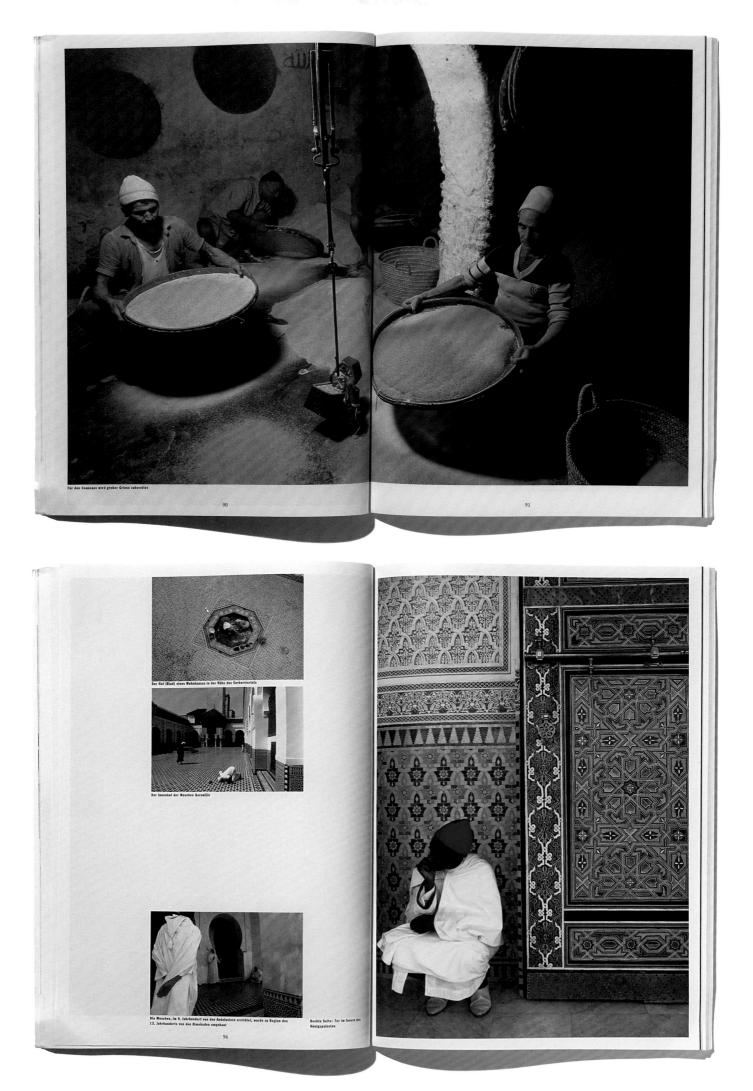

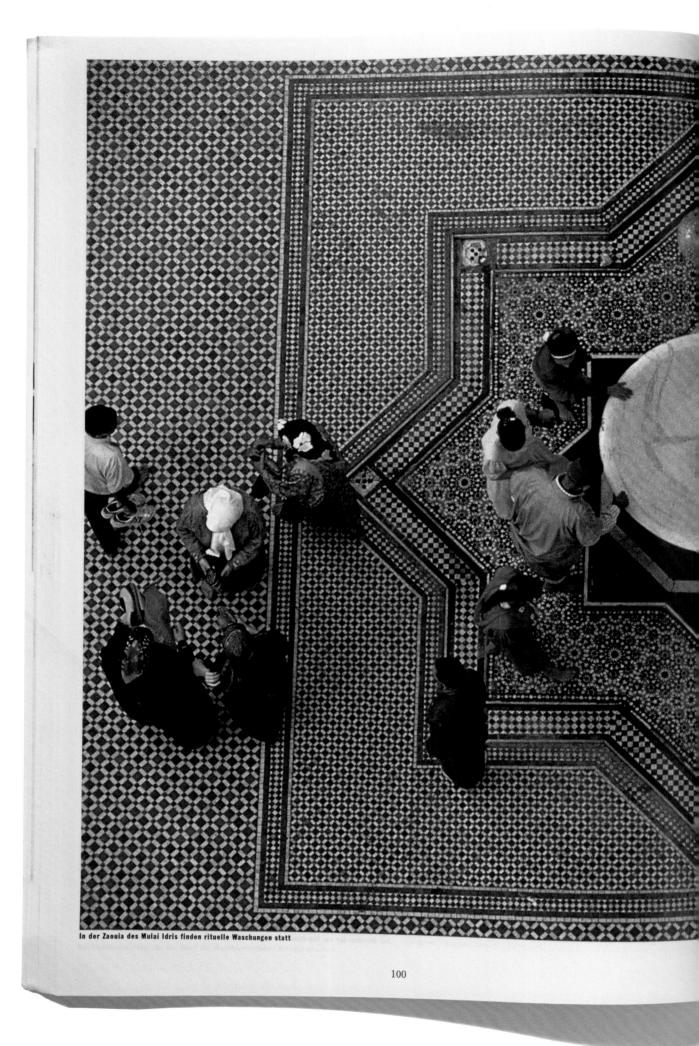

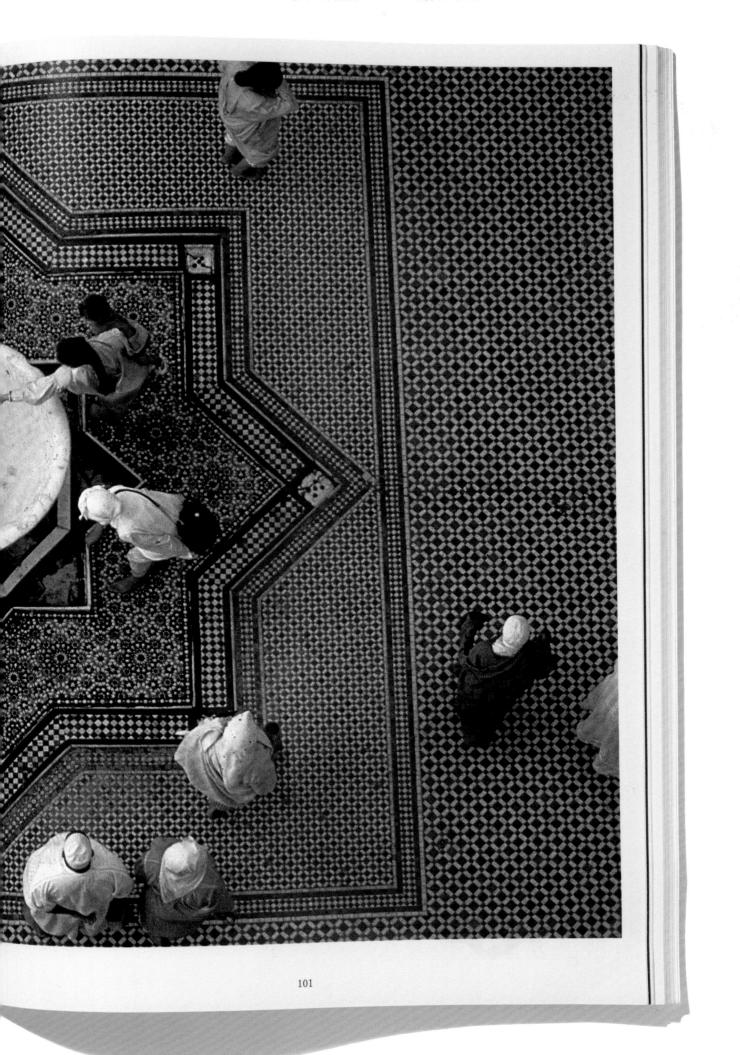

1995-2005 RISE OF THE REPORTER-ARTIST

PAUL LOWE CHECHNYA 300 NAN GOLDIN JAMES IS A GIRL 304 STANLEY GREENE CHECHNYA 308 JAMES NACHTWEY WAR IN EUROPE 312 1995 1996 MARTIN PARR SUN KITSCH 316 TIMES SQUARE NEW YORK TIMES 320 ANTER AUTCHINGS THE THATCHER ERA 326 1996 1996 Inem France MA FRANUEMUNIUM 33U TANN ARTHUS-BERTRAND EARTH FROM ABOVE 332 1996 1996 1997 1997 nu vu v^{yz} MEGATRANSECT 336 MICHAEL NICHOLS MEGATRANSECT 1997 uunuus ner uuse kannir kuusuna 330 340 GRISTINA GAREIA RODERO HAITI RITUAL GRISTINA GAREIA RODERO INKOLE REFUGEE CAMP COLORS 338 1997 AD VAN DENDEREN IMMIGRATION IN EUROPE 344 1999 JONAS KARLSSON 1999 WILLIAM ALBERT ALLARD UNTOUCHABLES 350 1999 THIS IS MY WORLD GAZETA WYBURGA 352 2000 2001 SIMON NORFOLK AFGHANISTAN 354 2001 RINKO KAWAUCHI AFGHANISTAN 356 2001 KADIA BENGHALIJAL NADIA BENGHALIJAL 2001 2002 ISRAEL PALESTINE DAYS JAPAN 363 2002 WRZIK & JARISCH FEET STORIES 366 2002 2003 JAMES NACHTWEY DARFUR 368 2003 RICHARD AVEDON DEMOERACY 372 2003 TSUNAMI PARIS MATCH 374 200^{4} 2004 20042004 2005

1995-2005 RISE OF THE REPORTER-ARTIST

As the digital era gets into swing, with digital cameras reaching the consumer marketplace and the internet now a household tool, technological change continues at breakneck pace. The human genome is decoded and scientists clone a sheep. The world becomes more divided between spectacular wealth and extreme poverty, between and within nations, and China becomes a formidable economic force. Then, on 11 September 2001, Islamic terrorists mount an unparalleled attack on symbols of the political and military power of America and the global economic order, shifting history into a new dynamic. America's invasion of Iraq polarizes world opinion, while the Middle East descends into a renewed quagmire of violence. For photojournalism, there's plenty to address, but the environment has changed. Its cottage industry era has given way to consolidated global corporations, with photographers becoming contentproviders low down on the supply chain. Princess Diana is killed in a car crash and photographers are blamed. The press tightens its belt, hard. Yet the public taste for photography grows more sophisticated and a booming market for photographic prints takes off. Photography moves from the fringe of the art world to its centre; the museum accommodates journalism and the magazine accommodates the artist. New opportunities are embraced by a group of brandname reporter-artists, while accessible digital production and distribution tools the camera-phone and the internet - challenge the authority of the professional photojournalist. Defining photo reports about American operations in Iraq and the Asian tsunami are by amateur photographers. Now everyone is watching.

LUCIAN PERKINS Washington Post

A bus on the road leading to Grozny during fighting between Chechen independence fighters and Russian troops. Chechnya, May 1995. World Press Photo of the Year 1995

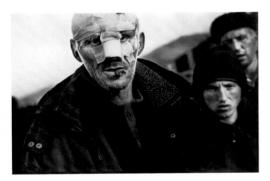

CLAUS BJØRN LARSEN Berlingske Tidende Wounded Kosovo-Albanian man walks the streets of Kukës, one of the largest gathering points for ethnic Albanian refugees fleeing violence in Kosovo. Albania, April 1999. World Press Photo of the Year 1999

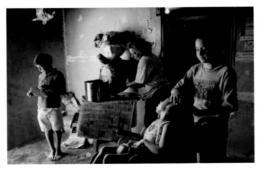

LARA JO REGAN *Life* Uncounted Americans: the mother of a Mexican immigrant family makes piñatas to support herself and her children. Texas, USA, 2000. World Press Photo of the Year 2000

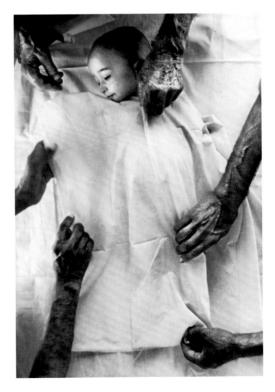

ERIK REFNER *Berlingske Tidende* The body of a one-year-old Afghan boy who died of dehydration is prepared for burial. Jalozai refugee camp, Pakistan, June 2001. World Press Photo of the Year 2001

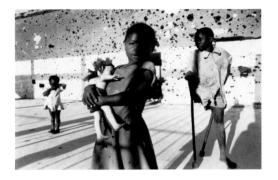

FRANCESCO ZIZOLA *Agenzia Contrasto* Landmine victims. Kuito, Angola, 1996. World Press Photo of the Year 1996

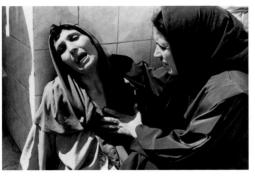

HOCINE Agence France-Presse A woman cries outside the Zmirli Hospital, where the

dead and wounded have been taken after a massacre in Bentalha. Algiers, Algeria, 23 September 1997. World Press Photo of the Year 1997

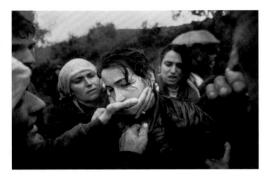

DAYNA SMITH Washington Post

At a funeral, relatives and friends comfort the widow of a Kosovo Liberation Army fighter shot dead the previous day while on patrol. Izbica, Kosovo, 6 November 1998. World Press Photo of the Year 1988

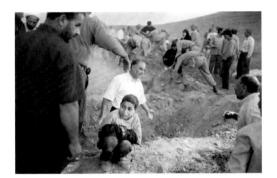

ERIC GRIGORIAN *Polaris Images* Boy mourns at his father's graveside after earthquake. Qazvin Province, Iran, 23 June 2002. World Press Photo of the Year 2002

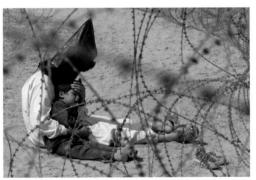

JEAN-MARC BOUJU *Associated Press* Iraqi man comforts his son at a holding center for prisoners of war. An Najaf, Iraq, 31 March 2003. World Press Photo of the Year 2003

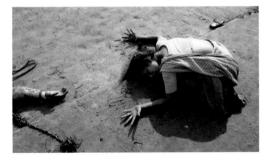

ARKO DATTA Reuters Woman mourns relative killed in tsunami. Cuddalore, India, 28 December 2004. World Press Photo of the Year 2004

1995 PAUL LOWE CHECHNYA INDEPENDENT

On January 15, 1995 the *Independent* magazine devoted a cover and a remarkable 20 pages to Paul Lowe's diary of Russia's assault on Grozny, following Chechen separatists' declaration of independence earlier in 1994. Lowe was one of only a handful of journalists in Grozny before the Russian tanks arrived, and the only independent photographer to stay through the Chechens' victory until the city finally fell – hence his coverage was uniquely comprehensive. Although the war subsequently dragged on and news media interest soon tired, news audiences at the time were riveted. Who were these Chechens? While Russia's spokesmen presented them as violent gangsters, Lowe painted a picture of a tribe of plucky Davids facing down a Russian Goliath. That the story ran so extensively was partly because the main events happened over Christmas (and in competition with the hijack of a French airliner), meaning the story stayed unusually fresh for a weekly supplement. The story proved Colin Jacobson's swansong: it was the last issue of the *Independent* magazine that he edited and seemed to signal the end of a photojournalistic era. (14 January 1995)

STORM IN THE CAUCASUS

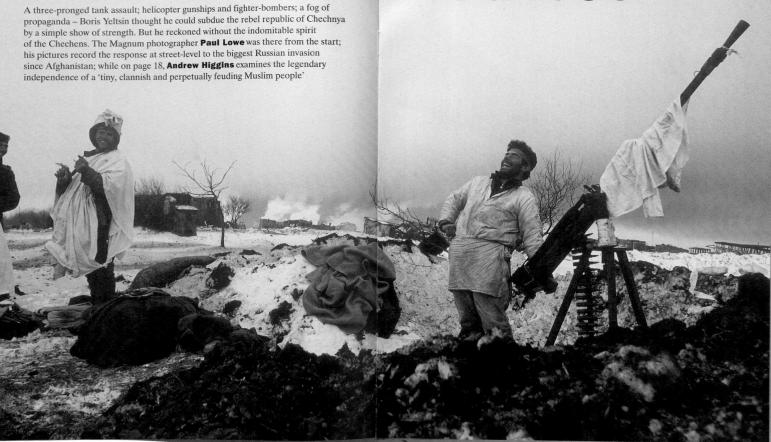

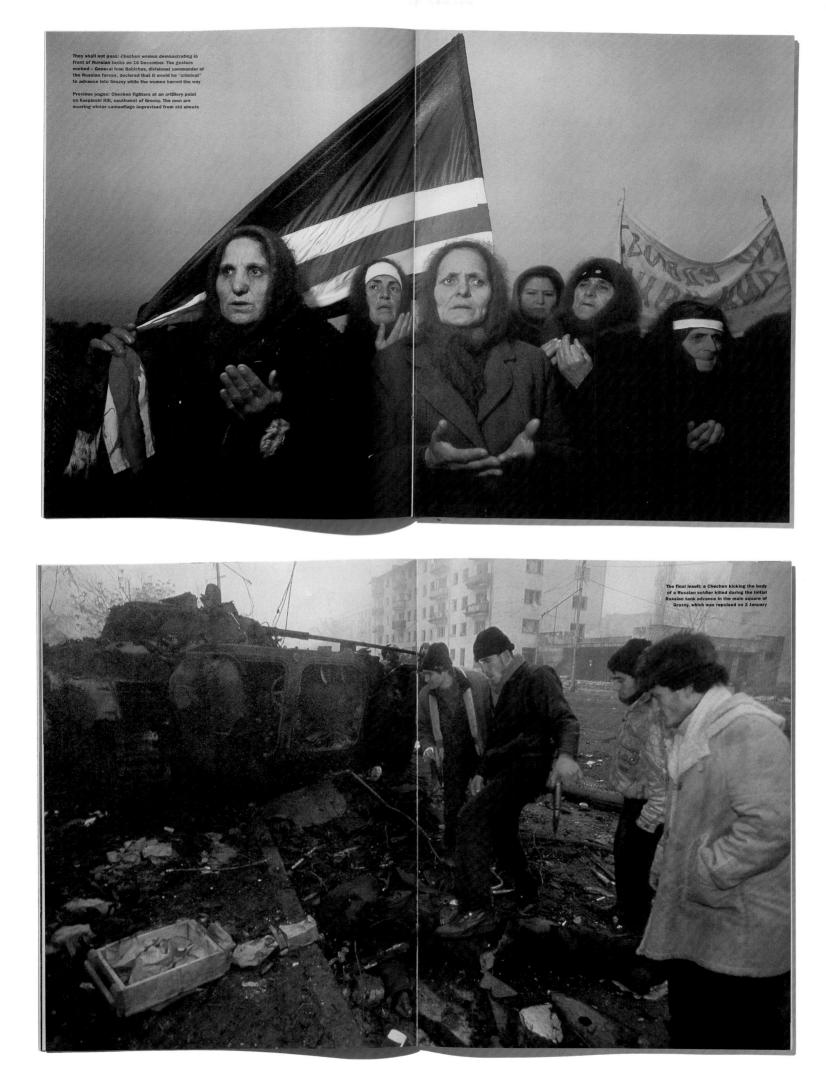

1996 S-21 REPORTAGE

The Khmer Rouge operated the secret prison S-21 at a former school in Phnom Penh, from 1975 to 1978, where those suspected of counter-revolutionary activity were photographed prior to their torture, forced confession and execution. Of the 14,200 political prisoners taken to S-21, only seven survived. Shortly after the fall of Pol Pot, the prison and its contents became a museum where, in March 1993, young American photographers Doug Niven and Chris Riley found the deteriorating negatives of the systematic prison records in a filing cabinet. They established the Photo Archive Group to clean, catalogue, print and present the approximately 6,000 photographs. First published in *Reportage* magazine, they have subsequently been widely published, exhibited and discussed. In February 1997, the Associated Press released an interview with Nhem Ein, revealing that he and five apprentices were the photographers responsible for the S-21 images. The true author, however, was the regime itself, and Ein another of its victims. The work stands as a model for the rescue of other historically important photographs, and the potential for their sensational contemporary impact. (April 1995)

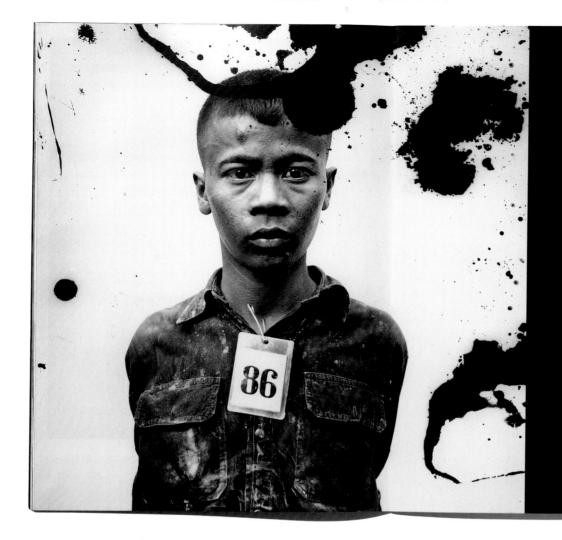

The sadness of S-21

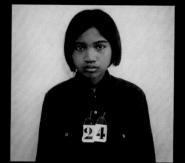

The catacomb-like heaps of bones exhumed from Cambodia's killing fields are a familiar, if grisly sight, but they are victims without faces. Less well-known are the prisoners of 'S-21' photographed by the Khmer Rouge

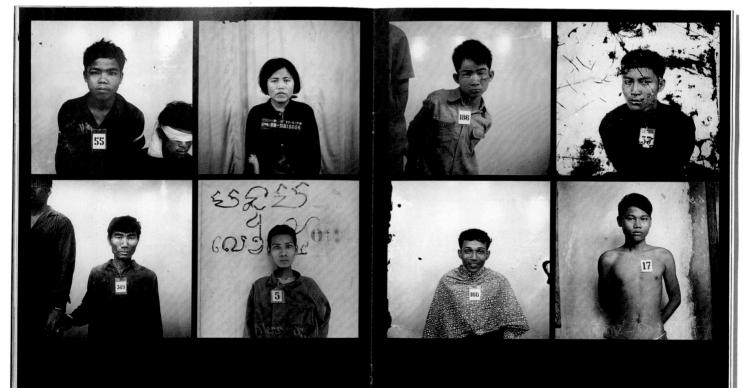

Umit 16 April 1975, identified a trub Slape light shool, like everywhere slacin the world, kinnply meant being kept that in class. The way next day that changed for ever: 17 April was the bindly of a new millentime, a historical apasm so convolve that in the progenitors decread an end to the old calendar. This was Year 22 crow, when the revolutionary Khmer Rouge forces: commanded by Pd to rand his Paris-educarde calere overthreew thourgoets in ell and forced the

of Cambodia out of the ciries renaming the fields. Under this was unin prefiguri. The second second second transfer of Massim the fields. Under the high 14,000 C Tool Sleeng acquired an through the second the second through the second second through the second second grim interseon, where those suspected grim interting counter-reconditionary their kills to were interrogated, to second the second second prime through the second grim intertion of the second second grim interpret the second second grim intertion of the second second grim intertion of the second grim intergrim intergr but also a photograph of every on By the time the Vietnamese intervention of 1979 forced the former schoolteacher Pol Pot intt exile, one million Cambodians – approximately one in seven of th population – had died of disease starvation. Another 200,000 wer killed as enemies of the state. The Khmer Rouge for the precedent of Stalin

something still more dementedly paranoid about Pol Pot's depredations. For all that it was a grotesque charade, the Maoist ritual of rectification and self-criticism did at least allow for eventual rehabilitation; likewise, Stallin's show trials were grim parodise of judicial process but they were conducted in mublic and alcoth persence. ons extracted in Tuol fifthy and mile he Pary's private efforts of the y; they provided no Archive Grow nency. Only seven negatives sur wn to have survived archives wither Phnom Penh, they or of prisones that Cambad ours earlifer, their had endured. Recently, at exhances was transed in Phnom Senh, they or memoral that cambad and endured. Recently, at exhances was different that part part of the image was different that cambad responsible for image was different that cambad responsible for image was different responsible for resp joined the Khnuer Rooge as a 10year-old. He was ent to China fortraining and returned in Mpy 1976; agged 16 to be delify thotographera at Taral Sleng, Interviewed in Phonon Panha by Roim Mar Dowell of the Associated Press, Niem Einestimated that the took show 110000 photographes at S-21 and recalled seeing front after for edited with frasing front after for edited with frasing front after for edited with frama fat deep adaptase." However that I was taking the pleatures of immocent peopher. But Davies the sild of -

1996 NAN GOLDIN JAMES IS A GIRL NEW YORK TIMES

Nan Goldin's pictures dominate writer Jennifer Egan's cautionary account of the life of an international runway model – James, a pretty fifteen-year-old girl from Nebraska. James' friends, mother, agent and fellow models all profess enormous affection for her, yet seem indifferent to the bleak rewards that accompany a childhood devoted to meeting the needs of the fashion industry; James coughs constantly, lives on coffee and cigarettes, and has no permanent home, yet on her own terms she has 'made it'. Goldin may seem an unusual choice for this editorial assignment, given her established reputation as an independent artist. On the surface, her autobiographical approach, snapshot aesthetic and the art world context in which her work is usually seen set her distinctly apart from the world of photojournalism. Yet her subject matter – drag queens, heroin addiction, sado-masochism and fighting Aids – and her interest in storytelling mean she has much in common with the typical photojournalist. 'James' was not her first editorial assignment; an earlier fashion story starring Goldin's friends had been rejected by the designer who said she 'would never let junkies like that sell her clothes'. (2 February 1996)

In the fashion world of the 90's, teen-age models simulate an adulthood they've yet to experience for women who crave a youthful beauty they'll never achieve. Sweet 16 it's not. By Jennifer Egan Photographs by Nan Goldin

A via class associated as Walks Autos Bole, ratio July Pill Autor Carlos associated as a walks Autos Bole, ratio July Pill where Hoh takens a strain for the Transmit, see the intermets, where and new particular that starts that Transmits, new in the most fact, as a first provide the start of the transmits, and the intermets, when and new particular that starts and the start fill known as figures (2008) Management andready represented plants Rehat, a say model. "Junesdendy Junes Reling" was also a start with the start fill known as figures (2008) Management andready that a start start that the spectration that the transmit alter of Junes Reling" was also as a start walk and the spectration that the start start of the start start of the start start of the start start of the start of the

""est, "Samenso says, nodding, "Yes." "Est, "Samenson says, nodding, "Yes." She has enormous dark eyes and braces on her teeth, and will t anyone who ask that her father is Russian mobster. Motherly beyon her years, she has taken a break from her studies in fashion-busins Jemifer Egan is the asthor of "The Invisible Crusu," a novel, and "Enters Circ," a collering of stories just adultion le Nare A. Taken-Dushidest."

is her first article for the Magazine. Nan Goldin is a New York-based photographer whose last assignment for the Magazine was on gang girls. She is having a retrospective at the Whitney Museum of American Art this fall pany James to this fall's ready-to-wear shows in Europe, which the first week in October in Milan. nana Republic rocks, I'm sorry," James says. is the morning of the John Galliano show, one of the mos ated of the collections being shown in Paris, and James has beer

— a trimple for any model, nor to gank of one hving her far; in more triangle and the relationshe her through account in Malon (add), popering in the Poris collections. Journe tarened 16 in April. In Journe 16 Ginolos Per braddias — easy a multipain as declared into d'Malletoro — I walk with her and Shorerrow to the Their relationship of the Poris and the second shorerrow to the Their relationship of the Poris and the second shorerrow to the Their relationship of the Poris and the second shorerrow to the their periodic here. The second shore the second shore the gradiest here filled the size with a throat-according using the built persons on the walk great in the shore of the California shows the errors and the Mig far in and who were. The shore haves there is the second shore the second shore the terror store by specific ways. Now We the shore the terror is the store by second shore the second shore the second shows the terror store by specific ways. A shore the shore the second shows the terror store by specific ways. Now the star to the target shore the shore the terror store by specific ways. Now that models have become itera, the there are shore by specific ways. Now that models have become itera is the shore and the store the second shore the second shore the specific shore the shore the specific scheme itera and the second shore the specific scheme itera and the shore the specific scheme itera and the second shore the specific scheme itera and the specific scheme itera and the shore the specific scheme itera and the shore the specific scheme itera and the specific scheme itera an

ugn the snow isn't scheduled to start until 6:30 P.M., models lak

toss for imperfect beauty that triumphed. Within minutes of to upermodels' arrival, the room is saturated with camera fashes a elevision crews, everyone tripping over wires and elbowing one anot like to set a those impossible beautiful faces. The media runoff falls to i

make to get at those Introduct based with lack. The model reported Tato to serve, Fursch-Rossen wave, Harris and Harris a

tantu, and Calitaton its Anappred the hereimportant, guest ciphe on the stage. The stage of t

TN THE FASHION WORLD, MODELS ARE always "girks". Successful models are "big girks." Stars like Mous and Campbell and Evangelists are "huge girks." Diminutive though the term may sound for 30-year-old like Brangelista, who has made millions during her career, "girl" captures the peculiar role played by a model of any age. Backstage at a solve or at a shooting in a loft. "girl" suggests, at its ment to,

In recent years, America hus become obserted white "gelts" and a final or work has a know place whyse recent have to achieve the place of the place of the second or the second place of the presence of the second place of the place of the second place of

But if models have always been young, they have not always celebrities, and nowadays, teen-agers like James must contend of attention — and the pressures that come with it — that wa the early 80's, when I modeled briefly. The media presence is and the avoid has showed a 16 overcold model mitted briefly to a show a world has showed a show the old model mitted briefly.

> week and 'rague the exct. She up part of a globalacd industry, make a girl' is to put her on the may. Fluiets begun making Junes a go, Junes is big today, and there are people in the fashion believer that her could be huge. She has long, stratphe blond hair arboecking face — sery and sorrowful. She has an endezinghy could mile and the iminious skin of a child. She is a leader gri liptuous woman. She is growing up before our cycs, and she is growing up very, vert fat.

James met Michael Flutte, founder and owner of the Company Management modeling agency, when she was 14. 'I wanted to go somewhere with my life and I wanted it now, she recalls.

> cus off her long borom hair and bleached it white, and Ledii Folde cently cus off her long blond hair and dyrd it blue-black (and, ram lista hooled fat, the rostways were full of blonder, some moe coming to Paris because of the neutralex testing in Table 7. Tyler, a black model, is having a mistrable time in Varis, Tyler, a black model, this season, and the table show.

te Romeo Gigli used mostly black models in his spring "95 show and ne wasn't a commercial hir. Upter turns to Andreea Radutoiu, a non-haired model with strong Eastern European features. "I never to come back here," she says, almost and sametrova. James looks exhaustnally, Fluite arrives with James and Sametrova. James looks exhaust-

in New York. It is a long and arduous day: five shows in about eight hours.

OTOGRAPH BY NAW GOLDIN FOR THE NEW YORK TIMES

NEW YORK TIMES MAGAZINE / FEBRUARY 4, 1996 31

The New York Times Magazine

FEBRUARY 4, 1996 / SECTION 6

She has a look that's earned her runway jobs, magazine covers, tens of thousands of dollars and a shot at celebrity. All she's lost is her youth. **At 16, A Model's Life By Jennifer Egan** Photographs by Nan Goldin

Top row, left to right: James with her boyfriend, Kyle, in town from Omaha; looking Lolita-like at one Paris show, and royal at Karl Lagerfeld's. Middle row: James and another model, Carolyn Murphy, at the Ghost show; in Paris at a fitting for Jean Colonna, and with her mother, Nancy King, who came to her daughter's shows in New York. Bottom row: "Her body rocks in a big way" is how James's best friendd described her; James on a Jean Colonna set made to resemble a hotel room, and with Kyle at a pool hall in New York.

32 PHOTOGRAPHS BY NAN GOLDIN FOR THE NEW YORK TIMES

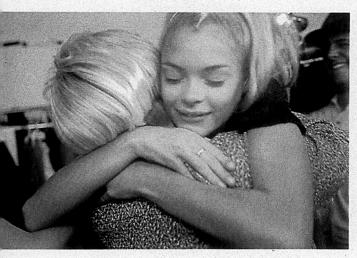

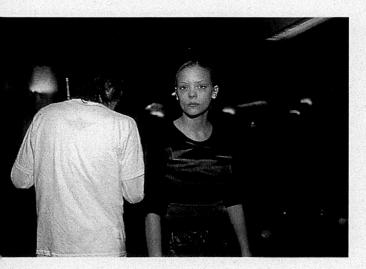

At Richard Tyler, one of James's biggest fall shows at Bryant Park, she wore three outfits that had in common transparency from the waist up, so that her breasts were fully visible.

process: haircuts, air fare, messenger fees, laser prints for her book, multiple copies of each magazine she appears in and even food. The model pays for everything, and it adds up. James, whose Corn Belt blond hair and blue eyes are more naturally the stuff of catalogues — a good source of income for models — will make an estimated \$150,000 in this, her second year. But she, too, will have a commission and expenses to pay. The rest will go to her parents, who invest it and provide her with a weekly allowance.

Striking a balance among editorial, advertising and catalogue work is crucial to the success of any model who, like Radutoiu or James, is shooting for the top. Editorial work — that is, posing for the photographs that appear in the fashion pages of magazines — is low paying (\$150 per day on average), but highly prestigious and a valuable source of tear sheets and exposure. Catalogues pay much better (day rates start at \$750 and can go as high as \$10,000 or more, for a star), but are useless in forwarding a career. To be perceived as a mere catalogue girl is to lose the hope of editorial work, without which a model has little chance at grasping for the real prizes of her business: campaigns, or seasonal advertising for designers, which can pay as much as \$20,000 per day; and most desired of all, contracts, in which a model becomes a representative for a company's products or apparel lines (Moss for Calvin Klein, Claudia Schiffer for Revlon). A contract model may earn sums in the millions.

There is an upright piano at Natacha, and James begins fooling around on it. She has a charisma that draws others to her, and soon a group is gathered at the piano. Watching her, I find myself thinking of her description of her first meeting with Flutie, when she was 14: "Michael asked me a question. He's like, 'Why do you want to do this?' And I said, 'Because I want to be a star.' It didn't mean that I want to be famous. It didn't mean that I wanted everyone to know me, it just meant that I want to be a star to myself. That I wanted to be successful to myself, that I wanted to go somewhere with my life and I wanted it then, I wanted it now."

AMES IS FROM OMAHA. "I GREW UP IN THE SUBURBS," SHE TELLS ME, "very normal family, like Mom, Dad, that kind of thing." She has an older sister and a younger brother. Her parents separated more than a year ago (something James never mentions), but the split is amicable and they still work together in Omaha, renting out mostly low-income apartments. "When I was 12 or 13," James says, "that's when I started looking at magazines, and I became literally obsessed with designers and models. Like, I would stay up till 3 o'clock in the morning slicing the best pictures out of Harper's Bazaar and Vogue and making collages and posting them up on my door, like the fiercest pictures that I saw, like of Gaultier and Galliano and whatever. I knew every model, I knew who Steven Meisel was."

In the minds of a great many young American girls, modeling has replaced Hollywood as the locus for fantasies of stardom. Kelly Stewart, a 14-year-old high-school freshman who has been with the Click agency for two years, says she became obsessed at age 8. A room plastered with pages from Vogue has become as emblematic of American girlhood as Barbie has, and the assiduous merchandising of models in books, magazines and cabletelevision shows is no doubt fueling this surge of interest.

"When I was in junior high, I had a lot of problems with people," James says. "I started getting my breasts earlier than everyone, I had my period

1996 STANLEY GREENE CHECHNYA NEW YORK TIMES

Stanley Greene began working in Chechnya in 1994, during the first war that the Chechen rebels launched against Moscow. The story became a personal mission, in which he clearly identifies with the Chechens against their 'mass murder' by Russian forces, and he continued to cover it long after the news media lost interest. He eventually made over twenty trips, financed by portrait and fashion photography, before ending his ongoing series in 2003. While working in the manner of a clandestine reporter (necessarily, given the difficulties of access), Greene's expressionistic, emotional style breaks from traditional documentary war coverage; at the same time his mysterious images of the bleak landscape aptly convey the opaque, complex and primitive ferocity of the Chechen-Russian conflict. 'You can't save the world,' he later told an interviewer, 'I'm not so naive to think that. But there are certain stories, certain issues, where you do your part, you make your statement. There are stories that get to you so deeply that you have to get them out – and this was mine.' (26 February 1996)

hero's work from Biafra to Bosnia, but he was tired of building latrines and flying in food. He wanted to be a peacemaker. a deal broker, a player. That ambition probably killed him.

What Happened to Fred Cuny?

A SA BASAYEV BELIEVES she saw him. "I remem-ber him because he was very big and a little bit heavy," she said. We were standing on the front steps of the burned-out municipal building in Sa-mashki, a small agricultural town in war-battered western Chechnya, and Basayev, an eld-erly woman with piercing gray eyes, was pointing toward the

By Scott Anderson

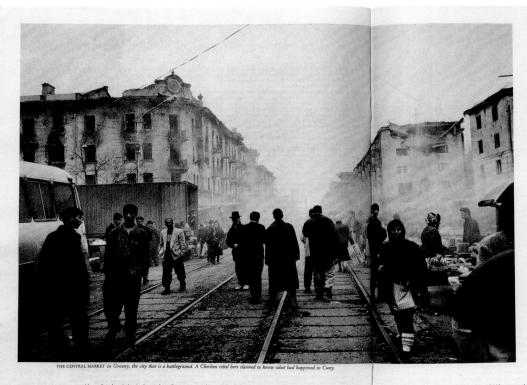

Cuny — whom . At this critical j enter a Chechn

n Caucasus or, at the rebels, fueled by persistent reports that the Russians were rewerd as increasing-infiltrating their areas with spies and agents provocateurs. The tar had grown ever-tar had grown ever-tar is a potential enemy. Despite the fact that a diagerous place seemed to be growing mins were operating more so every day, the Soros administrators bowed to Curry's so transformed as a transformed and agent or scened, at least res transform. Mean-ter property in the protein in Cherhwy and Ingushetis. But they do uper leaving the core leaving Moscoc, Curry was the protein the protein the protein the protein leaving Moscoc, Curry was the protein the protein the protein leaving Moscoc, Curry was the protein the protein the protein leaving Moscoc, Curry was the protein the protein the protein leaving Moscoc, Curry was the protein the protein the protein leaving Moscoc, Curry was the protein the protein the protein leaving Moscoc, Curry was the protein the protein the protein the protein leaving Moscoc, Curry was the protein the protein the protein the protein leaving Moscoc, Curry was the protein the protein the protein leaving Moscoc, Curry was the protein the protein the protein leaving Moscoc, Curry was the protein the protein the protein leaving Moscoc, Curry was the protein the protein the protein leaving Moscoc, Curry was the protein the protein the protein leaving Moscoc, Curry was the protein the protein the protein leaving Moscoc, Curry was the protein the p

LEFT. STANLEY GREENE/VU, FOR THE NEW YORK TIMES. RIGHT, INTERTECT

Chechnya, Cuny Miklavev, the

LOST IN CHECHNYA

By traveling with a native of Bamut, Cuny and the others had managed to enter Lower Bamut, the site of the nuclear-missile base. At that

point, their fate may well

have been sealed.

me 10 das

to me and aid, You know, I don't think we're gair to see Ferd agair." Son ArtER CLMY WA. ELPORTED MUSING America of ficials in Macsowa Mawhington America of ficials in Macsowa Mawhington America of ficials in Macsowa Mawhington America of ficials in Macsowa Takawa alive and well — and werking directly with the Chechen rela-duer, Dzhohkun Dudayer, as 2. CLA-aponsored advier. The rources of hese reports, the State Department pirturely disclose the second state of the second state of the analysis of the second state of the second state of the analysis of the second state of the second state of the disclose the second state of the second state of the analysis of the second state of the second state of the analysis of the second state of the second state of the disclose the second state of the second state of the disclo

there no irresponsible journalists in your stories?" he asked. "Well, we have journ The F.S.B. has never told these stories." v was stripped of his post after acting as a ian Government's ever-changing account tage-taking fiasco in the village of Pervo petere of high-level Russian involvemen of the

sist in the search ed defense-intelligence colones, fly flown in from Washington. tering held regular status-report a. To many Russians, particularly the very ambition the very am agen

Y 25. 1996 53

1996 WAR COLORS

Colors was born in 1990 when Italian photographer Oliviero Toscani, then in charge of Benetton's advertising, invited American design guru Tibor Kalman to create, design and edit a new magazine. 'Tibor's dearest dream was to be the editor of *Life*,' wrote his wife Mira, 'He worshipped that magazine. He also greatly admired Neville Brody's visionary aesthetics for the *Face* and the global view of *National Geographic*.' The result of this mix of inspirations was an innovative anthropological magazine with a radical graphic approach that featured strong and often controversial journalism, using stock news photographs drawn from agency archives. Distributed internationally in several languages, each issue provocatively approached a different social subject – Aids, shopping, animals, food – combining the languages of photojournalism and advertising to offer insights into human nature. Its 'War' issue, produced after Kalman left the magazine, staged a typically rhetorical assault on the conduct of war: catalogue-style product shots and descriptions of weapons were paired with pictures of injuries caused by their use. Indirectly, *Colors* also assaulted the traditional formula of the photo story. (March 1996; photograph below right by Guenay Ulutunçok; top right by Christopher Morris)

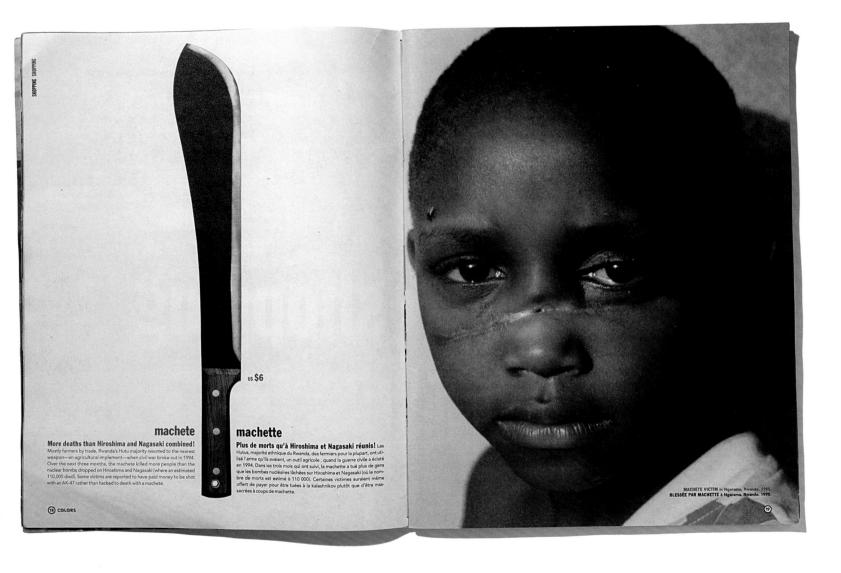

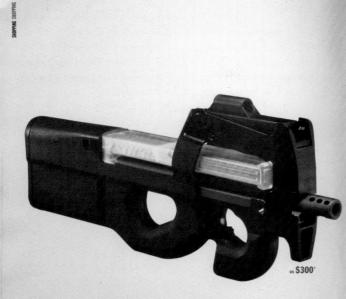

assault rifle fusil d'attaque

Ravage maximum Le P

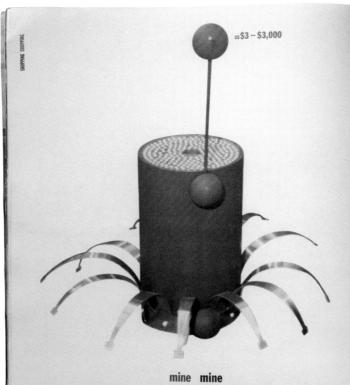

Pour les ar

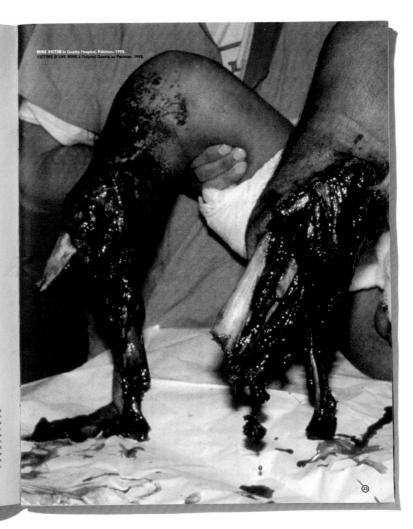

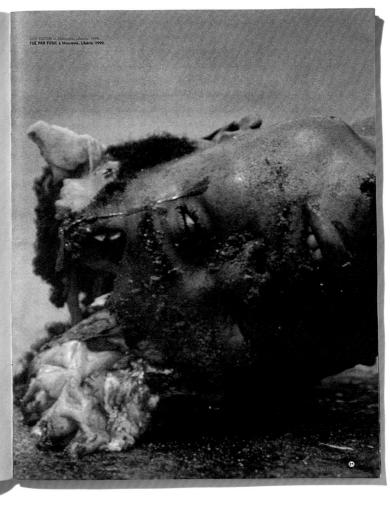

1996 JAMES NACHTWEY WAR IN EUROPE EL MUNDO

'On the brink of the millennium, war has returned to Europe' was how *La Revista*, supplement to the Spanish daily newspaper *El Mundo*, introduced one of a series of stirring war albums by James Nachtwey. Featuring photographs from Bosnia (1993-4) and Chechnya (1995-6) originally commissioned for *Time* magazine, they were presented as a dark panorama of the state of Europe and the period in general rather than as a report on immediate events. This suits the ambition of Nachtwey's work. He has said that he learned most about the photography of war from the etchings of Spanish artist Francisco Goya, whose *Disasters of War* (1810-20) depicts scenes from Napoleon's war with Spain. Like Goya, Nachtwey's photographs are explicit representations of particular wars, but tend to be read in a more general way as a searing vision of humanity's capacity for brutality. Nachtwey cites the series in *La Revista* as one of his most satisfying magazine collaborations and he used a similar layout approach in his book *Inferno* (1999) as well as in many subsequent magazine essays. (4 March 1996)

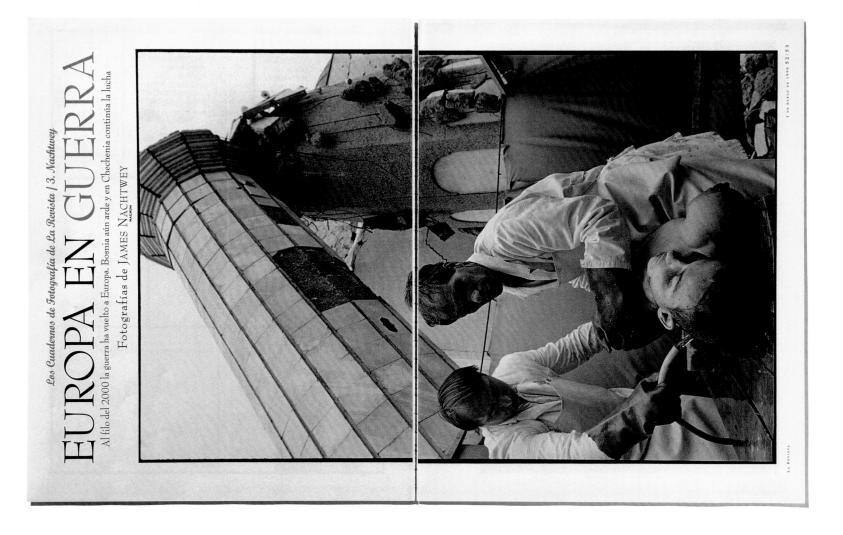

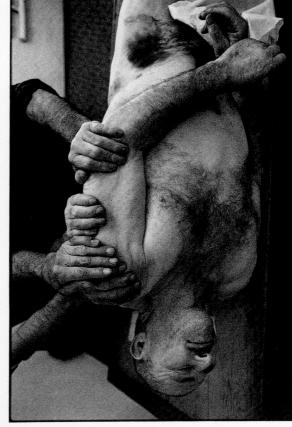

Al final, los conflictos se resumen en la suma de las cifras de muertos de cada bando: cientos de civiles o combatientes chechenos, cientos de civiles o soldados rusos.

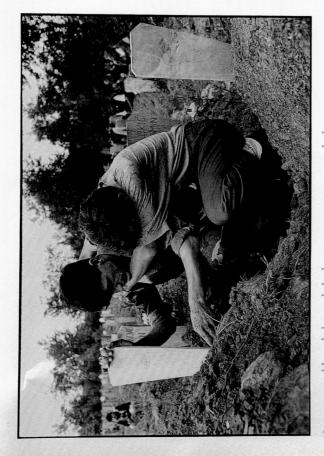

Los espacios libres de las ciudades bosnias, parques, campos de deportes... se convirtieron en improvisados cementerios, en sucesiones de tumbas y estelas funerarias.

Ancianos, niños, mujeres, civiles... toda la población bosnia ha sido objetivo. Unos, de las balas de los francotiradores, otros de las bombas artilleras, ellas de las violaciones...

LA REVISTO

185 396

3 DE MARZO DE 1996 56/57

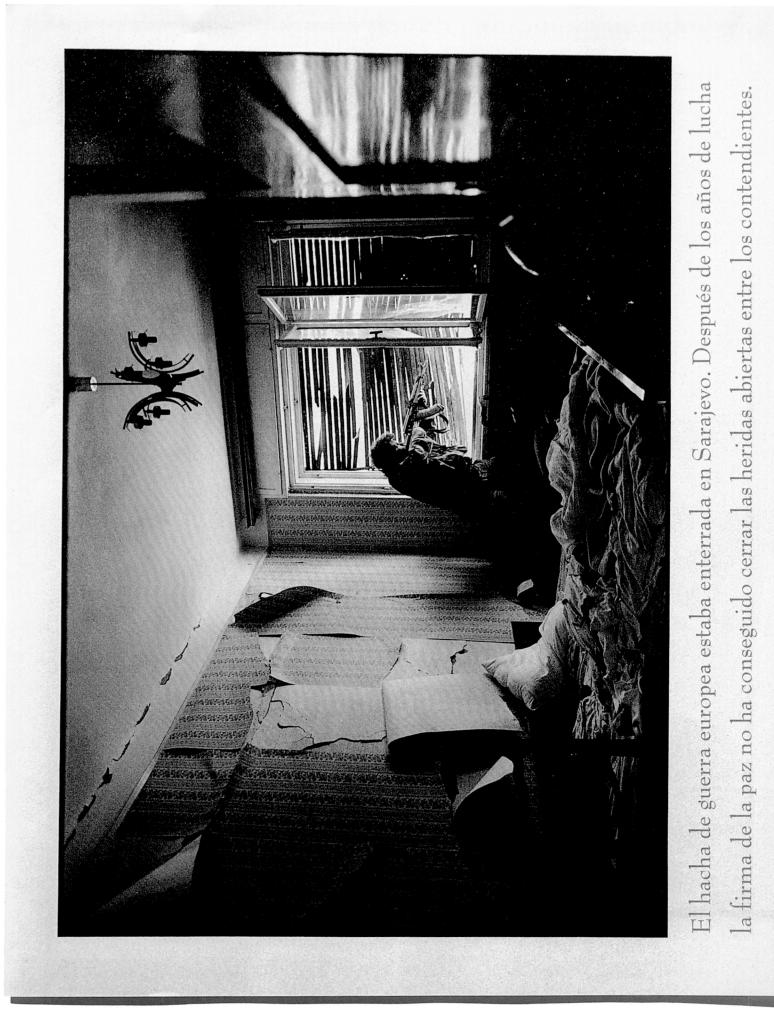

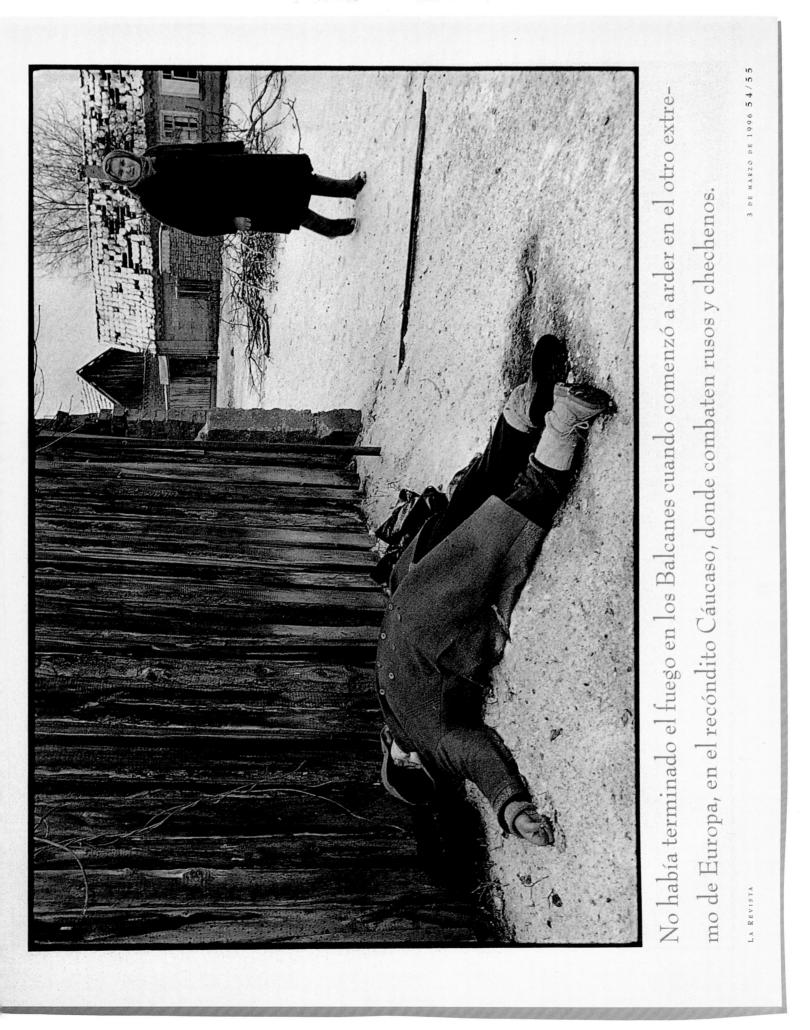

1997 MARTIN PARR SUN KITSCH W

When *W* magazine commissioned English photographer Martin Parr to explore the kitsch culture of Florida's beaches, he had already established a quirky iconography of resort behaviour. Eighteen months before the assignment, he published his essay about global tourism – *Small World* (1995) – that was part comedy of manners, part withering satire of globalization. But by 1997, Parr was developing a darker photographic style, both more intrusively detailed and more abstract, using a ring flash camera – normally used for forensic close-ups within medical photography. The resulting essay, influenced in its tone and layout by recent Japanese photography, surprised an audience familiar with Parr's work. Although the general territory and some of the essay's ingredients were recognizably Parresque – the suburban front yards, the hats – there was much that was new. The things that fascinated Parr in Florida, such as the toy dogs, gaudy jewellery and sunburned human skin, went on to become central motifs in the next phase of his work. 'Sun Kitsch' is one of the magazine features Parr is proudest of, and shows him in the process of reinventing the language of the documentary essay. (January 1997)

1997 TIMES SQUARE NEW YORK TIMES

As part of Mayor Rudolf Giuliani's project to revitalize Manhattan, making it attractive for tourism and corporate investment, he planned the transformation of the colourful but seedy Times Square into a gleaming new business, media and entertainment district. As the last of its old peep shows gave way to construction sites for new skyscrapers, the *New York Times* chose to mark the moment by commissioning 19 contemporary photographers to contribute to an ambitious photo essay, to fill a special issue of the magazine. Kathy Ryan, its photo editor, recruited a broad spectrum of leading talents from across the domains of photojournalism, documentary, art and fashion photography, with each photographer working to a brief that met their own particular visual interests. In retrospect, individual signature styles effectively trump the attempt to convey the social, economic and cultural implications of this profound alteration to the city. But in terms of photography, the issue became a statement of the *Times* magazine's visual direction, and a manifesto for the future of sophisticated magazine photography. (18 May 1997, with photographs by Nan Goldin, Edward Keating, Annie Leibovitz, Mary Ellen Mark, Abelardo Morell, Michael O'Neill, Larry Towell and Lars Tunbjörk)

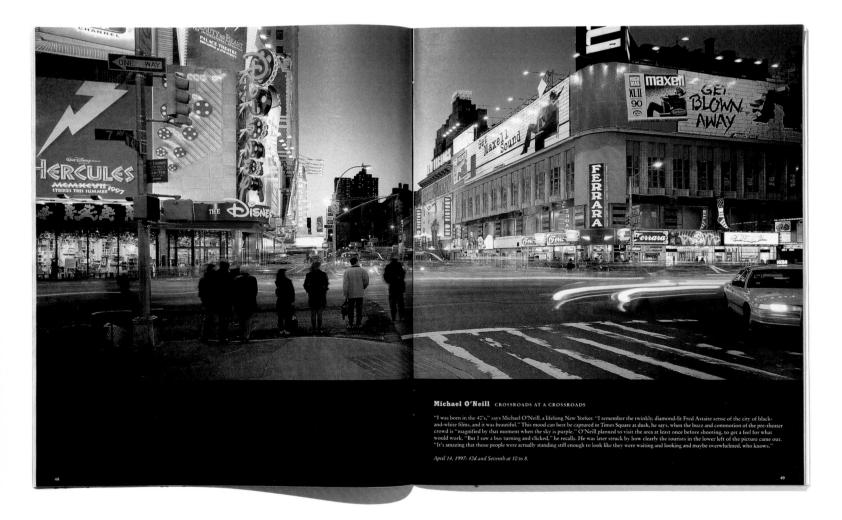

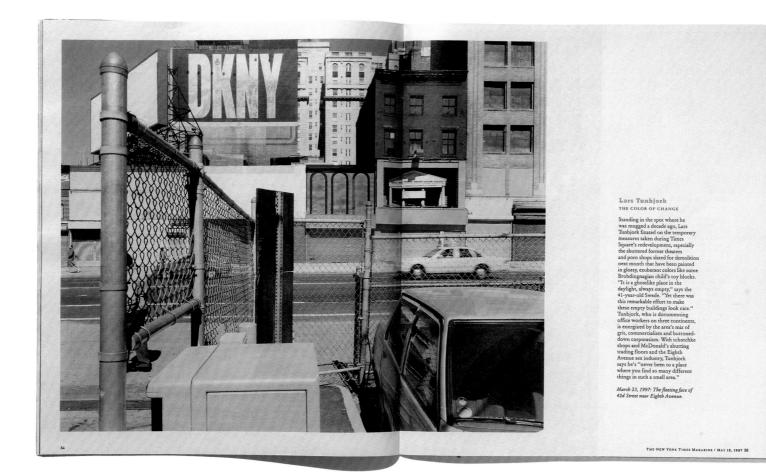

THEREPRESECT OF AN ABLESC Lary Torvell, who lives on a fam in Grance, went to the Port Authority Bus Terminal experients to see "multidness and a tenne of mensee." Finding the building antificide of open crime and homelesaness, he paired the confidence of the building's detective squad and was unbered into its detention cell. "This place radiated the ch "Dreel" reall, "A cone officer real dne, "Our job is to hide challenge of a documentary photographete in or "work with what you have, with subjects who are not villing." A stude detainess at the police holding center were detaided youwilling. "A site detainess at the police holding he instand captured the policy holding the instand captured the policy holding the set of the set of the set of the optimised of the set the set of the set the set of the set of the set of the set the set of the set of the set of the set the set of the set of the set of the set the set of the set of the set of the set of the set the set of the set of the set of the set of the set the set of the set the set of the set of

March 28, 1997: A grim detour at the Port Authority.

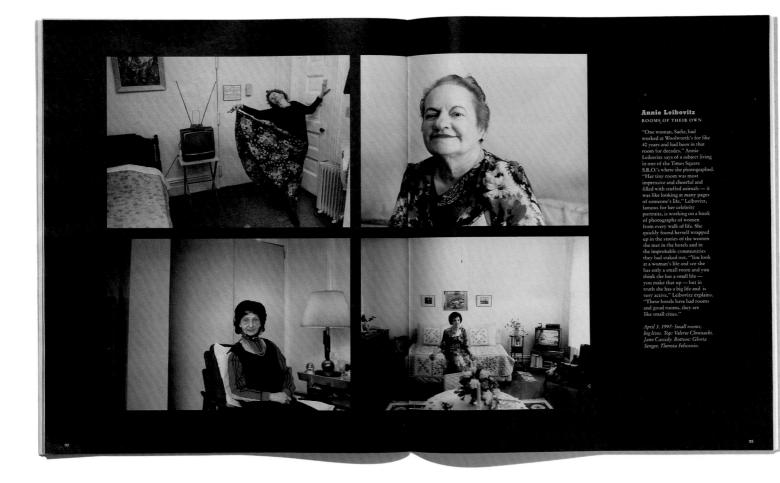

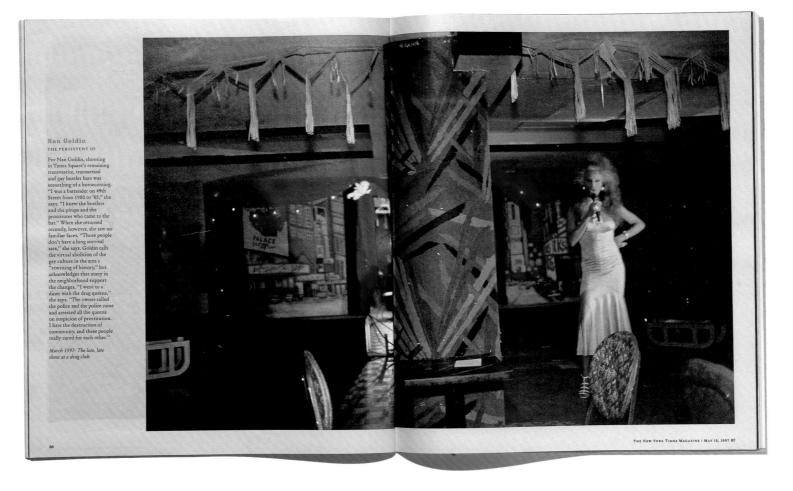

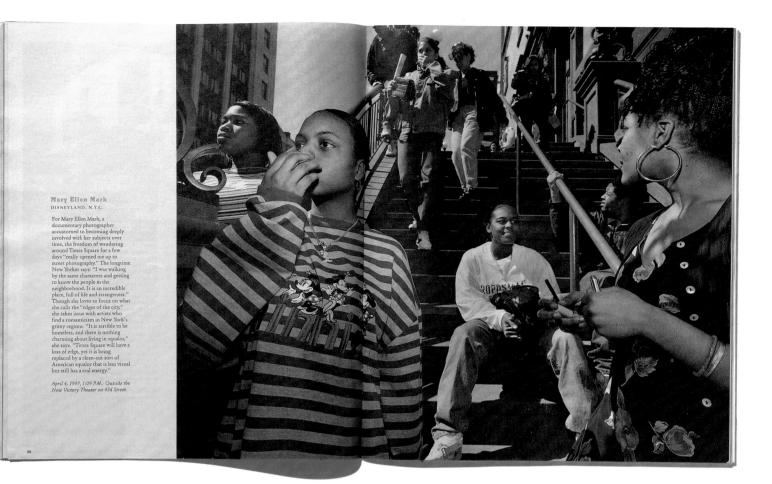

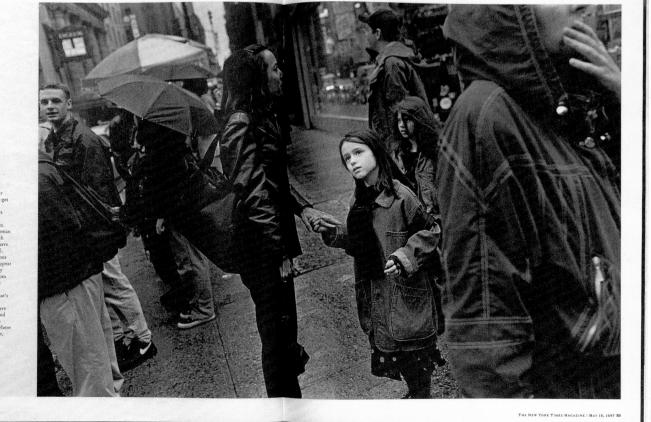

Edward Reating MEAN STREETS

MIAN STREETS "I'm always semiconscious that Times Square is forever changing and that I have to get some pictures that evoke the mood of the place," anys Edward Keating, as thif photographer for The Times. For Keating, 41, seeing a woman with two black eyes was such a moment. "Soon he will have to go somewhere else." Still, he asys he field such the Times Square he has watched diaspear played a cathatic cole in city life. "There is a klind of gloom that seet in at a certain hour that seet in at a certain hour that seet in at a certain hour that seet in at a sup lace where opporting. Flow you hour ouldn't cepticines somewhere the Zern fit was a hellhole," March 26, 1997, 48th and

March 26, 1997, 48th and Seventh, 5 P.M.: Under the unsheltering sky.

Abelardo Morell

"I want a sort of historical record of what a room sees," says Abelardo Morell, a 48-year-old Cuban immigrant who lives in Brookline, Mass. Thus his penchant for the ancient technique of the camera obscura, in this case constructed by using the room itself as a camera, blacking out all but a half-inch circle of a window - the aperture - in Room 1123 at the Marriott in Times Square. Morell then set a camera on a tripod near the aperture, directing it into the room to record the optical phenomenon. Making a single exposure over two days, he captured a scene of meditative calm - the room — superimposed with the anarchy of Broadway. "Think about how many people go through this site in two days — millions — and no one stood still long enough to get seen," he says. "It's so empty, almost a perverse picture."

March 20-21, 1997: Broadway all at once from a room at the Marriott.

50

ROGER HUTCHINGS THE THATCHER ERA L'EXPRESS 1997

Roger Hutchings began taking photographs in 1979, the year the Conservative Party gained power in Britain and Margaret Thatcher became Prime Minister. In between current affairs assignments - Hutchings covered the civil war in Sudan, the Velvet Revolution in Prague and the war in Bosnia - he steadily documented the radical transformation of Britain under the Conservatives. In a project that echoed the pioneering 1960s documentary survey of Britain by Tony Ray-Jones, he focused on Britain's class divisions, its social types from 'yuppies' to punks, as well as the strikes, protests and social conflicts of the period. As the era of Conservative rule drew to a close, Hutchings decided his work was finished. He released an edit of photographs aimed squarely at picture editors facing the perennial problem of how to address important elections with something other than politicians' mug shots. The French news magazine L'Express was one of several magazines that picked up the portfolio, publishing a picture 'dossier' (one of its regular features accompanying major political events) between pages otherwise dominated by news and analysis. Hutchings completed his story with a last photograph taken at Tony Blair's and New Labour's election victory celebrations on 1 May. (7 May 1997)

70 MONDE

	Un triple
	héritage - libéral,
	eurosceptique
	et sentimental -
	qui n'a pas fini
	d'imprimer sa
	marque sur le pays.
	er en al anti-
mêmes du mar- naie en est	

L'« autre pays » faconné par les tories

MONDE 71

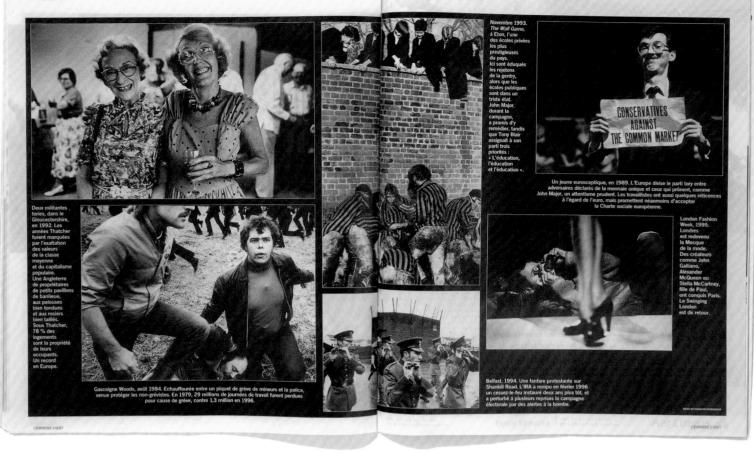

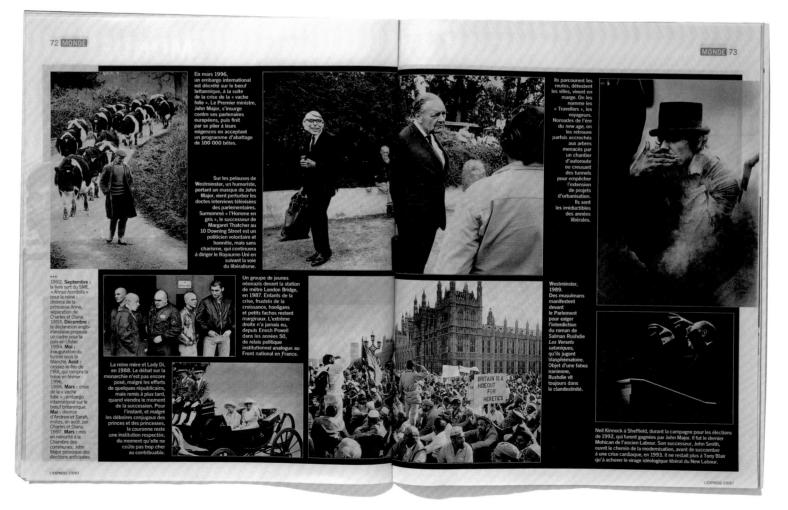

1997 ELAINE CONSTANTINE MOSH FACE

Particularly popular with young British punk and metal music fans in the late 1990s, 'moshing' involves dancers energetically throwing themselves at each other and 'surfing' the crowd in the 'mosh pit' at the front of the stage during live performances. After a period spent photographing metropolitan youth tribes, and at the start of her career in fashion, Elaine Constantine invited teenagers queuing for a London punk concert to a free gig she set up for the purpose of making this fashion story, for the magazine bible of style, the *Face*. Distributing clothes and providing alcohol for the shoot, Constantine then let the moshing take its own course, documenting it in a smart and ironic pastiche of photojournalism. The story signalled a break with the then-dominant convention of stylized fashion photography (often referred to as 'heroin chic'), with Constantine continuing to use non-professional models performing as themselves in narratives of youthful exuberance, presented in the language of reportage. Constantine's work is also an example of the reinvention of British documentary photography in the late twentieth century within the style press. (October 1997)

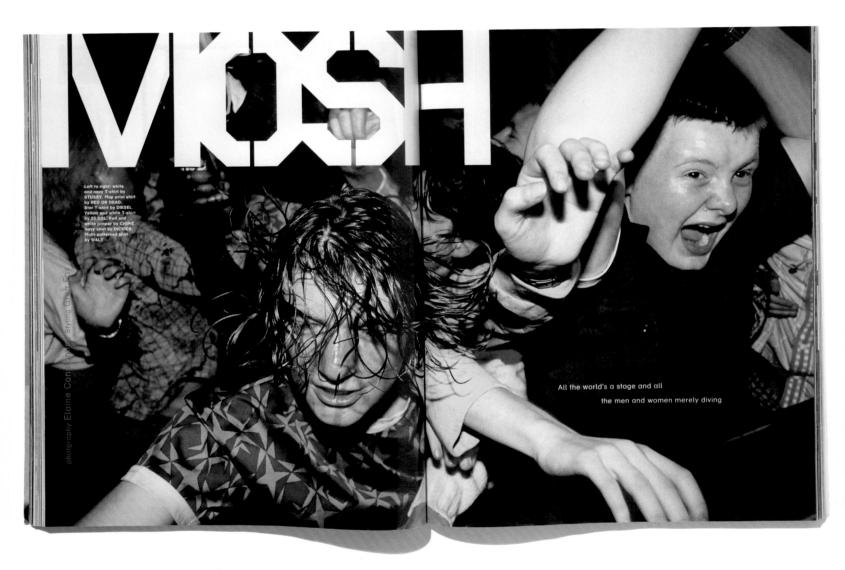

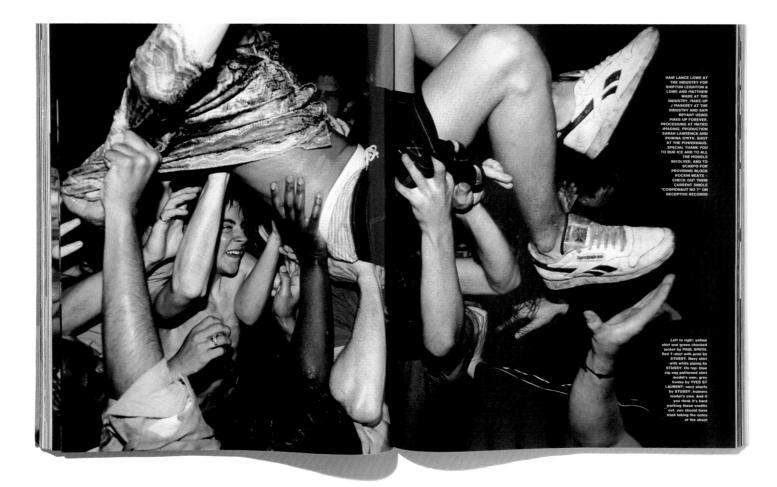

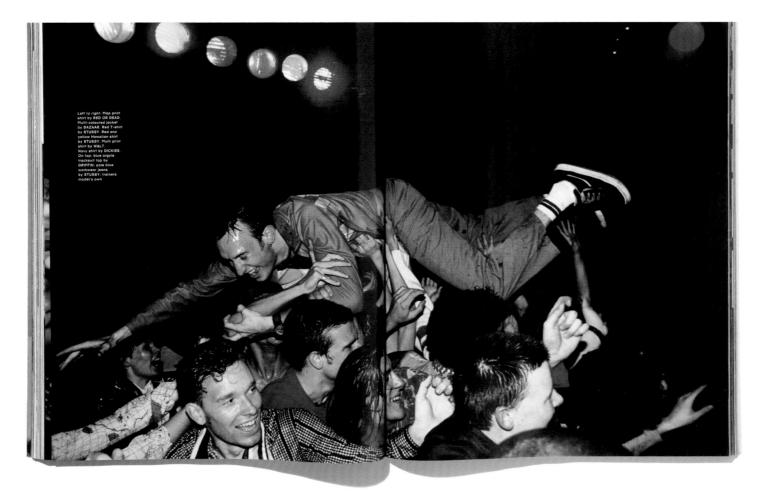

1999 TRENT PARKE MT PANDEMONIUM AUSTRALIAN

'The fact that there isn't a market for photo stories in Australian magazines has dictated the way I work. Galleries now do what magazines used to: expose photographers' work.' This is how photographer Trent Parke has commented on the transformed state of photojournalism in the 1990s. Formerly employed for eight years as sports photographer for the national newspaper, the *Australian*, he left to take on more ambitious projects independently. But like the experience of many of his peers, editorial photography for magazines became an occasional sideline, with magazines publishing stories about exhibitions of his work more often than they offered him new assignments. Parke's classic and atmospheric 'Mt Pandemonium' story is an exception, itself a digression from a sports assignment; while covering the Bathurst 1,000-kilometre car race around Mt Panorama for the *Australian*, Parke documented a group of inebriated men resembling characters from the film *Mad Max*, entertaining themselves by crashing cars on the fringe of the race. It ran in the lead up to the Bathurst race the following year. (18-19 September 1999)

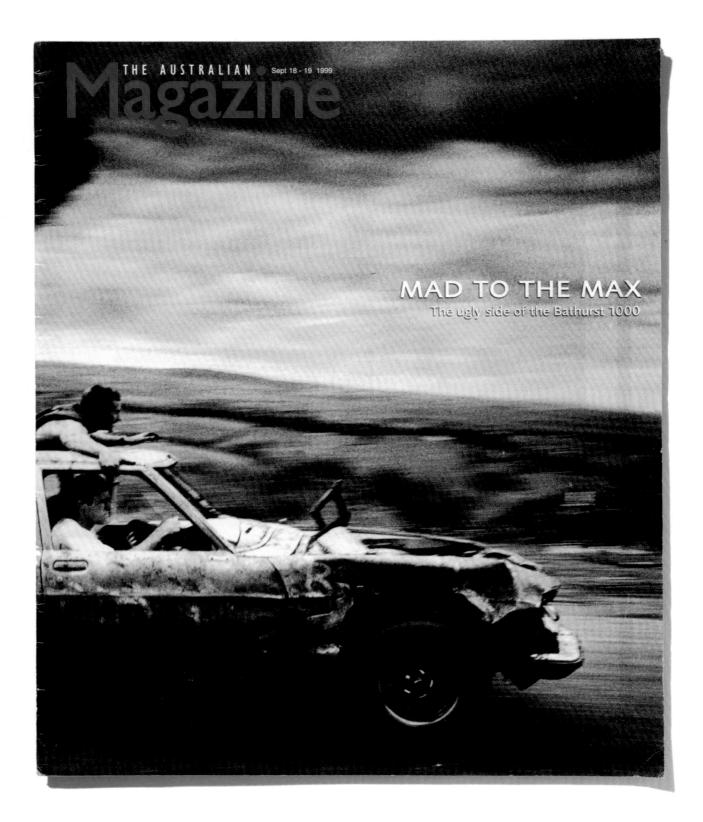

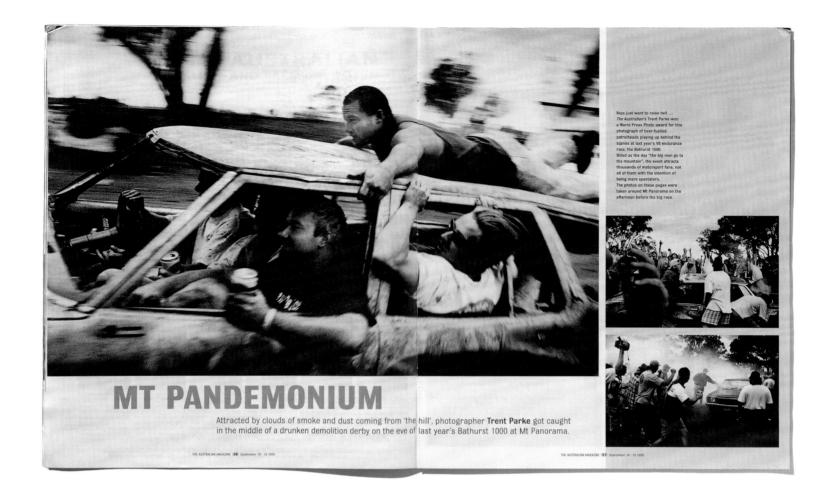

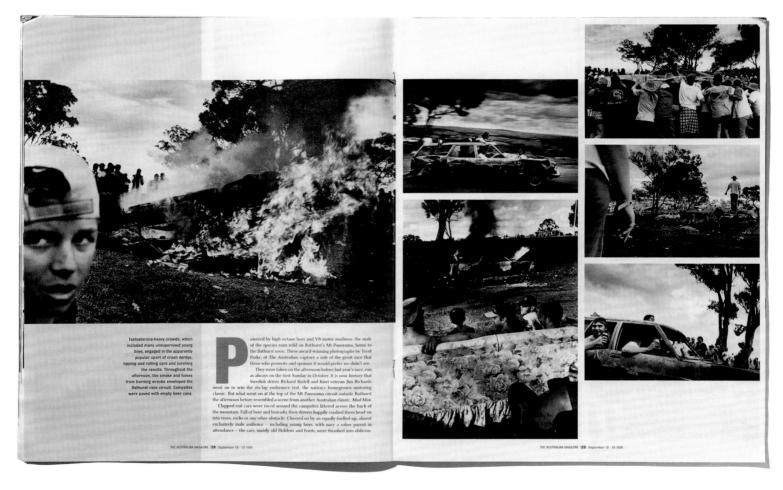

1999 YANN ARTHUS-BERTRAND EARTH FROM ABOVE GEO

In 1993, Yann Arthus-Bertrand began the project that eventually became *La Terre vue du Ciel* (2002) – a photographic documentation of the planet seen from the air. Its goal was to 'raise public awareness of the Earth's beauty in order to better condemn its problems'. The logistics of its production were even more ambitious: each picture required enormous preparation and expense, including necessary permits, a helicopter or light aircraft, and assistants to manage eight cameras and their respective lenses. Arthus-Bertrand planned the project around the coming millennium, and with the support of UNESCO, organized detailed scientific captions to explain the ecological or social problems that each of the images referred to. *Geo* published the first major portfolio of the finished project as it rose to become a global photography and publishing phenomenon – arguably the most popular and successful work of photojournalism ever produced and far exceeding even Arthus-Bertrand's ambitious expectations. In simply revealing the patterns of the earth's surface, he had found a formula which matched even *The Family of Man*'s ability to touch a universal chord. (October 1999)

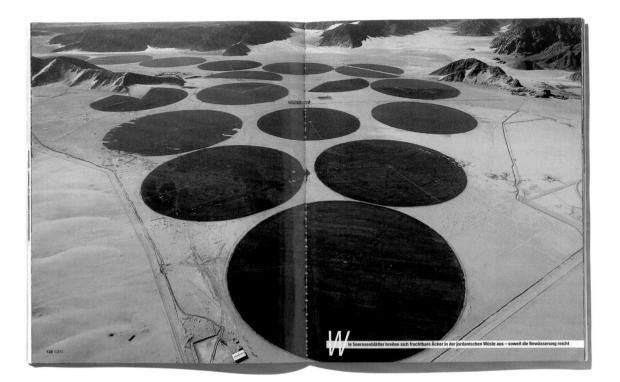

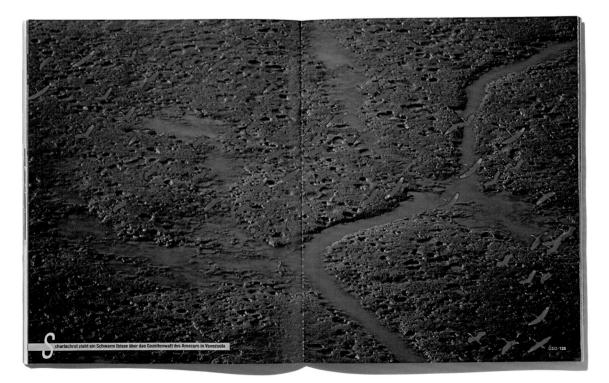

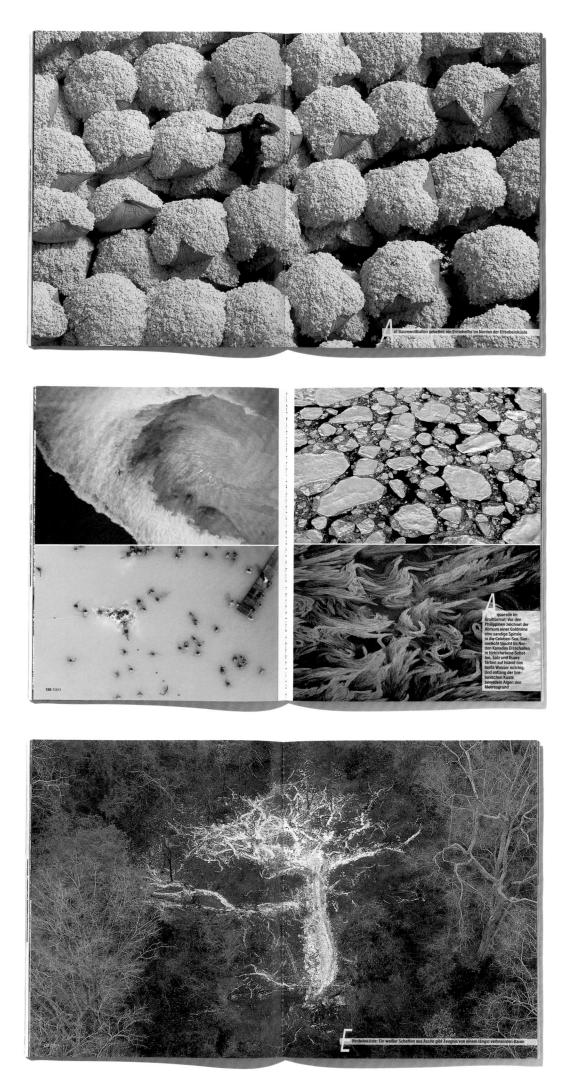

At its inception in Madrid in 1991, the bimonthly magazine *Big* declared itself 'free from the triviality and sound bite mentality that currently exhausts our media'. Blurring the boundaries between art project and consumer magazine, it set out to offer an image of a particular city or country, showcasing in each issue the vision of an invited editor/art director and their choice of contemporary art, fashion and reportage photography. This example, focused on Rio de Janeiro, is the work of Brazilian art director Rinco Lins. High-concept visual magazines like *Big* were not a phenomenon of the late twentieth century alone – earlier examples include *Lilliput*, *Interview* and *Provoke* – but *Big* belongs to an expanding group of designer-led publications that have established themselves as laboratories for new ideas and new aproaches to reportage, including *Purple* (Paris), *Re-Magazine* (Amsterdam), *Matador* (Madrid), *Foil* (Tokyo), *Visionaire* (New York) and *Ojo de Pez* (Barcelona). Few such conceptual magazines have become successes in consumer terms – one exception is *Wallpaper* (London) – but they wield a cultural influence that far exceeds their circulation figures. (1999, with photographs by Roberto Donaire, Bob Wolfenson and Adriana Pittigliani)

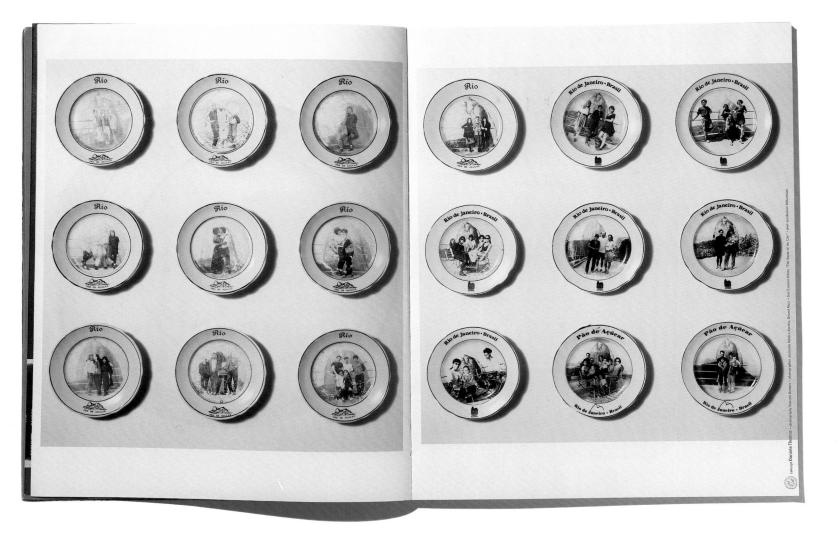

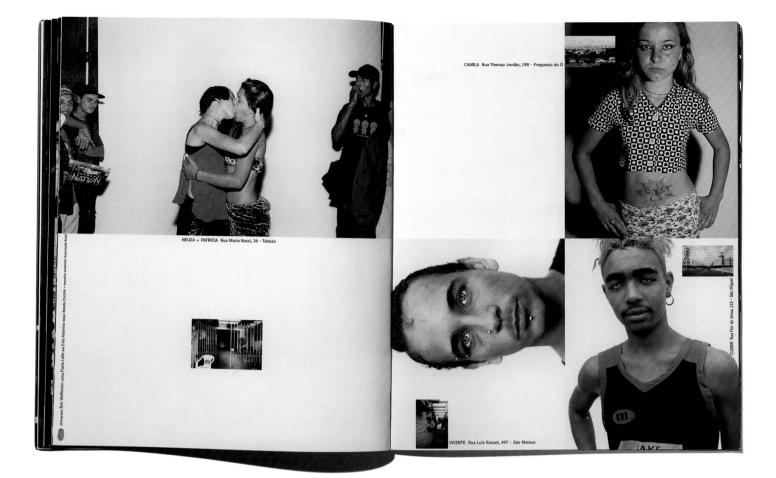

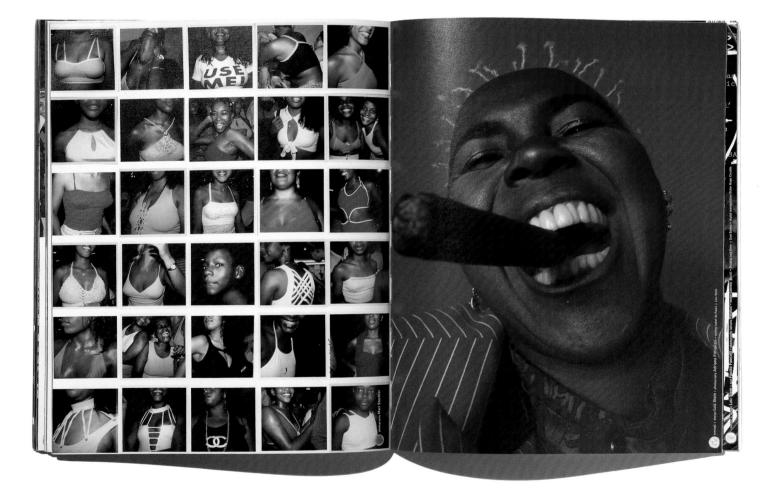

2000 MICHAEL NICHOLS MEGATRANSECT NATIONAL GEOGRAPHIC

Between 2000 and 2001, *National Geographic* published three stories on the 'Megatransect', conservationist Mike Fay's massive expedition – years in the planning – across 2,000 miles of the last pristine wilderness of Central Africa. This classic explorer's tale was highly popular with *Geographic* readers, thanks to both Fay's charismatic intensity and the work of photographer Michael 'Nick' Nichols. Fay's declared goal was simple and lofty: to assemble an encyclopedia of environmental data which could serve as a resource for conservation-minded politicians and scientists. As on previous occasions, Fay recruited expedition staff from a tribe of Bambendjelle pygmies, and Nichols travelled with them over several extended periods during the year, documenting the narrative of the trek in black and white. Meanwhile, he reserved the use of colour film for his natural subjects, creating an elegant distinction between the observers and the jungle they came to study. Unlike the tightly-framed telephoto shots typical of wildlife photography competition winners, Nichols photographs wild animals with a raw and sometimes disturbing edginess, communicating the thrill and danger of entering alien territory. (October 2000)

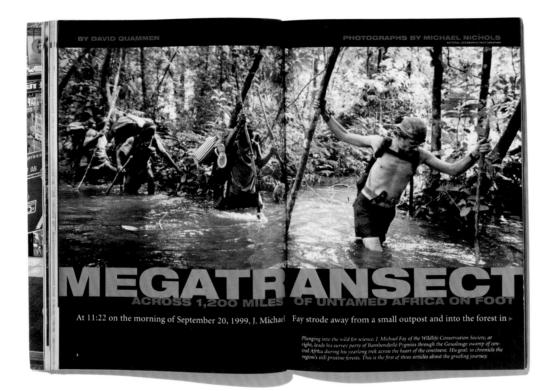

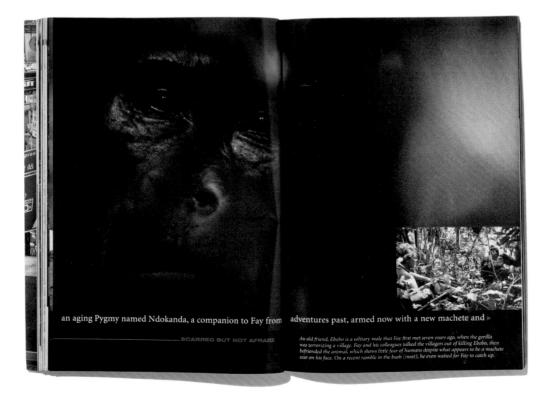

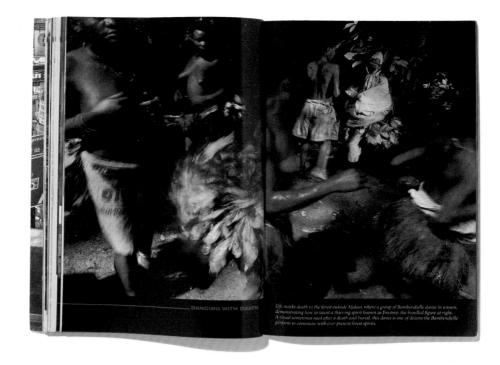

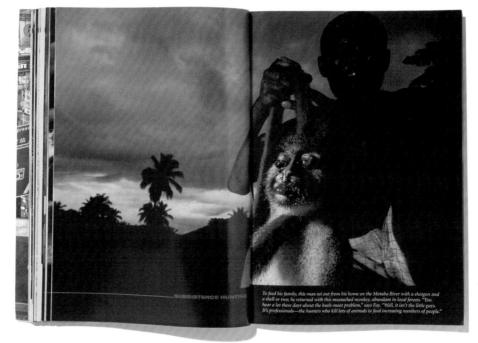

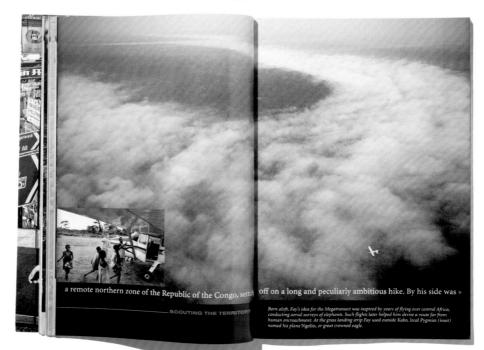

2001 LUKOLE REFUGEE CAMP COLORS

In 2001, photographer Oliviero Toscani's relationship with Benetton came to an end, and two young photographers – Adam Broomberg and Oliver Chanarin – took over as the editors of *Colors*. Their first decision was to ban the use of stock photography. Instead, young photographers from the worlds of fashion and advertising with distinct stylistic approaches were commissioned to document social stories, in most cases for the first time. The first issue of the new *Colors* set the tone. Broomberg and Chanarin, along with advertising photographer Stefan Ruiz and fashion photographer James Mollison, travelled with *Loaded* journalist Michael Holden and script writer Jonathan Steinberg to a refugee camp in Tanzania, home to 120,000 refugees from the conflict in Rwanda and Burundi. Their goal was to provoke engagement with the issues of poverty in Africa without resorting to clichéd representations. Working on medium- and large-format cameras, and drawing on the inspiration of different photographic genres (including architectural photography and colonial portraiture), they produced an in-depth account of community life in the camp. Broomberg's and Chanarin's approach in turn influenced the practice of many traditional photojournalists. (December 2000)

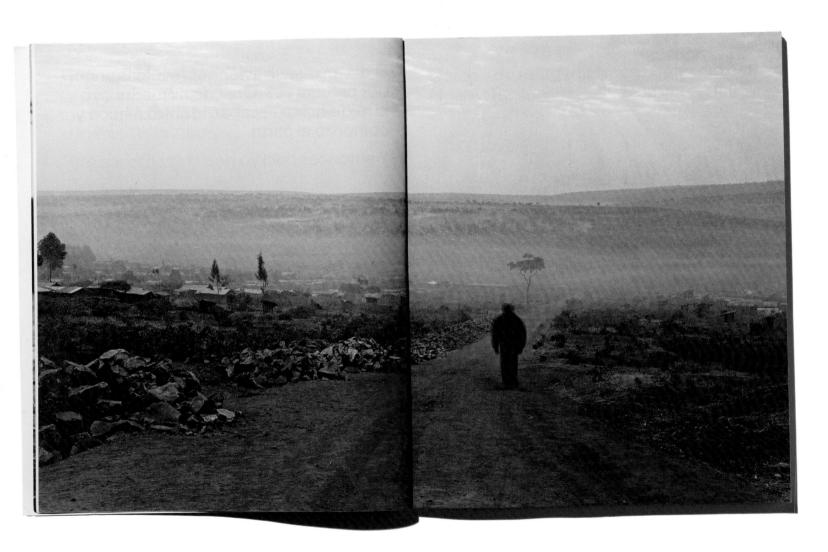

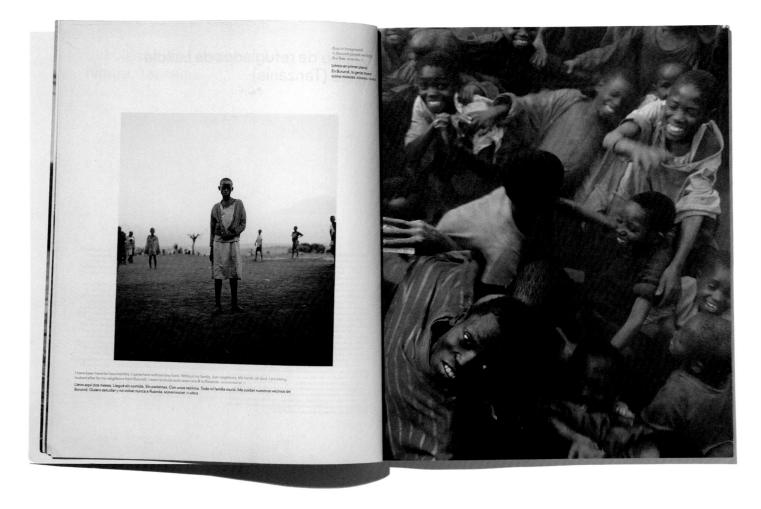

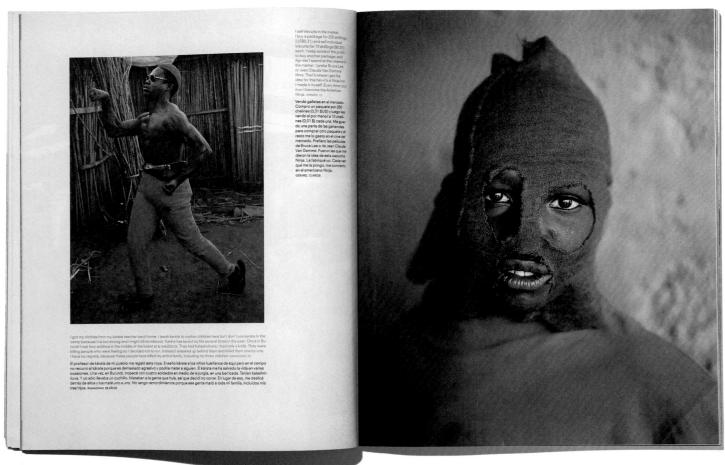

2001 CRISTINA GARCÍA RODERO HAITI RITUAL LA VANGUARDIA

The annual pilgrimage to Plaine du Nord, north of Port-au-Prince, attracts over 10,000 Voodoo believers to pay homage to Ogoun, the god of fire and war. In the ritual 'Bath of Power', pilgrims are immersed in a sacred pool from which they emerge covered with a glistening skin of mud, a spectacular sight that has drawn hundreds of photojournalists. Cristina García Rodero's images distinguish themselves with their intensity, offering psychological insight while sensually conveying the religious ecstasy of her subjects. Typically for 21st-century photojournalism, the work was first seen as an essay in the sophisticated supplement of *La Vanguardia*, the Barcelona-based daily newspaper, only after its exhibition in the Italian pavilion of the 2001 Venice Biennale. The project was part of García Rodero's broader survey of religious folklore that began in 1974 with her 15-year study of religious rituals and practices in Spain. Her photographs draw on traditions of anthropology, art, and journalism, and offer a model for how a photographer can enter and record religious experience. (17 June 2001)

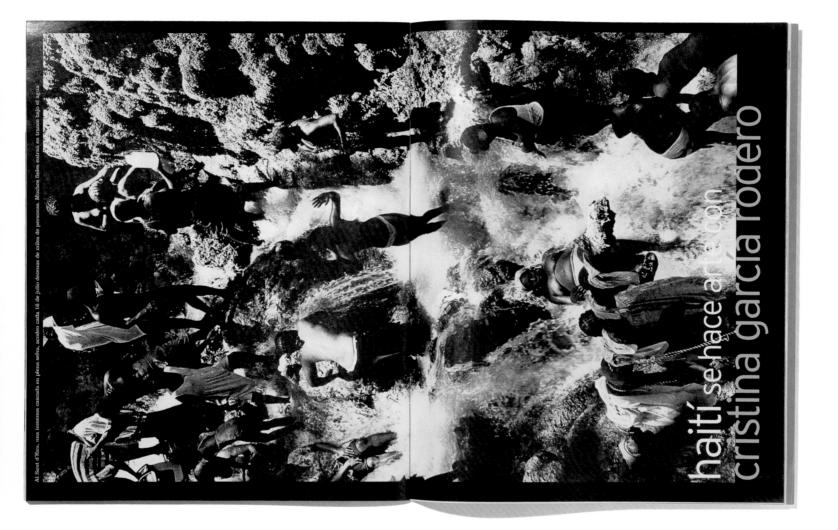

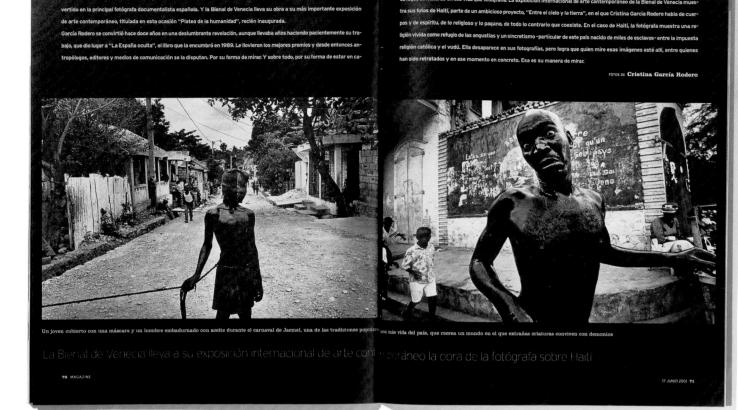

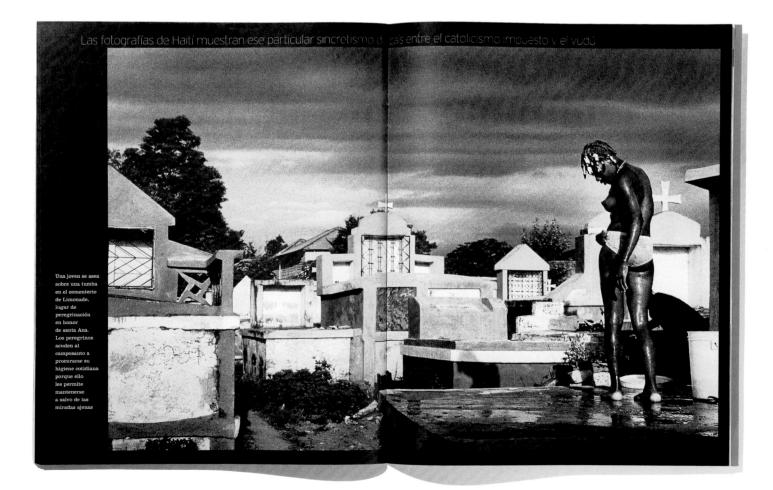

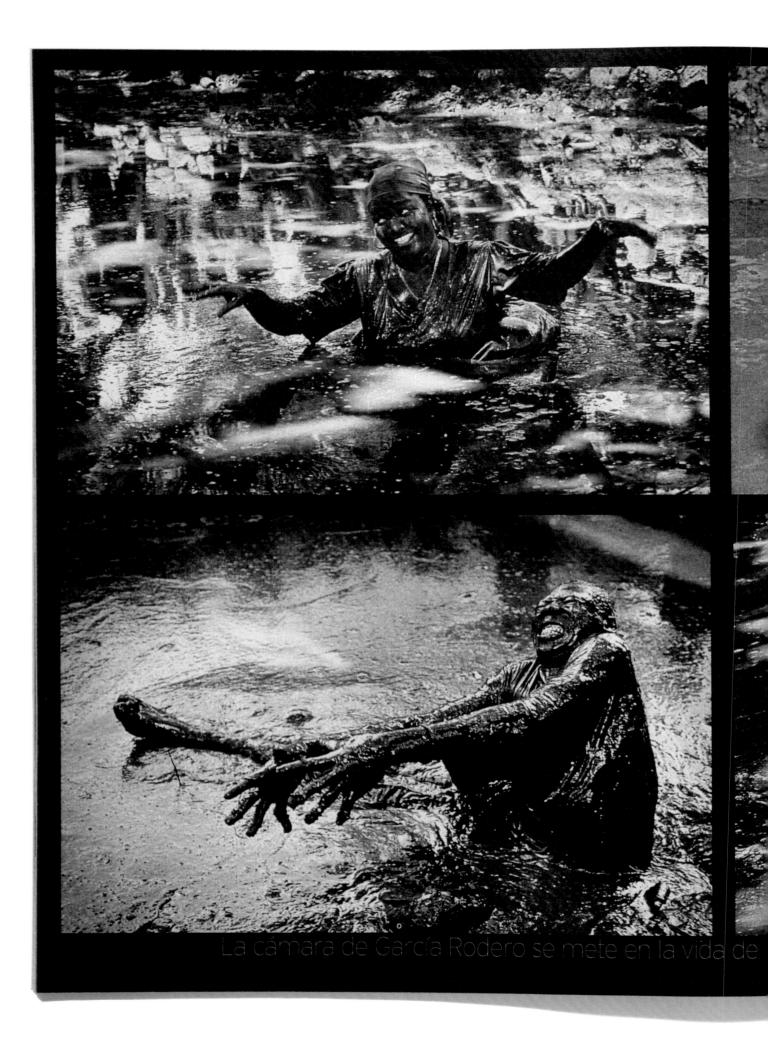

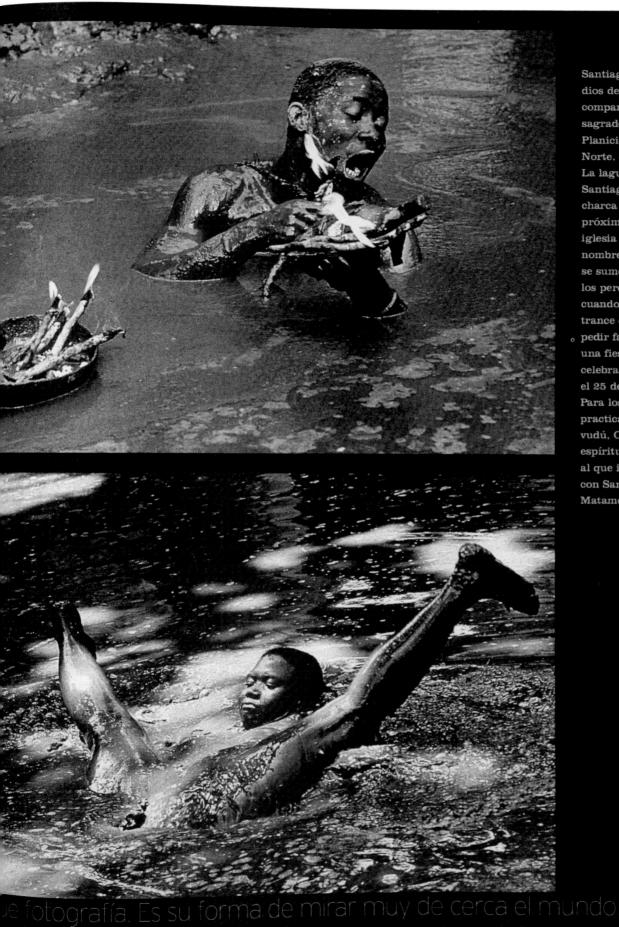

Santiago y Ogou, dios de la guerra, comparten lugar sagrado en la Planicie del Norte, en Haití. La laguna Santiago es una charca de barro próxima a la iglesia del mismo nombre y allí se sumergen los peregrinos cuando entran en trance o acuden a , pedir favores, en una fiesta que se celebra cada año el 25 de julio. Para los practicantes del vudú, Ogou es un espíritu guerrero al que identifican con Santiago Matamoros

2001 AD VAN DENDEREN IMMIGRATION IN EUROPE GEO

In the early 1990s Ad van Denderen began photographing the growing underclass of unemployed workers leaving their homes and families in the developing world in search of jobs in industrialized Europe. Within immigrant communities on Europe's margins, he investigated the culture they brought from home, the slum communities where they presently lived and the way they spent their time. He also documented the risks of crossing borders illegally – navigating the Straits of Gibraltar or travelling on foot from Turkey into Greece by means of an underground railroad – revealing what happened when they were caught. Van Denderen works in the style of a traditional humanist photographer, using his camera to fight political and social discrimination, but his style does not adhere to old-fashioned documentary rules; he does not follow the conventions that once spelled 'objectivity'. These are not cool, detached images. They neither glorify their subject, nor patronize immigrants as 'other', but invite the reader's empathy by presenting them as fellow citizens of an unequal world. (October 2001)

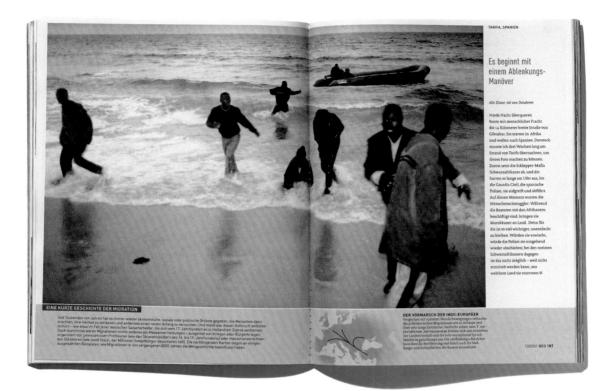

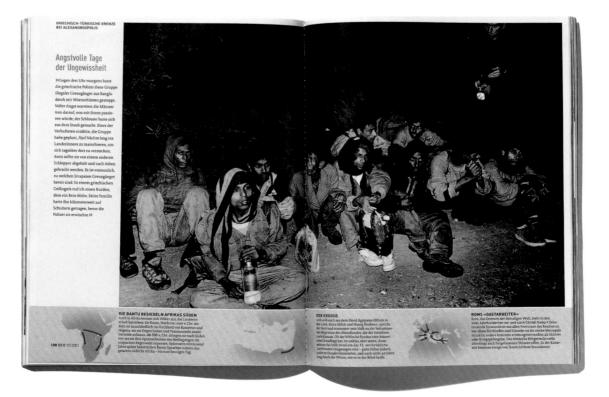

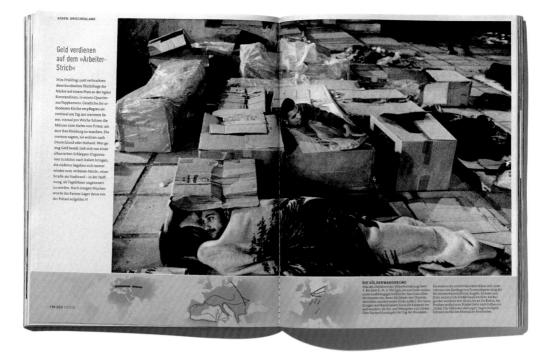

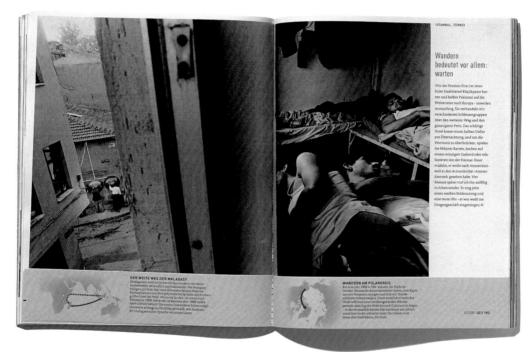

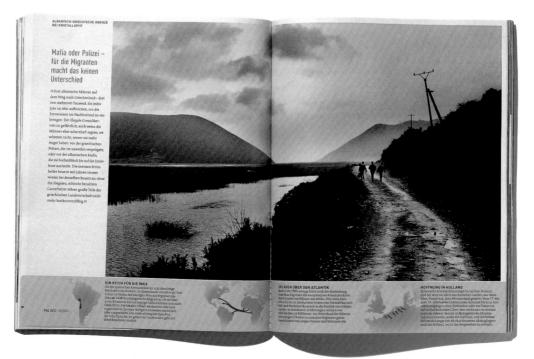

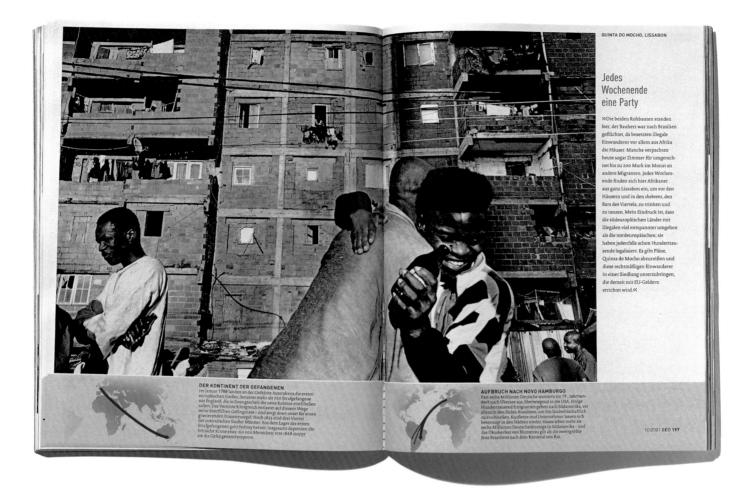

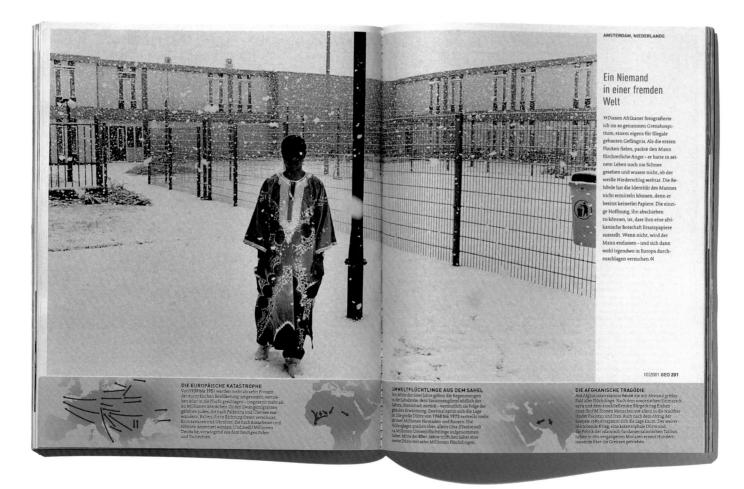

2001 JONAS KARLSSON ONE WEEK IN SEPTEMBER VANITY FAIR

On the morning of 11 September 2001, as terrorists flew two commercial passenger jets into the World Trade Center in New York, the staff of *Vanity Fair* were finalizing production of their November Music issue. Editor Graydon Carter immediately set about remaking the issue, devoting a substantial special section to the tragedy and redirecting all available staff to its coverage. Photographer Jonas Karlsson had first come to prominence shooting car advertisements for Volvo in his native Sweden. Together with photography producer Ron Beinner, the pair worked Manhattan's streets, making medium-format portraits of emergency service workers and volunteers as they responded in the aftermath of the attack. They penetrated the exclusion zone around Ground Zero by picking up tools and joining a group of volunteer community gardeners assigned to clean up Battery Park. After the terrible spectacle of the initial attack, the resulting portfolio is quiet and reflective (albeit in keeping with *Vanity Fair*'s vibrant style), capturing the shock and resilience etched onto the faces of ordinary New Yorkers. (November 2001)

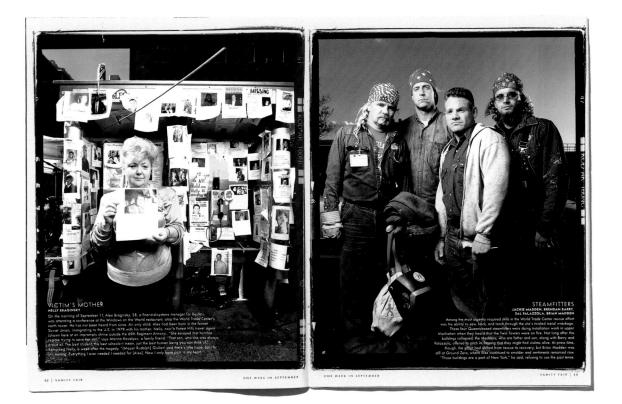

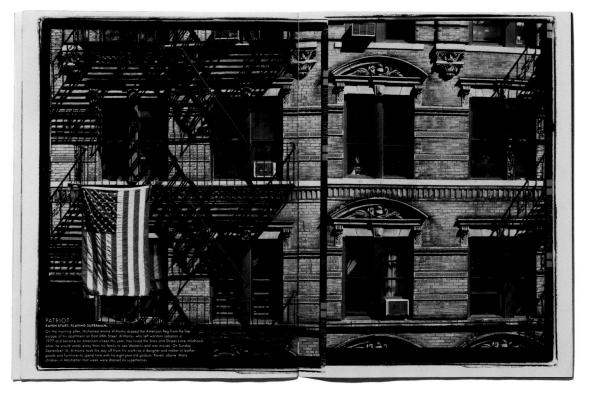

Playing the hostess at a trying time is no frivolous pursuit; exhausted relief and rescue workers were only too happy to be greeted by the smiling face of Kemmett, who tirelessly wove through the evacuationcenter crowds around 34th Street, offering vital replenishments.

111

VOLUNTEER RESCUE WORKER

Says Heward, of the Maryland Fire Network, seen here coming off a 14-hour shift at Ground Zero: "They had crews from Mississippi, Alabama, Texas. Firefighter-E.M.T.'s [emergency medical technicians] from an Indian reservation in South Dakota. That made us feel real proud. We weren't the only ones pitching in; the whole country was." NATIONAL GUARDSMAN PRASAD MAVINA For days, Naving-to mortgage consultant from Queens, helped test the air's toxicity-taking only two days off (to witness the birth of his first child, Elicia). Shortly offer the intract, amid rumors of war, his National Guard unit was called into service.

ROD"AK

160NC

J-AK

Five days into the ordeal, Schumer addressed the press outside New York City's 69th Regiment Armory. After President Bush agreed to provide \$20 billion in aid for New York, Schumer remarked, "I wanted to hug him, but he's the president."

AL AL

Quattrocchi, a welder from Brooklyn, wielded an acetylene torch at the disaster's epicenter, which he found "surreal, like a desert with rolling hills and valleys, like something out of a horror movie."

Sec. 10

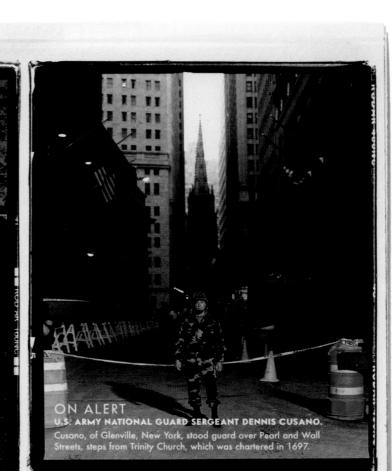

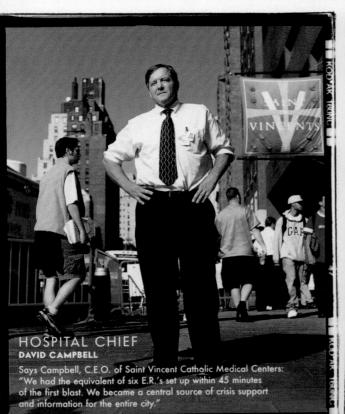

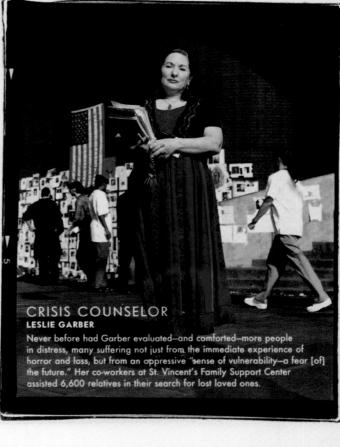

VANITY FAIR 29

2002 WILLIAM ALBERT ALLARD UNTOUCHABLES NATIONAL GEOGRAPHIC

National Geographic photographer William Albert Allard and writer Tom O'Neill produced a disarmingly direct story on the Untouchable caste, the elaborate Hindu hierarchy's lowest caste group, accounting for roughly 160 million people – 15 per cent of the Indian population. Saturated colours enhance the dense detail of these images, in which Allard's subjects address the camera with surprising openness – characteristics of Allard's photographs that have been a staple of *National Geographic* over 40 years. Arguably Allard is *the* quintessential *Geographic* photographer of recent times, in equal parts colourist (one of few among his generation who have only worked in colour), storyteller and ethnographer. His down-to-earth integrity and accessible personality, as well as the consistent quality of his essays, have made him a romantic model for a generation of American photographers. In his influential book, *The Photographic Essay* (1989), he defines as 'right' 'any assignment in which the photographer has a significant spiritual stake ... Spiritually driven work constitutes the core of a photographer's contribution to culture.' (June 2001)

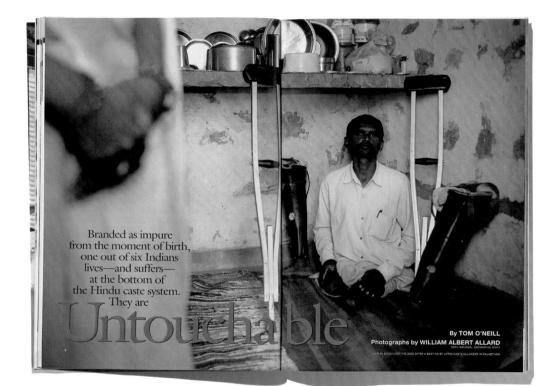

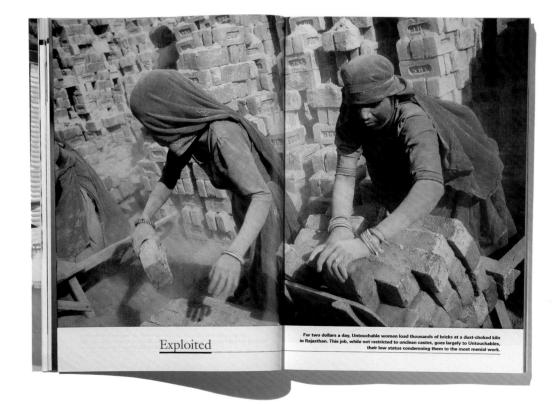

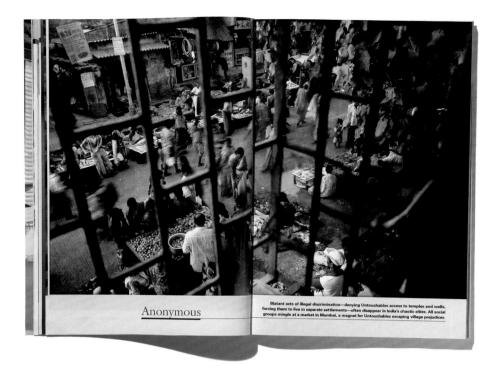

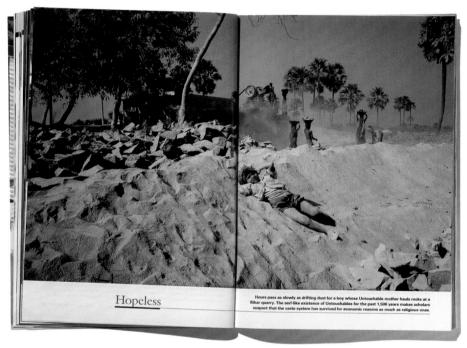

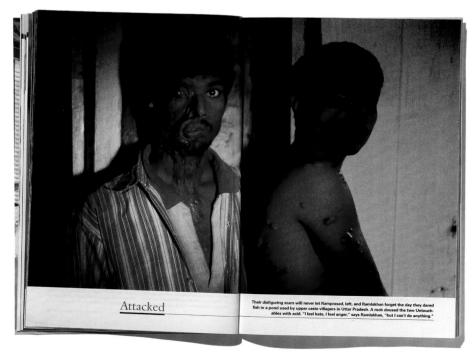

2002 THIS IS MY WORLD GAZETA WYBORCZA

In 2002, Poland's leading newspaper colour supplement published an essay of photographs made by children, with a title that translates as 'This is my teddy, this is my mum, this is my world.' Produced by the magazine's photographer, Piotr Janowski, it involved his distribution of 25 cameras and film to children in the villages of Krzywa and Jasionka in the poor region of Beskid Niski in southern Poland. Encouraged not to fear the camera (most had never held one before) and to think of it as a magician's hat that would make them invisible, the children made pictures of whatever they liked over one week. It resulted in an authentic, edgy and insightful document of Polish life drawn from 3,000 photographs. The practice of giving cameras to children in order to reveal their own view of the world was far from new – American Wendy Ewald developed an image-making practice that involved giving cameras to Appalachian children in the late 1960s – but *Gazeta Wyborcza*'s story is a strong example of a steady trend toward self-representation and the democratization of photography within the mainstream press. (3 November 2002)

352

2002 SIMON NORFOLK AFGHANISTAN EL PAÍS

Simon Norfolk drew on a range of references to represent the blasted landscapes he encountered on his self-initiated reportage on Afghanistan in November 2001, following the flight of the Taliban from Kabul. He recalled Romantic paintings of sublime landscapes, made to inspire terror and awe. The Afghan deserts and mountains reminded him of the illustrations in his childhood Bible, and he was prompted to remember images of Armageddon drummed into him at a Sunday school in Manchester, England. Norfolk drew on the work of Victorian archaeologist Heinrich Schliemann, who unravelled the successive dominions of the ancient city of Troy, as he set out to explore the layers of Afghanistan's recent history: abandoned tanks from the Soviet occupation of the 1980s, concrete buildings worn to skeletons by militia wars in the 1990s and cities charred by American and British bombs in 2002. Working with a large-format 4x5 camera for the first time, he established a different, more contemplative manner of storytelling compared to his prior work – which he felt was a personal breakthrough. The Afghan series was published in major magazines throughout the world. (8 September 2002)

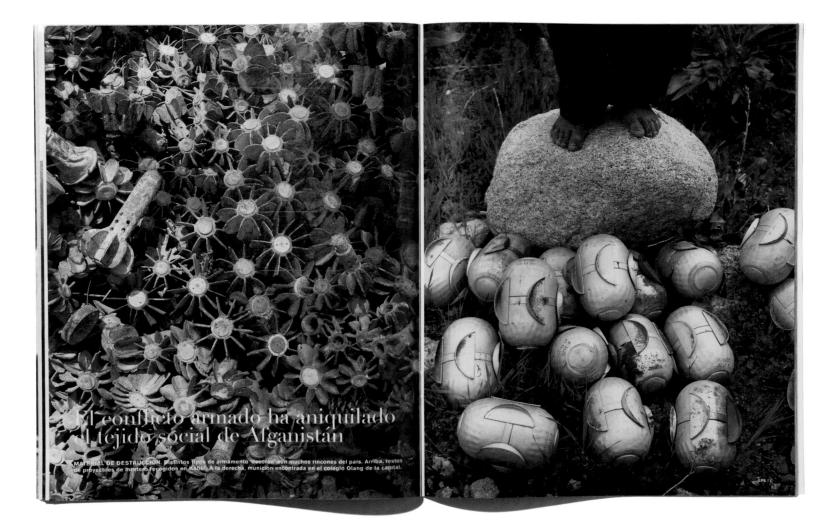

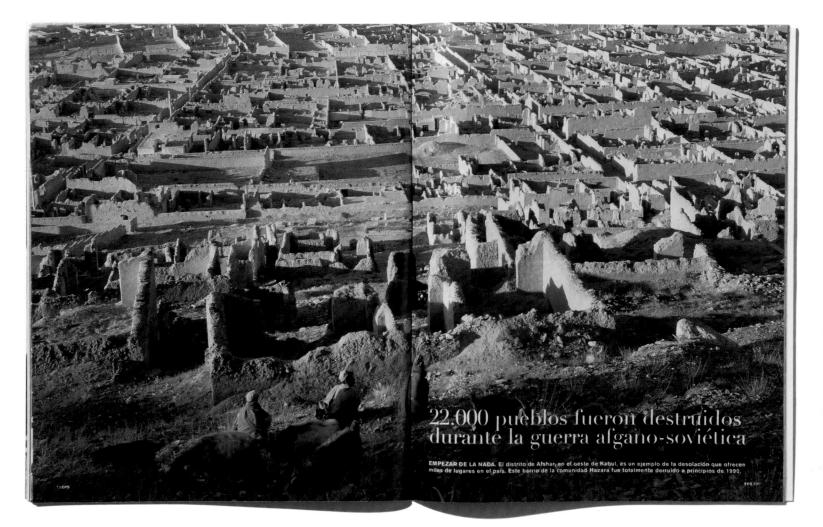

2003 RINKO KAWAUCHI AFGHANISTAN FOIL

Masakazu Takei, the editor-in-chief of *Foil* magazine and founder of the amorphous media company Little More, has proved a lightning rod for the new Japanese visual culture embracing pop culture, punk and manga comic books. *Foil* was conceived as a transgressive magazine that would change its form and design with each issue, presenting artists' work on a theme, with neither text nor advertising. The first issue brought together two cutting-edge, increasingly popular Japanese artists; Yoshitoma Nara, known for his paintings and sculptures of vulnerable cartoon children, and photographer Rinko Kawauchi, whose melancholic images play on the transient charms and cruelties of life. On assignment for *Foil*, these unlikely reporter-artists both visited Afghanistan in the aftermath of the American invasion. Over two hundred images were woven into an impressionistic comment on the fragile reemergence of Afghan culture and the enduring scars of its wars. This radical publication suggests both the death of traditional photojournalism as well as its sophisticated reinvention. (30 January 2003)

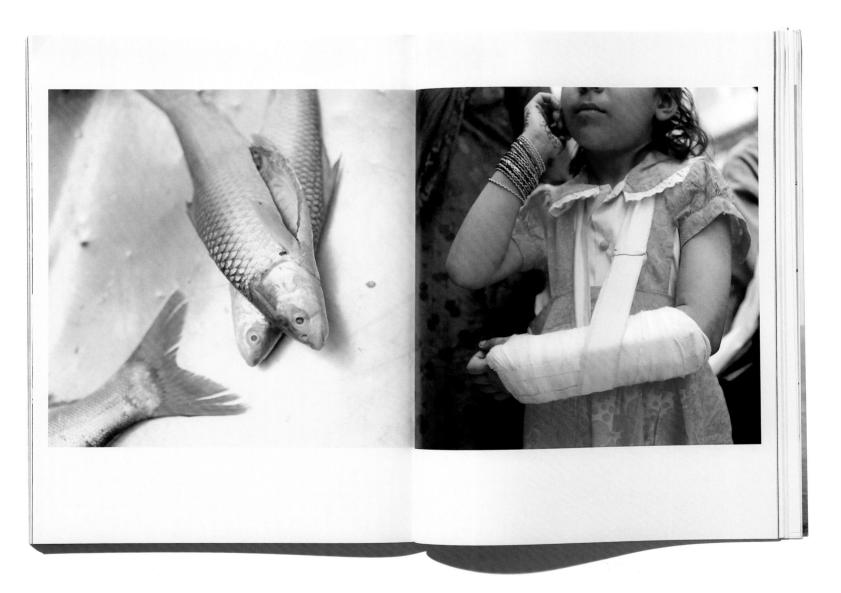

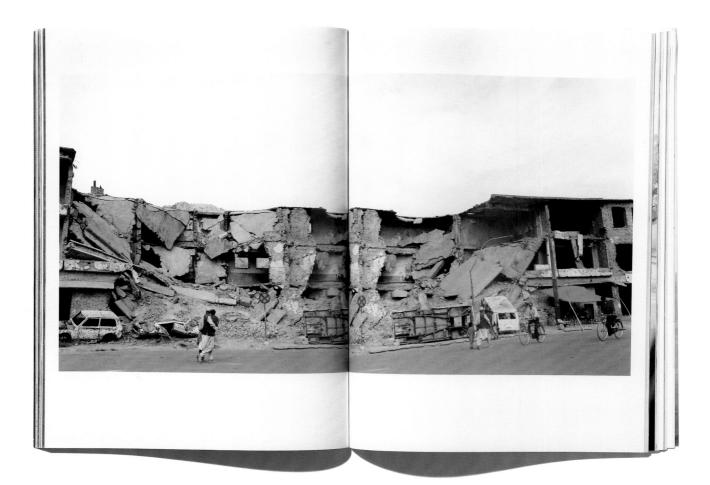

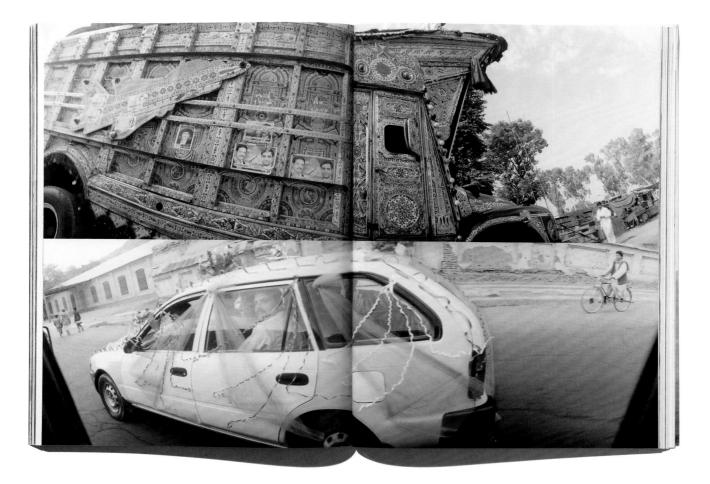

2003 PHILIP BLENKINSOP THE HMONG TIME ASIA

The subjects of this essay are a Hmong tribe who had lived in hiding in the Laotian jungle for thirty years, on the run since providing covert support for the US Army under the direction of the CIA during the Vietnam War. Believing Australian photographer Philip Blenkinsop and *Time*'s writer Andrew Perrin to be their American rescuers, the tribe's members greeted them on their knees and in tears. The resulting photographs were a major coup for Blenkinsop, and were published throughout the world. Previously, his brutally direct records of remote tribal wars across Southeast Asia were considered too gothic and extreme for mainstream publication. 'They saw what I do, and their first reaction was, "Christ, what a sick person – how can he photograph that?" They forgot that what I was doing was simply photographing what was there; it's life that can be painful and unjust.' In the following years, acknowledging the limitations of photojournalism, Blenkinsop has taken to writing on the surface of his prints and taking control of the 'caption' within the image itself. (5 May 2003)

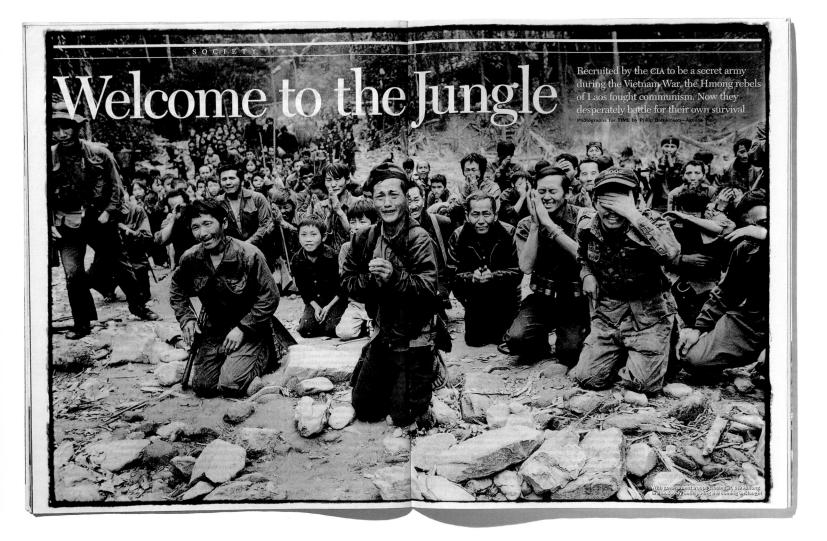

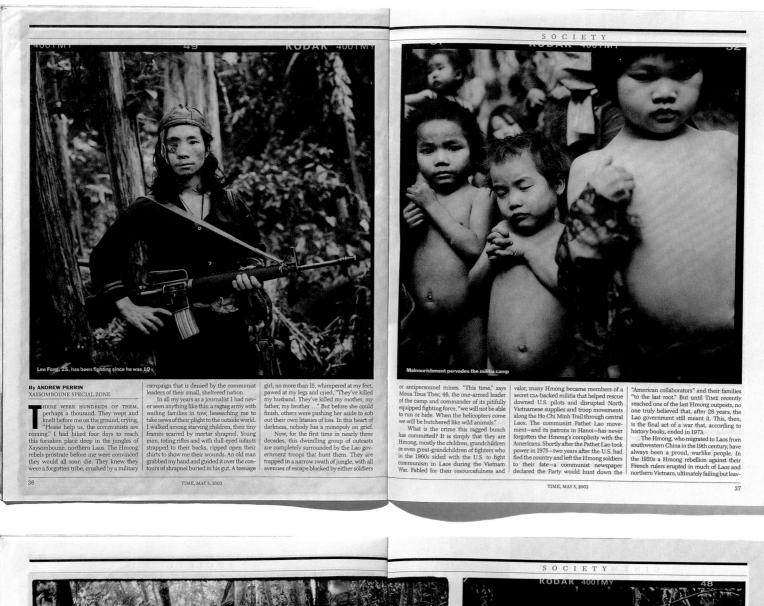

sofre

in the theorem out of the intercence of the inte

TIME, MAY 5, 2003

Ammunition is mostly day up from former IS. air base. According to You on only bird of the rounds are actually live, negating two ak for the Las government, which de-clined to talk to Task, it denies allegations as bandis. In February an ambush on albush as bandis. In February an ambush on abush that it is documating Himong redels and bames them for much of the unrest in the sources. We only defend and run," he commy. It insists that Himong redels and bames them for much of the unrest in the tag people dead, including two Swiss operated fire on a passenger bus, killing at sates at fire the games may bake to one and the competent fire on a passenger bus, killing at sates asy the gummen spoke to one another in the Himong language. Vang Pao angrify denise claims that his men are responsible for attacks on civilians. "In the past there

TIME MAY 5 2003

the others in a B-41 rocket attack that killed shift his fellow Hmong His leg still bleeds from a sprunting shrapped wound he mask of meldel flesh, with black sockets between a ear and an eye should be. "Terybody is dead," he says. "Sixtee between a still bleed by the community." In a hearthceaking refrance hear repeatedly during my stay in the tarm, be ead, "America musics have good the should bleed the start of the says. They should remember this have good food to eat" but as the world have food to eat" but as the world have food to eat" but as the world have started food to eat" but as the world have started in a, the final scenes of a 30-year-old war in the should be used to be used to be the final the final scenes of a started to be the final the final scenes of a started to be the final the final scenes of a started to be the started to be and the a ble to be used to the started to be the scene scene started to be used to be the started to be the started to be the started to be the scene scene started to be the scene started to be the scene started to be the started to be the scene started to the others in a B-41 rocket attack that killed six of his fellow Hmong His law with killed

38

2003 NADIA BENCHALLAL RAMALLAH FASHION VOGUE HOMMES

Born in France of Algerian parents, Benchallal's work explores representations of colonial power and national identity, as for example in her long-term project about the role of Muslim women in war and civil strife in Algeria, Bosnia, Iran, and the Gaza Strip. In this assignment for the international edition of *Vogue Hommes*, Benchallal plays with the conventions of photojournalism, producing an essay that might be taken for a documentary account of the life of young men in rubble-strewn Ramallah, the Palestinian capital – except that this is a cast fashion shoot. By no means the first to exploit the language of photojournalism in the context of fashion, and unlikely to have either shocked or fooled an audience of *Vogue* readers, her story is set so firmly within the territory of socially concerned journalism that it offers a radical assault on its traditions. It is disturbing here because it is a work of imagination and invention that also succeeds as a convincing description of a particular time and place. Its underlying suggestion is that photojournalism was ever thus. (Autumn/Winter 2003-4)

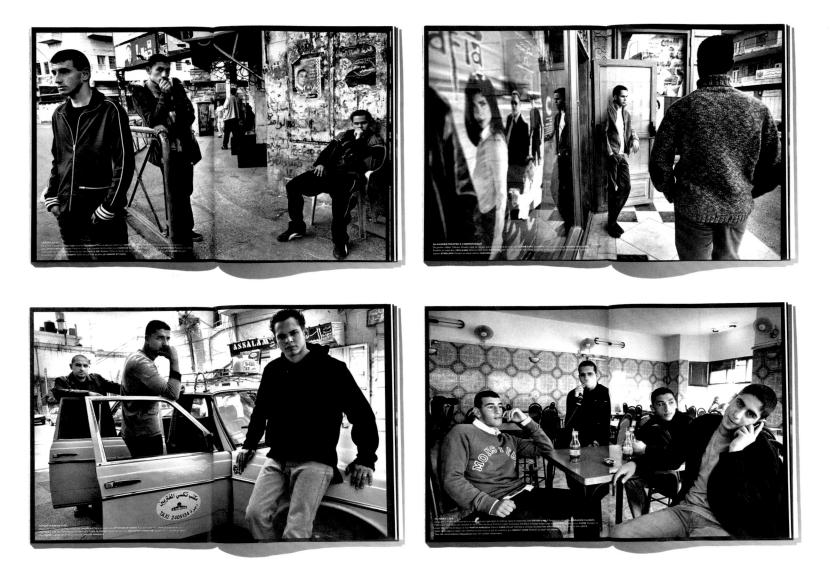

2004 ISRAEL/PALESTINE DAYS JAPAN

In the spring of 2004, political negotiation over the division of territory between Israel and Palestine reached a stalemate, to be replaced by a rash of military attacks and reprisals by Israeli soldiers and Palestinian guerrilla fighters. Palestinian teenage suicide bombers entered crowded markets and rode buses during rush hour, exploding home-made bombs strapped to their bodies, resulting in dozens of casualties and deaths, and fuelling a seemingly endless cycle of fear and retribution. *Days Japan*, re-launched in April 2004 as a dynamic, glossy visual news magazine, chose to address the events with strongly composed full-bleed pictures, run in saturated colours with only basic captions. Using images sourced from Reuters and Getty Images, its editors produced a story that is even-handed and brutally graphic – and quite unlike any photographic reporting seen amongst the magazine's mainstream Western equivalents. Casualties of conflict are presented frankly and without sentiment in images of a kind unlikely to be published by the Western press, where dead bodies are rarely shown and the faces of victims almost never revealed. (May 2004, with photographs by Ahmed Jadallah, top, Brian Hendler, bottom, and Yarif Katz, overleaf)

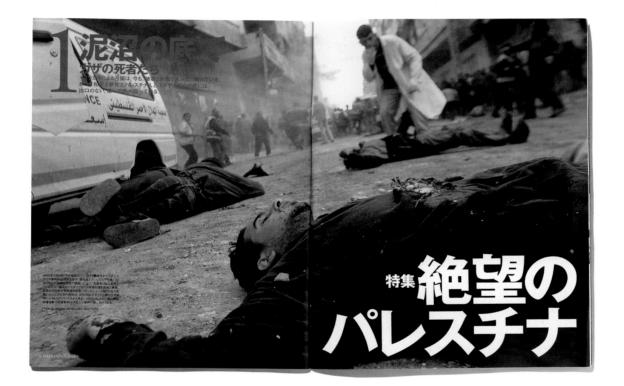

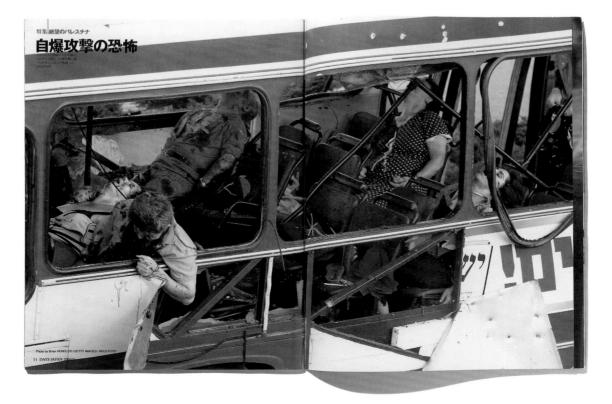

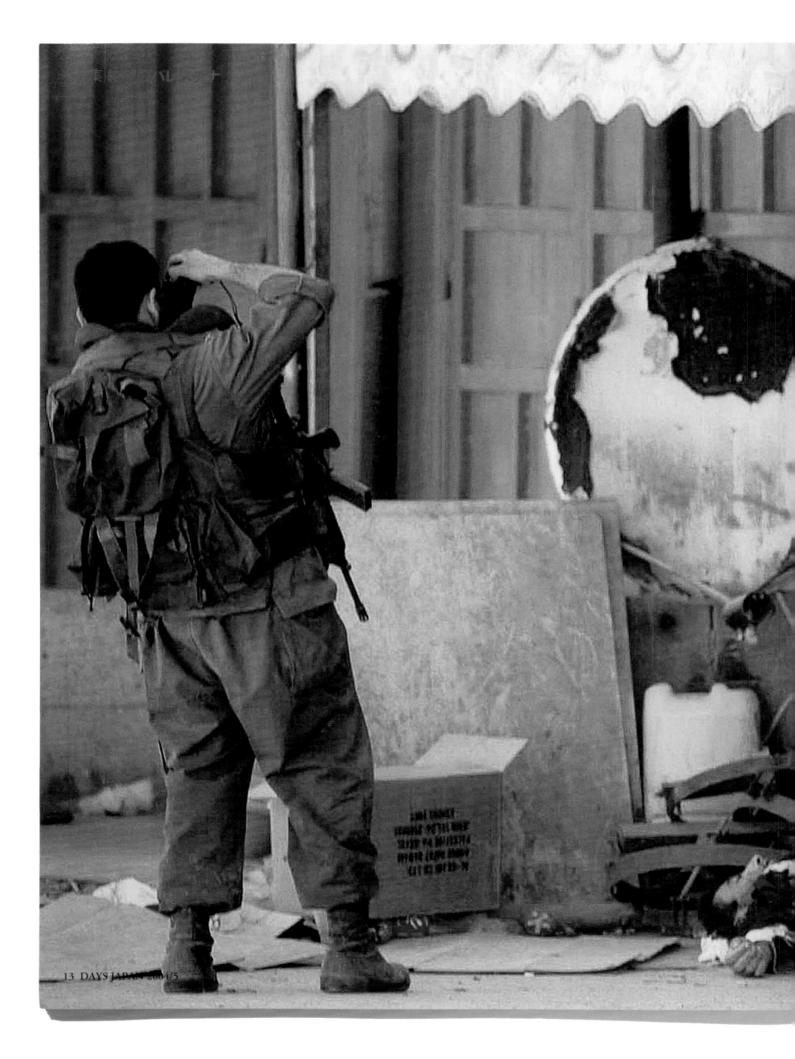

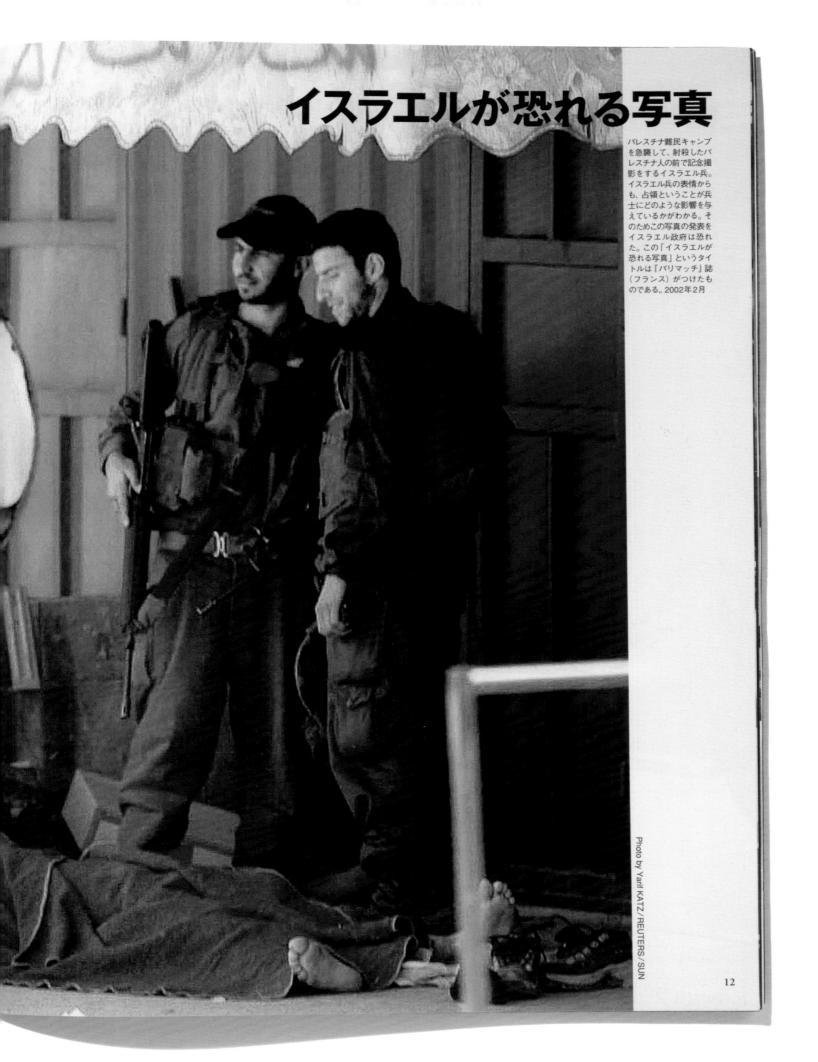

2004 MYRZIK & JARISCH FEET STORIES SÜDDEUTSCHE ZEITUNG

Munich-based photographers Ulrike Myrzik and Manfred Jarisch used anatomical studies of the soles of their subjects' feet to tell stories about work, class, age and gender in contemporary German society. Their subjects include a soccer star, a fruit vendor, an infant with a birth defect and a prostitute, with each picture accompanied by a short autobiographical statement. One subject, born without arms, describes how she uses her feet like hands to dress and feed her children. A mountain climber blandly comments that he lost several toes to frostbite in the Himalayas. The most disconcerting feet belong to Lisa-Maree Cullum, the first soloist of the Bavarian State Ballet. She proudly tells us that 'My feet mean everything to me, I love them, they are beautiful and strong' – while the viewer is likely to interpret their distorted form as evidence of extreme pain. The work demonstrates how once-strict boundaries around journalistic storytelling have dissolved; Myrzik and Jarisch apply formal art world tactics, treating their subjects' feet as detached objects, while at the same time offering a compelling magazine story. (14 May 2004)

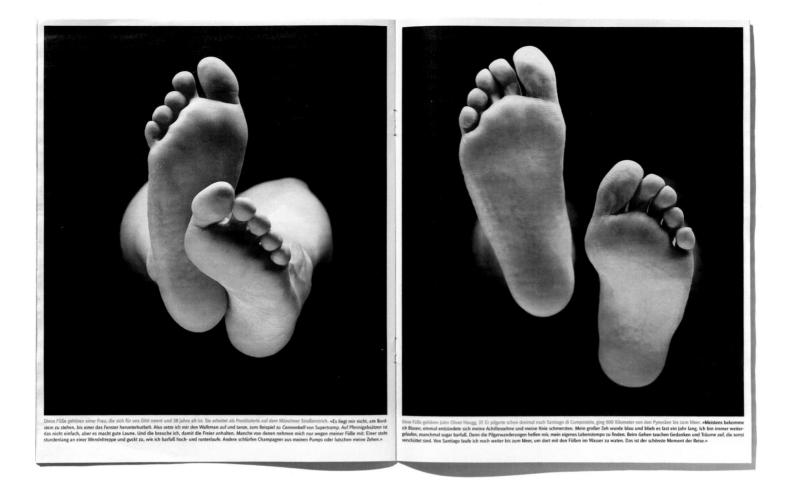

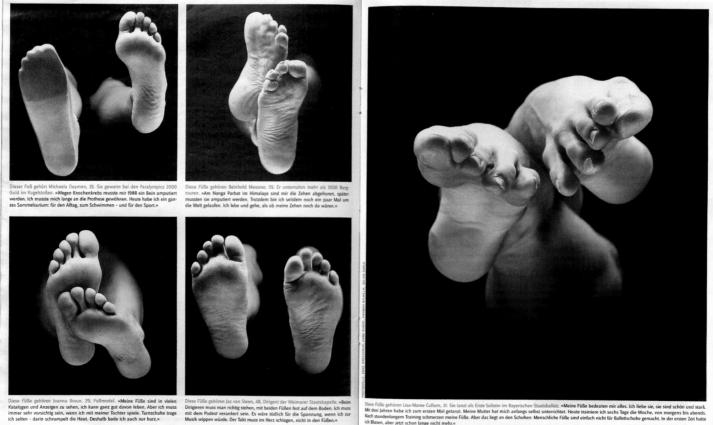

Diese Filde gehören Liss-Maree Cullum, 31. Sie tunzt als Erste Solistin im Bayerischen Staatsballett. Meine Füße bedeuten mir alles. Ich liebe sie, sie sind schön und stark. Mit drei Jahren habe ich zum ersten Mal gehant, Meine Mutter hat mich anfangs selbst unterrichtet. Heute trainiere ich sechs Tage die Woche, von morgens bis abends. Mich dauedangenet Training chmerere meine Füße. Aber das liegt an den Schuhen: Menschliche Füße sind einfach nicht für Ballettschuhe gemacht. In der ersten Zeit hatte ich Basten, aber jetzt schon lange nicht mehr.«

367

2004 JAMES NACHTWEY DARFUR TIME

For James Nachtwey, this issue of *Time* shows how effective photojournalism can be when a publication gives a photo essay its full support. With six full-bleed images run over twelve consecutive pages, followed by additional images illustrating the text, its cover story featuring James Nachtwey's photographs of Darfur commands a graphic power that can compete with anything appearing on the larger pages of *Paris Match*. As Nachtwey said in an interview in 2000, he sees his role as photojournalist in terms of social responsibility; its 'value ... to make an appeal to the rest of the world, to create an impetus where change is possible through public opinion. Public opinion is created through awareness. My job is to help create the awareness. ... I hope that people when they look at this work will engage themselves with it and not shut down, not turn away from it, but realize that their opinion counts for something, that they are part of a constituency that has the power to make decisions that affect the lives of thousands of people ... and they have to do something about it.' (4 October 2004)

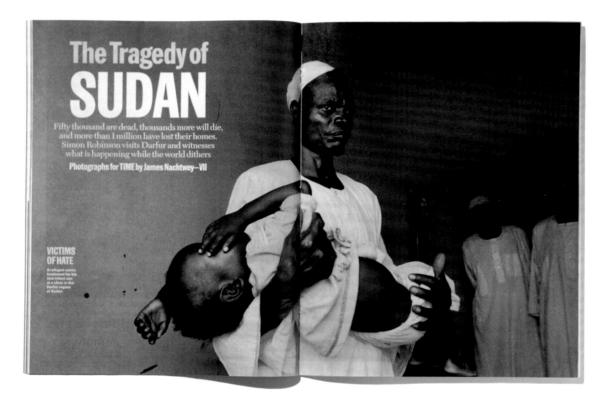

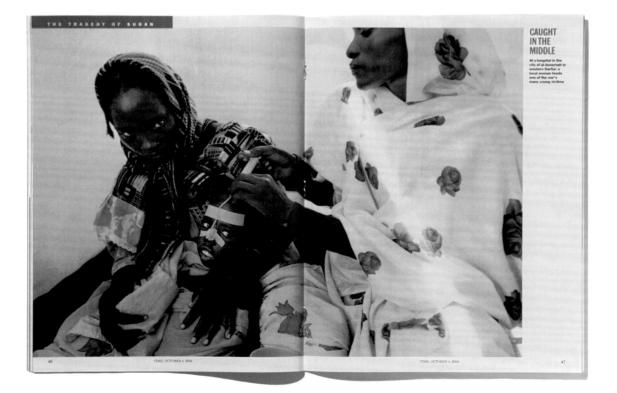

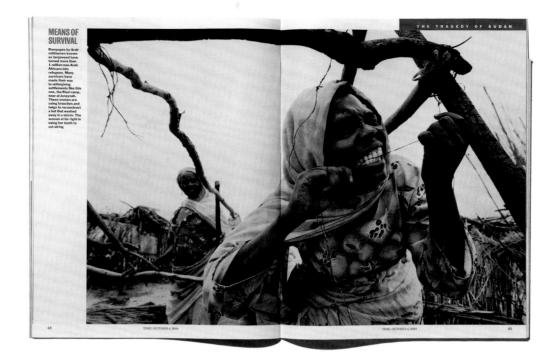

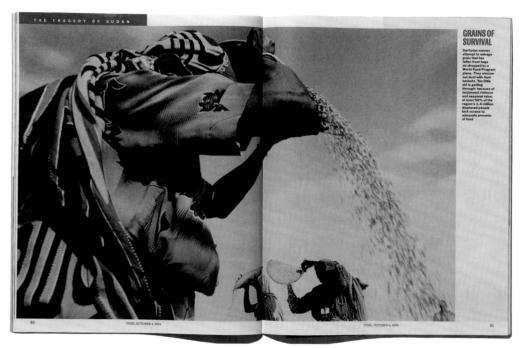

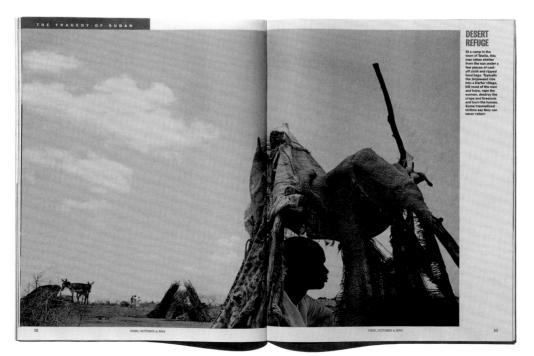

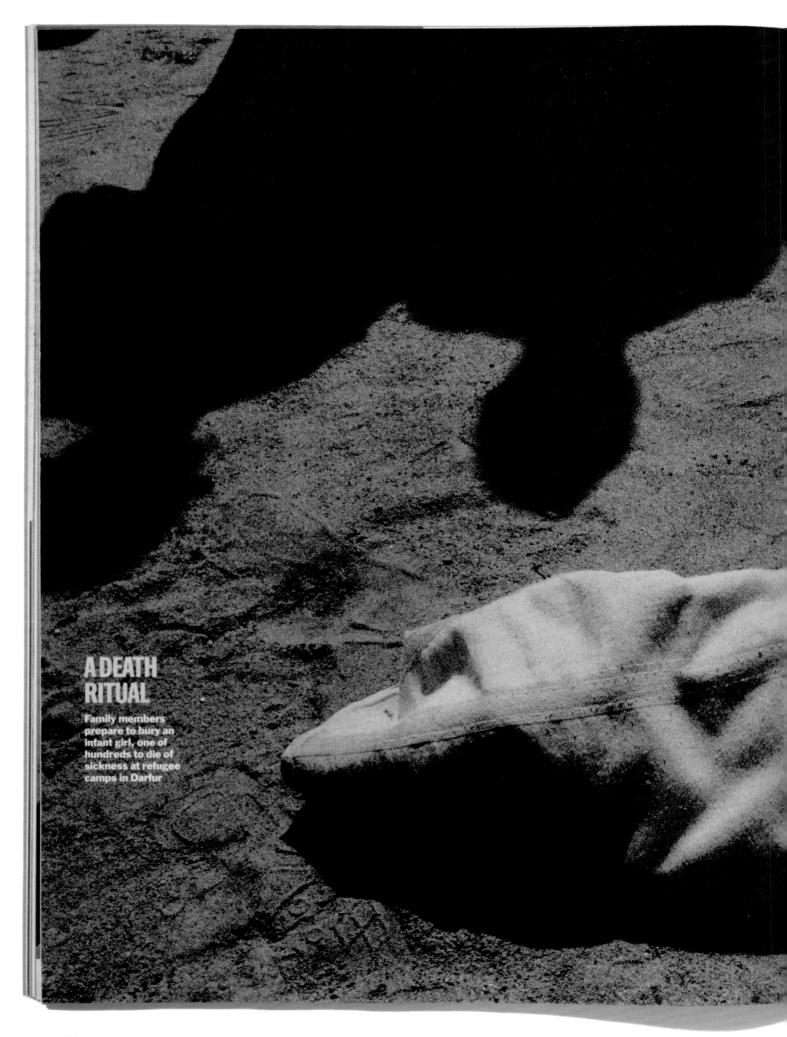

CHARD AVEDON DEMOCRACY NEW YORKER 2004

Richard Avedon's consummate skills as both portraitist and fashion photographer, and his forensic eye for nuance and detail, had been honed during a 50-year career when the New Yorker invited him to scrutinize America's democratic process in 2004. Republican President George W Bush and his Democrat rival Senator John Kerry were fighting a divisive election battle, at a time when the principles of democracy were being aggressively championed internationally in the 'war on terror'. Choosing to echo his 'The Family' series of 1976 (see page 204), Avedon trailed the conventions and sought out the activists, campaigners, politicians and pundits who defined the underlying issues of the campaign. On 24 September he visited the Brook Army Medical Centre, Texas, where he photographed Sergeant Joseph Washam who had suffered third-degree burns on a mission in Baghdad. The day after, Avedon was taken ill, and he died on the morning of 1 October 2004. Following the deaths of Henri Cartier-Bresson and Helmut Newton earlier the same year - together a powerful triumvirate who had ruled the magazine photography of their day - the New Yorker published Avedon's unfinished series as a respectful post-election epitaph. It signalled the passing of a classic era of photography. (1 November 2004)

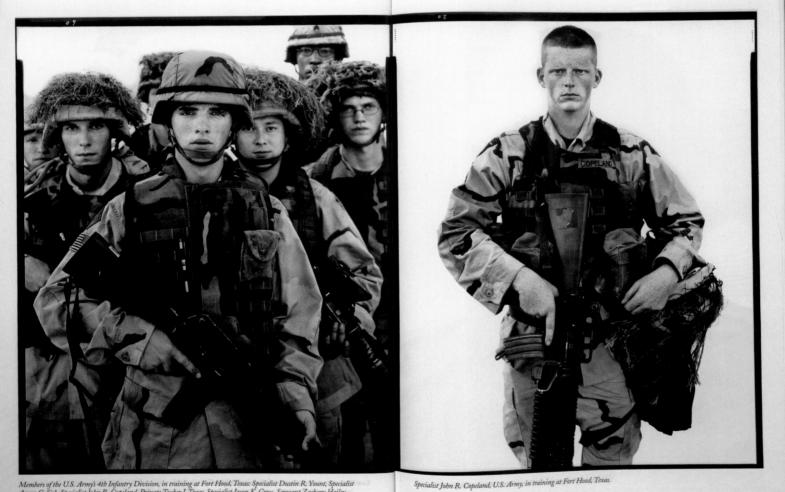

Members of the U.S. Army's 4th Infantry Division, in training at Fort Hood, Texas: Specialist Dustin R. Yount, Specialist Aaron C. Sisk, Specialist John R. Copeland, Private Tucker J. Tracy, Specialist Jason K. Gross, Sergeant Zachary Hailey, Specialist Travis Asline. All but one of them are veterans of the Iraq war.

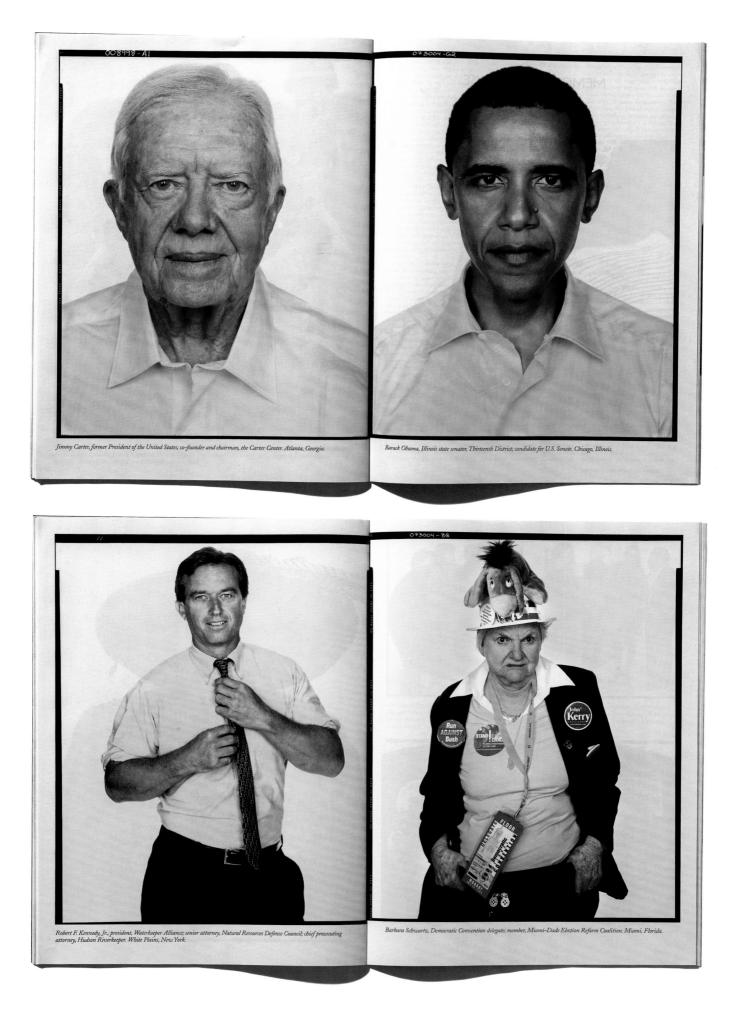

2005 TSUNAMI PARIS MATCH

Images from journalists, tourists and local non-professionals all contribute to the *Paris Match* special issue about the impact of the tsunami tidal wave that ravaged the coastline of the Indian Ocean on 26 December 2004. The story reflects the wide range of photographic images available to publishers of the news following the introduction of digital cameras, including camera-phones, and the ease with which images could now be distributed over the internet and by phone. The professional journalists' pictures are more polished, but photographs by amateurs capture the critical moments of the tsunami's arrival. Photography had long offered amateurs the chance to contribute to public reportage of unanticipated crises; but with the publication of images of the abuse of prisoners at Abu Ghraib in 2004, and of the tsunami, coinciding with the phenomenon of self-authored 'reality' television, a new appetite for amateur reports became established within the press. While this heralded a democratization of journalism, the most powerful and informative reports continued, for the time being, to result from the collaboration of editors and professional photographers in the capture of the news. (12 January 2005, including photographs by J R Fuller, top left, and Andrew Wong, bottom left)

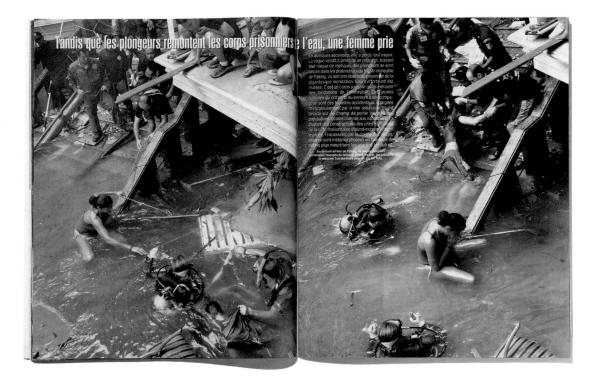

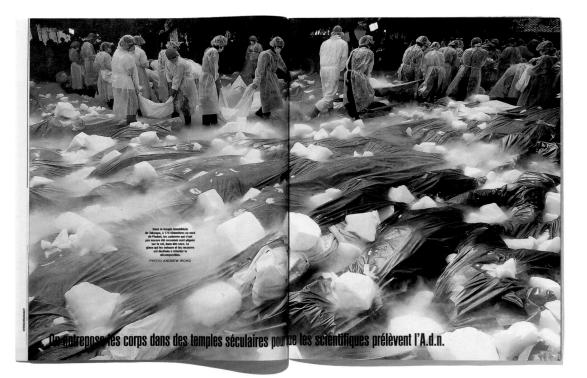

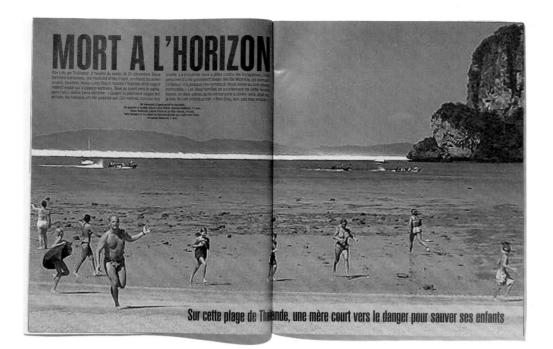

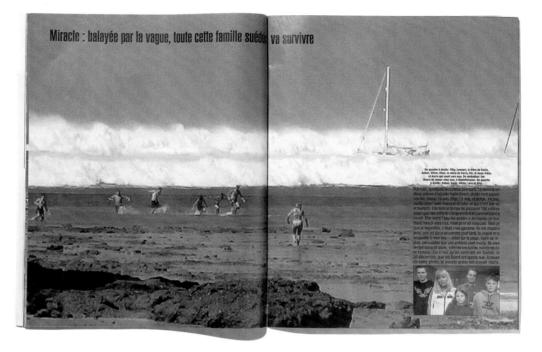

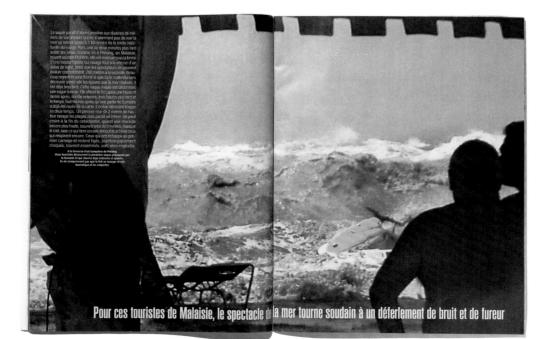

CHRISTIAN CAUJOLLE AFTERWORD

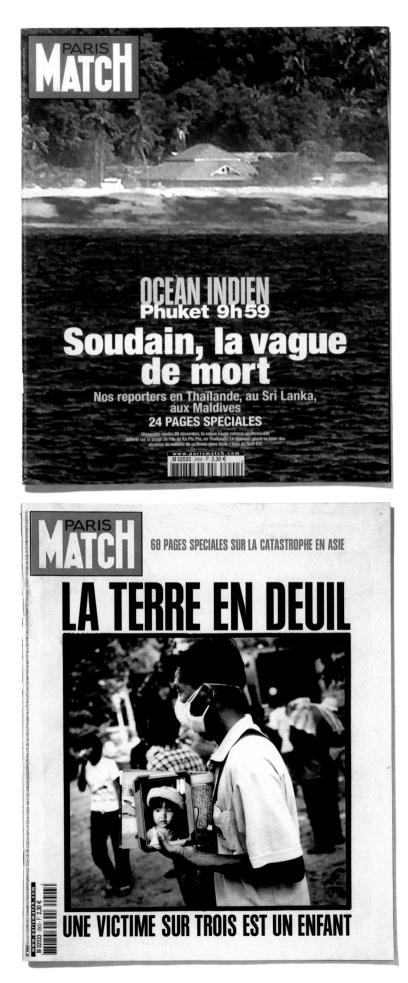

'Perhaps all of us have experienced a sort of unhappiness, if not terror, at seeing how the world and its history seem caught in an ineluctable movement, which keeps gaining momentum and which seems able to change, toward ever coarser ends, the visible manifestations of the world. This visible world is what it is, and our action on it cannot render it otherwise. So we yearn for a universe in which man, instead of acting so furiously on the appearance of things, strives to free himself from them, by refusing to act upon them, and by stripping himself down to the point where he discovers the secret place within himself from which an entirely different human adventure might possibly begin.' Jean Genet, *L'Atelier d'Alberto Giacometti* (1958)

The last *Paris Match* cover of 2004 and its first of 2005 were devoted to the tsunami that devastated parts of Southeast Asia. Placed side by side, they tell us much more about the current state of photography and its relationship with newspapers and news magazines than many analyses. The first reproduces an image taken by an amateur photographer, while the second carries a black and white photograph framed with a white border – by Philip Blenkinsop, an incisive professional reporter – reflecting a humanist point of view that respects both the fact of the event and the victims it created.

In their different ways, each of these covers is remarkable. The first, executed in haste, retains the peculiar green and blue tones of tourist photographs vaunting the paradisiacal beauty of Thailand's southern islands, and although the text enjoins us to 'see' the approaching wave, we see nothing! There seems to be a total contradiction between this pixellated image and the amateur videos, some of them impressive, depicting a ferocious sea churning sand and soil into a brown mass and carrying everything before it. The second cover, in a layout of unusual simplicity for this magazine, is set against a pure white background, without text overlay; two simple titles announce the enormity of the tragedy and the fact that 68 pages are devoted to it. It created a powerful visual and emotional impact. The covers of all the weeklies displayed in the kiosks carried perfectly interchangeable colour photographs, but it was *Paris Match* that caught the eye. Moreover, the sales of that issue were exceptional. The juxtaposition of these two covers perfectly illustrates a tension between distinct types of contemporary imagery; between instantly transmissible digital documents produced by amateurs, and those developed by professional photojournalists working in an auteur tradition, using their point of view to assert a dialectical relation between ethics and aesthetics.

The major change, signified by the two great news stories of the final months of 2004 – the revelation of torture at Abu Ghraib prison in Iraq, and the tsunami – stems from the fact that an immediate event captured by an amateur, who now has access to global markets, is as acceptable as the same event photographed by a professional. The privileged status (and, occasionally, the arrogance) the latter once enjoyed in the field of news photography is definitively over. This is neither good nor bad – anybody is entitled to witness and record an event - but it does raise certain questions. First, the question of reliability: how can we check the veracity of images produced with an automatic digital camera or mobile phone? How can we avoid the manipulations of hoaxers - or those with more sinister motives - who will undoubtedly seize the opportunity provided by digital technology to create seemingly credible vet totally inauthentic documents? The fabrication and manipulation of false documents is not a new phenomenon. It has occurred in various media and has been employed by every totalitarian power, during purges and in the interests of propaganda. In simple terms, new digital technology facilitates such practices with ease. The media is therefore obliged to exercise greater vigilance and pay closer attention to the ways in which digital images are used.

For example, it is surprising that most magazines chose to enlarge the images from Abu Ghraib, which were of a very poor technical quality. The pixels were so conspicuous that the images acquired a fictional dimension. There is little doubt that if these pictures of naked men being dragged around on leashes and terrorized by dogs had been accompanied by captions stating that they came from amateur sado-masochistic videos, or recordings of performances of contemporary art, we would not have been any the wiser. The only acceptable way to publish these images would have been to reproduce them in small format, grouped together in a way that emphasized the repetition and degradation of such conduct. But who, these days, thinks about the effects of meanings produced by the way in which images are presented? Very few, unfortunately, and especially in the media. At present, it seems almost indecent to ask the fundamental and absolutely essential question: for whom does the press publish these photographs?

For reasons having as much to do with space as with ignorance, our retrospective study of fifty years of photojournalism is inevitably incomplete. But by making a selection of what we believe to be important work, both in terms of the photographs and their presentation, and particularly with regard to the work presented from the last two decades, we are asserting a point of view. Readers may draw their own conclusions, whether optimistic or pessimistic, but the selection does at least confront issues vital to both photographers and their publishers. We are worlds away from spectacle and demagogy – from the facile and vain effects generated by a press whose sole imperative is economic gain; a press which is contemptuous of the readers to whom it owes its survival and which, because of its increasing focus on mediocrity, is in danger of sawing off the branch it sits on.

To avoid the myths and nostalgia that surround the subject of photojournalism, it should be remembered that the relationship between photographers and publications has always been difficult. This was true even in the 1950s and 1960s, when the weekly news magazines were enormously influential and relayed images that enabled the reader to experience a vicarious discovery of the world. In fact, there never was a golden age – one only has to read W Eugene Smith's account of his battles with *Life* magazine to be convinced of that – but simply a period in which photojournalism received considerably more exposure than it does today.

When television (now being overtaken itself by the internet) became the primary medium for the distribution of news images, few photographers or publications gave much thought to the way the rules had changed. Frightened by the competition that was depriving them of a considerable slice of their advertising income, they responded by gradually reducing the space reserved for news and photo stories, and competed with each other by according more and more prominence to 'celebrities' who, whether high-profile or relatively low-profile, were supposed to boost sales in a market avid for revelations. Celebrity culture, the pandering to voyeuristic tendencies, has always existed; but its nature has changed over the course of the last twenty years. Top models and television presenters are now more likely to appear on a magazine cover than royalty and film stars. But this has led to a situation in which a news story worth twelve pages in the *Paris Match* of the 1960s would be allotted no more than four pages today. The rates of payment offered for photographic essays have fallen proportionally.

In an even more pathetic reaction, the press attempted to fight television on its own ground by devising a print version of television. We now have daily newspapers designed to enable the reader to 'channel-hop' the contents, and have seen the appearance of sometimes successful but usually short-lived weeklies, particularly in Germany, filled with scores of very short and profusely illustrated articles. This attempt to reproduce the speed of television – which has become so fast over the last twenty years that its coverage of the news is often reduced to caricature – ignores the fact that television's arsenal contains sound and movement as well as images. There is worse: a televisual aesthetic – the frontal shots, the predilection for a supposedly neutral 'middle' distance – has contaminated the imagery chosen by the press. It is a dismal experience to pick up one's favourite newspaper in the morning and find that the front page displays a clone of the image one saw on television the night before. We are sometimes forced to question whether there is any point in buying

newspapers at all.

We know of no tool in history that has survived the loss of its practical or social function: we no longer carve meat with a sharp flint, and photography has put paid to the art of the miniaturist. The only chance of survival for the print media lies in its ability to assert its difference; to do what other media, either by their very nature or by editorial inclination, cannot do.

The print media's most striking and unique asset is the opportunity it affords the viewer to decide how long they spend on an image. Moreover, it can be revisited and reconsidered at leisure. The amount of time spent on the consumption of information and images is the prerogative of the reader rather than of a media terrified by emptiness and silence and obsessed by the supposed efficiency of speed. Nor should we forget that the degree of autonomy and flexibility available to photographers is far greater than that of television. Photographers can shoot from a variety of angles and gain access to scenes that more heavily equipped teams cannot reach. They can take different kinds of risk, and move with flexibility, if necessary disappearing from a scene, or becoming invisible – and produce outstanding documents of witness as a result.

I am a journalist and cannot predict the future, but I do wonder about certain possibilities. I wonder what the internet can do for photography, for its practitioners and the issues fundamental to it. With few exceptions, the internet in its present form is more a tool of distribution than of publication. The best sites attract a community of fans who share certain values, who seek quality and a sense of wonderment stimulated by the discovery of the new, and we can only hope that they attract more visitors as time goes on. But perhaps this is too much to expect. It should be acknowledged that the thousands of websites set up by photographers, agencies and visual institutions do not amount to more than portfolios, catalogues or other marketing vehicles. They bear little relation to the illustrated print media and do not share its fundamental characteristic: the production of meaning through the editing, sequencing and positioning of photographs in relation to text and other graphics. But I am optimistic. There is every chance that the internet will yet stimulate the invention of a totally new method of publishing photography. If this innovation does occur - if highquality, meaningful image-based reporting is made available at little or no cost to the widest possible audience, as was the case with magazines like Life and Paris Match - it is likely that the print media will be forced to undergo a transformation. It will become a luxury product extraordinary, elitist, sophisticated, creative, and collectible. This would be a bold project. impossible to achieve without the creation of economically viable models.

Although the mass-market magazine is in decline, it can survive if it deals appropriately with the work of the dedicated photojournalists who are still exploring, questioning and challenging the world. There is absolutely no reason why the work of such auteurs cannot appear in the press alongside relevant material produced by amateurs. To put it simply, if the press published more radical photojournalism distinguished by the kind of incisive text that exploits the tension between ethics and aesthetics, it could construct an identity, a brand, a unique position which would distinguish it from television and the internet and make its products worth buying. If that is to happen, greater attention and analysis must be devoted to every stage of the process that results in the production of meaning, including the choice of photographer, the selection of the images, the organization of the sequence and its graphic development, always bearing in mind that typography, like layout, affects the way photographs are interpreted. It is absolutely essential that we continue to ask the fundamental questions: for whom am I publishing these images? What is the point of view I am seeking to express, to render intelligible?

Some of the most brilliant photographers now prefer to work for the collectors' market, for galleries and museums. If we do not rise to the challenge, there is a strong possibility that photographers will cease to create the documents essential to our collective memory.

INDEX OF PHOTOGRAPHERS AND PUBLICATIONS

Abbot, Berenice, 19, 46 Abrahams, Mike, 260-3 Actuel. 26. 216-19 Adams, Eddie, 24, 109 Al Arabi, 67 Aldrin, Edwin ('Buzz'), 186-9 Allard, William Albert, 350-1 Alpert, Max, 15 American Photographer, 26, 220-3 Americans, The (1958), 25, 46 Anders, Bill, 176-7 Anders, Hanns-Jörg, 108 Anderson, Benedict, 9-10 Andujar, Claudia, 170-1 Arbeiter Illustrierte Zeitung, 13, 32 Arbus, Diane, 21-2, 87-9 Argus, 201 Armstrong, Neil, 186-9 Arthus-Bertrand, Yann, 332-3 Arts et Métiers Graphiques, 15 Asahi Camera, 82 Atget, Eugène, 19 Atwood, Jane Evelyn, 278-9 Australian. 330-1 Avedon, Richard, 22, 26, 148-51, 204-5, 372-3 Avenue, 144-7 Azoulay, Claude, 166 Bain, George Grantham, 12 Baltermans, Dmitri, 140 Barbey, Bruno, 56, 292-5 Bartholomew, Pablo, 201 Battaglia, Letizia, 212-13 Beaton, Cecil, 19 Benchallal, Nadia, 362 Berliner Illustrirte Zeitung, 8, 13, 15, 16, 33 Berlingske Tidende, 298 Big. 334-5 Bikeriders, The (1967), 25 Bizos, Alain, 216-19 Blenkinsop, Philip, 360-1, 376, 377 Bonneville, Floris de, 164-5 Boston Globe, 246 Boston Herald, 200 Bouju, Jean-Marc. 299 Boulay, Robert, 196 Bourdin, Guy, 182 Bourke-White, Margaret, 16, 19 Bourseiller, Philippe, 270-3 Bozdemir, Mustafa, 201 Brake, Brian, 24, 94-5 Brandt, Bill, 19, 25 Brassaï, 25 Broomberg, Adam, 338-9 Browne, Malcolm, 24, 37 Bryan, Julien, 19 Bultman, Janice, 28 Burkard, Hans-Jürgen, 27, 274-7 Burnett, David, 200 Burrows, Larry, 25, 106, 114-17

Camera,21 Capa, Robert, 15, 19, 26, 59 *Caretas*,27 Caron, Gilles, 26, **164-5**, 166, **168-9** Carter, Ovie, **109**

Cartier-Bresson, Henri, 10, 20, 25, 38-43 72-5 372 Casasola, AV, 12 Chanarin, Oliver, 338-9 Chapelle, Dickey, 96-7 Chessex, Luc, 56 Chicago Tribune, 109 Chuo Koron, 19, 21, 82-5 Clarín, 27 Cleveland Plain Dealer, 190 Cole Charlie 238 Cole, Ernest, 22, 138-9 Collier's, 12, 47-9 Colors, 32, 310-11, 338-9 Constantine, Elaine, 328-9 Corrales, Raúl, 20, 98-9 Corriere della Sera, 256 Cruzeiro, O, 19, 20, 27, 126 Cuba, 98-9, 142-3

Daily Express, 148 Daily Mirror, 12, 26 Daily Telegraph, 25, 172-5, 270-3 D'Amico, Alicia, 27 Datta, Arko, 299 Davidson, Bruce, 25, 160-3, 182 Days Japan, 363-5 de Biasi, Mario, 104 Decisive Moment, The (1952), 10 Deghati, Manoocher, 242 Delahaye, Luc, 33 Delta: the Perils, Profits and Politics of Water in South and Southeast Asia (1997), 280 Demulder, Françoise, 201 Denderen, Ad van, 344-6 Denver Post, 246 Depardon, Raymond, 26, 228-9 Detroit Free Press, 238, 239, 246 Diario La República, 37 Domon, Ken, 23, 25, 27 Donaire, Roberto, 334 Drum, 19, 86, 138 Du, 21, 126-9, 236, 280-1, 292-5 Duncan, David Douglas, 24, 25, 47-9.59-61 Dürst, Waldemar, 4, 56-7 East 100th Street (1970), 25, 160

Economist, 32 Ehrenburg, Ilya, 25 Ei8ht, 32 Ein, Nhem, 302 Eisenstaedt, Alfred, 15, 16 Elisophon, Eliot, 24 Elsken, Ed van der, 25, 144-7 English at Home, The (1936), 25 Epoca, 19, 27, 94, 104-5 Eppridge, Bill, 110-13 Espresso, L', 66 Esquire, 21, 87-9 Europeo, L', 19, 27, 100-3 Evans, Walker, 21, 28, 32, 44-5, 46,282 Ewald, Wendy, 352 Excelsior, 62 Exploding into Life (1986), 220 Express, L', 326-7

Face, 310, 328-9 Facio, Sara, 27 Fehr, Gertrude, 56 Femina 12 Ferrato, Donna, 246-9 Figaro, Le, 11, 12 Foil. 334. 356-9 Forman, Stanley, 200 Fortune, 16, 19, 21, 28, 44-5, 46, 110 Fotografie, Die, 21 Fotografisk Tidskrift, 21 Fournier, Frank, 238 Frank, Robert, 21, 25, 46, 58 Frankfurter Allgemeine Magazin, 290-1 Frankfurter Allgemeine Zeitung, 27,290 Frauen Rundschau, 12 Freund, Gisèle, 12, 13, 15 Friedlander, Lee, 22 Fuentes, Norberto, 20 Fukushima, Kikujiro, 27 Fuller, J R, 374

García, Héctor, 62-5 García Rodero, Cristina, 340-3 Gazeta Wyborcza, 352-3 Geller, Wolfgang Peter, 108 Geo, 24, 27, 68, 80, 224, 332-3.344-6 Gidal, Tim, 15 Gillhausen, Rolf, 34, 68-71 Goezs, Franz, 50 Goldin, Nan, 33, 304-7, 320, 322 González Palma, Luis, 27 Goro, Fritz, 15, 122-5 Grande, Sergio del, 104 Graphic, 12 Greene, Stanley, 32, 308-9 Griffiths, Philip Jones, 25, 114, 172-5 Grigorian, Eric, 299

Haas, Ernst, 24, 94 Habans, Patrice, 166, 258 Haeberle, Ron, 190-1 Hamaya, Hiroshi, 27 Hammond, Leslie, 201 Hanabusa, Shinzo, 202 Hannach, Leila, 376 Harper's Bazaar, 16 Haven, Mogens von, 36 Hendler, Brian, 363 Henrotte, Hubert, 26 Hindustan Times, 90 Hine, Lewis, 12 Hiroshima (1958), 23, 25 Hocine, 299 Hoff, Bernd, 250-1 ¡Hola!,27 Holiday, 38, 140 House of Bondage (1967), 138 Hubmann, Hans, 19 Hürrivet Gazetesi, 201 Hutchings, Roger, 326-7 Hutton, Kurt, 19

I-D, 282-3

Illustrated London News, 12 Illustrated Weekly of India, 90 Illustration, L', 12 Independent, **260-3**, **266-7**, **278-9**, **286-9**, **300-1** India Today, **234-5** Infante, Octavio, **28** Inferno (1999), 312 Interview, **230-2**, 334 Iturbide, Graciela, 27

Jadallah, Ahmed, **363** Janah, Sunil, 90 Janowski, Piotr, 352 Jarecke, Kenneth, 32, **268** Jarisch, Manfred, **296**, **366-7** *Jornada*, *La*, 27 *Journal Illustré*, *Le*, 12

Karales, James, 22, 118-19 Karlsson, Jonas, 347-9 Katz, Yarif, 363, 364-5 Kawauchi, Rinko, 356-9 Keating, Edward, 320, 323 Ken, 17, 19 Kertész, André, 15 Kessel, Dmitri, 24 Khaldei, Yevgeni, 140, 258 Kieffer, Gary, 268, 269 Kiosk: A History of Photojournalism (2001), 19 Klein, William, 22, 24, 25, 178, 182 Klutsis, Gustav, 16 Konkret 233 Kratochvil, Antonin, 27, 264-5 Kristall, 19, 80-1 Krull, Germaine, 15 Kubota, Hiroji, 202-3 Kuwabara, Shisei, 202 Kuznetsova, Lialia, 27, 253

Ladefoged, Joachim, 29 Ladies Home Journal, 12, 140 Lange, Dorothea, 10, 17, 264 Larrain, Sergio, 126-9 Larsen, Claus Bjørn, 298 Lebeck, Robert, 9, 19, 80-1 Lectures Pour Tous, 12 Leibovitz, Annie, 31, 32, 320, 322 Leifer, Neil, 120 Leipziger Illustrirte Zeitung, 12 Lentz, Vera, 27, 233 Leslie's, 12 Lessing, Erich, 50 Libération, 26, 228-9, 239, 240-1.242 Liberman, Alexander, 16 Life, 9, 16, 19, 20, 21, 22, 25, 37, 38, 47, 50, 72-5, 76, 91-3, 94, 98, 104, 106, 108, 109, 110-13, 114-17, 122-5, 130, 134-7, 140, 176-7. 180-1, 186-9, 190-1, 252, 298, 310, 378, 379 Life is good and good for you in New York (1956), 24, 25 Lilliput, 16, 334 Lissitzky, El, 16

Li ing with the Enemy (1992), 246 Loaded, 338 Look, 9, 22, 104, **118-19**, **148-51**, **152-5** Lotti, Giorgio, 104 Love on the Left Bank (1956), 25, 144 Lowe, Paul, **300-1** Lucien Aigner, 15 Luna Cornea, 27 Lyon, Danny, 25

McBride, Will, 22, 182-5 McClure's, 12 McCullin, Don, 22, 25, 26, 37, 114, 156-9, 192-5 McCurry, Steve, 284-5 Magubane, Peter, 22, 86 Mainichi Shimbun, 36 Man, Felix H, 15 Manchete, 19, 27 Man Ray, 15 Marianne, 15 Mark, Mary Ellen, 28, 224-7, 320, 323 Martin, Douglas, 37 Martin, Paul, 12 Matador, 334 Matthias, Paul, 50 Max, 256 Mayer, Ernst, 16 Mayer, Pedro, 32 Meiselas, Susan, 26, 27, 32, 198,206 Melcher-Berretty, 50 Mendel, Gideon, 286-9 Merillon, Georges, 238 Metinides, Enrique, 27 Mikami, Sadayuki, 201, 268, 269 Mikhailov, Boris, 27 Minotaure, 15 Modern Photography, 21 Mohanna, Mayu, 27 Moholy-Nagy, Lázlo, 15 Moi Parizh (1933), 25 Molinari, Oscar, 27 Mollison, James, 338-9 Monteux, Jean, 26 Moore, Charles, 22 Morell, Abelardo, 320, 324-5 Mori, Walter, 104 Moriyama, Daido, 27, 178-9 Moroldo, Gianfranco, 100-3 Morris, Christopher, 310, 311 Movement, The (1964), 25 Moyer, Robin, 201 Münchner Illustrierte Presse, 13, 15 Mundo, El, 312-15 Munkacsi, Martin, 8, 15, 16, 22 Mydans, Carl, 19 Myrzik, Ulrike, 296, 366-7

Nachtwey, James, **6**, 26, 32, **239**, 264, **312-15**, **368-71** *Nación*, *La*, 27 Nadar, Félix, 12 Nadar, Paul, **11**, 12 Nagao, Yasushi, **36**

Nakahira, Takuma, 27, 178 Nash's, 12 National Geographic, 10, 12, 20, 24, 27, 96-7, 254-5, 284-5, 310, 336-7, 350-1 Natori, Yonosuke, 27 Newsweek, 28, 238, 268-9 Newton, Helmut, 210-11, 372 New York Daily Graphic, 10, 12 New Yorker, 33, 372-3 New York Times, 30, 31, 33, 58, 109, 180, 198, 206, 214-15, 264-5, 304-7, 308-9, 320-5 Nichols, Michael ('Nick'), 336-7 Nilsson, Lennart, 130-3 Niven, Doug, 302 Norfolk, Simon, 354-5 Observer, 32, 37 Ogonyek, 16, 20, 27, 58, 98, 140-1,253 Ojo, 62-5 Ojo de Pez, 334 O'Neill, Michael, 320 Opinión, La, 27 Ora, L', 212-13 Pabel, Hilmar, 19 País Semanal, El. 27, 354-5

Panorama, Le, 12 Parekh, Kishore, 90 Paris de Nuit (1933), 25 Paris Match, 15, 19, 22, 26, 38-43, 50-5, 59-61, 94-5, 108, 164-5, 166-9, 196-7, 258-9, 368, 374-5, 376, 377, 378, 379 Parke, Trent, 330-1 Parks, Gordon, 20, 91-3 Parr, Martin, 250, 316-19 Pedrazzini, Jean-Pierre, 50 Penn, Irving, 22, 152-5, 182 People, 110 Peress, Gilles, 22, 27-8, 30, 31, 214-15 Pérez Barriopedro, Manuel, 200 Perkins, Lucian, 298 Peters, Mark, 268 Petersen, Anders, 207-9 Philadelphia Inquirer, 246-9 Photo, 26 Photo Communiqué, 21 Photographic Essay, The (1989), 350 Photo Magazin, 21 Picture Post, 16, 19, 76, 130 Pirath, Helmuth, 37 Pittigliani, Adriana, 334 Platiau, Charles, 268 Politiken, 28, 29 Popular Photography, 21, 26, 76-9 Pravda, 58, 140 Prensa, La, 27, 206 Proceso, 27, 32 Provoke, 27, 178-9, 334 Purple, 334 Queen, 12, 94

Queen, 12, 94 Quick, 37

Rai, Raghu, 234-5 Ray-Jones, Tony, 326 Reader's Digest, 96 Realidade, 130-3, 170-1 Refner, Erik, 298 Regan, Lara Jo, 298 Regards, 15 Reininger, Alon, 239, 252 Re-Magazine, 334 Renger-Patzsch, Albert, 18, 19 Rentmeester, Co, 109 Reportage, 302-3 Revista, La, 312-5 Revolución, 98, 142 Reza, 242 Richards, Eugene, 26, 220-3 Riefenstahl, Leni, 230 Riis, Jacob, 12 Riley, Chris, 302 Rodchenko, Alexander, 16 Rolling Stone, 26, 204-5 Rondón Lovera, Héctor, 37 Ruiz, Stefan, 338-9

Sadovy, John, 50, 53 Salas, Osvaldo, 142 Salas, Roberto, 20, 142-3 Salgado, Sebastião, 27, 28, 238, 240-1, 243-5, 264, 278 Salomon, Erich, 13, 15, 33 Saturday Evening Post, 12 Savin, Mikhail, 140-1 Sawada, Kyoichi, 108, 109 Schulke, Flip, 22 Schwartz, Daniel, 236, 280-1 Se. 130 Secchiaroli, Tazio, 66 Seiland, Alfred, 290-1 Sekai, 202-3 Sette, 27, 256-7 Sichov, Vladimir, 258 Sieff, Jean-Loup, 56 Silk, George, 120, 121 Small World (1995), 316 Smith, Dayna, 299 Smith, W Eugene, 9, 19, 20, 21, 26, 76-9,94,378 Sola, Michel, 196 Specchio, 256 Sports Illustrated, 110, 120-1 Statesman, 234 Steichen, Edward, 16, 19, 20 Stern, 19, 22, 26, 27, 34, 68-71, 80, 108, 148, 207-9, 224-7, 274-7.290 Stoller, Ezra, 46 Strömholm, Christer, 207 Suau, Anthony, 26, 239 Sucesos, 27 Süddeutsche Zeitung, 27, 296, 366-7 Sunday Times, 9, 25, 26, 108, 138-9, 156-9, 160-3, 192-5, 243-5

Telex Iran (1983),27,214 *Tempo*, **250-1** Tereba, Stanislav, **37** *Terre vue du Ciel*, *La* (2002),332 Thompson, Hunter, 26 Tillmans, Wolfgang, **282-3** *Time*, **6**, 110, 140, 201, 239, 312, **368-71** *Time Asia*, **360-1** *Times*, 10, 190 Tomatsu, Shomei, 21, 27, **82-5**, 178 Toscani, Oliviero, 32, 310 Tourtet, Jean-François, 50 Towell, Larry, **239**, 320, **321** Tunbjörk, Lars, 320, **321** Turnley, David, 26, **238**, **239**, 268, **269** *Twen*, 22, **182-5**, 290

UHU, **13** Ulutunçok, Guenay, **310** Umbo, 15 *USSR in Construction*, **15**, 16, 140 Ut, Huynh Cong ('Nick'), 24, **108**

Valli, Eric, **254-5** Vance, Vick, 50 Vanguardia, La, **340-3** Vanity Fair, 16, **31**, 32, **347-9** Vassal, Hugues, 26 Vietnam Inc (1971), 25, 172 Visionaire, 334 Vogue, 16, 22, 152, **210-11** Vogue Hommes, **362** Voilà, 15 Vu, **14**, 15, 16, 33

W, 316-19 Wallpaper, 334 Washington Post, 190, 298, 299 Weber, Bruce, 230-2 Weber, Wolfgang, 19 Weegee, 178 Weekly Illustrated, 16 Wells, Michael, 200 Welt der Frau, Die, 12 Welt ist Schön, Die (The World is Beautiful, 1928), 18, 19 Winogrand, Garry, 22 Woche, Die, 4, 12, 56-7 Wojazer, Philippe, 268 Wolfe, Tom, 26 Wolfenson, Bob, 334 Wong, Andrew, 374

Yuyanapaq. Para Recordar (2003), 28

Zachmann, Patrick, **256-7** Zapruder, Abraham, 22, **134-7** Zecchin, Franco, **212-13** Zhukov, Yuri, **58** Zille, Heinrich, 12 Zizola, Francesco, **299** *Zoom*, 26 The publisher, producers and authors of this book sincerely thank all the photographers (and where relevant their estates) and the publications whose work is featured here for their consent to include it.

Every attempt has been made to trace and properly acknowledge the owners of all the copyrights involved. However, should inaccuracies or omissions have occurred, World Press Photo would kindly call on the parties in question to contact the foundation office in order that we may correct this.

This book has been published under the auspices of the Stichting World Press Photo, Amsterdam.

All the illustration material is the copyright property of the photographers and/or their estates, and the publications in which they appear, in each case. Additionally, pages: 8, 14-17 & 20, photographs from the collection of the International Center of Photography; 32, from General Research Division, The New York Public Library, Astor, Lenox and Tilden Foundations; 33, photograph originally published in Vanity Fair, 2002; 46, photographs © Robert Frank, courtesy Pace/MacGill Gallery, New York; 76-79, photographs © The Heirs of W. Eugene Smith; 82-85, Asian and Middle Eastern Division, The New York Public Library, Astor, Lenox and Tilden Foundations; 98-99 & 142-143, from the library of The Center for Cuban Studies, NYC; 110-113, photographs LIFE Magazine © 1965 Time Inc. Used with permission; 122-125, photographs LIFE Magazine © 1965 Time Inc. Used with permission; 134-137, Zapruder Film © 1967 (Renewed 1995) The Sixth Floor Museum at Dealey Plaza, Dallas, All Rights Reserved; 144-147, photographs © Ed van der Elsken/Nederlands Fotomuseum, courtesy Annet Gelink Gallery; 207-208, photographs © The Helmut Newton Estate/ Maconochie Photography, for German Vogue; 240-241 & 243-245, photographs © Sebastião Salgado/Amazonas Images/nbpictures; 302-303, photographs © The Photo Archive Group; 347-349, photographs originally published in Vanity Fair, 2001.

We would like to thank the many people whose knowledge, suggestions, advice and practical help have made this book possible, including Maria Luisa Agnese, Jassim Ahmad, Shahidul Alam, Stuart Alexander, Judy Annear, Negar Azimi, Sara Barrett, Grégoire Basdevant, Jonathan Bastable, Patrick Baz, Patrizia Benvenuti, Marie Christine Biebuyck, Katarzyna Biernacka, Elisabeth Biondi, Katie Boot, Allain Brillon, Frish Brandt, Beverly Brannan and the staff of the Library of Congress, Sue Brisk, David Brittain, Martijn van den Broek, Jeff Burak, Neil Burgess, Kate Button, Sandra Byron, Giovanna Calvenzi, Emily Caplan, Clinton Cargill, Anna Lisa Cavazzuti, Elena Ceratti, Amit Chauhan, Cinzia Cozzi, Hamish Crooks, Illonka Csillag, Verna Curtis, Pete Daniel, Dominique Deschavanne, Bruno Dondolo, Elsa Dorfman, Thomas Doubliez, Stephen Dupont, Sandy Edwards, Ruth Eichhorn, Adrian

Evans, Daniela Fagnani, Prof. F S Faro, Brian Finke, Eva Fischer, Per Folkver, Alasdair Foster, Jimmy Fox, Dennis Freedman, Bevis Fusha, Rik Gadella, Nick Galvin, Laetitia Ganaye, Martin Gasser, Annet Gelink, Alice Rose George, Amir Ali Ghasemi, Daniel Girardin, Hilly Glasmacher, Rupert Godden, David Goldblatt, Ana Cecilia Gonzales-Vigil, Howard Greenberg, Mark Grosset, Arash Hanaei, Tim Hetherington, Marit Hoffman, Amanda Hopkinson, Graham Howe, Helen Hughes, Brooks Johnson, Frank Kalero, Judy Karasik, Erik Kessels, David King, Nathaniel Kilcer, Kent Kobersteen, Roberto Koch, Michael Koetzle, Ziv Koren, Peter Korniss, José Kuri, Michelle Lamuniere, Françoise Le Roch, Cordula Lebeck, Chris Lee and the staff of the British Library, Claudine Legros, Volker Lensch, Laura Leonelli, Tom Lisanti and the staff and librarians and of the New York Public Library, Roberta Lotti Lima, Celina Lunsford, Damon McCollin-Moore, Rebecca McLelland, John McMillan, Mary Ellen Mark, Ada Masella, Jacqui Masiza, Stephen Mayes, Frédérique Mersch, Maria Mayu Mohanna, Samer Mohdad, Lorraine Monk, Adriaan Monshouwer, Daniel Morel, John G Morris, Daniela Mrázková, Carlos Mustienes, William Nabers, Grazia Neri, Gael Newton, James Nicholls, Ute Noll, Junko Ogawa, Jason Orton, Philiy Page, Alessia Paladini, Prashant Panjiar, Lauren Panzo, Swapan Parekh, Sonia Pastrello, John Pelosi, Gianluca Perosillo, Peter Pfrunder, Françoise Piffard, Annie Polk, Stephné Posthumus, Astrid Proll, Daniele Protti, Walid Raad, Raghu Rai, Renza di Renzo, Tamás Révész, Reza, Phyllis Rifield, Arianna Rinaldo, Pamela Roberts, John Rohrbach, Jeff Rosenheim, Chiara Rostoni, Luc Salu, David Secchiaroli, Bree Seeley, Mike Selby, Liu Heung Shing, Erin Siegal, Agnès Sire, Rod Slemmons, Patricia Strathern, Aileen Mioko Smith, Adam Sobota, Tom Southall, Carol Squiers, Barbara Stauss, Nicola Steiner, Norma Stevens, Robert Stevens, Azmar Sukandar, John Szarkowski, Rob Taggart, Kay-Chin Tay, Shyam Tekwani, Dan Torres, Chab Touré, Anne Tucker, Tony White, Michael Wolf, Cynthia Young, and Akram Zaatari.

We would especially like to thank and recognize those people who, in addition to helping with their time and knowledge, generously loaned us valuable vintage magazines and generally provided us more assistance than we had any reason to expect, including Pablo Bartholomew, Letizia Battaglia, David Campany, Ian Denning, David Friend, Philippe Garner, Lotta and Oliver Hergesell, Anneke Hilhorst, Colin Jacobson, Elizabeth Krist, Robert Lebeck, Mikael Levin, Sandra Levinson and the staff of the Center for Cuban Studies, Meredith Lue, Susan Meiselas, Pablo Ortiz Monasterio, William Nabers, Martin Parr, Gilles Peress, Robert Pledge, Kathy Ryan, Sebastião Salgado, Gregoire Sauter, Bob Shamis, the editor and staff of the Sunday Times Magazine, Yoshiko Suzuki, Darcy Tell, Martha Takayama and Teizo Umezu.

We appreciate the support of photo agencies and photographers' representatives and would like to recognize and thank Associated Press, Black Star, Contact Press Images, Agenzia Contrasto, Corbis, Agencia EFE, Agence France Presse, Gamma, Getty Images, Laif, Tiggy Maconochie, Magnum Photos, NB Pictures, Network Photographers, Grazia Neri, Novosti, Panos Pictures, Polaris Images, Reuters, Marco Santucci, Sipa Press, Sygma, Agence Vu and VII.

This book accompanies a World Press Photo touring exhibition, curated by Christian Caujolle, opening at Foam Photography Museum, Amsterdam, in October 2005.

For Robert Lebeck.

Chapter opener photographs: page 4, *Die Woche* 17 January 1955, photograph by Waldemar Dürst; 6, *Time* 4 October 2000, photograph by James Nachtwey; 8, *Berliner Illustrirte Zeitung* 21 July 1929, photograph by Martin Munkacsi; 34, *Stern* 10 January 1959, photographs by Rolf Gillhausen; 106, *Life* 16 April 1965, photograph by Larry Burrows; 198, *New York Times* 30 July 1978, photograph by Susan Meiselas; 236, *Du* November 1992, photograph by Daniel Schwartz; 296, *Süddeutsche Zeitung* 14 May 2004, photograph by Ulrike Myrzik and Manfred Jarisch; 376 top, *Paris Match* 30 December 2004, photograph by Leila Hannach; 376 bottom, *Paris Match* 12 January 2005, photograph by Philip Blenkinsop.

World Press Photo Foundation

Executive Board

Chairman: Gerrit Jan Wolffensperger, former president board of management Netherlands Public Broadcasting, chairman Netherlands Photographers Federation. Vice chairman: Ron Wunderink, director Inconnection. Treasurer: Lillan Baruch, managing partner Interconsultants. Secretary: Vincent Mentzel, staff photographer NRC Handelsblad. Members: Ruud Taal, director & photographer Capital Photos.

Members: Peter Bakker, chief executive officer TNT; Andrew Boag, pr manager Canon Consumer Imaging Europe; Pieter Broertjes, editor-in-chief de Volkskrant; Peter Dejong, photographer Associated Press; Jan Geurt Gaarlandt, editor-at-large Balans Publishing House; Jan Christiaan Hellendoorn, director internal and external communications Albert Heijn; Bart Nieuwenhuijs, photographer studio XS; Dirk van der Spek, publisher/editorin-chief Focus Media Group; Ronald J. Vles, Van Benthem & Keulen, attorneys-at-law.

International Advisory Board

Executive Board: Christiane Breustedt, Germany; Christian Caujolle, France; Colin Jacobson, UK; Claudine Maugendre, France; Stephen Mayes, UK; Randy Miller, USA; Daniela Mrázková, Czech Republic; Grazia Neri, Italy; Robert Pledge, France/USA; Tamás Révész, Hungary; Teizo Umezu, Japan.

Members: Christopher Angeloglou, UK; Floris de Bonneville, France; Harold Buell, USA; Arnold Drapkin, USA; Harold Evans, USA; Eva Keleti, Hungary; Péter Korniss, Hungary; Prof. Erich Lessing, Austria; Mochtar Lubis, Indonesia; John G Morris, France; Michael Rand, UK.

World Press Photo UK Committee

Chairman: Michael Rand, consultant art director. Executive chairman: Neil Burgess, managing director NB Pictures. Members: Christopher Angeloglou, freelance consultant; Steve Blogg, director of photography, editorial, Getty Images; Chris Boot, publisher; Colin Jacobson, programme leader MA Photography, Falmouth College of Arts; Caroline Metcalfe, director of photography Condé Nast Traveller, Condé Nast publications.

World Press Photo France Committee

Christian Caujolle, art director Agence and Galerie Vu; Claudine Maugendre, director of photography Le Vrai Papier Journal.

World Press Photo is sponsored worldwide by Canon & TNT.

Supporters:

Dutch Postcode Lottery

BankGiroLoterij / Kleurgamma Photolab Amsterdam / Netherlands Ministry of Foreign Affairs

Contributors:

Sanoma Magazines / Stichting Democratie en Media City of Amsterdam / Aris Blok, Velsen-Noord / ASP4all / The Associated Press / DDB Amsterdam, Drukkerij Mart.Spruijt / Fiat Auto Nederland BV / Fotoware a.s./ Graphic Converter/Lemke Software / Hilton Amsterdam / Hotel Arena / MediaCatalyst / Nederlands Uitgeversverbond-Nederlandse Dagbladpers / NH Barbizon Palace Hotel / PricewaterhouseCoopers / SkyNet Worldwide Express / Stichting Sem Presser Archief / VSB-fonds *Front cover*: Susan Meiselas, Nicaragua, June 1978 *Back flap: New York Times Magazine*, July 1978, Susan Meiselas

things as they are PHOTOJOURNALISM IN CONTEXT SINCE 1955

By Mary Panzer With an Afterword by Christian Caujolle © World Press Photo 2005

First published 2005 by Chris Boot

First Aperture edition published in collaboration with Chris Boot and World Press Photo

Conceived & produced by Chris Boot Project editors: Sophie Spencer-Wood, Bruno Ceschel; Project editors for World Press Photo: Kari Lundelin, Marc Prüst; Additional text: Bruno Ceschel, Roger Hargreaves; Copy photography: Ian Bavington-Jones Design by SMITH

Printed and bound in Italy by EBS 10987654321

All rights reserved. No part of this publication may be reproduced, stored in a retrieval system or transmitted in any form or by any means, electronic, mechanical, photocopying, record or otherwise, without the prior permission of the publisher.

Library of Congress Control Number: 2005931654 ISBN 1-59711-014-0

aperturefoundation 547 West 27th Street New York, N.Y. 10001 www.aperture.org

The purpose of Aperture Foundation, a non-profit organization, is to advance photography in all its forms and to foster the exchange of ideas among audiences worldwide.

Aperture Foundation books are available in North America through: D.A.P./Distributed Art Publishers 155 Sixth Avenue, 2nd Floor New York, N.Y. 10013 Phone: (212) 627-1999 Fax: (212) 627-9484

World Press Photo Jacob Obrechtstraat 26 1071 KM Amsterdam The Netherlands Phone: +31(0)20 676-6096 Fax: +31 (0)20 676-4471 Email: office@worldpressphoto.nl TR 820 . P2935 2005

TR 820 .P2935 2005 Panzer, Mary. Things as they are

DATE DUE			
	A Salar		
	Calarian State		
			1.1.1
GAYLORD No. 2333			PRINTED IN U.S.A.